Advance Praise for *Adobe Photoshop CS3 One-on-One*

"As a Photoshop author, I hate picking up a book and learning things I didn't already know. But Deke's done it to me again! If you want to learn Photoshop CS3 from the ground up, look no further."

—Scott Kelby
President, National Association of Photoshop Professionals

"Adobe Photoshop CS3 One-on-One is like having Deke next to you while you learn how to organize, correct, retouch, and sharpen your photos. To me it's crystal clear! Deke loves exploring software to find the best techniques for improving images. And his easy-to-understand, cut-to-the-chase explanations are invaluable."

—Katrin Eismann
Chair, Digital Photography, School of Visual Arts

"Any book from Deke is always an asset to a professional's library. To a hobbyist, its a must!"

—Bert Monroy
artist, Photoshop author, 2004 inductee of The Photoshop Hall of Fame

"*Adobe Photoshop CS3 One-on-One* is a must-have book. Its author, Deke McClelland, is a treasure, and a rare master who beautifully shares his wisdom and experience with us all."

—Mikkel Aaland
photographer, author of *Photoshop RAW*

"It's like having Deke right there with you, with all his friendly insights, sharp skills, and vast experience. Only you don't have to feed him."

—Michael Ninness
Director of Product Management, lynda.com

"Deke will entertain you as much as teach you in this book (you might even laugh out loud!). If you are looking to learn Photoshop CS3 from the master, get this book!"

—Tim Grey
author of *Photoshop CS3 Workflow* and *Adobe Photoshop Lightroom Workflow*

Advance Praise for *Adobe Photoshop CS3 One-on-One*

"It's obvious why Deke is one of the most popular teachers of Photoshop. Throughout the book, he blends humor and authority in a way that makes simple work of Photoshop's most complex features. You feel like he's right there with you. It really is one-on-one!"

—Julieanne Kost
Photoshop Evangelist, Adobe Systems

"What an awesome way to get deep inside Photoshop CS3: with lessons and techniques that are easy to follow and bring a new insight! Thanks Deke, for the pearls of wisdom and wonderfully illustrated lessons and references. This book helps us develop techniques to bring image quality to a new level. A great source of learning, *one on one!*"

—Eddie Tapp, M.Photog.,Cr.,MEI,API,CPP
imaging and workflow consultant, educator, photographer, author

"Once again Deke pushes Photoshop training to the next level. His new book is a giant leap forward in the evolution of teaching Photoshop in easy-to-learn and understandable steps. *Adobe Photoshop CS3 One-on-One* is the next generation of how to learn Photoshop!"

—Kevin Ames
photographer, author of *Adobe Photoshop CS: The Art of Photographing Women*

"*Adobe Photoshop CS3 One-on-One* provides more bang-for-the-buck than any Photoshop book I've seen. With the very readable full-color pages and the incredible video training, Deke gives you a multi-media package, rather than just a Photoshop book. Informative and entertaining, instructional and engaging, *One-on-One* is appropriate both for self-study and classroom use. It's the fundamentals of Photoshop taught by one of the most accomplished Photoshop instructors of all time!"

—Pete Bauer
Help Desk Director, National Association of Photoshop Professionals

"With his *One-on-One* series, Deke McClelland has created what might just be the best all-around way to learn Photoshop. The combination of video material, which is created specifically for the book, along with the project-based lessons in each chapter, is unbeatably effective. Highly recommended!"

—Colin Smith
Proprietor, *photoshopCAFE.com*

Adobe
Photoshop CS3
one-on-one™

Also from Deke Press

Adobe Photoshop CS2 One-on-One
Adobe InDesign CS2 One-on-One
Photoshop Elements 4 for Windows One-on-One

Upcoming titles from Deke Press

Adobe InDesign CS3 One-on-One
Adobe Illustrator CS3 One-on-One

Adobe
Photoshop CS3
one-on-one™

DEKE McCLELLAND

deke™
PRESS
O'REILLY®

BEIJING • CAMBRIDGE • FARNHAM • KÖLN • PARIS • SEBASTOPOL • TAIPEI • TOKYO

Adobe Photoshop CS3 One-on-One

by Deke McClelland

This title is published by Deke Press in association with O'Reilly Media, Inc., 1005 Gravenstein Highway North, Sebastopol, CA 95472.

O'Reilly Media books may be purchased for educational, business, or sales promotional use. Online editions are also available for most titles (*safari.oreilly.com*). For more information, contact O'Reilly's corporate/institutional sales department: 800-998-9938 or *corporate@oreilly.com*.

Managing Editor:	Carol Person		
Associate Editor:	Susan Pink, Techright	**Video Producer:**	Max Smith
Contributing Editor:	Colleen Wheeler	**DVD Management and Oversight:**	Tanya Staples
Editorial Akimbo:	Steve Weiss	**DVD Graphic Design:**	Chris Mattia, Tanya Staples
Indexer:	Julie Hawks	**Live-Action Video:**	Garrick Chow, Melanie Wagner
Technical Editor:	Christine Shock		
Manufacturing Manager:	Sue Willing	**Senior Video Editors:**	Brian Coyle, Paavo Stubstad
Publicist:	Sara Peyton	**Video Editors:**	Scott Erickson, Mike Harrison, Jeff Perkins, Marcel Sylvester, Murphy Ward
Cover and Interior Designer:	David Futato		

Print History:

June 2007: First edition.

Special thanks to Michael Ninness, Lynda Weinman, Bruce Heavin, Jenn Cornelius, David Rogelberg, Sherry Rogelberg, Stacey Barone, Linda Thornton, Jason Woliner, James Dean Conklin, Brian Maffitt, Denise Maffitt, Kevin O'Connor, Mikkel Aaland, Henosir Facifysk, Derrick Story, Laurie Petrycki, Michele Filshie, and Tim O'Reilly, as well as Garth Johnson, Megan Ironside, Val Gelineau, Scott Kelby, Marjorie Baer, Tim Grey, John Nack, Ginna Baldassarre, Addy Roff, and the gangs at iStockphoto.com, PhotoSpin, NAPP, Peachpit Press, Microsoft, and Adobe Systems. Extra special thanks to our relentlessly supportive families, without whom this series and this book would not be possible.

This book was typeset using Adobe InDesign CS2 and the Adobe Futura, Adobe Rotis, and Linotype Birka typefaces.

0-596-52975-9 [10/07]
978-0-596-52975-8 [C]

RepKover™ This book uses RepKover,™ a durable and flexible lay-flat binding.

*To my lovely
Elle, who has my
back when my back
needs havin'.*

CONTENTS

PREFACE

HOW ONE-ON-ONE WORKS

Welcome to *Adobe Photoshop CS3 One-on-One*, another in a series of highly visual, full-color titles that combine step-by-step lessons with more than two hours of video instruction. As the name *One-on-One* implies, I walk you through Photoshop just as if I were teaching you in a classroom or corporate consulting environment. Except that instead of getting lost in a crowd of students, you receive my individualized attention. It's just you and me.

I created *One-on-One* with three audiences in mind. If you're an independent graphic artist, designer, or digital photographer—professional or amateur—you'll appreciate the hands-on approach and the ability to set your own pace. If you're a student working in a classroom or vocational setting, you'll enjoy the personalized attention, structured exercises, and end-of-lesson quizzes. If you're an instructor in a college or vocational setting, you'll find the topic-driven lessons helpful in building curricula and creating homework assignments. *Adobe Photoshop CS3 One-on-One* is designed to suit the needs of beginners and intermediate users. But I've seen to it that each lesson contains a few techniques that even experienced users don't know.

Read, Watch, Do

Adobe Photoshop CS3 One-on-One is your chance to master Photoshop under the direction of a professional trainer with more than twenty years of computer design and imaging experience. Read the book, watch the videos, do the exercises. Proceed at your own pace and experiment as you see fit. It's the best way to learn.

Figure 1.

Adobe Photoshop CS3 One-on-One contains twelve lessons, each made up of three to seven step-by-step exercises. Every lesson in the book includes a corresponding video lesson (see Figure 1) on the accompanying DVD, in which I introduce the key concepts you'll need to know to complete the exercises. Best of all, every exercise culminates in a real-world project that you'll be proud to show others (see Figure 2). The exercises include insights and context throughout so that you'll know not only what to do but, just as important, why you're doing it. My sincere hope is that you'll find the experience entertaining, informative, and empowering.

All the sample files required to perform the exercises are included on the DVD-ROM at the back of this book. The DVD also contains the video lessons. (This is a data DVD, not a video DVD. It won't work in a set-top device; it works only with a computer.) Don't lose, destroy, or otherwise harm this precious DVD-ROM. It is as integral a part of your learning experience as the pages in this book. Together, the book, sample files, and videos form a single comprehensive training experience.

Figure 2.

One-on-One Requirements

The main prerequisite to using *Adobe Photoshop CS3 One-on-One* is having Photoshop CS3 or Photoshop CS3 Extended installed on your system. You may have purchased Photoshop CS3 as a stand-alone package (see Figure 3) or as part of Adobe's Creative Suite 3. (Photoshop CS3 is included with all but the Web Standard edition of Creative Suite 3.) You *can* work through many of the exercises using Photoshop CS2 and earlier versions, but some steps and some entire exercises will not work. All exercises have been fully tested with Adobe Photoshop CS3 but not with older versions.

Figure 3.

Adobe Photoshop CS3 One-on-One is cross-platform, meaning that it works equally well whether you're using Photoshop installed on a Microsoft Windows-based PC or an Apple Macintosh. Any computer that meets the minimum requirements for Photoshop CS3 also meets the requirements for using *Adobe Photoshop CS3 One-on-One*. Specifically, if you own a PC, you will need an Intel Pentium 4, Xeon, or Core Duo processor running Windows Vista (Home Premium or better) or XP with Service Pack 2. If you own a Mac, you need a multicore Intel or PowerPC G4 or G5 processor running Mac OS X version 10.4.8 or higher.

Regardless of platform, your computer must meet the following minimum requirements:

- 512MB of RAM
- 2GB of free hard disk space (1GB for Photoshop, 470MB for the *One-on-One* project files, and the remaining 630MB for Photoshop's scratch disk files)
- 16-bit color video card with 64MB of video RAM
- Color monitor with 1024-by-768 pixel resolution
- DVD-ROM drive
- Broadband Internet connection for extras

To play the videos, you will need Apple's QuickTime Player software version 7.0 or later. Many PCs and all Macintosh computers come equipped with QuickTime; if yours does not, you will need to install QuickTime using the link provided on the DVD-ROM included with this book.

Finally, you'll want to install the *One-on-One* lesson files, color settings, and keyboard shortcuts from the DVD-ROM that accompanies this book, as explained in the next section.

One-on-One Installation and Setup

Adobe Photoshop CS3 One-on-One is designed to function as an integrated training environment. Therefore, before embarking on the lessons and exercises, I ask you to install a handful of files onto your computer's hard drive. These are:

- The QuickTime software (if it isn't already installed)
- All lesson files used in the exercises (470MB in all)
- *One-on-One* Creative Suite color settings
- Custom keyboard shortcuts, dekeKeys

We'll also run through a few Photoshop's preference settings that I suggest you change. These changes are optional—you can follow along with the exercises in this book regardless of your preferences. Nonetheless, I advocate these settings for two reasons: First, they make for less confusion by ensuring that you and I are on the same page, as it were. Second, some of Photoshop preferences are just plain set wrong by default.

PEARL OF WISDOM

Those of you who have used previous editions of this book may recall that I used to provide an automated installation utility. While theoretically convenient, it was prone to failure, in part because there's no predicting where Photoshop and its various support files are installed on your system. So the auto-installer is gone, which turns out to be a good thing. Not only is the success rate higher when you install the files yourself, but it's also a fairly straightforward process and it gives you an early chance to see how a few aspects of Photoshop work.

All of these files are provided on the DVD-ROM that accompanies this book. To install the files, follow these steps:

1. ***Insert the* One-on-One *DVD.*** Remove the DVD from the back cover of the book and place it in your computer's DVD drive. (Note: This disk is a DVD-ROM. It will not run on a set-top DVD player or in a CD-ROM drive.) Then do one of the following, depending on your platform:

 - On the PC, Windows will most likely display a dialog box asking you what action you'd like to perform on the disk. Scroll down the list and click **Open folder to view files using Windows Explorer**.

 - On the Mac, double-click the DVD icon on your computer's desktop.

Figure 4 shows the contents of the DVD. Although this screen shot happens to come from a Mac, you'll see the same six files on a PC, albeit either in list form or with different icons.

2. ***If necessary, get QuickTime.*** If your computer is already equipped with QuickTime, skip to Step 3. Otherwise, double-click the file *PsCS3 Videos.html* on the DVD to open the *Adobe Photoshop CS3 One-on-One* page in your default Web browser. Near the bottom of the screen are two small lines of type, magnified in Figure 5. The first one ends with a link, *www.apple.com/quicktime.* Click it (or just enter that URL into your browser if you prefer) to open a new window to Apple's QuickTime site. Follow the on-screen instructions to download and install the software. After you finish installing QuickTime (if you are asked to restart your system, do so), proceed to the next step.

3. ***Copy the lesson files to your desktop.*** Return to your computer's desktop (called the Explorer under Windows, the Finder on the Mac). Inside the window that shows the contents of the DVD, locate the folder called *Lesson Files-PsCS3 1on1.* This folder contains all the files that you'll be using throughout the exercises in this book. Drag the folder to the desktop to copy it, as you see me doing in Figure 6.

You don't absolutely have to copy the folder to the desktop; you can put it anywhere you want. But be advised, if you put it somewhere other than the desktop, I leave it up to you to find the *Lesson Files-PsCS3 1on1* folder and the files therein for yourself. Nuff said.

4. ***Copy the color settings to your hard drive.*** On the DVD, locate the Adobe CS3 color settings file called *Best workflow.csf.* Copy this file to one of two locations on your hard drive, depending on your platform:

- On the PC, the location is
 C:\Documents and Settings\\user\Application Data\Adobe\Color\Settings
 where user is the username for your computer system.

- On the Mac, choose **Go→Home** and copy the color settings to the folder
 Library/Application Support/Adobe/Color/Settings.

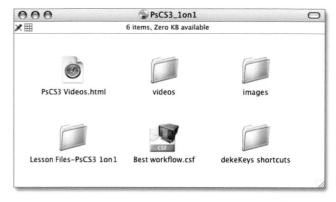

Figure 4.

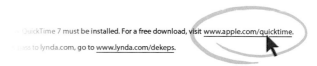

QuickTime 7 must be installed. For a free download, visit www.apple.com/quicktime.
...ess to lynda.com, go to www.lynda.com/dekeps.

Figure 5.

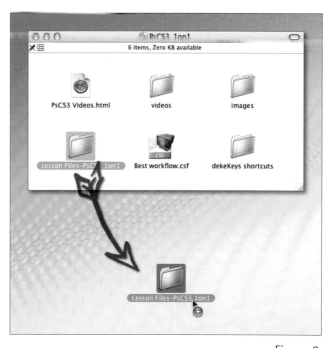

Figure 6.

If you can't find the Application Data folder on the PC, it's because Windows is making the system folders invisible. Choose **Tools→ Folder Options**, click the **View** tab, and turn on **Show Hidden Files and Folders** in the scrolling list. Also turn off the **Hide Extensions for Known File Types** and **Hide Protected Operating System Files** check boxes and click the **OK** button.

5. *Start Photoshop.* If Photoshop CS3 is already running on your computer, skip to Step 6. If not, start the program:

 • On the PC, go to the **Start** menu (under Windows Vista) and choose **Adobe Photoshop CS3**. (The program may be located in the **Programs** or **All Programs** submenu, possibly inside an **Adobe** submenu.)

 • On the Mac, choose **Go→Applications** in the Finder. Then open the *Adobe Photoshop CS3* folder and double-click the *Adobe Photoshop CS3* application icon.

6. *Change the color settings to Best Workflow.* Now that you've installed the color settings, you have to activate them inside Photoshop. Choose **Edit→Color Settings** or press the keyboard shortcut, Ctrl+Shift+K (⌘-Shift-K on the Mac). Inside the **Color Settings** dialog box, click the **Settings** pop-up menu and choose **Best Workflow** (see Figure 7). Then click the **OK** button. Now the colors of your images will match (or very nearly match) those shown in the pages of this book.

If you own the full Creative Suite 3 package (regardless of the edition), you'll need to synchronize the color settings across all Adobe applications. Launch the Bridge application by choosing **File→Browse**. Inside the Bridge, choose **Edit→Creative Suite Color Settings**. Locate the Best Workflow item in the scrolling list. (If you don't see it, turn on the **Show Expanded List of Color Settings Files** check box.) Then click **Apply**. Now all your CS3 applications will display consistent color.

7. *Install the dekeKeys keyboard shortcuts.* Return to the desktop level of your computer and open the *dekeKeys shortcuts* folder on the DVD. There you'll find two versions of my custom dekeKeys keyboard shortcuts, one for the Mac and one for the PC. Double-click the file that corresponds to your platform. Photoshop will spring to the foreground. If you get a message asking if you want to save the changes to your preexisting shortcuts, click **Yes**, give the shortcuts a filename, and click **Save**.

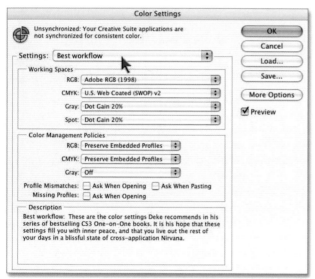

Figure 7.

8. *Confirm the dekeKeys installation.* To confirm that the dekeKeys shortcuts have successfully installed, choose **Edit→Keyboard Shortcuts** and do the following:

 - Confirm that the **Set** option at the top of the **Keyboard Shortcuts** dialog box reads **Photoshop Defaults (modified)**, meaning that some sort of shortcuts shift has occurred.

 - Set **Shortcuts For** to **Application Menus**.

 - Click the ▶ triangle to the left the **File** entry to view the commands in the File menu.

 - Scroll down to the command name **Place** (between Revert and Import). If it lists the shortcut Shift+Ctrl+D (or Shift+⌘+D), then you're looking at dekeKeys.

9. *Save the dekeKeys shortcuts.* Click the disk icon (💾) to the right of the **Set** option to save the modified shortcuts. Name the new shortcuts "dekeKeys CS3" (or your own name if you plan on customizing them further) and click the **Save** button, as in Figure 8. Then click **OK** to complete the process. You now have shortcuts for some of Photoshop's most essential commands, including Variations, Color Range, and Smart Sharpen.

10. *Adjust a few preference settings.* To minimize confusion and maximize Photoshop's performance, I'd like you to modify a few preference settings. Choose **Edit→Preferences→General** (that's **Photoshop→Preferences→General** on the Mac) or press Ctrl+K (⌘-K). Most of the default preferences are fine, but I would like you to change a few of them:

 - Photoshop lets you copy big images. And when you switch programs, Photoshop conveys those copied images to the system. Problem is, that takes time and the operation often fails. Best to avoid this problem and the associated delays by turning off the **Export Clipboard** check box.

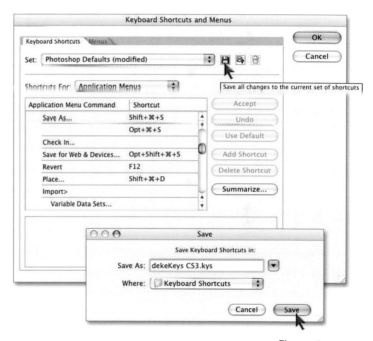

Figure 8.

- If you use a PC, turn on **Zoom Resizes Windows**. (On the Mac, it's on by default.) This option resizes the image window to accommodate changes in the zoom ratio, and trust me, you want that.

- Turn off the **Use Shift Key for Tool Switch** check box. This makes it easier to switch tools from the keyboard, as we'll be doing frequently over the course of this book. I've highlighted this and the preceding check boxes in Figure 9. Red means turn the option off, green means turn it on.

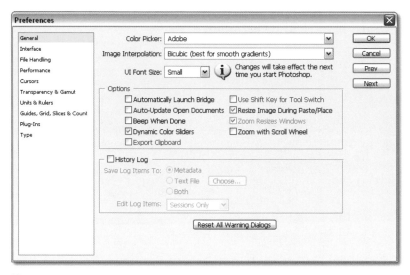

Figure 9.

- Click on **File Handling** in the left-hand list. Or press Ctrl+3 (⌘-3 on the Mac). This switches you to a new panel of options.

- Notice the pop-up menu labeled **Maximize PSD and PSB File Compatibility**? Unless you're a video professional, this option is best turned off. So set it to **Never**.

- Unless you work with a group that employs Adobe's Version Cue technology, turn the **Enable Version Cue** check box off, highlighted red in Figure 10.

- Click on **Display & Cursors** in the left-hand list, or press Ctrl+5 (or ⌘-5) to switch panels.

- Turn on the **Show Crosshair in Brush Tip** check box. Highlighted green in Figure 11 at the top of the facing page, this option adds a + to the center of every brush cursor, which helps you align the cursor to a specific point in your image.

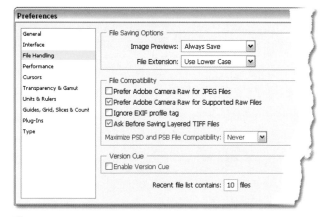

Figure 10.

- Click **Units & Rulers** in the left-hand list, or press Ctrl+7 (or ⌘-7) to display another panel of options.

- Set the **Rulers** pop-up menu to **Pixels**, which I've highlighted green in Figure 12. As you'll see, pixels are far and away the best unit for measuring digital images.

- Your preferences now match those of the loftiest image editing professional. Click **OK** to exit the Preferences dialog box and accept your changes.

11. *Quit Photoshop.* You've come full circle. On the PC, choose **File→Exit**; on the Mac, choose **Photoshop › Quit Photoshop**. Quitting Photoshop not only closes the program, but also saves the changes you made to the color settings and keyboard shortcuts.

Congratulations, you and I are now in sync. Just one more thing: If you use a Macintosh computer, the system intercepts a few important Photoshop keyboard shortcuts, which you'll want to modify according to the following tip. If you use a PC, feel free to skip the tip and move along to the next section.

Figure 11.

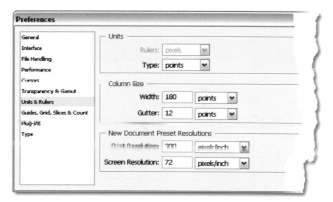

Figure 12.

Adobe intends ⌘-Option-D to choose the Feather command (which softens selection outlines, as you'll learn in Lesson 4). But under some versions of OS X, it hides the row of application icons known as the *dock*. To rectify this and other conflicts, choose **System Preferences** from the menu. Click **Show All** at the top of the screen, click the **Keyboard & Mouse** icon, and click **Keyboard Shortcuts**. Scroll down the shortcuts until you find one called **Automatically Hide and Show the Dock**. Click the ⌘⌥D shortcut to highlight it. Then press Control-D (which appears as ^D). Figure 13 shows a list of other shortcuts, all modified to avoid competition with Photoshop (except for Dictionary, which remains set to its default). When you have changed all of these shortcuts—to those shown in Figure 13, if you like—click the ⊗ in the upper-left corner of the window to close the system preferences. From now on, Control-D hides and shows the dock and ⌘-Option-D chooses Photoshop's Feather command.

If you run into other system-level conflicts with Photoshop for the Mac, most likely, you'll want to use the Keyboard Shortcuts section of the Keyboard & Mouse system preferences to solve them.

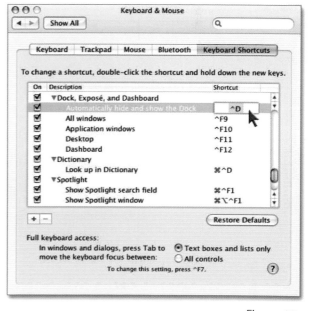

Figure 13.

Playing the Videos

At the outset of each of the lessons in this book, I ask you to do something most books don't ask you to do: I ask you to play a companion video lesson from the DVD-ROM. Ranging from 10 to 17 minutes apiece, these video lessons introduce key concepts that make more sense when first seen in action.

Edited and produced by the trailblazing online training company lynda.com, the video lessons are not traditional DVD movies. They're better. A standard DVD movie maxes out at 720-by-480 nonsquare pixels, of which only 720-by-240 pixels update at a time (an antiquated and generally unfortunate phenomenon known as *interlacing*). We have no such restrictions. Our movies play at resolutions as high as 880-by-660 pixels (see Figure 14), and every pixel updates at the same rate. The result is a high-quality, legible screen image, so that you're never squinting in an attempt to figure out what tool or command I'm choosing. And thanks to lynda.com's considerable experience supplying movies over slow Internet connections, every movie plays smoothly, even on older-model computers. This is video training at its finest.

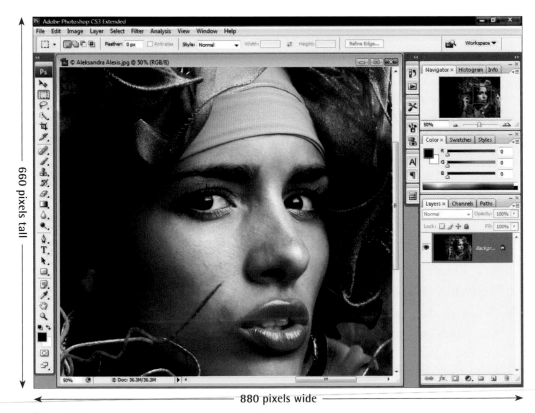

Figure 14.

Readers frequently ask me if the videos are excerpted from one of my full-length video series. The question comes up so often that I'm going to answer it preemptively: No. Every minute of the nearly three hours of video on the DVD is unique to this book. (The total length of the videos comes to two hours and 54 minutes. I know, the cover says "over 2 hours" and it's really just six minutes shy of three. Better to under-promise and over-deliver. Besides, I didn't want to overwhelm you.)

To watch a video, do the following:

1. *Insert the One-on-One DVD.* The videos reside in a folder called *videos*. You can copy that folder (which weighs in at 560MB) to your hard drive and play the videos inside QuickTime if you like. But that's by no means necessary, nor do I encourage it. I designed the videos to play from a simple Web page interface directly from the DVD, as these steps explain.

2. *Launch the video interface.* Open the DVD so you can see its contents. Then double-click the file named *PsCS3 Videos.html* to open the *Adobe Photoshop CS3 One-on-One* page in your default Web browser, as pictured in Figure 15.

3. *Click the link for the video lesson you want to watch.* The left side of the page offers a series of 17 links, each of which takes you to a different video. Click one of the five bold items to watch a live-action segment from your cordial host, me. The indented links take you to one of the twelve video lessons that accompany the twelve lessons in this book. You can watch the video lessons in any order you like. However, each makes the most sense and provides the most benefit when watched at the outset of the corresponding book-based lesson.

4. *Watch the first introductory video.* Click the **Navigation and Color Correction** link to watch the first welcoming message. It explains a bit more about how the book and video lessons work with each other. Plus, it permits me to accost you with some down-home, personal-training love.

Figure 15.

5. ***Watch the video lesson at your own pace.*** Use the play controls under the movie to play, pause, or jump to another spot in the movie. You can also take advantage of the following keyboard shortcuts and hidden tricks:

- Click inside the movie to pause it. Double-click to send the movie playing again.

- You can also pause the video by pressing the spacebar. Press the spacebar again to resume playing.

- I don't know why you'd want to do this, but you can play the video backward by pressing Ctrl+← (⌘-← on the Mac). Or Shift-double-click in the movie.

- Drag the circular playhead (labeled in Figure 16) to shuttle back and forth inside the move. Or just click in the timeline to move to a specific point in the video.

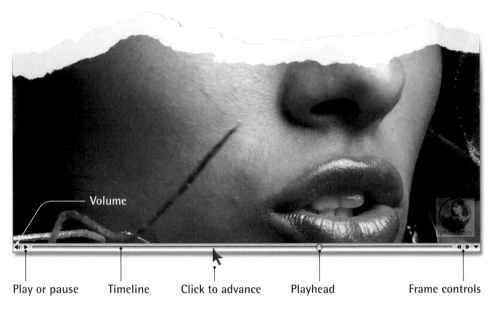

| Play or pause | Timeline | Click to advance | Playhead | Frame controls |

Figure 16.

- Press the ← or → keys to pause the movie and go backward or forward one frame.

- Press Ctrl+Alt+← (Option-←) to return to the beginning of the movie.

- Use the ↑ and ↓ keys to raise or lower the volume.

Here's a really weird one: Press the Alt key (Control on the Mac) and drag in the frame controls in the bottom-right corner of the window to change the playback speed.

That last technique is an undocumented trick dating back to the early days of QuickTime. It's hard to predict, but with a little bit of experimenting, you can fast-forward over the tedious stuff (when will I stop yammering?) or slow down the really useful information that otherwise goes by too fast.

PEARL OF WISDOM

One final note: Unlike the exercises inside the book, none of the video lessons include sample files. The idea is, you work along with me inside the book; you sit back and relax during the videos.

Structure and Organization

Each of the lessons in the book conforms to a consistent structure, designed to impart skills and understanding through a regimen of practice and dialog. As you build your projects, I explain why you're performing the steps and why Photoshop works the way it does.

Each lesson begins with a broad topic overview. Turn the page, and you'll find a section called "About This Lesson," which lists the skills you'll learn and directs you to the video-based introduction.

Next come the step-by-step exercises, in which I walk you through some of Photoshop's most powerful and essential image-manipulation functions. A DVD icon appears whenever I ask you to open a file from the *Lesson Files-PsCS3 1on1* folder that you installed on your computer's hard drive. To make my directions crystal clear, command and option names appear in bold type (as in, "choose the **Open** command"). The first appearance of a figure reference appears in colored type. More than 850 full-color, generously sized screen shots and images diagram key steps in your journey, so you're never left scratching your head, puzzling over what to do next. And when I refer you to another step or section, I tell you the exact page number to go to. (Shouldn't every book?)

Along the way, you'll encounter the occasional "Pearl of Wisdom," which provides insights into how Photoshop and the larger world of digital imaging work. Although this information is not essential to performing a given step or completing an exercise, it may help you understand how a function works or provide you with valuable context.

More detailed background discussions appear in independent sidebars. These sidebars shed light on the mysteries of color, bit depth, resolution, and other high-level topics that are key to understanding Photoshop.

A colored paragraph of text with a rule above and below it calls attention to a special tip or technique that will help you make Photoshop work faster and more smoothly.

Some projects are quite ambitious. My enthusiasm for a topic may even take us a bit beyond the stated goal. In such cases, I cordon off the final portion of the exercise and label it "Extra Credit."

If you're feeling oversaturated and utterly exhausted, the star icon is your oasis. It's my way of saying, you deserve a break. You can even drop out and skip to the next exercise. On the other hand, if you're the type who believes quitters never prosper (which they don't, incidentally), by all means carry on and you'll be rewarded with a completed project and a wealth of additional tips and insights.

Each lesson ends with a section titled "What Did You Learn?" which features a multiple-choice quiz. Your job is to choose the best description for each of twelve key concepts outlined in the lesson. Answers are printed upside-down at the bottom of the page.

Finally, every so often you'll come across an "Extra Credit Extreme" marker, which includes information about further reading or video training. Often times, I refer you to the lynda.com Online Training Library, which contains tens of thousands of movies, more than a thousand of them by me. And all available to you, by subscription, every minute of every waking day.

Just to be absolutely certain you don't feel baited into making yet another purchase, I've arranged a time-limited back door for you.

Go to *www.lynda.com/dekeps* and sign up for the 7-Day Free Trial Account. This gives you access to the *entire* Online Training Library, including all the movies in my "Extra Credit Extreme" recommendations. But remember, your seven days start counting down the moment you sign up, so time it wisely.

Then again, if you find the service so valuable you elect to subscribe, we're happy to have you. It's all good.

The Scope of This Book

No one book can teach you everything there is to know about Photoshop, including this one. Here's a quick list of the topics and features discussed in this book:

- Lesson 1: File management and navigation, including the new Adobe Bridge, as well as the Batch Rename and Contact Sheet II commands

- Lesson 2: Brightness and contrast adjustments, including the Levels, Curves, and Shadow/Highlight commands, as well as the Histogram palette

- Lesson 3: Color balance adjustments, including the Variations, Hue/Saturation, and Gradient Map commands, as well as the independent digital negative developer Camera Raw

- Lesson 4: Selection tools, including the lasso, magic wand, and pen tools, as well as the Select menu and Paths palette

- Lesson 5: Ways to crop and transform an image, including the crop tool and the Image Size and Canvas Size commands

- Lesson 6: Painting and retouching, including the paintbrush, healing brush, and red eye tools, as well as the Brushes and History palettes

- Lesson 7: Masking functions, including the Color Range and Extract commands, the quick mask mode, and the Channels palette

- Lesson 8: Focus and distortion filters, including the new Smart Sharpen and Vanishing Point commands as well as Photoshop's most powerful distortion function, Liquify

- Lesson 9: Layer functions, including the Layers and Layer Comps palettes, the Layer menu, the Free Transform and Warp commands, and Blending Options

- Lesson 10: Text and shape layers, including the type and shape tools, the Character and Paragraph palettes, and Warp Text

- Lesson 11: Layer styles and specialty layers, including Drop Shadow, Bevel and Emboss, the Styles palette, adjustment layers, and the amazing world of smart objects

- Lesson 12: Print functions, including the Print with Preview, Color Settings, and Picture Package commands

To find out where I discuss a specific feature, please consult the index, which begins on page 504.

Note that this book does not address every feature in Photoshop, including the following: the Actions palette; the Merge to HDR, Pixel Aspect Ratio, and Save for Web commands; or any of the 3D, video, medical, and architectural features available in Photoshop CS3 Extended but missing from the more affordable standard edition of the software.

EXTRA CREDIT ★ EXTREME

If actions in particular are of interest to you, I have an 18-hour video series that covers the wide world of actions, batch processing, droplets, and scripting called *Photoshop Actions and Automation*. To gain access to it right this minute, go to *www.lynda.com/dekeps* and sign up for your seven days.

I now invite you to turn your attention to Lesson 1, "Open and Organize." I hope you'll agree with me that *Adobe Photoshop CS3 One-on-One*'s combination of step-by-step lessons and video introductions provides the best learning experience of any Photoshop training resource on the market.

OPEN AND ORGANIZE

FEAR IS a great motivator. And the good folks at Adobe must agree. Otherwise, why would they have created Photoshop, a program seemingly designed to frighten and intimidate? Why did they make the program vast and complicated, with scores of redundant options, misleading commands, and downright ritualistically obscure functions, all devoted to the seemingly prosaic task of changing the color of a few pixels? And why is Photoshop so intent upon revealing the complexities of color corrections, image manipulations, and brushstrokes (as symbolically illustrated in Figure 1-1) instead of hiding them, the way other computer applications do?

The answers are as numerous as Photoshop's features. As much as I love Photoshop—call me sick, but as much as a man can love a retail computer application, I ❀♡love♡❀ this one—I'm the first to admit that virtually every feature requires a separate defense. Thankfully, the pain of learning this vast and at times ungainly behemoth is its own reward. Mastering a powerful tool such as Photoshop focuses the mind. It toughens the spirit. And in time, it transforms you into an image warrior.

This book takes you on that journey of pain and reward. Sure, there may be occasional times when you'll wonder if Photoshop is Adobe's idea of the Nine Circles of Hell. But just as Dante emerged from the lowest circle by climbing down the very Devil himself, we'll conquer Photoshop by descending directly into it and coming out the other side. We will make peace with Photoshop through understanding, the understanding borne by knowledge, the knowledge wrought by experience. In time, you (like me) will be sick with your ❀♡love♡❀ for Photoshop. That is to say, mastery will be yours.

Figure 1-1.

3

ABOUT THIS LESSON

Before you can use the vast array of tools and functions inside Photoshop, you must know how to open an image, move around inside it, and organize your image files on disk. As glad fortune would have it, that's precisely what this lesson is about. In the following exercises, you'll learn how to:

Video Lesson 1: Navigation

Another topic you should get under your belt right away is navigation. Not *doing* anything to an image, mind you, just moving around inside it: magnifying a portion of an image so you can do detail work, panning to the part of the image you want to modify, even stepping back and filling the screen with the image so you can take it all in.

Insert the DVD and double-click the file *PsCS3 Videos.html*. After the page loads in your Web browser, click **Lesson 1: Navigation** under the **Navigation and Color Correction** heading. The movie lasts 12 minutes and 54 seconds, during which time you'll learn about a dizzying assortment of tools and shortcuts, which I've listed below:

Tool or operation	Windows shortcut	Macintosh shortcut
Zoom in or out	Ctrl+⊞ (plus), Ctrl+⊟ (minus)	⌘-⊞ (plus), ⌘-⊟ (minus)
Magnify image with zoom tool	Ctrl+spacebar-click in image	⌘-spacebar-click in image
Shrink image with zoom tool	Alt+spacebar-click in image	Option-spacebar-click in image
Pan left or right with scroll wheel/ball	Ctrl-scroll up, Ctrl-scroll down	⌘-scroll up, ⌘-scroll down
Scroll up or down	Page Up, Page Down	Page Up, Page Down
Scroll left or right	Ctrl+Page Up, Ctrl+Page Down	⌘-Page Up, ⌘-Page Down
Scroll with the hand tool	spacebar-drag in image window	spacebar-drag in image window
Zoom inside Navigator palette	Ctrl-drag in palette preview	⌘-drag in palette preview
Zoom out so image fits on screen	Double-click hand tool icon	Double-click hand tool icon
Zoom image to actual pixels (100%)	Double-click zoom tool icon	Double-click zoom tool icon
Cycle through screen modes	F	F
Hide or show toolbox and palettes	Tab	Tab
Collapse or expand docking pane	Click ▶▶ or ◀◀ arrows	Click ▶▶ or ◀◀ arrows

What Is Photoshop?

Photoshop, as the fellow says, is an *image editor*. It lets you open an image—whether captured with a scanner or a digital camera or downloaded from the Web—and change it. You can change the brightness and contrast, adjust the colors, move things around, sharpen the focus, retouch a few details, and do scads more. When you're finished, you can save your changes, print the result, attach it to an email, whatever. If you can imagine doing something to an image, Photoshop can do it. It's that capable.

But it doesn't end there. You can also use Photoshop to enhance artwork that you've scanned from a hand drawing or created with another graphics program. If you're artistically inclined, you can start with a blank document and create a piece of artwork from scratch. If that's not enough, Photoshop offers a wide variety of illustration tools, special effects, and text-formatting options, from placing type on a path to checking your spelling.

Opening an Image

Like every other major application on the face of the planet, Photoshop offers an Open command under the File menu. Not surprisingly, you can use this command to open an image saved on your hard disk or some other media. But Photoshop offers a better way to open files: the Adobe Bridge. I'll be showing you several ways to use this independent and powerful application throughout this lesson. The following steps explain the basics:

1. *Start up the Bridge.* Click the icon on the far right side of the options bar or choose **File→Browse**. Both icon and command appear in Figure 1-2. The command's name, Browse, hearkens back to the old File Browser, a staple of Photoshop 7 and CS. Now, choosing File→Browse leaves Photoshop and launches the File Browser's replacement, the Adobe Bridge.

2. *Navigate to the Geneva folder.* The Bridge window is, by default, divided into five main panels: two on the left, the large *content browser* in the middle, and two more on the right, each labeled black in Figure 1-3 on the following page. (Blue-green labels show ancillary options.) The top-left section contains tabs that let you switch between the Favorites and Folders panels. The Favorites panel gives you instant access to commonly used folders, as well as a few places that Adobe thinks you'll find

Figure 1-2.

useful. The Folders panel lets you navigate to a specific folder on your hard disk or other media that contains the file or files you want to open. With that in mind, here's what I want you to do:

- If it isn't already selected, click the **Favorites** tab.

- Click the blue **Desktop** button (or, if you put the lesson files elsewhere or left them on the CD, go there).

- The content browser shows the files and folders on your computer's desktop. Find the folder called *Lesson Files-PsCS3 1on1* (you may have to hover your cursor over it to see the entire folder name) and double-click it.

- Click the **Folders** tab to switch to the *folder tree*, thus termed because it branches off into folders and subfolders.

- On the PC, click the plus sign (⊞) in front of *Lesson Files-PsCS3 1on1* to expand it; on the Mac, click the "twirly" triangle (▶). Then click the ⊞ or ▶ in front of the *Lesson 01* folder.

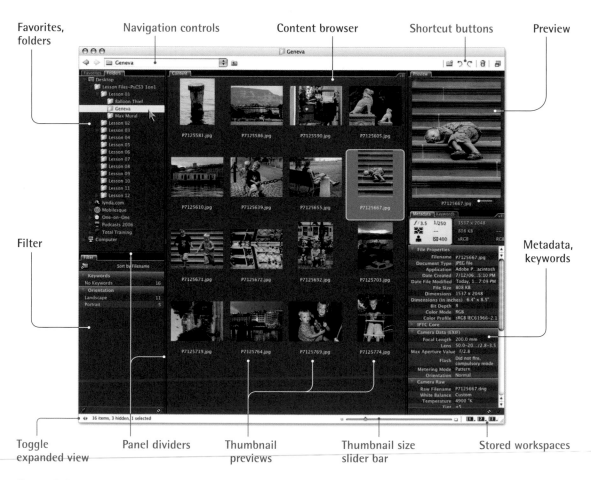

Figure 1-3.

- Finally you'll find a folder called *Geneva*, named for the city in which I shot the photos. Click that folder to fill the content browser with a collection of 16 tiny photographic *thumbnails*, as in Figure 1-3.

To change the size of the thumbnails, drag the slider triangle in the bottom-right corner of the window (labeled *Thumbnail size slider bar* in Figure 1-3).

3. *Select a thumbnail.* Locate and click the thumbnail called *P7125639.jpg*, highlighted in Figure 1-4. (These images were captured and automatically named by a digital camera, hence the cryptic filenames.) This activates the image and displays it in the Preview panel on the right side of the Bridge.

To see more detail, enlarge the Preview panel by dragging the vertical and horizontal panel dividers that separate the five panels.

4. *Double-click the image preview.* Alternatively, you can double-click the selected thumbnail, choose **File→Open**, or press Ctrl+O (⌘-O on the Mac). The Bridge hands off the image to Photoshop, which in turn loads the photograph and displays it in a new image window, as in Figure 1-5. The image is now ready to edit.

PEARL OF 🔵 WISDOM

The title bar lists the name of the image and magnification level followed by a color notation, **RGB/8***. These six characters convey three pieces of information. **RGB** tells you that you're working with the three primary colors of light—red, green, and blue—the standard for scanners and digital cameras. Next, **/8** lets you know that the image contains 8 bits (one byte) of data for each of the red, green, and blue color channels. This means the photo may contain as many as 16.8 million colors, the maximum a typical computer monitor can display. Finally, the asterisk (*) alerts you that you're working in a color environment other than the one you specified in the Color Settings dialog box (see Step 6 of the Preface, page xviii). The upshot: Photoshop is aware of this image's specific needs and is doing its best to accommodate them, thus ensuring accurate color.

Step 2 Step 3

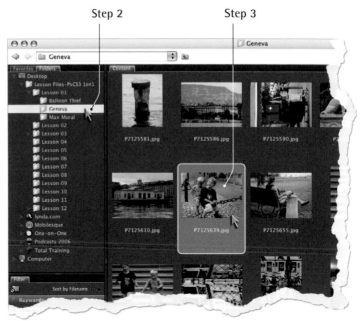

Figure 1-4.

Color notation in parentheses

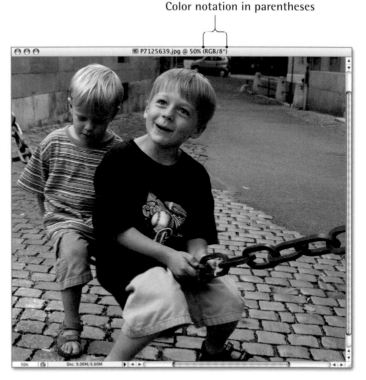

Figure 1-5.

Interface and Image Window

As with most computer applications, bossing around Photoshop is a matter of clicking and dragging inside the program's interface. Labeled in the figure below (which features an evocative photograph by Aleksandra Alexis from the iStockphoto image library), the key elements of the revamped Photoshop CS3 interface, in alphabetical order, are:

- **Cursor:** The cursor (sometimes called the *pointer*) is your mouse's on-screen representative. It moves as your mouse moves and changes to reflect the active tool or operation. Keep an eye on it and you'll have a better sense of where you are and what you're doing.

- **Cluster bar:** Absent an official term from Adobe, I call a set of stacked palettes represented by side-by-side tabs (such as Layers, Channels, and Paths) a *cluster*. The light gray area above the tabs is the cluster bar. Drag this area to move a cluster. Click the bar to collapse the cluster to tabs only. Click again to expand the cluster.

- **Docking pane:** New to Photoshop CS3, a docking pane contains a group of palettes, stacked one atop the other. Drag a palette tab or cluster bar and drop it onto a docking pane to add another palette to the group. Drop a palette next to an existing pane to begin a new pane.

PEARL OF WISDOM

Generally speaking, I'm a big fan of Photoshop's new interface. But I have to acknowledge one glaring oversight: You can't drag a docking pane to a new location. So much as clicking the dark gray bar at the top of a pane collapses the palettes into icons. To move palettes, you must drag either the light gray cluster bar or the individual palette tabs.

- **Image window:** Each open image appears inside a separate window, thus permitting you to open multiple images at once. In Photoshop, the image window is your canvas. This is where you paint and edit with tools, apply commands, and generally wreak havoc on an image.

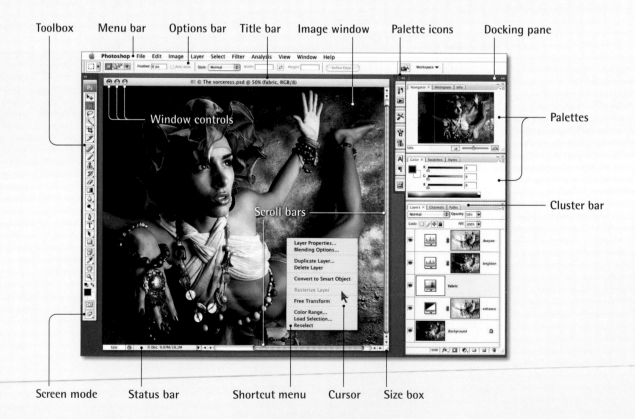

Toolbox Menu bar Options bar Title bar Image window Palette icons Docking pane

Window controls

Palettes

Scroll bars

Cluster bar

Layer Properties...
Blending Options...

Duplicate Layer...
Delete Layer

Convert to Smart Object

Rasterize Layer

Free Transform

Color Range...
Load Selection...
Reselect

Screen mode Status bar Shortcut menu Cursor Size box

- **Menu bar:** Click a name in the menu bar to display a list of commands. Choose a command by clicking on it. A command followed by three dots (such as New...) displays a window of options called a *dialog box*. Otherwise, the command works right away.

- **Options bar:** The settings here modify the behavior of the active tool. The options bar is *context sensitive*, so you see a different set of options each time you switch to a different tool. If the options bar somehow disappears, you can restore it by pressing the Enter or Return key.

- **Palettes:** A palette is a window of options that remains visible regardless of what you're doing. To switch between palettes in a side-by-side cluster, click a named tab. You can also move a palette out of a cluster by dragging its tab. Click the tiny ▾≡ in the top-right corner of a palette to bring up the palette menu.

Drag the left edge of a palette to make a pane wider or narrower. Drag the bottom edge of a palette to make its cluster taller or shorter. In the latter case, Photoshop scales neighboring palettes to accommodate.

- **Palette icons:** When you collapse a docking pane, Photoshop shows its palettes as icons. Click an icon to temporarily display the palette on screen. Click again to hide it. Drag the left edge of the pane to show or hide palette names next to the icons.

- **Screen mode:** Click the last icon in the toolbox or press the F key to cycle between four variations on the image window. An open image may appear in an independent window; fill the area between palettes; or fill the entire screen, with or without the menu bar. Shift-click the icon or press Shift+F to cycle backward between modes.

- **Scroll bars:** Only so much of an image can fit inside the image window at once. In the standard screen mode, the scroll bars let you pan the image horizontally or vertically to display hidden areas. If a scroll bar is empty, you are zoomed out far enough to see the entire width or height of the image. For more information on zooming and scrolling, watch Video Lesson 1, "Navigation," on the DVD (see page 4).

- **Shortcut menu:** Right-click with your mouse to display a shortcut menu of options for the active tool. If your Macintosh mouse doesn't have a right mouse button (older mice from Apple don't), press the Control key and click. Photoshop provides shortcut menus in the image window and inside many palettes. When in doubt, right-click.

- **Size box:** In the standard screen mode, you can drag the bottom-right corner of the image window to make the window bigger or smaller.

- **Status bar:** The bottom-left corner of each and every image window sports a status bar that includes a zoom value, the file size, a preview box, and a pop-up menu of various preview options.

- **Title bar:** In two of the four screen modes, an open image is topped off by a title bar that lists the name of the last saved version of the file on disk. If you haven't saved the image, it may appear as Untitled. Click a title bar to make an image window active so you can edit its contents.

- **Toolbox:** The toolbox provides access to Photoshop's selection and editing tools, as well as common color and screen controls. Click an icon to select a tool and then use the tool in the image window. A tool icon with a triangle (◢) in the bottom-right corner indicates that many tools share a single slot. Click and hold such an icon to display a flyout menu of alternates. Or press the Alt (or Option) key and click an icon to cycle between tools.

Press the Tab key to hide the toolbox, options bar, and all palettes. Press Tab again to bring them back. To hide or show the palettes independently of the toolbox and options bar, press Shift+Tab. Hover your cursor over the right edge of the screen to temporarily see the palettes when hidden.

- **Window controls:** The image window title bar contains three controls that let you minimize, size, and close the window. As illustrated below, the Mac controls are on the left, the Windows controls are on the right.

Apple Macintosh Microsoft Windows

Organizing and Examining Photos

A cynic might argue that the first incarnation of the Creative Suite was largely a marketing scheme designed to get Photoshop users to take up excellent but less popular products such as Illustrator and InDesign. But over time the collection has matured, and the standalone Bridge deserves a lot of the credit. The Bridge is no mere image opener—in many regards, it's a full-blown *digital asset manager.* In the Bridge, you can review images and illustrations, rotate them, delete them, move them to different folders, organize them into collections, and flag them for later use. And now, inside the revamped (and much accelerated!) Bridge 2.0, you can preview images at 100-percent view size, filter which images you see and which you don't, and group related images into stacks. If you have just a few dozen images lying around your hard drive, this may seem like overkill. But if you have a few hundred, a thousand, or a hundred thousand, it's an absolute necessity.

PEARL OF WISDOM

In many ways, the Bridge is a better and more flexible navigation tool than the current Windows or Macintosh operating system. Where else can you whip through a folder of images or illustrations and view instantly scalable, high-quality thumbnails? Or rename a group of files in a single operation? It's a media manager's dream.

To begin to get a sense of what the Bridge can do, including resizing and prioritizing thumbnails, try the following steps:

1. **Open the Bridge.** Click the 🌉 icon in the options bar. Or press the shortcut, Ctrl+Alt+O (or ⌘-Option-O).

2. **Navigate to the Geneva folder.** Click the **Folders** tab in the top-left corner of the Bridge and use the folder tree to navigate to the *Geneva* folder. Again, it's inside the *Lesson 01* folder inside *Lesson Files-PsCS3 1on1.*

3. **Enlarge the thumbnails.** By default, the thumbnails in the content browser are tiny. That's great for assessing the broad contents of a folder, but less than optimal when gauging the images' appearance. To increase the size of the thumbnails, drag the slider triangle in the bottom-right corner of the window, which I've circled in orange in Figure 1-6.

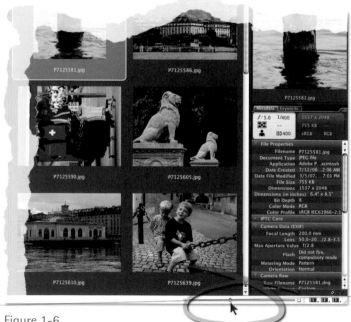

Figure 1-6.

Alternatively, you can zoom thumbnails from the keyboard. After selecting a thumbnail, press Ctrl+⊞ (or ⌘-⊞) to make the thumbnails larger; press Ctrl+⊟ (⌘-⊟) to make them smaller. The maximum thumbnail size is 1024 pixels in either direction.

4. *Move the Preview panel.* When working with large thumbnails, as I find myself doing regularly, the Preview panel serves little purpose. So let's tuck it away. Grab the **Preview** panel by its tab and drag it all the way to the left side of the window until a bright blue outline appears around the Folders panel. Release the mouse button to drop the panel into the top-left section of the Bridge.

5. *Rearrange some more panels.* Drag the **Metadata** panel from the top-right corner of the window to the bottom-left, as demonstrated in Figure 1-7. Similarly, drag the **Keywords** panel as well. This empties out the panels on the right side of the Bridge.

6. *Hide the empty panel.* Double-click the vertical divider that runs along the right edge of the content browser to hide the now-empty right panel. Then click the Folder and Metadata tabs to bring these important panels to the front, as in Figure 1-8.

7. *Save this workspace.* In both Photoshop and the Bridge, a *workspace* stores the basic configuration of the interface—which panels are visible, how panels are arranged, and even

Figure 1-7.

Figure 1-8.

Figure 1-9.

Figure 1-10.

the size of the thumbnails in the content browser. To save your current workspace, choose **Window→Workspace→Save Workspace**. Then do the following:

- Name this setting "Big Thumbs w/ Panels."

- If you like the size and position of the Bridge window, leave the **Save Window Location as Part of Workspace** check box turned on.

- To keep things flexible, I recommend you turn off the second check box, **Save Sort Order as Part of Workspace** (see Figure 1-9), so that you can maintain custom sort orders even after switching workspaces.

- Click **Save**. The saved setting appears as a command in the **Window→Workspace** submenu, permitting you to return to this expanded thumbnail view anytime you like.

8. *Increase the size of the content browser.* One of the downsides of larger thumbnails is that you can see fewer of them at a time. The next few steps will go smoother if we can see most if not all the thumbnails at once. The solution? Increase the amount of screen real estate devoted to the content browser:

- Maximize the Bridge window so it fills the entire screen by clicking the □ on the far right side of the Windows title bar or the ⊕ on the far left side of the Macintosh title bar.

- To gain still more room, turn over the entire Bridge to the content browser by clicking the ◄► icon in the bottom-left corner of the window (as in Figure 1-10) or pressing the Tab key. And by all means, feel free to drag the bottom-right slider triangle again so that the thumbnails adequately fill their new space.

At this exaggerated size, you might feel a bit intimidated by the sheer magnitude of the Bridge. Luckily, the program includes a *compact mode* that lets you toggle between the full view and a pocket size. To toggle the compact mode, click the ⊟ icon in the top-right corner of the window or press Ctrl+Enter (⌘-Return on the Mac). The compact Bridge stays in front of other applications. This means you can preview the contents of a folder while editing an image in Photoshop. Or drag a thumbnail into Microsoft Outlook or Apple's Mail program to create an email attachment. To exit the compact mode, click the ⊡ icon.

9. *Select all sideways images.* The digital camera I used to shoot these photos, an Olympus Evolt E-300 SLR, is smart enough to automatically rotate portrait shots. But every once in a while, a

In many ways, the Bridge behaves like your operating system's desktop-level file manager (called Windows Explorer on the PC and the Finder on the Mac). For example, if you click a thumbnail's filename, the Bridge invites you to enter a new name. Choose File→New Folder to create a new folder. Press the Delete key to toss a selected image in the trash. Through it all, the Bridge magically tracks your changes, never once asking you to save your work.

This may lead you to believe that every change you make is permanent and will be recognized not only by the Creative Suite applications but also by the operating system and other programs. But in fact, some actions are recorded in ways that only the programs in the Creative Suite can recognize; and sometimes even they ignore.

For the record, here are some permanent changes you can make in the Bridge that all applications will recognize:

- Renaming or deleting a file
- Creating or renaming a folder
- Dragging a file from one folder to another

Other changes are permanent, but they are written in such a way that only Photoshop CS3 and other applications that support specific elements of Adobe's XMP (Extensible Metadata Platform) protocol recognize. If an application does not recognize a particular XMP tag, the change is ignored. Such changes include:

- Rotating an image
- Assigning a rating or label
- Custom Camera Raw settings

The final variety of changes are temporary. The Bridge saves these to proprietary files called *caches*:

- The sort order of files in a folder
- Any and all image stacks in a folder
- Stunning, high-quality thumbnails

Although permanent and XMP changes are 100-percent safe, sort order and thumbnails are maintained only if you move and rename files and folders inside the Bridge. This is because the Bridge tracks temporary changes based on the *path*, or

specific location, of a file. If that path changes even slightly without the Bridge knowing about it—say, if you rename files or move them from the desktop—the program loses track of the files and the information is lost.

It might seem a tad fastidious to worry over such quick and invisible changes. After all, it only takes a moment for the Bridge to draw a thumbnail. But transfer a folder containing hundreds or even thousands of images to a CD without including their thumbnails and these moments can add up to a massive delay.

What's a savvy user to do? Tell the Bridge to stop hoarding centralized cache files deep in the system level of your computer and instead save them in the same folder as the images themselves. This way, the cache files stay with their images no matter what you name a folder or where you move it.

- Choose **Edit→Preferences** (**Bridge→Preferences** on the Mac) or press Ctrl+K (⌘-K).

- Click the word **Thumbnails** on the left side of the dialog box and select the option **Convert to High Quality When Previewed**. This ensures the best, fastest thumbnails.

- Click the word **Advanced** on the left side of the dialog box, select the **Automatically Export Caches To Folders When Possible** option (circled below). Then click **OK**. From now on, the Bridge will add two invisible cache files to every folder that you view in the program, one to track stacks, sort order, and other Bridge information, and the other for thumbnails.

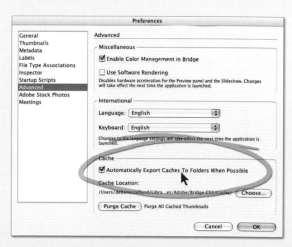

digital photo that should be vertical comes in horizontally. Among the 16 images in the *Geneva* folder, 3 are lying on their sides. No problem, the Bridge can turn them upright.

Select the three images highlighted with yellow borders in Figure 1-11 by clicking one and Ctrl-clicking (or ⌘-clicking) the other two.

If the images were sequential, you could click one and Shift-click another to select the entire range in between. Or hold down Shift while pressing one of the arrow keys (↑, ↓, ←, →). With each keystroke, the Bridge adds a single thumbnail to the selection.

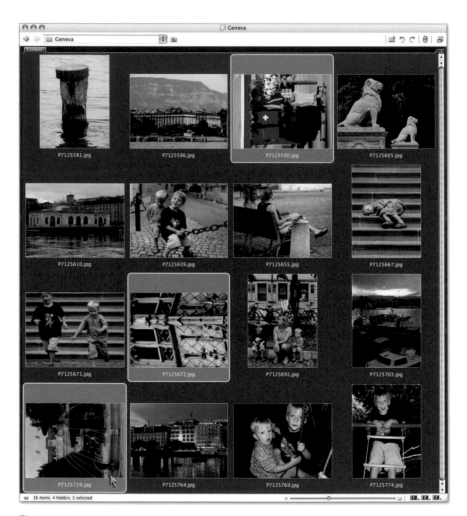

Figure 1-11.

10. ***Stand the thumbnails upright.*** In the upper-right corner of the Bridge is a group of five shortcut buttons. Click the ↻ button, as I'm doing in Figure 1-12 on the facing page. This rotates the selected thumbnails 90 degrees clockwise, so they snap upright.

To rotate a selected thumbnail clockwise from the keyboard, press the Ctrl or ⌘ key with the right bracket key, ⬚. Press Ctrl+⬚ or ⌘-⬚ to rotate the thumbnail counterclockwise.

It might sound odd, but the Bridge does not rotate the images when you click ↻. Rather, it rotates the thumbnails and appends a bit of extra information to the files that lets Photoshop know to rotate the images if and when you open them. A program that does not recognize this rotation instruction—such as your operating system, a Web browser, or even an older version of Photoshop (CS or earlier)—will open the image as it really is, on its side.

11. *Prioritize thumbnails by dragging them.* You can sort thumbnails by filename, creation date, size, and several other attributes by choosing a command from the top-right corner of the Filter panel or from the View→Sort submenu. But you can also create custom sorts by dragging selected thumbnails in the Bridge. Drag the rotated thumbnails to before the first thumbnail, as illustrated in Figure 1-13. A thick vertical line shows where the thumbnails will land.

The Bridge automatically saves your manual thumbnail reorganization as a custom sort state. This means you can choose View→Sort→Filename to alphabetize the thumbnails, and later restore your manual sort state by choosing View→Sort→Manually.

12. *Switch to the Vertical Filmstrip workspace.* Our next task is to evaluate a few images and decide which ones are the "money shots," the photos worth enhancing and manipulating in Photoshop. And that means being able to view and compare images inside a generously allotted Preview panel. To establish such a panel, click and hold the ▪ icon in the bottom-right corner of the Bridge window, then choose the **Vertical Filmstrip** command. The Bridge switches to a predefined workspace that displays a slim,

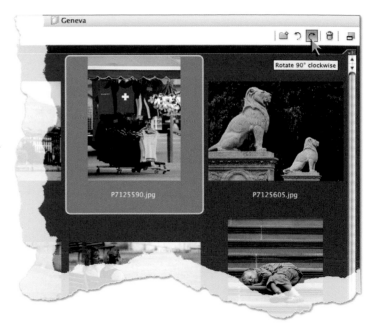

Figure 1-12.

Figure 1-13.

vertical Contents panel along the right side of the screen with a large Preview panel in the middle, ideal for evaluating a day's shoot on a wide-format screen.

PEARL OF WISDOM

If you're familiar with the previous version of the Bridge, you may wonder why Adobe swapped the sensible thumbnail and filmstrip icons for the meaningless **1**, **2**, and **3**? Because **1**, **2**, and **3** can be any workspaces you want them to be. By choosing Vertical Filmstrip from the **2** button, you set **2** to be Vertical Filmstrip. (By default, **2** is Horizontal Filmstrip, which in my experience is ill suited to modern wide-format LCD screens.) Now you have only to click on the **2** to return to this flexible photo-review mode.

Assuming that your rotated thumbnails remain selected, you should now see enlarged views of all three images in the Preview panel, as in Figure 1-14, thus making comparisons a snap. In contrast, the previous version of the Bridge allowed you to preview just one image at a time.

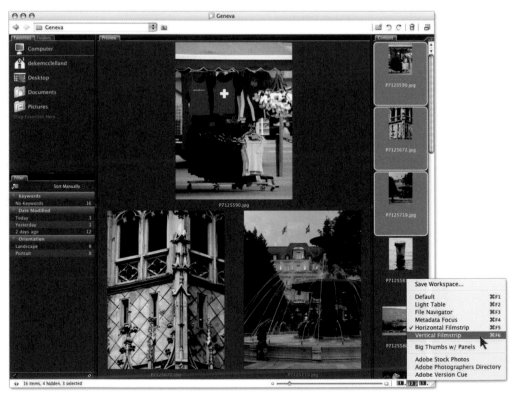

Figure 1-14.

13. ***Hide the panels on the left.*** Double-click the vertical divider along the left edge of the Preview panel to hide the panels on the left side of the Bridge window and devote more room to the large image preview.

14. ***Advance from one image to the next.*** Press the ↓ or → key to select the next thumbnail in the content browser and see an expanded version of the image in the Preview panel.

15. ***Single out the exemplary images.*** When you come across an image you like, you can mark it for later attention. The Bridge lets you assign each image a specific level of importance by rating it from one to five stars. For example, let's say you gauge the shot of the name-branded buildings across the Rhône with Mont Saleve rising in the background—filename *P7125586.jpg*—to be a four-star image. Here are your options:

 - Choose **Label**→★★★★, as in Figure 1-15.

 - Notice the row of five dots immediately below the selected thumbnail and above the filename in the content browser? Click the fourth dot and the · · · · · changes to ★★★★.

 - Press Ctrl+4 (⌘-4 on the Mac).

Figure 1-15.

To assign another thumbnail three stars, select it and click the third dot or press Ctrl+3 (⌘-3), and so on. To remove a star rating, click to the left of the first ★ (so that you see a small, momentary ⊘) or press Ctrl+⓪ (⌘-⓪).

If a yellow hint box obscures your view as you try to click below a thumbnail, turn the hinting off. Press Ctrl+K (⌘-K) to bring up the Preferences dialog box, click **Thumbnail** in the left column, and turn off **Show Tooltips** near the bottom of the dialog box.

EXTRA ⭐ CREDIT

At this point, I extend you the courtesy of opting out of the following steps. After all, you've stuck with it this far; if you're tiring, take a break. But like any good teacher, I have to let you know that I wouldn't have included the remaining steps if I didn't consider them of the utmost importance. So even if you take a break now, try to rejoin me later. Lots of good stuff coming up.

16. *Loupe the lions.* Advance to the next photo, *P7125605.jpg*, which features two lion statues (see Figure 1-16). I like the image, but before I can assign it a rating, I need to inspect the quality of the detail. The Preview panel includes a loupe (pronounced *loop*) function that—like a traditional optical loupe—lets you magnify small areas in a photo. To invoke the loupe:

 • Move the cursor over the image in the Preview panel. It immediately turns into a magnifying glass.

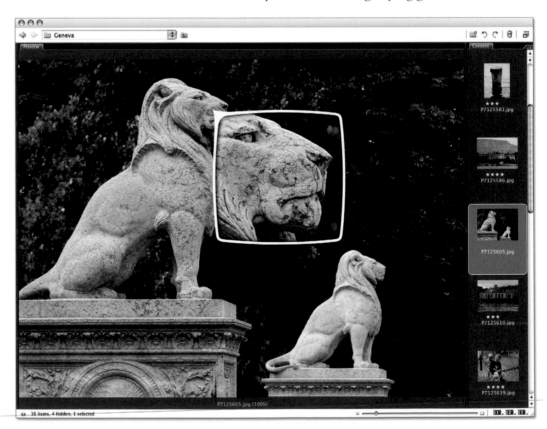

Figure 1-16.

- Click the detail you want to magnify. A rounded square appears with a sharp corner pointing to the center of the magnified view. (In Figure 1-16, I colored the loupe outline white to make it stand out; it's actually always black.)

- Drag the loupe to magnify other details in the image. If you drag too close to an edge, it spins around but the magnified view remains upright.

Use your mouse's scroll wheel (or scroll ball) to zoom in or out with the loupe. If your mouse lacks a scroll wheel, press the ⊞ and ⊟ keys. You can zoom in as far as 800 percent and as far out as 100 percent, as listed at the bottom of the Preview panel.

When you're finished with the loupe, click in it to dismiss it.

17. *Award the image five stars.* The focus checks out, so give it the full measure of your blessing by pressing Ctrl+5 (⌘-5) for five stars. Or give it some other rating, but give it something.

18. *Filter and rate the unrated images.* Bridge 2.0 lets you cut through the clutter by limiting, or *filtering*, the thumbnails that appear in the content browser. To see just those images that you haven't rated, choose **Window→Filter Panel** and then click **No Rating** in the Filter panel list. All star-rated images temporarily disappear, allowing you to focus your attention on images you may have overlooked. Click **No Rating** again to turn off the filter. Try other filter settings to limit which thumbnails you can and cannot see. The Filter panel is great for sifting through a big day of shooting.

19. *Restore the saved workspace.* After you're finished inspecting the images in the Bridge's Vertical Filmstrip mode—no rush, this is a set-your-own-pace publication—it's time to do some final organizing in that Big Thumbs mode that you saved in Step 7. Click and hold the 🔳 button in the bottom-right corner of the Bridge window and then choose **Big Thumbs w/ Panels**, as you see me doing in Figure 1-17. This switches the workspace and assigns new meaning to 🔳. From now on, a simple click on the 🔳 button will take you back to this practical, home-grown workspace.

Figure 1-17.

Bridge 2.0 offers a new organizational tool called an *image stack*. A stack is most useful when trying to cull one or two best pictures from a half dozen or more shot in a single sitting or under similar circumstances. All photos of the bride and groom cutting the cake in one stack, all shots of the bride dancing with her father in another—that kind of thing. I didn't photograph any brides in Geneva, so we'll be assembling an image stack from my family members instead.

20. ***Select all pics of my family.*** Most likely, you don't know my family. So I'll make it easy: The family pics are the ones with people in them. Assuming the images are still sorted in the custom order, here's how I recommend you select them:

- Click the eighth thumbnail, the one of the kids sitting on a chain (labeled ❶ in Figure 1-18).

- Press the Shift key and click the twelfth thumbnail, the one with the three family members, the naked statue, and the bicycles (labeled ❷), to select the range of thumbnails in between.

- The remaining people pics are separated from the other three. So press the Ctrl key (⌘ on the Mac), and click each of them (labeled ❸ in the figure).

❶ Click here

❷ Then Shift-click here

❸ And finally, Ctrl-click (⌘-click) each of these

Figure 1-18.

21. *Group the selected images into a stack.* Choose **Stacks**→**Group as Stack** or press Ctrl+G (⌘-G) to combine the selected images into a single, compact stack. As shown in Figure 1-19, a number (⑦) identifies the quantity of images in the stack. The first image sequentially becomes the stack's thumbnail.

Now that you have a stack, you may ask, what can you do with it? Here are a few things:

- Click the number (in our case, ⑦) to expand the stack and see the files within.

- With the stack expanded, drag a file to the front of the line (see Figure 1-20) or choose Stacks→Promote to Top of Stack to make it the lead image for the stack.

- Drag a file to a location outside the stack to remove it from the stack. You can also drag files into the stack from outside. If you drag one stack into another, the files are assimilated into the second stack and the first stack goes away. (The Bridge does not support nested stacks.)

- Click the number (⑦) again to collapse the stack to a single thumbnail.

- When working with a collapsed stack, clicking on the stack selects just the lead image. Drag the thumbnail to move the corresponding file out of the stack. To select all images in the stack, click the outer slide border or Alt-click (Option-click) the thumbnail. When the entire stack is active the outer border lights up, as Figure 1-21 illustrates.

Figure 1-19.

Figure 1-20.

Click inside the thumbnail to select the lead image only

Click the edge, or Alt-click inside, to select the entire stack

Figure 1-21.

- When an entire stack is selected, you can rate all the images in the stack using any of the techniques described in Step 15 on page 17. You can also rotate all images and view them together in the Preview panel.

- The Bridge even permits you to drag a selected stack and drop it into a different folder in the folder tree. However, note that this undoes the stack and moves all images to the new location, as independent thumbnails.

- To ungroup a stack and return the images to independent thumbnails, add Shift to the standard grouping shortcut, as in Ctrl+Shift+G (⌘-Shift-G on the Mac).

Note that a stack is a Bridge convention. It does not change the files themselves or the location or configuration of the files at your computer's desktop level.

22. ***Add a folder to favorites.*** If you want to view the images in a specific folder on a regular basis, save the folder as a favorite. Right-click the **Geneva** folder in the **Folders** panel (or Control-click if need be on the Mac) and choose **Add Folder to Favorites** from the pop-up menu. Then switch to the **Favorite** panel to see the new Geneva item, indicated by the red arrow in Figure 1-22.

For still more info on organizing and examining images in the Bridge—with some enlightening real-time demos—go to *www.lynda.com/dekeps* and start up your 7-Day Free Trial Account (introduced on page xxvi of the Preface). Then check out the 10-movie, hour-long Chapter 3, "The New and Improved Bridge," one of 27 chapters in my three-part series *Photoshop CS3 One-on-One*.

EXTRA CREDIT ★ EXTREME

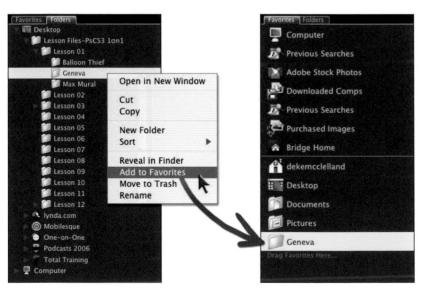

Figure 1-22.

If you have a single file that you use on a regular basis, you can make it a favorite as well. Just drag the file from the content browser and drop it in the empty area at the bottom of the Favorites panel. This works for folders as well.

To get rid of a favorite, right-click it and choose Remove from Favorites. For example, unless you plan on purchasing images from one of Adobe's stock photo partners, you may prefer to remove the Adobe Stock Photos entry, in which case, right-click Adobe Stock Photos and choose Remove. To reinstate one of Adobe's default favorites, press Ctrl+K (or ⌘-K) to bring up the Preferences dialog box. Then select General in the left list and turn on and off the Favorite Items check boxes as desired.

Using Metadata

The prefix *meta* comes from the ancient Greek preposition meaning (among other things) *after*. Nowadays, based in part on English critic Samuel Johnson's derisive characterization of fanciful 17th-century poets as "metaphysical" (by which he meant contrived), it has come to mean *beyond*. And so it is, *metadata* is data beyond the realm of the image.

In sum, metadata is extra information heaped on top of the core image that most applications don't pay any attention to. True to Johnson's vision, metadata is whatever the poet decides to make of it.

Fortunately, despite its otherworldly timbre, metadata has very practical applications. Digital cameras use metadata to record focal length, exposure time, f-stop, and other illuminating information. Search engines use it to retrieve topics and keywords. And designers and photographers can use it to store copyright statements and contact information. If that doesn't stoke the fires of your pecuniary self interest, perhaps the following steps will:

1. **Open the Bridge.** If you're still in the Bridge, stay there. If you've wandered into Photoshop, mosey back out by choosing pressing Ctrl+Alt+O (⌘-Option-O) or clicking the icon in the options bar.

2. **Navigate to the Balloon Thief folder.** Again, this folder is located inside the *Lesson 01* folder inside *Lesson Files-PsCS3 1on1*. Therein, you'll find six photos on the subject of everlasting brotherly love.

3. **Select all the photos and rotate them upright.** Currently, the photos are positioned on their sides. Choose **Edit→ Select All** or press Ctrl+A (⌘-A) to select all six thumbnails. Then click the ↻ icon or press Ctrl+⟧ (⌘-⟧) to turn the images upright. Figure 1-23 shows the results.

4. **Make more room for the metadata.** You'll be working inside the **Metadata** panel in the bottom-left portion of the Bridge, so you might as well make more room for it. Assuming that you're

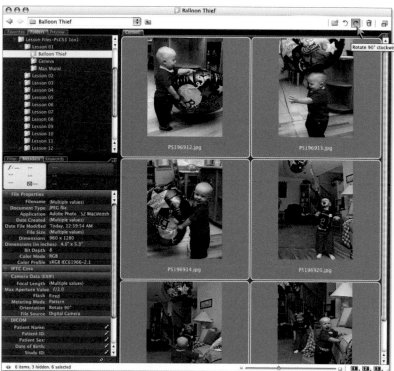

Figure 1-23.

Figure 1-24.

working in the same Big Thumbs workspace in which we ended the preceding exercise, click the **Metadata** tab on the left side of the screen and then drag the horizontal divider between the Folders and Metadata panels upward, as illustrated in Figure 1-24. This expands the Metadata and Keywords panels to about twice their previous size.

5. *Save your workspace.* It may seem compulsive, but there's no time like the present to develop good habits. And saving workspaces is about the best habit I know of that doesn't involve a toothbrush. Choose **Window→Workspace→Save Workspace** from the Photoshop menu bar, name the setting "Metadata," and click **Save**. Now you have a special metadata view that will serve you well into your dotage.

6. *Select a single thumbnail.* Each image contains different metadata, so you'll generally want to review one image at a time. Choose **Edit→Deselect All** or press Ctrl+Shift+A (⌘-Shift-A) to deselect all the thumbnails. Then click the picture taken last, titled *P5196922.jpg*. This image is the climax to the series, where one brother expresses displeasure with the habitual aggravated burglary of the other. (So that you can see the photo in all its glory, I zoomed the thumbnail as far as possible in Figure 1-25.)

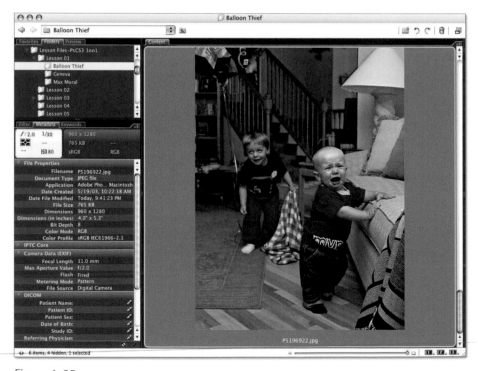

Figure 1-25.

7. *Review the metadata.* The Metadata panel starts off with the *metadata placard*. Detailed in Figure 1-26, the placard lists the most essential information about a photograph in the way it might be presented by a digital camera. A blank (--) means that the information is missing or isn't available in a way the placard understands. For example, each of the images in the *Balloon Thief* folder is set to a resolution of 144 pixels per inch, but the placard can't read it. So the resolution value appears blank, even though it's perfectly safe and readable by Photoshop.

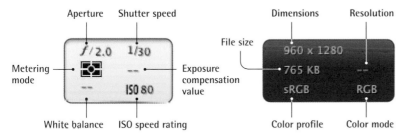

Figure 1-26.

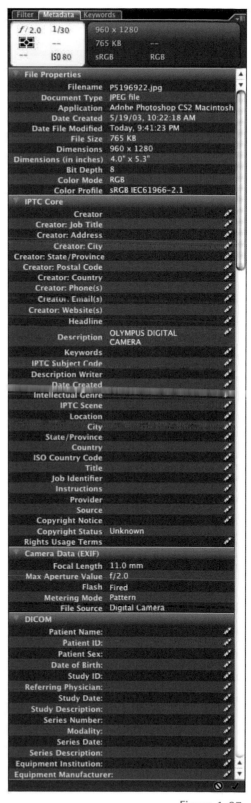

Below the placard, you'll see a few metadata categories that you can open or close. Exactly which categories you see depends on your version of Photoshop CS3, standard or Extended. Pictured in the elongated Figure 1-27, the categories are as follows:

- **File Properties** houses the most elemental image specifications, such as the name of the file, the date it was last modified, the height and width in pixels, and other attributes that have been listed in the header of digital images since the early years of personal computing.

- **IPTC Core** comes from the International Press Telecommunications Council, a group in charge of standardizing the inclusion of credits and instructions in the field of photojournalism. The tiny pencils next to the IPTC items indicate that you can edit the metadata, just as we shall in Step 9. The *Core* part is only there to distinguish this recent update from the format's earlier versions.

- **Camera Data (EXIF)** describes the inception of your photograph as witnessed by a digital camera. *EXIF* stands for Exchangeable Image File, supported by virtually every digital camera sold today. The EXIF data for this particular photograph tells us that it was shot with a wide aperture setting (f/2.0) and wide focal length (11.0mm). I can even confirm that the flash fired.

Figure 1-27.

Figure 1-28.

• **DICOM** appears only with those versions of the Creative Suite that include the more expensive Photoshop CS3 Extended. Short for Digital Imaging and Communications in Medicine, *DICOM* is the imaging standard employed by most hospitals and medical equipment providers worldwide. Whereas a digital photograph is a two-dimensional image—measuring so many pixels wide by so many pixels tall—a DICOM image also has depth. Imagine an MRI scan of a person's head. The device captures X-rays in slices and stores them as a single DICOM file, which can be viewed one slice at a time or as a three-dimensional, inside-out view of the brain and skull. The size of the image is recorded in *voxels*, or volumetric pixels. Unless you're in the medical industry, it's unlikely that you'll encounter a DICOM image. But who knows? Maybe you'll have cause to examine your own DICOM scans (in the distant future, knock on wood).

There's certainly a lot of information here. In fact, for the typical creative professional, I'd call it too much. Most folks don't need the DICOM info. And unless you're a photojournalist or work with one, the more than 30 IPTC Core properties are overkill. Thankfully, you can modify which properties are visible and which are not.

8. *Customize the metadata display options.* Click the ▼☰ in the top-right corner of the **Metadata** panel to display the panel menu. Choose the **Preferences** command to open the Bridge's Preferences dialog box with the Metadata options in full view. Then turn on and off the check boxes as illustrated in the impossibly long Figure 1-28. You'll probably need a magnifying glass to see those check boxes, so I document my recommended changes in the following list:

• If necessary, twirl open the **File Properties** category at the top of the list. Then turn off the check boxes that duplicate properties

that appear in the metadata placard, namely **File Size**, **Dimensions**, **Resolution**, **Color Mode**, and **Color Profile**. You might also turn off Filename since the filenames are listed in the content browser. But I suggest you leave this check box on; seeing the filename in the Metadata panel helps you confirm which image is active.

- Scroll down and turn off the **IPTC Core** check box—which deactivates a whole slew of properties—and twirl it closed. Now you might think, wait a second, some of that stuff was useful. Creator, Description, Copyright—these are properties any professional might need. I agree, which is why I have you restore those options next.

- Twirl open the preceding category, **IPTC (IIM, legacy)**. Short for *Information Interchange Model*, IIM is an older version of the IPTC standard. But most of its properties are the same, and those that aren't tend to be more compatible with Photoshop's other metadata editor, the File Info dialog box (which we'll see shortly). Turn on the following properties: **Document Title**, **Headline**, **Keywords**, **Description**, **Instructions**, **Author**, **Author Title**, **City**, **State/Province**, **Country**, **Copyright**, and **Copyright Info URL**.

- Skip down to **Camera Data (EXIF)** and twirl it open if need be. Then turn on three helpful check boxes, **Orientation** near the middle and **Make** and **Model** at the end. The first tells you whether an image has been rotated by the camera or in the Bridge. The other two list the make and model of the camera used to capture the image.

- Twirl everything that follows Camera Data (EXIF) closed— there's a lot!—to quicken the process of scrolling down the list. (Or zip down with your mouse's scroll wheel; totally up to you.) Then turn off the **DICOM** category. And by all means, if other categories such as Audio and Video are cluttering your Metadata panel, turn them off, too.

Take a moment to make sure the **Hide Empty Fields** check box at the bottom of the dialog box is selected. This frees up room in the panel that would otherwise be wasted on blank attributes that the camera did not record. Then click **OK**.

As shown in Figure 1-29, the Metadata list is now a more manageable length. In a glance, you can see the important information about the image. For example, right at the top of the list, we learn that the image was last modified in the previous

Figure 1-29.

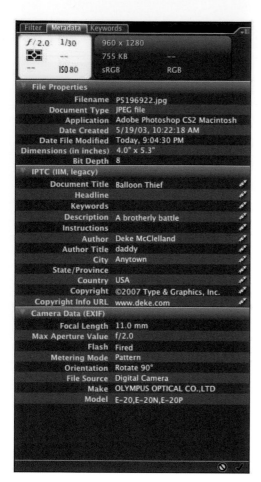

Figure 1-30.

version of Photoshop on a Macintosh computer. I shot the photo a couple of years back—at 10:22 A.M. on May 19, 2003—but I edited it today. Toward the bottom of the list, the Orientation property explains the nature of that edit: Rotate 90°. The metadata ends by reminding me that I captured the photo with an Olympus E-20.

Note that the accuracy of the Date Created property hinges on the veracity of the information recorded by your camera. So if you use a digital camera, make sure you set its time and date properly. A few months from now—when you haven't the vaguest idea of what you did when—you'll be glad you can trust your metadata.

9. *Modify the IPTC information.* Most categories of metadata are fixed attributes of the file. But the IPTC information is editable directly from the Bridge. Go to the IPTC area and click the text to the right of **Author**. The item becomes active, permitting you to edit it. In this example, I changed it to my name, which happens to be accurate on several counts, but you can enter anything you want. Then press the Tab key to advance to the next editable item, my Title, "daddy." Other entries appear in Figure 1-30. If you want to follow them, fine; if not, feel free to go your own way—I was never much of a stickler for metadata decorum. When you finish, press the Enter key on the keypad. If that doesn't work, try Alt+Enter.

To enter the copyright symbol © in the Copyright Notice field, make sure Num Lock is active. Then hold down the Alt key, type 0-1-6-9 on the numeric keypad, and release Alt. (On the Mac, just press Option-G.)

10. *Switch to the Keywords panel.* Click the **Keywords** tab to the right of the Metadata tab. *Keywords* allow you to identify specific items in a photograph and then search for them later. The most obvious concepts for keywords are who, what, and where, represented by the default categories People, Event, and Place. You can create more categories (which Photoshop calls *keyword sets*) and keywords, as we'll see.

11. *Assign a predefined keyword.* Check the **Birthday** item under **Event**. This is, after all, Sammy's Happy Birthday balloon.

12. *Make your own keywords.* Unless all your photographs are of people named Matthew and Ryan, you'll need to create your own keywords. To identify the kids in this domestic squabble, right-click (or if your Apple mouse has just one button, press Control

and click) the **People** item and choose **New Keyword**. Make one keyword for the inconsolable victim, Sammy, and another for the enthusiastic aggressor, Max. Then turn on their check boxes. I also added a couple of keywords under **Place**, namely Home and Living Room (see Figure 1-31). If you're feeling ambitious, you can add your own categories—such as Furniture, Frenzied Action, or Underlying Psychological Motivation—by right-clicking in the panel and choosing **New Keyword Set**.

13. *Mark the image as copyrighted.* Not all metadata info is available from within the Bridge. For example, to mark an image as copyrighted—so that Photoshop displays a copyright symbol in the title bar when you open it—you have to dig a little deeper. Choose **File→File Info** or press the keyboard shortcut Ctrl+Shift+Alt+I (⌘-Shift-Option-I). The ensuing **File Info** dialog box repeats much of the IPTC data you've already entered, including keywords. But there is one notable addition: **Copyright Status**. Set this option to **Copyrighted**.

Figure 1-31.

EXTRA ★ CREDIT

At this point, you're basically finished. The only problem is that it took thirteen steps to annotate a single image. Wouldn't it be great if you could annotate the others without repeating all these steps again? Fortunately, there is a way, as the remaining three steps explain.

14. *Save the metadata template.* To do so, click the ⊙ arrow in the top-right corner of the File Info dialog box and choose **Save Metadata Template**, as in Figure 1-32. Name the template "Birthday Balloon," or words to that effect, and click **Save**. Then click **OK** to exit the dialog box and return to the Bridge.

15. *Select the other images.* Once back inside the Bridge, press Ctrl+A (or ⌘-A) to select all the thumbnails. Then Ctrl-click (⌘-click) the last image to deselect it. The first five thumbnails should be selected.

16. *Apply the template.* Click the ▾◧ icon in the top-right corner of the **Metadata** panel and choose **Replace Metadata→Birthday Balloon**. (If you

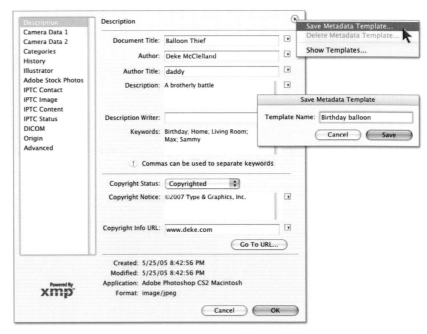

Figure 1-32.

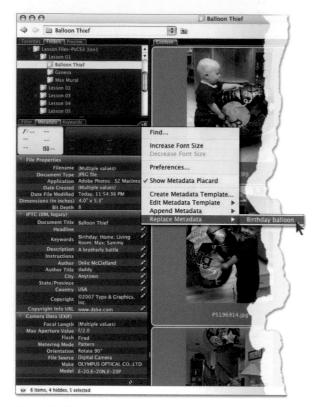

Figure 1-33.

were to choose Append Metadata instead, the Bridge would leave the Description property set to the all-caps Olympus advertisement.) Just like that, the Bridge updates the information in the Metadata panel, as in Figure 1-33.

Photoshop has now applied your IPTC information, your keywords, and the copyright status to all the images inside the *Balloon Thief* folder. And unlike sort order, stacks, and thumbnails (see "The Bridge and Its Slippery Cache," page 13), metadata and keywords are permanently appended to the image file without any additional saving. To confirm this, deselect the thumbnails by pressing Ctrl+Shift+A (⌘-Shift-A on the Mac). Then click any one of the thumbnails. Scroll to the top of the **Metadata** panel and look at the **Date File Modified** item in the **File Properties** section. The date should be today; the time, just a few minutes ago. You can copy these images anywhere you want and your changes to the metadata will travel with them.

Batch Renaming

All these exercises, and we have yet to name a single image. Well, that's about to change. In the next steps, you'll not only name a single image, you'll name lots of images, and all at the same time.

1. *Restore the saved workspace.* We're still inside the Bridge for this exercise. Assuming that you saved the Big Thumbs w/ Panels workspace and assigned it to the 🔳 button (see Step 19 on page 19), click the 🔳 button to revive that workspace now.

2. *Navigate to the Max Mural folder.* Locate the *Lesson 01* folder inside the *Lesson Files-PsCS3 1on1* folder, and open the *Max Mural* folder (see Figure 1-34 on the facing page). Inside are a perfect dozen photographs shot over the course of several weeks. They show the progress of a mural I painted in my eldest son's bedroom, inspired by what was for a brief moment my son's favorite book, Maurice Sendak's *Where the Wild Things Are*. (I keep thinking *this* will be his favorite book, but that hasn't happened yet.)

3. *Rename the first image.* Click the filename of the first image, located below its thumbnail, which is *P3226430.jpg.* The Bridge highlights *P3226430* so you can rename it without changing the *.jpg* extension. (This assumes you can see the extension, which is a system-level preference setting. If you can't see it, don't worry about it.) Enter a more descriptive filename. Permit me to suggest "MaxBedroomPencil-1" (see Figure 1-35). Then press the Tab key to record the name and advance to the second image.

4. *Rename the second image.* By pressing Tab, you advance to the second image and highlight its name. Enter the by-now-approved, improved filename "MaxBedroomPencil-2." Press Tab to accept the change and move to the third thumbnail.

5. *Select the remaining thumbnails.* The Tab key makes it convenient to jump from one filename to the next. But manually renaming images is a chore. Thankfully, the Bridge gives you a way to rename multiple images in one operation. Start by clicking the first painted version of the mural, *P3246445.jpg.* Then scroll down to the last image, *P4286767.jpg,* and Shift-click it to select the entire range of ten images.

Figure 1-34.

Figure 1-35.

6. **Initiate Batch Rename.** Choose **Tools→Batch Rename** or press the new shortcut Ctrl+Shift+R (⌘-Shift-R on the Mac). The Bridge opens the **Batch Rename** dialog box, shown in Figure 1-36.

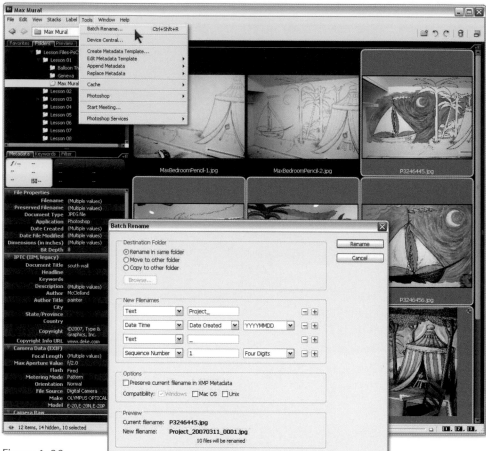

Figure 1-36.

7. **Delete the excess rows.** By default, you should see four rows of New Filenames options in the middle of the dialog box, as in the figure. We don't need that many. Click the ⊟ button (⊖ on the Mac) to the right of the second row a total of three times to delete all but the first row.

8. **Enter a base name.** By default, the row of New Filenames options begins with Text. If you see something else, click the ⊡ (or ⊞) to the right of the first option name and choose **Text** from the pop-up menu. Double-click in the field to the right of Text (which reads *Project_* by default) and change it to "MaxBedroomMural-" complete with the hyphen at the end. This becomes the base name for all selected images.

9. *Assign a two-digit sequence number.* Click the ⊞ (or ⊕) at the end of the line to add more text to the filenames. Choose **Sequence Number** from the new pop-up menu on the left. Yet another pop-up menu appears on the right; set this one to **Two Digits**, which will sequentially number the selected images from 01 to 10, as indicated by the **New filename** item in the bottom-right corner of Figure 1-37.

As it turns out, you don't have to start the numbering at 01; you can start it anywhere. Just enter the desired starting number in the middle field, which is by default set to 1. Enter as many digits as you need. In other words, whether you enter "7," "07," or "00007," the Bridge will make the number two digits long.

10. *Turn on all Compatibility check boxes.* Just because you're working on a Mac today doesn't mean you won't be using a UNIX box tomorrow. (Well, in a way, you already are, but that's another story.) And if you're among the 95 percent of folks who use Windows, who knows, maybe you'll come to love your iPod so much you'll decide to switch over to Apple technology. All I know is, it's a cross-platform world and you might as well be ready for anything that comes your way. The **Compatibility** boxes (seen at the bottom of Figure 1-38) ensure that your filenames subscribe to the naming conventions of other operating systems. You'll see that one check box is dimmed (the check box for your operating system) and the other two are available. Turn on both of the available check boxes.

11. *Copy the original filename to the metadata.* Turn on the **Preserve current filename in XMP Metadata** check box to store the filename assigned by the digital camera with the metadata for each file. It's a good precaution in the event you ever need to match an edited image to its source. The old filename will be listed in the File Properties area of the Metadata panel as a property called Preserved Filename.

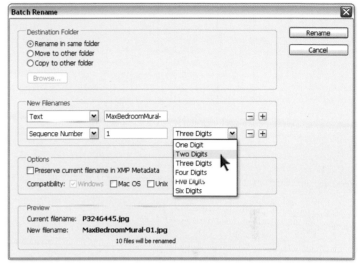

Figure 1-37.

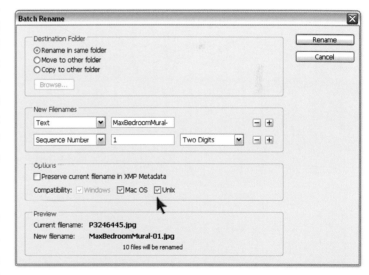

Figure 1-38.

12. *Rename the images.* When your settings match those pictured in Figure 1-38 on the preceding page, click the **Rename** button to send the Bridge on its merry batch-renaming way.

Figure 1-39.

Printing Thumbnails

After you back up your images to a CD or some other media, you might find it helpful to print a catalog of thumbnails that you can toss in a binder or fold into the CD sleeve. And wouldn't you just know it, Photoshop automates this operation with a command called Contact Sheet II, so named because Adobe overhauled it (a *long* time ago). Here's how it works:

1. *Go to the Max Mural folder.* If you're already looking at the 12 photos of the wall mural, stay where you are. Otherwise, point the Bridge to the *Max Mural* folder, which is inside the *Lesson 01* folder inside *Lesson Files-PsCS3 1on1*. The files should be renamed according to the steps in the preceding exercise. If you skipped that exercise, no big deal, but your filenames will be different than mine.

2. *Move the pencil drawings to the top of the sort order.* Click the ◆▶ icon in the bottom-left corner of the Bridge to hide the panels and expand the content browser. Then zoom the thumbnails so all 12 are visible at once. Select the 2 thumbnails that lack paint and drag them to the beginning of the group, as shown in Figure 1-39. (If they're already that way, you're good to go.) The photos will now print in the proper order.

You can achieve this same effect by choosing View→Sort→By Date Created, which sorts the images from oldest at top to newest at bottom.

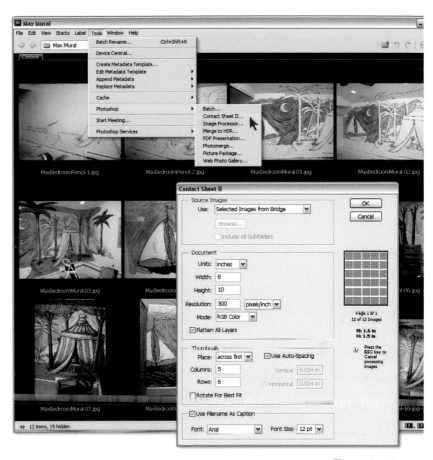

3. **Deselect all thumbnails.** Photoshop prints those thumbnails that are selected. If nothing is selected, it prints everything in the folder. So choose **Edit→Deselect All** or press Ctrl+Shift+A (⌘-Shift-A) to deselect—and thereby print—everything.

4. **Choose Contact Sheet II.** The Bridge offers access to Contact Sheet II but it doesn't actually run it; Photoshop does. Choose **Tools→Photoshop→Contact Sheet II** and watch in wonder as the Bridge conveys the folder of images to Photoshop, which loads the **Contact Sheet II** dialog box, pictured with default settings in Figure 1-40.

Figure 1-40.

5. **Target files from the Bridge.** Make sure that the **Use** option is set to **Selected Images from Bridge**. Most likely, it's set this way by default, but better to be safe than sorry.

6. **Specify the page size and resolution.** Assuming that you're printing to letter-sized paper, make sure **Units** is set to **Inches** and the **Width** and **Height** values are 8 and 10, respectively. (If you're printing a CD insert, set both values to 4.75 inches.) Also, confirm that the **Resolution** value is 300 pixels per inch, which ensures sharp, legible output.

7. **Set the color mode and flatten all layers.** You'll probably be printing on an inkjet printer, which is designed to use the RGB color space, so set the **Mode** option to **RGB Color**. For the smallest file size, turn on **Flatten All Layers**. Otherwise, Photoshop generates a layer for every thumbnail and caption, which can make for a bloated, unwieldy file.

8. **Set the rows and columns.** We have 12 images in all. So set the **Columns** value to 3 and the **Rows** value to 4. Photoshop updates the preview in the upper-right corner of the dialog box to show you the new approximate configuration.

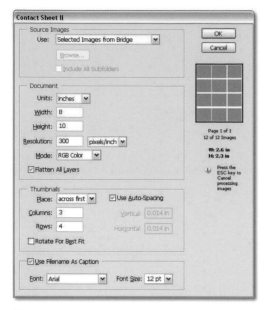

Figure 1-41.

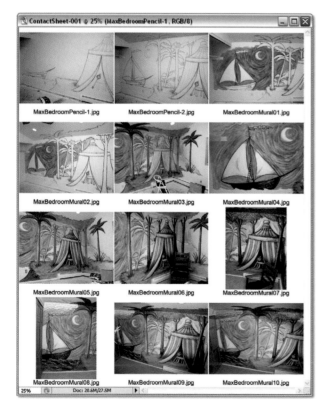

Figure 1-42.

9. **Click OK.** The remaining options are best left to their default settings. Your dialog box should look like the one shown in Figure 1-41. Confirm that it does, and click the **OK** button to put Photoshop to work.

When Photoshop finishes its various activities, you'll see a high-resolution contact sheet like the one in Figure 1-42. By virtue of the Best Workflow color settings that I suggested you select in the Preface (Step 6, page xviii), you have a one-layer document in the Adobe RGB color space. Many older inkjet printers prefer that you print a flat document (no layers) from the sRGB color space. As it turns out, you can perform both conversions with one command, as I explain in the next step. Mind you, it's not essential that you perform this step, and if for some reason you feel intimidated, you can skip it. But performing the step will help to ensure fast, color-accurate printing, so I urge you to try it.

10. **Convert the color space.** Choose **Edit→Convert to Profile**. In the subsequent dialog box, set the **Profile** pop-up menu in the **Destination Space** area to **sRGB IEC61966-2.1**, as highlighted on the facing page in Figure 1-43. (IEC61966-2.1 just happens to be the variety of sRGB that Photoshop supports.) Take a moment to make sure that:

 • **Engine** is set to **Adobe (ACE)**.

 • **Intent** is set to **Perceptual**, best for continuous-tone, photographic images.

 • All check boxes are turned on, particularly **Flatten Image**, which reduces the layers inside the file.

 Click **OK** to apply the conversion.

11. **Save the contact sheet to disk.** Unlike the other images we've been looking at, the contact sheet exists only in Photoshop's memory. To save it to disk, choose **File→Save** or press Ctrl+S (⌘-S on the Mac) to display the **Save As** dialog box. Then browse to the *Lesson 01* folder that you've stored on your hard drive and do the following (illustrated in Figure 1-44):

 • Select **TIFF** from the **Format** menu. On the PC, the option name is **TIFF (*.TIF; *.TIFF)**. The Tag Image File Format (TIFF) is best suited to high-contrast print documents like this one.

 • Name the file "Max Mural Snapshots.tif."

Figure 1-43.

Figure 1-44.

- Make sure the **ICC Profile** check box (called **Embed Color Profile** on the Mac) is turned on.

- On the PC, turn on the **Use Lower Case Extension** check box. (On the Mac, the option isn't there but the feature is turned on by default.)

12. *Set the file format options.* Click the **Save** button to save the file to disk. Photoshop next displays the **TIFF Options** dialog box shown in Figure 1-45. Set the **Image Compression** option to **LZW**, which applies harmless but helpful *lossless compression* to the image, thereby reducing the size of your saved file on disk. Set **Byte Order** to **IBM PC** if you plan to use the image on Windows, or to **Macintosh** if you're mostly working on the Mac. (Turns out, it doesn't really matter which you set; Photoshop and most other programs can read TIFF files regardless of which platform you use.) Don't worry about the other options; just click the **OK** button.

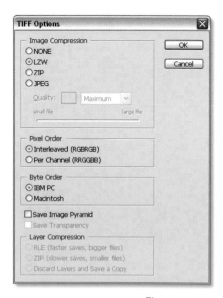

Figure 1-45.

After Photoshop finishes saving the document, you're ready to print the catalog. Make sure your printer is hooked up with the necessary driver software installed and that it's working properly. It should be loaded with paper and sufficient ink. Then choose **File→Print** or press that ubiquitous keyboard shortcut, Ctrl+P (⌘-P on the Mac). Select the desired settings (as I'll discuss in Lesson 12, "Printing and Output," the optimal settings vary depending on your platform and printer), and then click the **Print** or **OK** button. Assuming everything is working, your printer should deliver a page like the one in Figure 1-46.

FYI, you can also use Contact Sheet II to print ready-to-go pages for a photo album. Even if you prefer to cut your pictures apart and organize them individually, Contact Sheet II is a great way to maximize paper and reduce waste. For bigger snapshots, just print fewer images per page by reducing the Columns and Rows values. If you long for more control, try out the Picture Package command, which I discuss at length in "Packing Multiple Pictures onto a Single Page," which begins on page 497.

Figure 1-46.

WHAT DID YOU LEARN?

Match the key concept in the numbered list below with the letter of the phrase that best describes it. Answers appear upside-down at the bottom of the page.

Key Concepts

1. Adobe Bridge
2. Content browser
3. Save Workspace
4. Loupe function
5. Cache
6. Rotate clockwise/Rotate counterclockwise
7. Slide Show
8. Metadata
9. EXIF
10. Save Metadata Template
11. Batch Rename
12. Contact Sheet II

Descriptions

A. A command that saves the descriptions, credits, and keywords assigned to one image so that you can apply them over and over to other images.

B. Available exclusively inside the Bridge, this command lets you expand one or more images to fill the entire screen as well as zoom and navigate from the keyboard.

C. The portion of the Bridge that contains the thumbnail previews.

D. A command used to assign document names, sequence numbers, and more to multiple image files at a time.

E. By default centralized and sequestered—deep in the system level of your hard drive—this file stores transient information from the Bridge, such as sort order and high-resolution thumbnails.

F. Any information above and beyond the core image data, including the date the image was last saved, the copyright holder, and how the image was captured.

G. Click inside the Preview panel to access this feature, which allows you to zoom a detail from an image to anywhere from 100 to 800 percent.

H. Available in the Bridge but executable in Photoshop, this command prints the contents of a folder as a grid of thumbnails and filenames.

I. This Bridge operation stands portrait-style photographs upright and writes the results to metadata. You can perform the operation from the keyboard by pressing Ctrl (or ⌘) and a bracket key, ⊡ or ⊡.

J. A standalone application for opening and managing files that ships with all versions of Photoshop.

K. A specific kind of metadata saved by most modern digital cameras that records the time and date a photograph was captured as well as various camera settings.

L. A command that saves the size of thumbnails, the position and visibility of panels, and the size of the Bridge window itself.

Answers

1J, 2C, 3L, 4G, 5E, 6I, 7B, 8F, 9K, 10A, 11D, 12H

HIGHLIGHTS, MIDTONES, AND SHADOWS

AT HEART, Photoshop is an image cobbler. Its primary mission is to take a worn photograph, with the pixel-based equivalent of sagging arches and holes in its heels, and make it better. As with shoes, not all images can be repaired; some are hopelessly defective from the moment they leave the factory. But most images have more life left in them than you might suspect. And if anyone can fix them, you and Photoshop can (see Figure 2-1).

Over the course of the next several lessons, we'll examine the many different ways to correct a photograph *in the order that these corrections are best applied.* Pardon my prolonged use of italics, but this last part is important. In addition to telling you how to use Photoshop CS3's tools and commands to their utmost capability, I'll answer a rarely addressed question: When should you do what? Because every change you make to an image builds on the previous adjustment, sequence makes a difference.

In this lesson, you'll learn how to correct the brightness and contrast of an image. In the next lesson, we'll fix the colors. Later, we'll move on to straightening, cropping, sharpening, and so on. Amend each attribute of your troubled photograph in the order suggested by these lessons, and I swear to you, the results will look as good as they possibly can. This is how the pros do it.

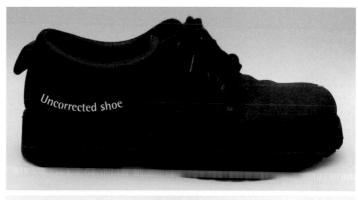

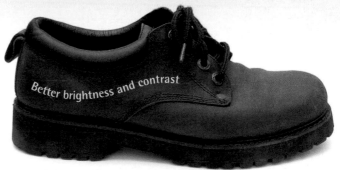

Figure 2-1.

ABOUT THIS LESSON

Project Files

Before beginning the exercises, make sure you've installed the lesson files from the DVD, as explained in Step 3 on page xvii of the Preface. This should result in a folder called *Lesson Files-PsCS3 1on1* on your desktop. We'll be working with the files inside the *Lesson 02* subfolder.

In this lesson, we examine Photoshop's best brightness and contrast correction commands: Levels, Curves, and Shadow/Highlight. We'll examine Photoshop's automatic color fixers, which are the three Auto commands. You'll learn how to:

Video Lesson 2: Introducing Levels

The once destructive Brightness/Contrast command has been fixed in Photoshop CS3, but you would hardly call it a professional-grade tool. If you want your images to look their very best, you're better off using more complex commands that give you precise control over highlights, shadows, and midtones.

To see one such command in action, watch the second video lesson included on the DVD. Insert the DVD and double-click the file *PsCS3 Videos.html*. Then click **Lesson 2: Introducing Levels** under **Navigation and Color Correction**. In 10 minutes and 58 seconds, you'll see Brightness/Contrast, the three Auto commands, and the best of the bunch, Levels. I also mention these shortcuts:

Command or operation	Windows shortcut	Macintosh shortcut
Hide or show right-hand palettes	Shift+Tab	Shift-Tab
Auto Levels	Ctrl+Shift+L	⌘-Shift-L
Undo an adjustment	Ctrl+Z	⌘-Z
Auto Contrast	Ctrl+Shift+Alt+L	⌘-Shift-Option-L
Auto Color	Ctrl+Shift+B	⌘-Shift-B
Levels	Ctrl+L	⌘-L
Apply an adjustment	Enter	Return

Brightness, Contrast, and Levels

If you've ever done any weight training, you know that you start by exercising your major muscle groups and then work your way down to the small stuff. Not that I'm a fitness expert—in fact, I'm pretty much of the opinion that lugging a pint of ice cream out of the freezer is enough physical labor to justify eating the entire thing—but as I understand it, you start with squats and leg presses and end by contracting your forehead with very small weights tied to your eyebrows.

Something similar can be said for editing images. You start with the major changes and then work your way down to more detailed adjustments. The biggest changes recruit the most pixels; therefore, they have a tendency to exaggerate any minor changes that precede them. Perhaps more important, big changes quickly reveal flaws in the image, so you can see what other changes need to be made.

The biggest changes tend to revolve around issues of *luminosity*—that is, light colors compared with dark ones. You most often hear this expressed as "brightness and contrast," where *brightness* is the lightness or darkness of a group of colors and *contrast* is the degree of difference between light and dark colors, as illustrated in Figure 2-2.

Photoshop pays lip service to this colloquialism with its Brightness/Contrast command. Although exceedingly easy to use—and vastly improved in Photoshop CS3—it lacks the control of Photoshop's more capable functions such as Levels, Curves, and Shadow/Highlight. These tools analyze an image according to three basic attributes—*highlights*, *shadows*, and *midtones*, or what the uninitiated might call light colors, dark colors, and everything in between. Figure 2-3 provides some examples.

Such distinctions not only let you adjust brightness and contrast but also provide you with *selective control* over an image. You can make the shadows darker,

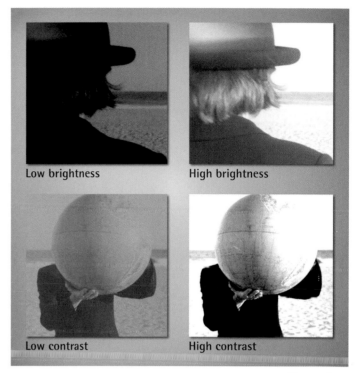

Figure 2-2.

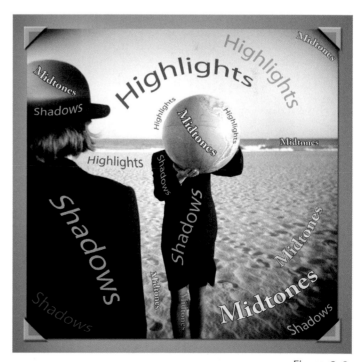

Figure 2-3.

make the midtones lighter, and leave the highlights unchanged. And you can make these changes without upsetting the color balance one iota; or you can adjust luminosity and color values together. Be it red or blue, night or day, the sky's the limit.

Automatic Image Correction

Photoshop offers three commands that correct the brightness and contrast of an image automatically (all labeled Auto in the Image→ Adjustments submenu). These commands don't always do a great job of it—sometimes far from it—but they do the job without any guidance from you. They're like employees who don't ask enough questions. Sometimes they nail the problem, in which case you're glad they didn't bug you. Other times they make a mess of things, in which case you *really* wish they had consulted you. Fortunately, with a bit of intervention on your part, you can make the most of these self-acting drones:

Figure 2-4.

Figure 2-5.

1. *Open a low-contrast image.* Use either **File**→**Browse** or **File**→**Open** to find the *Lesson 02* folder inside *Lesson Files-PsCS3 1on1*. Then open the image called *Worldly lucre.jpg*. Pictured in Figure 2-4, this photograph of legal tender from such remote locations as Kazakhstan and the United States suffers from low contrast and a slight yellow color cast, problems the Auto commands are designed to fix.

2. *Duplicate the image three times.* Choose **Image**→**Duplicate**, and when the **Duplicate Image** dialog box appears, name the new image "Auto Levels," as shown in Figure 2-5. Choose Image→Duplicate again and name the second duplicate "Auto Contrast." Choose Image→Duplicate a third time and name the final image "Auto Color." You should now have four image windows open, all with identical photographs. Each will permit you to see a different automatic image adjustment.

3. *Arrange the windows so you can see each one.* Click the *Worldly lucre.jpg* image window to bring it to the front. Next, choose **View**→**Zoom Out** or press Ctrl+⊡ (⌘-⊡ on the Mac) to reduce the image so it takes up no more than one-quarter of your screen. Choose **Window**→**Arrange**→**Match Zoom** to change all windows to this same zoom ratio. Then choose **Window**→**Arrange**→**Cascade** to match the window sizes. Now drag the title bars so you can see the images side by side. Press the Tab key to hide the toolbox and palettes if necessary.

4. *Apply the Auto Levels command.* Click in the *Auto Levels* image window to make it active. Then choose **Image→Adjustments→ Auto Levels**. In a flash, Photoshop corrects the image. There's no doubt that the result (shown in Figure 2-6) is an improvement. But is this the best Photoshop can do? It is, after all, a bit brown. The only way to know whether Photoshop can do better is to try out the other commands.

5. *Apply the Auto Contrast command.* Click in the image window titled *Auto Contrast* to make it active. Then choose **Image→ Adjustments→Auto Contrast**. The brightness and contrast are better, but like the original, the image is way too yellow (see Figure 2-7). So far, my money's still on Auto Levels.

6. *Apply the Auto Color command.* Click in the *Auto Color* image window and choose **Image→Adjustments→Auto Color**. Photoshop balances the brightness, contrast, and color cast in one fell swoop, as shown in Figure 2-8.

This result comes the closest to accurately representing the original scene. But it's not perfect. The shadows are a bit gray, as if the bills were printed with diluted ink on newsprint. And the contrast is too low. Perhaps we can solve both of these problems with the new and improved Brightness/Contrast command. Worth a shot, anyway.

Figure 2-6.

Figure 2-7.

Figure 2-8.

The Nature of Channels

To understand how to modify colors in Photoshop, you have to know how color is calculated. And this means coming to terms with the two fundamental building blocks of color: luminosity values and color channels. Be forewarned, a little math is involved. Nothing tough—no calculator required—just enough to get you grounded.

For starters, let's consider how things work without color. When you scan a black-and-white photo, the scanner converts it to a *grayscale* image, so named because it contains not just black and white but also hundreds of shades of gray. Because we're in the digital realm, each pixel in the image is recorded as a number, called a luminosity value, or *level*. A value of 0 means the pixel is black; the maximum value (typically 255) translates to white. Other luminosity values from 1 on up describe incrementally lighter shades of gray.

When you add color to the mix, a single luminosity value is no longer sufficient. After all, you

have to distinguish not only light pixels from dark, but also vivid colors from drab, yellow from purple, and so on.

The solution is to divide color into its root components. There are several recipes for color, but by far the most popular is *RGB*, short for red, green, and blue. The RGB color model is based on the behavior of light. In the illustration below, we see what happens when you shine three spotlights—one brilliant red, another bright green, and a third deep blue—at a common point. The three lights overlap to produce the lightest color that we can see, neutral white. By adjusting the amount of light cast by each spotlight, you can reproduce nearly all the colors in the visible spectrum.

Now imagine that instead of shining spotlights, you have three slide projectors equipped with slightly different slides. Each slide shows the same image, but one captures just the red light

from the image, another just the green, and a third just the blue. Shine the three projectors at the same spot on a white screen and you get the full-color photograph in all its glory.

This is precisely how a digital image works, except that in place of slides, you get *channels*. Each channel contains an independent grayscale image, as shown on the right. To generate the full-color composite, Photoshop colorizes the channels and mixes them together, as in the bottom-right diagram.

In each channel, white idicates a big contribution to the full-color composite image, black means no contribution, grays contribute something in between. The background is very bright in the blue channel and darker in the other two, so the composite sky is blue. The face is lightest in the red channel with some middle grays from the green channel. Red with a little bit of green make orange. The lips are dark everywhere except the red channel, so the lips are red.

Each channel contains 256 luminosity values—black, white, and the 254 shades of gray in between. When colored and mixed together, they produce as many as $256^3 = 16.8$ million unique colors. (For a less common scenario with even more colors, see "Exploring High Bit Depths" on page 98 of Lesson 3.)

You can access both the full-color composite and the individual channels in the Levels and Curves dialog boxes. To see what the grayscale channels in an image look like, choose **Window→Channels**, and click **Red**, **Green**, or **Blue** in the Channels palette. Click **RGB** to return to the full-color composite view.

Red channel **Green channel** **Blue channel**

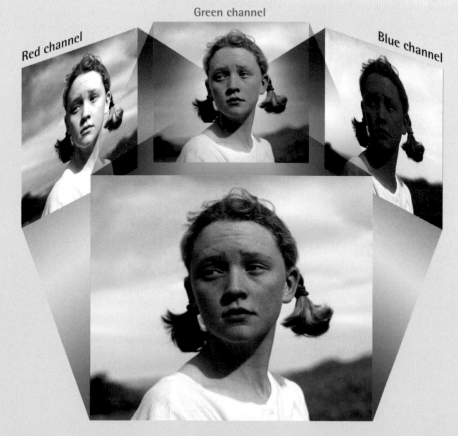

Green channel

Red channel Blue channel

File Edit **Image** Layer Select Filter View Window Help

Mode ▶

Adjustments ▶ | Levels... ⌘L
Auto Levels ⇧⌘L
Auto Contrast ⌥⇧⌘L
Duplicate... | Auto Color ⇧⌘B
Apply Image... | Curves... ⌘M
Calculations... | Color Balance...
Brightness/Contrast... ⌥⌘B
Image Size... ⌥⌘I
Canvas Size... ⌥⌘C | Black & White... ⌥⇧⌘B
Pixel Aspect Ratio ▶ | Hue/Saturation... ⌘U
Rotate Canvas ▶ | Desaturate ⇧⌘U
Crop ⌥⇧⌘C | Match Color...
Trim... | Replace Color...
Reveal All | Selective Color...
| Channel Mixer...
Variables ▶ | Gradient Map...
Apply Data Set... | Photo Filter...
| Shadow/Highlight...
Trap... | Exposure...

Invert ⌘I
Equalize
Threshold...
Posterize...

Variations... ⌘B

Brightness/Contrast

Brightness: -15 (OK)

(Cancel)

Contrast: 100 ☑ Preview

☐ Use Legacy

Figure 2-9.

7. *Choose the Brightness/Contrast command.* With the *Auto Color* image active, choose **Image→Adjustments→Brightness/Contrast**. Then do the following:

- Change the **Contrast** value to its maximum, 100 percent. Such a brazen value would have ruined an image prior to Photoshop CS3. Thankfully, the new Brightness/Contrast command is more able and forgiving (as, with help, we all shall be).

- The money is a bit too bright. So darken it by reducing the **Brightness** value to −15 percent.

Once you see what I see in Figure 2-9, click **OK**.

8. *Save the corrected image.* After making your changes (the result of which appears beside the original photograph in Figure 2-10), choose **File→Save** or press Ctrl+S (⌘-S). The image hasn't been saved before, so Photoshop asks you to name it and specify a location. Because this is a flat image (no layers), the JPEG file format is a good choice. Name the file "Better money.jpg," click **Save**, specify a **Quality** setting of 10 or higher, and then click **OK**. The saved image is hardly perfect—it seems a bit blue for one thing—but it's amazing given the slight time we put into it. And I'll be showing you lots more correction techniques in the following exercises.

Uncorrected money

Figure 2-10.

Auto Color plus Brightness/Contrast

By definition, an Auto command adjusts an image without troubling you with the details. But that doesn't mean it applies the same level of correction to one photograph as it does to another. Quite the contrary—each Auto command analyzes an image and corrects it accordingly. A dark image receives different correction than a light one, a yellowish image receives different correction than a bluish one, and so on.

Although every image gets individualized attention, it is modified according to a consistent set of rules. Auto Contrast subscribes to one set of rules, Auto Levels to another, and Auto Color to a third. The following list explains how each command works. But rather than discussing them in the order in which they appear in the Image→Adjustments submenu—as I did in the "Automatic Image Correction" exercise—I'll start with the most basic command, Auto Contrast, and work my way up:

Auto Contrast makes the darkest color in an image as dark as it can be and the lightest color as light as it can be without changing the color of either. For example, if the darkest color is green and the lightest color a drab peach—as in the image from iStockphoto contributor Roberta Osborne below—the green becomes a darker green and the peach a lighter peach. The color balance remains unchanged—just what you want when an image is properly colored, not what you want when it's not.

• **Auto Levels** makes no attempt to preserve colors. Instead, it analyzes each color channel independently and makes the darkest color in each channel black and the lightest color white. The result is more often than not a shift in color balance. This shift can be a good thing if the color balance needs fixing. But Auto Levels may go too far, replacing one color cast with another. In the example below, the color cast shifts from green to red.

• **Auto Color** can be a bit slower because it tries to do more. Like Auto Levels, it deepens shadows and lightens highlights on a channel-by-channel basis. But where Auto Levels may shift shadows and highlights from one color to another, Auto Color tries to change them to neutral grays. Auto Color also evaluates the midtones in an image. It finds all the midtones that are trending toward gray and then leeches away the color. Given the current state of technology, this is the best method for automatically correcting the color cast of a photo.

Because it attempts to remove color casts from all three brightness regions of an image—shadows, highlights, and midtones—Auto Color frequently outperforms the rest of the Auto pack. But it's by no means foolproof, as the "Automatic Image Correction" exercise illustrates. By testing all three Auto commands, you can decide for yourself which one delivers the most desirable results.

Original image Auto Contrast Auto Levels Auto Color

At the end of each exercise, you have the option of saving the results of your labors or closing the file and abandoning your changes. If you elect to save your work, I recommend you choose **File→Save As** to avoid overwriting the original file. Then add "-edit" to the end of the filename and click the **Save** button. In future exercises, I'll direct you to save a file only when I have a specific reason for doing so. Otherwise, it's entirely up to you.

Figure 2-11.

9. *Close all images.* Now that you've selected and saved your preferred corrected version of the image, you can discard the others. Choose **File→Close All** or press Ctrl+Alt+W (or ⌘-Option-W). When asked to save changes, click the **No** button on the PC or **Don't Save** on the Mac. If you prefer keystrokes, press N on the PC or D on the Mac.

Adjusting Brightness Levels

The Auto commands are fine and dandy, but they don't replace good old-fashioned manual labor. And when it comes time to roll up your shirtsleeves and smear on the elbow grease, the tool of choice is the Levels command. While not necessarily the most powerful brightness and contrast function in Photoshop's arsenal—as we'll see later, the Curves command outshines it in a few key areas—Levels provides the best marriage of form and function. It lets you tweak highlights, midtones, and shadows predictably and with absolute authority while maintaining smooth transitions among the three.

The Levels command is ideally suited to increasing or decreasing brightness values. Where contrast is concerned, Levels is better at increasing contrast than decreasing it. To decrease the contrast of an image—particularly one with overly harsh shadows and highlights—see the sections "Correcting with Curves" (page 57) and "Compensating for Flash and Backlighting" (page 63).

The following exercise explains how to correct the brightness and contrast of an image with the Levels command:

1. *Open an image.* Open *Quiriguá monument.jpg*, included in the *Lesson 02* folder inside *Lesson Files-PsCS3 1on1*. Captured in the Guatemalan city of Quiriguá—site of some of the largest Mayan stelae in existence—this image features some atrocious light metering (see Figure 2-11). Whether this was the result of a rushed photographer or an ancient Mayan curse (I prefer to think the latter), this image stands only to gain from some brightness correction. Fortunately, the powerful Olympus E-1 that I used to shoot this image captured enough color information to repair it in Photoshop.

2. *Duplicate the image.* I often find it helpful to give one of the Auto commands a try before resorting to Levels.

(After all, if I can get away with being lazy, more power to me.) But rather than mess up the original image, it's better to modify a copy. So choose **Image→Duplicate** and name the new image "Auto Color."

If you don't feel like naming the image, you can skip this part. Just press the Alt key (Option on the Mac) when choosing Image→ Duplicate. Photoshop skips the dialog box and names the image *Quiriguá monument copy*.

3. *Apply the Auto Color command.* Choose **Image→Adjustments→Auto Color**, or better yet, just press Ctrl+Shift+B (⌘-Shift-B). The result appears in Figure 2-12. The fact that Photoshop can retrieve this much color and brightness all by itself is flat-out amazing. But I'm afraid it's not good enough. The image remains dark and the command hasn't really brought out the monument's warm red tones.

4. *Return to the original image.* Click the title bar for the *Quiriguá monument.jpg* image window to bring the uncorrected photo to the front.

5. *Choose the Levels command.* Choose **Image→Adjustments→Levels** or press the shortcut Ctrl+L (⌘-L on the Mac). Photoshop displays the **Levels** dialog box (see Figure 2-13), which contains the following options:

 - The Channel pop-up menu lets you edit the contents of each color channel independently. To edit all channels at once, choose RGB, the default setting.

 - The black blob in the middle is the *histogram*, which is a graph of the brightness values in your image. (For more information, read the sidebar, "How to Read and Respond to a Histogram," on page 54.)

 - The three Input Levels values list the amount of adjustment applied to the shadows, midtones, and highlights, respectively. The default values—0, 1.00, and 255—indicate no change.

 - The Output Levels values let you lighten the darkest color and darken the lightest one, thus reducing the contrast. Although useful for dimming and fading, they rarely come into play when correcting an image.

 - The Save and Load buttons let you save a collection of settings to disk and later retrieve those settings.

Figure 2-12.

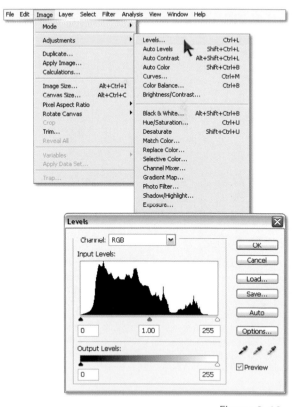

Figure 2-13.

- The Auto button applies the equivalent of the Auto Levels command, which you can modify as needed. Click the Options button to apply a different kind of Auto function—such as Auto Color—as well as modify its behavior.

- See the three eyedropper tools above the Preview check box? You can select an eyedropper and then click in the image window to modify the clicked color. The black eyedropper makes the clicked color black; the white one makes it white; the gray one robs it of color, leaving it a shade of gray.

- When on, the Preview check box applies your changes dynamically to the active image. You can magnify the image by pressing Ctrl+⊞ or zoom out by pressing Ctrl+⊟. (That's ⌘-⊞ and ⌘-⊟ on the Mac.) To navigate within your zoomed preview, press the spacebar and drag.

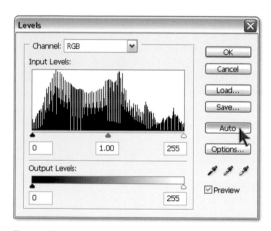

Figure 2-14.

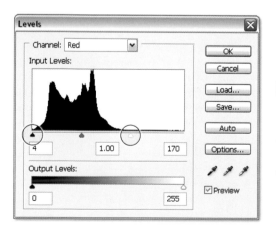

Figure 2-15.

Turn off the Preview check box to see what the image looked like before you chose the Levels command. Obvious as this may sound, the Preview option is great for before-and-after comparisons.

6. **Apply the Auto Levels function.** Click the **Auto** button to apply the Auto Levels function. The resulting image should look a lot like the Auto Color image you created in Step 3. The histogram stretches to fill the center portion of the dialog box, but the numerical Input Levels values stay the same, as in Figure 2-14. (You'll see why in the next step.) As before, Photoshop's automated adjustment isn't perfect, but it's a good starting point for our adjustments.

7. **Switch to the Red channel.** Choose **Red** from the **Channel** pop-up menu or press Ctrl+1 (⌘-1 on the Mac). You now see the Red-channel histogram with adjusted Input Levels values, as shown in Figure 2-15.

PEARL OF ⬤ WISDOM

Clicking Auto in Step 6 changed the Input Levels settings on a channel-by-channel basis. So even though you see an altered histogram in the composite view (as in Figure 2-14), you have to visit the individual channels to see the numerical changes.

8. **Nudge the shadows and highlights.** Notice the black and white slider triangles directly below the histogram (highlighted red in Figure 2-15)? They correspond to the first and last **Input Levels** values, respectively. In my case, the black slider tells me that any pixel with a brightness of 4 or less will be made black in

the Red channel; the white slider says any pixel 170 or brighter will be made white. (Your values may differ slightly. Remember, 0 is absolute black and 255 is absolute white.) Those values are okay, but I recommend you tighten them up a little—that is, send a few more colors to black or white. Nudge the black value from 4 to 10; nudge the white value from 170 to 143.

By *nudge*, I mean literally, using the arrow keys on the keyboard. Highlight the 4 and press ↑ six times to raise it to 10. Highlight 170 and press Shift+↓ two times and then press ↓ five times to lower the value to 145. Together, these adjustments make the image noticeably redder.

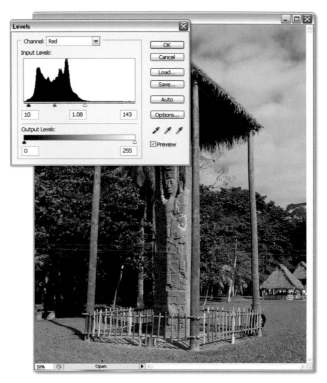

Figure 2-16.

9. **Raise the midtones value.** Increase the middle **Input Levels** value to 1.08, thus increasing the brightness of the midtones in the Red channel. The result appears in Figure 2-16.

The middle Input Levels number (which corresponds to the gray slider below the histogram) is calculated differently than the black and white points. Expressed as an exponent, this *gamma value* multiplies all colors in a way that affects midtones more dramatically than shadows or highlights. The default gamma value of 1.00 raises the colors to the first power, hence no change. Higher gamma values make the midtones brighter; lower values make the midtones darker.

10. **Switch to the Green channel.** Choose **Green** from the **Channel** pop-up menu or press Ctrl+2 (⌘-2 on the Mac).

11. **Adjust the shadows, midtones, and highlights.** Change the three **Input Levels** values to 20, 1.10, and 179. This change brightens the green values, as in Figure 2-17.

12. **Switch to the Blue channel.** Choose **Blue** from the **Channel** pop-up menu or press Ctrl+3 (⌘-3).

13. **Adjust the shadows, midtones, and highlights.** This time, change the three **Input Levels** values to 20, 1.15, and 235. The changes to the black and white values darken the Blue channel, while the revised gamma value lightens the midtones. The result is a subtle correction that slightly deepens the greens in the grass while keeping the sky a rich blue.

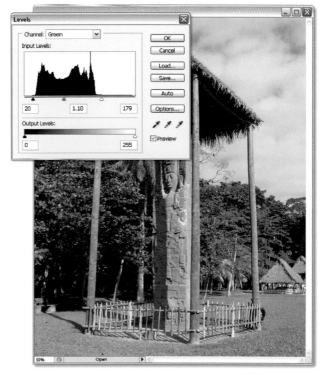

Figure 2-17.

How to Read and Respond to a Histogram

In the world of statistics, a *histogram* is a kind of bar graph that shows the distribution of data. In the Levels dialog box, it's a bit simpler. The central histogram in the Levels dialog box contains exactly 256 vertical bars. Each bar represents one brightness value, from black (on the far left) to white (on the far right). The height of each bar indicates how many pixels in your image correspond to that particular brightness value. The result is an alternative view of your image, one that focuses exclusively on the distribution of luminosity values.

Consider the annotated histogram below. I've taken the liberty of dividing it into four quadrants. If you think of the histogram as a series of steep sand dunes, a scant 5 percent of that sand spills over into the far left quadrant; thus, only 5 percent of the pixels in this image are dark. Meanwhile, fully 25 percent of the sand resides in the big peak in the right quadrant, so 25 percent of the pixels are light. The image represented by this histogram contains more highlights than shadows.

One glance at the image itself (opposite page, top) confirms that the histogram is accurate. The photo so obviously contains more highlights than shadows that the histogram may

seem downright redundant. But the truth is, it provides another helpful glimpse into the image. Namely, we see where the darkest colors start, where the lightest colors drop off, and how the rest of the image is weighted.

With that in mind, here are a few ways to work with the histogram in the Levels dialog box:

- **Black and white points:** Keeping in mind the sand dune analogy, move the black slider triangle below the histogram to the point at which the dunes begin on the left. Then move the white triangle to the point at which the dunes end on the right. (See the graph below.) This makes the darkest colors in the image black and the lightest colors white, which maximizes contrast without harming fragile details inside the shadows and highlights.

- **Clipping:** Take care not to make too many colors black or white. This will result in *clipping*, in which Photoshop renders whole regions of your image flat black or white. That's fine for graphic art but bad for photography, where you need continuous color transitions to convey depth and realism.

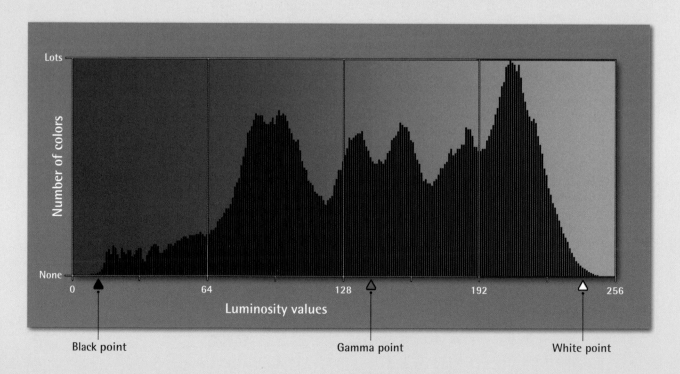

To preview exactly which pixels will go to black or white, press the Alt key (Option on the Mac) as you drag a slider triangle. When dragging the black triangle, any pixels that appear black or any color *except* white (as in the example at the bottom of this page) will be clipped. When dragging the white triangle, Photoshop clips the nonblack pixels.

- **Balance the histogram on the gamma:** When positioning the gray gamma triangle, think "center of gravity." Imagine that you have to balance all the sand in the histogram on a teetering board that is poised on this single gray triangle. If you position the gamma properly, you can distribute the luminosity values evenly across the brightness spectrum, which generally produces the most natural results.

Note that these are suggestions, not rules. Clipped colors can result in interesting effects. An overly dark image may look great set behind white type. Let these suggestions guide your experimentation, and you'll find yourself working more quickly and effectively in the Levels dialog box.

Figure 2-18.

Figure 2-19.

14. ***Switch to the RGB composite image.*** Choose **RGB** from the **Channel** pop-up menu or press Ctrl+⌐ (⌘-⌐ on the Mac). That's the tilde key, incidentally—the one to the left of the 1 key on a standard U.S. keyboard.

15. ***Darken the shadows; raise the gamma.*** Click the words **Input Levels** to select the black value. Then change it to 15. Next, Tab to the gamma value and raise it to 1.2. This darkens the shadows and lightens the midtones across all channels, as seen in Figure 2-18.

PEARL OF ⬤ WISDOM

Raising the gamma value does a fine job of lightening the image on most PC monitors. But if you're working on a Mac, you may find that a value of 1.2 goes a bit too far, leaving the photo looking washed out or overly bright. To compensate for this, darken the image by lowering the gamma value to 1.1.

16. ***Click OK.*** Or press Enter or Return to accept your changes and exit the Levels dialog box.

The resulting image is significantly brighter than the original photograph, especially the midtones. One of the downsides of lightening midtones is that it tends to suck some of the color out of an image. Fortunately, you can restore color using the Hue/Saturation command, as explained next.

17. ***Choose the Hue/Saturation command.*** Choose **Image→Adjustments→Hue/Saturation** or press Ctrl+U (⌘-U on the Mac). As you'll see in the "Tint and Color" exercise that begins on page 78 of Lesson 3, Hue/Saturation lets you modify the intensity of colors in an image.

18. ***Raise the Saturation value.*** Press Tab to advance to the **Saturation** value. Press Shift+↑ three times to raise the value to +30 percent. Then click the **OK** button. As witnessed in Figure 2-19, the once murky image is now brimming with brilliant color.

The final image is a resounding success. But you may wonder how I arrived at the specific values that you entered into the various Input Levels option boxes. The answer is trial and error. I spent a bit more time flitting back and forth between the channels and nudging values than the exercise implies, just as you will when correcting your own images. But as long as you keep the Preview check box turned on, you can review each modification as you apply it.

That said, my approach wasn't entirely random. Back in Step 11, I didn't know that 20 was the magic shadow value, but I suspected it was somewhere in that neighborhood. The trick is knowing how to read and respond to a histogram, as I explain in the aptly named sidebar "How to Read and Respond to a Histogram," on page 54.

Correcting with Curves

As a rule, the Auto and Levels commands work best when you want to increase the contrast of an image, not decrease it. Granted, you can darken or brighten midtones. But what if you want to tone down a group of highlights or shine a bit of light into the shadows? To perform these kinds of adjustments, you need more control than the basic three divisions—shadows, midtones, and highlights— can provide. You need to divide shadows and highlights into their component parts. In other words, you need to establish your own brightness divisions.

This is precisely what the Curves command does. You can set and edit a dozen or more brightness points. Or you can set just three or four and modify them with a precision that Levels can't match. And in Photoshop CS3, Curves has been upgraded to include slider controls, clipping previews, and even a histogram. The best command for editing brightness and contrast just got better.

1. *Open an image.* Open the image file *High contrast bird.jpg*, included in the *Lesson 02* folder inside *Lesson Files-PsCS3 1on1*. Captured in the quaint, little-known village of Orlando, Florida using the same Olympus E-1 as in the preceding exercise, the brightly lit image pictured in Figure 2-20 looks downright vibrant in most regards. But it exhibits a bit more contrast than I'd like. The direct sunlight delivered some bright surfaces and vivid colors, but the automatic exposure setting resulted in some pretty dark shadows. I think we can do better.

2. *Open the Histogram palette.* Choose **Window→ Histogram** to display the diminutive **Histogram** palette. Too diminutive, in my estimation. When scaled to fit the width of the other palettes, Histogram displays roughly 75 percent of the 256 brightness bars, and that's not good enough. To

Figure 2-20.

Figure 2-21.

Figure 2-22.

Figure 2-23.

expand the palette, click the ⯆≡ icon in the upper-right corner and choose **Expanded View,** as in Figure 2-21. Now the histogram permits you to see what you'd normally see in the Levels dialog box.

3. *Refresh the histogram.* Most likely, you'll see a tiny caution icon (⚠) in the upper-right corner of the histogram, which means you're viewing a *cached* (old and inaccurate) version of the histogram. Caching saves Photoshop some computational effort, but it proves a hindrance when you're trying to gauge the colors in an image. To update the histogram based on the latest and greatest information, click the ⚠ icon or the ⟳ arrows labeled Uncached Refresh in Figure 2-22.

4. *Show all color channels.* If you're a complete histogram freak—and for purposes of this exercise, you are—you'll want a separate histogram for each color channel. Choose **All Channels View** from the Histogram palette menu. Then choose **Show Channels in Color** (see Figure 2-23). The result is a series of color-coded histograms that you can check at a glance.

You may have noticed that the Histogram palette consumes the space of the three palettes below it. But click either the Navigator or Info tab—both of which by default share space with the Histogram—and Photoshop shrinks the Histogram palette and hides it from view. It's a great space-saving technique when the palette's not in use. However, we need it now, so be sure to click the **Histogram** tab to bring the palette back before proceeding.

5. *Choose the Curves command.* Choose **Image→Adjustments→ Curves** or press Ctrl+M (⌘-M on the Mac). Pictured in Figure 2-24 on the facing page, the **Curves** dialog box contains many of the same options found in the Levels dialog box, including the Channel pop-up menu; the Auto and Options buttons; the eyedropper tools; and the Preview check box. (For explanations of each, see Step 5 of the "Adjusting Brightness Levels" exercise on page 51.) But there are a few differences:

 • The central element of the Curves dialog box is the *luminance graph*, in which you plot points along a line called the *luminance curve*. When editing an RGB image, the curve represents all brightness values in the image from black in the lower-left corner to white in the upper-right. Click the curve to add a point to it. Then drag the point up or down to make the corresponding brightness value lighter or darker.

- In the middle of the luminance graph is a gray histogram. The histogram looks squished compared to the one in the Histogram palette, but really, it's scaled vertically to fit the square region of the graph. Note that this histogram is static; it always represents the image prior to your Curves modifications.

- The Curves dialog box provides two tools for editing the luminance curve, located near the top-left corner of the graph. The first is the point tool. Click in the graph with this tool to add a point to the curve. Then drag the point to bend the curve. The second tool, the pencil, lets you draw freehand curves. For example, if the curve flexes in a way that you don't like, switch to the pencil tool and draw directly inside the graph.

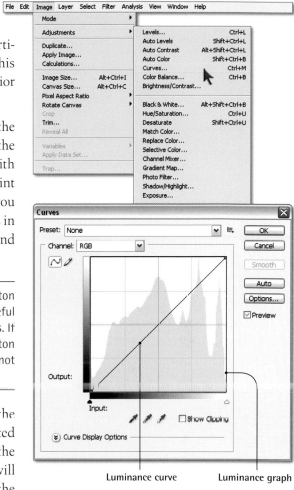

Available only when the pencil tool is active, the Smooth button rounds off rough corners in your graph. Smooth is especially useful after Shift-clicking with the pencil tool, which draws straight lines. If one click of the Smooth button doesn't do the trick, click the button again. In fact, clicking two or three times in a row is the norm, not the exception.

- When available, the Input and Output values show the coordinates of the selected point in the graph. Located below the graph, Input tells the original brightness of the color; to the left, Output indicates the brightness as it will be when you click OK. As with the Levels command, the brightness of an RGB image is measured from 0 to 255.

Luminance curve Luminance graph

Figure 2-24.

Now that we have the cursory introductions out of the way, let's see how these options fare in a real-world project. But first, let's change a preference setting.

6. *Expand the luminance graph.* Click the ⊗ in front of **Curve Display Options** at the bottom of the dialog box to expand the dialog box to reveal a few more options. Then click the ⊞ icon (below Show Clipping) to increase the number of grid lines in the luminance graph. The result is the 10-by-10 grid pictured in Figure 2-25, which you may find helpful when trying to hone in on a specific area of luminance in your image.

Bouncing ball

10 x 10 grid increments

Figure 2-25.

Another way to increase the number of grid lines is to press the Alt key (Option on the Mac) and click in the luminance graph. Alt-click again or click the ⊞ icon to restore the original number of grid lines.

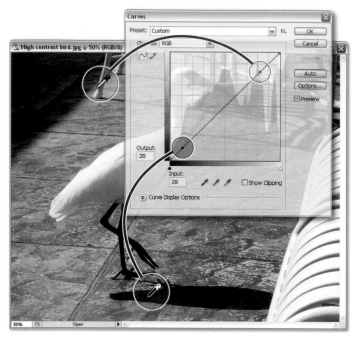

Figure 2-26.

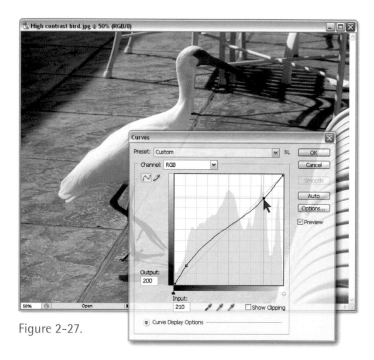

Figure 2-27.

The check boxes at the bottom of the dialog box (not shown in the figure) should all be on. Assuming they are, click the ⊗ to hide the options.

7. *Identify the problem areas.* To discover the colors you want to change, move your cursor into the image window—the cursor becomes an eyedropper—and then drag over colors. A "bouncing ball" floats up and down the luminance curve to show you the color under the cursor. The bright orange hues on the ground range between 120 and 170 (see Figure 2-25 on the previous page); the dark colors in the shadows range between 10 and 50. Seeing these values displayed helps you get a feel for the specific brightness values that reside in the image.

8. *Add points to the graph.* Now that you have a rough sense of the color composition of the bird image, it's time to return to the **Curves** dialog box and adjust the luminance curve. The first step in modifying the curve is to add a point. You can add a point by clicking anywhere along the diagonal line. But a better method is to lift points directly from the image itself.

To lift a point from the image, make sure the point tool is active. Then press Ctrl (⌘ on the Mac) and click in the image window. I recommend Ctrl-clicking once on a bright spot in the chair's leg (highlighted in yellow in **Figure 2-26**) and again in the bird's shadow (highlighted in red). You should end up with two points at opposite ends of the diagonal line, which identify key colors in the highlights and shadows.

9. *Adjust the Output values.* To brighten the shadows, drag the first point up a bit. To dim the cement tiles, drag the second point down very slightly. Watch the **Input** and **Output** values as you move the points. To match the results shown in Figure 2-27, do the following:

 • Set the first point to Input: 28 and Output: 43.

 • Set the second point to Input: 210 and Output: 200.

A few tricks can make editing points in the luminance graph a lot easier. First, you can activate a point from the keyboard. Press Ctrl+Tab to advance from one point to the next; press Ctrl+Shift+Tab to back up one point. (Both keystrokes are the same for Mac users: that is, you press the Control key, not ⌘.) Use the arrow keys to nudge the point in increments of 1; add Shift to raise the increment to 10. The ↑ and ↓ keys change the Output value; ← and → change the Input value.

10. **Update the histograms.** Unlike the histogram in the Curves dialog box, the one in the **Histogram** palette updates as you make your changes, dimming the old histograms and showing the new ones in black or RGB, as in Figure 2-28. However, the moment you choose Curves, the palette works from cached histograms. Refresh them by clicking the ⚠ or ↻ icon.

11. **Switch to the Red channel.** By now, I'm generally happy with the brightness and contrast of the image. But there remains a preponderance of red, as verified by the spike on the right side of the Red histogram in the Histogram palette. (A spike on the right means the channel is light, and therefore dominant; a spike on the left means the channel is dark, or recessive.) To edit the Red channel independently of the other channels, choose **Red** from the **Channel** pop-up menu in the Curves dialog box or press Ctrl+1 (⌘-1 on the Mac).

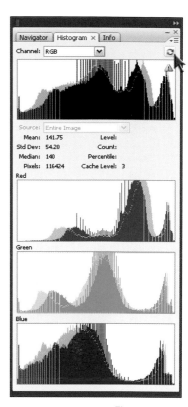

Figure 2-28.

12. **Add three points to the graph.** To decrease the brightness of the Red channel, set points at the following three coordinates (as I have in Figure 2-29):

- Input: 128, Output: 128. This setting doesn't change the image; it merely anchors the midtones at the center of the luminance curve. The result is a pivot point around which you can bend the rest of the curves, thus assuring that the midtones in the channel remain relatively unchanged.

- Input: 69, Output: 59. This adjustment darkens the deep reds in the shadows.

- Input: 224, Output: 215. This reduces the intensity of the reds in the cement tiles and helps smooth out color transitions.

13. **Accept your changes.** Click **OK** to accept your changes and exit the Curves dialog box.

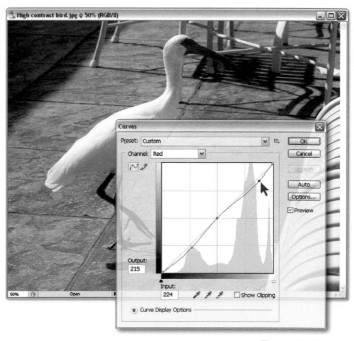

Figure 2-29.

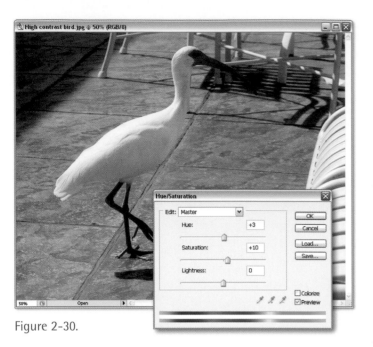

Figure 2-30.

The contrast of the photograph is much improved, with more diffused highlights on the ground and better details in the shadows. But the colors are a bit off. The easiest way to correct these colors is with Hue/Saturation.

14. ***Display the Hue/Saturation dialog box.*** Choose **Image→Adjustments→Hue/Saturation** or press Ctrl+U (⌘-U on the Mac).

15. ***Adjust the Hue and Saturation values.*** Click the **Hue** option and press ↑ three times to increase the Hue value to +3 degrees, which pushes the orange tones of the tiles to a more yellowish hue and helps differentiate it from the bird's beak (see Figure 2-30). Press Tab to advance to **Saturation** and press Shift+↑ to raise the value to +10%. Then click the **OK** button.

Figure 2-31 shows before-and-after views of the adjusted bird. The second image exhibits more detail in the shadows, a less overpowering background, and a more natural overall color balance. It's a more

Original Olympus E-1 photograph

Adjusted with Curves and Hue/Saturation

Figure 2-31.

subtle change than we saw in the preceding exercise, and frankly, that's just as it should be. The point-by-point control afforded by the luminance graph makes Curves the go-to command for highly exacting, even delicate brightness adjustments.

Compensating for Flash and Backlighting

Photography is all about lighting—specifically, how light reflects off a surface and into the camera lens. So things tend to turn ugly when the lighting is all wrong. One classic example of bad lighting is *backlighting*, where the background is bright and the foreground subject is in shadow. Every photographer knows that you adjust for backlighting by adding a fill flash, but even the best of us forget. An opposite problem occurs when shooting photos at night or in dimly lit rooms using a consumer-grade flash. You end up with unnaturally bright foreground subjects set against dark backgrounds.

Whether your subject is underexposed or overexposed, the solution is the Shadow/Highlight command, which lets you radically transform shadows and highlights while maintaining reasonably smooth transitions between the two. Here's how it works:

1. *Open an image.* Open the file called *Rooster in shadows.jpg*, found in the *Lesson 02* folder inside *Lesson Files-PsCS3 1on1*. When I shot the image, I chose an exposure setting with the bright Key West sunlight in mind. As a result, the highlights are balanced but the shadows are not (see Figure 2-32). A fill flash might have helped, but alas, I didn't have my flash with me. So an unacceptably dark and murky rooster is what I got.

2. *Open the Histogram palette.* Choose **Window→Histogram** to display the **Histogram** palette. (If the palette was already visible, choosing the command will hide it. Choose the command again to display it.)

EXTRA CREDIT ★ EXTREME

For further info on using the Curves command—including clipping options, the slider controls, and channel-by-channel luminance curves—go to *www.lynda.com/dekeps* and initiate your 7-Day Free Trial Account (introduced on page xxvi of the Preface). Start by watching a movie in the free *Photoshop CS3 New Features* series called "New and improved Curves," which covers all the new stuff in the Curves dialog box. Then go to my full *Photoshop CS3 One-on-One* series and check out the second half of Chapter 5, "Shadows, Highlights, and Midtones," which allows you to see the powerful luminance graph in action.

Figure 2-32.

Figure 2-33.

Figure 2-34.

3. *Hide the color channels.* Unlike Levels and Curves, the Shadow/Highlight command lacks individual channel controls. Photoshop applies your changes to all channels at once, so there's no point in wasting valuable screen real estate on multiple histograms. Click the ▾≡ icon in the upper-right corner of the Histogram palette, and then choose **Expanded View** from the palette menu to see just one large histogram, as in Figure 2-33.

4. *Choose the Shadow/Highlight command.* Choose **Image→ Adjustments→Shadow/Highlight**. The resulting **Shadows/ Highlights** dialog box is simple compared to the ones we've seen so far, containing just two slider bars (see Figure 2-34). The Shadows option lets you lighten the darkest colors; the Highlights option darkens the lightest colors.

5. *Adjust the shadows and highlights.* By default, Photoshop is too enthusiastic about lightening the shadows and not enthusiastic enough about darkening the highlights. To temper the dark colors, reduce the **Shadows** value to 30 percent. Then raise the **Highlights** value to 10 percent (see Figure 2-35).

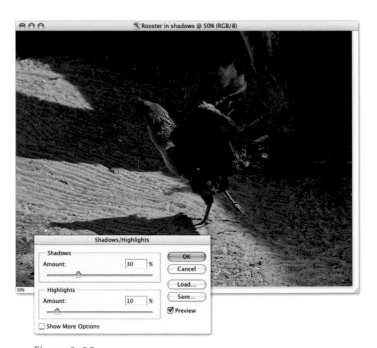

Figure 2-35.

6. *Show the advanced options.* The Shadows/Highlights dialog box may appear a bit feeble—especially when compared with the likes of Levels and Curves—but it's got a tiger in its tank. To unleash that tiger, select the **Show More Options** check box. Photoshop unfurls the options pictured in Figure 2-36.

7. *Maximize the Radius values.* The underlying code behind Shadow/Highlight bears a closer resemblance to the filters discussed in Lesson 8, "Adjusting Focus," than it does to Levels and Curves. (In fact, some of Shadow/Highlight's underlying code is based on the High Pass filter, discussed in the "Using Blur to Sharpen" sidebar on page 272.) This means that, left to its own devices, the Shadow/Highlight command tends to sharpen an image. To prevent an overly sharpened effect, raise both **Radius** values—one under **Shadows** and the other under **Highlights**—to 100 pixels. A large Radius value distributes the effect, resulting in the smoothest possible transitions between our friends the highlights, shadows, and midtones.

8. *Modify the Tonal Width values.* The two **Tonal Width** options control the range of brightness values that Photoshop regards as shadows or highlights. Because our image consists of slightly more shadows than highlights, we want to lightly narrow the definition of the former (the shadows) and barely widen the latter. So reduce the Tonal Width for **Shadows** to 40 percent and increase the Tonal Width for **Highlights** to 70 percent.

9. *Increase the amount of shadow.* Having tempered the shadows by decreasing the Tonal Width and increasing the Radius, the dark shades can tolerate a higher **Amount** value. Raise the Amount in the Shadows section from 30 percent to 60 percent to increase the brightness of the darkest colors in the photo.

10. *Lower the Color Correction value.* Much like the Saturation value in the Hue/Saturation dialog box (see Step 18, page 56), the **Color Correction** option lets you adjust the intensity of colors. For the most part, the colors are fine in this image, though the reds in the rooster's beak are a bit too intense for my taste. Lower the Color Correction value to +10 and leave the other **Adjustments** values as they are. Figure 2-37 shows the Shadows/Highlights dialog box with the final values entered.

Figure 2-36.

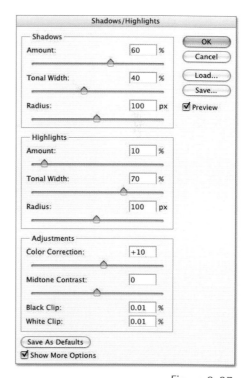

Figure 2-37.

11. ***Accept your changes.*** Click the **OK** button or press Enter or Return to apply your changes and exit the Shadows/Highlights dialog box.

Shown in Figure 2-38, the result is pretty impressive. Pressing Ctrl+Z (or ⌘-Z) a few times will show you how effectively this command has improved our image. We've successfully pulled a ton of detail from the shadows, all without blowing out the brighter areas, pushing the midtones into grays, or shifting the color balance (as Curves can sometimes do). This makes Shadow/Highlight the best one-stop method in all of Photoshop for correcting extremely high-contrast images.

Figure 2-38.

WHAT DID YOU LEARN?

Match the key concept in the numbered list below with the letter
of the phrase that best describes it. Answers appear upside-down
at the bottom of the page.

Key Concepts

1. Highlights, shadows, and midtones

2. Red, green, and blue

3. Color channel

4. Auto Levels

5. Auto Contrast

6. Auto Color

7. Brightness/Contrast

8. Levels

9. Histogram

10. Gamma value

11. Curves

12. Shadow/Highlight

Descriptions

A. This command automatically corrects the shadows and highlights of each color channel independently. As a result, it often shifts the color balance.

B. The three brightness ranges that you can edit independently using the Levels command.

C. This command lets you darken highlights and lighten shadows, just what you need when correcting flash photos.

D. The best tool for manually adjusting the brightness and increasing the contrast of an image on a channel-by-channel basis.

E. Expressed as an exponent, this value multiplies the brightness of an image to lighten or darken midtones.

F. This command both corrects and neutralizes the shadows, highlights, and midtones in an image, making it the most useful of Photoshop's automatic levels-correction functions.

G. A bar graph representation of all brightness values and their distribution in an image.

H. This command automatically corrects the shadows and highlights of an image but leaves the color balance unchanged.

I. An independent grayscale image that Photoshop colorizes and mixes with other such images to produce a full-color composite.

J. The one command that lets you pinpoint a specific color in an image and make it lighter or darker; best suited to reducing contrast.

K. The three primary colors of light, which mix together to form a full-color image.

L. Historically one of the worst functions in Photoshop, this newly improved and frankly useful command lets you correct the luminance of an image using two straightforward slider bars.

Answers

1B, 2K, 3I, 4A, 5H, 6F, 7L, 8D, 9G, 10E, 11J, 12C

LESSON
3

CORRECTING COLOR BALANCE

DEEP INSIDE the most primitive recesses of our minds—where thoughts such as "must eat to live" reside— we possess an implicit understanding of luminosity. Sunlight illuminates all things on this planet. And those things reflect highlights and cast shadows. These highlights and shadows permit our eyes to distinguish form, texture, and detail. We need variations in luminosity to see.

By comparison, color is a subjective abstraction. After completing Lesson 2, you could probably provide a concise one-sentence description of the word *midtones*. But could you so elegantly describe *orange* or *purple*, words that you've bandied about since you were a tot? And who's to say what you call *orange*, I might not call *scarlet*, *amber*, or even *red*?

In day-to-day life, our tenuous understanding of color is generally sufficient. After all, color is mostly window dressing. We don't use it to identify; we use it to clarify. As illustrated in Figure 3-1, you recognize a strawberry by its luminosity; you know whether it's ripe by its color. Millions of people suffer some degree of color blindness and get along with only minor inconveniences—picking unripe strawberries, for example. But if Figure 3-2 is any indication, without variations in luminosity, you'd have a hard time identifying anything.

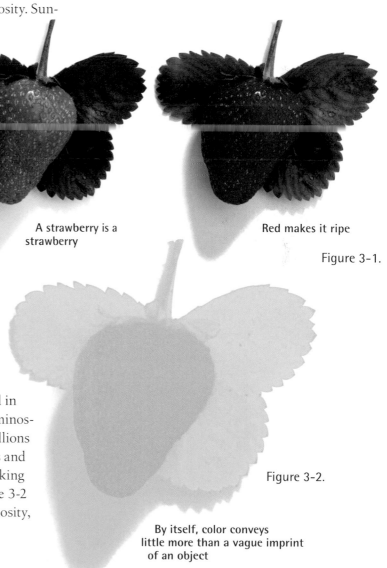

A strawberry is a strawberry

Red makes it ripe

Figure 3-1.

Figure 3-2.

By itself, color conveys little more than a vague imprint of an object

ABOUT THIS LESSON

Project Files

Before beginning the exercises, make sure you've installed the lesson files from the DVD, as explained in Step 3 on page xvii of the Preface. This should result in a folder called *Lesson Files-PsCS3 1on1* on your desktop. We'll be working with the files inside the *Lesson 03* subfolder.

This lesson introduces you to Photoshop's most capable color adjustment commands: Variations, Hue/Saturation, and Gradient Map. We'll also explore such concepts as white balance and color temperature when we look at one of Photoshop CS3's most powerful capabilities, Camera Raw, which allows you to open and develop native files from a digital camera. You'll learn how to:

- Neutralize an image with a widespread color imbalance page 72
- Increase the saturation of a drab photo page 78
- Colorize a black-and-white photograph page 81
- Import and edit a high-color photograph captured with a digital camera page 87

Video Lesson 3: Variations and Camera Raw

The most obvious command for adjusting color balance is, well, Color Balance. But as I noted in the preceding lesson, Photoshop's most obvious solutions are rarely its best. Better are functions that don't have the word *color* or *balance* in their names at all, such as Variations and Camera Raw.

To acquaint yourself with these features, watch the third video lesson on the DVD. Insert the DVD and double-click the file *PsCS3 Videos.html*. Then click **Lesson 3: Variations and Camera Raw** under the **Navigation and Color Correction** heading. This 12-minute 49-second movie introduces you to Color Balance, Variations, and the increasingly capable Camera Raw. Shortcuts include:

Command or operation	Windows shortcut	Macintosh shortcut
Change pasteboard color with paint bucket tool	Shift-click	Shift-click
Variations	Ctrl+B*	⌘-B*
Toggle full-screen mode in Camera Raw	F	F
Advance to the next option	Tab	Tab
Nudge the numerical value	↑ or ↓	↑ or ↓
Nudge values in 10× increments	Shift+↑ or ↓	Shift-↑ or ↓

* Works only if you loaded the dekeKeys keyboard shortcuts (as directed in Steps 7 through 9 beginning on page xviii of the Preface).

After we enter Photoshop, however, color changes from window dressing to prime commodity. To broker in that commodity, you must know how to take it apart, define the pieces, and reassemble it. Unless you aspire to become a color scientist—such folks do exist—this may seem like an arcane if not downright impossible task. But by the end of this lesson, terms such as *hue* and *saturation* will seem so familiar, you might be inclined never to utter the words *orange* or *purple* again.

What Are Hue and Saturation?

Color is too complex to define with a single set of names or numerical values. After all, if I describe a color as orange, you don't know if it's yellowish or reddish, vivid or drab. So Photoshop subdivides color into two properties, hue and saturation:

- Sometimes called the *tint*, the *hue* is the core color—red, yellow, green, and so on. When you see a rainbow, you're looking at pure, unmitigated hue.

- Known variously as *chroma* and *purity*, *saturation* measures the intensity of a color. By way of example, compare Figure 3-3, which shows a sampling of hues at their highest possible saturation values, to Figure 3-4, which shows the same hues at reduced saturations.

The stark contrast between Figures 3-3 and 3-4 may lead you to conclude that garish saturation values are better. But while this may be true for fruit and candy, most of the real world is painted in more muted hues, including many of the colors we know by name. Pink is a light, low-saturation variation of red; brown encompasses a range of dark, low-saturation reds and oranges. Figure 3-5 shows a collection of browns at normal and elevated saturation levels. Which would you prefer to eat: The yummy low-saturation morsel on the left or the vivid science experiment on the right?

Continuing the trend laid out in the preceding lesson, Photoshop provides several commands that give you selective control over all aspects of color, including hue, saturation, and more specialized attributes. Armed with these commands, you have all the tools you need to get the color balance just right.

Figure 3-3.

Figure 3-4.

Low-saturation cookie goodness

Unfit for human consumption

Figure 3-5.

Fixing a Color Cast

One of the most common color problems associated with digital images and photographs in general is *color cast*, a malady in which one color pervades an image to an unrealistic or undesirable degree. For example, an old photograph that has yellowed over the years has a yellow cast. A snapshot captured outdoors using the wrong light setting may suffer a blue cast.

Naturally, Photoshop supplies a solution, and a simple one at that. Designed to remove a prevailing color cast and restore the natural hue and saturation balance to an image, Image→Adjustments→ Variations may be Photoshop's most straightforward color adjustment command. Rather than previewing your corrections in the main image window, as other commands do, Variations presents you with a collection of thumbnail previews. Your job is to click the thumbnail that looks better than the one labeled Current Pick. You can click as many thumbnails as you like and in any order.

The following exercise walks you through a typical use for the Variations command:

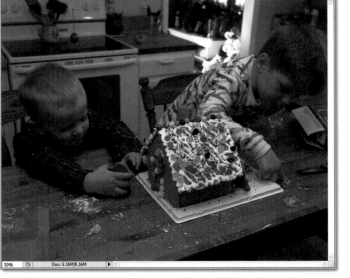

Figure 3-6.

1. ***Open an image.*** Open the file named *Craftsmen at work.jpg*, included in the *Lesson 03* folder inside *Lesson Files-PsCS3 1on1*. Captured using a decidedly incorrect light setting during an intense gingerbread house construction project—one of the few activities that lets you marry the crafts of Julia Child and Frank Lloyd Wright—this image suffers from what I like to call "An Unbearable Preponderance of Orange" (see Figure 3-6).

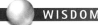

PEARL OF WISDOM

The problems with the image in Figure 3-6 bear some resemblance to those that we corrected with the Levels command in Lesson 2 (see "Adjusting Brightness Levels" on page 50). And in truth, you can fix much of what ails this photograph with Levels. But because the main offender here is color cast, Variations is the easier solution. Unlike Levels or any of the other commands from Lesson 2, Variations can recruit information from one channel and bring it into another, an enormous advantage when correcting color balance.

2. *Choose the Variations command.* Choose **Image**→**Adjustments**→**Variations**, as shown in Figure 3-7, to display the gargantuan **Variations** dialog box.

By default, Photoshop does not include a shortcut for Variations. Under Windows, you can access the command by pressing Alt and typing "ian." On the Mac, you have to assign a custom shortcut with **Edit**→**Keyboard Shortcuts** or use mine. If you loaded my dekeKeys shortcuts (see the Preface, Step 7, page xviii), you'll see that I've reassigned the shortcut that was formerly assigned to Color Balance, Ctrl+B (or ⌘-B).

Figure 3-7.

3. *Click the Original thumbnail.* Variations is one of the few color adjustment commands that automatically remembers the last adjustment you applied. This is helpful when revisiting the dialog box if a correction doesn't quite turn out the way you had hoped. But for this exercise, you'll want to clear the old correction (if indeed there was one) and start from scratch. Clicking the top-left thumbnail, the one labeled **Original**, does exactly that (see Figure 3-8).

4. *Select the Midtones option.* Like Levels, the Variations command lets you apply your changes to the highlights, midtones, or shadows in an image. You do so by selecting one of the first three radio buttons near the top of the dialog box. When correcting a color cast, however, you almost always want the default setting, Midtones. (Shadows is sometimes useful; Highlights almost never.) Make sure **Midtones** is selected.

5. *Turn off Show Clipping.* When and if you adjust highlights, shadows, and—as we'll see—saturation values, some colors may exceed the brightness range in one or more color channels. These colors are *clipped* to white or black. When the **Show Clipping** check box is on, as by default, Photoshop tries to warn you about these clipped colors by inverting them. The problem is, the warning is misleading—just because a color is clipped in one channel doesn't mean it is in another—and it blocks what is already a small view of your image. For my part, I always turn the Show Clipping option off.

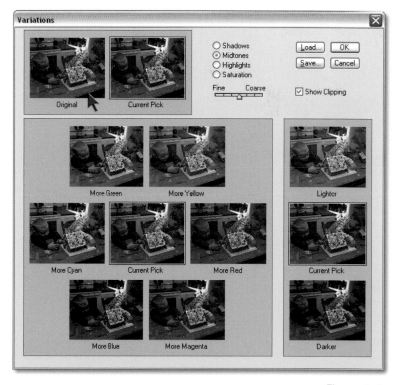

Figure 3-8.

Figure 3-9.

6. **Set the Fine/Coarse slider to the middle.** The slider bar, which is labeled **Fine** on one side and **Coarse** on the other, lets you modify the intensity of your edits. Under Windows, set the triangle to the exact middle of the slider. Strangely, on the Mac, there is no exact middle. The equivalent setting is three tick marks over from Fine, as in Figure 3-9.

7. **Click the More Cyan thumbnail twice.** When Shadows, Midtones, or Highlights is active, the central portion of the dialog box contains a total of seven thumbnails: six color variations grouped around Current Pick. Click any color variation thumbnail to nudge the image toward a range of hues. So, for example, More Yellow represents not simply yellow, but a whole range of colors—amber, chartreuse, and so on—that have yellow at their center (as you'll learn about in "The Visible-Color Spectrum Wheel" on the facing page).

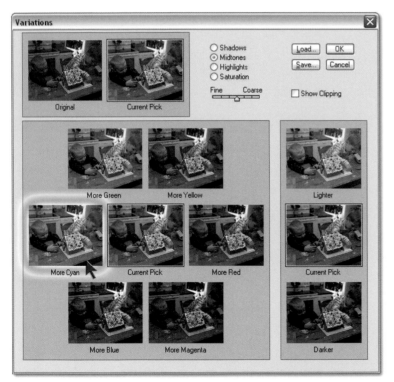

Figure 3-10.

PEARL OF WISDOM

Thumbnails arranged across from each other—if you were to connect them, you would get a straight line through the central Current Pick thumbnail—represent *complementary colors*. This means they form neutral gray when mixed together. For example, More Yellow appears on the other side of the Current Pick thumbnail from More Blue, so yellow and blue are complementary. In the Variations dialog box, Photoshop treats complementary colors as opposites. In other words, if you click the More Yellow thumbnail, Photoshop adds yellow and subtracts blue.

Our problem color is red, and based on the position of the More Red thumbnail, red's complement is cyan. We have a decent amount of red to get rid of, so click **More Cyan** twice. (Be sure to get both clicks in. For those used to double-clicking, don't. Click, pause, click. If you click too fast, Photoshop has a tendency to ignore one of them.) All the thumbnails, except the one labeled Original, update to reflect the change, as in Figure 3-10.

8. **Adjust the intensity.** Move the **Fine/Coarse** slider triangle one tick mark to the left. (PC or Mac, doesn't matter.) This reduces the intensity of the next step.

To feel comfortable working in the Variations and Hue/Saturation dialog boxes, you have to understand the composition of a little thing called the *visible-color spectrum wheel*. Pictured below, the wheel contains a continuous sequence of hues in the visible spectrum, the saturation of which ranges from vivid along the perimeter to drab gray at the center.

The colors along the outside of the circle match those that appear in a rainbow. But as the labels in the circle imply, the colors don't really fit the childhood mnemonic Roy G. Biv, short for red, orange, yellow, green, blue, indigo, and violet. An absolutely equal division of colors in the rainbow tosses out orange, indigo, and violet and recruits cyan and magenta, producing Ry G. Cbm (with the last name, I suppose, pronounced *see-bim*). Printed in large colorful type, these six even divisions just so happen to correspond to the three primary colors of light—red, green, and blue—alternating with the three primary pigments of print—cyan, magenta, and yellow. (The missing print color, black, is not a primary. Black ink fills in shadows, as we will discuss in Lesson 12.)

In theory, cyan ink absorbs red light and reflects the remaining primaries, which is why cyan appears a bluish green. This is also why More Red and More Cyan are treated as opposites in the Variations dialog box. Similarly, magenta ink absorbs its opposite, green; yellow ink absorbs blue.

Of course, Ry G. Cbm is just a small part of the story. The color spectrum is continuous, with countless nameable (and unnameable) colors in between. I've taken the liberty of naming secondary and tertiary colors in the wheel. Because no industry standards exist for these colors, I took my names from other sources, including art supply houses and consumer paint vendors. I offer them merely for reference, so you have a name to go with the color.

The practical benefit is that you can use this wheel to better predict a required adjustment in the Variations dialog box. For example, the color orange is located midway between red and yellow. Therefore, if you recognize that an image has an orange cast, you can remove it by clicking red's opposite, More Cyan, and then clicking yellow's opposite, More Blue.

Photoshop's other color-wheel-savvy command, Hue/Saturation, tracks colors numerically. A circle measures 360 degrees, so the Hue value places each of the six primary colors 60 degrees from its neighbors. Secondary colors appear at every other multiple of 30 degrees, with tertiary colors at odd multiples of 15 degrees. To track the difference a Hue adjustment will make, just follow along the wheel. Positive adjustments run counterclockwise; negative adjustments run clockwise. So if you enter a Hue value of 60 degrees, yellow will become green, ultramarine will become purple, indigo will become lavender, and so on. It may take a little time to make complete sense of the wheel, but once it sinks in, you'll want to rip it out of the book and paste it to your wall. Trust me, it's that useful.

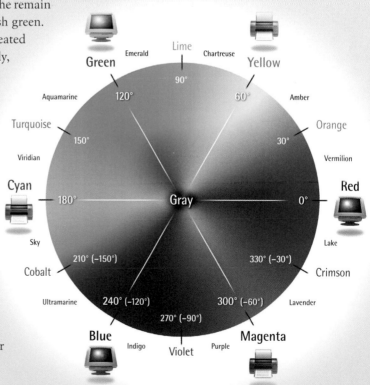

9. ***Click the Lighter thumbnail.*** At this point, the image strikes me as a wee bit dark. So click the **Lighter** thumbnail to make the image lighter. Because the Midtones radio button is active (Step 4), this adjustment affects only the midtone values. Therefore, clicking the Lighter thumbnail is like raising the gamma value in the Levels dialog box (see Step 9 of "Adjusting Brightness Levels," page 53). The shadows and highlights remain untouched, which helps to avoid clipping.

10. ***Click the More Blue thumbnail.*** After all these wonderful changes, the image remains a bit too yellow, particularly in the table, background, and skin tones. To remove yellow, click the complementary thumbnail, **More Blue**. Because you changed the intensity setting in Step 8, Photoshop's color adjustment is more subtle than in earlier steps.

11. ***Select the Saturation option.*** So much for the hue and luminosity, now on to saturation. To display the Variations command's saturation controls, select the **Saturation** radio button near the top of the dialog box. Photoshop replaces the thumbnails in the center and right portions of the dialog box with three new ones, all visible in Figure 3-11.

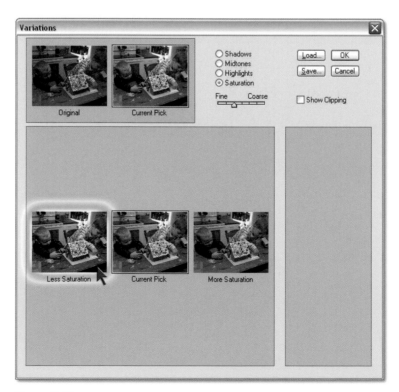

Figure 3-11.

12. ***Click the Less Saturation thumbnail.*** Currently, the colors in the image are a bit too vivid. Click **Less Saturation** to leech away colors and make them slightly grayer. (The current Fine/Coarse setting, specified in Step 8, is fine for this step.)

13. ***Click the OK button.*** It's hard to judge for sure from a bunch of dinky thumbnails, but the Current Pick image appears more or less on target. Click the **OK** button or press Enter or Return to exit the dialog box and apply your changes.

Well, as I said, it's hard to judge the accuracy of your color modifications from dinky thumbnails. And sure enough, after clicking OK, it becomes evident that I didn't quite hit the bull's eye. Although the harsh orange color cast has been efficiently zapped, I think we've gone a little overboard. After all, little boys need some warmth in their faces. Fortunately, Photoshop lets you reduce the impact of the most recent command you applied.

14. ***Fade the Variations adjustment.*** Choose **Edit→Fade Variations** or press Ctrl+Shift+F (⌘-Shift-F). This brings up the diminutive **Fade** dialog box. Reduce the **Opacity** value to 75 percent, as pictured in Figure 3-12. Then click **OK** or press Enter or Return.

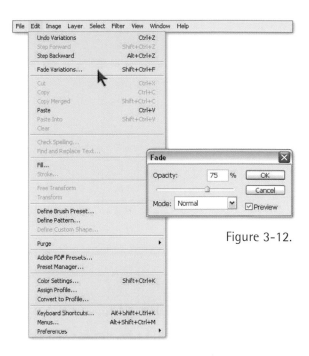

Figure 3-12.

The Opacity value acts as an ingredient mixer. If you think of the modified, post-Variations image as one ingredient and the original image as another, Opacity determines how much of each image goes into the final blend. A value of 100 percent favors the modified image entirely. So 75 percent gives the modified image the edge, with 25 percent of the original image showing through. Do not construe this to mean that Opacity lessens any specific option applied in the Variations dialog box. Instead, it reduces the effect of the command as a whole. Doubtless, we could have achieved a similar outcome by adjusting the Fine/Coarse setting before each thumbnail adjustment. But one application of Fade provides better feedback, not to mention heaps more convenience.

Figure 3-13 compares a detail from the original photo to its counterpart in the corrected one. Happily, my suddenly healthfully-hued boys appear determined to finish their creation and, without mercy, crush and eat it. And who can blame them? I can't remember the last time I saw a work of architecture that looked this delicious.

Original ultra-orange photograph

Corrected with Variations and Fade

Figure 3-13.

Tint and Color

Like the Variations command, Image→Adjustments→Hue/Saturation lets you edit a range of colors independently from or in combination with luminosity values. But where Variations permits you to limit your adjustments to brightness ranges (highlights, shadows, and midtones), the Hue/Saturation command lets you modify specific hues. This means you can adjust the hue, saturation, and luminosity of an entire photograph or constrain your changes to, say, just the blue areas. The following exercise provides an example:

Figure 3-14.

1. *Open an image.* Open the file titled *Helicopter & hotel.jpg* in the *Lesson 03* folder inside *Lesson Files-PsCS3 1on1*. Having awoken one Los Angeles morning to the unrelenting thrashing of a circling helicopter, I snapped this photo from the window of my hotel room. As shown in Figure 3-14, I was pointed more or less into the sun, so a copious amount of reflected light obscures our view.

2. *Apply the Auto Color command.* This image obviously suffers from low contrast and washed-out shadows. Choose **Image→Adjustments→Auto Color** or press Ctrl+Shift+B (⌘-Shift-B on the Mac).

3. *Fade the Auto Color adjustment.* Auto Color sends the image to the other extreme; it overcorrects the shadows and makes the side of the building too dark. To lighten the shadows, choose **Edit→Fade Auto Color** or press Ctrl+Shift+F (⌘-Shift-F). Then enter an **Opacity** value of 60 percent and click the **OK** button. The result appears in Figure 3-15 on the facing page.

4. *Choose the Hue/Saturation command.* Choose **Image→Adjustments→Hue/Saturation** or press the keyboard shortcut Ctrl+U (⌘-U) to display the **Hue/Saturation** dialog box, shown in Figure 3-16.

5. *Raise the Saturation value.* Press the Tab key to advance to the **Saturation** value. Then increase the value to +60 percent. This radical adjustment increases the intensity of colors throughout the photograph.

Figure 3-15.

Figure 3-16.

6. *Lower the Hue value.* The sky and mirrored windows of the building are trending distinctly toward purple. My sense is that they would look better if they trended toward blue. According to the color wheel (see "The Visible-Color Spectrum Wheel," page 75), shifting the hues from purple to blue is a clockwise rotation, which means a negative value. Press Shift+Tab to select the **Hue** value. Then press Shift+↓ to reduce the value to −10 degrees, which removes the slight purple tint, as in Figure 3-17 on the next page.

In general, the dramatic boost to the Saturation value holds up nicely. The red brick of the building looks terrific, as do the yellow reflections and some of the other touches. But the blue sky is just too much. In a lesser piece of software, we'd have to split the difference—that is, come up with a Saturation value high enough to boost the brick but low enough to avoid over-emphasizing the sky. Fortunately, Photoshop lets us work on the sky and brick independently.

Figure 3-17.

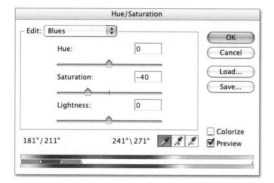

Figure 3-18.

7. **Isolate the blues.** The Edit pop-up menu at the top of the Hue/Saturation dialog box is set to Master. This tells Photoshop to transform all colors in an image by an equal amount. To limit your changes to just the sky colors, set **Edit** to **Blues** instead.

Now just because you select Blues doesn't mean you've isolated the *right* blues. The blues of this particular photograph could exactly match Photoshop's definition of blue, but just as likely they lean toward ultramarine, indigo, cobalt, or sky (again, see page 75). Although the Edit pop-up menu doesn't provide access to these colors, it does permit you to precisely nail the hues in the image by moving your cursor into the image window and clicking a specific color to identify it. The following step explains how.

8. **Confirm the colors in the image window.** The numerical values at the bottom of the dialog box read 195°/225° and 255°\285°. According to the color wheel chart, this tells you Photoshop is prepared to modify the colors between ultramarine (225°) and indigo (255°), centered at blue. The change will taper off as the colors decline to sky (195°) and purple (285°).

Now move your cursor outside the Hue/Saturation dialog box. It becomes an eyedropper. Click near the moon in the upper-left region of the image. The numbers at the bottom of the dialog box should shift to something in the neighborhood of 180°/210° and 240°\270°, as shown in Figure 3-18. (If your numbers differ by more than 5 degrees, move your cursor slightly and click again.) This translates to a range of cobalt (210°) to blue (240°), with a softening as far away as cyan (180°) and violet (270°). In other words, Photoshop has shifted the focus of the adjustment by −15 degrees; so instead of changing the blues in the image, you're all set to change the slightly greener ultramarines.

Admittedly, this is a lot of theory, but a single click is all it takes to put the theory into practice. And now that we have the colors in the sky properly isolated, it's seems a click well worth making.

9. *Lower the Saturation value.* Reduce the **Saturation** value to −40 percent to take some of the intensity out of the sky. This large Saturation shift may seem to make only a modest difference. But the sky no longer overwhelms other elements of the image, so all is well.

10. *Click OK.* Or press Enter or Return to accept your changes and exit the Hue/Saturation dialog box. The final image (see Figure 3-19) is both more accurate and more dramatic than the original. One might argue that, of the two attributes, drama has the edge. Hey, the photograph has a helicopter in it. If that doesn't call for drama, I don't know what does.

Figure 3-19.

PEARL OF WISDOM

You may have noticed that throughout that entire exercise, we never once touched the Lightness value. And for good reason—it's rarely useful. The Lightness value changes the brightness of highlights, shadows, and midtones by compressing the luminosity range. Raising the value makes black lighter while fixing white in place; lowering it affects white without harming black. It's not the worst luminosity modifier I've ever seen, but Levels, Curves, and Shadow/Highlight provide better results.

Colorizing a Grayscale Image

One of the major uses for the Hue/Saturation command is colorization. You can override the colors in a color photograph—particularly one in which the colors aren't in great shape. Or, more popularly, you can use the command to add color to a grayscale image. Hue/Saturation makes both tasks a breeze. But its limit of one Hue value and one Saturation value per operation makes it a flimsy tool for the job.

My preferred method for colorizing involves a little-known function called Gradient Map, which allows you to substitute luminosity values with as many hue and saturation values as you like. Problem is, so few Photoshop users know about

Gradient Map, and so many use Hue/Saturation for colorizing, that I feel compelled to do something I don't normally do in an exercise—compare and contrast. Therefore, in the following steps, we'll make use of both the Hue/Saturation and Gradient Map commands, and you can decide for yourself which is better (even though, truth be told, I'm pretty confident about your verdict).

1. *Open an image.* Open the grayscale image named *Woman in hood.jpg*, contained in the *Lesson 03* folder inside *Lesson Files-PsCS3 1on1*. Pictured in Figure 3-20, this photo hails from Ramsey Blacklock on behalf of iStockphoto. It's a swell pic, but it'll look livelier after we add some color.

Figure 3-20.

Figure 3-21.

2. *Convert the image to RGB color.* As you may remember from Lesson 2 (in "The Nature of Channels," page 46), a grayscale image contains just one channel of information and therefore is incapable of displaying colors. Before you can add color, you have to add channels. To do so, choose **Image→Mode→RGB Color**, as in Figure 3-21. If you have the **Channels** palette open, you'll see the one Gray channel turn into Red, Green, and Blue, plus the RGB composite. Otherwise, the photo won't look any different because the new channels are identical to the original one, as is necessary to maintain a neutral color balance. But you can take my word for it, the image is now ready for color to blossom.

3. *Choose the Hue/Saturation command.* Press Ctrl+U (⌘-U on the Mac) or choose **Image→Adjustments→Hue/Saturation** to display the **Hue/Saturation** dialog box.

4. *Turn on the Colorize check box.* Located in the lower-right corner of the dialog box, the **Colorize** check box applies the Hue and Saturation as absolute values. By this, I mean that all pixels are assigned one uniform Hue value and one uniform Saturation value. The moment you turn on Colorize, Photoshop updates the Hue value to match that of the current foreground color. If the foreground color is black or gray, the Hue becomes 0. Regardless, the Saturation automatically defaults to 25 percent. The result for me is a low-saturation red, as shown in Figure 3-22.

5. *Adjust the Hue and Saturation values.* At this point, I encourage you to experiment. Enter a **Hue** value documented in "The Visible-Color Spectrum Wheel" sidebar on page 75, and you'll see that color come to life before your eyes. Meanwhile, a **Saturation** of 0 percent invariably results in gray; 100 percent delivers the most vivid color Photoshop can muster.

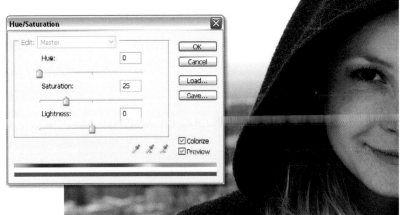

Figure 3-22.

While you experiment, you may want to try out a wonderful little trick called *scrubbing*. Drag your cursor back and forth over the word **Hue** or **Saturation** to scrub, or move, the corresponding value up or down. Press Shift as you drag to change the value in increments of 10.

For my part, I entered a **Hue** of 40 degrees and a **Saturation** of 30 percent. The result is a simulated orange-amber *duotone* because it contains two tones, black and the 40-degree amber (see Figure 3-23).

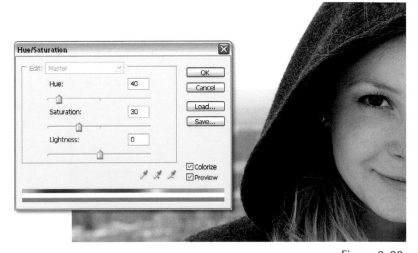

Figure 3-23.

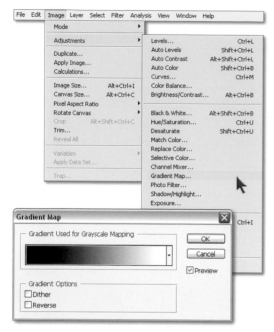

Figure 3-24.

Figure 3-25.

Figure 3-26.

6. **Cancel the adjustment.** That's interesting, but not good enough. Why? Because the moment you turned on the Colorize check box, you lost all selective control. The Edit pop-up menu dimmed, meaning that you lost the ability to adjust one color range independently of another. Rather than suffering under the oppression of such constraints, better to press Esc or click **Cancel** to abandon your work in Steps 3 through 5. Then turn to the little-known but far superior Gradient Map command.

7. **Choose the Gradient Map command.** Located with the other color commands in the **Image→Adjustments** submenu (see Figure 3-24), **Gradient Map** substitutes the luminosity values in the image with the colors in a gradient. Strange as this may sound, it's just the ticket for quality colorization. Armed with Gradient Map, you can swap every single gray value, from black to white, for a specific color. And all you need to make this happen is a gradient.

Incidentally, for those who may be wondering, a *gradient* is a continuous fountain of colors. The gradient may transition from black to white, from one color to another, or between a whole slew of colors, as illustrated by the examples in Figure 3-25.

PEARL OF WISDOM

For what it's worth, Photoshop offers yet another colorization function, Image→Mode→Duotone, that lets you print a grayscale image using a combination of two to four inks. It has the advantage of letting you assign spot colors to an image—thus permitting you to introduce color to a commercial print job using as few as two inks—but its implementation leaves a lot to be desired. In contrast, Gradient Map wouldn't know a spot color if it fell into a bucket of it. But it provides better feedback, more color choices, and the undeniable advantage of a more straightforward approach.

8. **Load the custom gradients.** Photoshop's predefined gradients don't work well for colorization, so I've created some colorization gradients for you to play with. In the **Gradient Map** dialog box, click the ▾ arrow to the right of the main gradient bar. This displays a panel of small gradient swatches. Click the ⊙ arrow to the right of the swatches and choose **Load Gradients** from the menu, as in Figure 3-26. After the **Load** dialog box appears, find the *Lesson 03* folder inside the *Lesson Files-PsCS3 1on1* folder and open the file called *A dozen gradients.grd*. Twelve new gradient swatches appear in the Gradient Map dialog box.

When working with complex gradients, I recommend you turn on the Large Thumbnail command (once again click the ⊙ arrow) so you can preview the gradients in detail. Each thumbnail shows the gradient at a −45-degree angle; that is, the gradient starts in the top-left corner and ends bottom-right.

9. *Select the Quadtone Supreme swatch.* Hover your cursor over the fifth of the new swatches, the one that shows the hint *Quadtone Supreme*, and click to select it. The gradient progresses from black to very dark magenta, dull red, a lighter but equally dull orange, and finally white. Assuming the **Preview** check box is on (as by default), each color finds a home over the course of the luminance levels in the photo, as illustrated in Figure 3-27. The gradient contains four colors not including white, hence a *quadtone.* (If your image remains black and white, you didn't convert the image from grayscale to RGB, as explained in Step 2.)

Figure 3-27.

10. *Open the Gradient Editor.* A gradient map behaves a lot like the Curves command (see "Correcting with Curves," on page 57 of Lesson 2) because it lets you lighten or darken individual luminosity values. To make brightness adjustments, click inside the gradient bar above the swatches panel to display the **Gradient Editor** dialog box.

Although the dialog box is brimming with options, most of the action centers on the gradient bar. Labeled in Figure 3-28, the gradient bar is festooned with tiny box icons above and below. The boxes above the bar (▮) control the opacity of the gradient and have no effect on the outcome of the Gradient Map command. The boxes below the bar (⬙) let you add key colors to the gradient. Because these boxes determine the position of the colors, they are known as *color stops.*

Click here . . .

to display this dialog box

Opacity stop
(no effect on gradient maps)

Gradient bar

Color stops

Figure 3-28.

11. **Edit the gradient.** Click the second color stop from the left—the dark magenta one—to select it. (I know, the swatch looks purplish, but if you go by the Hue value, it's magenta.) Two options, Color and Location, become available at the bottom of the dialog box. Click the Color swatch to change the color; modify the Location value or drag the color stop to move the color in the gradient. In a standard dark-to-light gradient like this one, increasing the Location value darkens the colors in the image; reducing the value lightens them.

Here's what I want you to do:

* With the dark magenta color stop selected, reduce the **Location** value for the color stop to 15 percent. This helps to lighten the shadows and bring out details in the hair.

* Click the next color stop over—the dull red one—and change its **Location** to 50 percent. Photoshop darkens the midtones in the face, giving it a more sculptural, volumetric appearance.

* Click the final, white color stop. This time I want you to try something a little different: Press the Alt (or Option) key and drag the color stop to the left until the **Location** value reads 83 percent. This duplicates the white color stop and draws out the highlights in the woman's face.

* Select the drab orange color stop, the one with a Location value of 65 percent. Alt-drag (or Option-drag) this stop to the right until **Location** reads 95 percent. Photoshop darkens the clouds from the overly bright background of the sky, as in Figure 3-29.

12. **Save your revised gradient.** Enter "Quadtone Modified" into the **Name** option box and click the **New** button to add your swatch to the end of the Presets list.

13. **Click OK.** This returns you to the **Gradient Map** dialog box.

14. **Try out the other gradients.** To see what other gradients look like when applied to this photograph, click the ⯆ arrow to the right of the gradient bar and select a different gradient swatch.

Figure 3-29.

15% 50% 65% 83% 95%

The images in Figure 3-30 illustrate four additional gradients that I provided as well as one of Photoshop's defaults, Copper. In the case of Copper, I turned on the Reverse check box, which reverses the order of the colors in the gradient.

15. **Click OK.** After you arrive at a favorite, click the **OK** button to accept the colorized image. (If the gradient swatch panel is visible, you may have to press Enter or Return twice.)

Note that a colorful gradient with lots of variety often results in a psychedelic, otherworldly effect. Unless psychedelic is your goal (see the Vivid Contrast example on the right), I advise subtle changes. Even small shifts in color can make a big difference.

Correcting with Camera Raw

The final method for correcting colors applies to photographs captured by a midrange or professional-level digital camera and saved in the camera's native format, known as its *raw format*. This raw file represents the unprocessed data captured by the camera's image sensor. Such a file is typically several times larger than an equivalent JPEG file, but it also contains more information and captures a wider range of colors. All of this adds up to a lot more flexibility when you're correcting the image.

Cool Palette

Crimson Reflect

Deep Sky

Vivid Contrast

Copper, Reverse

Figure 3-30.

Camera Raw's features cover a wide range of color-correction scenarios. So rather than direct Camera Raw's far-flung power on a single photograph, I've gathered a collection of images for you to work on, each with different color correction needs. Instead of producing one final composition (as in other exercises), you'll use the Bridge and Camera Raw to create an entire folder full of corrected photos. Given that this is the way you're most likely to use the plug-in, I believe this approach presents Camera Raw in its best light and most logical context.

Whether a raw image file is saved to DNG or one of the many proprietary camera formats, Photoshop supports it directly—without the need to preprocess the file using your camera's software—with the assistance of a powerful plug-in called Camera Raw. Photoshop CS3 includes Camera Raw 4, a plug-in so vast and sophisticated that I could devote a whole book to the topic (and many have). So in this exercise, we'll focus on Camera Raw's most essential capabilities and its copious new functions. We'll even see how you can process a JPEG image in Camera Raw. It's impressive stuff.

1. *Locate and select three raw images.* This time, we'll start things off in the Adobe Bridge, which makes it easier to select multiple images at the same time. If you're in Photoshop, switch to the Bridge by choosing **File**→**Browse** or by clicking the 🗗 icon on the right side of the options bar. Then do the following:

 • Assuming that you followed my advice in Lesson 1 (see "Organizing and Examining Photos," Step 12, page 15), click the 2 icon in the bottom-right corner of the window to switch to the Vertical Filmstrip workspace.

 • Navigate to the *Lesson 03* folder inside *Lesson Files-PsCS3 1on1*. Then double-click on the *Raw Images* subfolder, which contains a collection of images from pro photographer and fellow lynda.com trainer Chris Orwig.

 • Wait a few seconds for the thumbnails to generate. Then scroll down the Content panel until you come to the three *Sunset* photographs. Click *Sunset girl.dng* and then Shift-click *Sunset triplets.dng* to select a range of three images (which includes *Sunset tribe.dng*), as pictured in the Preview panel in Figure 3-31.

Captured with a Canon EOS 5D and converted from the CR2 format to DNG, each of these 12-megapixel photos weighs in at around 9MB, or somewhere between two and four times the size of an equivalent image saved as a high-quality JPEG file. The theoretical color range includes more than a billion possible variations,

Figure 3-31.

64 times as many as a JPEG image. To distill these billion or so colors down to the best 16 million (as explained in the sidebar, "Exploring High Bit Depths" on page 98), the Bridge requires the image to pass through the Camera Raw plug-in.

2. *Open the images in Camera Raw.* From the Bridge, you get to Camera Raw in one of two ways:

- Choose File→Open or double-click any one of the selected thumbnails to switch to Photoshop and display the Camera Raw interface.

- Choose File→Open in Camera Raw or press Ctrl+R (⌘-R) to load the Camera Raw interface directly inside the Bridge.

Although either method is fine, the latter is a bit more flexible, permitting you to examine one or more raw photos while keeping Photoshop free to perform more complex modifications. So choose **File→Open in Camera Raw** (see Figure 3-32) or press Ctrl+R (⌘-R) to display Camera Raw in the Bridge. As witnessed in Figure 3-33, Camera Raw includes a high-resolution preview of the selected image, a vertical filmstrip of thumbnails (visible only when adjusting multiple images), and a full color histogram, all of which update as you adjust the color settings. The title bar lists the model of camera used to shoot the photo.

Figure 3-32.

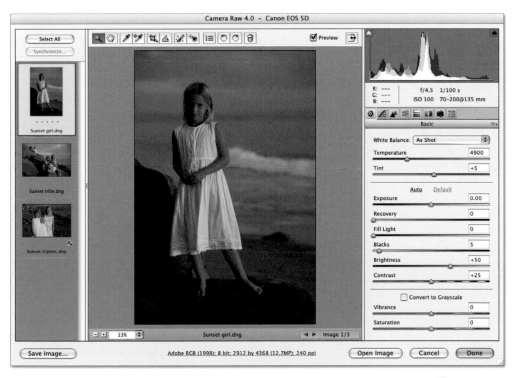

Figure 3-33.

For those of you who may be familiar with previous versions of Camera Raw and are wondering what happened to the ISO, exposure, aperture, and shutter speed that used to appear in the title bar, they've been moved to directly below the histogram. This EXIF data helps Camera Raw establish some of its automatic settings.

3. *Select all three images.* Even though Camera Raw is a plug-in (meaning it has to run in a host program), it's an independent utility with its own tools, options, and benefits. One of the features that sets it apart from the rest of Photoshop is its ability to apply corrections to multiple images at a time. The vertical filmstrip displays the three images you selected in the Bridge (see Figure 3-34). To modify all three images at the same time, click the **Select All** button at the top of that filmstrip or use the Select All shortcut Ctrl+A (⌘-A).

PEARL OF ⚪ **WISDOM**

The colors captured by a camera (as well as those we see in real life) are typically a function of light reflecting off the surfaces of objects. (The exceptions are objects that emit light such as, well, lights.) As a result, those reflected colors are informed by the color of the light source. This source defines the color of white, because no light-reflecting object can be whiter than the source. Hence, the color cast of the image is the direct result of the color of the light source. This relationship between the color cast of the scene and the color of the light source is known as *white balance.* I explain how you address white balance in the next step.

4. *Adjust the White Balance controls.* You can neutralize a color cast using the White Balance controls, found in the Basic panel on the right side of the interface. (If you see a different panel of options, click the ⚙ tab below the histogram.) Here's how the White Balance functions work:

 • By default, the White Balance pop-up menu is set to As Shot, which loads the white balance information conveyed by the camera. You can override this setting by choosing a lighting condition from the pop-up menu or entering your own Temperature and Tint values.

Select All

Synchronize...

Sunset girl.dng

Sunset tribe.dng

Sunset triplets.dng

Figure 3-34.

- The Temperature value compensates for the color of the light source, as measured in degrees Kelvin. Low-temperature lighting such as tungsten produces a yellowish cast, so Camera Raw "cools" the image by making it more blue. High-temperature light such as shaded daylight produces bluish casts, so Camera Raw "warms" the image by tilting it toward yellow. The closest thing to neutral light is direct sunlight, which hovers around 5500 degrees.

- Tint compensates for Temperature by letting you further adjust the colors in your image along a perpendicular color axis. Positive values introduce a magenta cast (or remove a green one); negative values do just the opposite.

These images were shot at sunset, giving the photos a warm, orangy glow. It's a nice look, but I think it might be too much of a good thing. The White Balance pop-up menu offers a series of predefined light sources, but the list doesn't include a Sunset option. The closest setting, Daylight, warms the image even further. It's time to apply some manual adjustments.

The Temperature and Tint sliders are colorized. For example, raising the Temperature value makes an image more yellow and lowering the value shifts it toward blue. But as when correcting an image with the Variations command, don't think about what color you want to add; think about the color you want to remove. If you reference "The Visible-Color Spectrum Wheel" (page 75), less orange equates to more cobalt, a near cousin to blue, which means we need to reduce the Temperature value.

I suggest you cool the photos by lowering the **Temperature** value to 4400 degrees. Then remove some of the magenta from the images by moving the **Tint** slider to the left (toward green) to a value of −14 or thereabouts. As you can see in **Figure 3-35**, the adjustment accurately accounts for the lighting conditions under which the preview image was shot.

Figure 3-35.

You can also correct a color cast using the white balance tool in the horizontal toolbar. Select the 🖋 icon near the top of the window and click a color in the image that should be a light neutral gray—in our case the dress or, even better, the foam in the surf. Photoshop sets the Temperature and Tint values as needed. If you don't like the results, try again or adjust the sliders slightly. Double-click the eyedropper icon to restore the As Shot values.

5. ***Check how the adjustments work for other images.*** However great our changes may look on the *Sunset girl.dng* photo, we're editing two other images as well. So let's see how our changes affect those images:

 • Use the ↓ key to move to the *Sunset tribe.dng* image. This one still looks a little pink. To compensate, change the **Tint** value to –21, as in Figure 3-36.

 • I'd like to go back to the first image by pressing the ↑ key. But that would raise the Tint value, which is active. So to see how our change affects our first image, hold down the Alt key (Option on the Mac) and click the *Sunset girl.dng* thumbnail in the vertical filmstrip. This way, we still have all three images selected.

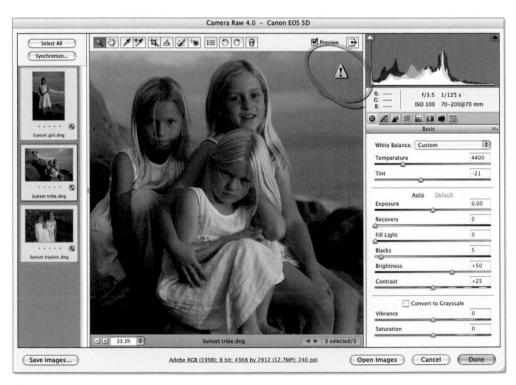

Figure 3-36.

When switching images, you may see a yellow ⚠ icon in the top-right corner of the preview, as in Figure 3-36. Don't fret, nothing's wrong with your image. The ⚠ merely means that Camera Raw is applying its adjustments. So don't make any decisions until the ⚠ goes away.

6. *Adjust an image independently.* Sunset is a time of radical light transition, making it a tricky time to photograph. So it's hardly surprising that the third photograph in our group requires individual attention. Click the third thumbnail in the filmstrip area, *Sunset triplets.dng*, and notice that only one image is selected. Select the white balance tool (✐) and click in a neutral area—an area that should not have color in it—like one of the white dresses, as demonstrated in Figure 3-37. This should cool the image. If things get a bit too chilly (as in the figure), adjust the **Temperature** value to about 3350 and, with any luck, you'll get a nicely balanced image.

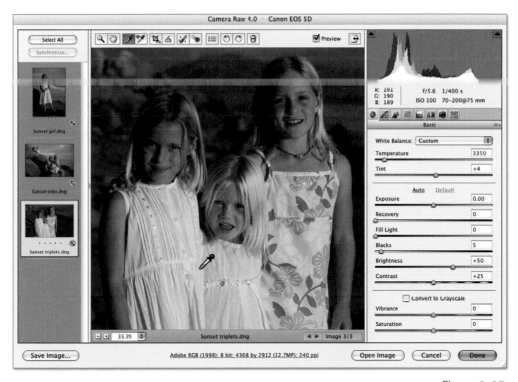

Figure 3-37.

7. *Save your changes.* Once you're happy with your white balance settings, you'll naturally want to save your work. But how you do this may surprise you. First, let's review the buttons along the bottom of the interface:

 • Open Image opens all the selected images inside Photoshop, where you can perform further edits.

Figure 3-38.

Press and hold the Shift key to change Open Image to Open Object. Clicking this button opens the raw image as a smart object, thus permitting you to modify your Camera Raw settings well into the future. For more information about smart objects, see "Working with Smart Objects," which begins on page 447 of Lesson 11.

- The Cancel button abandons all the adjustments that you've made during the session.

- On the far left, Save Image allows you to save the processed images to a different file format.

- Done saves your changes as metadata instructions (which are stored with the original DNG files), closes Camera Raw, and returns you to the Bridge.

We don't need to work in Photoshop, so click **Done**. A moment later, you should see the thumbnails update dynamically to reflect your changes, as in Figure 3-38. (If the images don't update—it can take a few seconds—choose **Tools→Cache→Purge Cache For Folder "Raw Images"** to rebuild the cache and generate new thumbnails.) The slider icon (⊜) below each thumbnail tells you that the corresponding file has been altered. These changes will be understood by any application that reads Camera Raw metadata, including (but not limited to) the Bridge, Photoshop, Lightroom, and other Adobe applications.

PEARL OF WISDOM

Note that while each DNG file has been updated, not a single pixel in these files has been harmed or otherwise changed. All the adjustments have occurred *parametrically*, meaning that you can revisit your settings, make additional changes without penalty, and even go back to the image's original state. You cannot permanently alter an image in Camera Raw.

8. ***Open a new image.*** Camera Raw offers some useful features to adjust the brightness and contrast of an image, so let's select a suitable photo. In the Bridge, select the *Hot highlights.dng* file in the *Raw Images* folder and press Ctrl+R (⌘-R) to open it in Camera Raw. As seen in Figure 3-39, this little fellow is rife with blown highlights.

In time, you may find that you prefer to double-click a thumbnail and have it open in Camera Raw in the Bridge. If so, press Esc to return to the Bridge, choose **Edit→Preferences** (**Bridge→Preferences** on the Mac), click **General**, and turn on the **Double-Click Edits Camera Raw Settings in Bridge** check box. Now click **OK**, double-click the *Hot highlights.dng* thumbnail, and watch the image open inside Camera Raw in the Bridge.

9. ***Adjust the highlights, shadows, and midtones.*** The Basic panel includes a collection of sliders that allow you to control the exposure and overall brightness of your images. Very briefly, here's how the options work:

- Exposure gives you control over the highlights of an image, much like the white slider triangle in the Levels dialog box, but with two big differences. First, Exposure is computed in f-stops. For example, raising the Exposure to +0.50 simulates opening the lens aperture of the camera a half-stop wider. Second, because a raw image includes colors beyond those rendered in the preview, you can sometimes use Exposure to recover blown highlights, as we will shortly.

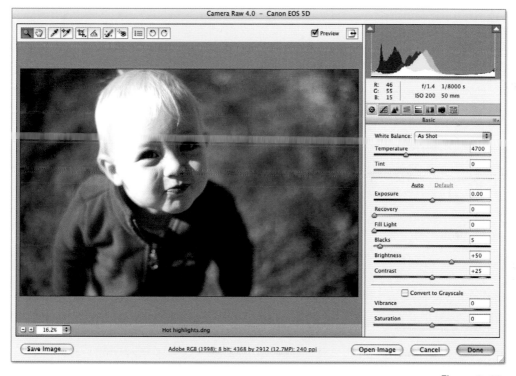

Figure 3-39.

- Recovery is a new feature that allows you to darken your highlights, reining them in from the extremes without affecting the exposure of the entire image.

- Fill Light brightens the shadows independently of the highlights. Recovery and Fill Light work much like the Amount values in the Shadows/Highlights dialog box.

- Blacks sets the black point of your image, permitting you to set the clipping point for shadows. It works just like the black slider triangle in Photoshop's Levels dialog box.

Press the Alt key (Option on the Mac) and drag the Exposure or Recovery slider triangles to preview clipped highlights. Anything that isn't black will be clipped in one or more color channels. Alt-drag (or Option-drag) the Blacks slider triangle to preview clipped shadows, which are any pixels that don't appear white.

- The Brightness value controls the midtones. It's computed as a percentage of an image's original linear luminance data. This data requires lots of darkening, which is why the default value is 50 percent. Values below 50 compress shadows and expand highlights, thereby lightening an image. Values over 50 do just the opposite, darkening the image.

- Increase the Contrast value to exaggerate the difference between shadows and highlights, creating a valley in the center of the histogram. Decrease the value to converge shadows and highlights into the midtones, so the histogram looks more like a central mountain.

PEARL OF WISDOM

It's a good idea to keep an eye on the histogram as you adjust the exposure values. Unlike its counterparts in Photoshop, this histogram comprises three overlapping graphs, one for each color channels. As you move the sliders, the histogram lets you predict how your colors will develop when the image is rendered in Photoshop. As usual, shadows are on the left; highlights are on the right. Spikes on the extreme ends of the graph tell you that you've clipped shadows or highlights.

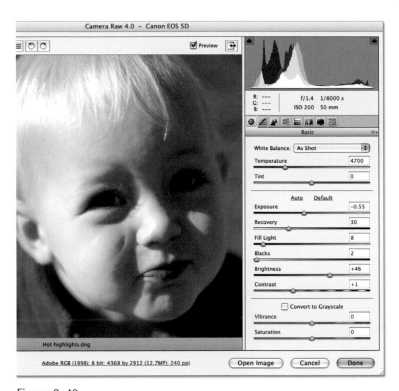

Figure 3-40.

For our image, let's do the following:

- Begin by lowering the **Exposure** value to recover some of the blown highlights on the left side of the toddler's head (his right). If you move the value down to −1.05, you'll recover the highlights but at the expense of making everything too dark.

- Compensate by raising the **Recovery** value to 30. This eliminates the spike on the right side of the histogram and restores the detail in the highlights. Then "assist" the Recovery control by backing off the Exposure setting to −0.55.

- Change the **Fill Light** value to 8 to bring back some of the details that were lost in the shadows. Lower the luminance levels by setting the **Blacks** value to 2.

- Darken the midtones by reducing the **Brightness** value a few clicks to 46. Then reduce the overly enthusiastic **Contrast** value to a scant +1. The final settings appear in Figure 3-40.

You may have noticed the Auto button above the Exposure slider. Use Auto to have Camera Raw assign its best-guess values to the six exposure settings. (To apply Auto from the keyboard, press Ctrl+U or ⌘-U, a leftover from the old Use Auto Adjustments command.) Like Photoshop's Auto Color command, the Auto button fails about as often as it succeeds. You can always try the Auto settings first and then make your adjustments.

10. *Accept your changes and open another image.* Click the **Done** button to update the metadata information and return to the Bridge. Then select that same *Sunset triplets.dng* file that we modified a few steps ago and press Ctrl+R (or ⌘-R) to open it again.

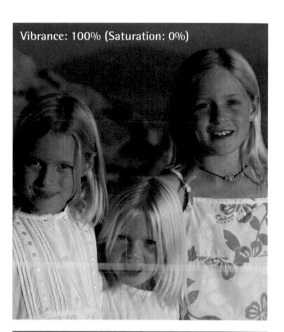

Vibrance: 100% (Saturation: 0%)

11. *Adjust the Vibrance and Saturation settings.* The final two sliders in the Basic panel of the Camera Raw plug-in let you modify the intensity of colors in an image. Because we've seen Saturation before (with the Variations and Hue/Saturation commands) and Vibrance is new, our discussion will make more sense if we address the sliders in reverse order:

 • The Saturation value increases or decreases the intensity of all colors across the entire image—flesh, fabric, background, everything.

 • The Vibrance slider, new to Camera Raw, changes color intensity more selectively, affecting low-saturation colors more than high-saturation ones.

Figure 3-41 compares the results of setting Vibrance and Saturation, each independently, to their maximum values of 100 percent. The bottom, high-Saturation image looks garish, especially when compared with the vibrant but plausible skin tones above. However, because Vibrance doesn't boost all colors evenly, you can have some rough transitions, such as the boundary between the rocks and water in the top image.

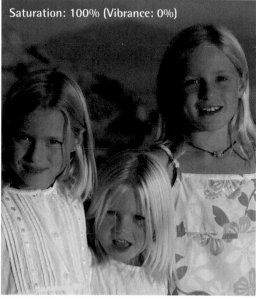

Saturation: 100% (Vibrance: 0%)

For the *Sunset triplets.dng* image, start by turning down the **Temperature** to about 3150 degrees. (Assuming it was 3350 before, click the Temperature value and press the ↓ key four times.) This cools the image slightly, offsetting the orange skin tones a fraction. Then set the **Vibrance** value to +20 and the **Saturation** to +5 to pump up the colors without overplaying them.

12. *Accept your changes and open yet another image.* Click the **Done** button to exit Camera Raw and save your changes. Select the one night image, *Strip lights.dng*, and press Ctrl+R (⌘-R) to open it.

Figure 3-41.

To understand how color works in an image, you have to start at the very beginning, at the assembly-language level: Your computer is a binary machine. It thinks and communicates entirely in the binary digits 0 and 1, known as *bits*. Pixels began life as single bits, either 0 or 1, black or white. Hence the earliest black-and-white images were called *bitmaps*.

Nowadays, a typical RGB image contains no fewer than 256 luminosity values per color channel, which means a whole

A 24-bit image shown head-on, the way we users see it

The same image with
colors mapped into the third dimension

lot of bits. For example, a pixel with 2 bits can be any of 4 colors—00, 01, 10, or 11. Each additional bit doubles the potential of the pixel, so you quickly progress from 8 colors to 16, 32, 64, and so on. A total of 8 bits gets you $2^8 = 256$ colors. Hence, a typical digital photograph is said to be an 8 bit-per-channel image. Three channels times 8 bits each is 24 bits, which means $2^{24} = 16.8$ million colors.

The name given to the number of bits assigned to a pixel is *bit depth*. So in addition to the height and width of an image, Photoshop sees a third dimension of bit depth associated with each and every pixel, as illustrated on the left.

Various digital cameras and scanners support higher bit depths. My Olympus Evolt E-300 supports 10 bits per channel, or 30 bits in all, which translates to $2^{30} = 1.1$ billion colors. Other devices capture 12 bits per channel, 36 bits in all, for $2^{36} = 68.7$ billion colors. Meanwhile, Photoshop supports two even higher bit depths: 16 bits per channel (which translates to $2^{48} = 281.5$ trillion colors) and 32 bits per channel (or $2^{96} = 79.2$ octillion colors).

The benefit of so many colors is somewhat theoretical. First, your computer's operating system cannot display more than 16.8 million colors. Second, even an extremely large image—such as one captured with a professional-quality drum scanner—might contain at most 100 to 200 million pixels, and most images contain a fraction of that. Given that each pixel can display just one color, that leaves at the very least billions of colors unused.

The advantage: So many potential colors are lying fallow that you can apply multiple radical color transformations without harming your image. It's like a game of musical chairs in which there are a million chairs for every contestant. No one comes within miles of each other, let alone sits in an occupied chair.

Consider the examples in the upper-right figure on the facing page. (Hey, it's an advertisement—the product name is *supposed* to be misspelled.) I start with a photo from a stock image library. Then I choose the Levels command and adjust the Output Levels values to dramatically reduce the contrast of the image so it can serve as

the background for a perfume ad (top middle). Now let's say I lose the original image and the lightened background copy is all I have. If I apply the Auto Color command to restore the highlights and shadows, I can revive a semblance of the original image. But you can see how few colors remain (top right). The corrected image is rife with color banding as well as flat highlights and shadows.

If I had chosen Image→Mode→16 Bits/Channel *before* creating the perfume ad (the command doesn't do you any good after the colors are lost!), this would not have been a problem. Choosing Auto Color would have restored the image to nearly its original coloring, as demonstrated by the lower-right example. It would have also produced a much healthier histogram. When you're working with 8 or 16 bits per channel, the histogram shows you just 256 levels of brightness. But when you stretch out a squished histogram, the 8-bit histogram reveals gaps and the 16-bit histogram is smooth, as the examples on the right show.

If you convert to 32 bits per channel (also known as *high dynamic range,* or *HDR*), you gain still more theoretical wiggle room. Suddenly, you are no longer bound by the conventional histogram. Colors can *float* outside the boundaries of the visible range, permitting you to regain blown highlights and flat black shadows.

What does all this have to do with Camera Raw? By default, Camera Raw reduces the bit depth to 8 bits/channel when opening an image in Photoshop. That makes sense given that the major benefit of a higher bit depth is the freedom it gives you when applying color adjustments, and chances are you'll do most of the destructive work in Camera Raw before setting foot in Photoshop. However, if you plan on applying a few more dramatic color adjustments, or you're merely keen on

protecting every single color that you can, click the blue link below the image preview in the Camera Raw interface. This displays the **Workflow Options** dialog box. Set the Depth option to **16 Bits/Channel** and then click **OK**. From now on (or until you restore the default Depth setting), all your raw photos will open in Photoshop's 16 bits/channel space.

Original photograph | Lightened using Levels | Auto Color produces banding

Radically lightened image | Auto Color in 8-bit/channel | Auto Color in 16-bit/channel

13. ***Switch to the Tone Curve panel.*** This 25-second exposure of the Las Vegas strip contains lots of electric highlights and midnight shadows, but little in the way of transitional midtones. Our job is to temper the contrast of the image without sacrificing its dramatic impact, a perfect job for Camera Raw 4's newly enhanced Tone Curve controls.

Click the ⊞ tab below the histogram to switch to the **Tone Curve** panel, which contains a luminance graph like the one from the Curves dialog box, as pictured in Figure 3-42. Then click the **Parametric** tab (below the panel title) and you'll see a set of sliders below the graph. These sliders let you adjust areas of luminosity without manually setting and moving points. The triangles below the graph (circled orange, highlighted yellow) let you scale the range of brightness levels.

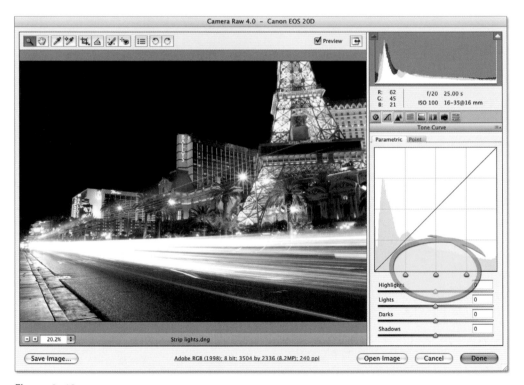

Figure 3-42.

14. ***Adjust the Tone Curve settings.*** This photograph requires some careful attention. So here's what I want you to do:

 • Start by expanding the range of values that Camera Raw considers to be highlights by moving the right triangle along the base of the graph to the left until it reaches 65.

 • Reduce the **Highlights** value to –40. This gently diminishes the radically bright highlights.

- The next option, **Lights**, adjusts the range of luminance levels from middle gray up to the true highlights. Technical photographers call the *high midtones* and *quarter highlights*. Reduce this value to –25.

- Move the middle triangle to the left to a value of 40. This integrates more brightness levels in the high midtones— the range of Lights—which should help to ensure smooth transitions.

- Next we have the *low midtones* and *three-quarter shadows*—from middle gray down to the shadows—represented by the **Darks** option. To maintain a rich dark background for the highlights, reduce this value to –10.

- Finally, raise the **Shadows** value to +25.

Figure 3-43 illustrates how easy it is to turn down the lights even in Vegas with the power of Camera Raw. Unlike Vegas, however, the result is subtle. To get a sense of just what a difference you've made, turn off and on the Preview check box or press the P key. The most noticeable result is the street reflections on the left, where the asphalt appears to have soaked up some of the light.

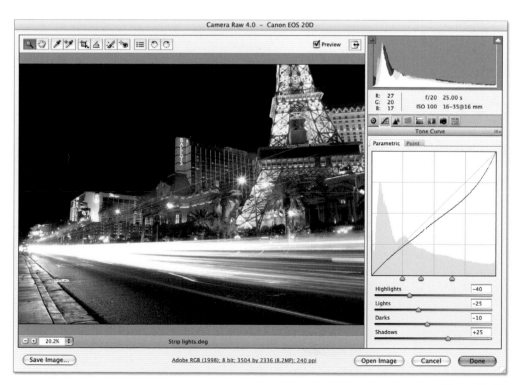

Figure 3-43.

15. ***Click Done to accept your changes.*** Back in the Bridge, the thumbnail and preview update to reflect your subtle adjustments, and the *Strip lights.jpg* thumbnail receives the telltale ⊜ to show that the Camera Raw metadata has been modified.

16. ***Open another trio of images.*** Again in our home-away-from-home, the Adobe Bridge, select *Big sky.dng*, *Flowers.dng*, and *Wing.dng*. When sorted alphabetically, the files are nonadjacent. So click one and Ctrl-click (or ⌘-click) the other two. Then, just for the sake of variety, right-click one of the selected thumbnails and choose the **Open in Camera Raw** command.

17. ***Switch to the HSL/Grayscale panel.*** This time, we'll edit each image independently. Click the *Flowers.dng* thumbnail in the vertical filmstrip. Then click the ▤ icon below the histogram to switch to the **HSL/Grayscale** panel. You'll find yourself automatically in the **Hue** subpanel, shown in Figure 3-44. As in the Hue/Saturation dialog box, the options permit you to adjust one set of colors independently of another. But instead of sticking to the six, evenly-spaced primaries, Camera Raw presents you with eight subjective color groups. Where's cyan? Who cares when you have such old chums as Oranges and Purples in its stead?

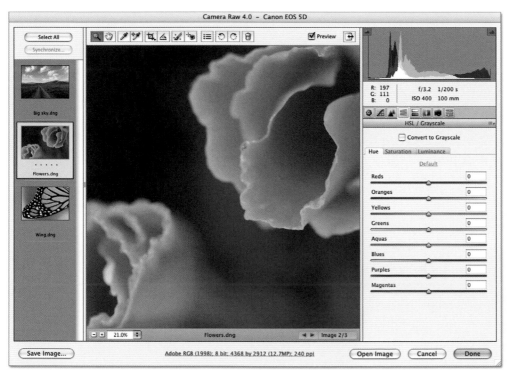

Figure 3-44.

18. ***Modify the hues of the flowers.*** When working in the Hue panel, you can change one range of colors independently of another. Let's say that you want to make the flowers red. The flower is primarily orange, so move the **Oranges** slider to the left toward red. A value of –70 produces the effect shown in Figure 3-45. Everything orange changes to red; other colors remain untouched.

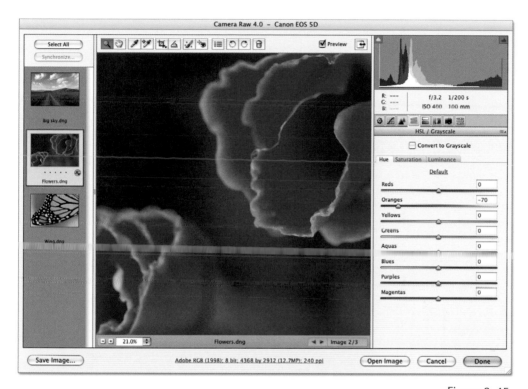

Figure 3-45.

Notice that your range for modifying any hue is limited. For example, I can rotate the hues of the flowers between red and yellow, but I can't make them purple. The other sliders in the Hue subpanel don't help because each slider operates on the original colors, not the modified ones.

19. ***Change the hues behind the wing.*** Case in point: click the macro shot *Wing.dng* in the vertical filmstrip. The background is a yellowish green; I want it to be blue. Change the **Greens** value to its absolute maximum, +100. The background becomes bluer, falling more or less in the aqua range. It's tempting to increase the Aquas value but there are no aquas in the base raw image, so the Aquas slider has no effect. I could get clever and heap on more color adjustments using Temperature, Tint, and the

options in the Camera Calibration panel. But if I really have my heart set on a blue background, I'm better off opening the image in Photoshop and applying the Hue/Saturation command.

20. ***Increase the saturation of the wing.*** Fortunately, I don't have my heart set on a blue background; I'm more concerned about lifting the saturation of the insect's wing. Click the **Saturation** tab to make it active. You'll see the same slider bars as before. But instead of drifting from one color to another, each slider progresses from gray to full saturation. To modify the saturation of the wing independently of its background, do like so:

 • The wing is orange, so raise the **Oranges** value to +100.

 • That's not enough. Luckily, the wing contains a good deal of yellow, so increase the **Yellows** value to +100 as well.

 • To settle down the background a bit, you might reason that Aquas is the proper choice. But as far as the HSL/Grayscale panel is concerned, the background is still green. Back off **Greens** to –50 to achieve the effect in Figure 3-46.

You've managed to increase the saturation of one part of the image and decrease the saturation of another, something you can't do with the Vibrance and Saturation sliders we saw earlier.

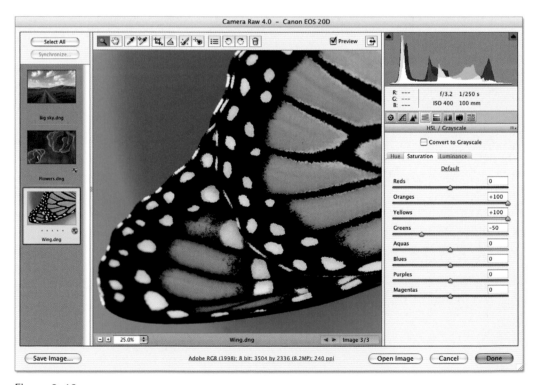

Figure 3-46.

21. ***Switch to the Luminance subpanel.*** To appreciate the amazing powers of the final set of options in the HSL/Grayscale panel, we need a great big sky. So click the *Big sky.dng* thumbnail in the left-hand filmstrip. Then click the **Luminance** tab to call up eight more sliders, these varying from one extreme in brightness to the other.

22. ***Darken the sky.*** The photograph has a stark elegance, but the texture is a bit flat. To heighten the drama, I suggest we deepen the sky by moving the **Blues** slider down to −80. The before and after versions of the image in Figure 3-47 show the dramatic difference this one simple change makes. You can see it for yourself by toggling the Preview check box off and on.

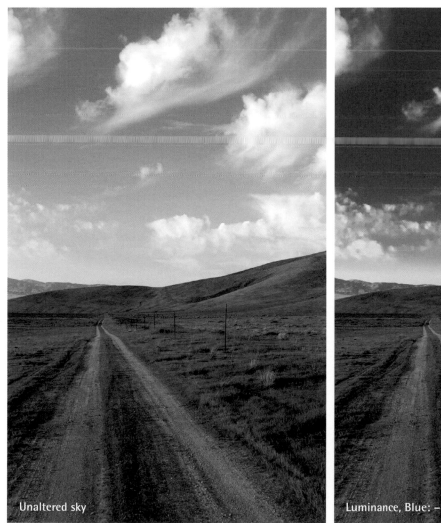
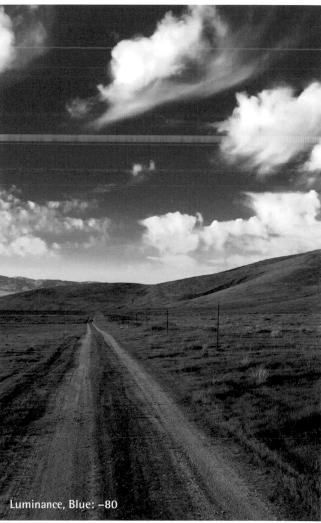

Unaltered sky

Luminance, Blue: −80

Figure 3-47.

23. *Accept your changes.* Click **Done** to return to the Bridge. The one option I haven't addressed is the Convert to Grayscale check box, which allows you to blend colors to create a custom black-and-white image. For info on this and other methods for creating grayscale artwork, read the sidebar "Converting an Image to Black and White," which begins on page 108.

24. *Open an image with specks and blemishes.* Select the thumbnail *Boat & beach.dng* in the *Raw Images* folder and press Ctrl+R (or ⌘-R) as we have so many times before. This time around, rather than discuss yet another a panel option, I'll introduce you to a new tool that allows you to retouch defects and unwanted details in a digital photograph. We won't get to Photoshop's retouching tools until Lesson 6, "Paint, Edit, and Heal," so consider this an early, slightly out-of-place preview. Oh, but what a preview it is.

25. *Automatically adjust the exposure settings.* Click the **Auto** button in the Basic panel to have Camera Raw automatically correct the brightness and contrast of the image. The adjustments are generally successful. My only manual imposition is to raise the **Recovery** value to 30, as in Figure 3-48.

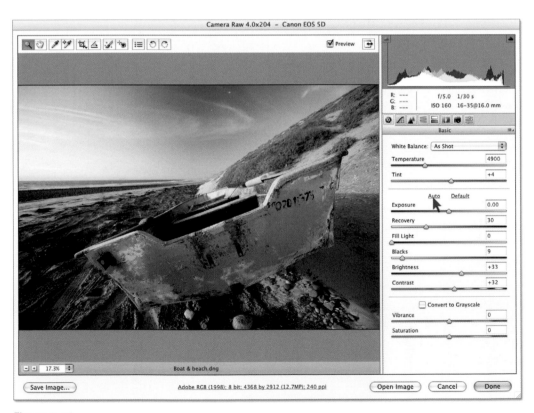

Figure 3-48.

26. ***Zoom in on the dust spots.*** With the zoom tool, click in the image to magnify the dust spots far above the boat at the top of the sky. At the 100-percent view size, you can see that the dust spots aren't dust spots at all, but blurry gulls, out beyond the focal range of the camera. Sea gulls serve an ecological purpose, I'm sure, but not in this photograph. Let's nuke 'em.

27. ***Select the retouch tool.*** New to Camera Raw 4, the retouch tool allows you to blend away unwanted details without a trace. You can select the tool by clicking the seventh icon (✏️) along the top of the interface (see Figure 3-49) or pressing B for blemish. The moment you do, Camera Raw displays an options bar, complete with Radius and Type options. Check to make sure **Type** is set to **Heal**; otherwise, you're good to go.

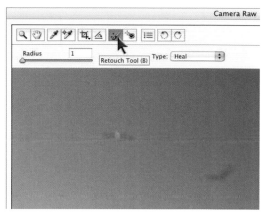

Figure 3-49.

28. ***Draw circles around the blemishes.*** Position your cursor at the center of one of the blurry gulls and drag outward to create a circle around the bird. When you release, Camera Raw not only makes the sea gull disappear—it's officially an ex-spot—but also shows you two circles, one red and one green, as in Figure 3-50. The green circle shows you the portion of the image that has been cloned, known as the *source*. The red circle is the area that the source has been cloned onto, called the *destination*. You can move either circle by dragging it. If the retouch radius (i.e., the circle) turns out to be too large or small, you can scale it using the Radius slider in the options bar.

29. ***Gauge the quality of your edits.*** Retouch away as many sea gulls as you like. (There are a lot of them, so I leave it up to you to decide how thorough you want to be.) After a while, you'll have several circles in the works. Problem is, the very circles that are miraculously erasing the birds are interfering with your ability to gauge the quality of your edits. To hide them temporarily, turn off the **Show Overlay** check box or press the V key. With any luck, you shouldn't see a ripple in the sky. If you do, turn on the check box and edit the circles as needed. (Click a circle to select it; press Backspace or Delete to delete it.)

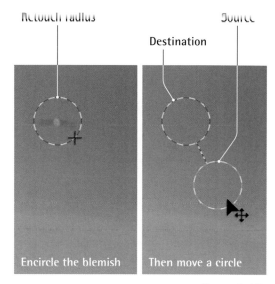

Figure 3-50.

30. ***Accept your changes.*** As always, when you click **Done**, Camera Raw saves your changes as part of the image file. Again, no pixels are modified; Camera Raw achieves its magic with metadata. Bear in mind that the retouch tool is new stuff, so older versions of Camera Raw will not support your edits.

Converting an Image to Black and White

In a world that is saturated with color, there is something about the elegant simplicity of black-and-white imagery that gets right to the heart of things. The removal of color allows our eyes and minds to focus on subtleties of shadow and shape in a way that's different from our everyday visual experience. Creating a beautiful black-and-white image can be very satisfying and relatively easy to do.

You can rob your pixels of color in Photoshop CS3 in many ways, from the classic Channel Mixer to the new Black & White command and Camera Raw's Convert to Grayscale check box. Happily, each one of these functions put you in charge of the color-to-grayscale conversion process.

By way of example, I'll start with a full-color image from iStockphoto photographer Joseph Jean Rolland Dubé, shown below. I turned on Monochrome and set the Red, Green, and Blue values to +60, +120, and −80, respectively. That's right, it's perfectly legal to subtract the brightness levels in one channel from those in another. The result is the high-contrast portrait pictured at the bottom of this page.

Photoshop CS3 introduces a new command that gives you more control and flexibility. Choose **Image→Adjustments→ Black & White** to display a series of six slider bars, one for each of the conventional primary colors. Instead of mixing channels, Black & White weights colors, making for a more

Most cameras give you the option of capturing a grayscale photograph from the get-go, but where raw images are concerned, it's a fake. The color information is there, it's merely turned off by a line of metadata, often one that Camera Raw doesn't recognize and therefore ignores. But that's okay, because all that color gives you a degree of post-processing control that didn't exist in the days of traditional black-and-white photography. My recommendation: Don't worry about whether you're going black-and-white or color behind the camera; save that decision for when you're in front of your computer.

Prior to Photoshop CS3, the best way to convert a color image to black and white was the Channel Mixer. With an image open in Photoshop, choose **Image→Adjustments→Channel Mixer**. Turn on the **Monochrome** check box at the bottom of the Channel Mixer dialog box and then adjust the **Source Channels** sliders to define the amount of brightness information to draw from each color channel. Assuming you're working on an RGB image, a good place to start is **Red**: +40, **Green**: +50, and **Blue**: +10 (roughly the recipe for black-and-white television). Note that these values add up to 100 percent, thus ensuring a consistency in brightness from color to grayscale. Happily, CS3 now tracks your total as you work so you don't have to do the math on your own.

Original full-color photograph

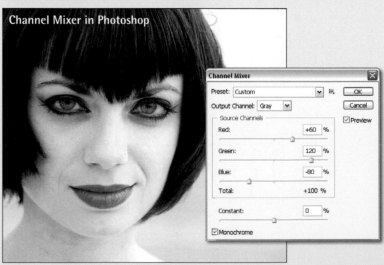
Channel Mixer in Photoshop

subjective experience. It also means you're not bound to make the values add up to 100 percent or any other total. Just raise a value to brighten a primary or lower the value to darken it. Once you've made a grayscale image that you're happy with, you can colorize the image by turning on the **Tint** check box and the **Hue** and **Saturation** values. (Note that the Tint options result in a straight duotone, making them less effective than the Gradient Map approach we learned about in the "Colorizing a Grayscale Image" exercise.)

Below and to the right, you can see the results of my application of the Black & White command, as well as the specific values that I applied—40, 130, 200, 120, 70, and 300, in that order. Of more interest is the control that each slider provided. The Reds slider affected lips and skin tones. Yellows let me further adjust the skin tones independently of the lips. I used Greens to add some brightness to the irises of the woman's eyes. Cyans and Blues were strictly background colors, while Magentas gave me exclusive control over the lips and the redness in the whites of the eyes. By setting the Magentas value to its maximum, 300 percent, I was able to clear up the eyes more surely than if the model had used Visine.

Camera Raw 4 permits you to convert an image to black and white nondestructively, whether the image begins life as a raw file or a JPEG. In the old days, the Camera Raw conversion process consisted of moving the Saturation slider on the Basic panel all the way down to the left to –100 and then adjusting how colors were weighted with the Temperature and Tint sliders. It was chancy work and difficult to predict. Now we have dedicated controls that slightly exceed the capabilities of the Black & White command.

Start by opening an image in Camera Raw, and clicking the ☰ icon below the histogram to switch to the **HSL/Grayscale** panel. Then turn on the **Convert to Grayscale** check box above the color sliders. At this point, the three subpanels are replaced with one called Grayscale Mix. Right away, Camera Raw applies its idea of the perfect mix automatically. From there, you can make any adjustments you

like. To add some color, click the ☰ icon to display the **Split Toning** panel, which lets you assign independent colors to highlights and shadows to create a tritone. It's better than the Black & White solution, but still not as good as Gradient Map.

To create the bottom-right example, I lowered the warm color values to darken the face and raised the cool color values to brighten the background and eyes. The lips fell completely in the Reds with the skin tones spread across the Oranges and Yellows. I was also able to integrate the Basic exposure controls and and Tone Curve to balance the brightness and boost the contrast. Finally, Camera Raw automatically opened the image as a single-channel document, saving me a step.

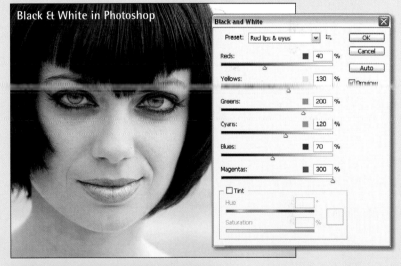

Black & White in Photoshop

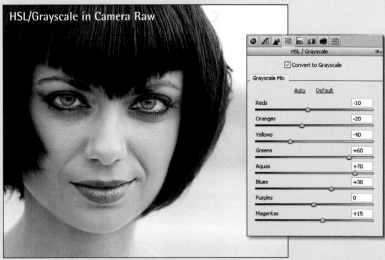

HSL/Grayscale in Camera Raw

Believe it or not, after 19 pages of steps and 4 pages of sidebars, we've only begun our journey into the amazing realm of Camera Raw. If you're interested in learning more—as well you should be—check out *Photoshop Camera Raw* from the free-thinking, take-no-prisoners mind of Mikkel Aaland. Or get started with your 7-Day Free Trail Account at *www.lynda.com/dekeps* (as introduced on page xxvi of the Preface) and watch a movie or two from the 12-hour video series *Photoshop: Mastering Camera Raw.* That's right, 12 hours. There's that much more to know.

31. ***Open a JPEG image in Camera Raw.*** Back in the Bridge, select the only file in the *Raw Images* folder that we haven't messed with so far, *Yellow letters.jpg.* Yes, Camera Raw 4 can open JPEG images, not to mention TIFF and a few other formats. To do so, just press Ctrl+R (or ⌘-R).

32. ***Adjust the color temp and exposure settings.*** This is a static file, so by default, all values are set to 0 and any changes you make are applied relative to the existing colors in the file. Change the **Temperature** value to –25. Set the **Exposure** to +0.80. Increase the **Recover** value to 15 and lower the **Brightness** to –20.

33. ***Selectively adjust the saturation values.*** Click the ≣ icon to switch to the **HSL/Grayscale** panel. Then click the **Saturation** tab. Reduce the **Blues** value to –90 to dispense with the blue cast of the walls, a side effect of the Temperature value that we assigned in the preceding step. To enhance the remaining colors in the bricks, rust, and letters, max out the **Reds**, **Oranges**, and **Yellows** values to 100 percent apiece, as in Figure 3-51.

34. ***Click Done, because, well . . .*** on so many levels, we are done.

At this point, you might reasonably wonder, what was that about? Isn't Photoshop big and powerful enough that we needn't resort to Camera Raw on behalf of a JPEG file? In which case, here are a few reasons why editing JPEGs and TIFFs in Camera Raw is so practical:

- Camera Raw is logical and capable, and you can apply lots of modifications from one dialog box.

- Unlike Photoshop, Camera Raw lets you modify multiple images in one fell swoop.

- Every modification you apply in Camera Raw is nondestructive, so there's no need to commit to permanent pixel modifications.

- Your Camera Raw settings remain live and viable not only in Photoshop CS3 and the Bridge but also inside modern photographic workflow applications such as Adobe Lightroom. It's a new world.

Given the inroads made by Camera Raw 4, you might be tempted to imagine a day when every edit you apply in Photoshop is parametric, nondestructive, and even pixel-free. But for the present, pixels are a day-to-day reality. We'll see why that's actually a good thing starting in the next lesson.

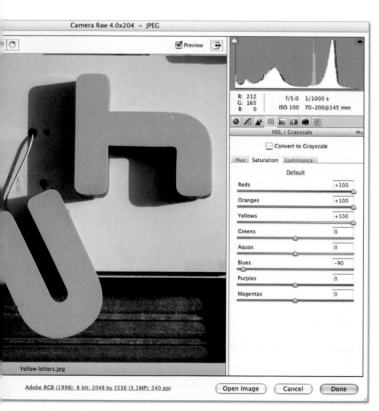

Figure 3-51.

WHAT DID YOU LEARN?

Match the key concept in the numbered list below with the letter
of the phrase that best describes it. Answers appear upside-down
at the bottom of the page.

Key Concepts

1. Hue and saturation

2. Variations

3. Red, yellow, green, cyan, blue, and magenta

4. Secondary colors

5. Gradient Map

6. Duotones and quadtones

7. Camera Raw

8. White Balance

9. Exposure

10. Vibrance

11. Bit depth

12. Black & White

Descriptions

A. These incremental steps between Photoshop's primary hues include orange, lime, turquoise, cobalt, violet, and crimson.

B. The predominant color of highlights, usually the result of an uncorrected light source.

C. Varieties of colorized monochrome images, rendered using two and four colors, respectively.

D. This command allows you to blend the six primary colors to create a perfectly mixed grayscale image, without having to worry about the combined sum of your numerical settings.

E. The equally spaced primary colors in Photoshop's rainbow of hues.

F. Adobe's tool for correcting and developing any of several varieties of unprocessed native image files captured by midrange and professional-level digital cameras.

G. Measured in f-stops, this option corrects the brightness of highlights in the Camera Raw window.

H. The best tool for colorizing a grayscale image, because it permits you to select three or more colors as well as modify luminosity values.

I. This straightforward command lets you correct an undesirable color cast by clicking thumbnail previews.

J. The number of digits required to express a single pixel, which in turn determines the potential number of colors in an image.

K. New to Camera Raw 4, this option raises the intensity of low-saturation colors more than high-saturation ones, making it well suited to boosting skin tones.

L. The two ingredients in color: The first is the tint, from red to magenta, and the second is the purity, from gray to vivid.

Answers

1L, 2I, 3E, 4A, 5H, 6C, 7F, 8B, 9G, 10K, 11J, 12D

4

MAKING SELECTIONS

MANY COMPUTER applications let you manipulate elements on a page as objects. That is to say, you click or double-click an object to select it, and then you modify the object in any of several ways permitted by the program. For example, to make a word bold in Microsoft Word, you double-click the word and then click the Bold button. In Adobe Illustrator, you can make a shape bigger or smaller by clicking it and then dragging with the scale tool. In QuarkXPress, you move a text block to a different page by clicking and dragging it.

The real world holds a similarly high regard for objects. Consider the three sunflowers pictured in Figure 4-1. In life, those flowers are objects. You can reach out and touch them. You can even cut them and put them in a vase.

Although Photoshop lets you modify snapshots of the world around you, it doesn't behave like that world. And it bears only a passing resemblance to other applications. You can't select a sunflower by clicking it—as you could had you drawn it, say, in Illustrator—because Photoshop doesn't perceive the flower as an independent object. Instead, the program sees pixels. And as the magnified view in Figure 4-1 shows, every pixel looks a lot like its neighbor. In other words, where you and I see three sunflowers, Photoshop sees a blur of subtle transitions, without form or substance.

Figure 4-1.

ABOUT THIS LESSON

Project Files

Before beginning the exercises, make sure you've installed the lesson files from the DVD, as explained in Step 3 on page xvii of the Preface. This should result in a folder called *Lesson Files-PsCS3 1on1* on your desktop. We'll be working with the files inside the *Lesson 04* subfolder.

This lesson examines ways to select a region of an image and edit it independently of another region using Photoshop's magic wand, quick selection, lasso, and pen tools as well as a few commands in the Select menu. You'll learn how to:

Video Lesson 4: The Power of Selections

Photoshop's selection tools rank among the program's most fundamental capabilities. Simply put, unless you want to apply an operation to an entire image or layer, you have to first define the area that you want to affect with a selection tool.

To see an overview of Photoshop's selection tools, as well as some of the most common selection-editing commands, watch the fourth video lesson on the DVD. Insert the DVD and double-click the file *PsCS3 Videos.html*. Then click **Lesson 4: The Power of Selections** under the **Select, Crop, and Edit** heading. The movie lasts 14 minutes and 44 seconds, during which you'll learn about the following operations and shortcuts:

Operation	Windows shortcut	Macintosh shortcut
Magic wand tool	W	W
Add to a selection	Shift-click or drag with tool	Shift-click or drag with tool
Inverse (reverse the selection)	Ctrl+Shift+I	⌘-Shift-I
Hide or show the selection outline	Ctrl+H	⌘-H
Gradient tool	G	G
Backstep through recent operations	Ctrl+Alt+Z	⌘-Option-Z
Copy an entire image	Ctrl+A, then Ctrl+C	⌘-A, then ⌘-C
Paste an image into a selection	Ctrl+Shift+V	⌘-Shift-V

So rather than approaching an image in terms of its sunflowers or other objects, you have to approach its pixels. This means specifying which pixels you want to affect and which you do not using *selections*.

Isolating an Image Element

For example, let's say you want to change the color of the umbrella shown in Figure 4-2. The umbrella is so obviously an independent object that even an infant could pick it out. But Photoshop is no infant. If you want to select the umbrella, you must tell Photoshop exactly which group of pixels you want to modify.

Fortunately, Photoshop provides a wealth of selection functions to help you do exactly that. Some functions select entire regions of colors, others automatically detect and trace edges. Still others, like the tools I used to describe the bluish regions in Figure 4-3, select geometric regions. And if none of those tools does what you need it to, you can whip out the big guns and painstakingly define a selection by hand, one meticulous point at a time. These tools can all be used together to forge the perfect outline, one that exactly describes the perimeter of the element or area that you want to select.

As if to make up for its inability to immediately perceive image elements such as umbrellas and sunflowers, Photoshop treats *selection outlines*—those dotted lines that mark the borders of a selection—as independent objects. You can move, scale, or rotate selection outlines independently of an image. You can combine them or subtract from them. You can undo and redo selection modifications. You can even save selection outlines for later use (as I demonstrate in Step 26 of "Refining a Selection with a Quick Mask," Lesson 7, page 242).

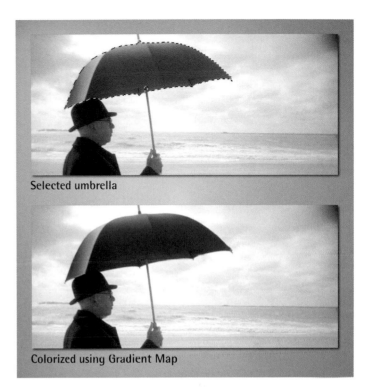

Selected umbrella

Colorized using Gradient Map

Figure 4-2.

Figure 4-3.

Figure 4-4.

Furthermore, a selection can be every bit as incremental and precise as the image that houses it. Not only can you select absolutely any pixel inside an image, you can also specify the degree to which you want to select a pixel—all the way, not at all, or in any of several hundred levels of translucency in between.

This means you can match the subtle transitions between neighboring pixels by creating smooth, soft, or fuzzy selection outlines. In Figure 4-4, I selected the umbrella and the man who holds it and transferred the two elements to an entirely different backdrop. I was able to not only maintain the subtle edges between the man and his environment, but also make the darkest portions of his coat translucent so they would blend with the backdrop. Selections take work, but they also deliver the goods.

Selecting Regions of Continuous Color

We'll start things off with one of Photoshop's oldest and most automated tools, the *magic wand*. A fixture of Photoshop since its very first release, the magic wand lets you select an area of color with a single click. It works especially well for removing skies and other relatively solid backgrounds, as the following exercise explains.

PEARL OF WISDOM

The Scarecrow and Farmhouse images come to us from the ultimate guerilla stock photo agency, *www.istockphoto.com*. Designed to serve as a conduit between independent artists and designers, iStockphoto sells high-quality, royalty-free images for as little as $1.50 apiece. Patricia Marroquin captured the colorful scarecrow; Matthew Dula is responsible for the weather-beaten farmhouse. Thanks to them both.

1. *Open two images.* Locate the *Lesson 04* folder inside *Lesson Files-PsCS3 1on1* and open two image files, *Scarecrow.jpg* and *Farmhouse.jpg*. Move the images so you can see as much of them as possible, and then click the title bar for *Scarecrow.jpg* to bring it to the front, as in Figure 4-5 on the facing page. Our goal during this exercise will be to select the scarecrow and bring it into the farmhouse image. The fact that the images were captured nowhere near each other and by different photographers doesn't bother Photoshop one bit.

2. *Select the magic wand tool in the toolbox.* Click and hold the quick selection tool icon (fourth tool down) to display a flyout menu of alternate tools, and then choose the magic wand, as in Figure 4-6. Or press the W key twice in a row.

Figure 4-5.

Figure 4-6.

3. *Confirm the options bar settings.* Pictured in Figure 4-7, the options bar displays a series of settings for the magic wand. Confirm that they are set as follows:

- The **Tolerance** value defines how many colors the wand selects at a time. I discuss this very important option in Step 5. In the meantime, leave it set to its default, 32.

Figure 4-7.

- Turn on the **Anti-alias** check box to soften the selection outline just enough to make it look like an organic, photographic boundary. I talk more about this option in Step 13 on page 122.

- Turn on **Contiguous** to make sure that the magic wand selects uninterrupted regions of color. You'll get a sense of how contiguous selections work in Step 6.

Because this image does not include layers, the Sample All Layers check box has no effect.

4. **Click anywhere in the sky.** For the record, I clicked at the location illustrated by the cursor in Figure 4-8. But unless I missed a spot, you can click just about anywhere and you won't select the entire sky. Which may seem like an odd thing. Here's this tool that selects regions of color, and it can't select what may be the most consistently colored cloudless sky ever photographed. What good is it?

What looks to you like a field of homogeneous blue that lightens a bit as it travels from top to bottom is in fact a collection of roughly 500,000 independent colors. Given current settings, the wand can select at most half that number, so some pixels are bound to get left out.

Figure 4-8.

5. **Raise the Tolerance value.** The **Tolerance** setting determines how many colors are selected at a time, as measured in luminosity values. By default, Photoshop selects colors that are 32 luminosity values lighter and darker than the click point (64 values in all). After that, the selection drops off. Given that Photoshop did not select the entire sky, the Tolerance must be too low.

I suggest raising it to 50. The easiest way is to press the Enter or Return key to highlight the value, enter 50, and press Enter or Return again. Note that this has no immediate effect on the selection. Tolerance is a *static* setting, meaning that it affects the next operation you apply, as Step 6 explains.

6. **Expand the selection using the Similar command.** The Select menu provides two commands that let you expand the range of a selection based on the Tolerance setting. They both affect any kind of selection, but they were created with the wand tool in mind:

 • Select→Grow reapplies the magic wand, as if we had clicked all the pixels at once inside the selection with the magic wand tool. In other words, it uses the selection as a base for a larger selection. Grow selects only *contiguous* pixels—pixels that are adjacent to the selected pixels.

 • Select→Similar is almost identical to Grow, except it selects both adjacent and nonadjacent pixels. So where Grow would select blue sky pixels up to the point it encounters

nonblue pixels, such as the straw that masquerades as the scarecrow's hands, Similar selects all blue pixels within the Tolerance range regardless of where they lie, including the blue pixels between his "fingers."

For our purposes, we want to get all the blue pixels, wherever they may reside, so choose **Select→Similar** as shown in Figure 4-9.

7. *Fill out the selection.* One application of Similar should be enough to select the entire sky. But if it misses a spot, press the Shift key and click that spot in the image window. Shift-clicking with the magic wand adds to a selection.

8. *Reverse the selection.* You may wonder if this approach makes sense. You want to select the scarecrow, and yet you've gone and selected the sky. As it turns out, this is by design. It's easier to select a solid-colored sky than a spotty-colored scarecrow, and you can always reverse the selection. Choose **Select→Inverse** or press Ctrl+Shift+I (⌘-Shift-I) to select those pixels that are not selected and deselect those that are, as in Figure 4-10. In this case, the scarecrow is selected and the sky is not.

9. *Select the move tool in the toolbox.* Click the move tool in the toolbox, as in Figure 4-11 on the next page, or press the V key (as in mooV). The move tool lets you move selected pixels within an image or from one image to another.

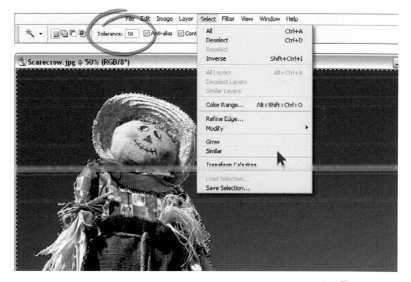

Figure 4-9.

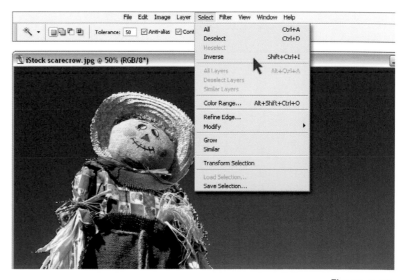

Figure 4-10.

Figure 4-11.

10. ***Drag the scarecrow into the farmhouse scene.*** This operation is a little tricky, so make sure you read the following paragraph before you begin.

Position your cursor inside the scarecrow so that the cursor appears as an arrowhead with a little pair of scissors. Then drag the scarecrow from the *Scarecrow.jpg* image window into the *Farmhouse.jpg* window. Before you release the mouse button, press and hold the Shift key. Finally, release the mouse button and then release the Shift key.

What you just did is called a d*rag with a Shift-drop*. By pressing Shift, you instructed Photoshop to register the scarecrow inside its new background. By *register*, I mean that the scarecrow occupies the same horizontal and vertical position in its new home as it did in its old one, as shown in Figure 4-12. Had you not pressed Shift, the scarecrow would have landed wherever you dropped it. (If you don't get it quite right, press Ctrl+Z or ⌘-Z to undo the operation and try again.)

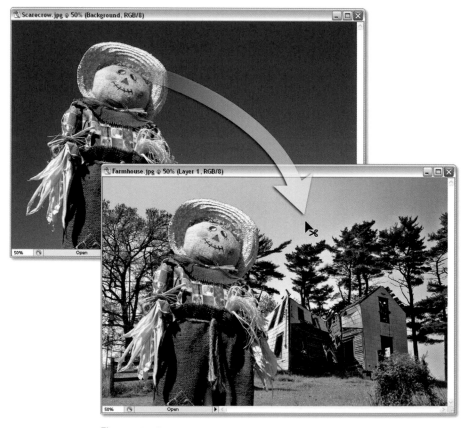

Figure 4-12.

At this point, you have successfully used the magic wand tool to transfer the scarecrow into a new habitat. The only problem is, it doesn't look particularly realistic. In fact, it looks like what it is—a Photoshop montage. If that's good enough for you, skip ahead to the next exercise, "Quick Selection and Refine Edge," which begins on page 124. But if you want to make this scarecrow look like it's really at home, we have a few steps to go.

Figure 4-13.

11. *Select the Background layer in the Layers palette.* The **Layers** palette most likely appears in the bottom-right corner of your screen. If not, choose **Window**→**Layers** or press the F7 key to open it. You should see two layers, one for the scarecrow—an imported selection always appears on a new layer—and another for the background. Click the **Background** layer to make it active, as shown in Figure 4-13.

12. *Apply the Lens Blur filter.* To create a realistic depth-of-field effect, blur the background by choosing **Filter**→**Blur**→**Lens Blur**. The Lens Blur filter is a fairly complex plug-in program. If it takes a few moments to load, don't worry and be patient. After the **Lens Blur** dialog box appears, do the following:

- Hold down the Alt (or Option) key to change the Cancel button to **Reset** and then click it. This recalls the filter's default settings.

- Tab down to the **Radius** value and raise it to 20 pixels. This moves the background well outside the range of focus.

- Confirm that your settings look like those in Figure 4-14 and click the **OK** button.

Of all Photoshop's blur filters, Lens Blur does the best job of simulating the image produced by a camera lens when focused on a different portion of a scene—which in our case happens to be the foreground scarecrow.

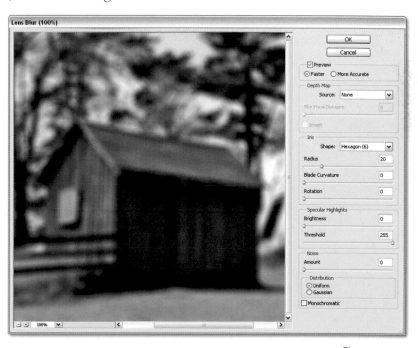

Figure 4-14.

Figure 4-15.

Layers × | Channels | Paths

Normal Opacity: 100%

Lock: Fill: 100%

Layer 1

Background

fx.

Blending Options...

Drop Shadow...
Inner Shadow...
Outer Glow...
Inner Glow...
Bevel and Emboss...
Satin...
Color Overlay...
Gradient Overlay...
Pattern Overlay...
Stroke...

Figure 4-16.

13. ***Zoom in on a few details.*** Use the zoom tool to zero in on the right side of the scarecrow (his left) to gauge how well the magic wand selected the image. As you can see in Figure 4-15, the selection has some problems.

 - The edges look jagged, meaning that you can see a clear division between one pixel and its neighbor. Fortunately, these "jaggies" are mitigated by a slight softening effect known as *antialiasing*, a function of the Anti-alias check box that you turned on back in Step 3. The check box instructed the magic wand to partially select the thin line of pixels around the perimeter of the selection, thus creating a slight fade between the scarecrow and its new background. Had you turned Anti-alias off, the edges of the straw and other details would look worse.

 - The straw also exhibits a problem called *haloing*, where a foreground image is outlined with a fringe of background color, in this case blue.

 The jagged edges aren't perfect, but they look fine when we're zoomed out and they're likely to print fine as well. The haloing is another matter. That needs to be fixed.

14. ***Select the scarecrow layer in the Layers palette.*** Click the **Layer 1** item in the **Layers** palette to make it active.

15. ***Choose the Inner Glow style.*** Click the *fx* icon at the bottom of the Layers palette to display a list of layer effects (see Figure 4-16). Then choose **Inner Glow** to display the large **Layer Style** dialog box.

 By default, the Inner Glow style creates a glow along the inside edge of a layer, but you can also use it to override a glow by applying a color that's indigenous to the image, as the next step explains.

16. ***Adjust the settings to remove the halo.*** Here are the settings that I recommend:

 - Set the **Blend Mode** to **Color**. This colorizes the fringe pixels rather than making them lighter.

 - Reduce the **Opacity** to 50 percent. Because the effect traces the perimeter of the entire scarecrow—not just the straw—you want to keep it subtle.

- Click the color swatch (the square above the word **Elements**) to display the **Color Picker** dialog box. Move your cursor into the image window—at which point the cursor becomes an eyedropper—and click in a medium-orange part of the scarecrow's left hand (your right) to lift a matching color. Then click **OK**.

- In the Elements section, change the **Technique** to **Precise** to trace into the corners of the straw and cover up all the blue.

- Set the **Size** value to 10 pixels to keep the glow small, so it doesn't bleed too much into appropriately colored portions of the scarecrow, such as his kerchief and pants.

The other options are best left set to their defaults (which is to say, Range set to 50 and all others set to 0). Once your setting match those in Figure 4-17, click the **OK** button.

The Inner Glow ably corrects the blue haloing, as demonstrated in Figure 4-18. (To learn more about layer styles, read Lesson 11, "Layer Styles and Adjustments.") Save your layered image in the Photoshop (PSD) format and move on to the next exercise.

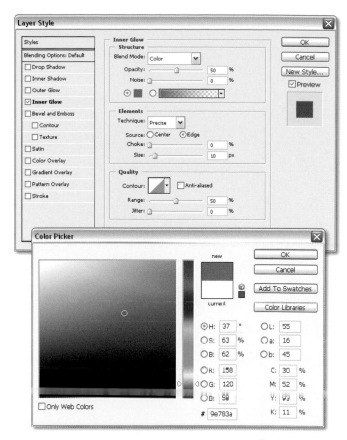

Figure 4-17.

Figure 4-18.

Quick Selection and Refine Edge

Seventeen years after the introduction of the magic wand, Photoshop CS3 includes a new automated selection tool. Inexplicably dubbed the quick selection tool—little about its performance suggests that you'll complete your selection chores faster—it is sensitive not to color ranges but to *edges* (that is, sudden transitions from dark to light). Paint inside the element you want to select and Photoshop grows the selection outline to what it considers to be the outlying edges of that element.

The quick selection tool is just okay by me. Actually, if you must know, it makes me yawn. It's easy enough to use that you don't need my help to figure it out; and there's not much advice I can offer for improving its less-than-ideal results. In fact, I include it in this exercise primarily as a preamble to another new selection function in Photoshop CS3—one that I find quite useful—called Refine Edge. This more complicated but equally more powerful command allows you to edit any selection outline and see the results of your edits—in several different ways—as you apply them. Nothing else in Photoshop behaves quite like this command.

Wonder if I'm being too harsh on the quick selection tool? Doubt the merit of my enthusiasm for Refine Edge? Judge for yourself in the following steps:

1. *Open two image files.* The files in question: *Sea monster.jpg* and *Sue & Timmy.jpg*, both located in the *Lesson 04* folder inside *Lesson Files-PsCS3 1on1*. In this exercise, we'll select the elegant but otherwise standard-issue giraffe from photographer Henk Badenhorst and merge it with tomorrow's preteen sensations, a couple of snorkeling mystery solvers captured by Tammy Peluso (both from iStockphoto, both pictured in Figure 4-19). The result of our labors will be a bit of early mar-

Figure 4-19.

keting art for a series of *Sue & Timmy, Shallow-Sea Adventurers* novels. According to our market research, merchandising alone should out-net Nancy Drew.

2. ***Select the quick selection tool in the toolbox.*** Bring the *Sea monster.jpg* image to the front. In this photograph, both the foreground and the background exhibit color mottling—that is, arbitrary hue, saturation, and brightness variations—making the quick selection tool the logical choice over the magic wand. Assuming you worked through the previous exercise, click and hold on the magic wand icon (fourth tool down) and choose the quick selection tool, as in Figure 4-20. Or press the keyboard shortcut, W (for Wand, which is the senior, albeit secondary, tool in this slot).

3. ***Increase the brush size.*** If you move the cursor into the image window, you'll notice that it turns into a round brush, anticipating your ability to paint a selection. Where this image is concerned, the default brush is too small. To make it bigger, click the ⊡ arrow to the right of the word **Brush** in the options bar and then raise the **Diameter** value in the ensuing pop-up palette to 100 pixels, as in Figure 4-21.

Figure 4-20.

Figure 4-21.

4. ***Paint in the background.*** Paint the background behind the giraffe to select it. You don't have to paint the entire background all at once. I recommend three strokes, one over its head, a second to the right of its neck, and a third below its jaw and chin, as demonstrated by the orange brushstrokes in Figure 4-22 on the next page. (Note that the quick selection tool is automatically configured to add to the existing outline, so you don't need to press the Shift key when painting additional strokes.) In each case, Photoshop grows the selection outline to meet the edges where the background stops and the giraffe begins.

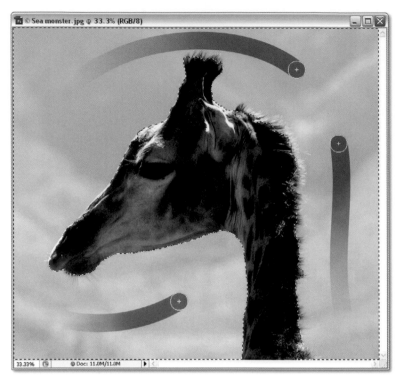

Figure 4-22.

5. **Reverse the selection.** Given the minimal effort we've put into this selection so far, I'd rate it pretty good with some obvious problems. But before we enhance it, let's swap the selected background for a selected giraffe by choosing **Select→Inverse** or pressing Ctrl+Shift+I (⌘-Shift-I on the Mac).

6. **Fine-tune the selection as desired.** The selection outline bites into the giraffe more than it should. Still armed with the quick selection tool, paint around the too-tight edges, such as the bottom-right fur on the neck, the top-right hairs behind the ears, and along the left side from the snout to the forehead. Exercise care when painting the snout or you'll incorporate the background. You may want to use a smaller brush size, which you can get by pressing the left bracket key, ⌷.

If for some reason you want to subtract from the selection, press the Alt (or Option) key and paint with the tool.

See what I mean about calling this tool "quick"? It's fast at delivering a sloppy selection, but it takes time to get a good one. Photoshop Elements offers a similar tool that goes by the name magic selection brush, which seems more in keeping with tradition. But perhaps I'm harping.

7. **Make sure you've got everything.** If your selection outline still needs a little topping off, choose **Select→Grow**. Assuming that the Tolerance value for the magic wand is still set to 50, as per the previous exercise, the Grow command helps to fill in some of the fine edges in the hair.

8. **Click the Refine Edge button.** Like the magic wand, the quick selection tool delivers a jagged selection outline with a soupçon of antialiasing. In other words, it's crude. To bring up its game a bit, click the **Refine Edge** button in the options bar, pictured in Figure 4-23 on the facing page. Available when any selection tool is active (and available as a command in the Select menu when not), Refine Edge lets you edit a selection using a series of slider bars and preview the results of those edits as you work.

9. *Preview the selection against a black background.* Turn your attention to the bottom half of the Refine Edge dialog box and the series of "Möbius tube" icons (the icons) above the Description item. Clicking an icon changes your preview of the selection in the image window. Because we'll be moving the giraffe into a dark background, we'll do well to preview the selection against black. So click the ⚭-on-black icon, as you see me doing in Figure 4-24. The selected portion of the giraffe now appears set against black in the image window.

Figure 4-23.

Cycle from one preview mode (or icon) to the next by pressing the F key. Press Shift+F to switch to the previous mode. You can also press X to see the unmodified image or P to turn on and off the Preview check box.

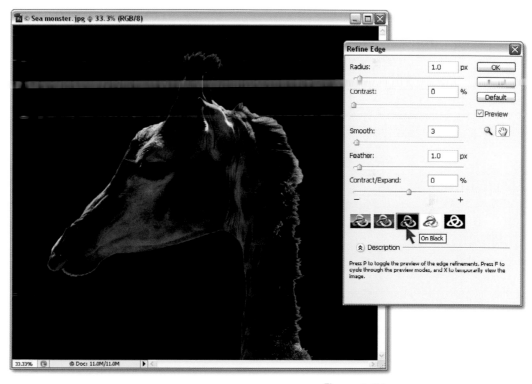

Figure 4-24.

10. *Turn off and on the preview.* Speaking of the **Preview** check box, turn it off or press the P key. You are now looking at the selection outline the way it really is, as created by the quick selection tool. Notice that it's quite jagged with lots of bluish fringing. Now turn the **Preview** option back on. The Refine Edge default settings soften the edges and reduce some of the fringing, but they don't go far enough.

11. **Adjust the settings.** Our goal where this giraffe is concerned is to soften the edges to allow the hair to blend better with its prospective background. We also want to contract the selection a bit to avoid fringing. In the interest of achieving that goal, I'll tell you how each of the five slider bars work and how I recommend you set them. (You can also find info about an option by hovering your cursor over it and reading the Description item at the bottom of the dialog box.) My suggested values, and the accompanying preview, appear in Figure 4-25.

- The Radius value applies an intelligent blur that spreads the selection according to the luminance levels inherent in the image. Areas of similar brightness blur more easily than areas of high contrast. The upshot is an effect known as *fuzziness* that softens contours and respects details. (Remember that term; we'll visit it again in Lesson 7.) The contrast between the beast and its background is high, so raise the **Radius** value to its maximum, 250 pixels.

- After better molding the selection outline to the image, you can sharpen the outline by raising the Contrast value. For a nice mix of softness and sharpness, enter a **Contrast** value of 25.

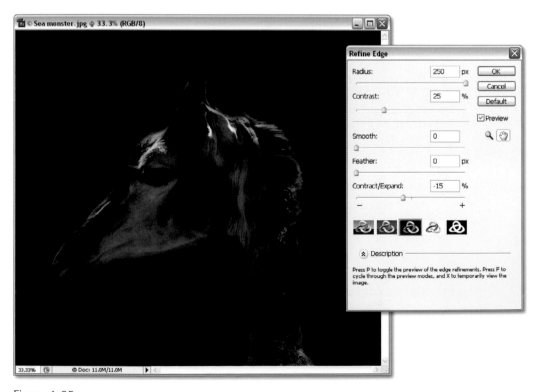

Figure 4-25.

- The Smooth option smooths away jagged edges in a selection. It's great for removing the effects of noise, film grain, and dust. But it also rounds off corners. We don't want to lose the sharp corners in the animal's mane, so set the **Smooth** value to 0.

- Feather applies a uniform blur that's substantially less discriminating than Radius. It's great for halos and vignettes, but otherwise, steer clear. Set the **Feather** value to 0.

- A negative Contract/Expand option contracts the selection outline inward, or *chokes* it. A positive value moves the selection outward, or *spreads* it. In our case, we want to choke the selection by applying a **Contract/Expand** value of –15 percent.

Feel free to press the F key a few times to try out the other preview modes, just to make sure you're comfortable with your selection outline. (Figure 4-26 shows the giraffe against white, for example.) Then click **OK** to apply your changes, whereupon Photoshop returns you to the standard marching ants-style selection mode.

Figure 4-26.

12. *Drag the selected giraffe into the Sue & Timmy image.* You can use the move tool, as explained in Steps 9 and 10 of the preceding exercise (see pages 119 and 120). This time, there's no need to press the Shift key on the drop. Or you can try a new technique:

Press and hold the Ctrl key (⌘ on the Mac) to get the move tool on-the-fly. With the key down, drag the selected portion of the giraffe from *Sea monster.jpg* into the *Sue & Timmy.psd* image window. Release the mouse button, and then release the key.

Either way, you should see a new Layer 1 in the Layers palette, nestled between the Background layer at the bottom and a folder called Dialog at the top.

Figure 4-27.

13. ***Move the giraffe layer low in the image.***
Drag the giraffe downward, well beyond
the bottom of the window, so only its eyes,
ears, and horns are visible, as in Figure 4-27.
You can Ctrl-drag (⌘-drag) the new layer,
or drag it with the move tool.

To get the layer exactly where you want it, you
can nudge it a few pixels by pressing the Ctrl
key (⌘ on the Mac) along with one of the four
arrow keys: ↑, ↓, ←, or →. Or just press an
arrow key when the move tool is active.

The animal looks pretty cheesy in its new
home. I suppose that's inevitable—it is an
underwater giraffe head, after all—but we
can do better than this.

14. ***Choose the Match Color command.*** For
one thing, the head needs to look as if it's
being photographed underwater, which
means subtracting the warm tones and
replacing them with blue. Choose **Image→
Adjustments→Match Color** to display the
Match Color dialog box (see Figure 4-28),
which lets you match the colors in one
image or layer to those in another.

Figure 4-28.

15. *Set the Source option to Sue & Timmy.* Match Color needs a destination and a source for its color modification. The *destination* is the image you want to change; the *source* is the image you want to match. Photoshop already knows that the giraffe head is the destination because it was active when you chose Match Color. But you have to tell it the source.

 Click the **Source** pop-up menu toward the bottom of the dialog box and choose **Sue & Timmy.psd**, the image you're working on. Next, set the **Layer** to **Background**. Right away, the beast turns a bright, vivid, radioactive blue.

16. *Adjust the Fade and Luminance values.* To back off the effect, raise the **Fade** value to 35 percent. This restores 35 percent of the original coloring mixed in with 65 percent of the new coloring. The brightness is still a problem, so reduce the **Luminance** value *way* down, to a mere 3 percent. When everything looks like it does in Figure 4-29, click **OK**.

Figure 4-29.

Figure 4-30.

17. **Open the Dialog folder.** Now to apply the finishing touches. The *Sue & Timmy.psd* file contains a handful of items that will add depth and drama to the composition. The Dialog folder at the top of the Layers palette contains two additional layers. To see those layers, click the ▶ twirly triangle to the left of the folder. You should now see one layer called Words and another called Balloons. (The latter name may be truncated for space; don't worry about it.)

18. **Transfer the layer effects to the giraffe head.** The *fx* icon to the right of the Words layer shows you that one or more layer effects have been applied to the layer. Drag the *fx* icon down to the giraffe head layer, presumably still named Layer 1. As you drag, you'll see a large *fx*, as in Figure 4-31. When you arrive at Layer 1, release the mouse button to drop the effects. Photoshop deletes the effects from the Word layer and adds them to the giraffe head.

If you're wondering how these layer effects are put together, double-click the Drop Shadow or Gradient Overlay effect listed below Layer 1. (If you don't see these effects, you may need to click the ▼ triangle to the right of the *fx* icon to reveal them.) The Layer Style dialog box shows you all the settings that I used. You'll discover, for example, that the Drop Shadow is actually responsible for the blue highlight radiating upward from the monster's head. The effects are entirely editable, so feel free to modify them as you like.

19. **Turn on the Dialog group.** To the left of the Dialog folder icon, you'll see a blank square. Click inside it to bring up the ◉ and display the contents of the folder. You should see a smattering of dialog in which the two mystery solvers recite their famous rhyming tagline, featured in the final composition in Figure 4-31. Or at least it *will* be famous after I finish writing my first exciting novel, which I'm guessing will be never.

PEARL OF WISDOM

A few last words on the subject of the Refine Edge command: If you've been using Photoshop for a while, you may recognize option names like Feather, Smooth, Contract, and Expand, all of which are named after commands in the Select→Modify submenu. The Refine Edge options are different in two ways: First, you can preview their effects, something you can't do with the Select→Modify commands. Second, the options work in connection with each other. For example, Contract/Expand does nothing by itself, but it works wonders when combined with softening created by the Radius or Feather option. If nothing else, you'll should get in the habit of using Refine Edge instead of the Feather command—being able to see your Feather radius before you apply it is a tremendous help.

Figure 4-31.

Selecting an Irregular Image

The lasso tools let you select irregular portions of an image. The default lasso tool requires you to drag around an image to trace it freehand. But like freehand tools in all graphics programs, the lasso is haphazard and hard to control. That's why Photoshop also includes a polygonal lasso, which allows you to select straight-edged areas inside an image. Admittedly, the polygonal lasso tool doesn't suit all images, particularly those that contain rounded or curving objects. But as you'll see, the lasso tool is easy to control and precise to boot.

In the following exercise, you'll experiment with both the standard and polygonal lasso tools and get a feel for why the latter is typically more useful. You'll also get the opportunity to play with a couple of special-effects commands from Photoshop's Filter menu.

Figure 4-32.

1. ***Open two images, one foreground and one background.*** Open *Courthouse.psd* and *Fireworks.jpg*, both located in the *Lesson 04* folder inside *Lesson Files-PsCS3 1on1*. Photographed by Matt Duncan, the courthouse is a nifty piece of architecture, but the composition lacks luster. A structure like this deserves a celebration—hence the fireworks. The result of four photographs set on separate layers and combined with the Screen blend mode, the fireworks image is precisely the sort of over-the-top background that our sleepy courthouse needs. For reference, both images appear in Figure 4-32.

2. ***Click the lasso tool in the toolbox.*** Or press the L key. As I said, the lasso tool (Figure 4-33) can be difficult to control. But I'd like you to experience the tool for yourself so you can decide what you think of it firsthand.

3. ***Try dragging around the courthouse.*** The portion of the building I'd like you to select appears highlighted in Figure 4-34. Trace along the yellow line to select the area inside the building. (The orange sky is outside the selection. Neither the orange sky or yellow line is part of the image.)

Figure 4-33. Figure 4-34.

The lasso is exceedingly flexible, automatically scrolling the image window to keep up with your movements and permitting you to drag outside the image to select the extreme edges. But it completely drops the ball when it comes to precision. If you're anything like me, you'll have a heck of a time getting halfway decent results out of it.

4. *Deselect the image.* Assuming your selection looks like garbage, choose **Select→Deselect** or press Ctrl+D (⌘-D on the Mac) to throw it away and start over. Now that we've seen the wrong way to do it, let's see the right way.

5. *Select the polygonal lasso tool in the toolbox.* Click the lasso icon to display a flyout menu of additional tools, and then choose the polygonal lasso. Or just press the L key (or Shift+L if you skipped the Preface). The polygonal lasso lets you select straight-sided areas inside an image by clicking at the corners.

6. *Fill the screen with the image.* Many of the areas that we want to select exist on the perimeter of the photograph. When selecting such areas with the polygonal lasso, it helps to have a little extra room to work with. So click the ▭ icon at the bottom of the toolbox or press the F key to enter the full-screen mode, which surrounds the image with an area of gray pasteboard. Scroll the image (spacebar-drag) until you can see about an inch of pasteboard below and to the right of it. Then zoom in so your screen looks something like the one in Figure 4-35.

7. *Select the bottom-right building.* The yellow arrowheads in Figure 4-35 point to the seven corners you need to click. Start by clicking at the corner labeled ❶. There's no special reason to start at this particular corner; it's as good a point of reference as any. Then move the cursor down to corner ❷, stopping a bit beyond the edge of the roof. As you do so, a straight line connects the cursor to ❶. Make sure the line follows the edge of the roof and then

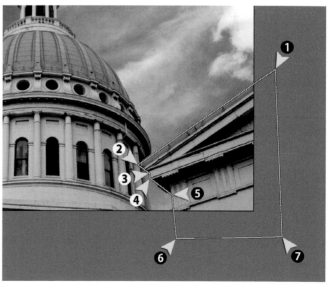

Figure 4-35.

click to set the corner in place. (Notice that we're simplifying this corner of the building; that's okay, because it will ultimately be incorporated into the selection around the dome.)

Keep clicking the corners in the order indicated in the figure. Don't worry too much about making these points perfectly precise; if anything, err on the side of overlapping the building instead of the sky. After you click at corner ❼, you have two options for completing the selection:

- Click corner ❶ to come full circle and close the selection outline.

- Double-click at ❼ to end the selection and connect points ❶ and ❼ with a straight segment.

8. **Select the elliptical marquee tool.** The central dome comprises a series of arcs, circles, and other ellipses. You could try to select these shapes using the lasso. Or you could use a tool better suited to ellipses. Press the M key a couple of times (Shift+M if you skipped the Preface) or select the elliptical marquee from the marquee tool flyout menu.

Figure 4-36.

9. **Select the elliptical area around the base of the dome.** This shape is illustrated by the red ellipse with the inset selection outline pictured in Figure 4-36. This turns out to be a tricky step, so read the following paragraph before you begin.

Press the Shift key and drag with the elliptical marquee tool to add the new ellipse to the existing straight-sided selection. (Shift always adds to a selection; Alt or Option subtracts.) After you begin your drag, you can release the Shift key.

As you drag, you can move the ellipse on-the-fly by pressing and holding the spacebar. When you get it into position, release the spacebar and continue dragging. When the ellipse is properly sized (as in Figure 4-36), release the mouse button.

10. **Add two more ellipses to the selection.** Press the Shift key and drag a couple more times to add two more elliptical areas to the selection. These areas

appear outlined in red and yellow in Figure 4-37. Remember to choke the selection into the dome—don't let it drift out into the sky. And feel free to ignore the little outcroppings and other surface details that fall outside the ellipses. Their absence will not be noticed when we add the fireworks.

11. ***Add the tower to the selection.*** As illustrated in Figure 4-38, the tower of the courthouse can be expressed as a combination of five ellipses (which I've outlined in red) and a four-sided polygon (in yellow). If you want the practice, you *could* draw the selection manually. Press the Shift key and trace each of the red shapes with the ellipse tool. Then press L to switch to the polygon lasso, press the Shift key, and click around the polygon.

Figure 4-37.

However, it occurs to me that all this ellipse-drawing might cross the line between good practice and sheer tedium. So in a moment of uncharacteristic charity, I've gone and drawn the selection for you. Here's how to get to it.

- Choose **Select→Load Selection**.

- Make sure **Document** is set to the present one, **Courthouse.psd**.

- Set the **Channel** option to **Tower**. (It follows Right Side, the Step 7 selection, and Central Dome, the product of Steps 9 and 10.)

- Select **Add to Selection** from the **Operation** options. This will add the tower to the existing selection.

- Click the **OK** button.

I'll show you how to save your own selections in Lesson 7 ("Refining a Selection with a Quick Mask," Step 26, page 242). In the meantime, just be thankful my selection is here. I really do spoil you.

Figure 4-38.

12. ***Select the polygonal lasso.*** Click the polygon lasso icon in the toolbox or press L to grab the tool.

13. ***Select the lower section of the structure.*** Press the Shift key and click around the remaining portions of the building. By my reckoning, you're looking

at a grand total of 17 corners, all indicated by the proliferation of yellow arrowheads in Figure 4-39. It's a complex selection—especially along that geometric column on the left side of the dome—so don't feel like you have to pull it off in one pass. As long as you have the Shift key down, you can add areas to your selection in as many pieces as you like.

If you find yourself struggling, failing, or on the brink of tears, go ahead and use my 17-point selection outline, which is ready and waiting for you. Choose **Select→Load Selection**. Set the **Channel** option to **Left & Bottom**. Turn on **Add to Selection** and click **OK**.

However you get there, the entire courthouse—from one extreme to the other—should appear encased in one great animated selection outline. Granted, we've rounded off a few details here and there, but nothing that the viewer's going to miss.

Figure 4-39.

14. ***Drag the courthouse into the fireworks image.*** Press and hold the Ctrl key (⌘ on the Mac) to get the move tool and drag the selected portion of the courthouse from *Courthouse.psd* into the *Fireworks.jpg* image window. Before you drop the building into place, press and hold the Shift key. Release the mouse button and then release both keys. Shown in Figure 4-40 on page 140, the result is spectacular but hardly credible. However impeccable the building's perimeter, its lighting and coloring broadcast that it's nowhere in the remote vicinity of a fireworks display. Thankfully, we can suggest otherwise using layer styles.

The final lasso tool, the magnetic lasso, is one of the most amazing selection tools in Photoshop's arsenal. No kidding, this tool can actually sense the edge of an object and automatically trace it, even when the contrast is low and the background colors vary. But as miraculous as this sounds, the magnetic lasso has never won the hearts and minds of Photoshop users the way, say, the magic wand has. Why? Part of the reason is that it requires you to work too hard for your automation. Perhaps worse, the tool makes a lot of irritating mistakes. Even so, the magnetic lasso can work wonders, especially when tracing highly complex edges set against relatively evenly colored backgrounds.

Select the magnetic lasso from the lasso tool flyout menu. As when using the polygonal lasso, click along the edge of the image element that you want to select to set a point. Next, move the cursor—no need to drag, the mouse button does not have to be pressed—around the image element. As you move, Photoshop automatically traces what it determines is the best edge and lays down square *anchor points*, which lock the line in place. In the figure below, I clicked the bottom-left corner of the courthouse dome and then moved the cursor up and around to the right.

Some other techniques:

- If the magnetic lasso traces an area incorrectly, trace back over the offending portion of the line to erase it. Again, just move your mouse; no need to press any buttons.

- Anchor points remain locked down even if you trace back over them. To remove the last anchor point, press Delete or Backspace.

- Photoshop continuously updates the magnetic lasso line until it lays down a point. To lock down the line manually, just click to create your own anchor point.

- Of the various options bar settings, the most useful is Width, which adjusts how close your cursor has to be to an edge to "see" it. Large width values let you be sloppy; small values are great for working inside tight, highly detailed areas.

The best thing about the Width setting is that you can change it from the keyboard. While working with the magnetic lasso, press [to make the Width value smaller; press] to make it larger.

- To complete the selection, double-click or press Enter or Return. You can also click the first point in the shape. Press the Esc key to cancel the selection.

Photoshop's smartest lasso tool is clearly the most challenging to use. But it's usually worth the effort. And remember, you can always combine it with other tools.

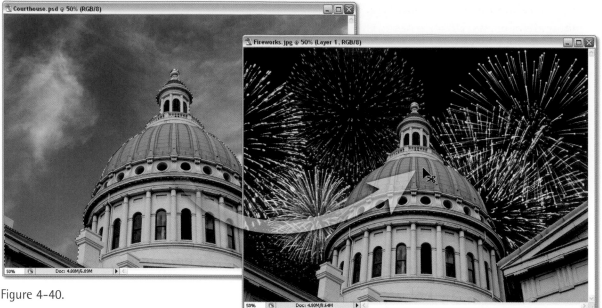

Figure 4-40.

Figure 4-41.

15. ***Choose the Color Overlay style.*** Click the ✿ icon along the bottom of the **Layers** palette and choose **Color Overlay**, as in Figure 4-41. Photoshop displays the **Layer Style** dialog box and fills the entire courthouse with red. Clearly, it's not the effect we want, but it will be soon.

16. ***Bathe the building in an orange glow.*** Here's how to change the color and the way it interacts with the courthouse:

 • Change the **Blend Mode** setting to **Overlay**. The red and building merge to create a sinister house of justice. Great for marching off to the gallows, bad for fireworks.

 • Click the red color swatch to the right of Overlay to display the **Color Picker** dialog box. Select a dull orange by changing the first three values to **H:** 20, **S:** 70, **B:** 80, as in Figure 4-42 on the facing page. Then click the **OK** button to return to the **Layer Style** dialog box.

17. ***Darken the top of the tower.*** I imagine that our courthouse is lit by ambient light from the fireworks reflecting off the ground and the surfaces of neighboring buildings. As a result, the light should decline as the structure rises. This means casting the top of the building in shadow.

 Click **Gradient Overlay** in the list on the left side of the dialog box to make the effect active and display its options. Because the Color Overlay effect mixes with the Gradient Overlay below

it, Photoshop fills the building with an opaque fountain of colors. Let's change that:

- Set the **Blend Mode** to **Multiply**. This burns in the black and drops out the white, giving the building a dark base. It's a nice effect but rather the opposite of what I want.

- Change the **Angle** value to –90 degrees. Now the top is in the gloom, just like I want it.

- Reduce the **Opacity** value to 65 percent.

- You can position a gradient just by dragging it. Move your mouse into the image window to see the ▸⊹ cursor. Then drag the gradient downward an inch to expand the shadow.

Confirm that your settings look like those in Figure 4-43 and then click **OK** to close the Layer Style dialog box and accept your changes.

Figure 4-44 shows the final effect, complete with radiant courthouse and bombs bursting in air. Granted, the composition demands a small suspension of disbelief. But given that it's all the product of a few polygons and ellipses, I'd rate it a soul-stirring success.

Figure 4-42.

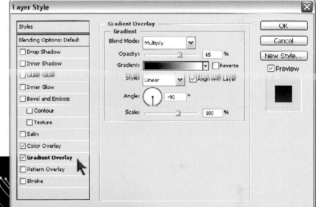

Figure 4-43.

Figure 4-44.

Drawing Precise Curves

The final category of selection tools is the most exacting, the most demanding, and the most obscure. Known collectively as the *path tools*, these let you draw and adjust free-form outlines one segment at a time. The process is less like drawing and more like building a shape with an erector set. In the right hands, the path tools can result in sculpted, organic outlines that precisely follow the edges of even the most complex image elements. But as the experts will tell you, it can be tedious, irksome work. I must admit, despite years of experience and heaps of admiration, I turn to these tools as instruments of last resort.

Figure 4-45.

The following steps provide a brief introduction to Photoshop's path tools. You'll select a man-made object composed of sloping curves, highly defined edges, and sharp corners—precisely the kind of object that the path tools are so good at selecting—and set it against a new background. In doing so, you'll learn how to draw a path, edit it, combine it with another path, and convert the resulting outline to a selection. I can't promise that you'll fall in love with paths—few folks in their right minds do. But at least you'll have a sense of how they work and when to use them.

1. **Open an image.** Open the file *Trash bird.psd* located in the *Lesson 04* folder inside *Lesson Files-PsCS3 1on1*. Shot at that least computerized of all possible events, the county fair, this happy, little trash can just screams, "Kids, I'm unsanitary! Come rub your hands all over me!" Honestly, it was lousy with flies. Just imagine how many diseases you'll avoid by selecting it from a distance (see Figure 4-45).

2. ***Select the ellipse tool in the toolbox.*** The filthy pelican's head is the simplest shape, so we'll start with it. Click and hold the rectangle tool icon to display the flyout menu pictured in Figure 4-46. Then choose the ellipse tool, which lets you draw oval path outlines, perfect for the nearly circular head.

PEARL OF WISDOM

Unlike other selection tools, the path tools don't draw selection outlines. Instead, they draw paths, which you convert into selection outlines after you draw them. This may sound like a weird approach, but it affords you the flexibility to manipulate and perfect a selection in ways that other tools can't match. Also worth noting, paths remain editable throughout the life of a document, and they're automatically saved with the image file. To make paths, you have to perform the following step.

3. ***Click the Paths button in the options bar.*** Pictured in Figure 4-47, the Paths button ensures that the ellipse tool draws a path outline as opposed to a colored shape layer. (Although shape layers are related to paths, they serve a completely different purpose, as I explain in Lesson 10, "Text and Shapes.")

Figure 4-46.

Figure 4-47.

4. ***Trace around the bird's head.*** Draw a circular shape around the pelican's head. As when using the marquee tools, you can press the spacebar to temporarily freeze the shape's size and reposition it as you drag. You won't be able to perfectly align the ellipse to the head—the head is a bit skewed, after all—so just get the ellipse roughly in place, as in Figure 4-48.

5. ***Enter the free transform mode.*** Right-click inside the path (on the Mac, Control-click) to display a shortcut menu. Then choose **Free Transform Path**. Or just press Ctrl+T (⌘-T) to invoke the Free Transform command under the Edit menu. Either way, Photoshop enters the free transform mode, which lets you scale, rotate, and slant a path.

Figure 4-48.

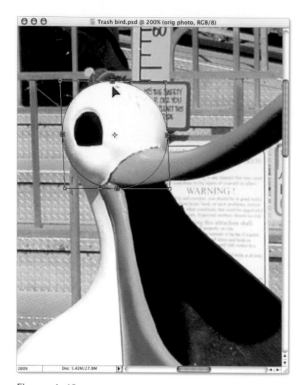

Figure 4-49.

6. **Skew the path to fit the head.** Press and hold the Ctrl key (⌘ on the Mac) and drag each of the four side handles—highlighted in red in Figure 4-49—to slant the oval to better fit the pelican's head. When you get a good match, press Enter (Return on the Mac) to apply your changes.

When working in the free transform mode, Ctrl-dragging (or ⌘-dragging) a side handle moves it independently of the opposite side, thus skewing the shape. Ctrl-drag (or ⌘-drag) a corner handle to distort the shape. Both techniques are useful when fitting ellipses and other geometric paths to image elements.

7. **Display the Paths palette.** Click the **Paths** tab in the **Layers** palette, or choose **Window→Paths**. This displays the **Paths** palette, which is where all path outlines in Photoshop reside.

Note that the Paths palette contains several path outlines. The first three are paths that I've drawn for you. The last, **Work Path**, is the path you just drew. Photoshop automatically names it and temporarily includes it as part of the file. However, if you deactivate the path and draw a new one, you will lose the slanted oval. To protect the path outline, you must rename it.

8. **Name the new path.** Double-click the **Work Path** item to display the **Save Path** dialog box, shown in Figure 4-50. Name the saved path "Pelican Outline" and click **OK**. The Pelican Outline path is now a permanent part of the file and will be saved to disk the next time you choose File→ Save, which you might want to do now. After all, where saving is concerned, there's no time like the present.

So far we've managed to trace the head. But that's just a small part of the waterfowl receptacle. The next several steps explain how to modify this path and combine it with the rest of the body.

9. **Select the pen tool.** Click the pen tool in the toolbox, as demonstrated in Figure 4-51, or press the P key. The pen tool lets you modify existing paths, as well as add straight and curved segments.

Figure 4-50.

Figure 4-51.

10. ***Insert points into the ellipse outline.*** First make sure the ellipse is selected. Four square points should appear around the perimeter of the shape. If not, press the Ctrl key (or ⌘ on the Mac) and click anywhere along the outline of the ellipse to make it active.

Then release the key and move the pen cursor over the path outline. Notice the cursor gets a small + sign (as in ✎+), which tells you that it's ready to add points to the shape. Click at the two spots along the outline that I've colored in red in Figure 4-52. These *anchor points* mark locations at which the path arcs or changes direction. In this case, the anchor points mark where the circular outline of the head meets the neck and beak.

11. ***Delete the bottom point.*** Press Ctrl (or ⌘) to temporarily access the white arrow tool and click the point at the bottom of the path, highlighted in red in Figure 4-53. Then release Ctrl and press the Backspace or Delete key to delete the point. A circular path should now travel a bit more than halfway around the bird's head.

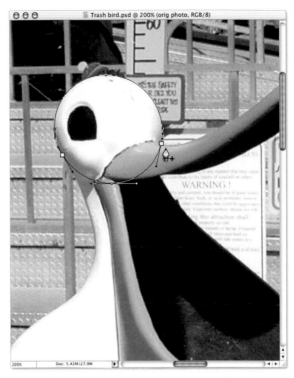

Figure 4-52.

The next phase of the exercise is to combine the pelican head with its body. But before we can do that, we must bring the two together in the Paths palette. This is a little tricky, so I've broken it into four steps (Steps 12 though 15). After that, we'll join the head and body.

12. ***Copy the Partial path.*** Go to the **Paths** palette and Alt-click (or Option-click) the **Partial** item. This displays and selects the path in one operation. This path outline traces most of the pelican. I drew it point-for-point with the pen tool, as you'll learn to do in just a moment.

Figure 4-53.

Figure 4-54.

13. *Copy the path.* Choose **Edit→Copy** or press Ctrl+C (⌘-C on the Mac).

14. *Switch back to the path in progress.* In the Paths palette, click the **Pelican Outline** item— that is, the path outline you named in Step 8 on page 144.

15. *Paste the path.* Choose **Edit→Paste** or press Ctrl+V (⌘-V). Photoshop shows the two paths near each other, as in Figure 4-54. But they remain disconnected. We will connect them in the next few steps.

16. *Click the anchor point on the inside edge of the beak.* Use the pen tool, which should still be active, to click the point that I've highlighted in red in Figure 4-55. When you click an endpoint with the pen tool, it activates the path outline and prepares it to receive more points and segments.

17. *Click to set the next point.* If you zoom in on the image, you'll notice a tiny straight edge along the inside of the top beak. Click the right side of the edge, at the point that I've highlighted in blue in Figure 4-55. This new

Figure 4-55.

point is called a *corner point*, because it acts as a corner in the path. Photoshop draws a straight segment between the new corner point (blue) and the one you clicked in the previous step (red).

18. **Drag from that same point.** Click the point that you just finished clicking, but this time drag from it in the direction indicated by the green arrow in Figure 4-56. The result is a circular *control handle*, which causes a line segment to curve in the direction of the handle. Think of it as a lever that bends the segment toward it. We'll see just how useful that can be in the next step.

19. **Drag to add a smooth point.** Move the cursor midway up the bottom edge of the top beak, to the point highlighted in red in Figure 4-57. Next, click and drag up and to the right, as indicated by the green arrow. Two control handles emanate from the point, one under your cursor and one opposite the cursor. The result is a continuous arc, or *smooth point*. Photoshop draws a curved segment between the new smooth point and the corner point you worked on in the preceding step.

Figure 4-56.

Figure 4-57.

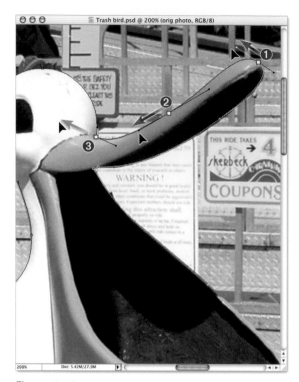

Figure 4-58.

20. **Add more smooth points.** Click and drag at the spot marked ❶ in Figure 4-58, in the direction indicated by the green arrow, to add a smooth point at the tip of the beak. Do the same to add another smooth point at the spot marked ❷.

If a segment doesn't curve just the way you want it to, don't worry. You can always edit it after that fact. While drawing the path, press and hold the Ctrl key (⌘ on the Mac) to access the white arrow tool, which lets you adjust individual anchor points and control handles. Then drag the point or handle you want to modify. When you're ready to again edit the path, release the Ctrl key (or ⌘ key) and continue drawing the path.

21. **Join the two path outlines.** Now to join the beak to the head. First, move your cursor over the right-hand point in the partial ellipse, marked ❸ in Figure 4-58. The pen cursor gets a little anchor point next to it, indicating that you're about to join paths. Press the Alt key (or Option on the Mac) and drag from the point in the direction indicated by the green arrow.

PEARL OF WISDOM

By pressing Alt (or Option) as you drag, you ensure that Photoshop joins the two paths with a curved segment that ends with a corner point. The control handle emanates from its point in the opposite direction of your drag. Strange as it may seem, this is the way the pen tool works across all Adobe applications.

22. **Close the path.** A gap remains along the left edge of the path outline. To close it, drag from the point marked ❶ in Figure 4-59. It may be hard to see the control handle—it's almost parallel to the path outline—so drag in the direction indicated by the green arrow. Then drag at the spot marked ❷, again as indicated by the green arrow, to create a continuous and precise closed path.

23. **Save your image.** Why take the chance of losing all that work? Choose **File**→**Save** or press Ctrl+S (⌘-S on the Mac) to update the file on disk. You haven't changed a single pixel in the document, so there's no risk of overwriting any important data.

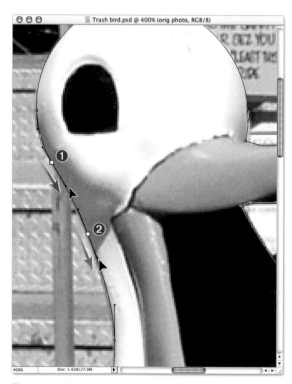

Figure 4-59.

If this is your first encounter with the pen tool, you may feel like you've been put through the proverbial wringer. No doubt about it, this is one of Photoshop's more daunting and challenging functions. That's why I'm going to give you permission to jump ship. Even though we haven't really done anything with our path, you've seen how the pen tool works, which is the ultimate point of the exercise. Then again, if you decide to stick it out, you have my assurance that it gets much easier (not to mention more fun) from here. Plus you'll actually get to *do* something with the path, which makes for a more satisfying experience.

24. *Load the path as a selection.* With the Pelican Outline path selected, click the dotted circle icon (◌) at the bottom of the **Paths** palette, highlighted in Figure 4-60. This hides the path and loads it as a selection.

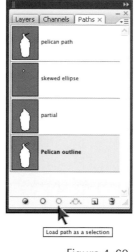

Load path as a selection

Figure 4-60.

Better yet, you can load a path as a selection by pressing the Ctrl key (⌘ on the Mac) and clicking its name in the Paths palette. I like this approach for two reasons: First, you can load any path, not just the active one. Second, this technique works for layers and channels, as we'll see in future lessons.

Figure 4-61.

25. *Switch to the Layers palette.* Click the **Layers** tab or press F7. Note that this image contains a handful of layers that I've created for you in advance. We'll be putting these layers to work in the remaining steps.

26. *Send the selection to an independent layer.* Choose **Layer→ New→Layer via Copy**, or press the keyboard shortcut Ctrl+J (⌘-J on the Mac).

27. *Adjust the order and visibility of the layers.* In the **Layers** palette, drag **Layer 1** above the layer called Shadow. Then click in the eyeball column to the left of **Shadow**, **Water Ick**, and **Text Elements** to turn on each of these items. (Little ◉ icons will spring up where you click.) Your Layers palette should look like the one in Figure 4-61.

28. *Merge Layer 1 and the Shadow layer.* With Layer 1 active, choose **Layer→Merge Down**. This combines Layer 1 with the Shadow layer below it, thus imbuing the former with a fetching drop shadow, as shown in Figure 4-62. (You'll learn more about creating and editing drop shadows in Lesson 11, "Styles and Specialty Layers.")

Figure 4-62.

Figure 4-63.

The layered composition looks great, in a putrid-pelican-trash-can sort of way. But one problem: The green "Thanx for the trash!" text doesn't stand out very well from its background. It needs the same white edges as the orange headline above it. Fortunately, Photoshop's selection commands make this a snap.

29. *Select the White Edge layer.* Click the ▶ in front of **Text Elements** to twirl the folder open. Inside, you'll find four layers. Click **White Edge** to make it active, as in Figure 4-63.

30. *Load the Green Type layer as a selection.* Press the Ctrl key (or ⌘) and click the thumbnail in front of the **Green Type** layer in the Layers palette to convert the letter outlines to a selection.

31. *Expand the selection.* Choose **Select→Modify→Expand** to increase the size of the selection outline by a specified amount. (Photoshop will grow the outline uniformly around the selection's perimeter.) In the **Expand Selection** dialog box, enter a value of 12 pixels and click the **OK** button.

32. *Smooth the sharp corners.* Choose **Select→Modify→Smooth** to round out the corners of the selection outline. It's as if you were tracing a circle around each corner, the radius of which you define with the **Sample Radius** value. Enter 6 pixels and click **OK**.

33. *Fill the selection with white.* First, press the D key to restore Photoshop's default foreground and background colors, which are black and white, respectively. Then press the keyboard shortcut Ctrl+Backspace (⌘-Delete on the Mac) to fill the selected area with the background color, white.

The utterly and completely fabulous result appears in Figure 4-64. Thanks to the power of the pen tool—as well as a few of Photoshop's other selection goodies—our once grubby birdie bin is now a vibrant, cheerful, sassy character, well deserving of even the most fastidious child's unmitigated devotion.

Figure 4-64.

WHAT DID YOU LEARN?

Match the key concept in the numbered list below with the letter
of the phrase that best describes it. Answers appear upside-down
at the bottom of the page.

Key Concepts

1. Magic wand
2. Tolerance
3. Similar
4. Move tool
5. Antialiasing
6. Refine Edge
7. Match Color
8. Polygonal lasso
9. Anchor point
10. Pen tool
11. Control handle
12. Smooth

Descriptions

A. A slight softening effect applied most commonly to selection outlines to simulate smooth transitions.

B. Use this tool to select free-form, straight-sided areas in an image.

C. A setting in the options bar that determines how many colors the magic wand selects at a time, as measured in luminosity values.

D. This command permits you to bring the colors in one image or layer into agreement with those in another.

E. This special kind of lever tugs at the line segment in a path outline, bending it to form a fluid curve.

F. Accessible by pressing Ctrl on the PC (or ⌘ on the Mac), this tool permits you to move selected pixels, even between images.

G. Click with this tool to select regions of color inside an image.

H. The most precise of Photoshop's selectors, this tool lets you draw free-form outlines one segment at a time.

I. A brilliant new command in Photoshop CS3 that lets you edit a selection using a series of slider bars and preview the results of those edits as you work.

J. A spot in a magnetic lasso or path outline that marks a location at which the outline arcs or changes direction.

K. This command expands a selection to include additional nonadjacent colors that fall inside the magic wand's Tolerance range.

L. Located in the Select menu, this command rounds off the corners in a jagged or straight-sided selection.

Answers

1G, 2C, 3K, 4F, 5A, 6I, 7D, 8B, 9J, 10H, 11E, 12L

LESSON

5

CROP, STRAIGHTEN, AND SIZE

IT'S ENTIRELY POSSIBLE that on some planet, there are those who believe that the perfect photograph is one that needs no editing. On this far-flung world, programs like Photoshop are tools of last resort. The very act of opening a photograph in an image editor is a tacit declaration that the photo is a failure. Every command, tool, or option applied is regarded as a mark of flimflam or forgery.

But that's hardly the case here on Earth. Although I do know a few traditionalists who disparage *any* edits—whether applied with Photoshop or otherwise—as unscrupulous cheats, such beliefs can hardly be characterized as mainstream. Despite oft-voiced and sometimes reasonable concerns that modern image editing distorts our perception of places and events, image manipulation is and has always been part and parcel of the photographic process.

There's no better example of this than cropping. Long before computers were widely available and eons before Photoshop hit the market, a professional photographer would frame a shot and then back up a step or two before snapping the picture. That way, he or she had more options when it came time to crop. And nothing said you had to crop the image the way you first framed it; you could crop it any way you wanted to. Even in the old days—back when, say, giant insects roamed the plains (see Figure 5-1)—photographers shot their pictures with editing in mind because doing so ensured a wider range of post-photography options.

Whole-Image Transformations

If image editing is the norm, the norm for image editing is whole-image transformations. This includes operations such as scale and rotate applied to an entire image at a time. Although this may sound like a dry topic, whole-image transformations can produce dramatic and surprising effects.

Figure 5-1.

ABOUT THIS LESSON

 Project Files

Before beginning the exercises, make sure you've installed the lesson files from the DVD, as explained in Step 3 on page xvii of the Preface. This should result in a folder called *Lesson Files-PsCS3 1on1* on your desktop. We'll be working with the files inside the *Lesson 05* subfolder.

In this lesson, we explore ways to crop, straighten, and resize digital photographs using a small but essential collection of tools and commands. You'll learn how to:

Video Lesson 5: Image Size versus Resolution

The exercises in this lesson deal with perhaps the most fundamental topic in Photoshop: changing and managing the number of pixels in an image. To fully grasp this topic, you must come to terms with the concepts of *image size* and *resolution*. The first describes the number of pixels in an image; the second defines how densely those pixels print.

For an introduction to these key concepts, watch the fifth video lesson on the DVD. Insert the DVD and double-click the file *PsCS3 Videos.html*. Then click **Lesson 5: Image Size vs. Resolution** under the **Select, Crop, and Edit** heading. The movie lasts 10 minutes and 43 seconds, during which you may hear mention of these shortcuts:

Command or operation	Windows shortcut	Macintosh shortcut
Preview printed size of image	Click bottom-left Doc item	Click bottom-left Doc item
View pixel dimensions of image	Alt-click Doc item	Option-click Doc item
Show or hide the Info palette	F8	F8
Change the unit of measure	Click the ⊹ icon in Info palette	Click ⊹ icon in Info palette
Cycle between open images	Ctrl+Tab	Control-Tab
Image Size	Ctrl+Alt+I	⌘-Option-I
Canvas Size	Ctrl+Alt+C	⌘-Option-C

More importantly, whole-image transformation forces you to think about basic image composition and ponder some big-picture questions:

- The photo in Figure 5-2 is clearly at an angle, but just what angle is it? Photoshop not only gives you ways to discover that angle (47.7 degrees), but automates the process to boot.

- After you rotate the image, you have to crop it. Never content to limit you to a single approach, Photoshop dedicates one tool, four commands, and a score of options to the task (symbolically illustrated in Figure 5-3). Variety is the spice of life, but which one do you use when?

- After the crop is complete, there's the problem of scale. Should you reduce or increase the number of pixels? Or should you merely reduce the resolution to print the image larger, as in Figure 5-4?

I provide these questions merely to whet your appetite for the morsels of knowledge that follow. If they seem like a lot to ponder, never fear; the forthcoming lesson makes the answers perfectly clear.

Figure 5-2.

Figure 5-3.

Figure 5-4.

The Order in Which We Work

At this point, you may wonder why I've waited until now to introduce a topic as fundamental as cropping. Given that we're addressing topics in the order you actually apply them, wouldn't it make more sense to first crop an image and then correct its brightness and color balance, as discussed in Lessons 2 and 3? The answer is: in some cases yes but in more cases no.

PEARL OF WISDOM

Scaling an image changes the number of pixels. Straightening an image changes the orientation of details. Both operations throw away pixels and make up new ones—a process called *interpolation*—which is best performed after you get the colors in line. In fact, interpolation can help a color adjustment by smoothing out the rough transitions that are often produced by commands such as Shadow/Highlight and Hue/Saturation.

On its own, cropping does not require interpolation and may therefore be applied before color adjustments. But several functions crop and interpolate an image all at once, in which case you're better off correcting the colors first.

By way of general advice, get your color adjustments out of the way first, and then set about cropping and straightening the image.

Auto Crop and Straighten

One method for straightening and cropping is applicable specifically to scanned images, particularly those captured by a flatbed scanner. Photoshop can open a crooked image, rotate it upright, and crop away the area outside the image—all automatically, without so much as batting an eye. Better yet, it can work this magic on multiple images at a time.

You begin by taking a handful of printed images and throwing them down on a flatbed scanner. Then, rather than using the scanner's software to assign each image to a separate file, go ahead and scan all images as a group to a single file. Figure 5-5 shows me scanning a total of seven images—from both the hardware and software perspective—using a relatively antique but perfectly serviceable Umax PowerLook 3000. Called *gang scanning*, this once ill-advised technique works wonders in Photoshop. The goal of this exercise is to take this gang scan and extract the individual images using a single command.

Gang scan

Those same pics as seen by the scanner

Figure 5-5.

1. *Open the scanned image.* Open *The gang.jpg* included in the *Lesson 05* folder inside *Lesson Files-PsCS3 1on1*. You'll see the collection of seven images of various shapes and sizes—some photographs, some printed artwork—pictured in Figure 5-6. Miraculously, Photoshop can work on them all at once.

Figure 5-6 shows the actual file produced by the scanner. This particular device is unusual in that the glass that holds the images moves as the sensor zips back and forth beneath it. The background is a mat that anchors the images in place. But regardless of the scanner you use, this exercise should match your experiences as you straighten and crop scanned artwork, assuming you don't pack your images too tightly.

2. *Choose Crop and Straighten Photos.* That's all there is to it. The moment you choose **File→Automate→Crop and Straighten Photos** (see Figure 5-7), Photoshop takes over. You may see a progress bar as Photoshop loads the plug-in from disk. Then the windows start flying as the program duplicates, rotates, and crops each image. Your only job is to sit back and watch. If all of Photoshop were this easy, I'd be out of a job.

Figure 5-6.

Figure 5-7.

3. **Review the cropped images.** In less than a minute on most modern systems, the Crop and Straighten Photos command makes order from chaos. In all, the command generates seven separate image windows, each named *The gang copy* followed by a number, in the order shown in Figure 5-8. Note that Photoshop analyzes the images strictly from top to bottom. This is why the baby photo of my son Sammy, which is slightly higher than the cat, comes up first.

Photoshop really does a swell job of straightening the images, even managing to accurately evaluate pictures with irregular edges, such as the perforated stamp and the clipped magazine photo of the hard drive. But it doesn't know when an image is on its side. That means the cat photo still needs work.

Figure 5-8.

4. **Rotate the cat photo.** Click the title bar for the cat photo, most likely named *The gang copy 2*. Then choose **Image→Rotate Canvas→90° CW**. Alternatively, if you loaded the custom dekeKeys shortcuts that I had you install in Step 7 on page xviii of the Preface, you can press Ctrl+Shift+Alt+⬚ (⌘-Shift-Option-⬚ on the Mac). This rotates the entire image, changing it from vertical to horizontal, as in Figure 5-9 on the facing page.

5. **Save the images.** Photoshop does not automatically save the images it generates; you have to do that manually. So go ahead and save the files you might want to use later. The JPEG format with a high Quality setting is fine for the

photographs. But because JPEG modifies image details in its attempt to minimize the file size, it is not well suited to high-contrast artwork, such as the stamps. You may prefer to save these images as TIFF files.

If an image (such as the hard drive) requires further cropping or you simply aren't happy with Photoshop's choices, turn to one of the techniques documented in the upcoming exercises.

Straightening a Crooked Image

Although the Crop and Straighten Photos command works wonders on an image that was scanned crooked, it doesn't work worth a hill of beans on an image that was shot crooked. Consider the parable of the two towers illustrated in Figure 5-10. Inexplicably, the original photograph appears at something of an angle (left). One is tempted to characterize the tower as "leaning." With such clear delineation between building and sky, you might expect Crop and Straighten Photos to be able to analyze it accurately. Instead, it overcompensates for the angle and completely botches the crop (right). Without an obvious rectangle to work with, the command has no way to properly identify the boundaries of the image.

Figure 5-9.

Photograph istockphoto.com/absolutely_frenchy

Figure 5-10.

Figure 5-11.

Figure 5-12.

When straightening a crooked photograph—digital or otherwise—the better solution is Image→Rotate Canvas→Arbitrary. This command permits you to rotate an entire image by a specific numerical increment, accurate to 0.01 degree. Of course, the trick is to figure out how much rotation to apply. You do this using the ruler tool, as we'll see in the following exercise:

1. **Open a crooked photograph.** Open the file named *Tikal temple.jpg,* located in the *Lesson 05* folder inside *Lesson Files-PsCS3 1on1.* At first glance, the photo doesn't look so bad. Heck, if I had gotten a little closer and lower to the ground, I might be able to justify the angle as "dramatic." But alas, from this vantage, the image just looks cockeyed. Our job is to straighten it.

2. **Duplicate the image.** Choose **Image→Duplicate** to copy the image. Name the duplicate "Temple Upright" (see Figure 5-11) and click **OK**. We'll straighten the duplicate version of the image; then in Step 7, we'll call on the original to assist in cropping the excess pixels produced by the rotation.

3. **Select the ruler tool in the toolbox.** Click and hold the eyedropper icon near the bottom of the toolbox and choose the ruler tool from the flyout menu (see Figure 5-12). This tool lets you measure the distance and angle between two points. Handy for us, it also shares that angle information with the Arbitrary command.

4. **Drag inside the image with the ruler tool.** For the best results, we would drag along the edge of an image element that ought to be exactly horizontal or vertical. Because I didn't capture a single side of the temple head on, dragging along the base of either of the two visible sides won't work for us. In this situation your best bet is to drag in a straight line from the farthest lower-left corner of the temple to the farthest lower-right corner, as illustrated in Figure 5-13. After you draw the line, feel free to drag the endpoints (still using the ruler tool) to get the line exactly right.

As you work with the ruler tool, the options bar notes the angle (A) and distance (D1) of the line. Angle is the inclination of the line, which translates to the number of degrees the line is "out of plumb" (off from absolute vertical or horizontal). Distance is the length of the line. When straightening an image, D1 is of no concern; only A matters.

If you drag from left to right, as I did, the A value will be something like –3.8 degrees. But if you drag from right to left, the A value will be more in the neighborhood of 176.2 degrees. Which is correct? As it turns out, both. Which should you use to rotate the image? Neither, because Photoshop will do it for you in the very next step.

5. *Choose the Arbitrary rotation command.* Choose **Image→Rotate Canvas→Arbitrary**. Or, if you loaded the dekeKeys shortcuts, you can press Ctrl+Shift+Alt+R (⌘-Shift-Option-R). The **Rotate Canvas** dialog box appears, bearing an Angle value that is the opposite of the A value tracked by the options bar. In my case, the value is 3.79 degrees counterclockwise (see Figure 5-14), which is the same as –176.21 clockwise. The angle of your measure line—and thus your Angle value—may be slightly different. But as long as the difference is just a few fractions of a degree, all should be fine. Click **OK** to accept the rotation.

Figure 5-13.

Figure 5-14.

Figure 5-15.

Your image should now be upright. But in expanding the boundaries of the image to include the rotated photograph, the Arbitrary command exposed empty wedges around the corners (see Figure 5-15). The wedges appear in the background color, which is white by default. You need to crop away the wedges, but how? Ideally, Photoshop would provide an automatic way to delete all the wedges without taking away any more of the image than is absolutely necessary, but it doesn't. Fortunately, you can work around this oversight using Canvas Size and a little math, as the remaining steps explain.

6. *Choose the Canvas Size command.* Choose **Image→Canvas Size** or press the keyboard shortcut Ctrl+Alt+C (⌘-Option-C on the Mac). This displays the **Canvas Size** dialog box shown in Figure 5-16, which allows you to scale the boundaries of an image—the *canvas*—without resizing the image itself. If you make the canvas smaller,

Figure 5-16.

you crop the image; if you make it larger, you add to the wedges. Naturally, we want to make the canvas smaller.

7. *Choose the original temple image.* From within the Canvas Size dialog box, choose **Window→ Tikal temple.jpg**. On occasion, Photoshop lets you choose menu commands from within dialog boxes. (Even with the Canvas Size dialog box open, for example, you still have access to the Window menu.) By choosing an open image, you load its exact canvas dimensions—in this case, 1382 pixels wide by 1843 pixels tall, as shown in Figure 5-17. (As I urged in the video lesson, you should be working in pixels.)

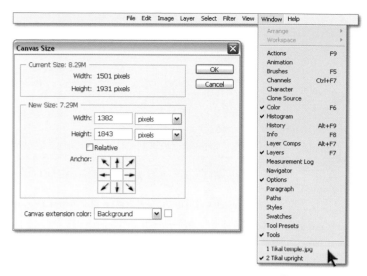

Figure 5-17.

8. *Turn on the Relative check box.* Selecting **Relative** changes the Width and Height values so that, instead of showing the absolute dimensions of the canvas, they show the number of pixels that will be added or cropped away. In this case, the Width and Height values change to –119 and –88, respectively (see Figure 5-18). Your numbers may differ slightly, depending on the amount of rotation you accepted in Step 5.

PEARL OF WISDOM

Why should you care about the dimensions of the original canvas compared to the post-rotation canvas? Because they provide insight into the size of the wedges. As an image rotates, it extends half into the old canvas and half into the new. This means each wedge is exactly twice the width or height of the relative difference between the old and new canvas dimensions. The upshot: All we have to do is multiply by 2.

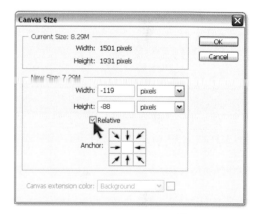

Figure 5-18.

9. *Double the Width and Height values.* If you can do the math in your head, go for it. If not, get a calculator. (Both Windows and the Mac have one.) For my part, 119 × 2 = 238 and 88 × 2 = 176. So I change the **Width** value to –238 pixels and the **Height** to –176 (see Figure 5-19). Whatever your values, a minus sign should precede each number. This ensures that Photoshop crops the image instead of adding to it.

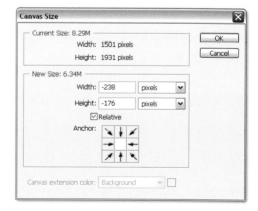

Figure 5-19.

Figure 5-20.

10. **Click the OK button.** After you do, Photoshop displays an alert message asking whether you're sure you want to reduce the canvas size and crop the image. Click **Proceed** or press the P key to move on. Pictured in Figure 5-20, the result is a straight, precisely cropped Mayan temple, with not so much as a sliver of a wedge in sight.

Using the Crop Tool

If an image requires cropping, the aptly named crop tool is your best bet. It lets you scale the canvas boundary directly in the image window (as opposed to working numerically, as with Canvas Size). You can also rotate the boundary to accommodate a crooked image. We're talking one-stop cropping.

1. **Open an image that needs cropping.** Open *Russian statue.jpg*, located in the *Lesson 05* folder inside *Lesson Files-PsCS3 1on1*. Pictured in Figure 5-21, this photograph comes to us from

Figure 5-21.

Evgeny Zimin. The subject happens to be a monument in Moscow that I'm told commemorates the first time someone uttered the words "In Russia, cold catches you! What a country!" But historical significance aside, I can't say I'm crazy about the letters cluttering up the lower section of the image. Plus, the framing is a little askew. Fortunately, we can easily put the finishing touches on this compelling image by straightening and cropping it with the crop tool.

2. *Select the crop tool in the toolbox.* Click the crop tool in the toolbox (see Figure 5-22) or press C for Crop (not to mention Clip, Cut, and Curtail).

3. *Draw the crop boundary.* Drag inside the image window to draw a rectangle around the portion of the image you want to keep, as in Figure 5-23. As you do so, you enter the *crop mode.* From now until you press Enter or Esc, most of Photoshop's commands and palettes are unavailable. You have now made a commitment to cropping.

Figure 5-22.

Figure 5-23.

As with the marquee tools, you can adjust the position of the crop boundary on-the-fly by pressing and holding the spacebar. But don't get too hung up on getting things exactly right. You can easily move and resize the crop boundary after you draw it, as demonstrated in Step 5.

Figure 5-24.

4. **Adjust the appearance of the shield in the options bar.** Photoshop indicates the area that will be cropped away by covering it with a translucent *shield*. Black by default, the shield is too dark to provide a clear distinction around the base of the statue and the, well, shield. Go to the options bar and click the **Color** swatch to display the **Color Picker** dialog box. Then set the color to white and click **OK**. I also recommend lowering the **Opacity** value to 35 percent, as illustrated in Figure 5-24.

5. **Move and scale the crop boundary.** Drag inside the crop boundary to move it. Drag the dotted outline or one of the eight square handles surrounding the crop boundary to scale it (that is, change its size). Also worth noting:

 • Press the Shift key while dragging a corner handle to scale the crop boundary by the same percentage horizontally and vertically.

 • Press the Alt key (Option on the Mac) while dragging to scale the boundary with respect to its center. In other words, the corners move but the center stays fixed in place.

6. **Rotate the crop boundary.** To rotate the rectangular crop boundary, move your cursor outside the boundary and drag. Because you want to straighten the image, you need to rotate the boundary in the opposite direction of your intended rotation. For example, rotating the crop boundary counterclockwise ultimately rotates the image clockwise. Which is precisely what I want you to do now.

To straighten the image, you'll need a frame of reference. Start by dragging the bottom edge of the crop boundary until it intersects the top of the statue's base. Then rotate the boundary to match the angle of the base, as demonstrated in **Figure 5-25**. (Don't worry that the right edge is now in the wrong place; we'll fix that in a moment.)

You may notice that Photoshop rotates the boundary around a central origin point, labeled in Figure 5-25. To rotate around a different spot, drag the origin from the center of the boundary to the desired location.

To monitor the angle of the rotation, choose Window→Info or press the F8 key to display the Info palette. Then note the angle value (A) in the upper-right corner of the palette. On the off chance that you want to match my settings, I finally settled on an angle of 2.3 degrees.

7. *Make any last-minute tweaks.* You'll at least need to move the right edge of the boundary back to the right of the seated figure, Prince Pozharsky, the man responsible for driving the Poles out of Moscow in 1612. But feel free to move, scale, and rotate the crop boundary as much as you like until you get it exactly the way you want it. And don't forget to include the outreached hand of famed citizen hero Kuzma Minin. My final boundary appears in Figure 5-26 on the next page.

8. *Apply your changes.* Click the ✔ on the right side of the options bar or press the Enter or Return key to accept your changes. Photoshop crops away the pixels outside the boundary and rotates the image upright.

Origin point

Rotate cursor

Figure 5-25.

Figure 5-26.

Shown in Figure 5-27 below, the result is a more engaging photograph, nicely framed by the colorful towers of the Intercession Cathedral in the background.

That's all there is to the cropping. But, I think this photo needs a little bit more. Specifically, it might look even better if we set it against a couple of mattes, like those in a traditional picture frame. And framing turns out to be another canvas operation. Fortunately, we can create a lovely matte effect by "uncropping" the image—or adding to the canvas—using the Canvas Size command. If you don't want to delve into this topic, skip to the next exercise, "Resizing an Image," which begins on page 171. Otherwise, let's add those mats.

9. *Copy the image to a new layer.* Choose **Layer→ New→Layer via Copy**. Or more simply, press Ctrl+J (⌘-J on the Mac).

10. *Choose the Canvas Size command.* Choose **Image→ Canvas Size** or press Ctrl+Alt+C (⌘-Option-C) to display the **Canvas Size** dialog box.

Figure 5-27.

11. *Change the Width and Height values to 50 pixels each.* Make sure that the **Relative** check box is turned on, so that the Width and Height values add to the existing canvas. Values of 50 pixels each will extend the canvas 25 pixels (half of 50) in all directions.

12. *Assign a canvas color.* Go down to the **Canvas extension color** option and choose **Other,** or click on the color swatch to the right of the pop-up menu. Inside the **Color Picker** dialog box, change the first three values to **H:** 20, **S:** 50, and **B:** 90 to get the light scarlet shown in Figure 5-28. Click **OK** to exit the Color Picker, and then click **OK** again to extend the canvas size.

13. *Give the matte a beveled edge.* Go to the **Layers** palette. (If necessary, choose **Window→Layers** to bring the palette to the front.) Make sure Layer 1 is active. Then click the *fx* icon at the bottom of the palette and choose **Bevel and Emboss,** as shown in Figure 5-29, to display the immense **Layer Style** dialog box.

14 *Apply the Outer Bevel effect.* Choose **Outer Bevel** from the **Style** pop-up menu at the top of the dialog box. This ensures that the bevel extends out from the image into the mat. From there, you can either accept the default setting or enter the custom settings shown in Figure 5-30. When you're finished, click **OK**.

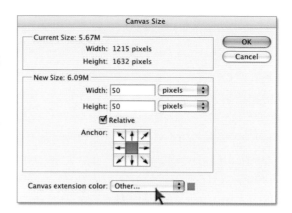

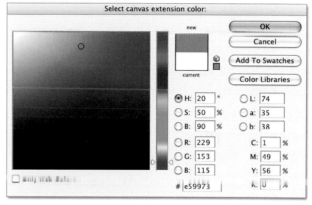

Figure 5-28.

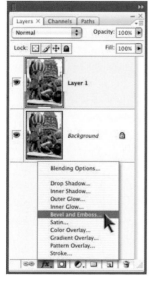

Figure 5-29.

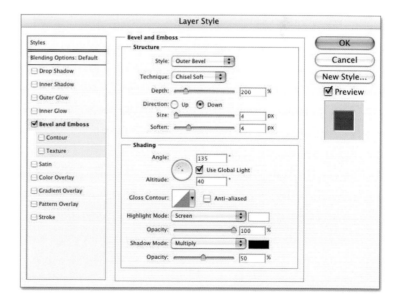

Figure 5-30.

Alt-drag
(Option-drag)
fx icon

Figure 5-31.

15. *Copy the Background layer to a new layer.* Click the **Background** item in the **Layers** palette to select the layer that contains the matte color. Then once again press Ctrl+J (⌘-J on the Mac) to clone the image to a new layer.

16. *Choose the Canvas Size command.* Choose **Image→Canvas Size** or press Ctrl+Alt+C (⌘-Option-C) to again display the **Canvas Size** dialog box. Then do the following:

 • Make sure **Relative** is turned on.

 • Change the **Width** and **Height** values to 150 pixels apiece.

 • Click the **Canvas extension color** swatch and lower the **B** value to 40. (The H and S values should still be 20 and 50, respectively.) This results in a deep, saturated brown.

 • Click **OK** to exit the Color Picker dialog box. Then click **OK** again to extend the canvas size.

Figure 5-32.

17. *Duplicate the layer style.* See the *fx* icon to the right of **Layer 1** in the **Layers** palette? This represents the Bevel and Emboss effect you applied in Steps 13 and 14. To duplicate this effect, press the Alt key (Option on the Mac), and then drag the *fx* icon and drop it immediately on the **Background copy** layer, as demonstrated in Figure 5-31. This copies the layer style from the top layer to the middle layer, creating another layer of matte.

> Those of you familiar with previous versions of Photoshop will notice that this behavior has changed since the old days. In Photoshop CS and earlier, you duplicated a layer style by dragging the ✦ icon. Now, not only do you have a different icon (the less elegant but more obvious *fx*), you have to press the Alt (or Option) key when dragging it as well.

The result is the double-matte effect that appears in Figure 5-32. Granted, we ventured a bit outside our mandate near the end of this exercise, but all's fair when cropping and framing a beautiful photograph. In case you're curious, we examine layers in full detail in Lesson 9, "Building Layered Compositions." For more information on Bevel and Emboss, read Lesson 11, "Styles and Specialty Layers."

Resizing an Image

Now we leave the world of rotations and canvas manipulations in favor of what may be the single most essential command in all of Photoshop: Image Size. Designed to resize an entire image all at once—canvas, pixels, the whole shebang—Image Size lets you scale your artwork in two very different ways. First, you can change the physical dimensions of an image by adding or deleting pixels, a process called *resampling*. Second, you can leave the quantity of pixels unchanged and instead focus on the *print resolution*, which is the number of pixels that get packed in an inch or a millimeter of page space when you print the image.

Whether you resample an image or change its resolution depends on the setting of a check box called Resample Image. As we'll see, this one option has such a profound effect on Image Size that it effectively divides the command into two functions. In this next exercise, we explore how and why you might resample an image. To learn about print resolution, read the "Changing the Print Size" sidebar on page 174.

PEARL OF WISDOM

Contrary to what you might reasonably think, print resolution is measured in *linear* units, not square units. For example, if you print an image with a resolution of 300 pixels per inch (*ppi* for short), 300 pixels fit side-by-side in a 1-inch wide row, In contrast, a square inch of this printed image would contain 300 × 300 = 90,000 pixels. Why say "90,000 ppsi" when "300 ppi" is so much easier? Also note that the print resolution, ppi, is measured separately from the printer hardware resolution, *dpi* (short for dots per inch), which we'll explore in Lesson 12, "Printing and Output."

1. *Open the image you want to resize.* Go to the *Lesson 05* folder inside *Lesson Files-PsCS3 1on1* and open the file named *Enormous chair.jpg.* Shown in Figure 5-33, this 21-foot-tall rocking chair is not only enormous in real life, but also contains the most pixels of any file we've seen so far (if you don't factor in layers).

2. *Check the existing image size.* To see just how many pixels make up the image, press the Alt key (Option on the Mac) and click the box that reads **Open** or **Doc: 17.5M/17.5M.** (This box is located in the status bar in the lower-left corner of the image window.) As pictured in Figure 5-33, this displays a flyout menu that lists the size of the image in pixels, along with its resolution. This particular image measures 2250 pixels wide by 2720 pixels tall, which translates to a total of 2250 × 2720 = 6.12 million pixels. When printed at 300 ppi, the image will measure 7.5 inches wide by a little more than 9 inches tall.

Figure 5-33.

3. *Magnify the image to the 100 percent zoom ratio.* Double-click the zoom tool icon in the toolbox. Then scroll around until you can see the sign tacked to the front of the chair. Pictured in Figure 5-34, the text on the sign is exceedingly legible—explaining the whats and the whens of the rocking chair but inexplicably omitting the whys—a testament to the high resolution of the photograph. But there's also a lot of noise (random variation in pixel coloring). So even though we have scads of pixels, they aren't necessarily in great shape.

4. *Decide whether all these pixels are necessary.* This may seem like a rather cerebral step, but it's an important one. Resampling amounts to rewriting every pixel in your image, so weigh your options before you plow ahead.

So let's say you want to email this image to a couple of friends. Surely your friends can print the image smaller than 7.5 by 9 inches. And in all likelihood, they won't print it at all; they'll just view it on the screen. A typical high-resolution monitor can display 1600 by 1200 pixels, a mere 30 percent of the pixels in this photo.

Conclusion: Resampling is warranted. This is a job for Image Size.

Figure 5-34.

5. ***Choose the Image Size command.*** Choose **Image→Image Size**. Alternatively, if you loaded my shortcuts as suggested on page xviii of the Preface, you can access the command from the keyboard by pressing Ctrl+Alt+I (⌘-Option-I on the Mac). Pictured in Figure 5-35, the ensuing **Image Size** dialog box is divided into two parts:

- The Pixel Dimensions options let you change the width and height of the image in pixels. Lowering the number of pixels is called *downsampling*; raising the pixels is called *upsampling*. We will be downsampling, by far the more common practice.

- The Document Size options control the size of the printed image. They have no effect on the size of the image on the screen or on the Web.

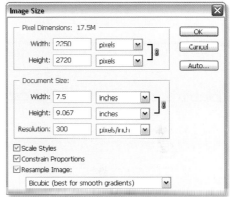

6. ***Turn on the Resample Image check box.*** Located at the bottom of the dialog box, this option permits you to change the number of pixels in an image.

7. ***Select an interpolation setting.*** Below the Resample Image check box is a pop-up menu of interpolation options, which determine how Photoshop blends the existing pixels in your image to create new ones. When downsampling an image, only three options matter:

Figure 5-35.

- When in doubt, select Bicubic, which calculates the color of every resampled pixel by averaging the original image in 16-pixel blocks. It is slower than either Nearest Neighbor or Bilinear (neither of which should be used when resampling photographs), but it does a far better job as well.

- Bicubic Smoother compounds the blurring effects of the interpolation to soften color transitions between neighboring pixels. This helps suppress film grain and noise.

- Bicubic Sharper results in crisp edge transitions. Use it when the details in your image are impeccable and you want to preserve every nuance.

Because this particular image contains so much noise, **Bicubic Smoother** is the best choice.

As often as not, you have no desire to change the number of pixels in an image; you just want to change how it looks on the printed page. By focusing exclusively on the resolution, you can print an image larger or smaller without adding or subtracting so much as a single pixel.

For example, let's say you want to scale the original *Enormous chair.jpg* image so that it prints 10 inches wide by 12 inches tall. Would you upsample the image and thereby add pixels to it? Absolutely not. The Image Size command can't add detail to an image; it just averages existing pixels. So upsampling adds complexity without improving the quality. There are times when upsampling is helpful—when matching the resolution of one image to another, for example—but they are few and far between.

The better solution is to modify the print resolution. Try this: Open the original *Enormous chair.jpg*. (This assumes that you have completed the "Resizing an Image" exercise and saved the results of that exercise under a different filename, as directed by Step 14 on page 176.) Then choose the **Image Size** command from the **Image** menu and turn off the **Resample Image** check box.

Notice that the Pixel Dimensions options are now dimmed and a link icon (⛓) joins the three Document Size values, as in the screen shot below. This tells you that it doesn't matter which value you edit or in what order. Any change you make to one value affects the other two, so you can't help but edit all three values at once. For example, change the **Width** value to 10 inches. As you do, Photoshop automatically updates the Height and Resolution values to 12.089 inches and 225 ppi, respectively. So there's no need to calculate the resolution value that will get you a desired set of dimensions; just enter one of the dimensions and Photoshop does the math for you.

Click **OK** to accept your changes. The image looks exactly the same as it did before you entered the Image Size dialog box. This is because you changed the way the image prints, which has nothing to do with the way it looks on the screen. If you like, feel free to save over the original file. You haven't changed the structure of the image; you just added a bit of sizing data.

To learn more about printing—including how you can further modify the print size and resolution using the Print with Preview command—consult Lesson 12, "Printing and Output."

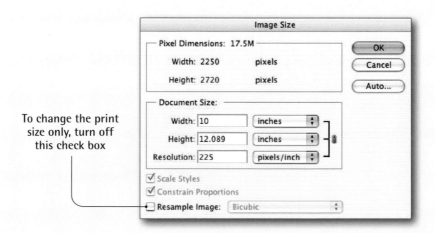

To change the print size only, turn off this check box

8. ***Turn on the Constrain Proportions check box.*** Unless you want to stretch or squish your image, leave this option turned on. That way, the relationship between the width and height of the image—known as the *aspect ratio*—will remain constant.

9. ***Specify a Resolution value.*** When Resample Image is checked (Step 6), any change made to the Resolution value affects the Pixel Dimensions values as well. So if you intend to print the image, it's a good idea to get the Resolution setting out of the way first. Given that we're emailing the image and we're not sure if it'll ever see a printer, a **Resolution** of 200 ppi should work well enough.

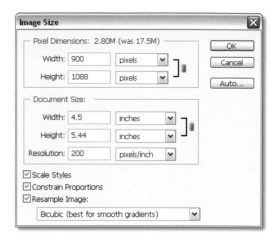

Figure 5-36.

10. ***Adjust the Width or Height value.*** The Pixel Dimensions have dropped to 1500 by 1813 pixels. But given that most screens top out at 1600 by 1200 pixels, that's still too big. Reduce the **Width** value to 900 pixels, which changes the **Height** value to 1088 pixels. This also reduces the Document Size to 4.5 by 5.44 inches (see Figure 5-36), plenty big for an email picture.

11. ***Note the new file size.*** The Pixel Dimensions header should now read 2.80M (was 17.5M), where the M stands for *megabytes*. This represents the size of the image in your computer's memory. The resampled image will measure 900 × 1088 = 979,200 pixels, a mere 16 percent of its previous size. Not coincidentally, 2.8M is precisely 16 percent of 17.5M. The complexity of a file is directly related to its image size, so this downsampled version will load, save, print, and email much more quickly.

12. ***Click OK.*** Photoshop reduces the size of the image on screen and in memory. As verified by Figure 5-37, the result continues to look great when printed, but that's in part because it's printed so small. The real test is how it looks on your screen, which we'll verify next.

Figure 5-37.

13. *Magnify the image to the 300 percent zoom ratio.* Use the zoom tool to zoom in on the sign, as in Figure 5-38. The letters are rougher—no surprise given the lower number of pixels—but they remain legible. And the photo overall is less grainy. Downsampling with the Bicubic Smoother setting (Step 7, page 173) goes a long away toward smoothing away the noise.

Figure 5-38.

14. *Choose File→Save As.* Or press Ctrl+Shift+S (⌘-Shift-S on the Mac). Then give the file a new name or save it to a different location. The reason I have you do this is to emphasize the following very important point.

PEARL OF WISDOM

At all costs, you want to avoid saving your downsampled version of the image over the original. *Always* keep that original in a safe place. I don't care how much better you think the downsampled image looks; the fact remains, it contains fewer pixels and therefore less information. The high-resolution original may contain some bit of detail you'll want to retrieve later, and that makes it worth preserving.

WHAT DID YOU LEARN?

Match the key concept in the numbered list below with the letter of the phrase that best describes it. Answers appear upside-down at the bottom of the page.

Key Concepts

1. Cropping
2. Whole-image transformations
3. Interpolation
4. Gang scanning
5. Measure tool
6. Canvas
7. Shield
8. Origin point
9. Print resolution
10. Downsampling
11. Bicubic Smoother
12. Aspect ratio

Descriptions

A. A quick and dirty method of capturing several images with a flatbed scanner to a single file and then sorting them out using the Crop and Straighten command.

B. A means of cutting away the extraneous portions of an image to focus the viewer's attention on the subject of the photo.

C. An interpolation setting that makes a special effort to suppress film grain, noise, and other artifacts.

D. The number of pixels that will print within a linear inch or millimeter of page space.

E. The process of throwing away pixels and making up new ones by averaging the existing pixels in an image.

F. To change the physical dimensions of an image by reducing the number of pixels.

G. To straighten a photo with this tool, drag along an edge that should be exactly horizontal or vertical.

H. The translucent film of color that covers the portions of an image that will be deleted after you apply the crop tool.

I. The relationship between the width and the height of an image.

J. Operations such as Image Size and the Rotate Canvas commands that affect an entire image, including any and all layers.

K. The center of a rotation or other transformation.

L. The boundaries of an image, as measured independently of the contents of the image itself.

Answers

1B, 2J, 3E, 4A, 5G, 6L, 7H, 8K, 9D, 10F, 11C, 12I

PAINT, EDIT, AND HEAL

SO FAR, WE'VE seen a wealth of commands that correct the appearance of an image based on a few specifications and a bit of numerical input. On balance, there's nothing wrong with these commands, and many are extraordinarily useful. But all the automation in the world can't eliminate the need for old-fashioned, roll-up-your-sleeves, slather-on-the-elbow-grease, sometimes-toilsome but always rewarding artistic labor.

Such is the case with painting and retouching in Photoshop. Whether you want to augment a piece of artwork or fix the details in a photograph, it's time to give the commands a slip and turn your attention to the toolbox. Photoshop devotes fully one-third of its tools—all those in the second section of the toolbox (see Figure 6-1)—to the tasks of applying and modifying colors in an image. The idea of learning so many tools and putting them to use may seem intimidating. And because they require you to paint directly in the image window, they respond immediately to your talents and dexterity, not to mention your lack thereof. Fortunately, despite their numbers, the tools are a lot of fun. And even if your fine motor skills aren't everything you wish they were, there's no need to fret. I'll show you all kinds of ways to constrain and articulate your brushstrokes in the following exercises.

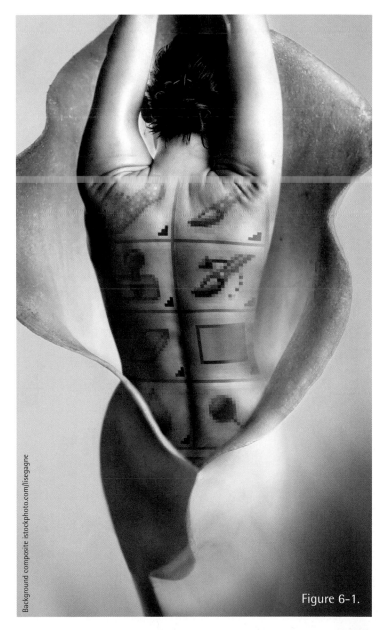

Background composite istockphoto.com/lisegagne

Figure 6-1.

ABOUT THIS LESSON

![Project Files icon] **Project Files**

Before beginning the exercises, make sure you've installed the lesson files from the DVD, as explained in Step 3 on page xvii of the Preface. This should result in a folder called *Lesson Files-PsCS3 1on1* on your desktop. We'll be working with the files inside the *Lesson 06* subfolder.

The exercises in this lesson explain how to use Photoshop's paint, edit, and healing tools to brush color and effects into an image. You'll learn how to:

Video Lesson 6: The Brush Engine

Many of Photoshop's paint, edit, and healing tools rely on a common group of options and settings that Adobe calls the *brush engine*. These options include such elements of brushstroke behavior as size, hardness, roundness, angle, pressure-sensitive taper, and scatter. You adjust brush engine settings from a variety of locations, including the options bar and the dedicated Brushes palette.

To get a feel for how these settings work, watch the sixth video lesson on the DVD. Insert the DVD and double-click the file *PsCS3 Videos.html*. Then click **Lesson 6: The Brush Engine** under the **Select, Crop, and Edit** heading. This 14-minute, 16-second movie includes the following operations and shortcuts:

Tool or operation	Windows shortcut	Macintosh shortcut
Brush tool	B	B
Display the brush options	right-click with brush tool	right-click with brush tool
Hide the brush options	Enter	Return
Incrementally enlarge or shrink the brush	⬚ or ⬚ (right or left bracket)	⬚ or ⬚ (right or left bracket)
Make the brush harder or softer	Shift+⬚ or Shift+⬚	Shift-⬚ or Shift-⬚
Show or hide the Brushes palette	F5	F5
Eyedrop color when using the brush tool	Alt-click	Option-click

The Essential Eight, Plus Three

Clicking and holding on any one of the icons pictured in Figure 6-1 produces a flyout menu of additional tools, 22 in all. Of those, seventeen are *brush-based*. Select such a tool and drag in the image window to create a brushstroke of colored or modified pixels. The remaining five tools are modeled after the selection tools discussed in Lesson 4. You either click to replace colored regions, as with the magic wand, or drag to change free-form areas, as with the lasso.

Mind you, not every one of these 22 tools is a winner. As with everything in Photoshop, some tools are good and some tools are not so good. In this lesson, we focus on what I consider to be the Essential Eight brush-based tools: the paintbrush (AKA the brush tool); the history brush; the dodge, burn, sponge, and smudge tools; and two variations on the healing brush. We also look at three selection-type tools: the paint bucket, the red eye tool, and the patch tool.

This emphasis on brushes may lead you to think that tools such as the paintbrush and sponge are best suited to creating original artwork. Although it's true that many people create artwork from scratch in Photoshop, it's not really what the program's designers had in mind. The real purpose of these tools is to help you edit photographic images or scanned artwork, and that's how we'll use them in this lesson.

The Three Editing Styles

Photoshop lets you use the tools in the second section of the toolbox to apply and modify colors in three ways:

- The first group of tools, the *painting tools*, comprises the paintbrush, the paint bucket, and others. They permit you to paint lines and fill shapes with the foreground color. I drew the lines in Figure 6-2 with the paintbrush while switching the foreground color between black and white.

Figure 6-2.

Figure 6-3.

Figure 6-4.

- *Editing tools* is a catchall category for any tool that modifies rather than replaces the existing color or luminosity of a pixel. The burn tool darkens pixels, the smudge tool smears them, and the color replacement tool swaps out hue and saturation values, as demonstrated in Figure 6-3.

- The *healing tools*—the healing brush, patch tool, and history brush among them—permit you to clone elements from one portion or state of an image to another. The history brush clones pixels from an older version of the image. The healing brush and patch tool go a step better, merging the cloned details with their new background to create a gradual or seamless match, as illustrated in Figure 6-4.

Coloring Scanned Line Art

Photoshop is possibly the best program on this or any other planet for manipulating digital photographs. But it's also a capable program for creating original art and coloring scanned artwork. This latter proficiency is especially valuable because it exploits the best aspects of traditional and digital media:

- It's easier to draw on paper with a pencil and pen than it is to sketch on screen. You can remedy this situation in part by swapping your clunky mouse for a more precise stylus and drawing tablet. But I still prefer to see the entire sheet of paper all at once without any need for zooming and panning.

- It's easier to add colors in Photoshop than hassle with conventional paints or assemble fussy, traditional mechanicals.

How you add colors depends on the effect you want to achieve. In the following exercise, we approach this topic in two stages. First you'll clean up a piece of scanned line art and apply color to the lines. Then you'll fill in the shapes, introduce a photographic background, and apply a texture or two. Throughout the entire process, you won't harm a single stroke in the original drawing. It really is the best of all worlds.

1. *Open the scanned artwork.* Go to the *Lesson 06* folder inside *Lesson Files-PsCS3 1on1* and open *Butterfly.tif*, which contains a sketch that I drew with a common, run-of-the-mill Sharpie on a piece of cheap copier paper, as pictured in Figure 6-5. Although these are admittedly low-tech art tools, I prefer them to anything Photoshop has to offer. The image is somewhat misnamed—after all, it's only half a butterfly. But we'll take care of that in the next few steps.

2. *Double the width of the canvas.* Before you can create the right half of the butterfly, you need to expand the canvas to give yourself room to work. Choose **Image→Canvas Size** to display the **Canvas Size** dialog box. Or press Ctrl+Alt+C (⌘-Option-C on the Mac). Then make the following changes, as shown in Figure 6-6:

 - We want to add to the existing canvas size, so turn on the **Relative** check box.

 - Change the unit of measure to **Percent**.

 - Set the **Width** value to 100. This adds 100 percent of the existing width to the canvas, making it twice as wide.

 - Click one of the three left-hand boxes inside the **Anchor** area to anchor the butterfly to the left side of the image and add new canvas to the right.

 - Change the **Canvas extension color** to **White**.

 - Click **OK** to make your changes.

3. *Select the butterfly with the rectangular marquee tool.* Click the rectangular marquee tool in the toolbox or press the M key, and then select the butterfly. Don't worry about being precise. Just draw a generous selection around the black outline and include a small white margin all the way around.

4. *Clone the selection and move it to the right.* Press Ctrl+Shift+Alt (or ⌘-Shift-Option) and drag the butterfly selection to the right. Hold those keys down until you release the mouse button. (Ctrl gets you the move tool, Alt clones the selection, and Shift constrains the angle of your drag.) You should now see two copies of the butterfly aligned horizontally.

5. *Choose the Free Transform command.* Choose **Edit→Free Transform** or press Ctrl+T (or ⌘-T) to enter the *free transform mode*, which lets you scale, rotate, skew, flip, or distort the selected pixels.

Figure 6-5.

Figure 6-6.

6. **Right-click and choose Flip Horizontal.** If your old-model Apple mouse doesn't have a right mouse button, press Control and click to bring up the shortcut menu. Then choose **Flip Horizontal**. After Photoshop flips the selection, as shown in Figure 6-7, press Enter or Return to accept the transformation.

You can flip the selection in one step by choosing **Edit→Transform→ Flip Horizontal** back in Step 5. Although this is arguably a quicker technique, I prefer to enter the free transform mode for two reasons: First, I'll do anything to avoid a submenu. Second, as you'll see at length in Lesson 9, "Building Layered Compositions," the free transform mode lets you apply multiple transformations in one operation, so entering the mode is a good habit to get into.

7. **Nudge the selection into position.** As long as you don't go and click somewhere or choose another command, your selection should be *floating* above the surface of the image. One of the great things about a floating selection is that you can move it without harming the underlying original. Press the ← key to nudge the selection 1 pixel or Shift+← to nudge it 10 pixels. Use these two key combinations to nudge the right half of the butterfly over the left half.

Figure 6-7.

If pressing the ← key moves the selection outline without moving the butterfly, your selection is no longer floating. Press Ctrl+← (⌘-←) to move the selection and get it floating again. Or you can backstep by pressing Ctrl+Alt+Z (⌘-Option-Z) a couple of times, which will reinstate the floating selection. Then try pressing the ← key again.

The obvious problem with trying to align the two halves of the butterfly is that you can't see through the white margins of the right half to line it up with the left half (see Figure 6-7). Although you could erase the white margin by Alt-clicking in the margin with the magic wand tool, that would likely mess up the edges of your line art. Better to make the white go away temporarily using the Fade command.

8. *Apply the Darken blend mode.* Choose **Edit→Fade** or press Ctrl+Shift+F (⌘-Shift-F on the Mac). Introduced in Lesson 3 (see Step 14, page 77), the Fade command lets you combine a corrected image with its original. But it also lets you blend a floating selection with its background. Instead of changing the Opacity value, which is the most common thing to do in this dialog box, I want you to change the **Mode** setting to **Darken**. Then click the **OK** button.

The Darken mode drops out the whites and ensures a seamless merging of the black lines in the artwork. You may need to nudge the selection with the ← and → keys to get the butterfly's halves to match up properly, as shown in Figure 6-8. Zoom in to 100 percent for the most accurate view.

Figure 6-8.

So much for the base art; now to color it. As I mentioned at the outset, we'll be coloring the artwork in a couple of stages. The first stage, coloring in the lines, requires you to select the lines and send them to a separate layer. Based on what you learned in Lesson 4, your natural tendency might be to reach for the magic wand tool. But there's a simpler way that produces better results.

9. *Go to the Channels palette.* If necessary, choose **Window→ Channels**. Because I scanned the artwork as a grayscale image, the palette lists one channel, **Gray**.

To see a larger view of this channel, right-click the empty space below it (inside the palette) and choose **Large**, as shown in Figure 6-9.

10. *Load the channel as a selection.* One of the fantastic things about channels is that you can convert

Figure 6-9.

them to selection outlines. Anything that's white becomes selected; anything that's black becomes deselected. To load the selection, press the Ctrl key (⌘ on the Mac) and click anywhere on the **Gray** item in the **Channels** palette.

This is one of those weird times in Photoshop where a shortcut—in this case, Ctrl-clicking (or ⌘-clicking)—is your primary means for performing an operation. This is not to say it's the *only* way; if you prefer, you can click the far left icon at the bottom of the Channels palette, the one that looks like ◌. But there is no equivalent menu command. None. I swear, sometimes it's like the whole program is one big secret passageway.

After you Ctrl- or ⌘-click, you should see marching ants all over the place. Every white pixel inside the image is now selected. There's just one small problem. You want to select the black lines, not the white background. So . . .

11. *Reverse the selection.* Choose **Select→Inverse** or press Ctrl+Shift+I (⌘-Shift-I on the Mac). Photoshop deselects the white pixels and selects the black ones.

12. *Make a new layer.* Click the **Layers** tab or press the shortcut F7 to switch to the **Layers** palette. Then choose **Layer→New→Layer** or press Ctrl+Shift+N (⌘-Shift-N) to add a new layer to your image. Inside the **New Layer** dialog box, name the layer "Line Art" (as in Figure 6-10), and click **OK**. You'll see a new layer called Line Art in the palette.

13. *Fill the selection with black.* The selection transfers to the new layer automatically. Press the D key to reset the default colors, black and white. Then press Alt+Backspace (Option-Delete on the Mac) to fill the selection with black. The black lines are now relegated to their own layer.

Figure 6-10.

If you prefer commands, you can avoid the shortcut by choosing **Edit→Fill**, changing the **Use** option to **Foreground Color** or **Black**, and clicking the **OK** button. Of course, you'd have to be out of your mind to do that, but it *is* an option.

14. *Select the Background layer.* Still inside the Layers palette, click the **Background** item to make it active.

15. *Deselect and fill with white.* Now that we have the butterfly transferred in all its glory to the Line Art layer, you can get rid of the background butterfly. Press Ctrl+D (⌘-D on the Mac) to deselect the artwork. Then press Ctrl+Backspace (⌘-Delete)

to fill the Background layer with white. (Or, if you prefer the long way, choose Edit→Fill, change Use to Background Color or White, and click OK.)

As long as we're in the Layers palette, we might as well make these thumbnails bigger, too. Right-click the empty space below the layer name and choose **Large Thumbnails**, as in Figure 6-11. When you bring up this pop-up menu, you'll notice two options at the bottom. The default, **Clip Thumbnails to Document Bounds**, scales all thumbnails equally to show the entire canvas. **Clip Thumbnails to Layer Bounds** scales each thumbnail independently according to the dimensions of the layer. Use the default setting when you want context; use the second when you want detail.

Lock transparency

Figure 6-11.

16. *Lock the transparency of the Line Art layer.* Click the **Line Art** layer to select it. Then click the first lock icon near the top of the Layers palette. (Labeled in Figure 6-11, the icon looks like a checkerboard, as in ▣.) This prevents you from changing the opacity of individual pixels in the layer. The opaque pixels stay opaque, and the transparent pixels stay transparent. The upshot is that any brushstroke you apply appears strictly inside the lines. In other words, you'll be painting the black lines.

17. *Convert the image to RGB.* Currently, the image is a single-channel grayscale image. That's perfect for scanning black-and-white line art because it keeps the file size to a minimum. However, it also means we can't paint in color—unless you count shades of gray as color. To open up the spectrum, choose **Image→Mode→RGB Color**.

At this point, Photoshop brings up a message that's very easy to ignore. But don't. Photoshop is telling you that it wants to flatten your artwork and toss out all the work you did in Steps 9 through 16. Ostensibly, this clumsy solution is intended to avoid the color shifts that sometimes result when recalculating blend modes. The problem is, those shifts are most likely to occur when converting between RGB and CMYK, and they simply can't happen when converting from grayscale to RGB. So be very sure to click **Don't Flatten**, or press the D key.

18. *Select the paintbrush tool.* Photoshop offers three painting tools: the paintbrush (also called the brush tool), the pencil, and the color replacement tool. The pencil paints jagged lines, making it most useful for changing individual pixels. The color replacement tool used to be okay for correcting red eye, but now it's been superseded by the simpler and more accurate red eye tool. That leaves the paintbrush, one of Photoshop's most

Figure 6-12.

Figure 6-13.

powerful functions. The paintbrush permits you to modify the sharpness of a line and tap into a wealth of controls that the pencil and color replacement tools can't touch. So don't just sit there; click the paintbrush icon in the toolbox (see Figure 6-12) or press the B key to select it.

19. *Select a color and a brush.* Choose **Window→Color** or press the F6 key to display the **Color** palette and dial in your favorite butterfly-painting color. I decided on red, which is **R**: 255, **G**: 0, and **B**: 0. Next, right-click in the image window to bring up a pop-up palette of brush options. Set the options as outlined below (and illustrated in Figure 6-13):

 - Adjust the **Master Diameter** value to change the size of the brush. For our purposes, a large brush works well, somewhere in the neighborhood of 150 to 200 pixels.

 - Use the Hardness value to adjust the softness of the brush. A Hardness of 100 percent results in an antialiased brush (mostly sharp with a tiny bit of softness). Set the **Hardness** to 0 percent to create a fuzzy brush.

 - Alternatively, you can ignore both the Master Diameter and Hardness values, and select a predefined brush from the scrolling list, which includes size values and previews. For more illustrative brushstroke previews—that show what a line might actually look like when set to a given brush—click the ⊙ arrow in the top-right corner of the palette and choose the **Stroke Thumbnail** command, as you see me doing in the figure.

To hide the pop-up palette and accept your changes, press Enter or Return. Or just start painting in the image window. (Press Esc to hide the palette and abandon your changes.)

You can change the brush attributes incrementally from the keyboard using, of all things, the bracket keys. Press ⌷ (the left bracket) to reduce the brush diameter; press ⌷ (the right bracket) to raise it. Press Shift+⌷ to make the brush softer; press Shift+⌷ to make it harder. These shortcuts may seem weird, but they're enormous time-savers when used properly.

20. *Paint inside the butterfly.* Paint as much of the butterfly as you like, wherever you like. As you do, Photoshop confines your brushstrokes to the interior of the line art, as shown in Figure 6-14 on the facing page.

By now, you should have a pretty clear idea of how to assign color to scanned line art. To add more colors, select a different foreground color from the Color palette and keep painting. For a more efficient approach, try the following steps, which document how to add a random collection of colors in a single brushstroke. Or you can skip ahead to the next exercise, "Adding Fills and Textures," which begins on page 191.

21. ***Bring up the Brushes palette.*** If you're hankering for more brush options, visit the **Brushes** palette. Click the 🗏 on the right side of the options bar or press F5. Click an item on the left side of the palette to switch to a different panel of options; then manipulate the settings on the right. The preview at the bottom shows how your changes might affect a sample brushstroke.

22. ***Select Scattering from the left list.*** Then increase the **Scatter** value to 100 percent. This separates the spots of color laid down by the paintbrush to create the effect previewed in the left half of Figure 6-15.

23. ***Select Color Dynamics from the list.*** The Color Dynamics settings cause the color laid down by the paintbrush to randomly fluctuate according to Jitter values. More Jitter means more random behavior. Set the **Hue Jitter** to 100 percent, the **Saturation Jitter** to 25 percent, and the **Brightness Jitter** to 50 percent, as in the right half of Figure 6-15. You may notice

Figure 6-14.

Figure 6-15.

that the preview remains unchanged. Not ideal, but nothing to worry about. The preview doesn't track the color of a brush, just its size and shape.

24. *Paint around the butterfly.* Increase the brush diameter to 400 pixels. (As you press the ⬚ key, you can track the specific diameter value in the options bar.) Then paint the perimeter of the butterfly. The effect will look something like the image in Figure 6-16, with random dollops of color darting in and out of view. This one edit goes a long way toward offsetting the rigid symmetry of the insect. Naturally, I'm all for that. The only reason the butterfly is symmetrical in the first place is because I was too lazy to draw the other half.

25. *Turn off Scattering and Color Dynamics.* Click the check boxes inside the **Brushes** palette. The settings remain in place in case you want to revisit them later, but the functions are turned off.

26. *Switch to black and choose the Overlay mode.* Press D to restore black as the foreground color. Then choose **Overlay** from the **Mode** pop-up menu in the options bar. The Overlay mode will paint with black while maintaining some of the most vivid colors that you added in previous steps.

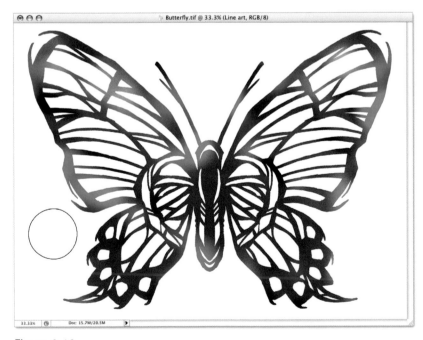

Figure 6-16.

27. *Paint inside the bug's body.* Paint the body and the two antennae—and try to do it in one stroke. Otherwise, you risk making the colors too dark.

28. *Press 5 to reduce the Opacity value to 50 percent.* You can also select the Opacity value and enter 50. But just pressing the 5 key is so much more convenient.

When using one of the paint or edit tools, you can change the Opacity value in 10 percent increments by simply pressing a number key. Press 1 for 10 percent, 2 for 20 percent, and so on. Press 0 for 100 percent. Press two numbers in a row to enter a specific value, such as 6-7 for 67 percent or 0-7 for 7 percent.

29. **Paint the tips of the wings.** Paint along the top and bottom edges to give the wings a bit of a toasting, as shown in Figure 6-17. This time, it's okay to paint in multiple strokes. For added contrast, press the X key to swap the foreground and background colors. Then paint inside the wings to brighten them.

30. **Save your artwork.** This has been a long exercise, so it's probably a good idea to save your work. To avoid replacing the original file, choose **File→Save As**. The native PSD format is generally best when saving layers, so choose **Photoshop** from the **Format** menu. Then click the **Save** button.

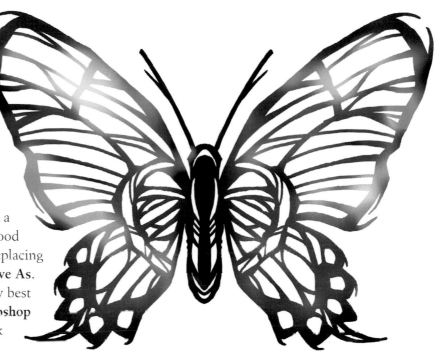

Figure 6-17.

Adding Fills and Textures

We now begin the second part of our look at coloring scanned line art. But this time, instead of coloring the lines themselves, we'll color the spaces between the lines, as well as add depth and shading.

1. **Open the revised butterfly composition.** Open the *Colored lines.psd* file located in the *Lesson 06* folder inside *Lesson Files-PsCS3 1on1*. This image contains the painted butterfly line art that I saved in Step 30 (in the preceding exercise) plus a few additional layers that we'll integrate over the course of the following steps.

2. **Make a new layer.** Click the **Line Art** layer in the **Layers** palette to make it active. Next, press Ctrl+Shift+N (⌘-Shift-N) to add a new layer to your image. Name the layer "Colored Fills" and click **OK**.

3. **Move the new layer backward.** In the Layers palette, drag the **Colored Fills** layer immediately under the Line Art layer, as in Figure 6-18. Or you can press Ctrl+⌊ (or ⌘-⌊ on the Mac). When combined with Ctrl or ⌘, the bracket keys move the active layer behind or in front of other layers in the image.

Figure 6-18.

Figure 6-19.

4. **Select the paint bucket tool in the toolbox.** Click and hold the gradient tool icon to display the flyout menu pictured in Figure 6-19. Then choose the paint bucket. We'll use the paint bucket tool to fill the areas inside the lines with color.

5. **Open the Swatches palette.** Choose **Window→Swatches** to view the **Swatches** palette (see Figure 6-20), which you can use to save frequently used colors.

6. **Choose Load Swatches from the palette menu.** Click the ▾≡ in the top-right corner of the Swatches palette and choose **Load Swatches**, as in Figure 6-20, to load a collection of color presets from disk. Find the file called *The vivid 24.aco* in the *Lesson 06* folder inside *Lesson Files-PsCS3 1on1*. Then select it and click the **Load** button. As shown in Figure 6-21, Photoshop adds 24 colors to the bottom of the Swatches palette, each of which represents a 15-degree interval along the perimeter of the color wheel (see "The Visible-Color Spectrum Wheel" on page 75 of Lesson 3). These vivid hues are the colors we'll use to fill the butterfly.

7. **Set the paint bucket options.** Go to the options bar and assign the following settings:

 - The pop-up menu should be set to **Foreground**, so the paint bucket fills an area with the foreground color.

 - When working with independent layers, the **Mode** and **Opacity** options are best set to **Normal** and 100 percent,

Figure 6-20.

Figure 6-21.

respectively. This ensures that the colors in the Colored Fills layer cover up the colors behind them. If you later decide to apply a blend mode or an opacity setting, you can apply it to the layer (as described in Step 18 on page 197).

- The paint bucket is essentially a magic wand tool that colors pixels instead of selecting them. So not surprisingly, it offers many wand-like options. First and foremost among these is Tolerance, which controls how many colors the paint bucket fills at a time. (To learn more, see "Selecting Regions of Continuous Color," Step 5, page 118.) Raise the **Tolerance** value to 100. This will help fill in tight corners and crevices.

- Leave **Anti-alias** and **Contiguous** turned on. The latter is especially important because Photoshop would otherwise fill in all white spaces at once (which, as we'll see, is not what we want to do).

- If you were to click inside the image at this point, the paint bucket would fill the entire window, from stem to stern. This is because the active Colored Fills layer is empty; it contains no outlines to hold the paint. To make the paint bucket "see" the outlines on the Line Art layer, turn on the **All Layers** check box. Now the paint bucket will fill just one shape at a time.

The screen detail in Figure 6-22 highlights the two options (**Tolerance** and **All Layers**) that I asked you to change from their default settings.

Figure 6-22.

8. *Select a color from the Swatches palette.* I recommend that you start with a light color such as yellow and work your way up. Because light colors produce the subtlest effects, you can use them the most and make some fast progress up front.

To confirm the name of a color in the Swatches palette, hover your cursor over it. The color name helps you distinguish yellow from, say, amber or chartreuse. (Note that Show Tool Tips must be on in the Preferences dialog box for this trick to work.)

9. **Click inside the lines.** Armed with the paint bucket, click a few of the gaps inside the butterfly line art to fill the areas with the foreground color, in this case yellow. As shown in Figure 6-23, I clicked in twenty areas in all, spread more or less evenly throughout the image. In each case, Photoshop applies the yellow pixels to the active layer, Colored Fills, while staying inside the lines defined by the Line Art layer.

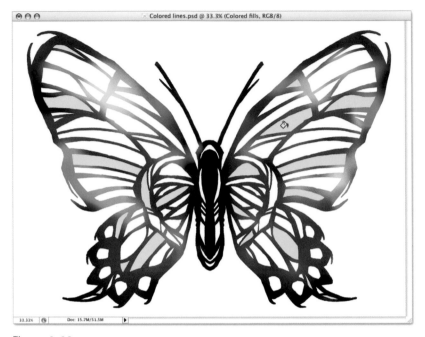

Figure 6-23.

10. **Fill in the other colors.** Exactly which colors you use and where you apply them is up to you. Of the two versions of the artwork in Figure 6-24 on the opposite page, the first shows how I applied the six primary colors (yellow, green, cyan, blue, magenta, and red); the second shows the additional eighteen secondary and tertiary colors, plus black and white.

My approach was mostly random. But I'd like you to notice a few things here and there:

- I tried to spread the colors out as much as possible, so that very few neighboring areas received the same color. There are exceptions, of course, and you can do as you like. It's ultimately an aesthetic choice.

- To better distinguish the wings, I filled all the areas inside the butterfly's body with black. (Remember, to make the foreground color black, just press the D key.) The result doesn't look very good right now, but it will later.

- The five oval areas along the bottom of each wing appear to have no color in them. But they are in fact filled with white. This will help set these areas apart from the background art in future steps. To make the foreground color white, press the D key followed by the X key.

With the preceding Pearl in mind, here are a couple of ways to swap out a fill color:

- If you catch a mistake right away, choose **Edit→Undo** or press Ctrl+Z (⌘-Z on the Mac) to get rid of all vestiges of the fill. Then select a different color and again click with the paint bucket.

- To change a color applied with an earlier click, first select the color with the magic wand. Then choose **Select→ Modify→Expand**, enter 4 pixels, and click **OK**. This selects an area slightly larger than the fill color. Now select a new color for the fill and press Shift+Alt+Backspace (Shift-Option-Delete on the Mac). This special keyboard shortcut recolors just the filled pixels in the selection and leaves the transparent pixels alone.

Figure 6-24.

11. *Magnify the image.* Press Ctrl+⊡ (⌘-⊡) a few times to get a closer look at the image. After some inspection, you may be able to make out fine white cracks between the fills and the line art, especially in very sharp corners, as witnessed in Figure 6-25 on the next page. The high Tolerance value that you specified in Step 7 helps mitigate this, but no Tolerance setting can make it go away entirely.

Figure 6-25.

Figure 6-26.

Fortunately, you can expand the fill using one of Photoshop's more obscure functions, the Minimum filter. Designed to expand dark areas inside an image, it has the added (and arguably more useful) effect of expanding the size of objects on a layer.

12. *Choose the Minimum command.* Choose **Filter→Other→Minimum** to display the **Minimum** dialog box. Then raise the **Radius** value to expand the fill objects in 1-pixel increments, as in Figure 6-26. Be forewarned that this command can also mess up colors in an image, so turn on the **Preview** check box and keep a close eye on the changes you make inside both the dialog box and the image window. In this particular image, a Radius value of 3 pixels works best; anything higher, and the colors start to ooze into each other. When you're satisfied, click **OK** to apply the effect.

13. *Move the Photocomp layer to the back of the stack.* In the **Layers** palette, click the **Photocomp** layer to activate it. Then click the blank square to the left of the layer to reveal an eyeball icon, ◉. Turning on the ◉ displays the layer, which contains a composite of photographs and effects that I created in advance.

 Choose **Layer→Arrange→Send to Back** to move the Photocomp layer to just above the Background layer. Or press the shortcut Ctrl+Shift+[(⌘-Shift-[on the Mac).

14. *Select the Colored Fills layer.* Click the **Colored Fills** layer or press Alt+[(Option-[on the Mac) to make the brightly colored interiors active.

 Now to add some texture to the Colored Fills layer. The combination of colors inside the line art looks a little like stained

glass, so I decided to emphasize the effect by setting a pattern layer into Colored Fills using something called a *clipping mask* We'll give it a quick whirl for now, and then learn more about it in Lesson 9, "Building Layered Compositions."

15. **Add a Pattern layer.** Along the bottom of the Layers palette, to the left of the little folder, is the ⊘ icon. Press the Alt key (Option on the Mac) and click this icon. Then choose **Pattern**, as shown in Figure 6-27.

16. **Name the layer and make it part of a clipping mask.** The Alt (or Option) key forces the display of the **New Layer** dialog box. Name the new layer "Glass." Then turn on the **Use Previous Layer to Create Clipping Mask** check box (as in the top dialog box in Figure 6-28, below) and click **OK**.

17. **Select the Metal Landscape pattern.** Inside the **Pattern Fill** dialog box, click the ▾ arrow to the right of the pattern preview and choose the fourth swatch on the bottom row, which Photoshop calls Metal Landscape (labeled at the bottom of Figure 6-28). Then raise the **Scale** value to 200 percent and click **OK** to create the layer.

18. **Change the blend mode and opacity.** Choose **Hard Light** from the blend mode pop-up menu at the top of the **Layers** palette (see Figure 6-29). Also change the **Opacity** value to 40 percent. The result is a series of fracture lines inside the cut glass of the Colored Fills layer.

Figure 6-27.

Turn on check box to place Glass pattern inside Colored Fills

Figure 6-28.

Figure 6-29.

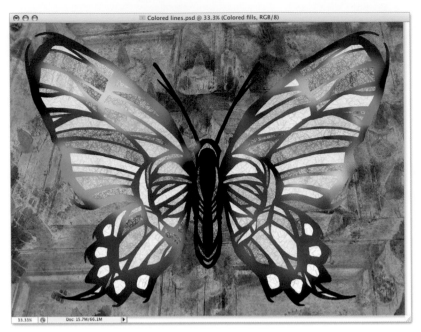

Figure 6-30.

19. **Set the blend mode for the Colored Fills layer to Screen.** Click the **Colored Fills** item in the Layers palette to make it active again. Then choose **Screen** from the blend mode pop-up menu. Photoshop reduces the saturation of the colors in the active layer by bleaching them into those of the Photocomp layer behind them, thus achieving the bright glass effect pictured in Figure 6-30.

PEARL OF WISDOM

Note that the fracture lines extend into the ovals at the bottom of the wings as well as the cuts inside the body, all thanks to the white and black fills combined with the pattern and blend modes. Modify a single fill, pattern, or blend mode and the effect would be compromised.

20. **Click the Spikes layer at the top of the stack.** In the Layers palette, click the word **Spikes** and then click on the blank square to the left of it to reveal the eyeball icon (👁), as in Figure 6-31. This turns on the layer and makes it active. The layer covers the artwork with a modified photo of a fortified wooden door from the PhotoSpin stock image library. I based the Photocomp layer on this same image, so my hope is that the two layers will echo each other.

21. **Create a clipping mask.** Choose **Layer→Create Clipping Mask** or press the keyboard shortcut Ctrl+Alt+G (⌘-Option-G on the Mac) to combine the Spikes layer with the Line Art layer immediately

Figure 6-31.

below it. The result: the contents of the Line Art layer mask the contents of the Spikes layer, once again revealing all the layers below. In other words, the Spikes layer is visible inside the boundaries of the Line Art layer but invisible outside it.

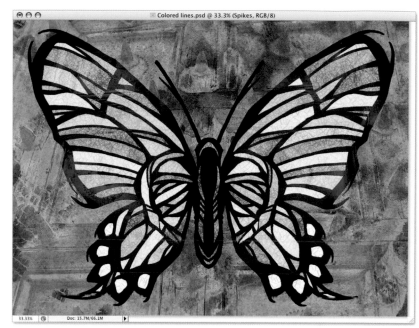

Figure 6-32.

22. *Set the blend mode to Multiply.* With the Spikes layer still active, choose **Multiply** from the blend mode pop-up menu at the top of the Layers palette or press Shift+Alt+M (Shift-Option-M). Photoshop burns the photo of the fortified door into the hand-painted butterfly lines, creating a darkened blend of the two, as seen in Figure 6-32.

23. *Load the outlines of the Colored Fills layer as a selection.* Like channels, layer outlines can be converted to selection outlines. Press F7 to make sure the **Layers** palette is visible. Then press the Ctrl key (⌘ on the Mac) and click the thumbnail for the **Colored Fills** layer in the Layers palette.

24. *Find the intersection of the existing selection and the body.* Select the rectangular marquee tool. Then press Shift+Alt (Shift-Option on the Mac) and drag around the insect's body, as demonstrated in Figure 6-33 on the next page. Be careful to enclose all the bug's body without cutting into the fills of the wings. If necessary, press the spacebar as you drag to properly align the marquee.

25. *Make a new layer.* Press Ctrl+Shift+N (⌘-Shift-N) to add yet another layer to your image. Name the layer "Body Dark" and click the **OK** button.

26. *Fill the selection with black.* Press the D key to restore the default foreground color, black. Then press Alt+Backspace (Option-Delete on the Mac) to fill the selection with black.

27. *Deselect the image.* Now that the selection is filled, the selection outline is redundant. Press Ctrl+D (⌘-D) to get rid of it.

28. *Reduce the Opacity value.* Press the 4 key, or change the **Opacity** value in the Layers palette to 40 percent. The result is a darker butterfly body.

29. *Twirl open the Line Art layer.* Notice the small ▾ to the far right of the **Line Art** layer (next to the *fx*)? Click that small ▾ to twirl the layer open and reveal its layer styles, as in Figure 6-34.

30. *Turn on the layer styles.* Click the dimmed ◉ icon next to either the words **Drop Shadow** or **Bevel and Emboss** to display all layer styles for the Line Art layer. Photoshop casts a shadow in back of the butterfly lines and traces the edges with thin highlights and shadows. For more information about layer styles, read Lesson 11, "Layer Styles and Specialty Layers."

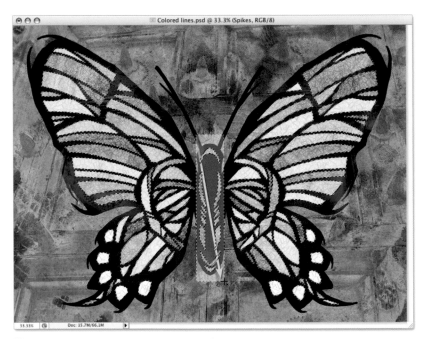

Figure 6-33.

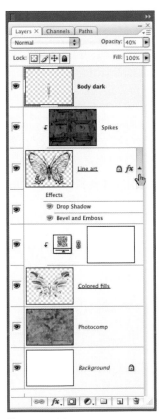

Figure 6-34.

And lo these many steps later, we arrive at the image in Figure 6-35. What was once a mere caterpillar of a sketch has emerged full grown into the world as a finished piece of artwork, complete with color, texture, and depth, thanks to the finishing capabilities of Photoshop.

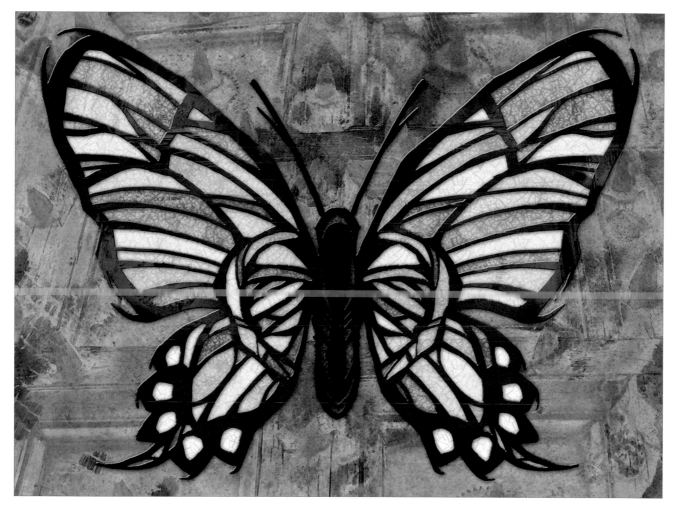

Figure 6-35.

Dodge, Burn, Sponge, and Smudge

We now move from painting to editing. And by *editing*, I mean using Photoshop's tools to modify the colors, luminosity values, and color transitions in a photographic image. We start with Photoshop's core editing tools, which are as follows:

- The dodge tool lightens pixels as you paint over them.

- The burn tool darkens pixels as you paint over them. If you're having problems keeping the dodge and burn tools straight, just think of toast—the more you burn it, the darker it gets.

Figure 6-36.

Figure 6-37.

- The sponge tool adjusts the saturation of colors, making them either duller or more vivid.

- The smudge tool smears colors. Used in moderation, it can be useful for smoothing out harsh transitions.

- Lifted from Photoshop's kid sibling Photoshop Elements, the red eye tool does one thing well: remove red eye.

There are other edit tools, but these are the ones you're most likely to use. (One in particular, the sharpen tool, is so poorly implemented as to be virtually useless—and I say "virtually" only as a courtesy to those who have the courage to try and prove me wrong.) The following exercise explains how to use the five edit tools and the paintbrush to solve some common retouching problems. At the end, we'll take a look at how a filter designed for smoothing out "noise" (random color variations) and JPEG artifacts can come in handy in an unlikely situation.

1. ***Open the photo of some poor sap who requires an emergency makeover.*** Open the image titled *Yours truly.jpg* in the *Lesson 06* folder inside *Lesson Files-PsCS3 1on1*. The file features an all too accurate head shot of me, your gruesome-looking author, pictured in horrifying detail in Figure 6-36. In his *Maxims for the Use of the Over-educated*, Oscar Wilde wrote, "A subject that is beautiful in itself gives no suggestion to the artist. It lacks imperfection." In that regard at least, my face is extremely suggestive. In that same volume, Wilde wrote, "Those whom the gods love grow young." Well, the gods may not love me in real life, but they're going to fawn all over me in Photoshop. *The Picture of Dorian Gray* has nothing on this program.

I continue to use this photo because, as unsettling as I find it, teachers around the world assure me that it serves as a source of abuse and high comedy for their students. If you don't like it—and really, who can blame you?—use a picture of yourself, a loved one, or a dire enemy. The specific concerns may be different, but the general approach will be the same. One potential difference: Because my flesh tones trend toward glow-in-the-dark freaky white boy, my face needs a tiny bit of dodging and a whole lot of burning. If the face you're working on is rich in melanin, it may require the opposite.

2. ***Click the dodge tool in the toolbox.*** A couple of icons up from the T (see Figure 6-37), the dodge tool is the first of Photoshop's *toning tools*. To get the dodge tool from the keyboard, press the O key.

3. ***Reduce the Exposure value to 30 percent.*** Located in the options bar, the **Exposure** value controls the intensity of edits applied by the dodge tool. In my experience, the default value of 50 percent is too extreme for most editing work. Press the 3 key to take it to 30 percent.

4. ***Drag over the image details you want to lighten.*** In my case, I started with my nose—my big, old, splotchy, freckly nose. I reduced the brush diameter a few notches (to, say, 40 pixels) and dragged inside the eyes, teeth, and eyelids. I also dragged over the smile lines trailing away from my nose. Figure 6-38 shows in color the areas that received my attentions. Unaffected areas are overlaid in blue-gray. (Hey, I know it looks horrible. It's my face, I can do what I want with it.) Feel free to follow my lead or go your own way.

Figure 6-38.

PEARL OF WISDOM

The biggest mistake people make when working with the edit tools is to push things too far. For example, it's tempting to scrub my coffee-stained teeth (positive note: no food stuck in them) until they're pearly white. But if you do that, my newly brilliant smile will look unnatural. Better to make small adjustments—one or two passes at most—so that you leave the shadows intact. We'll get rid of the yellow in Step 14.

5. ***Bring up the History palette.*** If the palette isn't already on screen, choose **Window→History**. The History palette tracks the most recent changes you made to an image, thus permitting you to step back to one of several previous *states* (the condition of the image at different stages in the recent past). In other words, the History palette lets you undo multiple operations. As if that's not enough, you can paint back portions of a previous state using the history brush.

PEARL OF WISDOM

It's this last option that makes the History palette so useful when retouching an image. After painting in an edit effect, you can turn around and erase portions of it with the history brush—provided, that is, that you manage your history states properly. By default, Photoshop tracks the last twenty operations. But as Figure 6-39 shows, it's easy to click and drag more than twenty times with the dodge tool without being aware of it. And once a state gets bumped off the History list, there's no restoring it. Of course, you could raise the number of history states, but doing so can dramatically slow down Photoshop when applying large-scale adjustments. A much better practice is to get in the habit of saving significant points in the adjustment of an image—such as when you finish using a certain tool—as *snapshots*.

Figure 6-39.

Figure 6-40.

6. *Create a snapshot of the current state.* Press the Alt (or Option) key and click the camera icon (📷) at the bottom of the **History** palette, labeled in Figure 6-39 on the previous page. Name the new snapshot "Dodged Image," and click the **OK** button. The snapshot appears at the top of the History palette and will steadfastly refuse to roll off, even after twenty more operations.

7. *Select the burn tool in the toolbox.* Click and hold the dodge tool icon to display a flyout menu, and then choose the little hand icon that represents the burn tool, as in Figure 6-40. Or if you prefer, press Alt (or Option) and click the dodge icon to advance to the next tool. Or just press the O key (or Shift+O if you skipped the Preface).

8. *Reduce the Exposure value to 20 percent.* Again, the default **Exposure** value is 50 percent, far too radical for burning. Press the 2 key to permit yourself more subtlety and flexibility.

9. *Drag over the image details you want to darken.* The burn tool adds shadows, and shadows give an image volume, depth, and form. I started by increasing the brush diameter several notches (200 to 300 pixels) and dragging up and down both sides of my face, including over the ears. Then I reduced the brush to around 80 pixels and painted under my eyebrows, nose, cheekbones, and chin; along the sides of my nose; and over my thinning hair, as indicated by the full-color areas in Figure 6-41. Basically, use the burn tool anywhere you would apply makeup.

Don't worry about dragging over the same spots with the burn tool as you did with the dodge tool. If they require burning, edit away. About the worst that can happen is you can undersaturate color values, but that's something you can remedy later with the sponge tool.

Note to the pale: The burn tool can serve as a nifty tanning aid but, as always, don't overdo it. A few brushstrokes are all that stands between plausibly augmented skin tones and surreal, overcooked, slightly cancerous territory, as in Figure 6-42 on the facing page.

Figure 6-41.

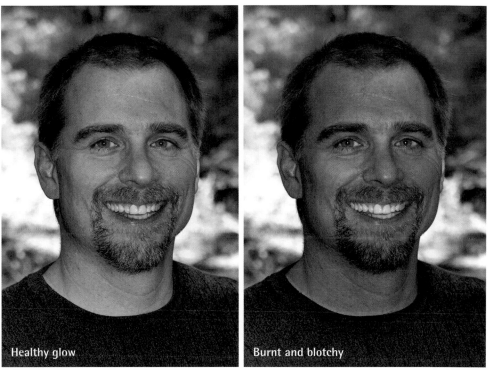

Healthy glow Burnt and blotchy

Figure 6-42.

10. **Brush away any mistakes** After you've toasted any and all desired details of my glow-in-the-dark flesh with the burn tool, you may want to temper the effects of the tool a bit with the history brush. Here's how: Click in front of the **Dodged Image** state in the History palette to set it as the source of the history brush edits. Then click the history brush in the toolbox (see Figure 6-43) and paint to restore details to their pre-burned appearance.

For example, while I was careful to avoid painting with the burn tool inside my eyes or teeth (see Figure 6-41), the blurry edges of the brush couldn't help but affect them. By painting with the history brush and a small brush diameter, I managed to restore the post-Step-4 brightness of eyes, teeth, and anything else that appeared too dark.

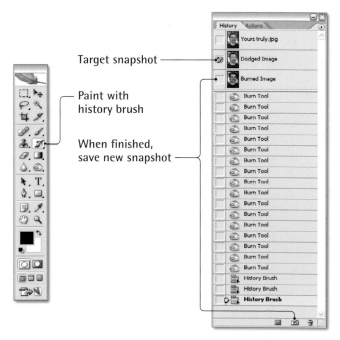

Target snapshot

Paint with
history brush

When finished,
save new snapshot

Figure 6-43.

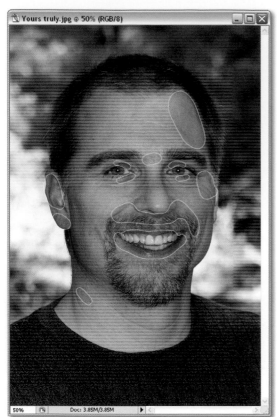

Figure 6-44.

Figure 6-45.

11. ***Create another snapshot.*** Having arrived successfully at another juncture in the editing process, press Alt (or Option) and click the 📷 icon at the bottom of the History palette. Name this snapshot "Burned Image," and click **OK**.

12. ***Select the sponge tool in the toolbox.*** Now to modify the saturation levels. Press Alt (or Option) and click the burn tool icon to advance to the next toning tool, the sponge. Or, if you loaded my dekeKeys shortcuts back in the Preface, you can press the N key, which I liberated from the notes tool. (Preface skippers, press Shift+O.)

13. ***Reduce the Flow value to 30 percent.*** Although it's calculated differently, the **Flow** value in the options bar serves the same purpose as the dodge and burn tools' Exposure value—it modifies the intensity of your brushstrokes. In my experience, the default value of 50 percent is too much. Press the 3 key to knock it down to 30 percent.

14. ***Drag in the image to leech away aberrant colors.*** Make sure the **Mode** option in the options bar is set to **Desaturate**. Then drag inside the teeth. A couple of passes gets rid of most of the yellow and leaves the teeth a more neutral white. (Be sure to leave behind some yellow. Gray teeth won't look right.) I also dragged over some of the more lurid pinks in the eyelids, ears, and lips, as well as some unusually orange patches in the forehead (see the colored areas in Figure 6-44).

15. ***Switch the Mode option to Saturate.*** You can also increase the saturation of colors using the sponge tool. After choosing **Saturate** from the **Mode** pop-up menu in the options bar, click a few times inside each of the irises. This brings out both the green and the red eye. We'll remedy the latter in a moment.

16. ***Create another snapshot.*** Not essential, but always a good idea. Alt-click (or Option-click) the 📷 icon at the bottom of the History palette, name this snapshot "Sponged Colors," and click **OK**.

17. ***Select the smudge tool in the toolbox.*** Click and hold the blur tool icon—the one that looks like a drop of water—to display a flyout menu of *focus tools*. Then choose the smudge tool (see Figure 6-45). If you loaded dekeKeys, press the R key a couple of times—once to select blur and again to advance to smudge. (If you skipped the Preface, press R and then Shift+R twice to get the smudge tool.)

18. *Reduce the Strength value and change the Mode setting.*
The smudge tool's default settings are designed to create painterly effects. If you want to use it to edit an image, you need to rein the tool in a bit. Press the 2 key to reduce the **Strength** value in the options bar to 20 percent. Then choose **Lighten** from the **Mode** pop-up menu (see Figure 6-46) and press the Escape key to accept. Now the tool will smear light colors into dark ones and not the other way around.

Figure 6-46.

19. *Drag in the image to smear colors.* Press the ⊡ key a couple of times to increase the brush diameter to 30 pixels. Then drag across my bottom lip to smooth over the grooves and make the skin look more hydrated. Be sure to trace along the lip, as demonstrated by the area highlighted in color in Figure 6-47. (Dragging across will recruit colors from the teeth and whiskers.) In all, you may have to drag across the lip three or four times to give it that "Just ChapStick'ed" look. I also painted across some of the more pitted portions of my skin (illustrated in Figure 6-47).

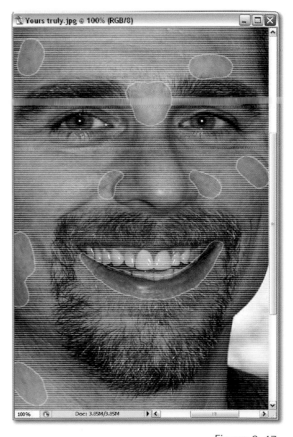

To limit the area affected by the smudge tool, draw a selection outline. For example, if you lasso the lower lip, you can drag anywhere you please inside the image but affect only the lower lip. This technique works for all the paint and edit tools, including the paintbrush. But it's especially useful when using the smudge tool, which is unique in that it can smear colors from deselected pixels even as it modifies selected ones.

20. *Create yet another snapshot.* I called mine "Smudged Colors." Heads up: This is the last time I'll remind you to create a snapshot in this exercise. But it is a really great habit. It's like saving a document—you do it in part to protect yourself in case something goes wrong.

PEARL OF ⬤ WISDOM

Speaking of saving, it's worth bearing in mind that Photoshop does *not* save anything tracked by the History palette. This goes for snapshots as well as individual states. If you want to save a particular snapshot, drag it onto the left icon at the bottom of the History palette, which copies the snapshot as an independent image. Then use File→Save to save the image to disk.

Figure 6-47.

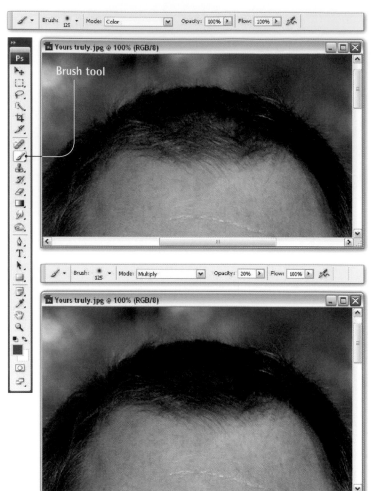

Brush tool

Figure 6-48.

Figure 6-49.

We've now seen all the tools mentioned in the name of this exercise, "Dodge, Burn, Sponge, and Smudge," and all but one of the tools I promised in the introduction. The lone remaining tool is the red eye tool. If you've had enough of editing, skip to the final exercise, "Healing and Patching," which begins on page 212. To learn how to fix a few more details in my uniquely imperfect face—and take advantage of the Reduce Noise filter—complete the remaining steps.

21. ***Click the paintbrush in the toolbox.*** Or press the B key. We'll use this tool to fill in my sparse hair.

22. ***Eyedrop a representative hair color.*** With the paintbrush active, press Alt (or Option) to temporarily access the eyedropper, and then click a color in one of the rare full portions of my hair. To see what color you lifted, bring up the **Color** palette. Mine was in the neighborhood of **R:** 100, **G:** 90, **B:** 80. But there is so much variation to the hair, and depending on how much you burned the hair back in Step 9, you may end up with something entirely different. Feel free to use the eyedropped color or enter the values suggested above—either should work fine.

23. ***Paint the scalp using the Color mode.*** Change the **Mode** setting in the options bar to **Color.** Or press Shift+Alt+C (Shift-Option-C). Raise the brush diameter to 125 pixels. Then paint the top of my scalp to get the effect shown at the top in Figure 6-48.

24. ***Paint some more using the Multiply mode.*** Choose **Multiply** from the **Mode** menu, or press Shift+Alt+M (Shift-Option-M). Press 2 to lower the **Opacity** value to 20 percent. Then paint short strokes in the light areas of the scalp to darken them, as in the bottom image in Figure 6-48.

25. ***Select the red eye tool in the toolbox.*** Your final task is to remove the red eye caused by the camera's flash. Click and hold the band-aid below the crop tool icon in the toolbox, and choose the red eye tool from the flyout menu (see Figure 6-49).

26. *Retouch each of the pupils.* Zoom in on one of the pupils and click it. Just like that, the red eye goes away. So eager is the tool to obliterate red eye that even if you click *near* an afflicted pupil, the tool more often than not finds the pupil and turns it black. If the tool has difficulty finding a pupil (as seldom but sometimes happens), you can help it by drawing a rectangular marquee around the redness. For the sake of comparison, before and after views appear in Figure 6-50. And to think, Adobe once considered withholding this tool from Photoshop, fearing that it might be regarded as too basic for professionals — as if professionals somehow *enjoy* performing complex, protracted, 30-step procedures. (Uh, speaking of which: only four more steps to go.)

27. *Choose the Reduce Noise filter.* Whether to include the next function in Photoshop was never in question—it's just too good. The ultimate purpose of the Reduce Noise command is to get rid of the random color variations that occur as a result of film grain, digital fuzz, and JPEG compression. Although Reduce Noise is hardly the only filter that can buff away color inconsistencies, it is unique in its attention to preserving edge detail. This means you can smooth out a guy's face, for example, without it looking like he has a nylon stocking pulled over his head.

Better still, Reduce Noise isn't limited to noise. The specks and patterns in my spotty flesh aren't photographic artifacts; they're actual, horrible parts of me. Thankfully, the nonpartisan Reduce Noise is able to smooth them out as well. Choose **Filter→ Noise→Reduce Noise** to bring up the large dialog box pictured in Figure 6-51.

28. *Adjust the Reduce Noise settings.* As witnessed by the preview inside the dialog box—as well as in the full image window if you turn on the **Preview** check box—the filter initially has little effect on my face. By default, the filter is too interested in smoothing over slight variations in noise and preserving edge details (the lines around my eyes, hair, mouth, and other features). My flesh tones demand more aggressive settings.

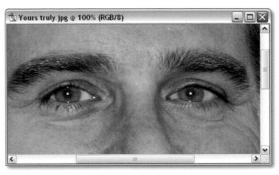

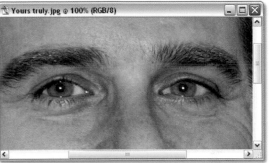

Figure 6-50.

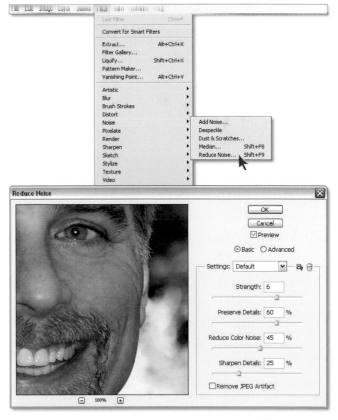

Figure 6-51.

The following is a rundown of the four numerical options in the Reduce Noise filter, and advice for their settings:

- The **Strength** setting smooths away "brightness noise" by averaging random variations in lightness and darkness between neighboring pixels. Brightness noise is my main problem, so raise this value to its maximum, 10.

- Use the Preserve Detail option to bring back lines of delineation that the Strength option may round off or smooth over. While this may sound like a great thing, this option also has the tendency to rein in the Reduce Noise filter to the extent that it makes barely any difference whatsoever. I recommend that you take the value down to 0. Then raise it incrementally, by pressing ↑ or Shift+↑, until you achieve the desired effect. I finally settled on a **Preserve Details** amount of 20 percent.

- The next option averages the colors in an image independently of the brightness levels. A very high value melts away the freckles and spots, but also bleeds the flesh tones into the whites of my eyes. I suggest you set the **Reduce Color Noise** value to 30 percent.

- Normally, I like to sharpen an image a bit after smoothing it. But where this particular photo is concerned, sharpening is the enemy. I don't need to see anything about my face in sharper focus and, frankly, neither do you. So have a heart and reduce the **Sharpen Details** value to 0.

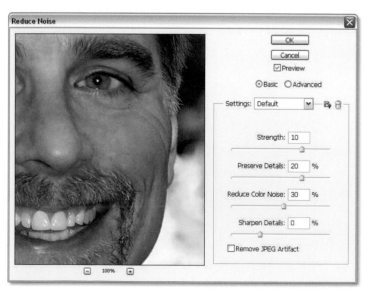

Figure 6-52.

Finally, make sure that the **Remove JPEG Artifact** check box is turned off. Although great for improving the appearance of low-quality JPEG images, it has the effect of softening hairs and other fine details when applied to high-quality images like this one.

29. *Click the OK button.* Confirm that your settings look like those pictured in Figure 6-52, and then click the **OK** button.

30. *Continue to adjust details as needed.* Don't expect to be able to retouch an image in one pass. After all, a change made with the Reduce Noise filter might beg you to make

another with the burn tool, which in turn requires you to take up the history brush tool, and so on. In short, expect to revisit all the tools as you create that near-perfect image. As you work back and forth inside your image, bear in mind these techniques and words of advice:

Very scary original

- You may notice that the dodge and burn tools affect isolated brightness ranges. By default, the Range setting in the options bar is Midtones, which permits you to modify the midtones while protecting the highlights and shadows. If you prefer to adjust the lightest or darkest colors, choose Highlights or Shadows instead. In Figure 6-53, I set the burn tool to Highlights to darken the perimeter of the background.

- The dodge and burn tools are interchangeable. Just press the Alt key (Option on the Mac) to darken with the dodge tool or lighten with the burn tool. This is a great way to take the settings assigned to one tool—such as a brush diameter and Range setting—and apply them to the opposite function.

- The dodge, burn, sponge, and smudge tools work best when used with a soft brush (typically, a Hardness value of 50 percent or lower).

- Feel free to cheat. Just because you have all these edit tools doesn't mean you have to use them. For example, my lower lip was resolutely determined to remain a bright crimson despite my best efforts. So I selected it with the lasso tool and used the Hue/Saturation command to nudge it more toward red and bring down the saturation. It doesn't matter how you get there as long as it works.

Figure 6-53 compares the original photograph to the edited version. Now you know why I never let an image out of my studio without a proper retouching.

After a big dose of edit tools

Figure 6-53.

Figure 6-54.

Figure 6-55.

Healing and Patching

The edit tools are well suited to a wide variety of retouching scenarios. But they can't create detail where none exists. To fix dust and scratches or cover up blemishes and wrinkles, you need tools that can paint imagery on top of imagery. Tools like the healing brush and patch tool:

- The healing brush paints one section of an image, called the *source*, onto another. One variety of the healing brush lets you specify a source; the other finds a source automatically. As the tool clones the source detail, it mixes it with the color and lighting that surrounds the brushstroke, thereby mending the offending detail seamlessly.

- The patch tool clones like the healing brushes. But instead of painting with the tool, you select areas of an image as you would with the lasso.

The following exercise shows you how to use these powerful tools to fix a variety of photographic woes, ranging from rips and tears to blemishes and age spots.

1. ***Open a damaged photograph.*** Open the file called *Bluebeard.jpg* located in the *Lesson 06* folder inside *Lesson Files-PsCS3 1on1*. Available in perfect condition from PhotoSpin's Ed Simpson International People collection, this particular version of the photo appears so tragically scratched because I scratched it. I printed the image to a continuous-tone Olympus P-400 image printer. Then I folded the output once vertically and again horizontally, scored the crease with a pair of scissors, pressed it flat, and scanned it into Photoshop. The result appears in Figure 6-54. The image is representative of the worst sorts of photographic wounds, directed both at the subject of the photo and the medium.

2. ***Select the spot healing brush in the toolbox.*** The spot healing brush is the default occupant of the healing tool slot. But if you're performing this step on the heels of the last exercise, you'll need to choose it from the flyout menu (see Figure 6-55) or Alt-click (Option-click) the red eye tool icon in the toolbox. True to its mission, the spot healing brush looks like a band-aid next to a little circular marquee that represents the "spot."

3. ***Heal the giant mole.*** Increase the brush diameter a couple of notches (say, to 30 pixels). Then zoom in on the giant mole on the fellow's right cheek and drag over it. As you drag, Photoshop dims the affected pixels, as illustrated by the first image in Figure 6-56. After you release the mouse button, the program blends the source—which it derives automatically from some other portion of the image—with the area around the brushstroke. The result is a *patch*.

The success of the patch hinges on the accuracy of the source. The tool may select a good source or a bad one. And which it'll do when is anyone's guess. Your patch may look seamless, or it may contain, say, another section of the white scratch. I'd call mine about half successful—not as bad as it could be, but hardly credible either.

4. ***Undo the giant mole healing.*** Undo the effects of the spot healing brush and write it off as a failed experiment, especially when compared with the infinitely more predictable healing brush discussed in the next step.

Figure 6-56.

5. ***Select the healing brush in the toolbox.*** Click the spot healing icon to bring up a flyout menu and choose the healing brush, as in Figure 6-57. Or press the J key (Shift+J if you skipped the Preface).

6. ***Confirm the default settings.*** In the options bar, make sure **Source** is set to **Sampled** and the **Aligned** check box is off. Sampled tells Photoshop to clone pixels from a spot inside an image (as you'll specify in the next step); turning Aligned off lets you clone several times in a row from that one pristine spot.

Figure 6-57.

You can restore the tool's default settings automatically. In the options bar, right-click the ▾ arrow next to the tool icon (highlighted red in Figure 6-58) and choose the **Reset Tool** command from the pop-up menu.

Figure 6-58.

7. ***Set the source point for the healing.*** The healing brush requires you to create a specific source point so that you can clone from one portion of an image to another. To set the source point, press the Alt (or Option) key and click at the spot below the left cheek (his right), as indicated by the crosshairs in Figure 6-59.

8. ***Heal the left part of the scratch.*** Press the ⬚ key to increase the brush diameter to 20 pixels. (Leave the brush hard to avoid edge errors. More on this in a moment.) Then do the following:

 • Assuming that you undid the effects of the spot healing brush in Step 3, again drag over the giant mole, as indicated by the yellow brushstroke in the top image in Figure 6-60.

 • Drag over the top-right fragment of the left scratch, indicated by the yellow brushstroke in the figure.

 • Next, press ⬚ to reduce the brush diameter to 10 pixels, and drag along the bottom fragment, indicated in cyan.

 • In a separate brushstroke, drag along the remaining portion of the left scratch, indicated in purple.

 • Finally, drag around the area indicated in green.

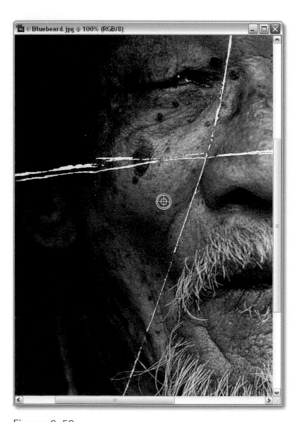

Figure 6-59.

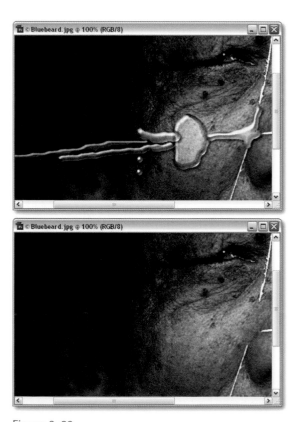

Figure 6-60.

In each case, I started my brushstroke on the right and dragged to the left. If you're right handed, this may seem backward. But follow my lead; if you drag from left to right, you'll clone the vertical scratch and mar your image.

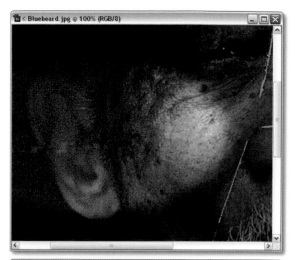

Figure 6-61.

Despite the increased control afforded by the healing brush, it's still at heart a highly automated tool. And the results of such tools sometimes fall short of perfection. For my part, I can clearly see rows of inconsistent pixels running through the old man's cheek and ear (see the spotlighted area in the top portion of Figure 6-61). Known as *scarring,* these bad seams tell the world that your image has been modified. Fortunately, you can re-heal an area by painting over it (or spot-clicking on it) as many times as you like.

9. ***Move the source and paint short strokes.*** Using the healing brush effectively is all about selecting a good source point. The previous source worked well across the forward portion of the cheek, but then we ran into a bad spot. So let's find a new one. Sources generally work best when set in an area that closely resembles the area you want to heal.

 • To heal inside the ear, Alt-click (or Option-click) in the top portion of the ear and drag over the scarred area.

 • To heal in the face, set the source point in the lower area of the cheek, where the flesh is relatively smooth.

 • To heal the black background, Alt-click somewhere in the black background. If you get some haloing along the edge of the ear—a function of Photoshop recruiting ear colors into its healing algorithm—Alt-click along the edge of the ear and paint again.

Keep your brushstrokes short. After some trial and error, I finally arrive at the revised cheek and ear shown in the bottom image in Figure 6-61. I can still make out some scarring, and the inner edge of the ear doesn't quite line up, but the bad stuff is sufficiently shadowed that few folks (if any) are likely to notice.

10. ***Set a new source.*** Now to fix the nearly vertical scratch in the bottom half of the image. Scroll down. Then press the Alt (or Option) key and click just to the left of the scratch along the red hat strap, as shown on the left in Figure 6-62.

11. ***Click and Shift-click to draw straight lines.*** Set the brush diameter to 20 pixels. Click at the point where the scratch intersects the red strap, indicated by the yellow target on the right side of Figure 6-62. Then press the Shift key and click midway up the scratch, at the cyan target in the figure. Photoshop connects the two points with a straight line of healing, which I've colorized in orange. Finish off the scratch by Shift-clicking just to the left of the nose, indicated by the purple target.

12. ***Heal the bottom of the scratch.*** That still leaves an inch or so of scratch at the bottom of the image. Once again, click where the strap intersects the scratch (the yellow target in Figure 6-62) to reset the relationship between the source and destination points. Then press Shift and click down and to the left to heal away the scratch.

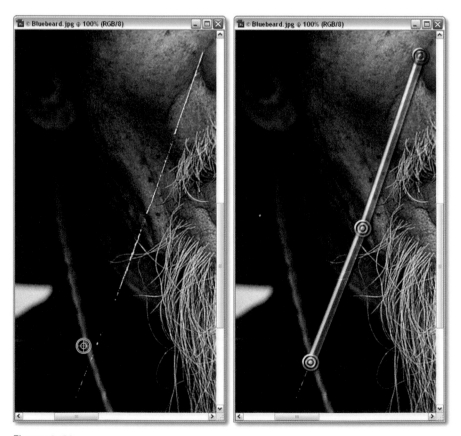

Figure 6-62.

13. *Fix the scars and repeated details.* If you look hard enough, you can make out repeated details around the nose and mouth. But the bigger problems occur near the collar and among the whiskers, as highlighted on the left side of Figure 6-63. To fix these, you'll need to source very similar areas—meaning collar-to-neck transitions and whiskers at similar angles—and paint them in using tiny brushes, as small as 6 or 7 pixels in diameter. To build up the two horizontal whiskers, I sourced what little remained intact of one, clicked to double its width, sourced that, clicked again, and so on. It takes a little patience, but in the end, you can build something out of nothing (shown on the right in the figure).

When using the healing brush, the options bar offers a handful of Mode options, including the Repeat function, which clones details without healing them. But the options bar lacks an Opacity setting. Fortunately, you can vary the opacity of a brushstroke after the fact. Immediately after painting a line with the healing brush, choose **Edit** › **Fade Healing Brush**. Then adjust the **Opacity** value to your liking and click **OK**.

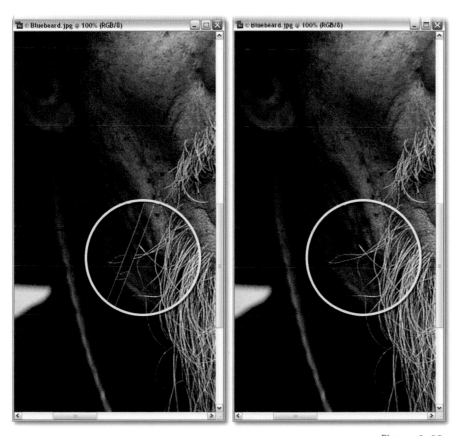

Figure 6-63.

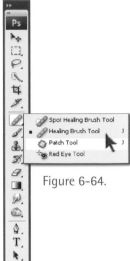

Figure 6-64.

14. ***Select the patch tool in the toolbox.*** We now turn our attention to the final healing function, the patch tool. Choose the patch tool from the healing brush flyout menu (see Figure 6-64). Or press the J key (Shift+J if you skipped the Preface).

15. ***Confirm the default settings.*** In the options bar, make sure **Patch** is set to **Source** and **Transparent** is turned off.

16. ***Drag around the portion of the image you want to heal.*** Initially, the patch tool works exactly like the lasso. To select an area inside the image, just drag around it. Be sure to select slightly outside the area you want to heal. You need a bit of margin for the tool to operate properly.

Need a polygonal patch tool? No problem. Press Ctrl+D (⌘-D on the Mac) to make sure nothing is selected. Then press and hold the Alt (or Option) key and click to set points in a straight-sided selection outline. I used this technique to select the scratch line at the top of the image, as shown on the left side of Figure 6-65. Notice that I kept my outline loose, selecting a few pixels of margin around the scratch.

Figure 6-65.

17. ***Turn off document snapping.*** Choose **View→Snap To→Document Bounds**. When active, this command forces a selection to snap into alignment with the boundaries of the image. Normally, that's great. But for the present, you want to move the selection without constraint, so it's best to turn the command off.

18. ***Source a good region of the image.*** Drag the selection outline to an area of the photograph that's not scratched. In Figure 6-65, I dragged about 30 pixels to the right and 10 pixels down. Helpfully, Photoshop shows you a live preview of the cloning operation on-the-fly. Release the mouse button to source the new area and heal the original selection.

One of the downsides of using the patch tool is that the selection outlines cover the mended edges and thus interfere with your ability to judge the quality of your edit. Fortunately, you can hide the selection outline by choosing **View→Extras** (which unchecks the command) or by pressing the keyboard shortcut Ctrl+H (⌘-H on the Mac).

19. *Select the magic wand in the toolbox.* The patch tool functions like a selection tool, but that's just a convenience. Its healing powers translate to any kind of selection. To heal the final scratch, press W to select the magic wand.

20. *Turn off Contiguous.* In the options bar, make sure the **Tolerance** value is set to 32 and **Anti-alias** is turned on, as by default. To select the entire scratch all at once, turn off the **Contiguous** check box.

21. *Click anywhere along the remaining scratch.* You can click just about anywhere. But you might as well make it easy on yourself and click at the thickest point in the scratch, on the tip of the man's nose. Photoshop selects the entire scratch along with lots of light pixels throughout the image.

22. *Deselect everything except the scratch.* Click the rectangular marquee tool in the toolbox to select it. Then press the Shift and Alt keys (Shift and Option on the Mac) and drag around the scratch as shown in Figure 6-66. If necessary, press the spacebar to move the marquee so you encompass the entire scratch, all the way to the right edge of the image.

As you may recall from the "Selecting an Irregular Image" exercise of Lesson 4 (see Step 9, page 136), pressing the Shift key while using a selection tool adds to a selection, and pressing Alt subtracts. Well, there's a third option: Press Shift and Alt (or Shift and Option) together to find the intersection of one selection outline and another. In the current case, this technique finds the intersection of the marquee and the wand selections, thus deselecting everything outside the marquee.

Figure 6-66.

23. *Choose the Expand command.* Choose **Select→ Modify→Expand** to bring up the **Expand** dialog box. Then enter 3 and click **OK**. This expands the selection to include just enough margin to make the healing function work properly.

24. *Select the patch tool.* Now that the selection is ready to go, press the J key to return to the active healing tool, which is the patch tool.

25. *Drag the selection to source another portion of the image.* Drag the selection outline to an area free of scratches. I dragged my outline about 40 pixels down and 5 pixels to the left, as shown in Figure 6-67. Make sure the edge of the face previewed inside the selection matches the edge outside the selection. Then release the mouse button to complete the operation.

Figure 6-67.

26. *Clean up any remaining problems.* The patch tool did a good job of healing the top and right scratches. But there are still a few rough edges. To clean them up, switch back to the healing brush. Press Ctrl+D (or ⌘-D) to deselect the image. Alt-click (Option-click) to set a new source and get to work.

The healing brush is an excellent tool for cleaning up blemishes. If you're looking for additional practice, this image gives you lots to work with. For my part, I went ahead and painted over most of the moles and age spots. But I left the wrinkles. Wrinkles give a face character, and this particular gentleman wears them well. (Oh sure, I know, talk to me in ten years and see if I'm still a member of the pro-wrinkle camp. But for now, as boss of this project, I say the wrinkles stay in.)

EXTRA ★ CREDIT

The final problem is that left eye (his right). The top eyelid droops so much it covers virtually the entire iris, not to mention the pupil. I have this overwhelming urge to mend the eye, but it's easier said than done. After all, there's nothing to clone from. Or is there? The next steps explore this special retouching scenario, in which we'll heal the eye from an independent layer.

27. *Open the Clone Source palette.* Choose **Window→Clone Source**. New to Photoshop CS3, the Clone Source palette allows you to scale, rotate, and even flip the source image as you clone it to a new destination. This means you can clone the good eye onto the bad, even though one is reflected and at a slightly different angle when compared with the other.

PEARL OF ⬤ WISDOM

The Clone Source palette was designed to permit video editors to clone between movie frames in the more expensive Photoshop CS3 Extended. But a few of us lobbied for it to be included in the standard version of the software. Adobe's engineers even agreed to give us the ability to flip the source, specifically to fix problems like this man's faltering eye. The flexibility and responsiveness of the Photoshop team never fail to amaze me.

28. ***Set the source point in the good eye.*** Press the Alt (or Option) key and click in the highlight (the tiny bright spot) of the right-hand eye to set the source for your healing, as in Figure 6-68. The **X** and **Y** values in the **Clone Source** palette should read 750 and 530 pixels (or thereabouts), respectively. If not, feel free to enter the values manually.

Normally, the W and H values in the Clone Source palette scale the source image. But making either value negative flips the source. A negative W value flips the source horizontally (as in the next step); a negative H value flips it vertically.

29. ***Reflect and rotate the source.*** Change the **W** value to −100 percent to flip the source horizontally. Then set the △ value to −6.0 degrees to rotate it slightly counterclockwise.

30. ***Turn on the source preview.*** If you need help aligning the source and destination points, try this: Turn on the **Show Overlay** check box in the palette. Then set the Opacity option to 50 percent and move the cursor into the image window, where you'll see the flipped and tilted source superimposed over the destination, as in Figure 6-69.

To temporarily preview the source over the destination—without having to turn on the Show Overlay check box—press and hold the Shift and Alt keys (Shift and Option on the Mac).

31. ***Click the bad eye.*** Center your cursor on the highlight in the bad eye—a much bigger target—and click. Don't drag, just click. All you're doing is establishing a relationship between the source and destination points. You'll see—it'll work out splendidly in the end.

32. ***Turn on the Aligned check box.*** Located in the options bar, this check box locks in the relationship between the source and destination points that you established in the preceding step. From now on, you can paint as many separate strokes as you like and all parts of the eye will remain properly aligned.

33. ***Turn off Show Overlay.*** But first, move your cursor around in the image window. Notice that the source image remains stationary, a function of having turned on Aligned in the last step. Now turn off the **Show Overlay** check box in the Clone Source palette so you can better see what you're doing.

Figure 6-68.

Figure 6-69.

Figure 6-70.

34. *Paint over the eye.* Start wherever you like and paint as much as you like. In the top example of Figure 6-70, I've highlighted my various brushstrokes as one big cyan mass. Below, we see the healed result. Photoshop not only replaced the bad eye with the good but also blended the edges and matched the deeper shadows and ambient colors of the destination.

35. *Reset the healing options and save your work.* The settings you established in Steps 29 and 32 will remain in force the next time you use the healing brush. Frankly, you don't want that. So turn off the **Aligned** check box in the options bar. Then click the second ⬛ icon at the top of the Clone Source palette. This keeps the original settings intact (on the off chance you want to revisit them) and switches over to a new set of default options.

Figure 6-71 compares the original version of the damaged image to the final healed version. If you search hard enough, you can find a few scars and flaws. And the eyes are more symmetrical than they would be in real life. But I suspect most people would have no idea this image has been tampered with.

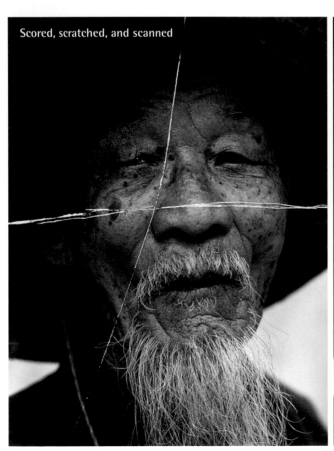

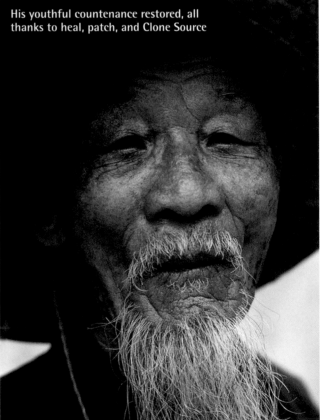

Figure 6-71.

WHAT DID YOU LEARN?

Match the key concept in the numbered list below with the letter
of the phrase that best describes it. Answers appear upside-down
at the bottom of the page.

Key Concepts

1. Edit tools
2. Floating selection
3. Lock transparency
4. Jitter
5. All Layers
6. Minimum
7. Snapshot
8. Dodge and burn
9. Sponge tool
10. Source point
11. Patch tool
12. Clone Source

Descriptions

A. Tools that lighten and darken portions of an image as you paint.

B. An option in the Layers palette that limits your edits to the existing opaque pixels in a layer.

C. A new palette in Photoshop CS3 that lets you scale, rotate, and even flip the source image as you paint it onto the destination, as well as preview the source as a translucent overlay.

D. When using the paint bucket, turn on this check box in the options bar to fill areas of line art on an independent layer.

E. Decreases or increases the saturation of an image, depending on the Mode setting in the options bar.

F. A special kind of state in the History palette that remains available well after twenty operations.

G. A loose collection of tools that modify the existing color or luminosity of a pixel without replacing its content.

H. Drag a selection outline to heal the selected area, whether it was created with this tool or some other selection function.

I. An image element that hovers above the surface of the image, permitting you to move or transform it without harming the underlying original.

J. A command in the Filter menu that can be used to expand the size of objects in a layer, especially useful with solid colors.

K. The spot from which the healing brush samples information when repairing a flaw in an image.

L. A series of percentage values in the Brushes palette that permit one or more attributes to vary randomly over the course of a brushstroke.

Answers

1G, 2I, 3B, 4L, 5D, 6J, 7F, 8A, 9E, 10K, 11H, 12C

CREATING AND APPLYING MASKS

IF YOU'RE LIKE most Photoshop users, you've at least heard of *masks*. Or perhaps you've heard them called *mattes* or *alpha channels* or any of a half dozen other terms. But whatever you call them, their purpose is the same: to block out one portion of an image and reveal another, as illustrated in Figure 7-1.

Essentially, what I did in Figure 7-1 is select the woman's face and move it into the mirror. But I never could have achieved such an accurate selection if I had relied exclusively on the lasso, wand, and pen tools. Masking lets you use the colors and luminosity values inherent in the image to define a selection outline. In effect, you use the image to select itself. Masking takes some getting used to, but once you do, no selection tool is as accurate or efficient.

Seeing through Photoshop's Eyes

In real life, we have a natural sense of an object's boundaries. You may not be able to make out an individual flower in a crowded garden from a distance, but get in close enough, and you can trace the exact border in your mind (see Figure 7-2, page 227). So why does Photoshop have such a hard time with it? Why can't you just say, "Pick the flower," instead of painstakingly isolating every single leaf, stem, and petal?

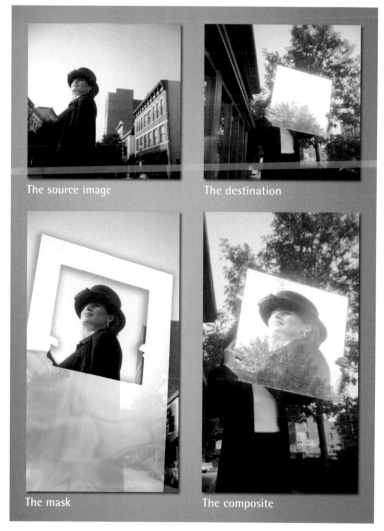

The source image

The destination

The mask

The composite

Figure 7-1.

ABOUT THIS LESSON

Project Files

Before beginning the exercises, make sure you've installed the lesson files from the DVD, as explained in Step 3 on page xvii of the Preface. This should result in a folder called *Lesson Files-PsCS3 1on1* on your desktop. We'll be working with the files inside the *Lesson 07* subfolder.

In this lesson, you'll wade slowly into the world of masking, starting with automated techniques, moving on to extraction, and finally taking on calculations and channel masking. You'll learn how to:

Video Lesson 7: The Power of Masks

This lesson explores two related functions, extractions and channel-based masks. To *extract* an image is to delete the background pixels and convert the foreground image to a new layer. A *mask* is an independent channel that can be converted to a selection outline and saved for later use. Of the two, masks are the more flexible, but both have their merits.

To learn just what these merits are and how the two functions compare, watch the seventh video lesson included on the DVD. Insert the DVD and double-click the file *PsCS3 Videos.html*. Then click **Lesson 7: The Power of Masks** under the **Masking, Filters, and Layers** heading. The 13-minute, 14-second movie explores the following commands and shortcuts:

Command or operation	Windows shortcut	Macintosh shortcut
Quick selection	W	W
Extract	Ctrl+Alt+X	⌘-Option-X
Move a selection	Ctrl-drag	⌘-drag
Register a dragged selection with its new background	Shift-drop	Shift-drop
Draw straight lines in the Extract window	Shift-click	Shift-click
Color Range	Ctrl+Shift+Alt+O*	⌘-Shift-Option-O*

* Works only if you loaded the dekeKeys keyboard shortcuts (as directed in Steps 7 through 9 beginning on page xviii of the Preface).

Well the truth is, you can, provided you know how to speak Photoshop's language. It may require a long conversation, and there may be some misunderstandings along the way. But with a little time, a bit more patience, and a lot of experience, you'll learn to translate your vision of the world into something that Photoshop can recognize as well.

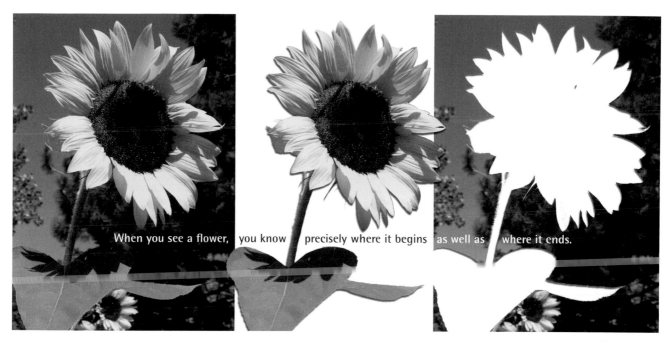

Figure 7-2.

As you may recall from Lesson 2 (see "The Nature of Channels," page 46), Photoshop never actually looks at the full-color image. Assuming that you're working in the RGB mode, the program sees three independent grayscale versions of the image, one for each color channel. A mask is just another kind of channel, one in which white pixels are selected and black pixels are not. So if any one of those channels contains a very light foreground subject against a very dark background, you've got yourself a ready-made mask.

More likely, however, each channel contains some amount of highlights, some amount of shadows, and lots of midtones in between. But that's okay, because the strengths of one channel can compensate for the weaknesses of another. Take the sunflower, for example. If you inspect the individual color channels, you'll find that each

highlights a different portion of the image. The petals are brightest in the Red channel, the stem is well-defined in the Green channel, and the sky is lightest in the Blue channel (see the colorized views in Figure 7-3).

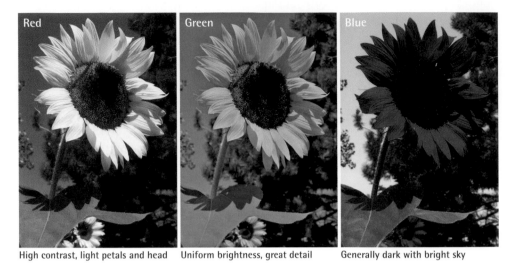

High contrast, light petals and head Uniform brightness, great detail Generally dark with bright sky

Figure 7-3.

Duplicating the Blue channel and inverting it makes the sky dark and other portions of the image light, a step in the right direction. Combining channels with Image→ Calculations permits you to emphasize portions of the image, such as the flower (see Figure 7-4, left) or stem (middle). From there, it's just a matter of selecting the pieces you like, splicing them together, and adjusting contrast values. After a few minutes of tinkering—a process that I explain in detail later in this lesson—I arrived at the rough mask shown on the right side of Figure 7-4. Five to ten minutes later, I completed the mask and used it to select the flower.

Invert Blue, combine with Red Invert Blue, combine with Green 5 minutes of hacking pieces together

Figure 7-4.

Photoshop gives you the raw information you need to accurately define the edges in the image. Then it's up to you to figure out how to assemble the pieces. Fortunately, you can do so using not just a few selection tools, but virtually every function in Photoshop's arsenal. And because a mask is a channel that can be saved as part of a TIFF or native PSD file, you can recall or modify the selection outline any time you like.

Using the Color Range Command

Photoshop's Color Range command uses a masking metaphor to generate selection outlines. In this regard, it serves as a bridge between the worlds of selections and masks, not to mention as a wonderful introduction to our lesson.

Essentially an enhanced version of the magic wand, Color Range lets you adjust the range of colors you want to select until you arrive at an acceptable, if not perfect, selection outline. And it does so dynamically, so there's no need to start a selection over again the way you sometimes must with the wand. Finally, Color Range interprets luminosity values in a more sophisticated manner than the wand, which results in smoother, more credible selection outlines.

1. **Open two images.** Open the *Duckbill in tent.tif* and *The planets.psd* image files, located in the *Lesson 07* folder inside *Lesson Files-PsCS3 1on1*. In this exercise, we'll use the Color Range command to trace the highly intricate outline of the dinosaur skeleton. Then we'll move the selected skeleton into *The planets.psd* composition. So click the title bar for *Duckbill in tent.tif* to make sure that image is in front, as in Figure 7-5.

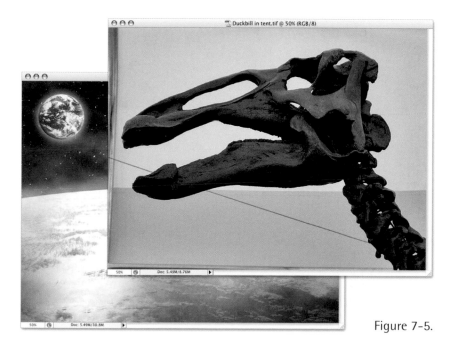

Figure 7-5.

Figure 7-6.

2. **Press the D key.** By now, you know this resets the foreground color to black. But what you might not know is that the Color Range command uses the foreground color as the basis of a selection. You don't always have to start with black; doing so merely assures that you and I start on the same foot.

3. **Choose the Color Range command.** Choose **Select→Color Range**. Alternatively, if you loaded the custom dekeKeys shortcuts I recommend in the Preface (Step 7, page xviii), you can press Ctrl+Shift+Alt+O (⌘-Shift-Option-O on the Mac). Either way, you get the **Color Range** dialog box, shown in Figure 7-6.

PEARL OF WISDOM

The central portion of the dialog box features a black-and-white preview, which shows you how the selection looks when expressed as a mask. The white areas represent selected pixels, the black areas are deselected, and the gray areas are somewhere in between. This might seem like a weird way to express a selection outline, but it's actually more precise than the marching ants we saw back in Lesson 4. Whereas marching ants show the halfway mark between selected and deselected pixels, a mask shows the full range of a selection, from fully selected to not selected to somewhere in between.

4. **Click somewhere in the background above the dinosaur.** When you move the cursor into the dinosaur image window, it changes to an eyedropper. Click to establish a base color for the selection. In our case, the tent ceiling behind the dinosaur divides into two main bodies of color: light gray at the top and a slightly darker gray toward the bottom. I'd like you to click in the light gray above and to the left of the animal's long nose. This resets the base color from black to a very light color, thus inverting the mask preview, as in Figure 7-7.

5. **Raise the Fuzziness value to 90.** Like the magic wand's Tolerance value (see "Selecting Regions of Continuous Color," Step 5, page 118), the **Fuzziness** value spreads the selection across a range of luminosity values that neighbor the base color. Lowering the value contracts the selection; raising the value expands the selection.

Figure 7-7.

Fuzziness improves on Tolerance in two important ways. First, whereas the static Tolerance value modifies the next selection, the dynamic Fuzziness value changes the selection in progress. Second, the magic wand selects all colors that fall inside the Tolerance range to the same degree, but Color Range gradually fades the selection over the course of the Fuzziness range. As a result, Fuzziness produces gradual, organic transitions.

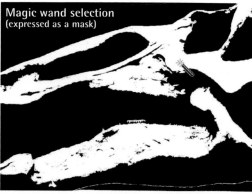

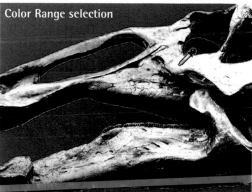

PEARL OF WISDOM

In the comparative illustrations in Figure 7-8, I rendered the selections as colorized masks to make it easier to see the transitions from black (not selected) to white (selected). In both cases, the Tolerance and Fuzziness values were set to 90. The cursors show the common location where I clicked to set the base color. (Note that this is not a step, so please don't click there yourself. If you do, reset the base color as instructed in Step 4. Then move on to Step 6.)

6. ***Add a base color to the selection.*** To add base colors to the selection, press the Shift key and click or drag inside the image window. For our purposes, Shift-click in the area of medium gray near the lower-left corner of the image window, as indicated by the eyedropper in Figure 7-9. This expands the selection to include more midtones, including a few inside the skull.

Figure 7-8.

PEARL OF WISDOM

It's worth pointing out that Shift-clicking produces a different effect than raising the Fuzziness value. When you Shift-click, you increase the number of colors that are fully selected (white in the mask). In contrast, the Fuzziness value defines how many pixels are partially selected (gray in the mask).

7. ***Check your mask in the image window.*** The mask preview inside the Color Range dialog box is helpful, but its dinky size makes it hard to accurately gauge a selection. To better judge the quality of your work, choose **Grayscale** from the **Selection Preview** pop-up menu, as in Figure 7-10 on the next page. Photoshop fills the image window with the mask preview, permitting you to zoom in (Ctrl+⊡ on the PC or ⌘-⊡ on the Mac) and see every little detail of your prospective selection.

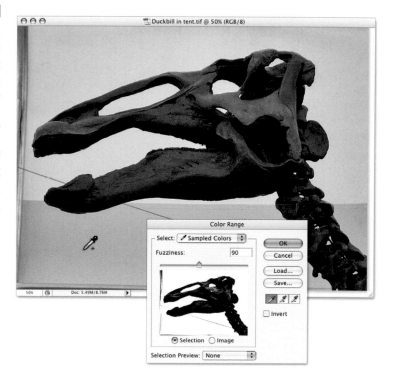

Figure 7-9.



Fuzziness improves on Tolerance in two important ways. First, whereas the static Tolerance value modifies the next selection, the dynamic Fuzziness value changes the selection in progress. Second, the magic wand selects all colors that fall inside the Tolerance range to the same degree, but Color Range gradually fades the selection over the course of the Fuzziness range. As a result, Fuzziness produces gradual, organic transitions.

In the comparative illustrations in Figure 7-8, I rendered the selections as colorized masks to make it easier to see the transitions from black (not selected) to white (selected). In both cases, the Tolerance and Fuzziness values were set to 90. The cursors show the common location where I clicked to set the base color. (Note that this is not a step, so please don't click there yourself. If you do, reset the base color as instructed in Step 4. Then move on to Step 6.)

6. ***Add a base color to the selection.*** To add base colors to the selection, press the Shift key and click or drag inside the image window. For our purposes, Shift-click in the area of medium gray near the lower-left corner of the image window, as indicated by the eyedropper in Figure 7-9. This expands the selection to include more midtones, including a few inside the skull.

Figure 7-8.

It's worth pointing out that Shift-clicking produces a different effect than raising the Fuzziness value. When you Shift-click, you increase the number of colors that are fully selected (white in the mask). In contrast, the Fuzziness value defines how many pixels are partially selected (gray in the mask).

7. ***Check your mask in the image window.*** The mask preview inside the Color Range dialog box is helpful, but its dinky size makes it hard to accurately gauge a selection. To better judge the quality of your work, choose **Grayscale** from the **Selection Preview** pop-up menu, as in Figure 7-10 on the next page. Photoshop fills the image window with the mask preview, permitting you to zoom in (Ctrl+⊡ on the PC or ⌘-⊡ on the Mac) and see every little detail of your prospective selection.

Figure 7-9.

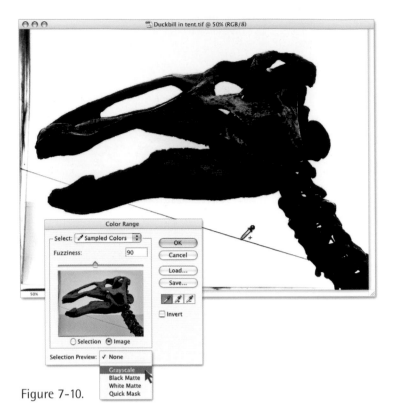

Figure 7-10.

Figure 7-11.

To see the mask preview and image at the same time, click the **Image** radio button directly under the preview. The preview box switches from a thumbnail of the mask to a thumbnail of the full-color image (again, see Figure 7-10).

8. ***Add any detail that still needs to be selected.*** For example, we need to get rid of that diagonal support cable. Press Shift and click the cable, as indicated by the eyedropper in Figure 7-10. Color Range samples the base color and adds the cable to the selection.

 Depending on where you Shift-click, Photoshop selects some or all of the cable. But in my case, it goes too far, selecting well into the skeleton, as shown in Figure 7-11. If this happens to you—as it likely will—you have two options. (For the moment, don't do them; just read about them.)

 - Press the Alt key (Option on the Mac) and click a color in either the image window or preview to deselect an area related to that base color. The problem is, this technique often overcompensates by deselecting too many pixels.

 - Choose Edit→Undo Color Sample or press Ctrl+Z (⌘-Z on the Mac). Great feature, but bear in mind that you have just one level of undo inside the Color Range dialog box. Use it wisely.

9. ***Choose the Undo Color Sample command.*** Given that you have just one level of undo, and Alt-clicking to subtract from a selection probably won't work, your best bet is to invoke **Undo** now before it's too late. Press Ctrl+Z (or ⌘-Z) to return to where you were after Step 7.

10. **Turn on the Invert check box.** As we did when selecting the scarecrow in Lesson 4 (see Step 8, page 119), we've gone and selected the background instead of the element we want to select. And wouldn't you just know it, we did it for exactly the same reason: because the background is easier to select. To get the foreground element instead, just turn on **Invert**. Now the skeleton turns white and the background black, as in Figure 7-12.

11. **Click the OK button.** Color Range uses the base colors and Fuzziness value to deliver a selection outline in the image window. Note that you will not see a mask; instead, you get a standard marching-ants-style selection, ready for immediate use.

12. **Drag the selected skeleton into the planets backdrop.** Press and hold the Ctrl (or ⌘) key to get the move tool, and drag the selected skeleton from *Duckbill in tent.tif* into *The planets.psd* image window. Before you drop it into place, press and hold the Shift key to center it. Release the mouse button and then release both keys. You should get the result depicted in Figure 7-13.

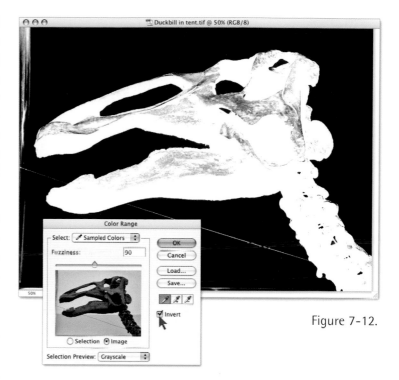

Figure 7-12.

Figure 7-13.

The planets.psd @ 200% (Layer 1, RGB/8)

200% Doc: 5.49M/38.1M

Figure 7-14.

The resulting composition is commendable. The Color Range command managed to trace a pretty complicated outline and omit all the right holes. But while I'd give Photoshop an A for effort, the implementation is imperfect. Portions of the dinosaur that should be opaque are translucent. As illustrated by Figure 7-14, the edges are fringed by hot yellow artifacts captured by the camera. And then there's that darn support cable.

13. *Choose the Undo command.* Choose **Edit→ Undo→Drag Selection** or press Ctrl+Z (⌘-Z) to abandon the imported skeleton. Before we can introduce the dinosaur into a new home, his selection has to be refined. And we'll be doing just that in the next exercise.

Refining a Selection with a Quick Mask

Photoshop's *quick mask mode* is nothing more than an alternate way to view and edit a selection outline. You enter the mode to view the selection as a mask, edit the mask as desired, and then exit the mode to see the updated selection outline. The mask remains available only as long as you stay in the quick mask mode, but during that time, you have access to Photoshop's full range of masking options. Frankly, there's nothing particularly quick about the quick mask mode—you can spend as long making a quick mask as any other kind of mask. The fact that it's temporary is what sets it apart.

The quick mask mode works especially well with the Color Range command. Color Range establishes the rough selection outline and then quick mask refines it. The goal of this exercise is to finesse the selection you began in the last exercise. As you may recall from Step 12, we have translucency issues, edge fringing, and that cable. I mean, how unrealistic is that cable? We'll address all these problems, and more, using quick mask.

1. *Open those same two images.* If you're performing these steps immediately after the others, and you still have both images open and the skeleton remains selected, bring the *Duckbill in tent.tif* file to the front and skip to Step 5. Otherwise, open *Duckbill in tent.tif* and *The planets.psd*, both in the *Lesson 07* folder inside *Lesson Files-PsCS3 1on1*.

2. *Choose the Color Range command.* Make sure the *Duckbill in tent.tif* file is in front. Then choose **Select→Color Range** or press Ctrl+Shift+Alt+O (⌘-Shift-Option-O on the Mac).

3. *Load the Color Range settings.* Click the **Load** button inside the **Color Range** dialog box. Then locate the file *Duckbill settings.axt* in the *Lesson 07* folder and click **Load** (or double-click the filename). This opens the settings applied back in the preceding exercise (Step 11, page 233).

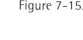

4. *Invert and accept the selection.* When you save a collection of Color Range settings, Photoshop stores the base colors and Fuzziness value. It does not remember the setting of the Invert check box. So Invert may be on or off, depending on the last selection you created with the Color Range command. Regardless, make sure **Invert** is turned on. Then click **OK**.

5. *Click the quick mask icon in the toolbox.* Click the ▣ icon near the bottom of the toolbox, as pictured in Figure 7-15. Or just press the Q key. Either way, Photoshop coats the deselected portion of the image with a red overlay, based on a traditional *rubylith*, a kind of film commonly used in the old days to stencil photographs and line art.

Figure 7-15.

6. *Change the color overlay.* Just because the overlay is red doesn't mean it has to stay that way. In this case, the red doesn't contrast well with the warm colors in the dinosaur bones. So double-click the ▣ icon in the toolbox to display the **Quick Mask Options** dialog box. Click the color swatch to open Color Picker, change the **H** value to 180 degrees (giving you cyan, the complement to red), and click **OK**. You can also change the Opacity value if you want, but I left mine at 50 percent (see Figure 7-16). Then click the **OK** button to accept your changes.

7. *Click the brush tool in the toolbox.* The most basic tool for editing a quick mask is the brush tool. Click its icon in the toolbox or press the B key to get the brush tool.

Figure 7-16.

If you're performing this exercise on the heels of Lesson 6, in which we last used a randomized scatter brush—the one with all the Jitter settings (see page 189)—you need to restore the default settings for the brush tool. Right-click the ▾ arrow next to the brush icon on the far left side of the options bar and then choose the **Reset Tool** command.

8. ***Set the foreground color to black.*** It probably is black already, but press the D key just to make sure. Regardless of the color of the quick mask overlay—red, cyan, whatever—painting with black adds to the mask and therefore deselects areas; painting with white adds to the selection. Or put more simply, black conceals and white reveals. (As when editing any mask, you can't paint in color because you're working with the equivalent of a grayscale image.)

9. ***Set the brush diameter and hardness.*** I found it best to use a 20-pixel brush. And you definitely want the **Hardness** set to 100 percent to avoid introducing incongruously soft edges. (If you reset the brush in Step 7, press the ⬜ key to increase the brush diameter one increment; then press Shift+⬜ four times to maximize the hardness.)

10. ***Paint away the diagonal support cable.*** The support cable is a straight line, so you can paint over it by clicking at one end of the cable and then Shift-clicking at the other end. Photoshop will draw a straight brushstroke between the two points, highlighted in purple in Figure 7-17. Keep your click and Shift-click points very close to the edge of the skeleton, as demonstrated by the yellow targets. Repeat the process to paint away the upper-left portion of the cable.

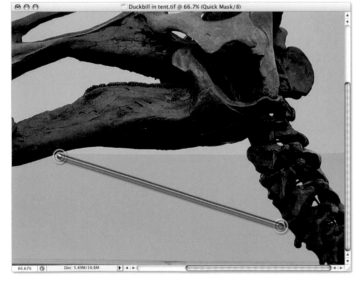

Figure 7-17.

PEARL OF WISDOM

Notice that even though black was your foreground color, you actually painted a faint cyan brushstroke. That's because both black and the translucent cyan overlay represent masked pixels. Had you been painting in white, you would have erased the cyan. This will make more sense as you experiment further with the quick mask mode.

11. ***Bring up the Channels palette.*** Even though you changed the overlay from red to cyan, you're probably still having problems telling which portions of the dinosaur are masked and which are not. Fortunately, you can view the mask independently of the full-color image from the Channels palette. Click the **Channels** tab or choose **Window→Channels**.

PEARL OF WISDOM

Note that the Channels palette contains the usual RGB and Red, Green, and Blue items. But it also contains a couple of surplus so-called *alpha channels*, Maskosaur and Choked. Each represents a saved selection outline you can load at will (as we'll witness first-hand by the end of this exercise). The last item, *Quick Mask*, is just that—the quick mask itself. The fact that the item is in italics tells you that it's temporary and lasts only as long as you stay in the quick mask mode.

If the thumbnails in the **Channels** palette appear tiny, right-click the empty portion of the palette and choose **Large**, as shown in Figure 7-18.

12. ***Hide the RGB image.*** The eyeballs (👁) in the Channels palette tell us that we're seeing the RGB channels and the quick mask together, hence the cyan overlay. Click the '👁' icon in front of **RGB** to turn it off. You see the quick mask by itself, in its true form, as a grayscale image (see Figure 7-19). It's now easy to see the large areas of black and white, as well as the inconsistent grays that need to go one way or the other.

Figure 7-18.

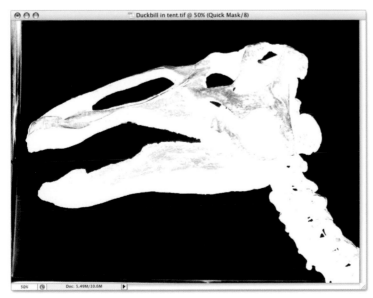

Figure 7-19.

The problem with the mask is that it has too many grays. Some need to be sent to black, others to white. In other words, we need to increase the contrast. And what better way to increase the contrast of an image than with the Levels command?

13. ***Increase the contrast of the mask.*** Choose **Image→Adjustments→Levels** or press Ctrl+L (⌘-L on the Mac) to display the **Levels** dialog box shown in Figure 7-20. Increase the first **Input Levels** value to 90, which sends everything with a luminosity value of 90 or lower to black. Reduce the third **Input Levels** value to 135, which turns just about all the light colors to white. Then click **OK**. The result is a sharper, more precise selection, with a ring of antialiased pixels remaining in the range of luminosity values between 90 and 135.

14. ***Restore the RGB image.*** In the **Channels** palette, click the blank square in front of **RGB** to again view image and quick mask together and inspect the mask for problems. You'll see that we've dealt with two of the three issues that diminished the original Color Range selection: The cable is now gone, and most of the interior of the skeleton is opaque. (We'll clean up the remaining spots in Step 17.) But we continue to have fringing around the outer edge of the skeleton. The problem is that the selection is slightly too big for the dinosaur. The solution is to contract, or *choke*, the mask.

I find it helpful to turn the full-color image on and off periodically as I work in the quick mask mode. Thankfully, you can do it from the keyboard. Just press the ⌐ key (called *tilde*, right above Tab) to hide the RGB image. Press ⌐ again to bring the image back.

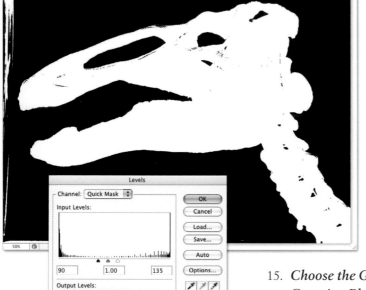

Figure 7-20.

15. ***Choose the Gaussian Blur command.*** Choose **Filter→Blur→Gaussian Blur**, change the **Radius** value to 2 pixels, and click **OK**. Photoshop blurs the mask and, in doing so, smooths the rough transitions and spreads the edges. This latter effect permits us to expand or contract the edges with precise control, as in the next step.

16. ***Increase the contrast again.*** Press Ctrl+L (or ⌘-L) to display the **Levels** dialog box. Set the first **Input Levels** value to 170 and the third to 195. Then click **OK**.

This time, we made most of the colors black, which has the effect of choking the mask and moving the edges inward. Very few values are permitted to remain gray, but that's okay because blurring the image gave us such a wealth of grays to work with. The net result is that we continue to have softer edges than we did by the end of Step 14, as Figure 7-21 illustrates.

17. ***Clean up the skeleton with the brush tool.*** Press the X key to make the foreground color white. Then paint away any spots of cyan inside the dinosaur's skull and spine that shouldn't be there. (Be careful: A few of the spots represent holes between the bones and should stay.) If you're feeling ambitious, you can clean up a few of the edges along the top of the skull as well. Just make sure you stay well inside the edge so you don't bring back any of that fringing.

18. ***Fix the image boundaries with the rectangular marquee.*** If you zoom out from the image, you'll notice some garbage along the left and bottom boundaries of the image. Press M to select the marquee tool. (Yes, you have full access to the selection tools when editing a mask.) Select the left and bottom areas as shown in Figure 7-22. Then press Ctrl+Backspace (⌘-Delete) to fill them with the background color, black.

19. ***Exit the quick mask mode.*** Either click the ⬚ icon near the bottom of the toolbox or press the Q key. Photoshop immediately converts the mask to a marching-ants-style selection outline.

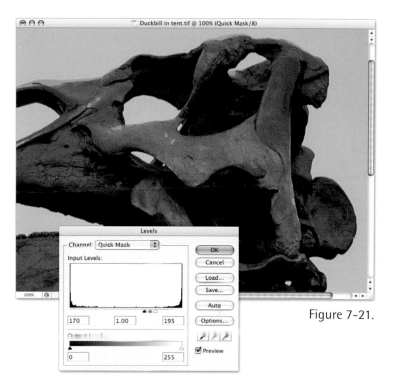

Figure 7-21.

Figure 7-22.

20. ***Drag the skeleton into the planets backdrop again.*** Press the Ctrl (or ⌘) key and drag the selection from *Duckbill in tent.tif* into *The planets.psd* image window. Before you drop, press and hold Shift. The result appears in Figure 7-23.

The figure below may make your work appear a bit subtle. But zoom in on your image and you'll see just how perfect things really are. Frankly, I'm stunned at just how good this selection has turned out.

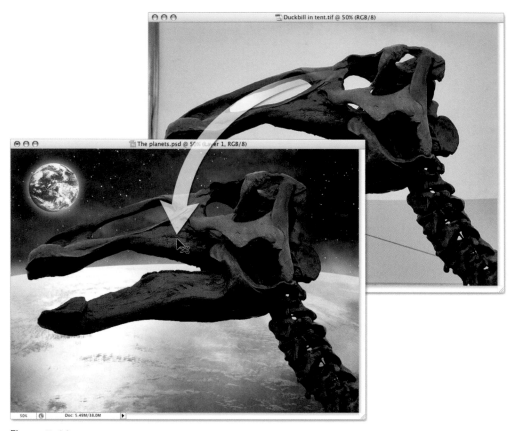

Figure 7-23.

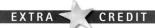
The skeleton looks swell in its new home, but you have to wonder why it's there. That is to say, what's a dinosaur skeleton doing miles above the surface of a planet that hovers so close to Earth? The remaining steps reveal the answer. Don't care about the answer? Skip to the "Extracting a Photographic Element" exercise on page 243. Care deeply? Then onward we go.

21. ***Add a Gradient Overlay style.*** Let's begin our process of discovery by adding a bit of drama. Choose **Gradient Overlay** from the *fx* pop-up menu at the bottom of the **Layers** palette, as shown in Figure 7-24.

22. ***Adjust the gradient settings.*** To give the dinosaur skeleton a darker aspect, as if obscured by shadows, apply the following settings (all of which appear in Figure 7-24):

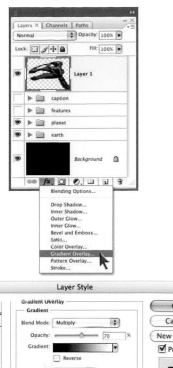

- Set the **Blend Mode** to **Multiply** and the **Opacity** to 70 percent. This ensures that the gradient darkens its background, as with a shadow.

- Make sure the **Gradient** bar shows a black-to-white ramp. If it doesn't, click the ▾ arrow and select the black-to-white gradient.

- Rotate the **Angle** value to –146 degrees.

- Move the gradient slightly to the right by dragging it directly in the image window.

When you're finished, click **OK** to accept the newly shaded dinosaur. The result is a shadow that fades from upper right to lower left, as if the skeleton is very close to us, deep in the foreground.

23. ***Turn on the Features and Caption layer sets.*** In the **Layers** palette, you'll see that a couple of folders are turned off. Click to the left of them to bring back their eyeballs (👁) and make them visible. The **Features** folder contains several layers that make up the dinosaur's eye and spindly hands. The **Caption** folder displays a passage of text that explains the hideous monster's dreadful plans (see Figure 7-25).

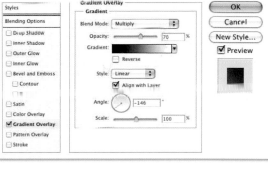

Figure 7-24.

Figure 7-25.

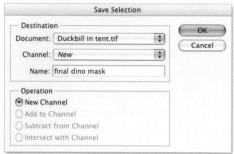

Figure 7-26.

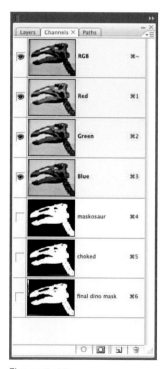

Figure 7-27.

24. **Save your artwork.** Choose **File→Save As** and name your masterpiece "Dinosaur Planet.psd."

25. **Return to Duckbill in tent.tif.** If that image is worth saving, certainly all the hard work you put into making the selection outline is worth saving, too.

26. **Save the selection.** Choose **Select→Save Selection**. In the **Save Selection** dialog box, enter a **Name** for the new alpha channel, which I called "Final Dino Mask," as in Figure 7-26. The other settings are fine, so click **OK**.

 Go back to the **Channels** palette and notice that the final item now reads **Final Dino Mask** (see Figure 7-27). If you like, you can now press Ctrl+D (⌘-D on the Mac) to deselect the image. After all, it's all backed up, pixel for pixel, in this new channel.

27. **Compare your masks.** To reload a mask, press the Ctrl (or ⌘) key and click anywhere on its channel. This allows you to load and compare multiple variations of a selection so you can decide which one's best. In this case, I created my earlier selections, Maskosaur and Choked, using lesser techniques than those we ultimately employed in this exercise. So Final Dino Mask rules the day.

28. **Save your changes.** Step 26 saved the selection in memory, but it still needs to be saved to disk. Choose **File→Save** or press Ctrl+S (⌘-S) to update the *Duckbill in tent.tif* file on your hard drive. You have now saved your selection outline for all time.

Extracting a Photographic Element

One of the biggest problems that arises when transferring an image from one background to another is *fringing*. The edges of every element in a photograph incorporate ambient colors from the photograph's background. So when you move an element to another background—or replace the background with another color, as in Figure 7-28—the edges have an alarming habit of retaining their original coloring. The result is a sharp and defiant border that screams, "This image does not belong here! It is a stranger to this shabby composition!"

Photoshop's solution is the Extract command. When you *extract* an image, you erase its background and leech out the fringe coloring from the old background. The process is hardly perfect—it permanently erases pixels, and the tools aren't as expertly implemented as I'd like—but on occasion, it comes through with flying colors. Or more accurately, without them.

In the following exercise, we'll extract the foreground subject from one photograph and place it against a handful of foreign backgrounds. The foreground and backgrounds contain a range of different colors, providing us with a chance to judge just how well Extract works.

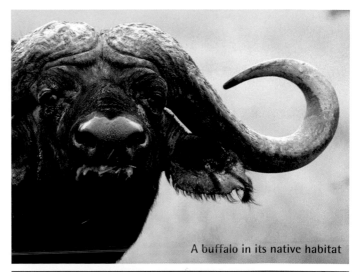

A buffalo in its native habitat

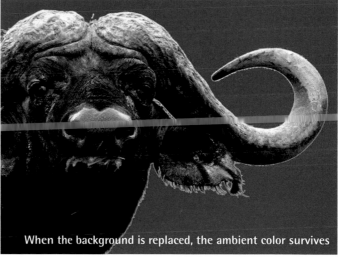

When the background is replaced, the ambient color survives

Figure 7-28.

1. ***Open an image and a prospective background.*** This time around, the files are *Buffalo.jpg* and *Vacation destinations.psd*, located in the *Lesson 07* folder inside *Lesson Files-PsCS3 1on1*. First, observe that the animal—a member of the PhotoSpin image library—really is a buffalo, not an American bison, for those of you who are sticklers on such topics. (I myself am not. I attended the University of Colorado where the mascot, a bison, is called a "buff." It remains unclear whether this is willful misidentification or a frank acknowledgment that the animal is naked. Either way, I'm scarred for life.) Second, and much more to the point, the buffalo's background is as smooth as it is pervasive. The Extract command functions best with homogeneous backgrounds with obvious transitions around the foreground element; busy textures tend to confuse it.

Figure 7-29.

2. **Choose the Extract command.** Make sure that the *Buffalo.jpg* window is in front, as it is in Figure 7-29, and then choose **Filter→Extract** or press Ctrl+Alt+X (⌘-Option-X on the Mac). Photoshop displays the **Extract** window, which behaves like a separate extraction utility, complete with its own tools and options, as pictured in Figure 7-30.

The center of the window features a large preview of the image. You can zoom it or scroll it using the standard navigation tricks introduced in Video Lesson 1, "Navigation" (see page 4). Strangely, however, the window lacks scroll bars or any mention of a zoom ratio percentage. So it's difficult to know if you're seeing all the image or how many pixels are being interpolated away. Fortunately, you can always double-click the zoom tool icon on the left side of the dialog box to switch to the 100 percent view. Then spacebar-drag the preview to scroll it.

3. **Click the edge highlighter tool.** Or press the B key (so used because the edge highlighter behaves like the pencil in the main toolbox). The edge highlighter is active by default, but if you double-clicked the zoom tool as suggested in the preceding tip, you'll need to switch back.

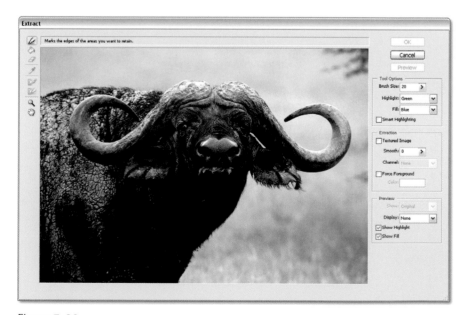

Figure 7-30.

4. *Set the brush diameter.* By default, the diameter is 20 pixels. You can change this by entering a new Brush Size value (under Tool Options, upper right). Or press the ⬚ key to increase the diameter in 2-pixel increments. For my part, I started with a **Brush Size** of 30 pixels.

5. *Trace the perimeter of the buffalo.* Make sure you can see the far left side of the image, every pixel of it. Then begin dragging from the top-left point in the buffalo's back. Trace along the back, taking care to center the brush on the border between the buffalo and the grass. Then trace over the double hump of horns at the top of the head. Stop at the point marked with the cyan target in Figure 7-31.

6. *Change the highlight color.* By default, the line that you draw is colored green, which is hard to see against a green background. Under **Tool Options**, change the **Highlight** option to **Red** to make the line red instead.

7. *Shift-click around the right horn (the beast's left).* Reduce the brush diameter to 20 pixels. Then click at the last point you drew. From here on, press Shift and click in short segments around the inner and outer portions of the horn, until you get to the end of the red line shown in Figure 7-31. Photoshop draws straight lines between each Shift-click.

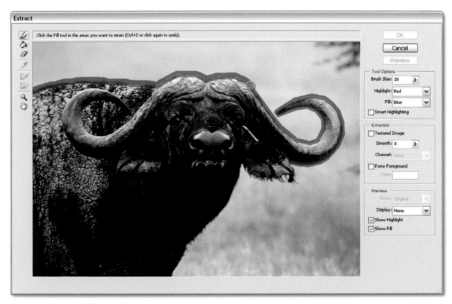

Figure 7-31.

8. *Paint around the ear and right side.* The ear is the hairiest part, so raise the **Brush Size** value to 50 pixels to get it all. Then drag around the ear and all the way down the right side of the body (the animal's left) until you reach the very bottom.

9. *Paint with the Smart Highlighting function.* We still have one area to paint, that tiny sliver of green between the ear and the horn on the right side. You could paint it freehand with a very small brush, but Extract gives you a better way to paint fine details. Turn on the **Smart Highlighting** check box, and then paint along the sliver and watch the tool work its magic. Even though your brush diameter is still 50 pixels, Smart Highlighting manages to draw a thin, precise line.

10. *Click the fill tool.* Or press the G key to get the second tool down, the one that looks like a paint bucket. This tool tells Extract what portion of the image to keep and what to erase.

11. *Click inside the buffalo.* The fill tool coats the interior of the buffalo in translucent blue, as shown in Figure 7-32.

If the blue spills outside the red outline, there's a break somewhere in the outline (possibly along an edge that is scrolled out of view). Find the break, paint it in with the edge highlighter tool (as in Step 5 on the preceding page), and then try filling the buffalo again.

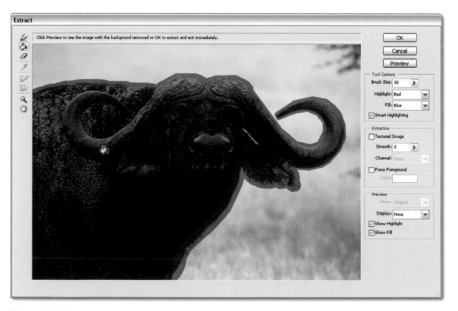

Figure 7-32.

12. ***Click the Preview button.*** After you achieve an unbroken outline and a contained fill, click **Preview** to see what the extraction will look like right inside the Extract window. The checkerboard pattern (see Figure 7-33) represents transparent pixels—that is to say, those that will be erased.

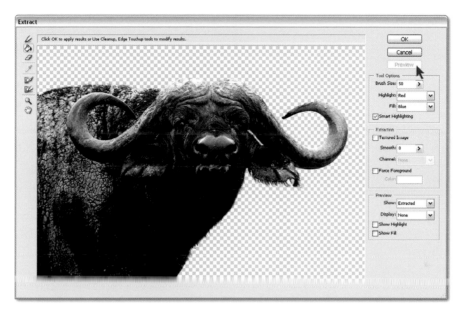

Figure 7-33.

13. ***Select a Display setting.*** After Photoshop finishes calculating the preview, examine the extracted edges for defects. If the checkerboard pattern is too noisy to make sense of the image, try one of the other settings from the **Display** pop-up menu. Choose a Matte setting to see the image against a solid colored background. Choose Mask to see the extraction expressed as a grayscale mask; white is opaque, black is transparent.

Press the F key to cycle between the different Display settings.

14. ***Apply the edge touchup tool.*** You have two ways to fix any problems you may find. Press the T key to select the edge touchup tool, which automatically adjusts pixels that fall inside your original red highlight line (Steps 5 through 9). I found this tool especially helpful at increasing the contrast around the horns. But because it sharpens the transitions, you probably won't want to use it around the ears and other hairy areas.

To move the edge in or out from the buffalo, press and hold the Ctrl key (⌘ key on the Mac) as you drag. It's a weird technique, but it sometimes comes in handy. You can also increase or decrease the intensity of the tool by pressing a number key; 0 is the most intense and 1 is the least. (The dialog box doesn't provide any direct feedback—for example, there is no corresponding numerical option—so you have to accept your changes on faith.)

15. ***Apply the cleanup tool.*** Press C to select the cleanup tool. Then drag to erase pixels. Press the Alt (or Option) key and drag to make pixels opaque. I found this tool most useful for fixing some of the messy edges around the animal's body and ears. I also used it to shift some of the edges around the horns that had stubbornly resisted the edge touchup tool.

I often use the cleanup tool in the Mask mode. Drag to paint with black; Alt-drag (or Option-drag) to paint with white. The final mask view should look nice and clean—free of stray gray pixels in the predominantly black and white areas—as shown in Figure 7-34.

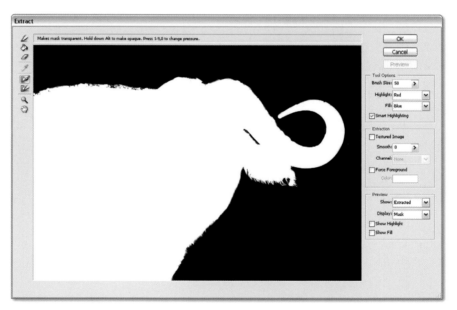

Figure 7-34.

16. ***Click the OK button.*** Like Color Range, the Extract command does not deliver a mask, but nor does it give you a selection outline. Rather, it transfers the extracted element to its own layer and eliminates the background.

Despite your best efforts, the Extract command may erase pixels you wanted to keep. In my case, I lost pixels across the top of the back and horns, as well as at the very tip of the right horn. Fortunately, the history brush can bring them back.

17. ***Bring back lost pixels with the history brush.*** Press the Y key to select the history brush. Then select a small, sharp brush—say, 20 pixels with **Hardness** cranked all the way up to 100 percent. Now zoom in tight and paint to bring back the pixels you lost. If you end up bringing back patches of green, undo and try again.

18. ***Drag the buffalo into the Mt. Rushmore backdrop.*** When you're finished using the history brush, press the Ctrl key (⌘ key on the Mac) and drag the new buffalo layer from the *Buffalo.jpg* image window into the *Vacation destinations.psd*. No need to press the Shift key this time around; just drop when ready. Once inside the Mt. Rushmore composition—which I shot, in case you're curious—Ctrl-drag (or ⌘-drag) the buffalo to move it into the approximate position shown in Figure 7-35.

19. ***Turn on the other layers.*** Thanks to its relative lack of color fringing, the buffalo is comfortable anywhere, including some of America's hottest vacation destinations. To see the versatile bovine in action for yourself, go to the **Layers** palette and

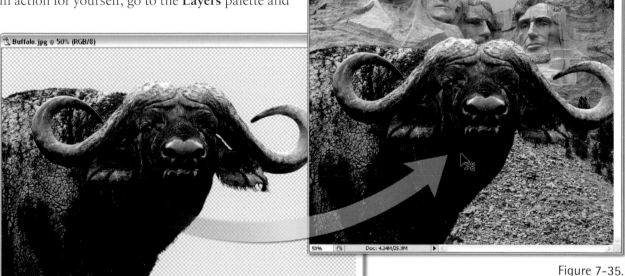

Figure 7-35.

Figure 7-36.

turn on the **Glacier Bay** layer and then the **Carnegie Deli** layer. As exhibited in Figure 7-36, the lighting may not entirely match, but the edges look terrific. In fact, I came across just one subtle patch of fringing around the right ear (the animal's left). If this bothers you—and bear in mind, it barely shows up in print—perform the following two steps.

20. *Lock the transparency of the buffalo layer.* Click the layer name (presumably **Layer 0**) in the Layers palette to make sure it's active. Then press the ⌷ key to lock the transparency.

21. *Hand-paint the ear.* Press the B key to get the brush tool. Then press the Alt key (Option on the Mac) and click inside a dark portion of the ear to lift a representative color. Set the **Mode** to **Color** and the **Opacity** to 50 percent. Select a soft brush and paint over any overly green hairs to reinstate the buffalo's natural red coloring. If one pass of the brush doesn't do the trick, give it a second pass. The 50 percent Opacity lets you build up color incrementally.

Defining a Mask from Scratch

Working with automated commands such as Color Range and Extract is all well and good. But the true power of masking resides in its ability to use an image to select itself. Although this approach requires a lot more thought and experimentation, the irony is that it frequently takes less time than monkeying around in the quick mask mode and less patience than trying to get Extract to function properly. In other words, once you get the hang of it, manual masking is actually easier than the automatic options. Plus, wouldn't you know it, the manual approach delivers better results.

This next exercise shows how to take a couple of color channels from an RGB photograph and combine them to produce a complex, naturalistic mask. And just for fun, we'll be using this technique to select some of the most fragile of all image details: individual strands of hair and—get this—willowy wisps of flame. Enjoy.

1. ***Open one foreground photo and one background photo.*** The images for this exercise are *Match girl.tif* and *Forest blur.jpg*, each available in the *Lesson 07* folder inside *Lesson Files-PsCS3 1on1*. Both photos comes to us from iStockphoto. Andrzej Burak captured the young lady brandishing the match. While skillfully applied, the flame is a skillful fake, itself created in Photoshop. Even so, we're going to keep that flame and make it look even better with masking. Meanwhile, Eugenijus Marozas photographed the trees; I applied the Lens Blur effect. The two images share little if anything in common. One is contrived and heavily edited; the other is natural, appearing more or less as-shot. One relies on studio lights; the other on sunlight. One is predominantly red; the other contains richly saturated earth tones. But as you'll soon see, thanks to masking, the two can work together splendidly. Click the title bar of the *Match girl.tif* image to bring her to the front, as in Figure 7-37.

Figure 7-37.

2. ***Survey the color channels.*** Go to the **Channels** palette and click the individual channel names **Red**, **Green**, and **Blue**. (For the moment, ignore the three alpha channels, Soft Blob, Flame, and Final Mask.) Or press the keyboard shortcuts Ctrl+1, Ctrl+2, and Ctrl+3 (⌘-1, -2, and -3 on the Mac). Now you can peruse the channels and decide which ones are the best candidates for building a mask. The three channels appear slightly colorized in Figure 7-38.

Red

Green

Blue

PEARL OF ⬤ WISDOM

You're looking for the two channels that represent the biggest extremes—that is, extreme contrast between shadows and highlights as well as extreme contrast between each other. In our case, the best candidates appear to be Red and Green, as is typical in portrait photography. The Green channel conveys excellent contrast and, unlike Blue, contains a nice bright flame. The Red channel is bright in the flame, flesh, and hair, and has the added distinction of being most unlike Green.

Figure 7-38.

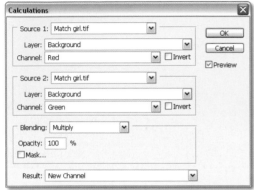

Figure 7-39.

3. **Return to the RGB composite view.** Now that we've decided on our channels, click **RGB** at the top of the Channels list or press Ctrl+⌐ (⌘-⌐) to make the full-color image active.

4. **Choose the Calculations command.** Go to the **Image** menu and choose **Calculations** to display the **Calculations** dialog box, as in Figure 7-39. This feature lets you mix two channels to form a new alpha channel using a blend mode and an Opacity value. Back in the days before layers, the Calculate commands (there were many of them back then) were your primary tools for mixing and merging images. Although today's Calculations command is more powerful, it's relegated almost exclusively to the creation of masks.

This is an elaborate dialog box, so it's a good idea to turn on the **Preview** check box, if it's not turned on already. With Preview on, you can observe the results of your changes in the full-image window. Unfortunately, the preview function can be a tad buggy, occasionally refusing to update when you make a change. If this happens to you, just turn the check box off and then back on to refresh the preview.

5. **Select the desired Source channels.** You can think of the Calculations dialog box as layering one channel on top of another. Source 2 is the background channel; Source 1 is the channel in front. Source 1 is in a position of emphasis and should therefore contain the channel with the highest contrast. Accordingly:

 • Make sure the **Source 1** and **Source 2** pop-up menus are set to **Match girl.tif**.

 • This is a single-layer document, so both **Layer** options are automatically **Background**. No need to change them.

 • Set the first **Channel** option to **Red**. Set the second one to **Green**, as I have in Figure 7-39.

6. **Experiment with Invert and Blending.** This is the least predictable step in the process because the ideal settings vary radically depending on the composition of your image. Bear in mind, the goal is to select the foreground subject by making it white against a deselected black background. This may mean inverting the brightness levels in at least one of the channels. In our case, the subject of the photograph is lighter than her background, so inverting is generally unnecessary, except when combined with a blend mode that inverts the image, such as Difference.

I include a few of my experiments (with slight colorization, to better convey gray values) in Figure 7-40.

- In the first image, I left both Invert check boxes turned off and set the Blending option to Hard Light. This heightened the contrast of the image significantly, but I need more contrast than this to create a good mask. The blend modes Vivid Light and Linear Light push the effect further, but not quite enough.

- Next, I turned on the Invert check box for the Red channel and set the Blending option to Difference. This gave me dark edges against a light background. So I clicked OK to apply the Calculations command. Then I chose Image→Adjustments→Invert to achieve the effect directly to the right. Interesting look, nice edges, but I've lost some distinction between foreground and background on the left side of the woman's head (her right).

- I returned to the RGB composite (Ctrl+⌀ or ⌘-⌀) and choose Image→Calculations again. I turned off the Invert check box for the Red channel. Then I set Blending to Add. This particular blend mode adds the brightness levels in the Red channel to those in the Green channel, which results in an overly bright image. This blend mode includes an Offset value that, when negative, subtracts brightness across the image. I lowered the value to −70, which reduced the luminosity and helped eliminate some of the rampant clipping inherent with Add.

7. *Assign the ideal settings.* In this case, my last experiment comes the closest to what I'm expecting from the finished mask. So, as shown in Figure 7-41:

- Leave the **Invert** check boxes turned off.

- Change **Blending** to **Add**.

- Set the three numerical values (**Opacity**, **Offset**, and **Scale**) to 100 percent, −70, and 1, respectively, as shown on the right.

- The **Result** setting should be **New Channel**. This tells Photoshop to add an alpha channel to hold your mask.

After you do all that, click **OK**. Photoshop adds a new channel to the Channels palette and displays the contents of that channel in the image window.

Red Green Hard Light

Red Green Difference (and Invert)

Red Green Add, Offset: −70

Figure 7-40.

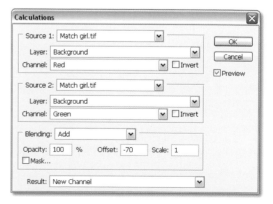

Figure 7-41.

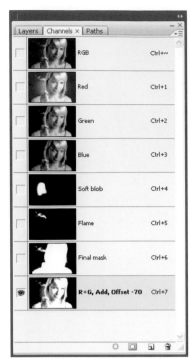

Figure 7-42.

8. *Name the new alpha channel.* Double-click the new **Alpha 1** item at the bottom of the **Channels** palette. I like to name my channels after how I created them, so I called mine "R+G, Add, Offset –70" (see Figure 7-42), but you can call yours whatever you want. Press Enter or Return to accept the new name.

9. *Duplicate the new channel.* Make a copy of the channel you just created by clicking it and then dragging it onto the tiny page icon (⊡, to the left of the trash can) at the bottom of the Channels palette. Double-click the name of the new channel and enter the new name, "1st Levels Adjustment."

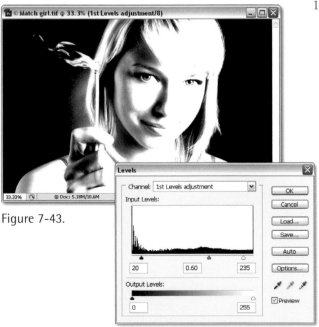

Figure 7-43.

10. *Increase the contrast of the hair.* Choose **Image→Adjustments→Levels** or press Ctrl+L (⌘-L on the Mac). Increase the first value to 20, reduce the second value (the gamma) to 0.60, and reduce the third value to 235. Then click **OK**. As shown in Figure 7-43, these settings do a nice job of increasing the contrast in the right half of the image, helping to better define the hair and shoulders. But the transitions on the left side remain weak, particularly in the highlighted area between the woman's knuckle and the flame. The obvious question is, why not find a better combination of Levels values? Because there isn't one. We can accommodate either the right half of the image or the left, but not both. Unless, that is, we call in another channel.

11. ***Duplicate the seventh channel again.*** Go back to the channel you created in Steps 4 through 8 (the one I called **R+G, Add, Offset –70**) and drag it onto the 🔲 icon at the bottom of the **Channels** palette. After Photoshop duplicates the channel, rename it "2nd Levels Adjustment."

12. ***Increase the contrast of the shoulders.*** Press Ctrl+L (⌘-L) to display the **Levels** dialog box. Change the first value to 160, the second to 1.30, and the third to 235. Then click **OK**. This leaves just 75 brightness levels to express the grays; if there were any fewer, the hairs would start getting jagged and wouldn't look natural. The good news: We've managed to get rid of that pesky highlight (see Figure 7-44).

13. ***Click the Soft Blob channel.*** I created this alpha channel in advance to mask the area where the two Levels adjustment channels diverge. The black area indicates where the First channel is good; the white area is best expressed in the Second channel. How did I create such a sophisticated mask? Using the brush tool and a soft brush, I traced a vague blob around the portion of the image that contains the highlight. That's all there was to it.

14. ***Choose the Calculations command.*** Now to put the blob in play. Choose **Image**→**Calculations** to display the **Calculations** dialog box. Then set the options as follows:

- Set the **Channel** option for **Source 1** to **2nd Levels Adjustment**.

- Set the **Channel** option for **Source 2** to **1st Levels Adjustment**.

- Turn off both **Invert** check boxes.

- Set **Blending** to **Normal**.

- Turn on the **Mask** check box.

- Set the **Image** option to **Match girl.tif**, the image we're currently working in.

- Change the final **Channel** setting to **Soft Blob**.

Click the **OK** button to create the new alpha channel, which appears in Figure 7-45.

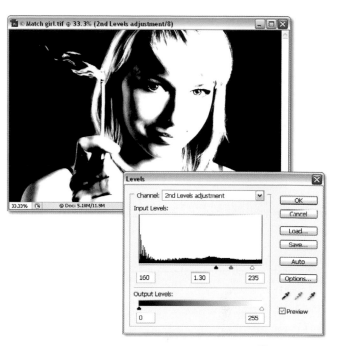

Figure 7-44.

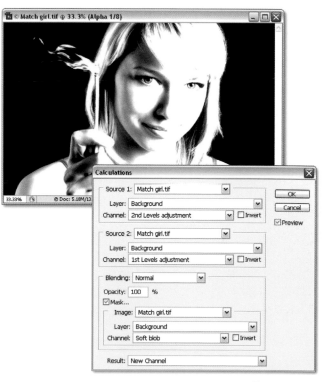

Figure 7-45.

15. *Name the new alpha channel.* Double-click the newest **Alpha 1** item in the **Channels** palette to highlight the channel's name. Then call it "Best of Two" to indicate that it's the best of two different Levels adjustments.

16. *Select the dodge tool in the toolbox.* Now let's clean up the alpha channel by painting inside the image window. But instead of using the brush tool, we'll be lightening and darkening pixels with the dodge tool. Click the dodge tool icon in the toolbox or press the O key.

17. *Change the Range setting in the options bar to Highlights.* You can do this from the keyboard by pressing Shift+Alt+H (or Shift-Option-H). The **Highlights** setting restricts the dodging to only the lightest colors in the mask. Also, change the **Exposure** to 50 percent and enlarge the brush diameter to somewhere between 150 and 200 pixels. For the smoothest results, keep the brush soft (**Hardness**: 0 percent).

18. *Drag over the areas that should be white.* Paint around the shoulders, hand, flame, and hair. (Don't worry about the central stuff such as the face; we'll delete that wholesale in a moment.) Drag as many times as you need to, but be careful not to lighten too much. Used in excess, the dodge tool can expand the selection too far beyond the natural edges of the hair.

For trickier areas like the knuckle, the left shoulder (her right), and the two shoulder straps, try clicking. And when I say click, I mean repeatedly. Click-click-click-click-click. Each click sends the grays farther into remission, fortifying the selection. For example, about twenty clicks directed at the knuckle makes it perfectly white. Think woodpecker.

19. *Change the Range to Shadows.* Or press the keyboard shortcut Shift+Alt+S (Shift-Option-S) to restrict the next round of changes to the darkest colors.

20. *Alt-drag over the areas that should be black.* If you're working on a Mac, press the Option key and drag. As you may recall from Lesson 6, pressing Alt or Option when dragging with the dodge tool burns the image (second bullet, page 211). This modifier permits you to continue using the same brush size and Exposure settings that we established in previous steps.

As ever, beware of overdoing it. Overdarkening can choke the selection and result in transitions that are too sharp. You can rarely go wrong by leaving too many gray pixels, especially around the edges of hairs.

21. ***Lasso the central portion of the image.*** Now to round up all that extraneous junk in the center of the image. Press the L key to get the lasso tool and drag around the interior details. In Figure 7-46, I pressed Alt (Option) and clicked with the lasso tool to draw a polygonal selection. (Of course, you should feel free to use the polygonal lasso if you prefer.)

22. ***Fill the selection with white.*** Press D for the default colors, which are foreground white and background black when working in a mask. Then press Alt+Backspace (Option-Delete on the Mac) to make the face, neck, dress, and straps go away. When the woman looks like one big white mass against a black background, press Ctrl+D (or ⌘-D) to deselect the image.

23. ***Add the enhanced flame.*** The only part of the mask that bothers me is the flame. Don't get me wrong, it's expertly rendered—in fact, too much so. Cropped so tight, I'm afraid the flame will drop away to nothing against its new (and lighter) background. That's why I made a more generous mask for the flame in the Flame channel. Here's how to add it to your current mask:

 • Choose **Image→Calculations**.

 • Change the first **Channel** option to **Best of Two** (your current channel) and the second to **Flame**.

 • Set **Blending** to **Screen**. This keeps the brightest pixels, thus adding the masks together.

 • The **Mask** check box should be off. Then click **OK**.

Figure 7-47 shows the final mask, complete with enhanced flame and proper Calculations settings.

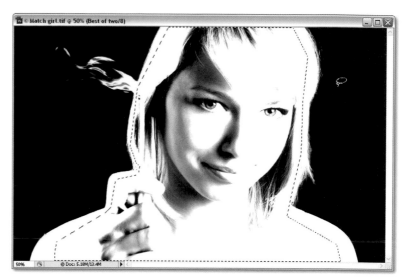

Figure 7-46.

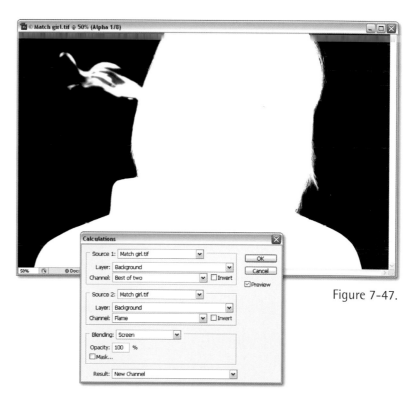

Figure 7-47.

24. *Save your alpha channels.* Rename the new channel "Mask with Enhanced Flame." Then press Ctrl+S (⌘-S on the Mac) or choose **File→Save** to save the changes made to your image, including all five new alpha channels.

Congratulations. Your professional-quality mask is complete. But don't go closing the file. More discoveries await you in the next exercise.

Putting the Mask in Play

At this point, I'd say you owe yourself a pat on the back. Whether you know it or not, you just finished creating and saving one of the Most Closely Held Secrets of the Photoshop Masters, a continuous-tone mask. I mean, how easy was that? Okay, so it took a few more steps than the Extract command. But truth be told, I strung things out a bit in the dodge and burn section. Besides, wait until you get a load of how well this baby works.

In the following steps, you'll use the mask you created in the preceding exercise to select the young woman and set her against the blurry forest. Then you'll adjust the colors of the background, the woman herself, and that tricky flame to create about as perfect a photographic composite as computer imaging allows.

1. *Open the photographs.* If the photos are already open (per my instructions at the end of the last exercise), skip to the next step. If for some reason you had to close the images, go ahead and open *Match girl.tif* and *Forest blur.jpg* from the *Lesson 07* folder inside *Lesson Files-PsCS3 1on1*. Even if you didn't save your changes (Step 24 above)—even if you didn't do the last exercise—no worries, I got your back. There's a finished mask ready and waiting for you.

2. *Load the final mask as a selection.* Inside the **Channels** palette, press the Ctrl key (⌘ key on the Mac) and click the **Mask with Enhanced Flame** channel that you named in Step 24. If you would prefer to work from my mask, Ctrl-click (or ⌘-click) the **Final Mask** item instead.

If you prefer commands, choose **Select→Load Selection** and then choose **Mask with Enhanced Flame** or **Final Mask** from the **Channel** menu. If you hate commands and desire even speedier keyboard techniques, press Ctrl+Alt+6 (or ⌘-Option-6) to load my Final Mask. (If you followed along with me, your final mask is the eleventh channel, which has no shortcut.)

3. **Switch to the RGB image.** You may already be there. If not, click the **RGB** item at the top of the Channels palette—click on the actual word **RGB**—or press Ctrl+⌐ (or ⌘-⌐). The image name in the title bar should end with the parenthetical *RGB/8*.

4. **Drag the young woman into the blurry background.** Press the Ctrl (or ⌘) key and drag the selection from *Match girl.tif* into the *Forest blur.jpg* image window. As with the first example in this lesson, press and hold the Shift key as you drop to center the image in its new background, as illustrated in Figure 7-48.

5. **Match the background to its new subject matter.** It's one thing to have independent foreground lighting; strobes create it all the time. But it's another to have a woman bathed in red against a comparably muted Fall backdrop. Normally, I recommend matching the subject to its background. But this time, I'd like you to do just the opposite:

 • Press the F7 key to switch to the **Layers** palette. Then click the **Background** layer or press Alt+⌐ (Option-⌐).

 • Choose our friend from Lesson 4, **Image→Adjustments→Match Color**.

 • Set the **Source** option to **Forest blur.jpg** and the **Layer** option to **Layer 1**. This tells Photoshop to gather the source colors from the woman-with-flame layer.

 • The effect is nice, but it's too bright to show off that wonderful fake flame. So reduce the **Luminance** value to 10.

 • To offset the pinkness in the sky, back off the **Color Intensity** to 80.

 Click **OK** to invoke the change shown in Figure 7-49. The trees now exhibit a conspicuous rose cast, but it looks great with our red-hot young lady, so I'm okay with it.

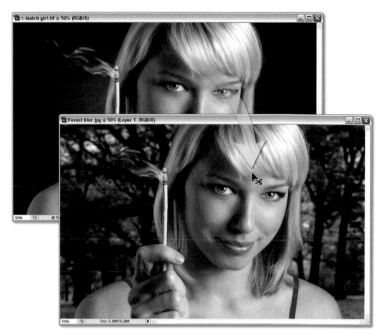

Figure 7-48.

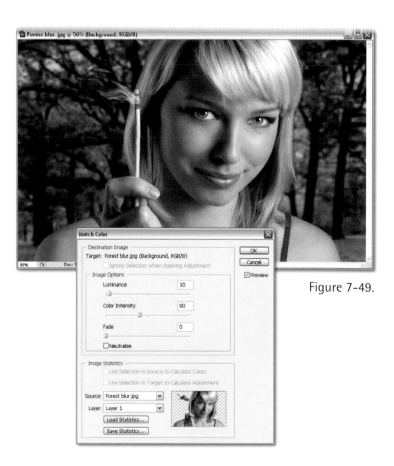

Figure 7-49.

6. **Inspect the edges of the masked image.** Switch back to the top layer, either by clicking **Layer 1** in the Layers palette or by pressing Alt+☐ (Option-☐). Zoom in on the woman and scroll around her head to see the transitions. While the detail of the hair is fantastic, you can make out a dark border around her hair and shoulders that fairly screams "Composite!"—as Figure 7-50 attests. Known as *edge artifacts*, such transitions are virtually impossible to avoid in the masking phase but a snap to fix in the compositing phase.

Figure 7-50.

7. **Apply the Screen blend mode.** Select **Screen** from the upper-left pop-up menu in the Layers palette, or press Shift+Alt+G (Shift-Option-G). Like a slide in a projector, this shines the top layer onto the background. Then press 7 to reduce the **Opacity** value to 70 percent. (On the PC, you may have to first press the Esc key to deactivate the Screen option.) The result appears in Figure 7-51.

Although this step works wonders to get rid of the dark edges, it also messes up the general appearance of the composition. To reinstate the portrait, you'll need another layer.

8. **Duplicate the layer.** Choose **Layer→New→Layer via Copy** or press Ctrl+J (⌘-J).

Figure 7-51.

9. ***Reinstate the Normal blend mode.*** Press the ⊙ key to restore the **Opacity** value to 100 percent. Then choose **Normal** from the pop-up menu at the top of the Layers palette, or press Shift+Alt+N (Shift-Option-N).

10. ***Load the selection outline for the layer.*** Press the Ctrl key (⌘ key on the Mac) and click the thumbnail for the top layer in the Layers palette, presumably **Layer 1 Copy**. (Don't Ctrl-click the layer name or you'll deactivate the layer, which creates problems in future steps.) This operation traces the edges of the layer with a highly accurate selection outline.

11. ***Choose the Contract command.*** Choose **Select→Modify→Contract**, enter a value of 2 pixels, and click **OK**. The Contract command shrinks the size of the selection outline by an even increment all the way around the perimeter of the layer.

12. ***Choose the Feather command.*** Choose **Select→Modify→Feather**, enter a **Feather Radius** value of 1 pixel, and click **OK**. This low pixel value blurs the selection outline by half the previous Contract amount, which will soften the transitions between the colors in Layer 1 Copy and Layer 1 below.

13. ***Click the layer mask icon.*** Click the ◻ icon at the bottom of the Layers palette to convert the selection into a layer mask. The upshot is that everything outside the selection is masked away. This eliminates the fine dark outlines around the layer and reveals the light edges from the layer below, as in Figure 7-52.

Figure 7-52.

14. ***Fix the flame.*** All in all, I'm pretty happy with this composition. Just one problem: the flame. It's opaque. This means there are places where the flame is lighter than its background, and that's just plain impossible. Here's how to make it better:

- The layer mask is probably already active, but just to be sure, click the layer mask thumbnail in the Layers palette.

- Press D and X to set the foreground color to black. Then press B to get the paintbrush. Get yourself a 100-pixel brush and paint over the flame (not the match head). This erases the opaque flame and reveals the lighter version on the Screen layer below.

- Now the flame is too weak. No problem; we can fix that, too. Click **Layer 1** or press Alt+⌷ (Option-⌷) to select the next layer down.

- Press the L key to get the lasso tool. Drag around the flame to select it. (Again, select just the flame, not the match head.)

- Choose **Select→Feather**, enter a **Radius** of 2 pixels, and click the **OK** button. This helps to soften the transitions.

- Press Ctrl+J (or ⌘-J) to copy the flame to a new layer. The flame grows brighter. Press Ctrl+J (⌘-J) again. Brighter still. Press Ctrl+J (⌘-J) a third time. Now that's what I call a flame!

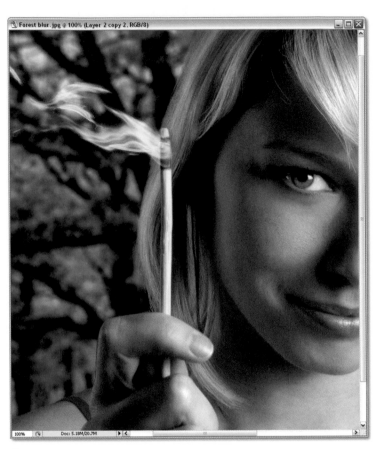

Figure 7-53.

15. ***Recolor the background.*** The composition is impressive, but it'd be even more so if foreground and background weren't so similar in color. Click the **Background** layer to make it active, press Ctrl+U (or ⌘-U) to bring up the **Hue/Saturation** dialog box, change the **Hue** value to +70 degrees and the **Saturation** value to –30 percent, and click **OK**.

Wow, talk about contrast. And yet, even zoomed in, the edges hold up wonderfully (see Figure 7-53). Plus, that flame looks gorgeous. Smokey the Bear might not approve of such reckless match-holding in the midst of all those trees, but even he would have to admit that this is an impressive composition.

WHAT DID YOU LEARN?

Match the key concept in the numbered list below with the letter
of the phrase that best describes it. Answers appear upside-down
at the bottom of the page.

Key Concepts

1. Masking
2. Color Range
3. Fuzziness
4. Mask preview
5. Quick mask mode
6. Alpha channel
7. Save Selection
8. Extract
9. Edge touchup tool
10. Calculations
11. Subtract
12. Edge artifacts

Descriptions

A. This better version of the magic wand tool lets you adjust the range of colors you want to select and see the results dynamically.

B. Any channel beyond the core color channels, used almost exclusively in Photoshop to hold masks.

C. A tool in the Extract dialog box that automatically adjusts pixels along the edges of the extracted image element.

D. A special masking blend mode available in the Calculations dialog box that subtracts the luminosity values in the Source 1 channel from those in the Source 2 channel.

E. A method for creating a selection outline as an independent channel, which you can then edit and save like any other image.

F. A command that erases the pixels outside an image element and leeches the fringe coloring conveyed by the original background.

G. This dynamic setting in the Color Range dialog box gradually fades the selection over a range of luminosity values.

H. Harsh transitions along the edge of a layer that belie your masking efforts and are best fixed when compositing the image against a new background.

I. A dialog box thumbnail or image that shows an ongoing selection outline as a grayscale image, where white selects and black deselects.

J. Saves the selection outline as an alpha channel, which can then be saved with any image file stored in the TIFF or PSD format.

K. This feature lets you press the Q key to view and modify the selection outline as a rubylith overlay.

L. A command in the Image menu that lets you blend two channels to form a new alpha channel that will eventually serve as a mask.

Answers

FOCUS AND FILTERS

PHOTOSHOP CS3 offers more than a hundred *filters*. Although Photoshop's filters were named for the interchangeable camera lenses once commonly used to adjust and tint a scene before it was captured on film, comparing them to *anything* is an exercise in futility. Some filters modify the contrast of neighboring pixels, others trace the contours of a photograph, still others deform an image by moving pixels to new locations. (See Figure 8-1 for examples.)

Original photograph istockphoto.com/humonia

Original photograph | Filter→Blur→Surface Blur | Filter→Artistic→Colored Pencil | Filter→Distort→Glass

Figure 8-1.

If I had to come up with a definition for filters, I would call them a loosely associated collection of commands—some easy to use, others quite complex—that apply effects to an image. Otherwise, filters are as varied as they are abundant. As parlor tricks, filters rate high marks. But as a rule, they make better time-wasters than tools. So for the sake of expediency, I'll spend this lesson homing in on a small handful of representative filters that serve a corrective or creative purpose. These

ABOUT THIS LESSON

Project Files

Before beginning the exercises, make sure you've installed the lesson files from the DVD, as explained in Step 3 on page xvii of the Preface. This should result in a folder called *Lesson Files-PsCS3 1on1* on your desktop. We'll be working with the files inside the *Lesson 08* subfolder.

In this lesson, I explain ways to modify the perceived focus of a photograph to account for slight blurriness, grain, noise, and other imperfections. You'll learn how to:

Video Lesson 8: Filter Basics

In a program that seems to pride itself on its crowded menus, Photoshop's Filter menu is the most jam-packed of them all. Its commands (known generically as *filters*) range from extremely practical to wonderfully frivolous to just plain lame.

We're not going to look at *all* the filters—that would be pointless—just the best ones. To get a sense for how they work—as well as how to adjust their results—watch the eighth video lesson on the DVD. Insert the DVD and double-click the file *PsCS3 Videos.html*. Then click **Lesson 8: Filter Basics** under the **Masking, Focus, and Layers** heading. The 16-minute, 28-second movie discusses operations that are served by the following options and shortcuts:

Command or operation	Windows shortcut	Macintosh shortcut
Add a filter inside the Filter Gallery	Click the ⬒ icon	Click the ⬒ icon
Hide or show thumbnails in the Filter Gallery	Click the ⊗ or ⊗ icon	Click the ⊗ or ⊗ icon
Fade last-applied filter	Ctrl+Shift+F	⌘-Shift-F
Unsharp Mask	Shift+F5*	Shift-F5*
Adjust selected value incrementally	↑ or ↓	↑ or ↓
Adjust selected value by 10x increment	Shift+↑ or ↓	Shift-↑ or ↓

* Works only if you loaded the dekeKeys keyboard shortcuts (as directed in Steps 7 through 9 beginning on page xviii of the Preface).

include the new Vanishing Point filter, which lets you select and retouch an image in a simulated three-dimensional environment, as well as that perennial favorite Liquify, which lets you stretch and distort pixels to modify the structure of a face or other element. First, however, we're going to explore the Smart Sharpen filter, which I regard as the most practical filter in all of Photoshop.

The Subterfuge of Sharpness

When an image is formed by the camera lens, its focus is defined. The moment you press the shutter release, you accept that focus and store it as a permanent attribute of the photograph. If the photograph is slightly out of focus, it stays out of focus. No post-processing solution can build more clearly defined edges than what the camera actually captured, or fill in missing or murky detail. So how is it that we can do a lesson on adjusting focus? We fake it. Although Photoshop can't reach back into your camera and modify the lens element for a better shot, it can *simulate* the appearance of better focus by comparing neighboring pixels and enhancing the already existing edges. Your eyes think they see a differently focused image, but really they see an exaggerated version of the focus that was already there.

Consider the photos in Figure 8-2. The first comes from a high-resolution image that was shot to film and then scanned. This macro shot includes a generous depth of field, with the focus varying from dead-on in the eyes to soft as the creature's scales bulge toward us or recede away. The second and third images show variations imposed by Photoshop. Softening blurs the pixels together; sharpening exaggerates the edges. Softening bears a strong resemblance to what happens when an image is out of focus. Sharpening is a contrast trick that exploits the

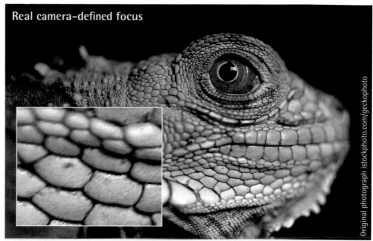

Real camera-defined focus

Original photograph istockphoto.com/geckophoto

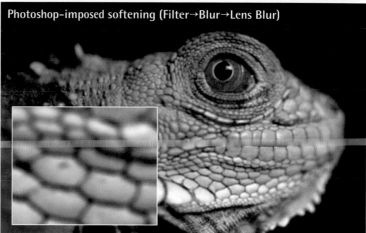

Photoshop-imposed softening (Filter→Blur→Lens Blur)

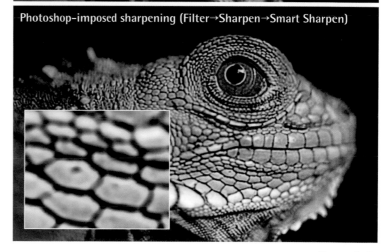

Photoshop-imposed sharpening (Filter→Sharpen→Smart Sharpen)

Figure 8-2.

way our brains perceive definition, particularly with respect to distant or otherwise vague objects. A highly defined edge with sharp transitions between light and dark tells us where an object begins and ends.

But so what if it's a contrast trick? Does that say less of Photoshop's sharpening capabilities? After all, photography itself is a trick that simulates reality, very specifically geared to human eyes and brains. If Photoshop's sharpening augments that trick, more power to it. I just want you to know what you're doing. After all, the magician who truly understands his bag of tricks is better equipped to perform magic.

Sharpening an Image

Of the five filters that reside in the Filters→Sharpen submenu, only two, the ancient Unsharp Mask and the Smart Sharpen filters, let you control the amount of sharpening you apply to an image. As a result, they do everything the other three filters do—which isn't much, frankly—plus a whole lot more.

Unsharp Mask derives its name from an old and largely abandoned traditional darkroom technique in which a photographic negative was sandwiched together with a blurred, low-contrast positive of itself and printed to photographic paper. Ironically, this blurred positive (the "unsharp" mask) accentuated the edges in the original, resulting in the perception of sharpness.

To see how Unsharp Mask's arcane origins translate to the way Photoshop's sophisticated sharpening functions work, read the upcoming sidebar "Using Blur to Sharpen" on page 272.

Once upon a time, Unsharp Mask was the only professional-level sharpening tool in town. Now it takes a back seat to Smart Sharpen, which is essentially Unsharp Mask: Extreme. That is to say, it includes the best elements of the Unsharp Mask filter, plus it offers several additional controls. Although Smart Sharpen still lacks the power to generate detail that doesn't exist (for that, you'll have to wait for the Magical Fairy Sharpen filter), I can say with some confidence that it has altogether usurped the title of "Undisputed Sharpening Champion" from the once-mighty Unsharp Mask. Which is why we'll focus exclusively on Sharp Sharpen in this exercise.

1. ***Open a couple of images.*** Go to the *Lesson 08* folder inside *Lesson Files-PsCS3 1on1*, and you'll find two photos of a great taxidermied grizzly, *Soft bear.jpg* and *Motion bear.jpg* (see Figure 8-3). Shot without a flash while visiting a fearsome restaurant in Michigan's famed Upper Peninsula, both images have slight focus problems. The first image suffers from a tiny amount of *lens blur*, meaning that it's a bit off from its ideal focus. The second image has a bigger problem. Understandably nervy in the face of such an imposing set of chompers, I moved the camera while the shutter was open. Hence, the resulting image is in motion.

2. ***Bring the lens blur image to the front.*** We'll start with *Soft bear.jpg.* Click its title bar to make sure it's active and ready for edits.

3. ***Choose the Smart Sharpen filter.*** Go to the **Filter** menu and choose **Sharpen→Smart Sharpen** to display the **Smart Sharpen** dialog box, complete with a cropped preview (see Figure 8-4). When the **Preview** check box is turned on, Photoshop applies the effect to the larger image window as well. On by default, I can think of only two reasons to turn Preview off: first, if you want to compare before-and-after versions of an image, and second, if you're working on a very large image and the program just can't keep up with your changes.

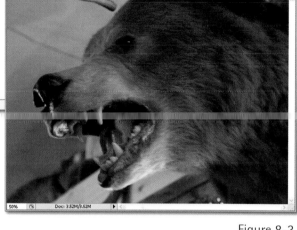

Figure 8-3.

Virtually every image you edit will require some amount of sharpening. That means you'll be choosing Smart Sharpen a lot. To save you some effort (the damn thing's in a submenu, after all), I've assigned it a shortcut. If you loaded dekeKeys as I advised in the Preface, you can invoke Smart Sharpen by pressing Shift+F6. My logic? Smart Sharpen has two S's; so do Shift and 6 (of F6). For whatever reason, that's been enough to stick it in my head.

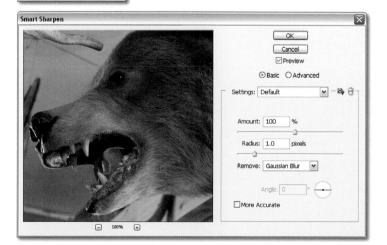

Figure 8-4.

4. **Set the zoom ratios for the image previews.** Press Ctrl+Alt+⊡ (⌘-Option-⊡) to set the image window to the 100 percent view size. Then click a couple of times on the ⊟ below the preview inside the dialog box to reduce that preview to 50 percent. Now you have two ways to gauge the results of your changes.

Why did I use 100 and 50 percent? Because the 100 percent view shows you every pixel in the image, and the 50 percent view more closely represents its appearance when printed, at which point more pixels are packed into a smaller space. Also worth noting, 50 percent is an interpolated zoom, meaning that Photoshop properly smooths over pixel transitions. By comparison, odd zoom ratios such as 67 and 33 percent are jagged and misleading.

5. **Set Remove to Lens Blur.** The default setting for the **Remove** option—Gaussian Blur, which highlights edges in gradual, circular patterns—duplicates the one and only behavior of the Unsharp Mask filter. And although it does a serviceable job, the **Lens Blur** setting enjoys a higher degree of accuracy and is better suited to reversing the effects of the soft focus, particularly in digital photography. Think of it as Photoshop's next-generation sharpening algorithm.

6. **Increase the Amount value.** Set the **Amount** value to the maximum value, 500 percent. This is a temporary setting that exaggerates the effect and permits us to see what we're doing.

7. **Specify a Radius value of 4 pixels.** Even though Radius is the second value, we'll play with it first because it's really the linchpin of the sharpening operation. Like Unsharp Mask before it, Smart Sharpen simulates sharper transitions by drawing halos around the edges (see "Using Blur to Sharpen," page 272). The Radius value defines the thickness of those halos. Thin halos result in a precise edge; thick halos result in a more generalized high-contrast effect. A few examples appear in Figure 8-5.

The best Radius value is the one you can just barely see. What you can see depends on how your final image will be viewed:

- If you intend to display the image on screen (say, as part of a Web page or PowerPoint presentation), enter a very small value, between 0.5 and 1.0 pixel.

- For medium-resolution printing, a Radius value of 1.0 to 2.0 pixels tends to work best.

- For high-resolution printing, I recommend a Radius between 2.0 and 4.0 pixels.

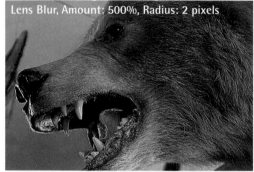

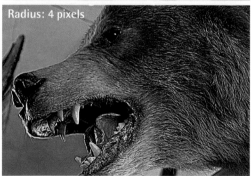

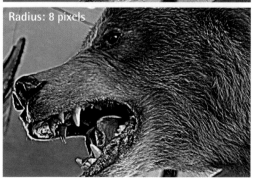

Figure 8-5.

The examples in Figure 8-5 were printed at 356 pixels per inch, so the 4-pixel Radius delivers the best edges. (For more information on print resolution, read Lesson 12, "Printing and Output.") A smaller Radius value will most likely look better on your screen, but for now, I'd like you to imagine you're going to print, so enter a **Radius** value of 4.

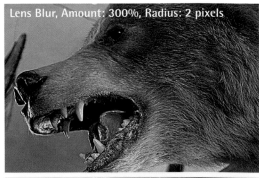

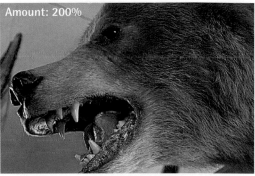

Use the up and down arrow keys to nudge the selected value by its smallest increment: 0.1 in the case of Radius, 1 in the case of Amount. Add Shift to nudge 10 times that increment.

8. *Lower the Amount value to 200 percent.* The Amount value controls the degree to which the image gets sharpened. Higher values result in more edge contrast. The effects of the Amount value become more pronounced at higher Radius values as well. So where 300 percent might look dandy with a Radius of 2 pixels, the effect may appear excessive at a Radius of 4 pixels. An image exposed to too high an Amount value is said to be *oversharpened*, as is presently the case for our bear.

Press Shift+Tab to highlight the **Amount** value. Then experiment with the setting by pressing Shift+↓ a few times, which lowers the Amount in 10 percent increments. Figure 8-6 shows a few examples. The top image is too harsh, the bottom image is too soft, the middle one is just right. (Forgive my storybook analogy, but this is a *bear*, people.) So do like me and set the value to 200 percent.

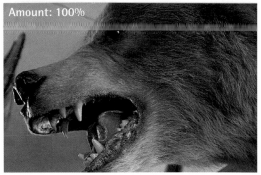

Figure 8-6.

9. *Leave the More Accurate check box turned off.* The dialog box ends with a new and improved Threshold called More Accurate. On first blush, you might assume you should turn this option on. After all, who doesn't want a more accurate sharpening effect? But it's a little more complicated than that:

- Turn on More Accurate to burrow into the image and extract all the edges the filter can find.

- Leave More Accurate turned off, as by default, to trace only the most pronounced edges.

Using Blur to Sharpen

The "unsharp" that drives both Unsharp Mask and its successor Smart Sharpen is a function of the softly tapering halo applied by the Radius value. Once you understand this concept, you can master the art of focus in Photoshop.

Consider the line art in the figure below. The top-left image features dark lines against a light background. The other three are sharpened with increasingly higher Radius values. Throughout, the Amount value is 200 percent and the Reduce pop-up menu is set to Gaussian Blur. In each case, the sharpening filter traces the dark areas inside the lines (the brown areas) with a blurry dark halo and the light areas outside the lines (the green areas) with a blurry light halo. Regardless of the Reduce setting—Gaussian Blur, Lens Blur,

or Motion Blur—the thickness of these halos conforms to the Radius values.

Given that the Radius value is all about blurring, it's no surprise that this option also appears in the Gaussian Blur dialog box, where it once again generates halos around edges. In fact, if we were to trace the lineage of these filters, Gaussian Blur is Unsharp Mask's grandparent, which in turn witnessed the birth of Smart Sharpen. It's downright biblical, I tell you. The missing family member in between is an obscure command called High Pass.

Why should you care? Because Unsharp Mask's parent, High Pass, is in some ways a more flexible sharpening agent than its first- or second-generation progeny.

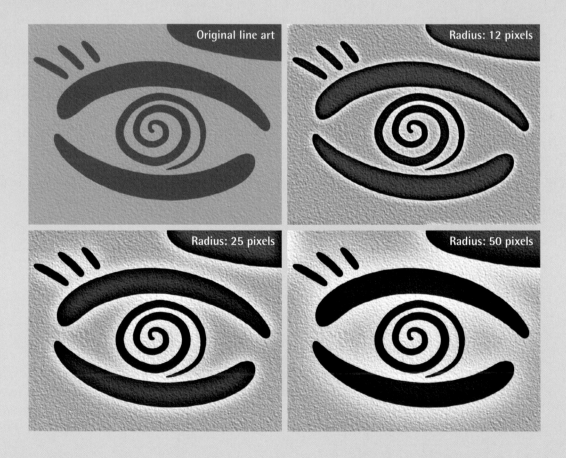

Try this: Open *Soft bear.jpg*. (If it's still open from the "Sharpening an Image" exercise, press F12 to revert the image to its original appearance.) Then press Ctrl+J (or ⌘-J) to copy the image to an independent layer. Now choose **Filter→Other→High Pass**. Pictured below, the High Pass dialog box contains a single option, **Radius**. Change this value to 4 pixels, the same Radius you applied in the exercise using Smart Sharpen. Then click **OK**.

Looks like a big mess of gray, right? But there are tenuous edges in there. To bring them out, press Ctrl+L (or ⌘-L) to display the **Levels** dialog box. Change the first and third **Input Levels** values to 75 and 180 brightness levels, respectively, as in the figure below. Then click **OK**.

Still looks terrible. But what you're looking at are the very same light and dark halos that Smart Sharpen creates. To apply those halos to the original photograph, go to the **Layers** palette and choose **Overlay** from the top-left pop-up menu. Just like that, Photoshop drops out the grays, blends in the edges, and makes it all better, as shown below. The result is almost exactly what you'd get if you applied the Smart Sharpen filter with a Reduce setting of Gaussian Blur, a Radius of 4 pixels, and an Amount of 200 percent. (In other words, the current High Pass layer has more than twice the impact of a default application of Smart Sharpen.) You can now freely adjust the Amount by reducing the top layer's Opacity setting until you're satisfied. To my eyes, an **Opacity** setting of around 60 percent works great.

Why go through all this just to get the same effect we achieved in the exercise? Because now you have a floating layer of sharpness whose Amount you can change at any time by adjusting the layer's Opacity setting. This means you can change your mind well into the future, as opposed to being locked into the static result of Smart Sharpen. And because it's a separate layer, you even have the option of limiting the area that you sharpen by adding a layer mask. It's an unusual approach—especially in light of Photoshop CS3's new smart filters (which we'll discuss in Lesson 11)—and it takes a bit of experience to get it down pat. But given the importance of sharpening in digital imaging, it helps to have a versatile filter like High Pass at your disposal.

Counterintuitive as it may seem, you usually don't want to enhance all edges in an image, just the major ones. Two reasons for this: First, slight edges—such as those produced by film grain, noise, and skin blemishes—are often bad edges. Do you really want to sharpen someone's pores? Second, More Accurate more than doubles the amount of time it takes the filter to preview and apply an effect. When editing a high-resolution, noiseless product shot—in which you want to see every last detail—More Accurate can work wonders. But for portraits and day-to-day work, I generally recommend you leave it off.

10. *Save and apply your settings.* Because the Smart Sharpen options are so complex—even more so than we've seen thus far—it's a good idea to save your settings for later use. Click the tiny disk icon (🖫), name the settings "Soft Bear" (see Figure 8-7), and click **OK**. Now your settings are ready and waiting for later use. Click **OK** again to apply those settings to the image.

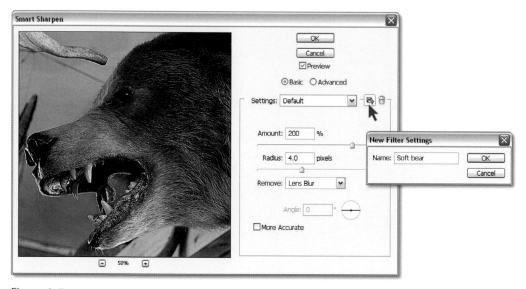

Figure 8-7.

Look closely at the side of the bear's face and notice the bright purple striations woven into the fur. The filter can't distinguish color detail from luminosity detail, so it exaggerates the contrast of the hue, saturation, and brightness of an image in equal amounts. To return the colors to their previous appearance—free of purple—while retaining the sharpness, drop out the colors as explained in the next step.

11. *Fade the Smart Sharpen filter.* Choose **Edit→ Fade Smart Sharpen** or press Ctrl+Shift+F (⌘-Shift-F) to display the **Fade** dialog box. Then choose **Luminosity** from the **Mode** pop-up menu and click **OK**. Photoshop merges the new sharpness with the original colors, as illustrated in Figure 8-8. This technique is so extraordinarily useful that you may want to follow up every application of the Smart Sharpen filter with a preventative dose of the Fade command. Because whether you see the aberrant colors or not, they're there, just beyond view, ready to spring forth when you print the image.

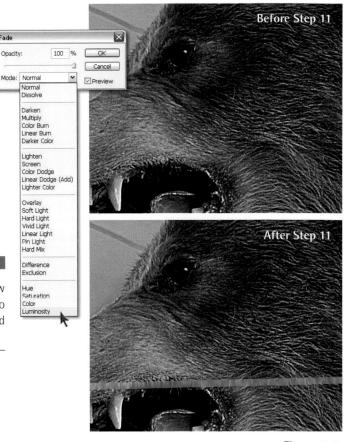

12. *Bring the second image to the front.* That takes care of the first photograph. How about the second one? Bring the *Motion bear.jpg* image forward so you can work on it, either by clicking its title bar or selecting its name from the bottom of the **Window** menu.

13. *Again display the Smart Sharpen dialog box.* But don't choose Filter→Sharpen→Smart Sharpen. Instead, bring up the **Filter** menu and notice that the first command now reads Smart Sharpen, as in Figure 8-9. Choosing this command would reapply the filter with the same settings as before, so don't do that. Instead, let go of the menu for a moment. Then press and hold the Alt key (Option on the Mac) and choose **Filter→Smart Sharpen**. Or better yet, press the keyboard shortcut Ctrl+Alt+F (⌘-Option-F). Photoshop revisits the **Smart Sharpen** dialog box, permitting you to apply the filter with different settings.

Figure 8-8.

Figure 8-9.

14. ***Set Remove to Motion Blur.*** This photograph suffers from motion blur, so select **Motion Blur** from the **Remove** pop-up menu. At first, it may seem like the filter is making the image blurrier, which it may. The Motion Blur setting replicates the image at a specific distance, as determined by the Radius value and Angle. If the Radius and Angle are set wrong, as they are by default, the filter won't do any good. Let's remedy that.

Real fang

Ghost fang

Figure 8-10.

15. ***Set the Angle to –5 degrees.*** Somehow, you have to determine the angle at which I moved the camera and set the Angle value accordingly. The hair is too thick and random to make sense of it. So I suggest you judge the angle just as you might judge the health of the animal—by looking at its teeth. In particular, zoom in on the carnivore's savage fangs. As documented in Figure 8-10, each fang is haunted by a light "ghost" fang, which trails behind about five pixels to the left and a quarter pixel or so above. You can drag the line inside the circle to the right of the Angle option until it seems to match. Or set the **Angle** to my best guestimate, –5 degrees.

16. ***Set the Radius value to 11 pixels.*** When using the Motion Blur setting, I find that the Radius value works best when set to about twice the distance of the movement. We're looking at roughly 5 pixels of horizontal movement and a fraction of vertical movement. Normally, this would be a great time to whip out Pythagorean's theorem, but I'm feeling merciful. Let's just take 5 and some change, multiply it by 2, round up, and satisfy ourselves with a **Radius** value of 11 pixels.

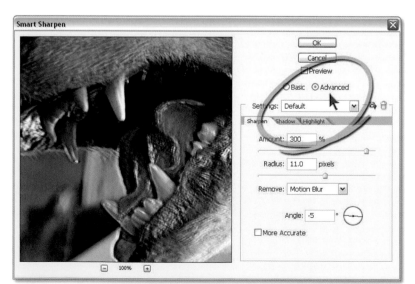

Figure 8-11.

17. ***Raise the Amount value.*** This image is a blurry mess, so it's not surprising that it requires more sharpening than the first one. Click the word **Amount** and raise the value to 300 percent.

18. ***Click the Advanced option.*** If you take a look at the fur, you'll see that it's a bit "crunchy," with perhaps too much contrast between lights and darks. Plus, there are those purple highlights again. Fortunately, Smart Sharpen still has a couple of tricks up its sleeve. Click the **Advanced** radio button to reveal two additional tabs of options, Shadow and Highlight (circled in Figure 8-11),

which allow you to fade away the extreme darks and lights created by the Smart Sharpen filter.

19. *Fade the shadows.* Click the **Shadow** tab and increase the **Fade Amount** value to 20 percent. This option works like an inverted Opacity value, so the blacks become 20 percent more transparent, or 80 percent opaque. The result is softer shadows.

20. *Fade the highlights.* The highlights could likewise use some reining in. Click the **Highlight** tab and set the **Fade Amount** value to 20 percent. But nothing happens. That's because Smart Sharpen's notion of highlights is too limited. To broaden the definition, raise the **Tonal Width** value to 100 percent. The highlights, including the purple striations, recede.

21. *Raise the Amount value further.* Having nicely tempered the shadows and highlights, we've gone and reduced the impact of the effect. So we need to compensate by raising the Amount value. Click the **Sharpen** tab to return to the familiar controls. Then increase the **Amount** value to 400 percent.

22. *Save and apply your settings.* Click the ▤ icon and name your newest settings "Motion Bear." Then click **OK** twice to apply the Smart Sharpen filter to the blurry photograph. The resulting image is definitely better but not great. Just eyeballing it, I'd say it's about as sharp as the *Soft bear.jpg* file was when we first opened it. Makes you think we might be able to bring the *Motion bear.jpg* photo up to speed by repeating the Soft Bear settings, huh? Well, I reckon it's worth a shot.

23. *Repeat the Soft Bear settings.* Press Ctrl+Alt+F (⌘-Option-F) to again display the **Smart Sharpen** dialog box. Choose **Soft Bear** from the **Settings** pop-up menu to restore the Lens Blur setting as well as the Amount and Radius values you saved back in Step 10. Then click **OK**.

PEARL OF ⬤ WISDOM

Congratulations, you just performed what would have been a cardinal sin with just about any other filter, including Unsharp Mask—you applied a filter twice in a row to the same image. But it's actually okay. The Remove option changes the fundamental behavior of Smart Sharpen. So having Remove set to Motion Blur in one pass and Lens Blur in another is tantamount to applying two different filters. Besides, you can't compensate for motion blur and lens blur in one pass of the Smart Sharpen filter. So for better or for worse, what choice do you have but to apply the filter twice?

Figure 8-12.

24. *Once more, fade the Smart Sharpen filter.* No doubt about it, the image is sharper. In fact, it's too sharp. So go ahead and press Ctrl+Shift+F (⌘-Shift-F) to display the **Fade** dialog box. Change the **Mode** to **Luminosity**. And because the filter went too far, reduce the **Opacity** value to 50 percent. Then click **OK**.

The final sharpened versions of both bears appear in Figure 8-12. Amazingly, the *Motion bear.jpg* photo holds up remarkably well. Bear in mind (in fact, I have a rather specific bear in mind) that Smart Sharpen is no miracle cure. But it's a welcome improvement on Unsharp Mask.

Using the Vanishing Point Filter

Despite Photoshop's considerable and much-ballyhooed capabilities, it typically confines you to the two dimensions of your canvas, height and width. Granted, you can add bevels and drop shadows to simulate depth, but unless you own Photoshop CS3 Extended—which offers 3D layers (but still no ability to create, model, or build images in 3D)—there's precious little in the way of three-dimensional imaging tools. And that precious little goes by the name of Vanishing Point.

The Vanishing Point filter lets you edit an image in perspective. Mind you, it doesn't miraculously bring your 2D layers into 3D space, but it does a heck of a job pretending. The filter lets you divide your canvas into a series of rectangular planes that match the angles of the actual objects and surfaces in the photograph. Then you can move, paint, clone, and even heal areas of your image within that simulated 3D space. It takes a little bit of time to set up the planes, and the tools don't always work the way you might expect them to. But I think you'll agree that Vanishing Point opens a whole world—or at least another dimension—of image-editing flexibility and fun.

1. *Open a photograph that contains obvious perspective.* Open the file *Dingy subway.psd* located in the *Lesson 08* folder inside *Lesson Files-PsCS3 1on1*. Captured by Josef Kubicek, this Czech subway platform could use some sprucing up. Fortunately, its obvious perspective (see Figure 8-13) makes it a perfect candidate for Vanishing Point.

Vanishing Point is ultimately a flat imaging tool, meaning that it works from the merged version of all visible layers. But it delivers its results to the active layer. The upshot is that you should *always* create a new layer before choosing Vanishing Point. This makes it easier to edit the results of the filter and protects the original image from harm.

Figure 8-13.

2. *Create a new layer.* Choose **Layer→New→Layer** or press the shortcut Ctrl+Shift+N (⌘-Shift-N on the Mac) to add a new layer to the **Layers** palette. When invited to name the layer, call it "Perspective Edits" and click **OK**.

3. *Choose the Vanishing Point filter.* Choose **Filter→Vanishing Point** or press Ctrl+Alt+V (⌘-Option-V) to reveal the **Vanishing Point** window, which appears in Figure 8-14. Vanishing Point is really a separate application that runs inside Photoshop, so it may take a few moments to load.

4. *Select the create plane tool.* Before we can edit the image in 3D space, we have to define that space. And that's the purpose of the create plane tool. The tool should be active by default. If it isn't, click the ⊞ in the top-left corner of the window or press the C key.

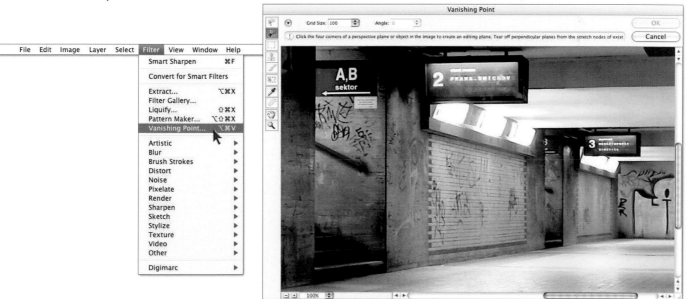

Figure 8-14.

5. ***Draw a four-cornered plane against the middle wall.*** Zoom in on the second of three walls along the left side of the subway station. As shown in Figure 8-15, you'll probably want to magnify the image to 200 percent. Then create the first plane by clicking at each of four points in the image preview. I recommend that you start by clicking the top-left corner of the tiles, identified by ❶ in the figure. This sets the first corner of the plane. Then click on spots ❷, ❸, and ❹ to complete the plane, as illustrated in the figure.

Create plane tool

Zoom in to 200%

Click at each of the four corners around the middle wall

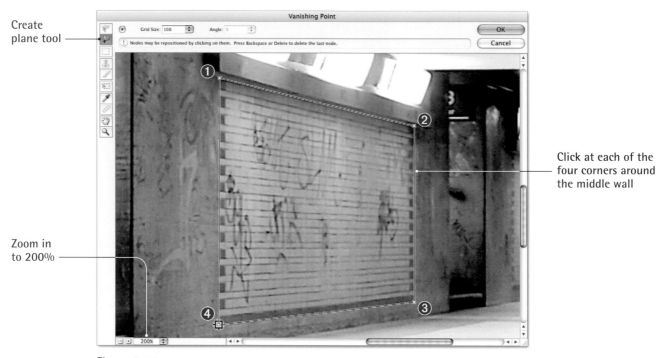

Figure 8-15.

To magnify the location directly under your cursor by an additional factor of 2, press and hold the X key. Release the X key to return to the original zoom level. This technique works when using any tool inside the Vanishing Point window.

6. ***Adjust and expand the plane.*** After you finish drawing your plane, Vanishing Point automatically switches you to the edit plane tool (⬉⊞), which lets you adjust the position, shape, and size of the plane. With any luck, your plane appears as a blue grid. If the grid is yellow, the filter has problems with it; if it's red, something's terribly wrong. In either case, you'll need to adjust the plane by dragging one or more corner handles until the grid turns blue, indicating that Vanishing Point is happy.

After you achieve a blue grid, you can expand it to cover the entire left side of the station. Zoom out to see more of the image. Drag the top and bottom handles to the top and bottom edges of the wall. Then drag the left side handle all the way beyond the left edge of the canvas; and drag the right side handle until the grid meets with the back wall, as in Figure 8-16.

Drag left side of grid beyond canvas

Drag right edge of grid to back wall

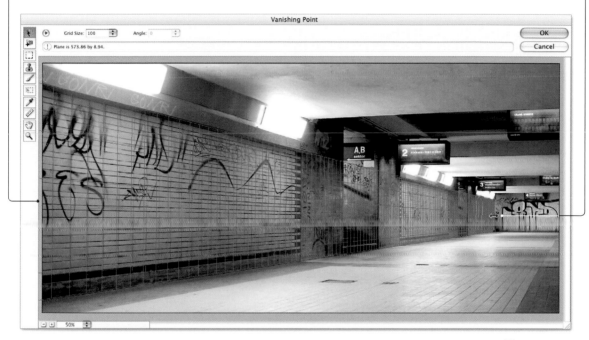

Figure 8-16.

7. *Drag out a perpendicular plane.* We'll place a grid over the back wall by creating a plane that runs perpendicular to the current one. Press Ctrl (⌘ on the Mac) and drag the right side handle (see Figure 8-17). Instead of expanding the plane, you get a new plane attached to the original one at a right angle.

Ctrl-drag (⌘-drag) perpendicular plane

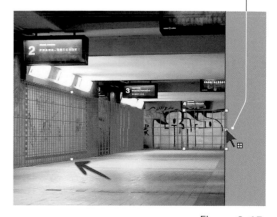

If the new plane is skewed or at the wrong angle, that means the original grid isn't in perfect alignment with the scene. Press Ctrl+Z (⌘-Z) to undo the new plane. Then drag the four corner handles until they're perfectly aligned with the left wall. When everything looks ship-shape (or subway-shape in this case), repeat Step 7 and see if it doesn't work better.

8. *Complete the grid.* Press the Ctrl (or ⌘) key and drag the bottom handle of the main left plane—the one with the little red arrow pointing to it in Figure 8-17—to stretch another perpendicular plane along the floor. Your completed 3D wireframe should look like the one in Figure 8-18 on the next page.

Figure 8-17.

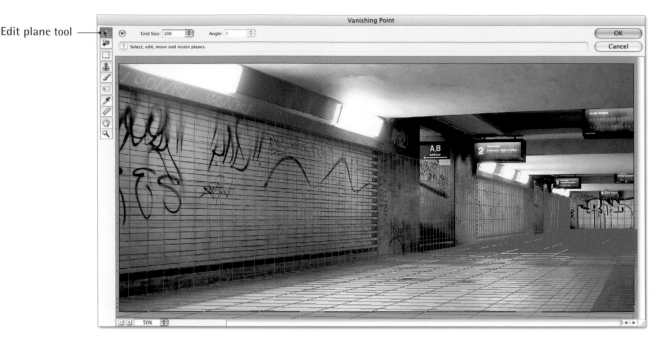

Figure 8-18.

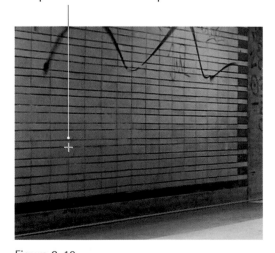

Figure 8-19.

9. **Save your planes.** This is a tenuous moment in the life of your planes. If you were to click the Cancel button or press Esc—for heaven's sake, don't!—Photoshop would abandon your planes, leaving you no other option than to redraw them. So let's take a moment to save the planes, like so:

 • Click **OK** to accept the planes and exit Vanishing Point.

 • Choose **File→Save** or press Ctrl+S (⌘-S) to save the planes with the file. Vanishing Point is the only command under the Filter menu that lets you save its internal settings along with an image file.

 • Again choose **Filter→Vanishing Point** to regain access to your saved planes.

10. **Switch to the stamp tool.** Now it's time to get out the spit and polish and give this grimy subway station a good working over. We'll start by cloning away the graffiti on the near wall. You clone inside Vanishing Point much as you do with the healing brush (see "Healing and Patching," Lesson 6, page 212). The main difference is that you use the stamp tool. Click the fourth tool down on the left side of the window or press the S key. The grid lines disappear but the planes remain in force.

11. **Set a clone source.** Press the Alt (or Option) key and click a graffiti-free intersection of the bricks—as indicated by the cross cursor in Figure 8-19—to set a source point for your cloning.

With your source set, notice a behavior that significantly improves upon the regular healing brush: Your brush shows the source pixels, before you even start painting. Now try moving the brush around the different planes and watch as it pops into the correct perspective. Nice.

12. *Set the stamp tool options.* Vanishing Point offers tool options at the top of the dialog box. Here's how I want you to set them:

- Set the **Diameter** to 175 pixels. As elsewhere, you can change the brush size by pressing the bracket keys, ⬚ and ⬚.

- Set **Hardness** to 80 percent. (Shift+⬚ and ⬚ work, too.)

- Leave the **Opacity** value set to 100 percent.

- Set the **Heal** option to **On**. This tells the stamp tool to mimic the healing brush and blend pixels as you paint.

- Make sure the **Aligned** check box is turned on.

13. *Clone away the graffiti.* Align the source pixels in your brush with an area covered in graffiti until the bricks match up perfectly, as in Figure 8-20. Then paint a series of short, careful strokes to heal away the graffiti. If your source pixels dip into the wrong area, press Ctrl+Z (⌘-Z) to undo, Alt-click (Option-click) to sample a new area, and continue painting until the tiles are free of graffiti, as in Figure 8-21. Feel free to change the brush size and hardness to get into those hard-to-reach places.

Move cursor to see the source superimposed over the image

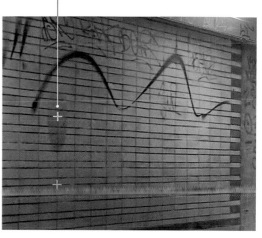

Figure 8-20.

Stamp tool

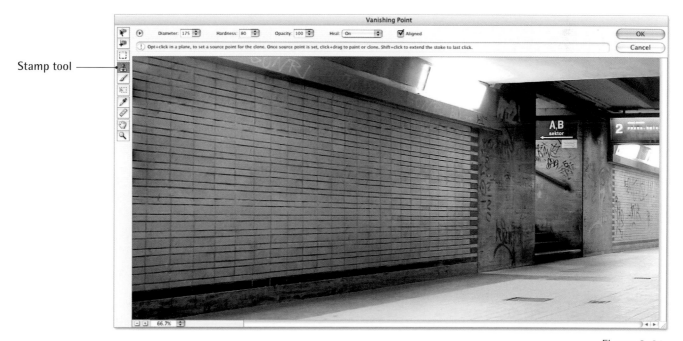

Figure 8-21.

As you work, you'll see that the walls are covered in diagonal scuff marks. As far as I know, these scuffs are part of the actual scene—at least, they aren't artifacts of previous image editing on my part. If you want to clean them up, knock yourself out, but I for one just cloned the scuffs over the graffiti.

Figure 8-21 (on the preceding page) shows the scrubbed walls without the plane edges. I did this by turning off Show Edges, which you get by clicking the ⊙ arrow in the top-left corner of the window. You could also press Ctrl+H (or ⌘-H). Press Ctrl+H again to bring the edges back.

14. *Switch to the marquee tool.* You can also patch over areas in an image using selection outlines. For example, now that we have a nice clean area of wall, we can use it to clean up the other walls with the help of the marquee tool. Click the third tool icon down or press the M key to select the marquee tool.

15. *Draw a marquee around the middle wall.* Zoom in on the middle wall—the one we used to orient the very first plane in Step 5—and drag around it with the marquee tool. Vanishing Point automatically pivots the rectangular region in perspective, as in Figure 8-22.

You know that wonderful spacebar trick that lets you move a marquee on-the-fly during the course of normal editing in Photoshop? Well, I hate to be the bearer of bad tidings, but this trick doesn't work inside Vanishing Point and there is no equivalent. So take care to draw your marquee properly the first time. After you draw the marquee, you can move it by dragging in the selected area or by pressing an arrow key.

16. *Set the marquee options.* At the top of the dialog box, set the **Feather** value to 5 pixels and change the **Heal** setting to **On**. The latter turns the marquee into a rectangular patch tool. Leave the **Move Mode** set to **Destination**. This setting isn't exactly what we want, but thanks to a keyboard trick, it doesn't matter.

17. *Clone the closest wall onto the middle wall.* Zoom out to view your entire image. Then press and hold the Ctrl (or ⌘) and Shift keys and drag the selection to the left. (You must have the keys down for this technique to work.) The pixels inside the marquee change to display the area over which you drag. Line up the vertical column of darker bricks in the source with the same bricks in the middle wall. As shown in Figure 8-23 on the facing page, this leaves some light pixels on the left side of the selection. When your screen matches the figure, release the mouse button and then release the Ctrl (or ⌘) and Shift keys.

Figure 8-22.

Ctrl+Shift-drag (⌘-Shift-drag) the marquee
until this column of bricks . . .

. . . lines up with this column

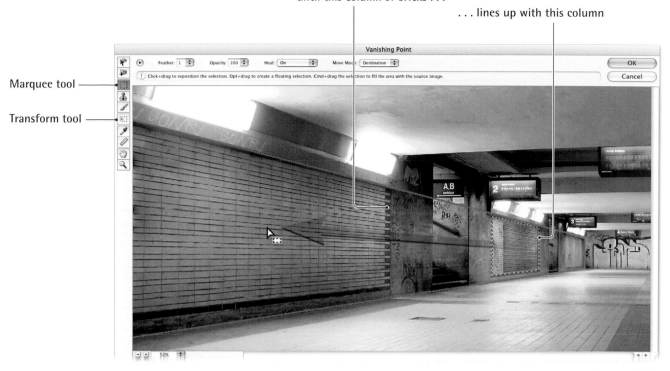

Marquee tool

Transform tool

Figure 8-23.

After you release the mouse button, Vanishing Point heals the cloned selection into its new home. If you're not happy with the appearance of the healed selection and you want to try again, you'll need to press Ctrl+Z (or ⌘-Z) *twice*. This is because Ctrl+Shift-dragging a selection performs two operations: First it floats the selection and then it clones from the new source. And you have to undo both operations before reattempting Step 17.

18. *Switch to the transform tool.* Click the sixth tool down on the left side of the dialog box or press the T key to select the transform tool, which lets you scale and rotate a selection.

19. *Scale the cloned area.* Drag the left edge of the rectangle and pull it toward you, to the left, to scale the selection horizontally and fill the entire tiled area, as in Figure 8-24. If necessary, you can also use the arrow keys to nudge the selection until all the pixels line up correctly.

Figure 8-24.

Because the selection floats above the rest of the image, Vanishing Point is able to continuously heal and reheal the selection as you transform it, thus ensuring smooth transitions between the cloned source and its new surroundings. If only things worked this way outside Vanishing Point.

20. ***Copy the cloned area to the far wall.*** Now that you've created the perfect wall patch, you might as well make the most of it. Still armed with the marquee tool, press the Shift and Alt keys (Shift and Option on the Mac) and drag the floating selection to the right to duplicate it. Align the floater with the farthest wall on the left side of the station. Then release the mouse button and release the keys.

21. ***Click the OK button.*** Having washed away the graffiti from the entire left side of the station, click **OK** to exit the Vanishing Point filter and apply your changes to the previously empty layer. Figure 8-25 shows our progress so far.

Figure 8-25.

⭐ **EXTRA CREDIT**

And our progress so far may be all the progress you care to make. After all, Vanishing Point is a challenging filter, and you've expended a lot of effort to get to this point. But we're not done yet. We still have that back wall with the big graffiti on it. It's not quite rectangular, so it demands a special approach. Plus, you haven't seen how to add text to your perspective scene. If you can tolerate to miss out on such things, skip ahead to the "Applying Free-Form Distortions" exercise, which begins on page 293. If you're like me and you can't stand to miss out on anything, much less more rollicking 3D fun, join me in the madcap Step 22.

22. ***Load the Back Wall channel as a selection.*** Vanishing Point is limited to a single selection tool, the marquee. If you want to heal an irregularly shaped area like that faraway wall, you need to define a selection before choosing the filter. I've prepared

such a selection in advance. To get to it, switch to the **Channels** palette. Then Ctrl-click (or ⌘-click) on the alpha channel, **Back Wall** (see Figure 8-26), to load it as a selection outline. Photoshop will now limit Vanishing Point to the selected area.

23. *Return to Vanishing Point.* No sense in creating a new layer—we can safely keep adding to the layer we have. Just choose **Filter→ Vanishing Point** to open the filter.

24. *Select the farthest plane.* We need to select the entire plane, which happens to be a snap. Select the marquee tool and double-click on the rear wall to select it, as in Figure 8-27.

25. *Heal the farthest wall using the closest wall.* Notice that the options at the top of the window have returned to their defaults. So set the **Feather** value to 10 pixels and **Heal** to **On**. Then Ctrl+Shift-drag (on the Mac, ⌘-Shift-drag) the selection to the left until it fills with the now extremely stretched-looking pixels of the panel closest to us. When things appear reasonably aligned, release the mouse button and keys and Vanishing Point will heal the back wall, as in Figure 8-28.

Figure 8-26.

Remember, if you don't like the effect and you want to try it again, you need to press Ctrl+Z (⌘-Z) twice before reattempting Step 25.

26. *Scale the cloned area.* The cloned area is stretched too wide and doesn't completely fill the rear wall, so we need to scale it. Press the T key to get the transform tool. Then drag the top

Figure 8-27.

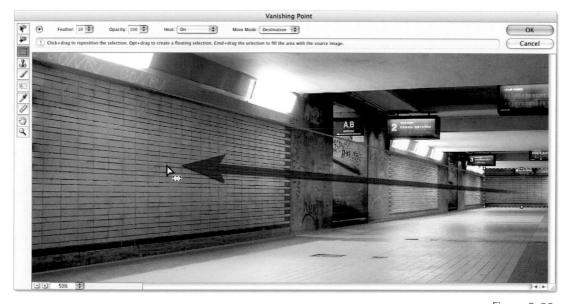

Figure 8-28.

The Vanishing Point filter was one of the way-cool additions to Photoshop CS2. And it's gotten even better in CS3. Now you can connect nonperpendicular surfaces and wrap an image around multiple surfaces at a time. To demonstrate, I'll wrap Bruce Heavin's artwork for my *Photoshop Channels & Masks* video around a photograph of a naked DVD case, captured by Chris Mattia. For those of you who'd like to follow along, I've included both images (pictured below) in the *Lesson 08* folder. The filenames are *Chans & Masks. tif* and *DVD case.psd*.

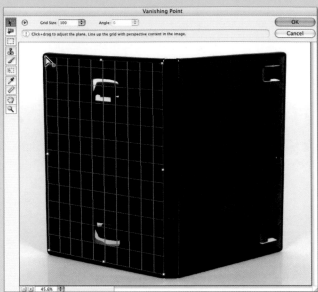

Anytime you need to import an image into Vanishing Point, the first step is to copy it to the Clipboard. So press Ctrl+A, Ctrl+C (on the Mac, that's ⌘-A followed by ⌘-C) to select the artwork file and load it onto the Clipboard.

Then switch to the image of the DVD case. Press Ctrl+Shift+N (or ⌘-Shift-N) to display the New Layer dialog box. Name the layer "Artwork" and click OK.

Choose Filter→Vanishing Point to bring up the Vanishing Point plug-in. Click at each of the four corners of the transparent plastic on the back side of the DVD case to make a four-point plane. Then drag the corner handles to align them as precisely as possible, as illustrated in the top-right figure. As always, make sure that the grid is blue, not yellow or red (Vanishing Point's warning colors).

Press and hold the Ctrl (or ⌘) key and drag from the right-hand side handle of the plane to draw forth a perpendicular plane. Then press and hold the Alt (or Option) key and drag the right handle of the new plane. The grid swings like a door on a hinge, allowing you to move the plane to any angle. Once you have the angle you want, release and then drag (with no key pressed) to retract the edge so it aligns with the DVD case's slim spine, as shown below.

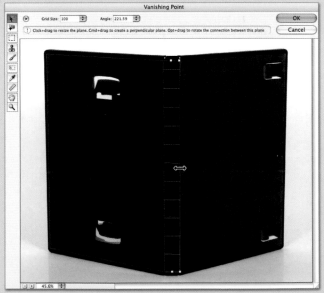

Next, use the Ctrl (or ⌘) key to drag out another right-hand plane. Because the plane extrudes 90 degrees away from you, it appears foreshortened, meaning that it's deeper than it looks. So keep your drag very short. Then Alt-drag (or Option-drag) the right handle to swing the plane forward so it aligns with the front of the DVD box. You can also adjust the Angle value at the top of the window. A value between 125 and 130 degrees works best. When you get the angle right, drag the far edge of the overly long plane (see below) to the right edge of the box.

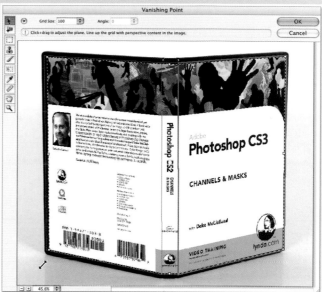

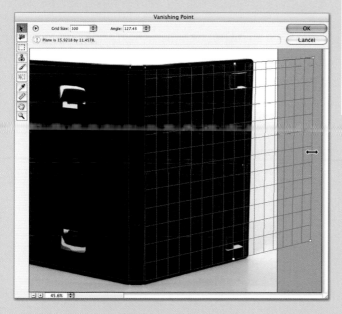

Vanishing Point is a 3D surface wrapping tool, it doesn't light the image or render shading. So the label art in no way matches the luminance of the DVD case. To add a faux-shading effect, go to the Layers palette and turn on the Depth layer, which is a special bit of painting that I created in advance. Click the Depth layer to make it active and press Ctrl+Alt+G (or ⌘-Option-G) to clip the shading effect to the artwork below. The finished effect appears below.

Now it's time to import the artwork. Press Ctrl+V (or ⌘-V) to paste the label image from the Clipboard. Drag it down into its new home and watch as it wraps into place. As usual, the art is too big. Click the ⊙ arrow and turn off Clip Operations to Surface Edges (so you can see the corner handles) and turn on Allow Multi-surface Operations (so the artwork can wrap all the way around the box). Press the T key to switch to the transform tool. Then drag a corner handle to reduce the size of the artwork. Make sure the artwork falls entirely inside the transparent plastic overlay, the way it would in real life (see top right). Drag the pasted artwork until the spine art aligns with the spine plane. Nudge the artwork as needed with the arrow keys. Then click OK to accept the modification and exit the Vanishing Point plug-in.

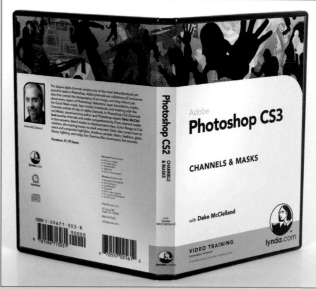

Figure 8-29.

handle up and the bottom handle down to stretch the selection vertically and fill the wall, including the area behind the sign with a 4 on it, as in Figure 8-29. The selection will continuously heal every time you adjust the bounding box.

27. *Click OK yet again.* When you're satisfied with the color and placement of the bricks, click **OK** to apply your changes and exit the Vanishing Point filter.

28. *Deselect the current selection.* From here on out, we're no longer working exclusively on the back wall. So press Ctrl+D (or ⌘-D) to clear the active selection.

29. *Create a new layer.* So far, in our three tours of the Vanishing Point filter, not so much as a single pixel of what we've done has covered up another pixel on the Perspective Edit layer. But that's about to change. We're going to open a new image and bring it into the 3D world we've created. So it's time to create a new layer. Choose **Layer**→**New**→**Layer** or press Ctrl+Shift+N (⌘-Shift-N), name the layer "New Wall Art," and click **OK**.

30. *Open a multilayer file that contains text.* Open the layered file that contains the new art for our subway walls, *Scrubbco banner.psd*. This image is included in the *Lesson 08* folder inside *Lesson Files-PsCS3 1on1*.

Figure 8-30.

31. *Copy the banner to the Clipboard.* The security of a corporate slogan beats the raw energy of independently inspired graffiti any day of the week. Besides, the banner is quite colorful (see Figure 8-30). Press Ctrl+A (⌘-A) to select the entire canvas followed by Ctrl+Shift+C (⌘-Shift-C) to copy a merged version of the image. As it turns out, the only way to get text into Vanishing Point is to copy and paste.

32. *Apply Vanishing Point to the subway image.* Click the title bar for the *Dingy subway.psd* image to make that window active. Then, for the fourth and final time, choose **Filter**→**Vanishing Point**.

33. *Paste the copied selection into Vanishing Point.* Press Ctrl-V (⌘-V on the Mac) to paste the merged image from Step 31 into Vanishing Point. At first, it appears flat and in 2D, the very antithesis of Vanishing Point. To fix this, drag the yellow word *Free* downward into the closest plane. As soon as you cross into

the plane, the pasted selection snaps into perspective. Too bad the text appears way too huge, covering both the wall and floor (see Figure 8-31). That'll mean another step or two, for sure.

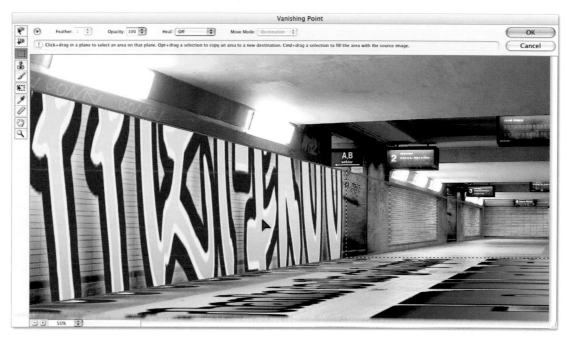

Figure 8-31.

34. ***Prepare to scale the graphic.*** Press T to select the transform tool. Notice that you have no handles to work with. That's because they're cropped out of view. To find them, zoom all the way out (6.3 percent). Then click the ⊙ arrow in the top-left corner of the window and turn off the **Allow Multi-surface Operations** and **Clip Operations to Surface Edges** commands, as in Figure 8-32. With any luck, you now see the handles.

35. ***Adjust the scale and position of the graphic.*** Drag a corner handle to scale the text; Alt-drag (or Option-drag) a handle to scale with respect to the center; drag inside the text to move it. No matter how you approach it, scale and position the text so it fits snugly inside the first portion of the wall on the left (before the AB staircase).

36. ***Clone three copies onto the other walls.*** After you get the text in place, it's time to duplicate it. Press Shift and Alt (or Shift and Option) and drag the selection to the right to pull a copy of the banner to the middle wall. Shift+Alt-drag that copy to duplicate the text to the most distant left side wall; then Shift+Alt-drag it one more time onto the rear wall. Finally, drag the side handles to scale the last item so it better fits the rear wall. When your results match those pictured in Figure 8-33 on the next page, click **OK** to exit Vanishing Point and apply your changes.

Figure 8-32.

Figure 8-32 shows a few commands that appear only in Photoshop CS3 Extended. If you're using the less expensive (but entirely satisfactory) standard version of the program, your menu will be shorter. Don't take it personally; as always, you rock.

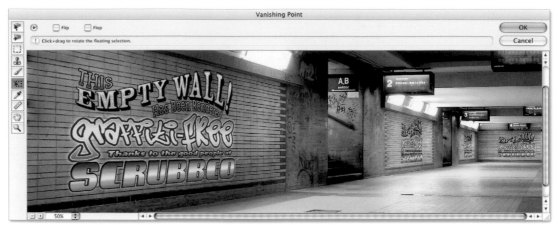

Figure 8-33.

37. *Blend the banners with the photograph.* The banners are rendered in perspective, but they don't blend properly with the walls. Good thing we rendered the banners to an independent layer so we can address that. Make sure the rectangular marquee tool is active. Then press the 8 key to reduce the **Opacity** of the text to 80 percent. Also press Shift+Alt+M (or Shift-Option-M) to set the layer to the **Multiply** mode.

38. *Blur the last three banners.* Using the rectangular marquee tool, drag around the three farthest copies of the banner to select them. Then choose **Filter→Blur→Gaussian Blur**, enter a **Radius** of 0.6 pixel, and click **OK**. This softens the distant text so it better matches the depth-of-field of the photograph. The finished image appears in Figure 8-34.

Figure 8-34.

Applying Free-Form Distortions

If Smart Sharpen is the most practical filter and Vanishing Point is the most exciting, the award for the most powerful filter in Photoshop goes to Liquify. Like Vanishing Point, Liquify is less a filter and more an independent program that happens to run inside Photoshop. This particular program lets you distort an image by painting with a collection of tools. One tool stretches pixels, another twists them into a spiral, and a third pinches them. These and other tools make Liquify ideally suited to cosmetic surgery. Whether you want to tuck a tummy, slim a limb, or nip a nose, Liquify gives you everything you need to do the job.

In this exercise, we'll do something radical. We'll take a photo of my mild-mannered, little boy Sammy and morph him into a teenage superhero, complete with square chin, rugged jaw, cocky sneer, and eyes bright with righteous anger. In all Gotham City, only one filter can aid us in this goal, and that filter is Liquify.

1. ***Open an image that you want to distort.*** After capturing the very cute picture of Sammy dressed up for Halloween that appears at the top of Figure 8-35, it struck me that it might be fun to make him appear every bit the caped crusader that his outfit suggests. A couple of hours of dodging, burning, sponging, healing, and finally painting the snapshot produced the bottom image in the figure. Although it possesses an undeniably graphic, surreal quality, my fair-haired boy continues to exude cuteness, the kind one associates less with a guardian angel and more with an excitable cherub. Few superheroes list "cute" or "cherubic" on their resumés, and so these attributes, however laudable, must be eradicated. To join me in my quest to convert child into champion, open the image titled *Gold hero.jpg*, included in the *Lesson 08* folder inside *Lesson Files-PsCS3 1on1*.

Figure 8-35.

2. *Choose the Liquify command.* Go to the **Filter** menu and choose **Liquify** or press Ctrl+Shift+X (⌘-Shift-X on the Mac). Photoshop displays the **Liquify** window, which appears in Figure 8-36. The window sports twelve tools on its left edge and a row of options on the right. The rest of the window is devoted to the image itself.

Many of the same navigation techniques that work outside the Liquify window work inside it as well. You can zoom in or out by pressing Ctrl+⊞ or Ctrl+⊟ (⌘-⊞ or ⌘-⊟ on the Mac), respectively. Press the spacebar and drag to pan the image.

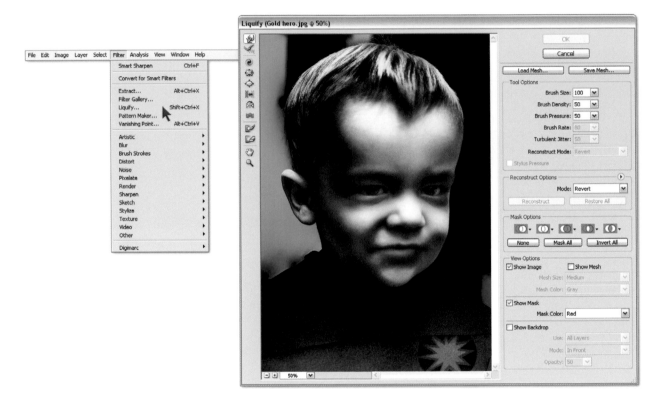

Figure 8-36.

3. *Select the warp tool.* Click the topmost tool in the Liquify window or press the W key to select the warp tool, which lets you stretch or squish details in an image by dragging them. Of all Liquify's tools, this one is the most consistently useful.

4. *Adjust the Brush Settings.* Set the **Brush Size** to 100 and the **Brush Pressure** to 50.

As with the other tools in Photoshop, you can change the brush size by pressing a bracket key. But the shortcut behaves a bit differently. Press the ⬚ or ⬚ key to scale the brush by 2 pixels. Press and hold the key to scale more quickly. Press Shift+⬚ or ⬚ to scale the brush in 20-pixel increments. (In Liquify, there is no such thing as brush hardness.)

5. *Arch the eyebrows.* Using the warp tool, drag the eyebrows to make them appear arched, as in Figure 8-37. This is an exaggerated effect, so if you try to pull it off in one or two brushstrokes, you'll smear the colors and wind up with digital stretch marks. Here's how to achieve more photorealistic results:

- Keep your strokes very short—just a few pixels at a time.

- Because you're keeping your brushstrokes short, you'll need a lot of them. I reckon I laid down twenty strokes in all.

- Drag *on* the detail you want to move. For example, to move an eyebrow, center your brush cursor on the eyebrow and then drag. If you drag next to the eyebrow (which, although it may sound weird, is the more natural tendency), you'll pinch the eyebrow and slim it down to a thin line.

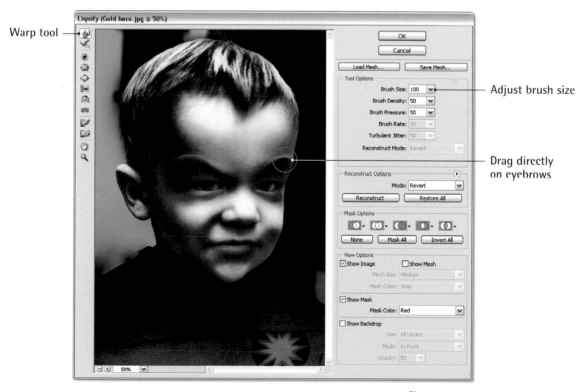

Figure 8-37.

If you make a mistake, you'll be glad to learn that Liquify offers multiple undos using the same keyboard shortcuts available elsewhere in the program. Pressing Ctrl+Z (⌘-Z on the Mac) undoes or redoes a single brushstroke. To revert multiple brushstrokes, press Ctrl+Alt+Z (⌘-Option-Z). To redo a brushstroke, press Ctrl+Shift+Z (⌘-Shift-Z).

For the present, be careful to avoid painting the eyes. We'll edit them in the next steps with a different tool.

6. ***Switch to the pucker tool.*** Click the fourth tool down or press the P key. This selects the pucker tool, which lets you pinch portions of an image. If you're familiar with the Pinch filter, Pucker is similiar but offers about a million times more control.

7. ***Reduce each eye.*** Toddlers have lots of physical characteristics that distinguish them from adults. They're short, they have pudgy cheeks, and their skin is really smooth except for occasional patches of dried snot and spaghetti sauce. But if I had to choose their most unique feature, it'd be their eyes. Kids have adult-sized eyeballs packed inside pint-sized heads, which makes their eyes look enormous. Outside Japan, superheroes don't have big old baby eyes, so Sammy's must be reduced.

 Raise the **Brush Size** value to 200 pixels. Then click each of Sammy's eyes. Click quickly and do not drag. If one click doesn't do the trick, do another one. The finished eyes should look like those shown in Figure 8-38 on the facing page.

8. ***Switch to the twirl clockwise tool.*** To give Sam a menacing appearance—so that he can more easily intimidate criminals and thwart their evil plans—I want to slant his eyes very slightly. Click the third tool on the left side of the window or press the C key to select the twirl clockwise tool.

9. ***Slant the eyes.*** Center the brush cursor on the iris of the left eye (his right). Then click. Again, click briefly; do not hold or drag. The eye spins a degree or two clockwise, raising the outside edge and lowering the inside.

To slant the right eye (his left) in the opposite direction, you could switch to the twirl counterclockwise tool. But as it turns out, both tools do double duty. To twirl a detail opposite to the direction in which the tool usually works, press the Alt key (Option key on the Mac) and click. The results of both twirls appear in Figure 8-39.

Pucker tool ───

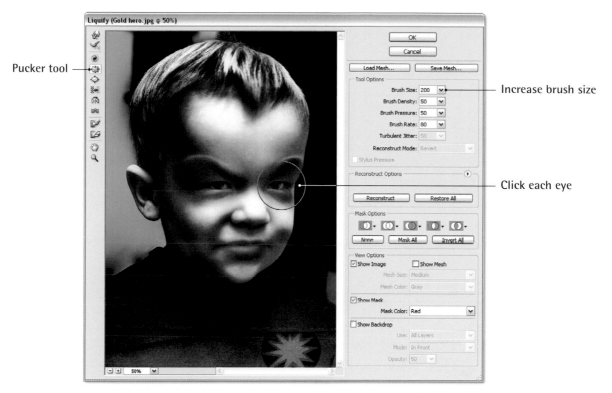

Increase brush size

Click each eye

Figure 8-38.

Twirl clockwise tool ───

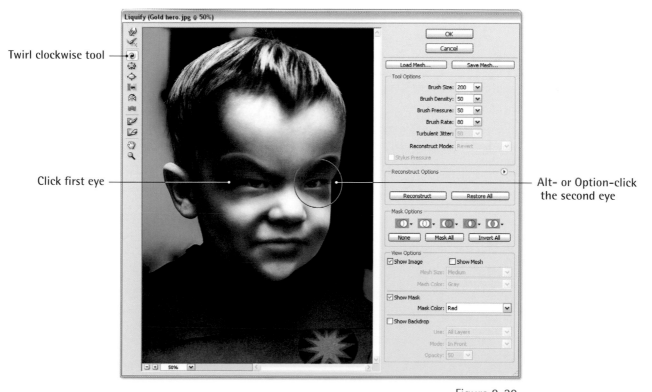

Click first eye ───

Alt- or Option-click
the second eye

Figure 8-39.

10. ***Return to the warp tool.*** I imagine Sammy to be the sort of edgy, cynical, postmodern superhero who openly sneers at his archenemies and lesser opponents. And there's no better tool for constructing sneers than the warp tool. Get it now by pressing the W key.

11. ***Work the nose and mouth into a sneer.*** Reduce the **Brush Size** to 120 pixels. Then drag downward on the nose, up on the nostrils, up on the left side of the mouth, and down on the right. You'll also want to drag that crease that connects the nose and mouth on the left side of the image. The results of my thirty or so brushstrokes appear in Figure 8-40.

12. ***Switch to the bloat tool.*** Okay, we've managed to outfit Sam with smaller eyes, arching eyebrows, and a tough-guy sneer. But he's still a little kid. It's time to bulk him out. Click the fifth tool on the left side of the window or press the B key to select the bloat tool.

13. ***Bloat the chin and jaw.*** Start by increasing the **Brush Size** value to 400 pixels. Then test the waters by clicking and holding for a brief moment on Sammy's chin. Also click a few times along the left and right sides of his jaw. I want you to really exaggerate the jaw line (see Figure 8-41), so feel free to hold down the mouse button for, say, a half second or so at a time. However, as when using the pinch and twirl tools, I recommend you refrain from dragging. (In other words, hold the mouse button down but keep the mouse still.)

14. ***Pucker the forehead.*** In real life, Sammy doesn't have much hair, so he has an ample forehead. That gives him a sort of Poindexter look that superheroes shun. Best way to get rid of it? Pinch the forehead down to a more reasonable size. Best tool for the job? The one you already have, the bloat tool.

Center your brush cursor somewhere along the hairline. Then press the Alt key (Option on the Mac) and click for a half second or more. The Alt key reverses the behavior of the tool, swelling with the pucker tool or, in our case, pinching with the bloat tool.

Continue to Alt-click (or Option-click) along the hairline until you get an effect similar to the one pictured in Figure 8-41. For the best results, move the mouse at least slightly *between* (not during) clicks. This varies the center of the distortion and keeps your pinches from resulting in sharp points of converging color.

Warp tool

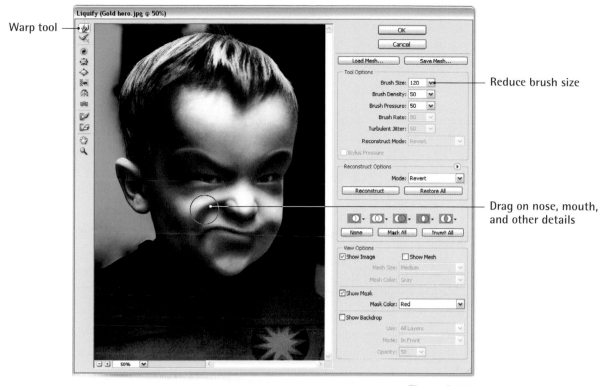

Reduce brush size

Drag on nose, mouth, and other details

Figure 8-40.

Bloat tool

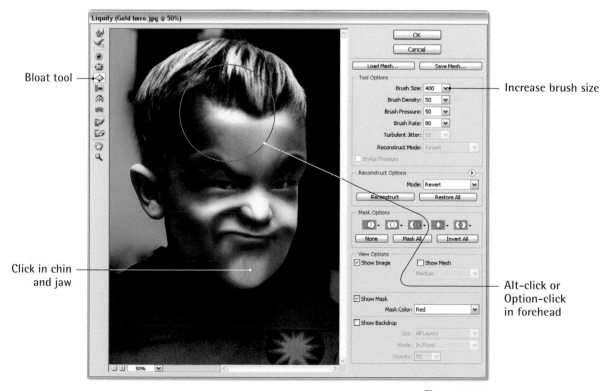

Increase brush size

Click in chin and jaw

Alt-click or Option-click in forehead

Figure 8-41.

15. ***Apply your finishing touches.*** Continue distorting my son's face as you see fit. (Naturally, I rely on you to apply your adjustments in good taste—he is my beloved progeny, after all.) For my part, I smoothed out the eyebrows, lifted the cheeks, tugged down the hairline, lifted the shoulders, and increased the size of the chest, all using the warp tool. When you arrive at an effect you like, click the **OK** button to accept your changes and exit the dialog box. Just for the sheer joy of it, Figure 8-42 shows my final effect incorporated into an elaborate poster treatment. Note that I used Image→ Image Size to stretch the image vertically. This gives the head a less squat appearance. I also dodged and burned the chin to lend it more volume.

Figure 8-42.

PEARL OF WISDOM

Unlike the other filters in Photoshop, Liquify does not remember your last-applied settings the next time you choose the command. So if you apply the filter, think better of it, undo the operation, and decide to take another stab at it, steel yourself to start the Liquify process over again from scratch. My advice: Be sure you've *completely* finished distorting an image before clicking the OK button. And don't even think about clicking Cancel unless you're content to trash everything you've done since you chose Filter→Liquify. If you're really in love with a distortion, you can save a wireframe *mesh* that reflects your brushstrokes by clicking the Save Mesh button and entering a filename. But be sure to click Save Mesh before you click OK or you will lose your mesh forever.

WHAT DID YOU LEARN?

Match the key concept in the numbered list below with the letter
of the phrase that best describes it. Answers appear upside-down
at the bottom of the page.

Key Concepts

1. Focus
2. Filters
3. Edge
4. Unsharp Mask
5. Smart Sharpen
6. Radius
7. High Pass
8. Perspective plane
9. Stamp tool
10. Allow Multi-surface
 Operations
11. Warp tool
12. Pucker tool

Descriptions

A. This Liquify function lets you pinch selective portions of an image.

B. The thickness of the effect applied by a filter, often expressed as a softly tapering halo.

C. The clarity of the image formed by the lens element and captured by the camera, whether digital or film.

D. This Vanishing Point tool lets you heal an image in perspective and includes a source preview right inside the brush cursor.

E. The successor to Unsharp Mask, this filter lets you correct specific kinds of softness, including lens blur and motion blur.

F. Named for the camera lenses once commonly used to adjust and tint a scene before it was captured on film, these permit you to modify the focus, edge detail, and structure of an image after it's captured.

G. A rectangle tilted in three-dimensional space that defines a grid on which you can edit your image in the Vanishing Point filter.

H. A filter named for a traditional technique in which a photographic negative is combined with a blurred version of itself.

I. The most consistently useful of the Liquify functions, this lets you stretch or squish details in an image by painting them with a circular brush.

J. A ridge formed by the meeting of two areas of extreme contrast.

K. A filter that mimics the functionality of Unsharp Mask by retaining areas of high contrast and sending low-contrast areas to gray.

L. New to Vanishing Point 2.0, this option wraps a pasted image around multiple connected planes, which can meet at any angle so long as the planes share a common edge.

Answers

1C, 2F, 3J, 4H, 5E, 6B, 7K, 8G, 9D, 10L, 11I, 12A

BUILDING LAYERED COMPOSITIONS

EVERY IMAGE begins life as a few channels of data—most commonly, one each for red, green, and blue—fused into a single pane of pixels (see Figure 9-1). Whether it comes from the least expensive digital camera or a professional-level drum scanner, the image exists entirely on one layer. One and only one full-color value exists for each and every pixel, and there is no such thing as transparency. Such an image is said to be *flat*.

But add images (like the extra arms in the figure) and you add layers. Each layer serves as an independent image that you can stack, transform, or blend with other layers.

An image that contains two or more layers is called a *layered composition*. There's no need to wait until a certain point in the editing cycle to build such a composition—you can add layers any old time you like, as we have several times in previous lessons. But layers have a way of becoming even more useful after some of the basic editing is out of the way. That's why I've waited until now to show you the many ways to create and manage layers in Photoshop.

Figure 9-1.

The Benefits and Penalties of Layers

Photoshop's reliance on layers makes for an exceedingly flexible (if sometimes confusing) work environment. As long as an image remains on a layer, you can move or edit it independently of other layers in the composition. Moreover, you can create relationships

Project Files

Before beginning the exercises, make sure you've installed the lesson files from the DVD, as explained in Step 3 on page xvii of the Preface. This should result in a folder called *Lesson Files-PsCS3 1on1* on your desktop. We'll be working with the files inside the *Lesson 09* subfolder.

In this lesson, we explore all facets of building a layered composition, from transformations to stacking order, blend modes to knockouts, clipping masks to layer comps. You'll learn how to:

Video Lesson 9: The Layered Composition

Layers are nothing more than independent images that you can set to interact with each other. But what a difference they make. By relegating image elements and effects to independent layers, you give yourself the flexibility to adjust your artwork well into the future.

To get a sense of how layers work and see a brief sampling of the benefits they provide, watch the ninth video lesson on the DVD. Insert the DVD and double-click the file *PsCS3 Videos.html*. Then click **Lesson 9: The Layered Composition** under the **Masking, Filters, and Layers** heading. The movie lasts 17 minutes and 16 seconds, during which time you'll learn about the following shortcuts:

Operation	Windows shortcut	Macintosh shortcut
Show or hide Layers palette	F7	F7
Select range of layers	Click one layer, Shift-click another	Click one layer, Shift-click another
Group selected layers	Ctrl+G	⌘-G
Change Opacity setting of active layer	1, 2, 3, . . . 0*	1, 2, 3, . . . 0*
Duplicate active layer to new layer	Ctrl+J	⌘-J
Mover layer forward or backward	Ctrl+� or Ctrl+⦊	⌘⦋ or ⌘⦌

* Works only if selection tool is active.

between neighboring layers using a wide variety of blending options and masks, all of which work without changing the contents of the layers in the slightest.

But layers come at a price. Because they are actually independent images, each layer consumes space both in memory and on your hard drive. Consider this:

- I start with an image from the Corbis image library that measures 2100 by 2100 pixels, or 7 by 7 inches at 300 pixels per inch (see Figure 9-2). Each pixel takes up 3 bytes of data. The result is a total of 4.41 million pixels, which add up to 12.6MB in memory. Because the image is flat, I can save it to the JPEG format, which compresses the file down to 3.7MB at the highest quality setting.

- I introduce another image from the Corbis collection that measures the very same 2100 by 2100 pixels. Photoshop puts the image on its own layer. I apply the Multiply blend mode to get the effect shown in Figure 9-3. The image size doubles to 25.2MB in memory. I can no longer save the layered composition in the JPEG format because JPEG doesn't permit layers. Thus, I save it in the native Photoshop (PSD) format instead. The Photoshop format lacks JPEG's exceptional compression capabilities, so the file on disk balloons to 25.7MB.

- I then add a series of image and text layers to fill out the composition, as pictured in Figure 9-4 on the next page. Because the layers are smaller, and the text layers are defined as more efficient vectors (see Lesson 10, "Text and Shapes"), the size of the image grows only moderately in memory (34.4MB) and barely at all on disk (26.2MB).

So as you add layers, your composition gets bigger. And as your composition gets bigger, Photoshop requires more space in memory and on disk to manage the file. Generally speaking, you can let Photoshop worry about these sorts of nitty-gritty details on its own. But bear in mind, no matter how sophisticated your computer, its memory and hard disk are finite. And if either the memory or (worse) the hard disk fill up, your ability to edit your marvelous multilayer creations may come to a skidding halt.

Flat image, 2100 × 2100 pixels
12.6MB in memory, 3.7MB on disk (saved in JPEG format, Quality 12)

Figure 9-2.

Second layer, another 2100 × 2100 pixels
25.2MB in memory, 25.7MB on disk (saved in native PSD format)

Figure 9-3.

How to Manage Layers

Fortunately, a few precautions are all it takes to keep layered compositions on a diet and Photoshop running in top form:

- First, don't let your hard disk get anywhere close to full. I recommend keeping at least 25GB available at all times, and more than that is always welcome. (Consult your computer's documentation to find out how to check this—or just hope and pray you're okay, like everyone else does.)

- Back up your Photoshop projects regularly to CD, DVD, or some other storage medium. This not only preserves and protects your images but also permits you to delete files from your hard disk if you start running out of room.

- As you work in Photoshop, you can keep an eye on the size of your image in memory by observing the Doc values at the lower-left corner of the image window, or inside the Info palette. The value before the slash tells you the size of the image if flattened; the value after the slash tells you the size of the layered composition.

- You can reduce the size of an image by *merging* two layers into one using Layer→Merge **Down**. (For more information on merging, see Step 21 of "Importing, Transforming, and Warping Layers" on page 322.)

- To merge all layers and return to a flat image, choose Layer→Flatten Image. But beware, this is a radical step. I usually flatten an image only as a preamble to importing it into another program, such as QuarkXPress or InDesign. And even then, I make sure to save the flattened image under a different name to maintain my original layered file.

Finally, when in doubt, err on the side of too many layers as opposed to too few. This may sound like strange advice, but it's better to push the limits and occasionally top out than unnecessarily constrain yourself and hobble your file. After all, you can always upgrade your computer to better accommodate your massive compositions. But you can never recover an unsaved layer (that is, one that you merged or flattened before saving and closing the file).

Additional layers, various sizes
34.4MB in memory, 26.2MB on disk (saved in native PSD format)

Figure 9-4.

Arranging and Modifying Layers

The most basic use for layers is to keep objects separated from each other so you can modify their horizontal and vertical position as well as their front-to-back arrangement. Photoshop also permits you to transform layers by scaling, rotating, or even "warping" them into all sorts of contortions, a feature that we'll be exploring in the second half of the upcoming exercise.

By way of demonstration, we'll take a cue from the classical artist I believe would have benefited most from layers, 16th-century imperial court painter Giuseppe Arcimboldo. Regaled in his time as a master of the composite portrait, Arcimboldo rendered his subjects as fanciful collections of fruits, vegetables, flowers, trees, animals, meats—he even famously represented one fellow upside-down (right image, Figure 9-5). We'll embark on something infinitely simpler—Giuseppe had to thrill and delight Emperor Maximilian II; happily, we do not. But even so, you'll get an ample sense of just how much pure imaging flexibility layers afford.

In the following exercise, you'll begin the process of assembling a layered piece of artwork. You'll establish the content and order of the key layers in the composition, and in the process, learn how to select layers, modify their contents, change their order, and even rotate them.

Figure 9-5.

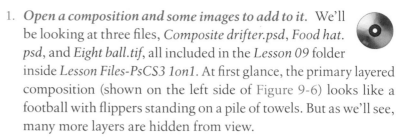

1. *Open a composition and some images to add to it.* We'll be looking at three files, *Composite drifter.psd*, *Food hat. psd*, and *Eight ball.tif*, all included in the *Lesson 09* folder inside *Lesson Files-PsCS3 1on1*. At first glance, the primary layered composition (shown on the left side of Figure 9-6) looks like a football with flippers standing on a pile of towels. But as we'll see, many more layers are hidden from view.

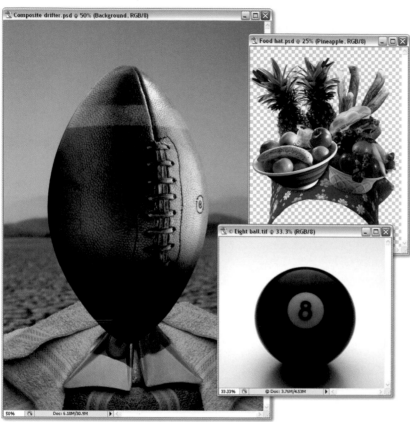

Figure 9-6.

2. *Bring up the Layers palette.* If it's already on screen, fabulous. If not, choose **Window→Layers** or press the F7 key. The **Layers** palette shows thumbnails of every layer in the document, from the front layer at the top of the palette to the rearmost layer (usually a base Background layer) at the bottom. This arrangement of layers from front to back is called the *stacking order.*

3. *Make the layered composition active.* Click anywhere in the *Composite drifter.psd* image to make it active. If you take a peek at the Layers palette, you'll see that the file contains a total of ten layers. And yet we can see just four items in the image window—football, flippers, towels, and background. (In case you're curious, the flippers are found on the Collar layer.) The other layers are turned off or hidden by the football.

4. *Send the football layer backward.* Click the **Football** layer to highlight the layer and make it active. Then drag it down the stack in the Layers palette to just between the Teeth and Collar layers. You should now see all visible layers from the Teeth upward, as illustrated in Figure 9-7 on the facing page. Of course, things don't look at all right, but they will.

5. *Switch to the Paths palette.* Click the **Paths** tab in the Layers palette, or choose **Window→Paths**. You'll find one path that I drew in advance, Face Outline.

6. *Load the path as a selection.* Press the Ctrl key (⌘ on the Mac) and click the **Face Outline** item in the **Paths** palette. Photoshop selects the drifter's face.

7. *Reverse the selection.* Choose **Select→Inverse** or press the shortcut Ctrl+Shift+I (⌘-Shift-I) to reverse the selection and select the area outside the drifter's face.

8. *Delete the selected pixels.* Return to the **Layers** palette and make sure the **Football** layer is active by clicking it. (You know the layer is active if you see the word *Football* in parentheses in the title bar). Then press Backspace or Delete to erase the selected pixels. Only the drifter's silhouette remains, as shown in Figure 9-8.

9. *Deselect the image.* We're finished with the selection, so press Ctrl+D (⌘-D).

10. *Click the path in the Paths palette.* Paths are good for more than loading selections. You can use them to paint as well. Any paint or edit tool can trace the outline of a path. To begin, click the **Face Outline** path in the **Paths** palette to select it.

11. *Select the brush tool in the toolbox.* Press the B key. The paintbrush is the tool we'll use to perform the tracing.

12. *Specify the brush attributes.* Click the round brush icon in the options bar to display the pop-up brush palette, and then select the fifth preset in the scrolling list to get a 13-pixel hard brush. Also, make sure the **Mode** is **Normal** and the **Opacity** is 100 percent.

13. *Select a color.* Go to the **Color** palette. (Press F6 if it's not available.) Then set the values to **R:** 255, **G:** 240, and **B:** 180. The result is a pale yellow.

14. *Create a new layer.* No need to switch out of the Paths palette; the Layers palette doesn't have to be visible to make a new layer. Just choose **Layer→New→Layer**, or press Ctrl+Shift+N (⌘-Shift-N on the Mac). Then name the layer "Drifter Outline" and click the **OK** button.

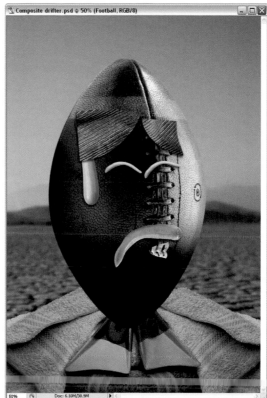

Figure 9-7.

Figure 9-8.

15. **Stroke the path.** Click the second icon (○) at the bottom of the Paths palette. Or just press the Enter key on the keypad. Either way, Photoshop traces a 13-pixel hard yellow brushstroke around all parts of the path, as shown in Figure 9-9.

16. **Deactivate the path.** Click in the empty area of the Paths palette, below **Face Outline**, to hide the path and turn it off. This is an important step. An active path outline can distract Photoshop's attention from selection outlines and other elements.

17. **Display the Scruff layer.** Return to the **Layers** palette, and then click the blank square next to the item called **Scruff** to toggle the 👁 icon and reveal the layer. It looks like badly rendered sandpaper, but it's actually our fellow's stubbly beard.

18. **Set the blend mode to Multiply.** Click the **Scruff** layer itself to make it active. Next click the word **Normal** at the top of the Layers palette to display a list of blend modes, and choose **Multiply** from the list. Or press the M key to switch to the marquee tool, and then press Shift+Alt+M (Shift-Option-M). Multiply

With the brush tool active . . .

click this icon

Figure 9-9.

drops out the whites and preserves the dark colors, thus burning the stubble into the football flesh, as in Figure 9-10.

19. ***Turn on the Hayseed layer.*** Click the blank square in front of the **Hayseed** layer to make it visible. The layer in question turns out to be a sliver of barley clasped tightly in the drifter's teeth (the latter of which are actually seams in a baseball, for what it's worth). Shown in Figure 9-10, the new layer highlights a problem in the stacking order. The face outline should be in front of the teeth, hayseed, and scruff. The football flesh needs to be nudged up a couple of notches as well.

20. ***Select the Drifter Outline layer.*** You may find it simplest to just click the layer name. But I would be remiss in my duties if I didn't tell you how to do it from the keyboard.

You can cycle from one layer to the next by pressing Alt (or Option) with a bracket key. Alt+⬚ selects down the layer stack; Alt+⬚ selects up. In this case, pressing Alt+⬚ three times cycles from the Scruff layer down to the Drifter Outline layer.

Blend mode pop-up menu

Figure 9-10.

21. ***Drag the Drifter Outline layer in front of Scruff.*** You can accomplish this by choosing **Layer→Arrange→Bring Forward** three times in a row. But isn't life short enough without choosing inconveniently located commands multiple times in a row? Yes it is. Better to learn the shortcut.

To move a selected layer up or down the stack, press Ctrl (or ⌘) with a bracket key. Ctrl+☐ moves the layer back one notch; Ctrl+☐ moves it forward. To properly arrange the Drifter Outline layer, press Ctrl+☐ three times in a row.

22. ***Select the Football layer.*** Again, you can just click the **Football** layer name. But I have another technique for you to try.

Figure 9-11.

Press and hold the Ctrl key (⌘ on the Mac) to temporarily invoke the move tool. Then right-click in the image window to display a shortcut menu of layers directly below your cursor. (If you use a one-button mouse on the Mac, press ⌘ and Control and click to see the shortcut menu.) For example, if I Ctrl-right-click the bottom left tip of the hombre's mustache, the shortcut menu lists four layers (see **Figure 9-11**), all of which contain opaque pixels at the point I clicked. Choose **Football** to go to that layer.

23. ***Bring the Football layer in front of the Hayseed layer.*** Press Ctrl+☐ (or ⌘-☐ on the Mac) twice to make it happen. The properly arranged layer elements appear in Figure 9-11.

24. ***Select the Collar layer.*** Click on the **Collar** layer in the Layers palette to select the layer that contains the reddish snorkeling fins. You might reckon those flippers look more like a dandy kerchief than a rugged collar, but that's because they're upside-down. Let's remedy that, shall we?

25. *Choose the Free Transform command.* Choose **Edit→Free Transform**, or press Ctrl+T (⌘-T), to enter the *free transform mode*, which is where you perform all varieties of transformation—scale, rotate, flip, skew, or distort—in Photoshop.

26. *Rotate the flippers 180 degrees.* Right-click in the image window (or Control-click if you don't have a right mouse button) to display a shortcut menu of common transformation options, as shown in Figure 9-12. Then choose **Rotate 180°** to spin the collar upside-down.

27. *Nudge the flippers upward.* Press Shift+↑ seven times in a row. Each press of Shift+↑ nudges the layer up 10 pixels, so you will have moved it 70 pixels in all. Or, if you prefer to move the layer manually, you can drag inside the transform boundary. Press Enter or Return to accept the transformation and exit the free transform mode.

28. *Save the changes you've made thus far.* Choose **File→Save** to update the existing *Composite drifter.psd* document on your hard disk. Or if you prefer to save versions as you go along—always a splendid idea because it means you can come back and recover elements from your original image later—choose **File→Save As** and give your file a new name. Make sure the **Layers** check box is on and the **Format** option is set to **Photoshop (*.PSD)** or just plain **Photoshop** on the Mac. Photoshop also lets you save layers to the TIFF and PDF formats, but where multilayer compositions are concerned, the native PSD format enjoys wider support among other imaging applications (including older versions of Photoshop itself).

Figure 9-12.

Importing, Transforming, and Warping Layers

Now that you've successfully arranged the layers in the composition, it's time to bring the rest of the elements into the mix, namely the eyes and the hat. In this exercise, you'll introduce portions of the *Food hat.psd* and *Eight ball.tif* images into the composition that you've created so far (and saved in Step 28 of the preceding exercise). Then you'll scale and otherwise transform the layers so they fit into place. The result will be a fanciful face made of objects that you don't often see on desperate men of the desert—especially that hat.

1. *Bring the eight ball image to the front.* Make sure all documents from the preceding exercise remain open (namely *Composite drifter.psd*, *Food hat.psd*, and *Eight ball.tif*). Then click the title bar for *Eight ball.tif*.

2. *Select a central portion of the pool ball.* Use the elliptical marquee tool to select the circular area shown in Figure 9-13. Or, to guarantee that your circle exactly matches mine, load the **Circle** mask that I've included in the **Channels** palette. You can do this by Ctrl-clicking (⌘-clicking) the alpha channel. Or press Ctrl+Alt+4 (⌘-Option-4).

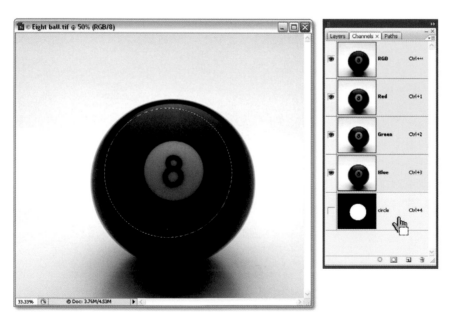

Figure 9-13.

3. *Drag the eight ball into the drifter composition.* Press and hold the Ctrl key (⌘ on the Mac) to get the move tool, and drag the selection from *Eight ball.tif* into the *Composite drifter.psd* image window. Drop it near where one of the eyes should go and notice that it lands in an undesirable position, behind the head, as shown in Figure 9-14. This is because Photoshop is putting the object in front of the previously selected layer, Collar. Looks like we'll need to rearrange.

4. *Rename the new layer.* Double-click the current layer name, **Layer 1**, to highlight the letters. Then change the name to the more descriptive "Eyes."

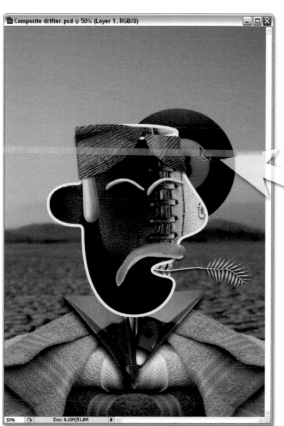

5. *Bring the Eyes layer in front of the Drifter Outline.* Either drag the layer up the stack or press Ctrl+⦋ or ⌘-⦋ five times.

6. *Choose the Auto Contrast command.* The eight ball is dimly lit with respect to its new surroundings. So choose **Image→Adjustments→Auto Contrast** or press Ctrl+Shift+Alt+L (⌘-Shift-Option-L on the Mac) to correct the brightness without upsetting the color balance.

Figure 9-14.

7. *Choose the Free Transform command.* The pool ball is too big, so naturally we need to scale it. Choose **Edit→Free Transform** or press Ctrl+T (⌘-T) to enter the free transform mode.

8. *Scale the layer to 32 percent proportionally.* You can pull this off in two ways:

 • Press the Shift key while dragging a corner handle to constrain the proportions of the ball. Keep an eye on the scale values in the options bar, circled in Figure 9-15. When they reach 32 percent (or thereabouts), release the mouse button, and then release Shift.

 • Click the 🔗 icon between the W and H scale values in the options bar to constrain the proportions. Enter 32 for either one of them (both values will change), and then press the Enter or Return key to accept the new values.

Figure 9-15.

To accept the scaled image and exit the free transform mode, press the Enter or Return key (yes, again) or click the ✔ on the right side of the options bar.

9. *Move the eye into position.* This eight ball is designed to serve as the left eye (which, to be fair to this fictitious person, is the drifter's right). Press Ctrl (or ⌘) to get the move tool and drag the eye under the eyebrow. When you feel the eye snap into alignment, release the mouse button and then press Ctrl+← (⌘-←) five times in a row to nudge it into its proper position, as shown in Figure 9-16.

Figure 9-16.

10. *Set the blend mode to Screen.* Return to the **Layers** palette and change **Normal** to **Screen**. You can also use the keyboard shortcut Shift+Alt+S (Shift-Option-S on the Mac). The opposite of Multiply, Screen drops out the blacks and preserves the light colors, creating the appearance of a glass eyeball against the football background, as in Figure 9-17.

Figure 9-17.

11. *Add a drop shadow.* The eyeball does indeed look glassy now, but it lacks definition. To give it more depth, we'll assign a couple of shadows. First, choose **Drop Shadow** from the *fx* icon at the bottom of the Layers palette to bring up the **Layer Style** dialog box. Then enter the following settings, as shown in Figure 9-18 on the facing page:

- Set the **Opacity** value to 100 percent.

- Increase the **Distance** value to 10 pixels.

- Change the **Size** value to 25 pixels.

- Make sure **Layer Knocks Out Drop Shadow** is turned on. This prevents shadows from appearing inside the translucent portions of the eye. (Turn the check box off if you want to see the difference.)

12. *Add an inner shadow.* Still inside the Layer Style dialog box, click the **Inner Shadow** item in the left list. Then enter the same values that you entered in the preceding step, once again as shown in Figure 9-18. (There is no Layer Knocks Out Drop Shadow check box, so don't worry about it.) When you finish, click **OK** to exit the dialog box and accept your changes.

13. *Return to the eight ball image.* The drifter needs two eyes. You could just duplicate the existing eye, but that's not the best approach. Imagine that the circle with the 8 inside it is the drifter's iris. Those irises should really point slightly in toward each other so that the drifter's focus is on the viewer. This means we need to make a new eye. Click the title bar for *Eight ball.tif* to bring the window to the front.

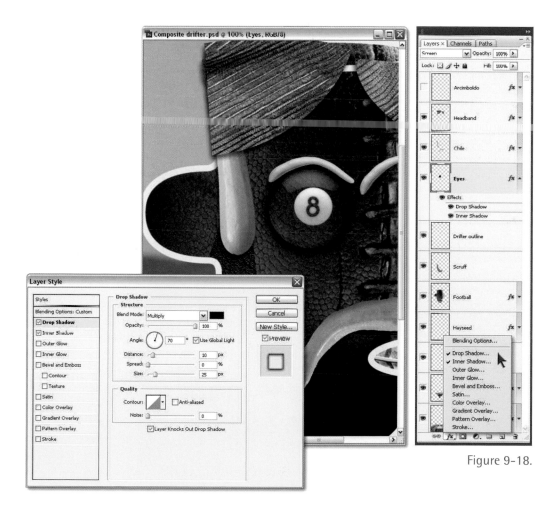

Figure 9-18.

14. *Nudge the selection outline to the right.* The circular selection should still be intact. (If not, press Ctrl+Alt+4 or ⌘-Option-4 to bring it back.) The iris needs to shift left, so the selection should shift right. Press the M key to bring up the marquee tool—so you're moving the selection, not the pixels—and then press Shift+··→ four times to nudge the selection outline 40 pixels.

15. *Drag the eight ball into the drifter composition.* Press and hold Ctrl (⌘ on the Mac) and drag the selection from *Eight ball.tif* into the *Composite drifter.psd* image window. Photoshop imports the eight ball in front of the previously active layer, in this case, Eyes. (There's no need to name this new layer because we'll be merging it with the underlying Eyes layer in Step 21.)

16. *Choose the Auto Contrast command.* Once again, choose **Image**→**Adjustments**→**Auto Contrast** or press Ctrl+Shift+Alt+L (⌘-Shift-Option-L) to brighten the pool ball.

17. *Repeat the last transformation.* Choose **Edit**→**Transform**→ **Again** or press Ctrl+Shift+T (⌘-Shift-T) to reapply the last transformation, which in our case happens to be the 32 percent proportional scaling. Just like that, both eyeballs appear the same size, as pictured in Figure 9-19.

Figure 9-19.

18. ***Drag the eye into position.*** Although the new eye is sized properly, it's hardly positioned properly. Ctrl-drag (or ⌘-drag) the right eye into the horizontal position shown at the top in Figure 9-20. Thanks to Photoshop's layer snapping function (View→Snap To→Layers, turned on by default), you should feel the eye snap into alignment with the eyebrow above it. You could likewise snap the right eye into vertical alignment with the left, but don't. I want to show you another way.

19. ***Select both eye layers.*** In versions CS and earlier, Photoshop required you to go through the awkward process of linking layers to adjust two or more at the same time. Happily, the program permits you to select multiple layers at a time. With the right eye (Layer 1) still selected, press the Shift key and click the **Eyes** layer to add it to the selection. Both layers appear highlighted, as in Figure 9-20.

Figure 9-20.

20. *Align the eyes vertically.* Assuming that the translucent Eyes layer is higher—vertically, that is—than the opaque Layer 1, choose **Layer→Align→Top Edges**. Photoshop scoots the opaque eye upward to meet the elevation of the translucent one. The result is two eyes placed side-by-side, as in the bottom image in Figure 9-20 (preceding page).

21. *Merge the right eye with the left.* Click **Layer 1** in the **Layers** palette so that it's the only layer selected. (It's very important you do this; otherwise, the next command will behave differently.) Then choose **Layer→Merge Down** or press Ctrl+E (⌘-E on the Mac). Photoshop combines the two pool ball layers into one. But that's not all it does. As shown in Figure 9-21, the program retains all attributes of the lower layer, including:

- The layer name, Eyes

- The blend mode, Screen

- The two layer styles, Drop Shadow and Inner Shadow

Figure 9-21.

The result shown in Figure 9-21 is amazing. In fact, it may appear more amazing than it really is. The right eye looks as if it's distorting the laces of the football just as a piece of rounded glass really would. But that's an illusion—Photoshop is doing no such thing. The fact that the effect reads like a glass distortion is pure bonus.

EXTRA ★ CREDIT

The only element missing is the outrageous, food-filled hat. The thing is, getting that hat and fitting it to the composite drifter's head is a rather challenging process, requiring as many steps as we've performed so far. If fitting flouncy hats to strange men's heads isn't exactly your life's ambition, skip ahead to the next exercise, "Masks, Knockouts, and Luminance Blending," which starts on page 329. But be forewarned: If you do, you'll miss one of the most exciting transformation features in Photoshop, custom image warping. And take it from me, you don't want to miss that. So do like the drifter and keep on keepin' on.

22. *Bring the hat composition to the front.* Click the title bar for *Food hat.psd* to make it the active image. This twelve-layer composition features ingredients from the PhotoSpin and iStockphoto libraries, including elements from Leah-Anne Thompson, Louis Aguinaldo, Jim Jurica, and David Shawley.

23. *Select and copy the hat composition.* This brightly colored feast might seem like an odd choice of headgear for our rugged, virile, football-faced drifter. But if there's one skill you need to make it on the road, it's pragmatism. Who hasn't sat by a campfire, strumming a banjo on a cool desert night, and felt a craving for a hamburger? Or some churros? I've already masked and assembled the vittles; all you need to do is bring them over:

 - Choose **Select→All** or press Ctrl+A (⌘-A on the Mac) to select the entire composition.

 - Choose **Edit→Copy Merged** (see Figure 9-22) or press Ctrl+Shift+C (⌘-Shift-C) to copy a merged version of the composition, with all transparency intact.

24. *Paste the hat into the drifter composition.* Click the *Composite drifter.psd* title bar to make it active. Then choose **Edit→Paste** or press Ctrl+V (⌘-V) to paste the hat onto a new layer. Naturally, it comes

Figure 9-22.

in too low on the head, too far down the stack, and *way* too big, as in Figure 9-23. Such are the ways of the layered composition, and the reason for the remaining steps.

25. ***Rename the new layer.*** Double-click the current layer name (as always, **Layer 1**) and change its name to "Hat."

Figure 9-23.

26. ***Bring the hat to the front of the composition.*** Choose **Layer**→**Arrange**→**Bring to Front** or press Ctrl+Shift+⌷ (⌘-Shift-⌷). The layer pops to the top of the stack where it belongs.

27. ***Lower the Opacity value to 50 percent.*** Assuming a selection tool is active, press the 5 key.

We want the final hat to be fully opaque. So why lower its opacity? By making the hat translucent in the short term, it's easier to transform the hat with respect to the elements underneath. Note that it's essential that you perform this step now; you cannot modify the opacity or blend mode when inside the free transform mode.

28. ***Choose the Free Transform command.*** Choose **Edit**→**Free Transform** or press Ctrl+T (⌘-T on the Mac).

29. *Scale and rotate the layer.* Shown at the top of Figure 9-24, the ideal settings are as follows:

- Scale the hat to 48 percent. Either Shift-drag a corner handle or click the 🔒 icon between the W and H values in the options bar and change the **W** or **H** value to 48.

- Move your cursor outside the transform boundary and drag to rotate the hat slightly counter-clockwise until the rotate value in the options bar (the △ to the right of H) reads −2.5 degrees. Or just enter −2.5 into the △ option box.

- Drag inside the transform boundary to move the hat above the ears. To exactly match my placement, set the **X** and **Y** values to 585 pixels and 300 pixels, respectively.

Don't press Enter or Return yet. We want to remain in the free transform mode for the next step.

Figure 9-24.

30. *Choose the Warp command.* Photoshop provides a *warping* function that lets you apply multipoint distortions directly in the image window, without having to enter a separate interface, the way you do with the Liquify filter. Warping doesn't eliminate the need for Liquify (which remains a powerful and essential retouching tool), but there's no disputing its convenience. And as you'll see, it offers a degree of precision that Liquify lacks. You have several options for entering the warp mode:

- Right-click inside the transform boundary and choose the **Warp** command.

- Click the ⛫ icon to the left of V in the options bar, which I've circled in Figure 9-25.

- If you loaded the dekeKeys shortcuts, press Ctrl+Shift+R (⌘-Shift-R on the Mac).

31. *Apply the Inflate style.* Our goal is to give the hat a little depth and fit it more naturally onto the fellow's head without making the warp too obvious. No sense giving the fruit bowls any more of an unnatural bend than we absolutely have to. As a starting point, bulge the layer outward by selecting the **Inflate** option from the **Warp** pop-up menu.

Figure 9-25.

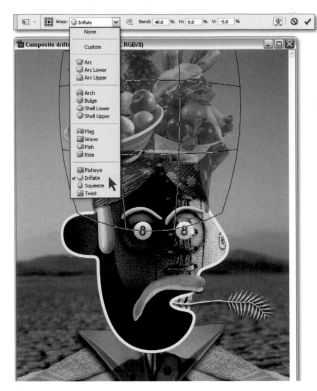

Figure 9-26.

To make the effect a bit more subtle, decrease the **Bend** value to 40 percent. Then bend the top of the hat outward by setting the **V** value (for vertical distortion) to –5 percent. The result appears in Figure 9-26.

32. *Apply a custom warp.* Presets like Inflate are nice, but when distorting one image to match another, you need to be able to customize the warp. Choose **Custom** from the **Warp** pop-up menu. The shape of the grid stays the same, but you now have access to square corner handles, which let you stretch the image, and round control handles, which let you twist and bend the image. (For an introduction to control handles, see Step 18 of "Drawing Precise Curves" on page 147 of Lesson 4.) Drag the points and handles to warp the hat until you wind up with something like the image in Figure 9-27.

Click the middle ⬜ along the bottom of the toolbox to enter the full-screen mode so you drag points and handles in the pasteboard. And incidentally, no one says you have to drag points and handles. You can drag any spot inside the warp grid to push the layer's pixels. If the grid's in your way, hide it by choosing View→Extras or pressing Ctrl+H (⌘-H). You lose sight of the points and handles, but you can drag and smush the layer all the same. Press Ctrl+H (⌘-H) to bring the grid back.

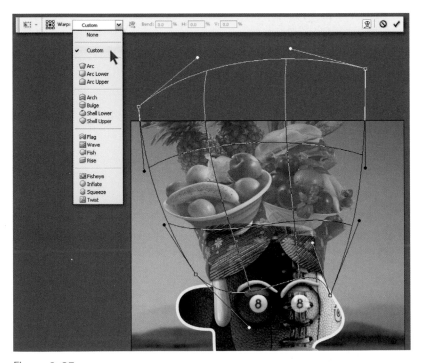

Figure 9-27.

33. *Tweak and accept the transformation.* Take care to get the bottom prongs of the red kerchief aligned with the pale yellow stroke around the drifter's head. Drag the pineapples left and up to prevent the hat from leaning too far forward on the head. And note that every action creates reactions throughout the image, so after dragging one handle, you'll most likely have to drag an opposite handle to compensate. When you've finished obsessing over your custom warp, click the ✔ in the options bar or press Enter or Return to accept the transformation.

PEARL OF WISDOM

Notice that we applied several operations inside one free transform session. You should work this way when creating your own projects as well. Each session rewrites the pixels in the image, so each is potentially destructive. By applying all your changes in a single session, you rewrite pixels just once, minimizing the damage caused by multiple interpolations. (For an exception to this rule, see "Working with Smart Objects" in Lesson 11.)

34. *Restore the opacity to 100 percent.* Press the ⓪ key (zero) or change the **Opacity** value in the Layers palette.

35. *Copy the Collar layer's drop shadow.* The Hat and Drifter Outline layers are just begging for drop shadows. But rather than create the shadows from scratch, let's repurpose them from another layer. In the Layers palette, scroll down to the **Collar** layer. Then right-click (or Control-click) that layer and choose **Copy Layer Style**, as in Figure 9-28.

36. *Select both the Hat and Drifter Outline layers.* Click the **Drifter Outline** layer to make it active. Then hold down the Ctrl (or ⌘) key and click the **Hat** layer to select it as well. Ctrl-clicking a layer's name (not its thumbnail) selects non-adjacent layers.

37. *Paste the drop shadow on the selected layers.* Right-click either of the selected layers and choose **Paste Layer Style** (see Figure 9-29). Both the hat and the yellow outline receive drop shadows that match the one applied to the flippers.

Figure 9-28.

Figure 9-29.

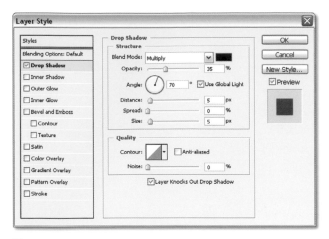

Figure 9-30.

Figure 9-31.

38. *Modify the Drifter Outline drop shadow.* You can paste a layer style onto multiple layers simultaneously, but you can edit just one layer style at a time. Double-click the *fx* icon on the right side of the **Drifter Outline** layer in the Layers palette to display the **Layer Style** dialog box. Click the **Drop Shadow** item in the left list. Change the **Opacity** value to 35 percent. Then change both **Distance** and **Size** to 5 pixels, as in Figure 9-30. Click **OK** to update the Drifter Outline layer.

39. *Modify the Hat drop shadow.* I like the way the Hat shadow shades the two pieces of the blue headband, but I don't like the way it leaks into the pale yellow outline. Right-click the *fx* to the right of the **Hat** layer and choose **Create Layer**. If you see an alert message, don't worry about it; just click **OK**. Photoshop separates the drop shadow to a new layer called Hat's Drop Shadow.

40. *Mask the shadow inside the Headband layer.* This step is a little tricky, so I'll walk you through it one keystroke at a time:

 • Press Alt+⬚ (Option-⬚ on the Mac) to select the **Hat's Drop Shadow** layer.

 • Press Ctrl+⬚ (⌘-⬚) to move the drop shadow down one layer, just above Headband.

 • Press Ctrl+Alt+G (⌘-Option-G) to combine it with the Headband layer, so that the blue headband masks the shadow. To learn more about this technique, read the next exercise, which starts on the facing page.

41. *Turn on the Arcimboldo layer.* Click the blank square in front of the **Arcimboldo** layer to display a line of frivolous text that I drew by hand with a Wacom tablet. The final composition appears in Figure 9-31.

42. *Save your composition.* So ends another jam-packed exercise. Choose **File→Save** to update the file on your hard disk. Or if you prefer, choose **File→Save As** to save an independent version.

Masks, Knockouts, and Luminance Blending

Another advantage to layers is that they permit you to blend multiple images while keeping them entirely independent of each other. For example, changing the mode setting or Opacity value in the Layers palette blends the active layer with all layers below it. Such operations are said to be *parametric* because they rely on numerical entries and mathematical parameters that Photoshop calculates and applies on-the-fly. The benefits of parametric effects are threefold:

- You can't make a mistake. If you select a blend mode and you don't like it, no big deal; just choose another one. You have unlimited opportunities to experiment.

- Parametric data is forever editable. As long as you save the composition with all layers intact, you can modify those layers to your heart's content days, months, and years into the future.

- Thanks to their mathematical nature, parametric effects take less time to apply and consume less memory and disk space than traditional pixel-level modifications. In other words, parametric effects are as fast as they are flexible.

Parametric effects aren't the only way to blend layers. You can also apply one of three varieties of layer-specific masks:

- A *layer mask* creates holes in a layer without erasing pixels.

- A *clipping mask* uses the boundaries of the active layer to crop the contents of one or more layers above it.

- A *knockout* uses the contents of the active layer to cut holes in the layers below it.

Plus, you can temporarily drop out brightness levels and a whole lot more. In this exercise, you'll use these wonderful functions to create the latest installment in the exciting Dinosaur Planet saga (begun in Lesson 7).

1. *Open a multilayer composition.* There's just one file to open, *The escape.psd*, located in the *Lesson 09* folder inside *Lesson Files-PsCS3 1on1*. At first blush, the file looks like nothing more than a snapshot I captured close to a decade ago of South Dakota's breathtaking Badlands (see Figure 9-32). But there's much more to it.

Figure 9-32.

2. *Select the Badlands layer in the Layers palette.* Go to the **Layers** palette and make sure the **Badlands** layer is active. Note that there are several other layers and folders of layers (called *layer groups*), most of which are currently hidden. We'll turn on these layers in future steps.

3. *Scoot the layer downward 200 pixels.* You can do this in a couple of ways:

 • Press Ctrl+Shift+↓ (⌘-Shift-↓) twenty times in a row. Sounds ridiculous, but it's pretty routine.

 • Press Ctrl+T (⌘-T) to enter the free transform mode. Then click the delta symbol (Δ) in the left half of the options bar to turn on relative positioning, as labeled in Figure 9-33. Change the **Y** value to 200 pixels and press the Enter or Return key.

Relative positioning

Figure 9-33.

We've revealed 200 pixels of sky from the Thin Sky layer behind the Badlands layer. The sky is dramatic, but the transition between the two layers leaves something to be desired, so let's blend them together with a layer mask.

4. *Load the Planet Arc mask as a selection.* Go to the **Channels** palette and Ctrl- or ⌘-click the **Planet Arc** channel. Or just press Ctrl+Alt+4 (⌘-Option-4 on the Mac). A curved selection appears along the horizon of our emerging world.

5. *Click the layer mask icon.* Return to the **Layers** palette and click the tiny ▢ icon at the bottom, indicated by the arrow cursor in Figure 9-34. This converts the selection to a layer mask, creating a smoother transition between Earth and sky.

Figure 9-34. Add layer mask

PEARL OF WISDOM

The mask appears as a thumbnail in the Layers palette, identical to how it appears in the Channels palette. In fact, for all intents and purposes, you just duplicated the mask from one location to another. Where the mask is white, the layer is opaque; where the mask is black, the layer is transparent.

6. *Click the brush tool in the toolbox.* The problem with the curved mask is that it scalps away too much of the rocky cliffs in the central and right portions of the image. But because it's a mask, you can paint the cliffs back. Press B to select the brush tool and then press D to make the foreground color white, the default setting when working in a mask.

7. *Paint inside the mask.* Select a small, hard brush, about 20 pixels in diameter, and paint along the rim of the mountaintops in the image window. Assuming that the layer mask is active (as it should be), you'll reveal the tops of the ridges.

- If you reveal too much of a ridge, press the X key to switch the foreground color to black and then paint inside the image window to erase pixels.

- If you erase too much, press X again to restore white as the foreground color and then paint.

- You don't have to limit yourself to brush work. You can select an area with the lasso tool and fill it with white to reveal an area or with black to erase it.

Keep painting until you achieve more or less the effect pictured in Figure 9-35. And don't fret too much if you end up with some stray sky pixels from the Badlands layer. We'll cover them up in a few moments. In other words, be tidy but don't knock yourself out.

If you find yourself adding white or black brushstrokes to your image, it's because you accidentally activated the image instead of the mask. (Inspect the icon to the right of the 👁 icon for the Badlands layer. A 🖌 indicates that the image is active, which is not what you want. A ▢ icon tells you that the mask is active and all is well.) If you encounter this problem, undo any damage and then click the black-and-white layer mask thumbnail directly to the left of the word **Badlands** in the Layers palette. This returns Photoshop's attention to the layer mask, as the ▢ makes clear.

Figure 9-35.

Alternatively, you can switch between the image and the layer mask from the keyboard. Press Ctrl+⌐ (⌘-⌐ on the Mac) to activate the layer mask. Press Ctrl+⌐ (⌘-⌐) to switch back to the image. The ▢ and 🖌 icons monitor your status.

8. *View the mask independently of the image.* To see the layer mask by itself, press the Alt key (Option on the Mac) and click the black-and-white layer mask thumbnail in the Layers palette. You should see a mask like the one pictured in Figure 9-36. Paint or otherwise modify it if you like. To return to the composite image, Alt-click the mask thumbnail again.

To view the mask as a rubylith overlay—thus permitting you to see both mask and image—press the backslash key, ⌐. To hide the image and view just the mask, press the tilde key, ⌐. To display the image, press ⌐ again. To hide the mask, press ⌐. Throughout, the layer mask remains active.

9. *Select the Gradient layer.* Still in the Layers palette, turn on the 👁 to the left of **Gradient** to display the layer and then click the layer itself to select it. This previously hidden layer contains a combination of black and brown gradient patterns.

10. *Change the blend mode and opacity.* Choose **Multiply** from the blend mode pop-up menu in the top-left corner of the **Layers** palette. (You can also use the shortcut Shift+Alt+M or Shift-Option-M, but only *after* you switch from the brush tool to a selection tool.) Photoshop burns in the blacks and browns and drops out the whites, as shown in Figure 9-37 on the facing page. To temper the effect, reduce the **Opacity** value in the Layers palette to 80 percent.

11. *Set the Badlands layer to mask the Gradient layer.* Choose **Layer→Create Clipping Mask**. This clips the Gradient layer to the boundaries of the layer below it, Badlands. As a result, the gradient fits entirely inside the horizon mask (see Figure 9-38) that you established in Step 7. In the Layers palette, the Gradient layer appears inset; the Badlands layer appears underlined to show that it's the base of the clipping mask.

You can use two shortcuts when creating a clipping mask. Press Ctrl+Alt+G (or ⌘-Option-G) to invoke the Create Clipping Mask command. (Clipping masks used to be called clipping *groups*, hence the G key.) Or press the Alt (or Option) key and click the horizontal line between the Gradient and Badlands layers in the Layers palette. To release a layer from a clipping mask, press Ctrl+Alt+G (⌘-Option-G) or Alt-click (Option-click) the horizontal line again.

Figure 9-36.

Figure 9-37.

Figure 9-38.

Figure 9-39.

Figure 9-40.

12. **Select and show the Moon layer.** Click the **Moon** layer and turn on its 👁. The moon hovers bright and enormous over the horizon, as pictured in Figure 9-39. How did it get so big? Because it's actually the dread Dinosaur Planet in disguise! (Don't be frightened; it's just an exercise.)

13. **Set the blend mode to Screen.** Assuming a selection tool is active, you can press Shift+Alt+S (or Shift-Option-S). As I mentioned earlier, Screen drops out the blacks and preserves the light colors. In this case, however, it adds brightness all over the place, even in the black areas (see Figure 9-40).

PEARL OF ⬤ WISDOM

Well, not quite. Admittedly, the area behind the moon is quite dark, but it isn't altogether black. And unless it's absolutely pitch black, Screen makes it brighter. That means you'll have to drop out the dark colors manually using luminance blending.

14. **Double-click the Moon thumbnail in the Layers palette.** Or right-click the **Moon** layer and choose **Blending Options**. Either way, Photoshop greets you with the Blending Options panel of the **Layer Style** dialog box, which contains a vast array of parametric effect options.

15. **Drag the black This Layer slider triangle.** Confirm that the **Preview** check box is turned on. Then turn your attention to the two slider bars near the bottom of the dialog box:

- The first slider bar, This Layer, lets you drop out the darkest or lightest colors in a layer.

- The second slider, Underlying Layer, causes the darkest or lightest colors from all layers below to shine through the active layer. (The option name should really be plural, but I'm nitpicking.)

Drag the black triangle associated with **This Layer** to the right until the space around the moon turns invisible, as shown in Figure 9-41. I find this happens when the first numerical value reads 50, meaning that any color with a luminosity level of 50 or darker is hidden.

16. *Add some fuzziness.* The problem with the current solution is that it results in a very abrupt transition between visible and invisible pixels. (Zoom in on the left side of the moon to see what I mean.) To soften the drop off, you need to add some fuzziness. Press the Alt key (Option on the Mac) and drag the right side of the black triangle to split the triangle in half. Then drag to the right until the first of the **This Layer** values read 50/105 (again, see Figure 9-41).

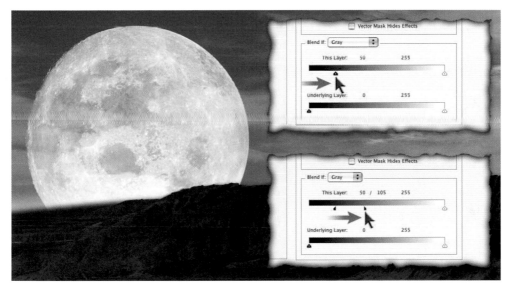

Figure 9-41.

Here's what the 50/105 values mean:

- Any color with a level of 50 or darker is invisible.

- Any color with a level of 105 or lighter is visible.

- The colors with luminosity levels between 105 and 50 taper gradually from visible to invisible, respectively. This is the fuzziness range.

The effect looks slick, but not very realistic. The moon appears to be sitting on the sky instead of sunken into it. Part of the problem is that the moon is in front of the clouds. Fortunately, the Underlying Layer slider lets us push the clouds forward.

17. *Drag the white slider triangle.* Drag the white **Underlying Layer** triangle to the left until the second value reads 140, which is when about half the clouds start to obscure the moon. This uncovers any color with a luminosity level of 140 or lighter.

18. *Again, add some fuzziness.* This time, we have some wicked jagged edges. Press Alt (or Option) and drag the left side of the white triangle until the value reads 80/140. The clouds fade in and out of visibility, blending smoothly with the moon, as shown in Figure 9-42.

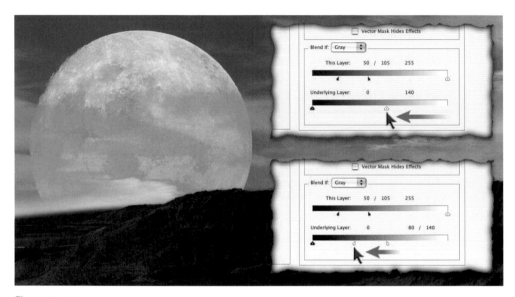

Figure 9-42.

19. *Reduce the opacity to 40 percent.* The **Opacity** value at the top of the Layer Style dialog box is identical to the one in the Layers palette. Click **OK** to accept your changes. The resulting moon appears in Figure 9-43.

20. *Select and show the Me on T layer in the Layers palette.* This layer sports an off-center picture of me with one of Rapid City's world-famous, poorly rendered plaster dinosaurs. This one is supposed to be a tyrannosaur! The plaster T. Rex really exists and I am really sitting on it. The only change I made to the image was to add the red mittens. The poor thing looked kind of chilly.

21. *Load the Dino Outline path as a selection.* Go to the **Paths** palette. Press Ctrl (or ⌘) and click the **Dino Outline** path to convert it to the selection outline pictured in Figure 9-44.

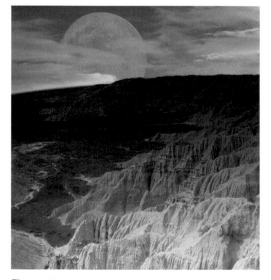

Figure 9-43.

22. *Click the layer mask icon.* Press F7 to switch back to the **Layers** palette and then click the ▢ in the row of icons at the bottom of the palette. This converts the path selection to a layer mask, eliminating my previous background and placing me squarely in the action.

23. *Show the Nippers folder in the Layers palette.* Click the gray square in front of the **Nippers** folder to display a group of layers that include two little dinosaurs nipping at my heels, as in Figure 9-45.

Figure 9-44.

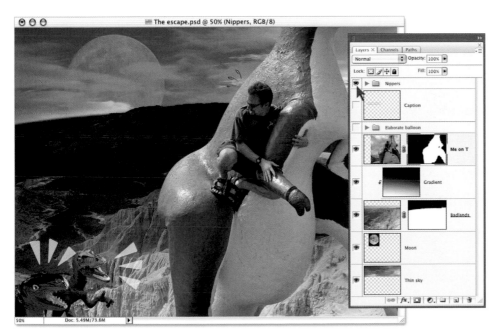

Figure 9-45.

24. ***Show the Elaborate Balloon folder and its caption.*** Click in front of each item to turn on the 👁s. The Elaborate Balloon group contains the talk balloon as well as several layers of patriotic falderal required to frame the commanding urgency of the caption. Turn on the **Caption** layer to display more of my hand-drawn text (which appeals to the dinosaur I'm riding to get a move on). Everything we're about to do works just as well with the sort of live typeset text that we discuss in the next lesson; the hand-drawn text just happens to better suit my graphic novel composition.

As shown in Figure 9-46, the text is currently green. But that's just a placeholder color. I ultimately want the letters to cut holes through all the layers in the Elaborate Balloon group and reveal the dark shadows of the Badlands background. I can approach this vexing conundrum in one of two ways:

- Layer masks can be applied to individual layers or entire groups of layers. So I could create a mask for the Elaborate Balloon group in which the text was black (invisible) and the area around the text white (visible). But it would take extra work and it might limit my options in the future.

- I could establish the Caption layer as a knockout, thereby cutting holes in the layers in back of it. Not much work + very flexible = preferred solution.

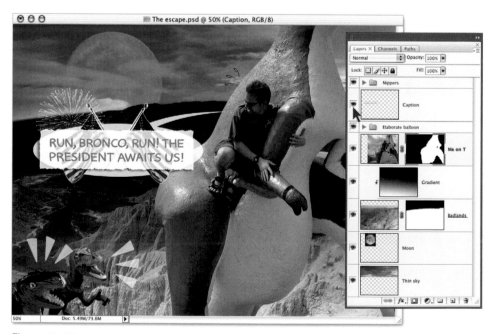

Figure 9-46.

The big question when creating a knockout is, how deep does it drill? Knockouts are either "deep," going all the way to the Background layer (or transparency if there is no Background), or "shallow," ending at the base layer of a group. We just want to burrow through the Elaborate Balloon layers, so we need a group with a shallow knockout.

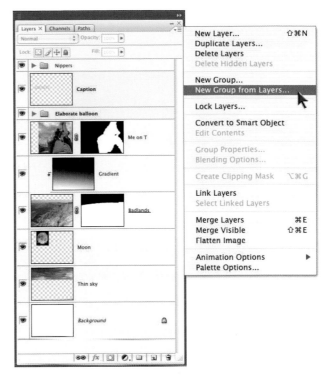

25. *Select both the Caption layer and the Elaborate Balloon group.* Click the **Caption** layer to select it. Then Shift-click the **Elaborate Balloon** group to add it to the selection.

26. *Place the selected layers inside a new layer group.* Click the ⊙ arrow at the top of the Layers palette and choose **New Group from Layers**, as in Figure 9-47. Or better yet, press the simple and memorable shortcut, Ctrl+G (⌘-G on the Mac). Name the new group "Knockout Text" and click the **OK** button.

27. *Twirl open the new layer group.* Click the ▶ arrow in front of the Knockout Text folder to reveal the new group's contents.

28. *Double-click the Caption layer thumbnail.* Photoshop once again displays the always fascinating **Blending Options** panel of the **Layer Style** dialog box.

29. *Choose Shallow from the Knockout pop-up menu.* The **Knockout** option appears circled in red in Figure 9-48. Contrary to what you might reasonably expect, this option has no immediate effect. Instead, it merely establishes the layer as a potential knockout. To put the knockout in play, see the next step.

30. *Reduce the fill opacity to 0 percent.* Identical to the Fill value in the Layers palette, Fill Opacity changes the translucency of pixels in a layer independently of drop shadows and other styles. (See Lesson 11 for more info.) But it also has a symbiotic relationship with the Knockout option. Drag the **Fill Opacity** slider triangle and watch the text

Figure 9-47.

Figure 9-48.

fade into the background art. At 0 percent, all you see is background. To complete the effect, close the dialog box by clicking the **OK** button.

31. *Move the Me on T layer into the group.* If you look closely at the text, you'll see that the word *US!* is bisected by the green back of the plaster dinosaur. To make the text bore through the dinosaur as well, just move it into the group. In the **Layers** palette, drag the **Me on T** layer onto the Knockout Text folder icon (see Figure 9-49). When you release the mouse button, Photoshop places Me on T at the back of the group and knocks the letterforms out of the dino's hip, just as it should be.

Figure 9-49.

32. *Save your composition.* Choose **File→Save** to update the file on your hard disk. After all, why bother with File→Save As when everything is either a mask or a parametric effect?

The beauty of this exercise is that every single one of the changes you've made is reversible. You can delete the layer masks that you added in Steps 5 and 22, unravel the clipping mask from Step 11, modify the blending options applied in Steps 15 through 19, and bust up the knockout from Step 29. And the reason the composition is so exceedingly, wonderfully, downright obscenely flexible is because you never changed a single pixel on any of the core layers. If only everything in Photoshop were this flexible—well, the world would be a happier place, wouldn't it?

Working with Layer Comps

As you increase the complexity of your layered documents, you'll find yourself experimenting with different compositional arrangements. What if you moved this layer over here? What if that layer were hidden? What if you gave a third layer a drop shadow? Sometimes the answer is obvious the moment you give it a try. Other times, the answer eludes you until several steps or even sessions later.

Photoshop's Layer Comps palette lets you save the current state of a document before you venture down an unclear road. As long as you don't delete or merge any of the layers in the saved *layer comp*, you can restore the saved state in its entirety later. Layer comp states are actually saved as part of the PSD file on disk, just like layers, channels, paths, and other specialized data.

To learn which layer attributes the Layer Comps palette can track, see the upcoming sidebar "What Layer Comps Can and Can't Save" (page 343). To learn how to use layer comps, immerse yourself in the following steps.

1. *Open a layered composition.* Open the next image in our gripping drama, *The capture.psd*, included in the *Lesson 09* folder inside *Lesson Files-PsCS3 1on1*. As before, we see the Badlands photo and nothing more. But this time you won't have to build up the layers manually. I performed very nearly all the work ahead of time and saved my progress using layer comps.

2. *Open the Layer Comps palette.* By default, the Layer Comps palette is tucked away in the column of icons to the left of the main palettes. To bring it up, click the ▤ icon (presumably the last icon in the column) or choose **Window**→**Layer Comps**. You can work this way if you like, with the palette hanging open like a flyout menu, but in my humble opinion, layer comps are too important to be given such short shrift. Which is why I recommend that you drag the **Layer Comps** palette into the main docking pane on the right side of the screen, as witnessed in Figure 9-50. (Here you see me dragging Layer Comps into a cluster that includes History and Actions. Those of you blessed with long and enduring memories may recall that I established this cluster in Video Lesson 1, "Navigation," introduced way back on page 4.)

Figure 9-50.

3. *Click in front of a comp name to switch to it.* Clicking in the column on the left side of the Layer Comps palette displays a tiny manuscript icon and shows the layers and effects saved with the corresponding comp. In Figure 9-51, I clicked in front of the third comp, **Rapid City Photo**. Notice that the photo is centered and fully visible. Click in front of **Dinosaur Elements** to see the photo offset and masked. This is the amazing power of layer comps.

Figure 9-51.

Figure 9-52.

4. *Examine a layer comp's settings.* Any comp that has a triangle next to it includes a description. To view the description, click the ▶ to twirl open the comp, or double-click to the right of the comp name (not directly on the name) to display the **Layer Comp Options** dialog box shown in Figure 9-52. The dialog box lets you view the complete description, as well as which

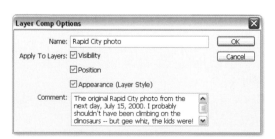

As shown in the dialog box on the right, a layer comp can save any of
the following three attributes:

- **Visibility:** This includes which layers and
 layer masks are turned on and off. (You
 turn a mask on and off by Shift-clicking its
 thumbnail in the Layers palette.)

- **Position:** Remarkably, a layer comp can
 track the horizontal and vertical position of
 a layered object. This means you can move
 layers around between saved comps.

- **Appearance (Layer Style):** Photoshop saves
 the Opacity setting and blend mode as-
 signed to each layer, as well as knockouts,
 luminance blending, drop shadows, and all
 other parametric effects. This one check box
 is worth the price of admission.

That's all very well and good, but this list of three attributes represents
a fairly small collection, especially when you consider that the list hasn't
changed since the last version of the program and there's plenty of stuff
that the Layer Comps palette *can't* track, including:

- **Arrangement:** If you move a layer up or
 down the stack, it changes inside all saved
 comps. This goes for moving layers into or
 out of sets as well. Frankly, I regard these
 oversights as enormous gaffs, but that's the
 way it is.

- **Clipping masks:** Mask a layer with the layer
 below it, and it'll be masked inside all saved
 comps. Again, a big oversight; again, noth-
 ing we can do.

- **Scale and orientation:** Transformations are
 pixel-level modifications. So if you scale or
 rotate a layer, it changes inside all comps.

- **Pixel-level changes:** The same goes for
 cropping, image size, brushstrokes, color
 adjustments, and filters. Any of these changes
 affects all comps.

- **Adjustment layer settings:** As you'll see
 in Lesson 11, "Styles and Specialty Layers,"
 adjustment layers and smart objects are spe-
 cialized layers that permit you to edit images
 without permanently altering so much as a
 single pixel. Rather bizarrely, layer comps
 can't track adjustment layer settings or smart
 object transformations.

- **Additions:** If you add a layer, all existing
 layer comps treat it as off unless otherwise
 instructed.

- **Deletions:** If you delete a layer, merge a
 few layers, or delete a set, the Layer Comps
 palette fills with yellow ⚠ icons. In all like-
 lihood, the comps will work as well as can
 be expected. But you'll have to update the
 comps (see Step 8 on page 346) to make the
 warning icons go away.

layer attributes are saved with the comp. To learn more about the check boxes, read the sidebar "What Layer Comps Can and Can't Save." When you're through poking around, press the Esc key to exit the dialog box.

5. *Click the arrow buttons to cycle from one comp to the next.* The small ◄ and ► buttons at the bottom of the **Layer Comps** palette let you switch to the previous or next saved state, respectively. I clicked the ► button a few times to advance to the final comp, **Surveillance**. Shown in Figure 9-53, this comp features a few layers that we haven't seen before. If the comp is to be believed, it would seem my movements are being monitored.

6. *Go to the Layers palette.* If you're ever curious to see how a comp was created, just refer to the **Layers** palette. There you'll find several new layers and sets, some of which are turned on to create the green-TV-artifact effect. Feel free to explore the layers as you see fit.

Figure 9-53.

7. *Delete the Plans Identified layer.* Click the layer called **Plans Identified**. This is an editable (not hand-drawn) text layer that identifies the target around the rolled-up paper so deftly hidden in Bronco the dinosaur's mitten, as seen in Figure 9-54 below. The idea is fine, but I ultimately decided that it ruins the subtlety of the piece. (Yes, the piece has subtlety—loads of it.) To delete the layer, click the trash can icon at the bottom of the Layers palette. Then click **Yes** to confirm the deletion, as in the figure.

To bypass the confirmation and delete the layer without any grousing from Photoshop, press the Alt (or Option) key when clicking the trash can. Or just turn on the **Don't show again** check box and, forbidding a crash or a corrupt preferences file, you really never will see it again.

Figure 9-54.

Deleting the Plans Identified layer upsets two layer comps, Surveillance and Rough Comp, which are now marked with yellow ⚠ warning icons. Although only one of the comps actually displayed the layer, both comps were created or updated since the Plans Identified layer was introduced. Therefore, they both knew of the layer's existence; the other comps did not. To get rid of the ⚠ icons, you must update the comps as explained in the next step.

8. *Update the affected layer comps.* You update the two comps in slightly different ways:

 • Because the Surveillance comp represents the current state, you don't need to reload it. Just click the word **Surveillance** in the **Layer Comps** palette to make sure it's active. Then click the ↻ update icon at the bottom of the palette, identified by the cursor in Figure 9-55.

 • To update **Rough Comp**, first click to the left of it to restore the comp's layer settings. (It's very important that you load the comp before updating; otherwise you'll wreck it by overwriting it with the layer settings from the Surveillance comp.) Then click the ↻ icon as before.

9. *Restore the Surveillance comp.* Now we'll create our own comp by basing it on the last comp, **Surveillance**. Click in front of the comp name to restore its layer settings.

10. *Turn on the three hidden layer items.* Go to the **Layers** palette and turn on the hidden group, **Emperor Scratch**, as well as the top two layers, **Text** and **Backcard**. (The quickest way to display all three 👁s is to click in the left column in front of Emperor Scratch and drag up.) The result is the malevolent duckbill skeleton from Lesson 7—augmented with a spiffy row of suspiciously unduckbillish carnivore teeth—along with a fiendish new caption, all of which appear in Figure 9-56 on the facing page. Sounds like he's talking about me, but he's really after Bronco. Bad blood, you know. They're stepbrothers or something, I forget.

Figure 9-55.

Figure 9-56.

11. *Create a new layer comp.* Click the ⬛ icon at the bottom of the **Layer Comps** palette to display the **New Layer Comp** dialog box. Name the comp "The Menacing Observer" and turn on all three check boxes. If you want to annotate the comp, enter a comment like the one shown in Figure 9-57. Click the **OK** button to add the new state to the Layer Comps palette.

Figure 9-57.

Badlands photo

Rough comp

The menacing observer

Figure 9-58.

12. *Cycle through the comps as desired.* In Figure 9-58 we see details from three of the eight comps. Given that these are views of a single file, and that every one of them relies on the very same collection of 27 layers and five groups, it's amazing just how unique each comp is.

13. *Save your changes.* Because we deleted a layer (Step 7, page 345), I recommend that you choose **File→Save As**. Give the image a new name, but keep it in the Photoshop (PSD) format. Photoshop saves all layers and comps with the file. The comp that was active when you saved the file will be in effect the next time you open it.

The results of your toils are eight independent pieces of artwork saved inside one layered composition. This file consumes much less room on disk than it would if each comp was saved as a separate PSD file. And as an added convenience, you can edit the various comps together inside a single file.

Aligning Layers and Blending Photographs

We've seen how layers allow you to arrange elements from different images into a new composition. And we've exploited this wonderful feature to create grand (if occasionally absurd) compositions. But what if you have something more pedestrian in mind? What if you want to take similar photographs with common subjects, each with less than ideal details, and merge them together to create an ideal mix?

Imagine this all-too-typical scenario: You're shooting a group of people. Naturally, you snap multiple shots so that you have a variety of pictures to choose from. But no single one of them is perfect. In one shot, Jane has her eyes shut. In another, Bob looks like someone just handed him a pink slip. In a third, Trev is

starting to say something that gives him a weird lip thing. The solution is to combine the photos so that Jane's eyes are open, Bob is smiling, and Trev looks semi-normal (he is Trev, after all), all in one seamless composition.

This has always been possible, but not easy. One of the big difficulties is matching the backgrounds. Assuming that you were holding the camera (as opposed to working with a tripod), the background rotates and shifts from one shot to the next. Getting that shifting background to look continuous from one layer to the next can be a real chore.

Or, at least, it used to be. Photoshop CS3 introduces the Auto-Align Layers command, which matches multiple images captured from a single vantage point. As long as you, the photographer, remained relatively stationary—that is, you can't wander to a different position—the command is capable of marrying handheld shots, even if you alternated between horizontal and vertical orientations. Throw in a bit of layer masking and you have everything you need to blend the best ingredients of your various shots to create a seamless, near-perfect whole. (Alas, Trev will remain Trev regardless of your efforts.)

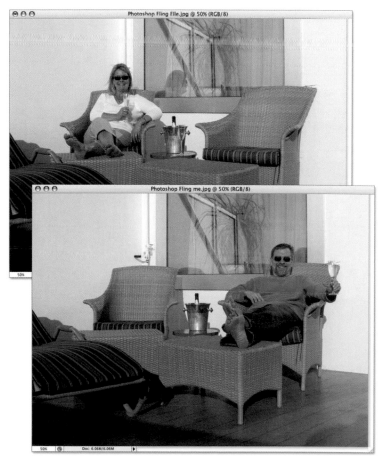

1. *Open two photographs shot from a common vantage point.* The files are *Photoshop Fling Elle.jpg* and *Photoshop Fling me.jpg*, both found in the *Lesson 09* folder inside *Lesson Files-PsCS3 1on1*. The subjects are my wife, Elizabeth, and myself, captured on the balcony of our stateroom on the Photoshop Fling cruise, a week-long Geek Cruises event held every February. (Yes, we actually cruise around the Caribbean and discuss Photoshop for a week. How sick is that?) I didn't want to jump up again and again to invoke the auto-timer. And me being me, I didn't think to pack a tripod. So we photographed each other separately by setting the camera on a table and taking turns pressing the shutter release. Judging by Figure 9-59, the photos look pretty well in sync. But as you'll see in a moment, the camera and the footstool that my feet are on moved. The upshot: Slats of wood, striped fabric, and little bits of wicker don't quite line up.

Figure 9-59.

2. *Combine the two images into a single composition.* Press the Ctrl key (⌘ on the Mac) and drag me into my wife's image; then hold down the Shift key and drop me into place. The result is two perfectly registered (though misaligned) photographs on independent layers.

3. *Rename the new layer.* Double-click the name of the new layer in the **Layers** palette and change it to "Me." You may also want to press the F key to switch to the maximized screen mode. This helps you get in a little closer and keeps you from confusing the Me layer with the Me file.

If you have any doubt that the two images are misaligned, turn the Me layer off and on by clicking the ● icon. The difference between the two photos is slight, but it's enough to ruin the effect. Comparing the photos also prepares you for the miraculous transformation to come.

4. *Apply the Auto-Align Layers command to both layers.* Assuming that the **Me** layer is active, Shift-click on the Background item in the Layers palette to select both layers. Then choose **Edit→Auto-Align Layers** to display a dialog box of alignment options, shown in Figure 9-60. Make sure **Auto** is selected, which tells Photoshop to distort the images as it sees fit so that they precisely match, detail for detail. (For complete descrip-

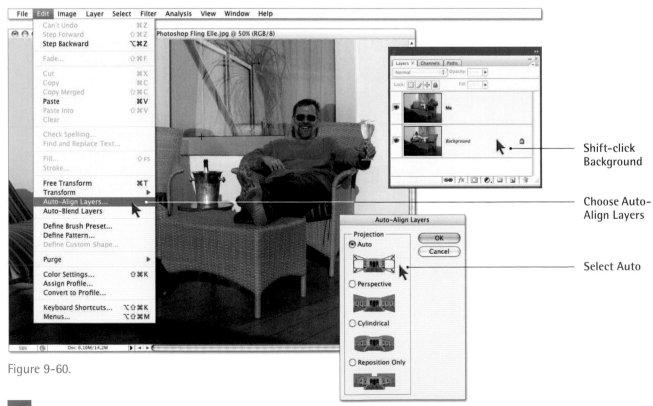

Figure 9-60.

tions of the alignment options, see "The New and Improved Photomerge" sidebar, which begins on page 352.) Click the **OK** button to let the command do its thing.

After a progress bar, you'll see the image shift slightly. Photoshop has distorted both layers to make them match each other. Turn off and on the Me layer to see how well the images match.

5. *Add a layer mask to the Me layer.* Make sure the **Me** layer is visible and click it to select it independently of the Background. Then click the ▢ icon at the bottom of the Layers palette to add a blank layer mask, which will allow us to "erase" in Elizabeth.

6. *Select the brush tool.* Click the brush tool icon in the toolbox and press the B key. For this task, I recommend a soft 150-pixel brush. But as always, I encourage your experimentation.

7. *Make the foreground color black.* Assuming the default masking colors, press the X key to swap the foreground and background colors so you can paint temporary holes in my layer.

8. *Paint Elizabeth into the image.* It's hard to imagine how effortless and downright magical this is until you do it for yourself. Suffice it to say, paint inside the empty chair and Elizabeth appears, perfectly aligned into place. Figure 9-61 finds me midway into the process.

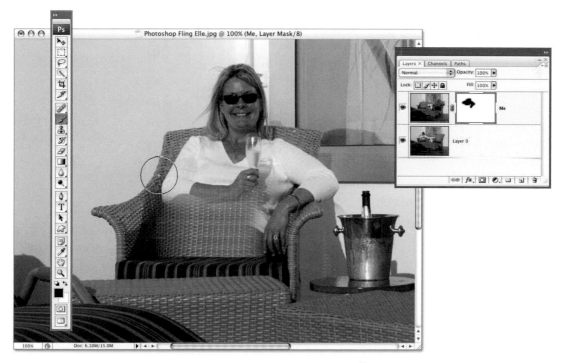

Figure 9-61.

The New and Improved Photomerge

Photomerge, the command in Photoshop that automatically combines images to form larger panoramas, ties with Brightness/Contrast as the most improved feature in CS3. Photomerge's renaissance can be attributed to the new Auto-Align Layers command and its companion, Auto-Blend Layers, the latter of which automatically adjusts and masks images so they merge seamlessly. In fact, after assembling a group of images into a layered composition, all the revamped Photomerge does is apply Auto-Align Layers and Auto-Blend Layers in sequence. Amazingly, that's all it takes to create panoramas of astonishing quality—particularly astonishing to anyone who's experimented with the far less successful implementation of Photomerge included with previous versions of Photoshop.

To give you a sense of how well Photomerge works, I've included a collection of photographs captured by graphic artist Bruce Heavin in his very own front yard in sunny Ojai, California. Even though Photomerge is a Photoshop function, it is most efficiently invoked from the Adobe Bridge. Click the ![icon] icon on the right side of the options bar to switch to the Bridge. Then navigate to the *Ojai pics* subfolder in the *Lesson 09* folder inside *Lesson Files-PsCS3 1on1*. Cleverly named *Pic-01.jpg* through *Pic-20.jpg*, these images capture sky, ground, and everything in between, as shown on the right.

Although Bruce did not use a tripod, he did shoot every image from a single vantage point. By this, I mean that he pivoted his head and camera but kept his feet and torso fixed. This is the key to shooting a successful Photomerge composition: rotate left and right, tilt up and down, but never alter your physical position.

Press Ctrl+A (or ⌘-A on the Mac) to select all 20 images. Then choose **Tools→Photoshop→Photomerge**. The Bridge switches back to Photoshop and displays a dialog box showing all the images you selected in the Bridge. On the left side of the dialog box, you'll see a list of Layout options, which allow you to define the variety of distortions used to align the merged photographs. Here's how they work:

- Select Auto to let Photoshop apply one of the next three options according to its own internal calculations. Sometimes it works great, other times not.

- The next option, Perspective, flares the images to create an exaggerated bow-tie pattern. The result simulates the effect of images at the perimeter of the panorama wrapping around your head. Again, rarely the best solution.

- Cylindrical wraps each image around a virtual cylinder, so that they bulge in the center and map into alignment at the outside edges. It sounds weird, but it works great.

- Reposition Only moves the images into alignment but does not distort them. Select this option only if you plan on applying the Auto-Align Layers command manually at a later point.

- The final setting, Interactive Layout, sounds the best but is the worst, applying the old-style Photomerge from CS2 and earlier.

Go ahead and select **Cylindrical**—even though Photoshop would probably opt for it if we selected Auto—and click **OK**. Then sit back and watch as Photomerge assigns each photo to its own layer. Shortly thereafter, you'll see progress bars for the Auto-Align and Auto-Blend functions.

When the magic is finally revealed, you'll see an irregular image that comprises a breathtaking patchwork of layered puzzle pieces, as pictured below. Each layered photo includes its own custom layer mask. How can you beat that?

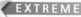

9. *Extend the mask to reveal other details.* This is the phase of the process where you will want to make sure all the essential ingredients are in place. After you finish masking in Elizabeth, you'll want to paint her reflection in the window behind her. If you care to add some intrigue to the image, try brushing in front of the gold ice bucket to reveal a third champagne glass. Is there a *trois* in our *ménage*? Or is the glass for you? At the risk of being a spoiler, it's actually the glass I left behind when I went to take Elizabeth's picture. If that ruins it for you, press X to switch the foreground color to white and paint it away.

10. *Crop the image.* Notice the hairline strips of transparency tracing the perimeter of the composition. In the course of distorting the layers, the Auto-Align command has left us with two irregularly shaped images. Use the crop tool to cut away the distorted edges and return the image to its former rectangular proportions. The final composition, *avec le troisième verre de champagne*, appears in Figure 9-62.

There you have it: Husband and wife reunited on the high seas thanks to the amazing automatic alignment capabilities of Photoshop CS3. Now if only someone would wash our filthy feet. (Note to Adobe: Where's the soapy washcloth tool?)

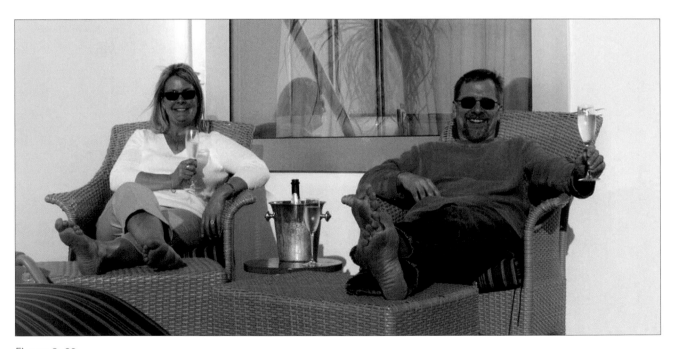

Figure 9-62.

WHAT DID YOU LEARN?

Match the key concept in the numbered list below with the letter
of the phrase that best describes it. Answers appear upside-down
at the bottom of the page.

Key Concepts

1. Stacking order
2. Warp
3. Photoshop (PSD) format
4. Merge Down
5. Layer mask
6. Group
7. Clipping mask
8. Luminance blending
9. Knockout
10. Layer comp
11. Auto-Align Layers
12. Photomerge

Descriptions

A. The name given to a pair of slider bars in the Layer Style dialog box that let you hide or reveal colors based on their luminosity levels.

B. The state of a layered composition at a certain point in time, replete with visibility, vertical and horizontal positioning, blending options, and layer styles.

C. Created by pressing Ctrl+G (⌘-G on the Mac), this collection of layers appears as a folder icon in the Layers palette.

D. The arrangement of layers in a composition, from front to back, which you can adjust by pressing Ctrl or ⌘ with the bracket keys, ⬚ and ⬚.

E. The ideal file format for saving all layers, masks, and parametric effects in a layered composition.

F. Long a staple of Photoshop, this command automatically stitches multiple images into a seamless panaroma. Difference is, now it actually works.

G. An option that uses the contents of the active layer to cut holes in the layers below it.

H. When working with this function, painting with black temporarily erases the pixels on a layer; painting with white makes the pixels visible again.

I. A means for cropping the contents of a group of layers to the boundaries of a layer below them.

J. Choose this command to combine the contents of the active layer with the layer below it.

K. This command lets you distort a layer by dragging corner handles and pen tool-style control handles.

L. New to Photoshop CS3, this command takes multiple handheld shots that share a common background and moves and distorts them so that they match up as precisely as possible.

Answers

1D, 2K, 3E, 4J, 5H, 6C, 7I, 8A, 9G, 10B, 11L, 12F

TEXT AND SHAPES

AS YOU'VE NO doubt discerned by now, Photoshop's primary mission is to correct and manipulate digital photographs and scanned artwork. (If this comes as a shock, I'm afraid you're going to have to go back and re-read—gosh how should I put this?—*the entire book!*) But there are two exceptions. The culprits are text and shapes, two features that have nothing whatsoever to do with correcting or manipulating digital photos, scanned artwork, or pixels in general.

Where text and shapes are concerned, Photoshop is more illustration program than image editor. You can create single lines of type or set type inside columns. You can edit typos and check spelling. You have access to all varieties of formatting attributes, from those as common as typeface to those as obscure as fractional character widths. You can even attach type to a path. In addition to type, you can augment your designs with rectangles, polygons, and custom predrawn symbols—the kinds of geometric shapes that you take for granted in a drawing program but rarely see in an image editor.

All this may seem like overkill, the sort of off-topic falderal that tends to burden every piece of consumer software these days. But although you may not need text and shapes for *all* your work, they're incredibly useful on those occasions when you do. Whether you want to prepare a bit of specialty type, mock up a commercial message (see Figure 10-1), or design a Web page, Photoshop's text and shape functions are precisely the tools you need.

This text acts as a label to the above graphic. If only I had something to say.

Figure 10-1.

ABOUT THIS LESSON

In this lesson, I show you how to use Photoshop's text and shape tools, as well as ways to edit text and shapes by applying formatting attributes and transformations. You'll learn how to:

Project Files

Before beginning the exercises, make sure you've installed the lesson files from the DVD, as explained in Step 3 on page xvii of the Preface. This should result in a folder called *Lesson Files-PsCS3 1on1* on your desktop. We'll be working with the files inside the *Lesson 10* subfolder.

- Create a text layer and modify its appearance using formatting attributes, layer styles, and filters page 360

- Adjust common formatting attributes using mouse clicks and keyboard shortcuts page 374

- Draw vector-based shapes, convert text to shapes, and repeat a shape using series duplication page 379

- Force text to follow the contours of a path and warp text by bending and distorting it page 392

Video Lesson 10: Vector-Based Objects

Normally, we think of Photoshop as a pixel-based image editor, and normally, we're right. But Photoshop provides two exceptions, text and shapes, which are treated as vector-based layers. As long as these layers remain intact, you can edit them to your heart's content. And because they're vectors, you can transform them without degrading their quality.

To learn more about the incredible world of scalable vector art inside Photoshop, watch the tenth video lesson on the DVD. Insert the DVD and double-click the file *PsCS3 Videos.html*. Then click **Lesson 10: Vector-Based Objects** under the **Type, Styles, and Output** heading. Lasting 14 minutes and 43 seconds, this video includes the following shortcuts:

Tool or operation	Windows shortcut	Macintosh shortcut
Type tool	T	T
Select all type while creating it	Ctrl+A	⌘-A
Incrementally enlarge or reduce type	Ctrl+Shift+⬚ or Ctrl+Shift+⬚	⌘-Shift-⬚ or ⌘-Shift-⬚
Accept changes to a text layer	Enter on keypad (or Ctrl+Enter)	Enter on keypad (or ⌘-Return)
Nudge text or shape layer	Ctrl+↑, ↓, ←, or →	⌘-↑, ↓, ←, or →
Cycle through custom shapes	⬚ or ⬚ (left or right bracket)	⬚ or ⬚ (left or right bracket)
Move shape while drawing it	spacebar	spacebar

The Vector-Based Duo

Generally speaking, Photoshop brokers in pixels, or *raster art*. But the subjects of this lesson are something altogether different. Photoshop treats both text and shapes as *vector-based objects* (or just plain *vectors*), meaning that they rely on mathematically defined outlines that can be scaled or otherwise transformed without any degradation in quality.

For a demonstration of how vectors work in Photoshop, consider the composition shown in Figure 10-2. The Q is a text layer with a drop shadow. The black crown and the orange fire are shapes. The background is a pixel-based gradient. The artwork looks jagged because it contains very few pixels. The image measures a scant 50 by 55 pixels (less than 2800 pixels in all) and is printed at just 15 pixels per inch!

Clearly, you'd never create such low-resolution artwork in real life. I do it here to demonstrate a point: If this were an entirely pixel-based image, we'd be stuck forever more with jagged, indistinct artwork. But because the Q, crown, and fire are vectors, they are scalable. In other words, unlike pixel art, vectors become smoother when you make them bigger.

One way to scale the vectors is to print them to a PostScript-compatible printer, which automatically scales the artwork to the full resolution of the device. The result is a breathtaking transformation. Believe it or not, the low-resolution, jagged artwork from Figure 10-2 prints to a PostScript output device as shown in Figure 10-3. All pixel-based portions of the composition—namely, the gradient and drop shadow—print just as they look on screen. But Photoshop conveys the text and shapes as true PostScript vectors; therefore, they render at the full resolution of the printer.

Few people own PostScript printers; most of us are stuck with standard raster printers. (Your everyday average inkjet device prints just the pixels you see on screen, as in

An incredibly low-res composition
(50 x 55 pixels), rendered at 15 ppi

Figure 10-2.

The very same low-res file,
output from a PostScript printer

Figure 10-3.

The same image, this time scaled to 480 ppi (3200%) using Image Size

Figure 10-4.

Figure 10-2.) So fortunately, there's a second, arguably better way to scale vectors—the Image Size command. To achieve the result pictured in Figure 10-4, I chose Image→Image Size and turned on the Resample Image check box. (Scale Styles and Constrain Proportions were also turned on.) Then I increased the Resolution value to a whopping 480 pixels per inch. The result looks every bit as good as the PostScript output, except for the drop shadow, which looks even better. (The Image Size command can scale drop shadows, whereas PostScript printing can't.) Now I can print this artwork to any printer—PostScript, ink-jet, or otherwise—and it'll look every bit as good as it does in Figure 10-4.

The upshot is that vectors are a world apart from anything else inside Photoshop, always rendering at the full resolution of the image. To see more on this topic, watch Video Lesson 10, "Vector-Based Objects" (introduced on page 358).

Creating and Formatting Text

Text inside Photoshop works a lot like it does inside every major publishing application. You can apply typefaces, scale characters, adjust line spacing, and so on. However, because Photoshop isn't well suited to routine typesetting, we won't spend much time on the routine functions. Instead, we'll take a look at some text treatments to which Photoshop is very well suited, as well as a few functions that are exceptional or even unique to the program.

In this exercise, we'll add text to an image and format the text to fit its background. We'll also apply a few effects to the text that go beyond anything you can accomplish outside Photoshop.

1. *Open an image.* Not every image welcomes the addition of text. After all, text needs room to breathe, so your image should have ample "dead space." Such is the case with *TV movie ad.psd* (see Figure 10-5 on the facing page). Found in the *Lesson 10* folder inside *Lesson Files-PsCS3 1on1*, this is the foundation for an advertisement for a made-for-TV movie starring some of basic cable's brightest names. In reality, it's an amalgam of a few images from PhotoSpin, which may be the best resource there is for photos of people smirking or shrugging. I already did the compositing; now we need to insert the "copy" (industryspeak for blather).

When you open this document, you may see the following alert message: "Some text layers might need to be updated before they can be used for vector based output." If you do, click the **Update** button to make the one live text layer in this document editable.

Figure 10-5.

2. *Make sure the guidelines are visible.* You should see three cyan *guidelines*—two horizontal and one vertical—in the image window. If not, choose **View→Show→Guides** to make them visible. Also make sure a check mark appears in front of **View→Snap**, which makes layers snap into alignment with the guides.

Guidelines are nonprinting elements that ensure precise alignment in Photoshop. They are especially useful for positioning text layers, as we'll see in upcoming steps.

3. *Click the type tool in the toolbox.* Or press the T key. Photoshop provides four type tools in all, but the horizontal type tool—the one that looks like an unadorned T (see Figure 10-6)—is the only one you need.

Horizontal Type Tool (T)

Figure 10-6.

4. **Establish a few formatting attributes in the options bar.** The options bar provides access to a few of the most common *formatting attributes*, which are ways to modify the appearance of live text. Labeled in Figure 10-7, they include the following:

- **Font family**. Click the second-from-left ▾ arrow to see a list of typefaces available to your system. I prefer the term *font families* (or just plain *font*) because, technically speaking, most typefaces include multiple stylistic alternatives, including bold, italic, and so on.

Figure 10-7.

If you purchased the full Adobe Creative Suite, select **Adobe Caslon Pro** (look under the C's). If you purchased a standalone copy of Photoshop CS3, select **Times**, **Times New Roman**, or a similar font.

- **Type style**. The type style pop-up menu lists all stylistic alternatives available for the selected font. Change the style to read **Bold**.

- **Type size**. If using Caslon Pro, set the type size to 33 points. For Times or Times New Roman, set the value to 38 points.

- **Antialiasing.** The next menu determines the flavor of antialiasing (edge softening) applied to the text. We'll examine this option a bit more in Step 21 (page 369), but for now, either **Crisp** or **Sharp** will suffice.

- **Alignment**. The alignment options let you align rows of type to the left, center, or right. Click the middle icon (▤) to create center aligned text.

- **Text color**. The color swatch determines the color of the type. By default, it matches the foreground color. For the moment, press the D key and then the X key to make the swatch white.

- **Character palette**. Click the rightmost of the type tool icons to display the **Character** palette, which offers access to several more formatting attributes. We'll need this palette a few steps from now.

You can change every single one of these formatting attributes after you create your text. Getting a few settings established up front merely saves a little time later.

5. *Click in the image window.* Click somewhere in the lower-middle portion of the image. For now, don't bother trying to align your cursor with the guidelines. Better to get the text on the page and align it later.

6. *Enter some text.* Type "chief executive." Lowercase letters are fine. Then press the Enter or Return key to advance to a new line and type "nephew." You should see white type across the bottom of your image, as in Figure 10-8. If the **Layers** palette is visible, you'll also notice a new layer marked by a **T** icon (also in the figure). This **T** indicates that the layer contains live text.

Figure 10-8.

7. *Select all the text.* Press Ctrl+A (⌘-A on the Mac) to highlight all three words. Now you can modify the type.

8. *Capitalize the letters.* Click the ⏧ icon in the **Character** palette, as in Figure 10-9 on the next page. This switches the lowercase letters to capitals using a temporary style option. You can also press Ctrl+Shift+K (⌘-Shift-K). If you decide later to restore lowercase letters, turn the ⏧ off or press the shortcut again.

9. **Drag the text into alignment with the guides.** Press the Ctrl (or ⌘) key and drag the text until the left and bottom edges of the letter *C* in *CHIEF* snap into alignment with the vertical guideline and the higher of the two horizontal guides.

Figure 10-9.

10. **Select the last word of type.** With the text still active, double-click the word *NEPHEW* in the image window to select it.

11. **Adjust the type size and leading.** In the Character palette, click the T̲T̲ icon and change the type size to 67 points. Then press the Tab key, change the next-door ᴬ option to 55 points, and press Enter or Return. The ᴬ value sets the *leading* (pronounced *ledding*, for the strips of lead used in the hand-set printing days to space lines of type), which is the amount of vertical space between the selected word and the line of type above it. The new value shifts the text up, as pictured in Figure 10-10.

12. **Accept your changes.** Press the Enter key on the keypad (not the one above the Shift key) to exit the type mode and accept the new text layer. You can also press Ctrl+Enter (or ⌘-Return).

At this point, Photoshop changes the name of the new text layer in the Layers palette to chief executive nephew. The program will even update the layer name if you make changes to the type. If you like, you can rename the layer just as you would any other layer (especially helpful when the layer name becomes too long), but doing so will prevent Photoshop from automatically updating the layer name later.

13. *Select and show the Body Copy layer.* Click the **Body Copy** layer in the **Layers** palette and then turn on its 👁 to make it visible. This layer contains a paragraph of type set in the world's ugliest font, Courier New. (For you, it may appear in some other Courier derivative, but rest assured, they're all dreadful.) The only reason the layer is here is to spare you the tedium of having to enter the type from scratch. But that doesn't mean there's nothing for you to do. Much formatting is in order.

Figure 10-10.

This particular variety of text layer is called *area text*. To create such a layer, drag with the type tool to define the bounding box around the area text, also known as a *text block*. As you enter text, Photoshop wraps words down to the next line as needed to fit inside the block.

14. *Assign a better font.* As long as a text layer is active, you can format all type on that layer by adjusting settings in the options bar or **Character** palette. For starters, click the word **Courier** in either location. This highlights the font name and provides you with a couple of options:

 • Press the ↑ or ↓ key to cycle to a previous or subsequent font in alphabetical order. This permits you to preview the various fonts installed on your system, handy if you have no idea what fonts like *Giddyup* or *Greymantle* look like. (Those are just examples; your strange fonts will vary.)

 • Enter the first few letters of the font you'd like to use.

For example, type V-e-r, which should switch you to Verdana (see Figure 10-11), which is included on all personal computer systems. Then press Enter or Return to apply the font and see how it looks.

Figure 10-11.

15. ***Make the first three words of the paragraph bold.*** Zoom in on the words *What a situation!* at the beginning of the paragraph to better see what you're doing. Then with the type tool still selected, do the following:

 • Select all three words by double-clicking *What* and dragging over *a situation!*

 • Choose **Bold** from the type style menu in the options bar, as shown in Figure 10-12. You can do the same from the keyboard by pressing Ctrl+Shift+B (⌘-Shift-B on the Mac).

16. ***Make the words*** *the hard way* ***italic.*** Find the phrase *the hard way* in the eighth line of the paragraph and drag over it to select it. Then choose **Italic** from the type style menu in the options bar or press Ctrl+Shift+I (⌘-Shift-I on the Mac).

PEARL OF WISDOM

Even if a font doesn't offer a bold or italic style (known as a *designer style* because it comes from the font's designer), the keyboard shortcuts still function. In place of the missing designer style, press Ctrl+Shift+B to thicken the letters for a *faux bold*; press Ctrl+Shift+I to slant them for a *faux italic*. Beware: Faux styles don't always look right or even good.

17. *Show the rulers and the Info palette.* The Body Copy text is looking better, but its placement is for the birds. Before we size and position the text block, it helps to lay down a few guidelines. And before we can do that, we have to do the following:

- Guidelines come from the rulers, so choose **View→Rulers** or press Ctrl+R (⌘-R) to display them.

- To track the coordinate position of your guides, press F8 or choose **Window→Info** to display the **Info** palette.

Figure 10-12.

18. *Add three guidelines.* Drag from the left ruler to create vertical guides, and drag from the top ruler to create horizontal guides. As you do, you can track the location of the guidelines by watching the X and Y values in the Info palette. With that in mind, create the following guides:

- Drag a vertical guide to the coordinate position **X**: 80.

- Drag another vertical guide very close to the right edge of the document, to the coordinate position **X**: 860.

- Drag a horizontal guide to **Y**: 30.

Figure 10-13 shows me in the process of creating the last guide. Note that these values assume your rulers are set to pixels (as we established when setting preferences in Step 10 of "One-on-One Installation and Setup," page xvi). If your rulers are set to some other unit of measurement, right-click (or Control-click) either ruler and choose **Pixels**.

Here's a helpful tip: As you drag, press the Shift key to snap the guideline to the tiny tick marks in the ruler (also known as *ruler increments*). If you drop a guideline at the wrong location, you can move it by pressing Ctrl (or ⌘) to get the move tool and then dragging the guide. To delete a guide, Ctrl-drag (or ⌘-drag) it back into the ruler.

Figure 10-13.

19. *Scale the text block to fit within the guides.* We're finished with the rulers, so press Ctrl+R (⌘-R on the Mac) to hide them. With the type tool selected and some portion of the body text block still active (if the words *the hard way* are still highlighted, that's fine), move the cursor over the upper-left corner handle. The cursor should change to a bidirectional arrow, indicating that it's ready to scale. Drag the handle until it snaps to the nearest guide intersection. Similarly, drag the lower-right corner handle until it snaps to the rightmost guideline, as shown in Figure 10-14 on the facing page.

20. ***Hide the guides.*** At this point, you're finished with the guidelines. To hide them so you can focus on your composition, choose **View**→**Show**→**Guides**. Or better yet, press Ctrl+⌷ or ⌘-⌷ (the semicolon key, to the right of the L). The guidelines will no longer be visible, nor will they snap.

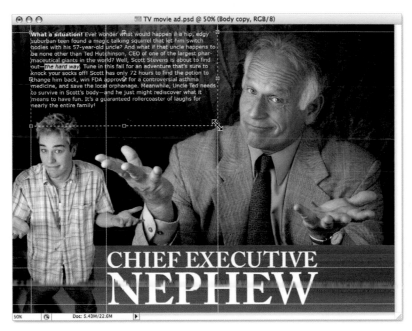

Figure 10-14.

21. ***Change the antialiasing to Strong.*** Now comes one of Photoshop's subtlest formatting options. Located in the center of the options bar (as labeled in Figure 10-7 on page 362), the antialiasing setting controls the way the outlines of characters blend with their backgrounds. Your options are:

- Sharp, which manages to antialias the type while maintaining sharp corners. This preserves the best character definition, especially when applied to small letters with serifs (the flourishes at corners and ends of letters).

- Crisp, which rounds the corners slightly.

- Strong, which shores up small type by expanding the edges very slightly outward, thus resulting in bolder characters.

- Smooth, which supposedly rounds corners even more than Crisp. In practice, the two settings are virtually identical.

- None, which turns off antialiasing and leaves the jagged transitions. For Web work, this is a terrible setting. But for high-resolution print work, it helps reduce some of the blur that can result from antialiasing.

The examples in Figure 10-15 show all settings except Smooth applied to a magnified detail from the Body Copy layer. The differences verge on trivial, but for this particular layer, I would argue that **Strong** helps thicken the characters and boost legibility. So choose it.

Sharp

What a situation! E
suburban teen found
bodies with his 57-ye
be none other than Te
maceutical giants in t

Crisp

What a situation! E
suburban teen found
bodies with his 57-ye
be none other than Te
maceutical giants in t

Strong

What a situation! E
suburban teen found
bodies with his 57-ye
be none other than Te
maceutical giants in t

None

What a situation! E
suburban teen found
bodies with his 57-ye
be none other than Te
maceutical giants in t

Figure 10-15.

22. *Turn on Fractional Widths.* This next option is likewise subtle but, in my estimation, much more important. By default, Photoshop spaces characters by whole numbers of pixels. This is essential when working with jagged type (as when antialiasing is set to None), but otherwise results in inconsistent letter spacing. To better space one letter from its neighbor, click the ▾≡ in the top-right corner of the **Character** palette and choose **Fractional Widths**. This calculates the text spacing for the entire layer in the same way other design programs do, in precise fractions of a pixel. You'll see the text tighten up slightly; you may even see one or two words shift up to different lines.

23. *Turn on the every-line composer.* Flush left type is sometimes said to be "ragged right," and the body text in this composition is nothing if not a case in point. To even out the choppy edges, switch to the **Paragraph** palette by clicking its tab in the Character palette cluster. Then click the ⬇≡ in the top-right corner of the palette to bring up the palette menu and choose **Adobe Every-line Composer**. Photoshop better aligns the right edges of the type, as in Figure 10-16.

Single-line composer

> **What a situation!** Ever wonder what would happen if a hip, edgy suburban teen found a magic talking squirrel that let him switch bodies with his 57-year-old uncle? And what if that uncle happens to be none other than Ted Hutchinson, CEO of one of the largest pharmaceutical giants in the world? Well, Scott Stevens is about to find out—*the hard way*. Tune in this fall for an adventure that's sure to knock your socks off! Scott has only 72 hours to find the potion to change him back, win FDA approval for a controversial asthma medicine, and save the local orphanage. Meanwhile, Uncle Ted needs to survive in Scott's body—and he just might rediscover what it means to have fun. It's a guaranteed rollercoaster of laughs for nearly the entire family!

Every-line composer

> **What a situation!** Ever wonder what would happen if a hip, edgy suburban teen found a magic talking squirrel that let him switch bodies with his 57-year-old uncle? And what if that uncle happens to be none other than Ted Hutchinson, CEO of one of the largest pharmaceutical giants in the world? Well, Scott Stevens is about to find out—*the hard way*. Tune in this fall for an adventure that's sure to knock your socks off! Scott has only 72 hours to find the potion to change him back, win FDA approval for a controversial asthma medicine, and save the local orphanage. Meanwhile, Uncle Ted needs to survive in Scott's body—and he just might rediscover what it means to have fun. It's a guaranteed rollercoaster of laughs for nearly the entire family!

Figure 10-16.

Photoshop's *single-line composer* (active prior to Step 23) analyzes each line of type on its own, in a vacuum. The *every-line composer* (illustrated in Figure 10-16) examines the entire text layer as a whole and spaces the text to give it the most even appearance possible.

24. *Justify the type.* Less ragged text is great, but let's say you want both the left and right edges to be flush. Click the fourth icon (▤) in the top row of the Paragraph palette to justify the paragraph and leave the last line flush left, as shown in Figure 10-17. You can also press the shortcut Ctrl+Shift+J (⌘-Shift-J).

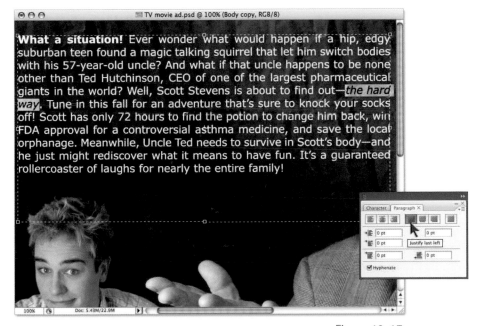

Figure 10-17.

Even after justifying the paragraph, the every-line composer remains in effect, thus ensuring more evenly spaced words from one line of type to the next.

25. *Select the entire paragraph, except the first three words.* Let's change all but the first three words, the bold *What a situation!*, to a light blue hue that matches a color in the clothing of our shrugging actors. Start by double-clicking the fourth word, *Ever*. Then press Ctrl+Shift+↓ (⌘-Shift-↓ on the Mac) to extend the selection to the end of the paragraph.

26. *Change the color to a bluish cyan.* Click the white color swatch in the options bar to display the **Color Picker** dialog box. Then move the cursor into the image window and click in one of the lighter blue areas inside the nephew's shirt, as shown in Figure 10-18. You should end up with a color in the approximate vicinity of **H**: 200, **S**: 20, **B**: 100. When you do, click the **OK** button to recolor the text.

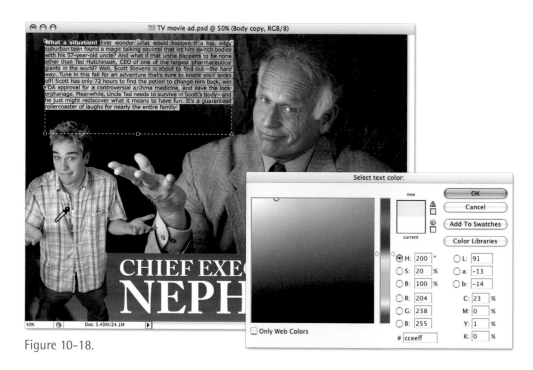

Figure 10-18.

27. *Accept your changes.* Press the Enter key on the keypad or press Ctrl+Enter (⌘-Return) to exit the type mode and accept the changes to the Body Copy layer.

All this editing and formatting is fine and dandy, but it's the kind of thing that you could accomplish in a vector-based program (such as Illustrator or InDesign), which is better designed for composing and printing high-resolution text. For the remainder of this exercise, we'll apply the sort of text treatment that's possible only in Photoshop. Due to the length of this exercise, I've marked these steps as Extra Credit. But between you and me, you won't want to miss them.

28. *Turn on the Style Holder layer in the Layers palette.* A tiny orange suitcase appears next to the CEO's head. This layer holds some of the attributes we'll be applying to the large *Chief Executive Nephew* text.

29. *Eyedrop the orange suitcase.* Press the I key to select the eyedropper tool, and then click the little suitcase to make its orange the foreground color.

30. *Fill the Chief Executive Nephew layer with the sampled orange.* Click the **Chief Executive Nephew** layer in the **Layers** palette to make it active. Then press Alt+Backspace (Option-Delete on the Mac) to fill the text with orange, as shown in Figure 10-19. When filling an entire text layer, this handy shortcut lets you recolor text without visiting the Color Picker dialog box.

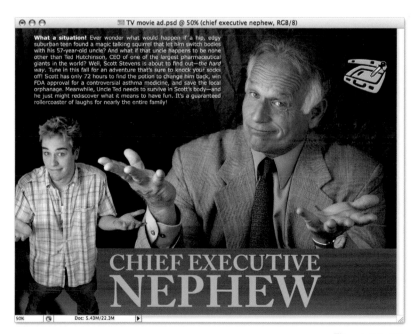

Figure 10-19.

A Dozen More Ways to Edit Text

I couldn't begin to convey in a single exercise, even a long one, all the wonderful ways Photoshop permits you to edit and format text. So here are a few truly terrific tips and techniques to bear in mind when working on your own projects:

- Double-click a T thumbnail in the Layers palette to switch to the type tool and select all the text in the corresponding layer.

- Armed with the type tool, you can double-click a word to select it. Drag on the second click to select multiple words. Triple-click to select an entire line; quadruple-click to select a paragraph.

- To increase the size of selected characters in 2-point increments, press Ctrl+Shift+⟩. To reduce the type size, press Ctrl+Shift+⟨. (That's ⌘-Shift-⟩ and ⌘-Shift-⟨ on the Mac.)

- In the design world, line spacing is called *leading*. By default, the leading in Photoshop is set to Auto, which is 120 percent of the prevailing type size. To override this, click the $\overset{A}{I\!A}$ icon in the Character palette to highlight the leading value (Auto), and then replace the value with a number. In the figure below, I changed the leading to 16 points. Note that the new leading value affects the distance between the selected text and the text above it.

- After you enter a manual leading value (something other than Auto) in the Character palette, you can increase or decrease the leading using keyboard shortcuts. Press Alt+↓ (or Option-↓) to increase the leading; press Alt+↑ (Option-↑) to tighten it.

- Click between two characters and press Alt+← (Option-←) to move them together or Alt+→ (Option-→) to move them apart. This is called *pair kerning*.

- You can apply those same keystrokes to multiple characters at a time. For example, in the figure below, I selected a line of type and pressed Alt+← to move the characters together; this wrapped another word onto that line. Photoshop calls this *tracking*. In this example, the Adobe every-line composer has shifted letters above the selected area to space the text as expertly as possible.

- When text is active, press Ctrl (or ⌘) and drag inside the text to move it.

- Also when text is active, press Ctrl+T (⌘-T) to display or hide the Character palette. Press Ctrl+M (⌘-M) to do the same with the Paragraph palette.

- The Color palette does not always reflect the color of highlighted text. But if you change the Color palette settings, any highlighted text changes as well.

- To change the formatting of multiple text layers at a time, first link the layers. Then press the Shift key when choosing a typeface, style, size, or other formatting settings. When Shift is down, all linked text layers change at once.

- When editing text, you have one undo, which you can exercise by pressing Ctrl+Z (or ⌘-Z). If you need more undos, press the Esc key to abandon *all* changes made since you entered the type mode. But be careful when using this technique. If you press the Esc key in the midst of making a new text layer, you forfeit the whole thing. Esc can't be undone. Esc is forever.

31. ***Determine the angle of our shadow.*** The next trick is to add a *cast shadow*—that is, a shadow cast by the letters in the opposite direction from the light source. In this case, we can gauge the light source based on the shadow behind the nephew. Our new shadow should extend up and leftward in the area behind the letters.

32. ***Transform and duplicate the text layer.*** Press Ctrl+Alt+T (⌘-Option-T on the Mac). This does two things: It duplicates the layer and enters the free transform mode. But for the moment, you'll have to take this on faith; the Layers palette doesn't show you the new layer until you begin editing it.

33. ***Scale and position the duplicate layer.*** I have a few instructions for you here:

 • Drag the top handle upward and stretch the duplicate vertically until you've reached a **Height** of about 130 percent.

 • In the options bar, change the **Y** value to 1090 pixels so that the bottom edges of both the original layer and its duplicate line up exactly. (The Δ icon should be off.)

The final position of the duplicate text appears in Figure 10-20. When your screen matches mine, click the ✔ or press Enter or Return to accept the transformation.

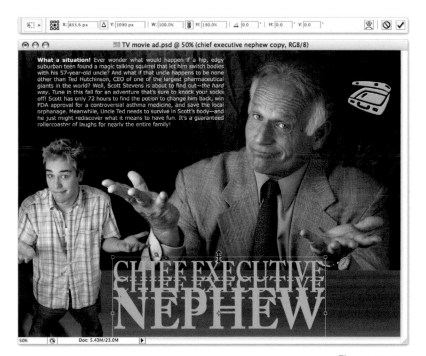

Figure 10-20.

A couple of special benefits when transforming a text layer: The type remains editable, so you can add text or fix typos after you've accepted your transformation. And because Photoshop is working from vectors, the transformation does not degrade the quality of the characters—even if you transform the text multiple times in a row

34. ***Rename the layer and move it one layer down.*** Double-click the name of the new layer in the Layers palette and change it to "Cast Shadow." Then press Ctrl+🔲 (⌘-🔲 on the Mac) to move it behind the Chief Executive Nephew layer.

35. ***Adjust the color of the layer.*** Press the D key to make sure our default colors are selected. Then press Alt-Backspace (or Option-Delete) to fill the layer with black.

36. ***Apply the Gaussian Blur filter.*** To create a soft shadow, you need to choose **Filter→Blur→Gaussian Blur**. But because Photoshop's filters were originally designed to modify pixels, the program alerts you that you must first *rasterize* the type—that is, convert it to pixels. This means two big sacrifices: You'll no longer be able to edit the text and you'll lose access to the type's high-quality vector outlines. Fortunately, there's a better way. Here's what I want you to do:

- Click **Cancel** to avoid rasterizing the type.

- Choose **Filter→Convert for Smart Filters**. New to Photoshop CS3, the smart filter feature permits you to apply dynamic effects to live objects, such as type.

- Photoshop displays a message, letting you know that by choosing Convert for Smart Filters, you are converting the text to a smart object. That's just fine, so click OK, as you see me doing in the none-too-understated Figure 10-21.

- Again choose **Filter→Blur→Gaussian Blur**. Photoshop displays the **Gaussian Blur** dialog box.

For complete information on smart objects and smart filters, stay tuned for Lesson 11, "Styles and Specialty Layers."

37. ***Change the Radius value.*** Enter a **Radius** value of 6 pixels and click **OK**. If you look at the Layers palette, you'll see that the Cast Shadow layer now includes an editable Gaussian Blur item, which I've circled in Figure 10-22 on the facing page.

38. ***Reduce the layer's opacity.*** Press 4 to reduce the **Opacity** value in the **Layers** palette to 40 percent.

Figure 10-21.

39. **Skew the blurry type.** Now let's give the shadow some directional perspective so it looks more realistic. Choose **Edit→Transform** or press Ctrl+T (⌘-T) to again enter the free transform mode. An alert message tells you that the Gaussian Blur filter will be disabled during the transformation process. Don't worry, it'll come back when you're done. For now, click **OK** to accept the news.

Inexplicably, the options bar lacks skew options when working with a smart object. So you have to slant the type by hand, as follows:

- Press the Ctrl key (⌘ on the Mac) and drag the top handle to the left. Photoshop slants the type.

- Keep dragging until you reach the inside of the two buttons on the older gentleman's exposed cuff, as indicated by the area circled in light green in Figure 10-23.

When you're satisfied that your shadow looks like mine—or, if you prefer, more to your liking than mine—press the Enter or Return key to apply the skew and restore the Gaussian Blur effect.

40. **Send the shadow backward.** In the Layers palette, click the ▶ in front of **Background Composition** to twirl open the group. This reveals the parts and pieces that make up the rest of our advertisement. Drag the **Cast Shadow** layer down the stack and drop it between the Uncle Ted and Blurred Background layers. Now the shadow exists inside the brown motion-blurred desktop. It doesn't extend out into the weird, hammy uncle, nor does it overlap the weird, hammy nephew.

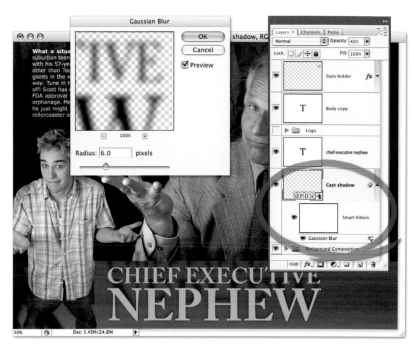

Figure 10-22.

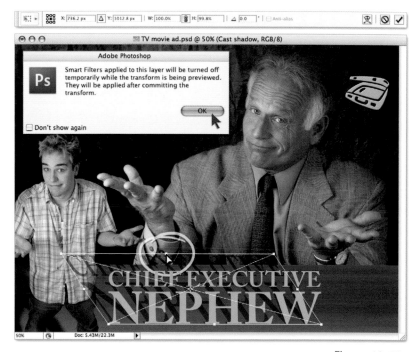

Figure 10-23.

Figure 10-24.

41. *Reveal the network logo.* In the Layers palette, click the empty gray square to the left of the **Logo** group to display the 👁 icon and reveal our network's distinctive logo. This group also includes some obligatory promo information about the movie.

42. *Move the effect from the Style Holder layer.* Let's finish by adding a bevel effect to the main title. In the Layers palette, drag the *fx* belonging to the **Style Holder** layer and drop it on the **Chief Executive Nephew** layer, as in Figure 10-24. Once upon a time, moving a style would copy it onto the new layer while leaving the original intact. But nowadays, dragging a style shifts it entirely from one layer to another, which works great here.

If you want to copy a style from one layer to another while leaving the original layer intact, hold down the Alt (or Option) key as you drag.

43. *Delete the Style Holder layer.* Drag the **Style Holder** layer to the trash can icon at the bottom of the Layers palette. The finished artwork appears in Figure 10-25.

44. *Choose File→Save As.* Give the file a different filename and click **Save**. If you decide to visit the file later, the live text remains editable. To change the text in a smart object, double-click the smart object's thumbnail in the Layers palette.

Figure 10-25.

Drawing and Editing Shapes

Photoshop's shape tools allow you to draw rectangles, ellipses, polygons, and an assortment of prefab dingbats and symbols. On the surface, they're a pretty straightforward bunch. But when you delve into them a little more deeply, you quickly discover that the applications for shapes are every bit as wide-ranging and diverse as those for text.

If you have even a modicum of experience using the marquee tools (you may recall the elliptical marquee tool from pages 136 and 137 of Lesson 4), then you know how to draw rectangles and ellipses in Photoshop. So in the following exercise, we'll focus on the shapes we haven't yet seen—polygons, lines, and custom shapes—as well as ways to blend vectors and images inside a single composition.

1. *Open an image.* For simplicity's sake, we'll start with a more or less neutral background. Open the file *Election.psd* located in the *Lesson 10* folder inside *Lesson Files-PsCS3 1on1*. You'll be greeted by what appears to be a couple of text layers set against a white fabric background, as in Figure 10-26. But in fact, the word ELECTION is a shape layer. I had originally set the text in the Copperplate font—a popular typeface but one you may not have on your system. So to avoid having the letters change to a different font on your machine, I converted the letters to independent shapes. This prevents you from editing the type, but you can scale or otherwise transform the vector-based shapes without any degradation in quality.

Figure 10-26.

Note that the numbers *2012* are now surrounded by path outlines, like those we learned about in the section "Drawing Precise Curves" in Lesson 4 (page 142). The Layers palette shows a mostly gray *vector mask* thumbnail, as shown in Figure 10-27. The area inside the mask (indicated by white in the thumbnail) is opaque; the area outside the mask (indicated by gray) is transparent.

2. ***Convert the 2012 layer to shapes.*** Let's say we want to similarly prevent the text *2012* from changing on another system. Click the **2012** layer in the **Layers** palette. Then choose **Layer→Type→Convert to Shape**. Photoshop converts the characters to shape outlines, which will easily survive the journey from one system to another.

3. ***Display the guidelines.*** This image contains a total of eight guides—four vertical and four horizontal. If you can't see the guides, choose **View→Show→Guides** or press Ctrl+☐ (⌘-☐). The guides will aid us in the creation of our shapes.

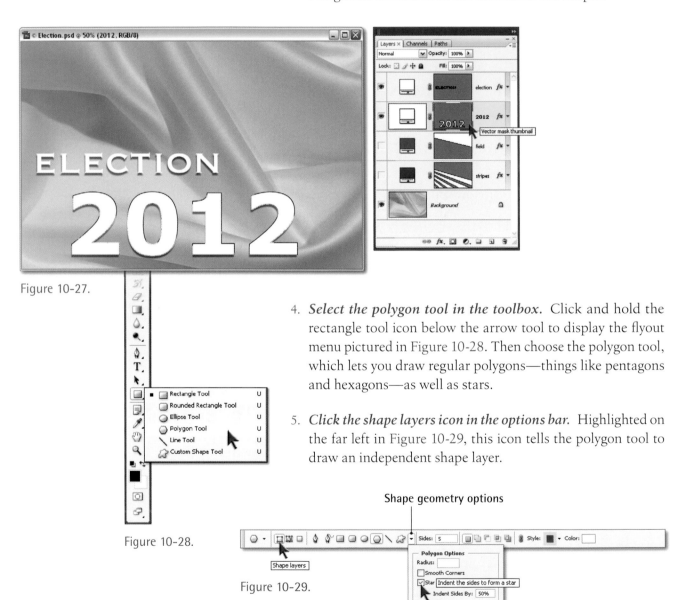

Figure 10-27.

Figure 10-28.

4. ***Select the polygon tool in the toolbox.*** Click and hold the rectangle tool icon below the arrow tool to display the flyout menu pictured in Figure 10-28. Then choose the polygon tool, which lets you draw regular polygons—things like pentagons and hexagons—as well as stars.

5. ***Click the shape layers icon in the options bar.*** Highlighted on the far left in Figure 10-29, this icon tells the polygon tool to draw an independent shape layer.

Figure 10-29.

6. *Set the Polygon Options to Star.* Our image is an election graphic, so naturally one feels compelled to wrap the composition in stars and stripes. Click the ▾ arrow to the left of the **Sides** value in the options bar (labeled *Shape geometry options* in Figure 10-29) to display the **Polygon Options** pop-up menu:

 - Select the **Star** check box to make the tool draw stars.

 - Make sure both **Smooth** check boxes are turned off so the corners are nice and sharp.

 - Set the **Indent Sides By** value to 50 percent. This ensures that opposite points align with each other, as is the rule for a 5-pointed star.

7. *Set the Sides value to 5.* This is the default value, so it's unlikely you'll have to make a change. But if you do, here's a trick:

 To raise the Sides value in increments of 1, press the ⏺ key. To lower the value, press the ⏺ key. Add the Shift key to change the value by 10. This trick works for any value that occupies this space in the options bar.

8. *Draw the first star.* Press D and then X to make the foreground color white. Then draw the star shown in Figure 10-30. The polygon tool draws shapes from the center out, so drag from the guide intersection highlighted by the yellow ⊕ to the one highlighted by the dark green ✦. Make sure you end your drag on the vertical guide just above the left half (not the middle) of the 2. (I've made my guides white so they show up in print. Yours will appear cyan.) Photoshop matches the attributes of the 2012 layer, giving the star a white fill and a drop shadow.

Figure 10-30.

9. **Carve a second star out of the first.** Press the Alt key (Option key on the Mac) and draw another star from the same starting point (marked by the yellow ⊕ in Figure 10-31) to the next guideline intersection (the dark green ⬕ in the figure). Because the Alt or Option key is down, Photoshop subtracts the new shape from the previous one. The result is a star-shaped white stroke.

Figure 10-31.

Figure 10-32.

10. **Click the arrow tool in the toolbox.** Or press the A key to select the black arrow, which Photoshop calls the path selection tool (see Figure 10-32). As we'll see, it permits you to select and modify path outlines in a shape layer.

11. **Select both inner and outer star paths.** Click one of the star paths to select it. Then press the Shift key and click the other star. Photoshop selects both paths.

12. **Transform and duplicate the star.** Press Ctrl+Alt+T (⌘-Option-T on the Mac) to duplicate the selected star paths and enter the free transform mode. As usual, you have to take on faith that you've duplicated the star because, for the moment, the cloned paths exactly overlap the originals.

13. *Scale, rotate, and move the duplicate star.* At this point, I need you to make some precise adjustments:

- In the options bar, click the ⚭ icon between the W and H values to scale the star paths proportionally. Then change either the **W** or **H** value to 80 percent.

- Tab to the rotate value (△) and change it to −16 degrees. This tilts the star counterclockwise.

- Drag the star until what used to be the upper-left handle clicks into alignment with the intersection of the topmost and leftmost guidelines, as shown in Figure 10-33.

When the new star appears in the proper position, press the Enter or Return key to confirm the transformation.

Figure 10-33.

14. *Repeat the previous transformation three times.* Press Ctrl+Shift+Alt+T (⌘-Shift-Option-T on the Mac) to repeat all the operations performed in the preceding step. This tells Photoshop to duplicate the second star group, scale it proportionally to 80 percent, rotate it −16 degrees, and move it to the left. Press Ctrl+Shift+Alt+T (⌘-Shift-Option-T) twice more to further repeat the operations. The result is the arcing sequence of five stars shown in Figure 10-34 on the next page.

This succession of duplicate, transform, and repeat is known as *series duplication*. In Photoshop, it invariably begins with the keyboard shortcut Ctrl+Alt+T (⌘-Option-T) and ends with several repetitions of Ctrl+Shift+Alt+T (⌘-Shift-Option-T). Set up properly, series duplication helps automate the creation of derivative paths and shape patterns.

15. *Name the new layer.* By default, the layer full of stars is called Shape 1. Double-click the layer name in the **Layers** palette and enter the new name "Stars."

If you find that the names of some of your layers are getting truncated, it's because the Layers palette is too narrow to display them. Move the palette away from the right edge of your screen, and then drag the lower-right corner of the palette to expand it.

Figure 10-34.

16. *Turn on the Field layer.* Click in front of the **Field** layer in the Layers palette to turn on its ◉ and display a slanted blue shape. I created this layer by drawing a rectangle with the rectangle tool and then distorting the shape in the free transform mode.

17. *Set the Field layer to Hard Light.* In the Layers palette, click the **Field** layer to select it and choose **Hard Light** from the blend mode pop-up menu. Or press Shift+Alt+H (Shift-Option-H). If you chose the blend mode on the PC, press the Esc key to deactivate it. (On the Mac, it's not necessary.) Then press 8 to lower the **Opacity** value to 80 percent. Even though Field is a vector shape layer, it's subject to the same blend modes and transparency options available elsewhere throughout Photoshop.

18. ***Turn on the Stripes layer.*** Click the 👁 icon in front of the **Stripes** layer to display a sequence of red stripes. I created the top stripe by distorting a rectangle. Then I used series duplication to make the other four.

19. ***Set the Stripes layer to Multiply.*** Select the **Stripes** layer by clicking it and then press Shift+Alt+M (or Shift-Option-M) to burn the stripes into the background image. The result appears in Figure 10-35.

By now, you may have noticed Photoshop's penchant for showing you the outlines of your paths whenever you view a shape layer. To hide the paths, click the vector mask thumbnail to the right of the color swatch in the Layers palette. Alternatively, if the arrow tool or one of the shape tools is active, you can press Enter or Return.

Figure 10-35.

Now suppose we want the stripes to vary in opacity, from nearly transparent on the left to opaque on the right. One solution is to fill the layer with a transparent-to-red gradient (Layer→ Change Layer Content→Gradient). But a more flexible solution is to add a layer mask. This may seem like an odd notion, given that the layer already has a vector mask. But any kind of layer in Photoshop—even a text layer—can include one vector mask *and* one pixel-based layer mask, thus permitting you to blend the best of both worlds.

If adding a layer mask to a vector shape doesn't sound like a regular barrel of monkeys to you, skip to the "Bending and Warping Type" exercise, which begins on page 392. Then again, if it sounds like more fun than you've had in years, enjoy the remaining steps.

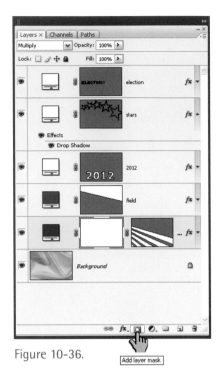

Figure 10-36.

Add layer mask

20. *Add a layer mask.* With the Stripes layer still active, click the small ⬜ icon at the bottom of the Layers palette. Photoshop adds another mask thumbnail, as shown in Figure 10-36.

21. *Click the gradient tool in the toolbox.* Or press the G key. (If this selects the paint bucket, press the G key again.) Also, confirm the following settings:

- Press the D key to set the foreground color to white and the background to black (the masking defaults).

- Make sure the gradient bar on the left side of the options bar displays a white-to-black gradient. If it does not, press Shift+⬚ (that's Shift+comma) to reset it.

- Select the first style icon in the options bar (the one labeled Linear Gradient in Figure 10-37).

- The other options should be set to their defaults: **Mode**: **Normal**, **Opacity**: 100 percent, **Reverse**: off, and the last two check boxes on.

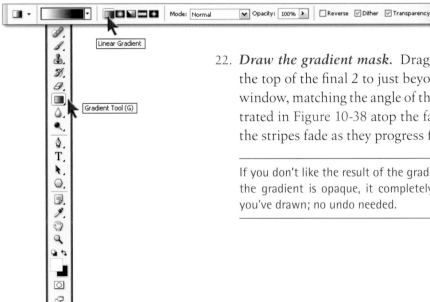

Linear Gradient

Gradient Tool (G)

22. *Draw the gradient mask.* Drag in the image window from the top of the final 2 to just beyond the left edge of the image window, matching the angle of the neighboring stripe, as illustrated in Figure 10-38 atop the facing page. The result is that the stripes fade as they progress from right to left.

If you don't like the result of the gradient mask, just redraw it. Because the gradient is opaque, it completely replaces any previous gradient you've drawn; no undo needed.

Figure 10-37.

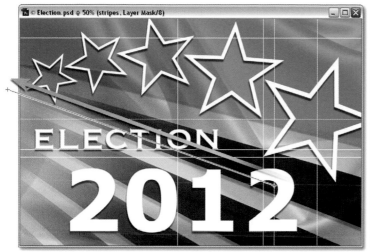

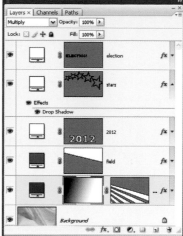

Figure 10-38.

23. **Select the line tool.** The next step is to draw a rule under the word *ELECTION*. The best tool for this job is the line tool. You can select it in any of the following ways:

- Select the line tool from the shape tool flyout menu, just as you chose the polygon tool back in Step 4.

- Click the current occupant of the shape tool slot. Then click the line tool icon in the options bar, as shown in Figure 10-39.

Figure 10-39.

- Press the U key twice. The first keystroke selects the last used shape tool, the polygon tool; the second advances to the line tool. (If you skipped the preference settings recommended in Step 10 on pages xix through xxi of the Preface, press U and then Shift+U.)

24. **Increase the Weight value to 12 pixels.** The **Weight** value determines the thickness of lines drawn with the line tool. You can modify the value directly in the options bar, or press Shift+🔲 to raise the value by 10 and 🔲 to raise it by another 1.

25. **Click the Stars layer in the Layers palette.** By selecting this layer, you do two things: First, you tell Photoshop to create the next shape layer in front of the Stars layer. Second, you tell it to match the Stars layer's color and style attributes.

26. ***Draw a line under the word*** **ELECTION.** Because we want the rule to extend beyond the left edge of the canvas, it's easiest to draw from right to left. So begin your drag just to the right of the *N* in *ELECTION* and between the two horizontal guides, as demonstrated in Figure 10-40. (If you find yourself snapping to one guideline or the other, zoom in and try again.) *After* you begin dragging, press and hold the Shift key to constrain the rule to precisely horizontal. (If you press Shift before starting to drag, you'll add the line to the existing star layer.) Drag beyond the edge of the canvas before releasing the mouse button, and then release Shift.

Figure 10-40.

You can adjust the position of the line as you draw it or after you finish. To move the line as you draw it, press and hold the spacebar. To move the line after you draw it, press Ctrl (or ⌘), click the path outline to select it, and press the appropriate arrow key (↑, ↓, ←·, or ⋯→).

27. ***Name the new layer.*** Again, the layer is called Shape 1. Double-click the layer name and enter the new name "Underscore."

28. ***Select the custom shape tool.*** Now to draw the final shape, which will be a crown over the letter *T.* Photoshop permits you to draw prefab graphics using the custom shape tool. To select this tool, click the 🏵 icon, the one to the right of the line tool in the options bar. Or press the U key.

29. ***Load all the custom shapes included with Photoshop.*** Photoshop ships with a large custom shape library, but only a few are loaded by default. To load every single one of them (close to 300 in all):

- Click the ⏷ arrow to the right of the word Shape in the options bar.

- Click the ⊙ arrow in the pop-up palette to display a long menu of options, and then choose **All**.

- As shown in Figure 10-41, Photoshop asks whether you want to append the shapes from the All library or replace the current shapes. As its name implies, the All library includes *all* of Photoshop's custom shapes, so click the **OK** button to avoid duplicates.

Figure 10-41.

30. ***Select the Crown 2 shape.*** To better see the shapes, choose **Large Thumbnail** from the pop-up palette's menu. Photoshop's shape collection includes five crowns. Select the second one (♕), which I've outlined in red in Figure 10-42.

31. ***Draw the crown shape.*** Draw the crown above the letter *T*, as demonstrated in Figure 10-43 on the next page. As you do, press and hold the Shift key to constrain the crown to its original aspect ratio, so it appears neither stretched nor squished. (Again, be sure to press Shift *after* you begin dragging, not before.) Don't forget that you can press the spacebar to position the crown on-the-fly.

Figure 10-42.

Figure 10-43.

Figure 10-44.

32. **Name the new layer.** Double-click the newest layer's name in the Layers palette and enter "Crown" instead.

33. **Switch to the Background layer.** That takes care of all the shapes. My remaining concern with the design is that the word *ELECTION* is too near in color to its background. So I'd like to add a gradient just above the Background layer to create more contrast. Click the **Background** layer to make it active.

34. **Change the foreground color.** Press D to call up the default foreground and background colors and select black. The active foreground color influences the gradient we're about to create.

35. **Add a gradient layer.** Press the Alt key (Option on the Mac) and click the ⊘ icon at the bottom of the Layers palette. Then choose the **Gradient** command. This forces the **New Layer** dialog box to appear. Enter the settings shown in Figure 10-44 and described below:

 • Name the new layer "Shading."

 • Set the **Mode** option to **Multiply**. You can always change this later directly inside the Layers palette, but we might as well set it up properly in advance.

 • Lower the **Opacity** value to 50 percent.

 Then click the **OK** button.

36. *Set the angle to 50 degrees.* Photoshop next displays the **Gradient Fill** dialog box (see Figure 10-45), which shows a black-to-transparent gradient, perfect for our needs. (The black comes from the foreground color, as set in Step 34.) Change the **Angle** value to 50 degrees and click **OK**. The result is an independent gradient layer that you can adjust later by double-clicking its thumbnail in the Layers palette.

37. *Hide the guidelines.* Choose **View→Show→Guides** or press Ctrl+⌶ (⌘-⌶). The final artwork appears in Figure 10-46.

Figure 10-45.

Figure 10-46.

The beauty of this design is that virtually everything about it is scalable. For example, to turn this into a piece of tabloid-sized poster art, choose **Image ›Image Size** and change the **Width** value in the **Document Size** area to 17 inches. Make sure all three check boxes at the bottom of the dialog box are selected, and then click **OK**. Every single shape, drop shadow, and gradient scales to fit the new document size, as shown in Figure 10-47. The background image gets interpolated, of course, but given the dominance of the foreground elements, it's not something that anyone's going to notice.

Figure 10-47.

Bending and Warping Type

Back in Step 39 of the "Creating and Formatting Text" exercise (see page 377), we skewed some text backward using Edit→Free Transform command. But what if we wanted to apply a more elaborate distortion? When working on text, Distort and Perspective are dimmed in the Edit→Transform submenu. But that doesn't mean distortions are applicable only to images. Photoshop offers two ways to distort live text layers:

- You can combine a text layer with a shape outline to create a line of type that flows along a curve, commonly known as *text on a path*.

- If that doesn't suit your needs, you can warp text around a predefined shape. This feature is similar to the Warp command that we used on the food hat in the "Importing, Transforming, and Warping Layers" exercise (Lesson 9, Step 30, page 325), except that you can't apply a custom distortion. For that, you have to convert the text to shapes.

This exercise shows you how the two features work. First, we'll wrap text around the perimeter of a circle. Then we'll stretch and distort letters inside the contours of a text warp shape. All the while, our text layers will remain live and fully editable.

Figure 10-48.

1. *Open two images.* The files in question are *Space radio.psd* and *Space text.psd*, both in the *Lesson 10* folder inside *Lesson Files-PsCS3 1on1*. If Photoshop complains that some layers need to be updated, click the **Update** button. The first file contains a handful of text, shape, and image layers, many of which I've assigned layer styles (the subject of the next lesson). The second file contains two lines of white type against a black background. Our first task is to take the text from the second file and flow it around the black circle in the first file. So click the title bar for *Space text.psd* to bring it to the front, as shown in Figure 10-48.

2. *Copy the top text layer.* In the **Layers** palette, double-click the T in front of the layer named **Everyone (top line)**. Photoshop switches to the type tool and selects all the type in the top line. (If it does not, it's probably because you double-clicked the layer name instead of the T. Try again.) Choose **Edit→Copy** or press Ctrl+C (⌘-C on the Mac).

3. **Switch back to the Space radio.psd composition.** Press the Esc key to exit the text-editing mode. Then click the title bar of the image that contains the microphone.

4. **Display the guidelines.** If you can already see the guidelines, super. If not, choose **View→Show→Guides** or press Ctrl+⊡ (⌘-⊡ on the Mac).

5. **Select the ellipse tool in the toolbox.** To create text around a circle, we need to draw a circle for the text to follow. Click and hold the shape tool icon and choose the ellipse tool, as shown in Figure 10-49.

Figure 10-49.

6. **Click the paths icon in the options bar.** You can set text around any kind of path outline, whether it's part of a shape layer or stored separately in the Paths palette. But given the number of circles in this document, it'll be easier to see what's going on if we work with the Paths palette. So click the icon highlighted in Figure 10-50.

Figure 10-50.

7. **Draw a big circle.** Drag from one guide intersection to the opposite intersection. Figure 10-51 illustrates the correct and proper left-hander's view. Those of you cursed with the popular blight of right-handedness can drag from left to right instead.

Speaking of Figure 10-51, the cyan lines are the guides, the black circle is the new path. The beginning of my drag appears as an orange ⊕; the end appears as a violet ⊕. The actual image is dimmed so you can better see what's going on.

8. **Name the new path.** Strictly speaking, you don't *have* to name the path. But you might as well be organized and save your work as you go along. So with that in mind, switch to the **Paths** palette, either by clicking the **Paths** tab or by choosing **Window→ Paths**. Then double-click the **Work Path** item and rename it "Big Circle."

9. **Hide the guidelines.** The sole purpose of the guides was to help you draw the big circle. Now that we're finished with that, choose **View→Show→Guides** or press Ctrl+⊡ (or ⌘-⊡) to make them go away.

Figure 10-51.

Figure 10-52.

10. ***Click the type tool in the toolbox.*** Or press the T key. As I mentioned earlier, the horizontal type tool is the only text tool you'll ever need. It creates point text, area text, and now, text on a path.

11. ***Click at the top of the big circle.*** When you move your cursor over the circular path, the cursor changes slightly to include a little swash through its center. This indicates you're about to append text to the path. Click at the center topmost point in the path to set the blinking insertion marker on the path, as shown in Figure 10-52.

12. ***Paste the text.*** Choose **Edit→Paste** or press Ctrl+V (or ⌘-V). Photoshop pastes the text you copied back in Step 2 along the circumference of the path. The copied text was centered, so the pasted text is centered as well, exactly at the point at which you clicked in the preceding step. The result is a string of characters that rest evenly along the top of the circle, centered between the red ⊘s, as shown in Figure 10-53.

Figure 10-53.

If your text is not quite evenly centered as in Figure 10-53, you may need to reposition it slightly. Press the Ctrl key (or ⌘ on the Mac) and move the cursor over the letters to get an I-beam with two arrows beside it. Then drag the text to move it around the circle until the first E and the last A are equidistant from the two red ⊘s. Small drags usually produce the best results.

When you have the type where you want it, press the Enter key on the keypad (or Ctrl+Enter or ⌘-Return) to accept the new text layer and move on.

13. *Copy the second line of type.* Now to create the text along the bottom of the circle. Switch to the *Space text.psd* window. Double-click the T in front of the layer named **Except (bottom line)** in the **Layers** palette to select the text. Then choose **Edit→Copy** or press Ctrl+C (⌘-C).

14. *Select the next layer down in the composition.* Press Esc to deactivate the text. Then return to the *Space radio.psd* composition. Press Alt+⬚ or Option-⬚ to select the **Radio-Free Space!** layer. We're doing this for two reasons: First, I want the next layer you create to appear in front of this one. Second, it'll allow us to start with a fresh circle path instead of repurposing the one used in the top layer.

15. *Click along the bottom of the big circle.* Go to the **Paths** palette and click the **Big Circle** item to once again display the circle in the image window. Still armed with the type tool, click at the center of the bottom of the circular path. Photoshop displays a blinking insertion marker, this time emanating down from the circle.

16. *Paste the text.* Again, choose **Edit→Paste** or press Ctrl+V (⌘-V). As before, Photoshop pastes the text along the perimeter of the circle. But this time, the text comes in upside-down, as shown in Figure 10-54.

Figure 10-54.

17. *Flip the text to the other side of the path.* Press and hold the Ctrl key (⌘ on the Mac) and hover the cursor over the bottom of the text (roughly the *O* in *COMPLETE*) to get the I-beam with the double arrow. Then drag upward. Photoshop flips the text to the other side of the path, turning it right-side-up as shown in Figure 10-55.

18. *Select all the type.* Next we need to nudge the type down using a function called *baseline shift*, which raises or lowers selected characters with respect to their natural resting position, the *baseline*. Press Ctrl+A (or ⌘-A) to select all the characters in the new text layer.

Figure 10-55.

Figure 10-56.

19. *Bring up the Character palette.* Click its tab if it's already on screen. Otherwise, choose **Window→ Character** or press Ctrl+T (⌘-T).

20. *Set the baseline shift.* In the **Character** palette, click the icon that looks like a capital letter paired with a superscript one (**A$^{\underline{a}}$**) to select the baseline shift value, highlighted in Figure 10-56. Then enter −8.5 to shift the letters down 8.5 points, which translates to about 18 pixels inside this 150 ppi image.

You can also nudge the baseline shift value incrementally from the keyboard. Press Shift+Alt+↓ (or Shift-Option-↓) to lower the characters 2 points at a time. Shift+Alt+↑ (or Shift-Option-↑) raises the characters.

Press Enter on the keypad to accept your changes. (If the baseline shift value is selected, you may have to press Enter twice.) This completes the text on the circle. Now let's move on to warping some text.

21. *Select the Radio-Free Space! layer.* Press Alt+☐ (Option-☐ on the Mac) to drop down to the layer. Right now, the text treatment is almost comically bad. Cyan letters, wide leading—how much worse could it get? We'll start by spicing up the text with some layer styles, and then we'll warp the text for a classic pulp fiction look.

22. *Turn on the layer styles.* In the **Layers** palette, click the ▼ to the right of the **Radio-Free Space!** layer name to twirl open the layer and reveal a list of three styles I applied in advance: Outer Glow, Bevel and Emboss, and Stroke. Click in front of the word **Effects** to display the three styles.

23. *Set the blend mode to Overlay.* Select the **Overlay** mode from the pop-up menu at the top of the Layers palette. Or press Shift+Alt+O (Shift-Option-O on the Mac). The result appears in Figure 10-57.

24. *Click the warp icon in the options bar.* The type tool should still be active. Assuming that it is, look to the right side of the options bar for an icon featuring a skewed T above a tiny path (highlighted in Figure 10-58). Click this icon to bring up the **Warp Text** dialog box.

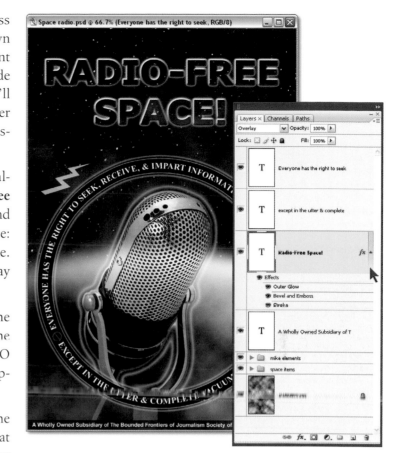

Figure 10-57.

Figure 10-58.

25. *Apply the Arc Lower style.* The Warp Text dialog box features the following options:

- Select the shape inside which the text bends from the Style menu. The icons provide hints as to what the effect will look like. But if in doubt, choose an option and watch the preview in the image window.

- Change the angle of the warp by selecting the Horizontal or Vertical radio button. Assuming Western-world text like we're working with here, Horizontal bends the baselines and Vertical warps the individual letters.

- Use the Bend value to determine the amount of warp and the direction in which the text bends. You can enter any value from −100 to 100 percent.

- The two Distortion sliders add perspective-style distortion to the warp effect.

For example, Figure 10-59 shows four variations on the Arc Lower style. The icon next to the style name shows that the effect is flat on top and bent at the bottom. Assuming Horizontal is active, this means the warp is applied to the bottom of the text. A positive Bend value tugs the bottom of the text downward (first image); a negative value pushes it upward (second).

To achieve a strict perspective-style distortion, choose any Style option and set the Bend value to 0 percent. Examples of purely horizontal and vertical distortions appear in the last two images in Figure 10-59.

For this exercise, choose **Arc Lower** from the **Style** pop-up menu. Then set the **Bend** value to −40 percent. The resulting effect looks awful—easily the worst of those in Figure 10-59—but that's temporary. Have faith that we'll fix it and click **OK**.

Figure 10-59.

26. ***Increase the size of the word SPACE!*** With the type tool, triple-click on the word *SPACE!* to select both it and its exclamation point. Press Ctrl+Shift+⌑ (⌘-Shift-⌑) to increase the type size incrementally until the width of the selected text matches that of the text above it. (To resize faster, press Ctrl+Shift+Alt+⌑ or ⌘-Shift-Option-⌑.) Or just click the T̲T icon and change the type size value to 88 points, as in Figure 10-60.

Figure 10-60.

27. ***Increase the vertical scale of all characters.*** One of the byproducts of warping is that it stretches or squishes characters, thus requiring you to scale them back to more visually appealing proportions. In our case, the text is *really* squished, so some vertical scaling is in order. Press Ctrl+A (or ⌘-A) to select all type on the active layer. In the **Character** palette, click the ↕T icon to select the vertical scale value, which I've highlighted in Figure 10-61. Enter 167 percent to make the letters taller without making them wider, and then press the Enter or Return key.

Figure 10-61.

Figure 10-62.

28. **Increase the leading.** Press Alt+↓ (or Option-↓ on the Mac) to incrementally increase the leading. Press Ctrl+Alt+↓ (or ⌘-Option-↓) to increase the leading more quickly. I eventually arrived at a leading value of 126 points (see Figure 10-62).

29. **Press Enter to accept the warped text.** Remember to press Enter on the keypad. The final composition appears in Figure 10-63.

It's important to note that throughout all these adjustments, every single text layer remains fully editable. For example, to change the text from *RADIO-FREE SPACE!* (indicating a space free of radio) to *RADIO FREE SPACE!* (which implies that the radio in space is free to all), simply replace the hyphen with a space character. The layer effects are likewise live. To change the style of warp, simply select the text layer and click the text warp icon in the options bar.

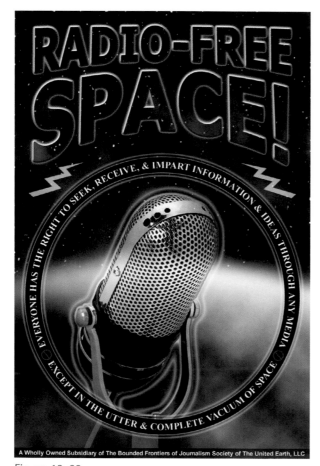

Figure 10-63.

WHAT DID YOU LEARN?

Match the key concept in the numbered list below with the letter of the phrase that best describes it. Answers appear upside-down at the bottom of the page.

Key Concepts

1. Raster art
2. Vector-based objects
3. Formatting attributes
4. Point text
5. Area text
6. Fractional character widths
7. Every-line composer
8. Pair kerning
9. Indent Sides By
10. Series duplication
11. Text on a path
12. Warp Text

Descriptions

A. Font family, type style, size, leading, alignment, and a wealth of other options for modifying the appearance of live text.

B. This numerical value lets you adjust the sharpness of points in a star drawn with the polygon tool.

C. A column of type created by dragging with the type tool, useful for setting long sentences or entire paragraphs.

D. Digital photographs and scanned artwork composed exclusively of colored pixels.

E. A special kind of text layer in which text is attached to a path outline to create a line of type that flows along a curve.

F. The best means for calculating text spacing, which permits Photoshop to move a character by a fraction of a pixel.

G. A succession of duplicated objects, scaled, rotated, and otherwise transformed in equal increments.

H. Mathematically defined text and shapes that can be scaled or otherwise transformed without any degradation in quality.

I. An option that spaces all lines of type in a selected layer by similar amounts to give the layer a more even, pleasing appearance.

J. A text layer that has no maximum column width and aligns to the point at which you clicked with the type tool.

K. This dialog box bends and distorts live text to create wavy, bulging, and perspective effects.

L. The adjusted amount of horizontal space between two neighboring characters of type.

Answers

STYLES AND SPECIALTY LAYERS

PHOTOSHOP IS two programs. The first permits you to adjust colors, heal imperfections, and sharpen the focus of a photograph on a pixel-by-pixel basis. The second lets you apply many of these same edits using layers so that no pixel is permanently changed. The first Photoshop is immediately satisfying but utterly static. Each modification builds on its predecessor, creating a trail of destructive adjustments that can, if left unchecked, harm the quality of your image. The second Photoshop demands more planning, attention to detail, and mental gymnastics, but rewards your efforts with dynamic edits that you can change whenever you like. Anything you do, you can later undo or redo, and in any order you like. And you always have access to your original image.

The Amazing World of Dynamic Edits

Photoshop's dynamic edits fall into four categories. *Layer effects* are collections of dynamic color and contour attributes that let you add dimension, lighting, and texture to otherwise flat objects. *Adjustment layers* are groups of settings that correct or modify the colors of the layers behind them. *Smart objects* are placed images that remember their original appearance, allowing you to apply nondestructive transformations and replicate objects from a single source. *Smart filters* are collections of filter effects applied to a smart object. Examples of all four applied to a repeated starburst appear in Figure 11-1.

Paper background www.istockphoto.com/spxChrome

Figure 11-1.

ABOUT THIS LESSON

Project Files

Before beginning the exercises, make sure you've installed the lesson files from the DVD, as explained in Step3 on page xvii of the Preface. This should result in a folder called *Lesson Files-PsCS3 1on1* on your desktop. We'll be working with the files inside the *Lesson 11* subfolder.

In this lesson, you'll explore the worlds of layer effects and adjustment layers. Specifically, you'll learn how to:

Video Lesson 11: Styles and Effects

Photoshop's layer effects are more than a means for adding drop shadows. Used properly, layer effects are automated painting tools that let you not only enhance photographic layers but also turn hand-drawn elements, text layers, or vector shapes into fully realized objects with dimension and depth.

For a firsthand introduction to layer effects, as well as the predefined layer styles that ship with Photoshop, watch the eleventh video lesson on the DVD. Insert the DVD and double-click the *PsCS3 Videos. html* file. Then click **Lesson 11: Styles and Effects** under the **Type, Styles, and Output** heading. In this 15-minute, 56-second movie, I tell you about the following operations and shortcuts:

Operation	Windows shortcut	Macintosh shortcut
Inspect effects that make up a style	Click ▼ to right of layer name	Click ▼ to right of layer name
Display Layer Style dialog box	Double-click *fx* or effect name	Double-click *fx* or effect name
Convert Background to independent layer	Double-click Background, Enter	Double-click Background, Return
Combine one layer style with another	Shift-click item in Styles palette	Shift-click item in Styles palette
Copy effect from one layer to another	Alt-drag layer effect	Option-drag layer effect
Free Transform	Ctrl+T	⌘-T

As their names imply, both layer effects and adjustment layers depend on layers to work their magic. So I've assembled a simple layered document to show you how both features work:

- Figure 11-2 shows a composition with two floating layers—an image and a strip of torn paper—set against a beige background. To each layer, I applied one of the most common kinds of layer effects, a *drop shadow*, which is nothing more than a silhouette of the layer that is offset and blurred. The shadows imply a gap in depth between the layers. And because they drop downward, the shadows suggest a light source that shines from above.

- Drop shadows are handy, but they are just one of several kinds of layer effects. In Figure 11-3, I created a new layer. Using two separate layer effects, I traced a dark outline around the outside of the layer and a light outline around the inside. This results in a slight "toasting" effect, which helps separate the layer from its environment even more.

- The lower-right corner of Figure 11-4 sports an adjustment layer. Based on the Gradient Map command (see the "Colorizing a Grayscale Image" exercise,

Figure 11-2.

Figure 11-3.

Figure 11-4.

Figure 11-5.

which begins on page 81 of Lesson 3), this adjustment layer inverts and colorizes the paper, photograph, and background layers beneath it.

- Figure 11-5 illustrates the results of another adjustment layer modeled after the Gradient Map command. But this one doesn't invert colors; it changes them. I even managed to assign an effect to the adjustment, one that sculpts and chisels the perimeter of the layer.

- As a finishing touch, I selected the largest of the globes in the composition and converted it into an independent smart object. Then I duplicated the object twice to create three globes linked to a single base image. Finally, I colored each globe using a Color Overlay effect. I also applied the Gaussian Blur smart filter to the green and red globes, as in Figure 11-6.

The upshot is that layer effects, adjustment layers, smart objects, and smart filters possess an amazing capacity for interaction. One layer effect mixes with another; one adjustment layer modifies another; one smart filter builds on another. All three can be applied to a smart object, and that smart object may contain layers that are subject to their own layer effects, adjustment layers, and smart filters. You'll see examples of these interactions—and get a sense of just how useful they can be—in the upcoming exercises.

Figure 11-6.

Layer Attributes Versus Layers

Styles and specialty layers are accessible from the Layers palette. Also, they remain editable as long as you save them in the native Photoshop PSD or TIFF format. But each is ultimately a unique function, implemented in its own special way:

- You assign a layer effect or smart filter to an existing layer. Smart objects and adjustment layers exist as layers of their own. Figure 11-7 shows examples of each, along with their masks (small labels) and markers (small and violet labels).

- A layer effect controls the appearance of just one layer at a time. A smart filter affects a single smart object, which may contain multiple layers. An adjustment layer affects the color and luminosity of all layers beneath it. A smart object can be linked to several duplicate layers, thus letting you edit all duplicates in one pass.

- You can duplicate layer effects and smart filters by Alt-dragging (or Option-dragging) them from one layer to another. To duplicate a smart object or adjustment layer, press Ctrl+J (or ⌘-J).

- You can store a collection of layer effects as a custom *layer style* in the Styles palette. To save all dynamic edits that make up your composition, choose File→Save.

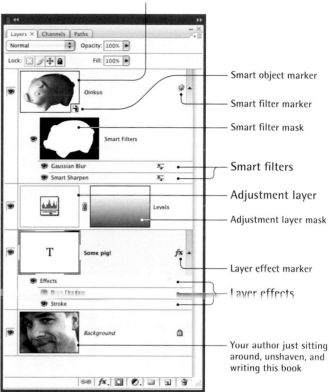

Figure 11-7.

The first four exercises cover some of the many applications for layer effects. Adjustment layers are every bit as useful, but because we already looked at the core color adjustment commands in Lessons 2 and 3, I cover them in a single exercise, beginning on page 433. The final two exercises address smart objects and smart filters.

Adding Layer Effects

Layer effects serve two opposing purposes: to set layers apart and to bring them together. A layer effect that casts a shadow suggests that the layer hovers above its surroundings. The shadow traces the layer and adds depth to the image, both of which help to distinguish the layered element from a busy composition. A layer effect can also blend the interior or perimeter of a layer with its background. The independent layers appear not as disparate elements of a composition, but as seamless portions of a cohesive whole.

The following exercise demonstrates both capacities of layer effects using Photoshop's most venerable effects, Drop Shadow and Inner Shadow. Both are *directional effects*, meaning that they cast colors by a specified distance at a specified angle. The effects may occur either outside or inside the layer and, as you'll see, they can just as easily result in highlights as in shadows. The exercise will end with the Color Overlay effect, which is most useful for overriding the colors in a layer.

1. *Open a couple of images.* Go to the *Lesson 11* folder inside *Lesson Files-PsCS3 1on1* and open the files *Happy Juice.psd* and *Max in kitchen.tif*, both of which appear in Figure 11-8. (If Photoshop asks to update the text layers, click the **Update** button.) The former is a half-finished advertisement for a snappy fruit-like beverage; the latter is a picture of my son Max enjoying his first carbonated beverage.

2. *Display the guidelines.* Bring the *Happy Juice.psd* image to the front. You should see three guides—one horizontal and two vertical. If not, choose **View→Show→Guides** or press Ctrl+⦂ (⌘-⦂ on the Mac) to make them visible. You will use these to position the imported image of Max.

Figure 11-8.

3. *Load Max's mask as a selection.* After reading the former aloud three times fast, click the *Max in kitchen.tif* title bar to bring that image window to the front. Then open the **Channels** palette and Ctrl-click (or ⌘-click) on the **Mask** item or press Ctrl+Alt+4 (⌘-Option-4 on the Mac) to load the selection outline.

4. *Drag the selection into the ad composition.* Press the V key to select the move tool. (Or press and hold the Ctrl or ⌘ key to get the move tool on-the-fly.) Then drag Max from *Max in kitchen.tif* into the *Happy Juice.psd* image window. Drop him any old place for now. Max should land directly in front of the Background layer, as in Figure 11-9 on the facing page.

5. **Move Max into alignment with the guides.** Still armed with the move tool, drag Max in his new home until he exactly aligns with all three guides. A vertical magenta *smart guide* may appear to show you that Max is centered. Figure 11-9 uses red arrowheads in white highlights to mark the three points of contact.

6. **Hide the guides and rename the new layer.** We're finished with the guides, so press Ctrl+[] (or ⌘-[]) to make them go away. In the **Layers** palette, double-click the new layer name, **Layer 1**, and rename it "Spokesboy."

The mask around Max is pretty darn good, if I do say so myself. (Heaven knows, I spent enough time on it!) But the transitions are still a bit iffy in places. Also, given the extreme nature of this ad, I want Max to pop off the page, as if he's a cartoon character pasted into a different environment. Thankfully, you can smooth out transitions and add a bit of cartoon depth using layer effects.

7. **Choose the Drop Shadow layer effect.** We'll start with the most popular and arguably the most useful layer effect, the drop shadow. Click the effects icon (*fx*) at the bottom of the Layers palette to bring up a menu of ten layer effects. Then choose **Drop Shadow** (see Figure 11-10).

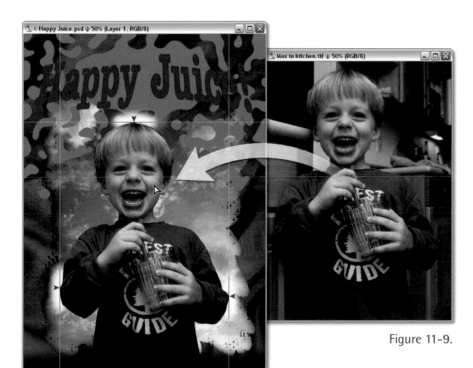

Figure 11-9.

Figure 11-10.

8. ***Turn on the Preview check box.*** You'll be working inside the **Layer Style** dialog box for several long steps, so naturally you'll want to be able to see what you're doing to the image.

9. ***Adjust the Drop Shadow settings.*** The Layer Style dialog box is notorious for the sheer number of options it offers. But every one of them serves a purpose, so it's worth taking a moment to understand them. Here's a quick rundown of the options that currently confront you, along with the settings I want you to enter (pictured in Figure 11-11):

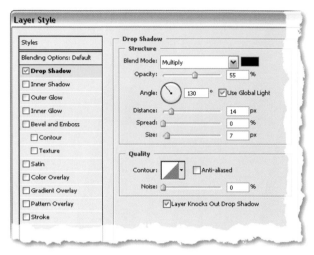

Figure 11-11.

- Leave the **Blend Mode** set to **Multiply**. Although it has no effect on black (black doesn't get any darker), Multiply is the one blend mode that ensures that any color, black or otherwise, darkens its background in the same manner as a bona fide shadow.

- Leave the color swatch set to black. Other colors can serve as shadows, but since black does the job just fine, why change it?

- At 100 percent **Opacity**, the black shadow would be fully opaque, subject to the softness specified by the Size value. For my son, reduce this value to 55 percent.

- Set the **Angle** value to 130 degrees, which puts the light source, or sun, above and to the left of the layer. This casts a shadow in the opposite direction, –50 degrees, or down and to the right.

- Turn on **Use Global Light**. This locks in the sun at 130 degrees for all directional layer effects, including Drop Shadow, Inner Shadow, and Bevel and Emboss.

- Enter a **Distance** of 14 pixels, so that the shadow is offset down and to the right 14 pixels from the original.

For the record, modifying values isn't the only way to change the angle and distance of a drop shadow. You can also move your cursor into the image window and drag the shadow directly. If the Use Global Light check box is on, Photoshop moves all other directional effects linked to this option as well.

- The **Spread** value defines the sharpness of the shadow. Leave it set to 0 percent for a soft, blurry effect.

- The **Size** value blurs the shadow. It's a lot like the Radius value in the Feather or Gaussian Blur dialog box, except that it's calculated as a linear function instead of tapering. In other words, the shadow drops off evenly like a gradient, and the Size value defines the size of that gradient. However you care to think about it, change the value to 7 pixels.

- The **Contour** option lets you change how the shadow drops off. For example, if you want a Gaussian distribution, choose the hill-shaped Gaussian icon, as in Figure 11-12. But in our case, the default **Linear** setting (the straight slope) works just fine.

- The **Anti-aliased** check box smooths out rough spots in the event you select a spiky Contour setting. We did not, so leave it turned off.

- The **Noise** value lets you add random flecks to an image to mimic the look of film grain. In this case, it's unnecessary. Leave the value set to 0 percent.

- Leave the **Layer Knocks Out Drop Shadow** check box turned on. This ensures that the drop shadow appears exclusively around the edges of a layer and not inside. Turn off the option only if you want to see through a layer to its shadow (as when the layer is translucent or includes a blend mode).

Figure 11-12.

The result of all these settings is a small but relatively focused shadow that darkens everything behind it. And because it's parametric, you can modify it on-the-fly. It also takes up just a few K in memory and on disk.

PEARL OF WISDOM

At this point, we've given Max a kind of cardboard-cutout depth, but we've done nothing to fix the wonky edges, most noticeable along the left side of his hair. In Lesson 4, you learned how to fix selection edges using Inner Glow, which traces the perimeter of a layer (see Steps 15 and 16, page 122). But because Max's problematic edges are relegated to one side, the directional Inner Shadow will serve us better.

10. **Add an Inner Shadow effect.** Click the **Inner Shadow** item on the left-hand side of the dialog box (the words, not the check box) to turn on the default Inner Shadow effect and display its settings in the Layer Style dialog box.

11. **Adjust the Inner Shadow settings.** Most of the options available when defining an Inner Shadow are the same as those we saw when defining the Drop Shadow. So I'll focus strictly on the options that are different or whose values I want you to change (as shown in Figure 11-13):

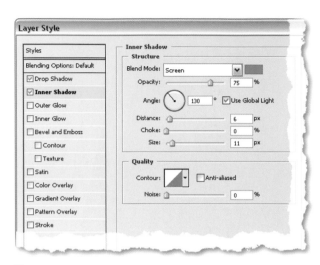

Figure 11-13.

- The left side of Max's hair is too dark compared with its background, so let's lighten it. That's no problem—the Inner Shadow effect can lighten just as easily as it can darken. Start by setting the **Blend Mode** option to **Screen**, which initially appears to make the shadow disappear.

- Click the black color swatch to bring up the **Color Picker** dialog box. Then click a light portion of the image background to bring some of the blue sky into Max's hair. For my part, I got **H**, **S**, and **B** values of 210, 55, and 95, respectively. Click the **OK** button to return to the **Layer Style** dialog box.

- Change the **Opacity** value to 75 percent (unless it's that way already, in which case, leave it).

- As long as **Use Global Light** is turned on, the **Angle** value is 130 degrees, as before. The difference is that the shadow now extends down and to the right from the upper-left inside edge—that is, inside Max's hair. Perfect, move on.

- You want the effect to be as subtle as possible—to fix the problem, but no more. The best way to accomplish this is to combine a small Distance value with a larger Size value. Set the **Distance** value to 6 pixels.

- **Choke** is the equivalent of Spread in the Drop Shadow panel; that is, it sharpens the effect. You want blurry, so leave it set to 0.

- Enter a **Size** value of 11 pixels. This results in a soft, diffused highlight.

Figure 11-14 compares Max before and after the drop and inner shadow effects. The drop shadow is consistent with the shadows on his face; the inner shadow highlights the dark edges of his hair.

12. **Add a Color Overlay effect.** Still inside the Layer Style dialog box, click **Color Overlay** (again, the words) on the left side. Photoshop covers Max with an opaque shellacking of red. Why would you want to coat a layer with red? Clearly, you wouldn't, which is why you'll modify the settings in the very next step.

13. **Adjust the Color Overlay settings.** In a pleasant change of pace, Photoshop presents us with mercifully few options. Set them as shown in Figure 11-15 and outlined below:

 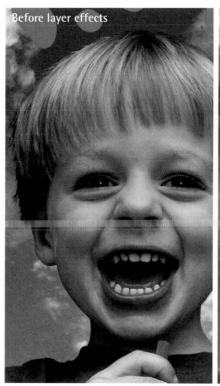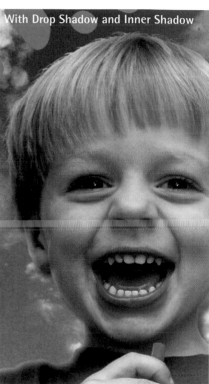

 • Reduce the **Opacity** value to 30 percent. Now you can see Max through the red.

 • Click the red color swatch and change the **H** value in the **Color Picker** dialog box to 30 degrees, or orange. Then click **OK**.

 • Back in the **Layer Style** dialog box, set the **Blend Mode** to **Color**. Photoshop restores the original luminosity values and blends them with the orange skin tones.

 The new coat of orange serves two purposes. First, it evens out some of the variations in Max's skin tones. Second, it matches him to the product color, as if he's chock full of Happy Juice.

Figure 11-14.

Figure 11-15.

Figure 11-16.

14. ***Click the OK button.*** Photoshop closes the Layer Style dialog box and accepts your changes. Three new effects appear below the Spokesboy layer in the Layers palette—Drop Shadow, Inner Shadow, and Color Overlay—as in Figure 11-16.

If you apply a layer effect and then decide you don't want it, don't throw it away. Just click its eyeball icon (👁) to turn it off. This hides the effect without trashing it entirely, thus permitting you to reestablish the effect later, with all your previous settings intact.

15. ***Save your composition.*** Choose **File→Save As**. Name your modified composition "Happy Juice edit-1.psd" and save it in the same *Lesson 11* folder inside *Lesson Files-PsCS3 1on1*. Be very certain you've saved this file because it will serve as the starting point for the next exercise.

Applying Strokes and Glows

So far, you've seen three of the ten layer effects available to Photoshop. Although we won't be looking at every single one of them, we owe it to ourselves to experiment with a few more.

And so it is we proceed to the next category of effects, strokes and glows, which trace colors uniformly around the perimeter of a layer. A *stroke* traces the layer with an outline of a specified thickness. The two *glows*, Outer Glow and Inner Glow, heap on additional attributes such as blur, noise, and contour. As with shadows, a stroke or glow may produce a light or dark effect depending on the blend mode and color you select.

In this exercise, you'll use strokes and glows to outline a few elements in our ongoing Happy Juice composition. As you'll see, these effects can be used to delineate objects and improve the legibility of large display type.

1. ***Open the image you saved in the last exercise.*** If you're following on the heels of the last exercise, the file may still be open. If not, open the file *Happy Juice edit-1.psd* in the *Lesson 11* folder inside *Lesson Files-PsCS3 1on1*. The file and its layers should appear as in Figure 11-16. (Note that this is a file you created and saved in the last exercise. If you cannot locate the file, you can create it by following the steps in the preceding section.)

2. ***Turn on and select the Balloon layer.*** Three levels up from Spokesboy is a layer called **Balloon**. Click its check box in the **Layers** palette to display the layer, and then click the gray vector mask thumbnail to make it active and prevent the path outline from displaying on screen. (You have to move your cursor away from the thumbnail for the outline to go away.) If the path outline persists, click the vector mask thumbnail again. Your composition should now contain a talk balloon.

3. ***Choose the Stroke layer effect.*** Click the *fx* icon at the bottom of the Layers palette and choose the **Stroke** option. Photoshop displays the **Layer Style** dialog box.

4. ***Adjust the Stroke settings.*** Shown in Figure 11-17, the options for the Stroke effect are a relatively simple bunch, so I'll run through them quickly:

 - The **Size** value determines the thickness of the stroke. Set it to 2 pixels.

 - Use the **Position** option to define how the stroke traces the perimeter of the layer. It may be fully inside the layer, fully outside, or half in, half out (Center). Select **Outside** to create the smoothest corners.

 - Set the **Blend Mode** to **Normal** and the **Opacity** to 100 percent for a solid, opaque stroke.

 - The **Fill Type** may be a solid color, a gradient, or a predefined pattern. For this image, leave the option set to **Color**.

 - Click the **Color** swatch. Inside the **Color Picker** dialog box, change the **S** and **B** values to 0 percent to get black. Then click **OK**.

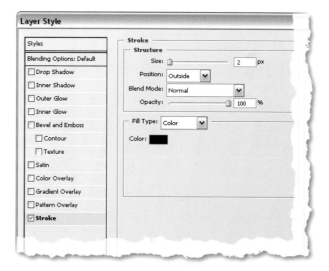

Figure 11-17.

Figure 11-18.

When you're finished, click **OK** to close the Layer Style dialog box and apply the black stroke. The stroked talk balloon appears in Figure 11-18.

Notice that the stroke appears antialiased, with soft transitions around the curves. This is a function of the stroke tracing a shape layer. If you applied the stroke to a pixel-based image layer, it would appear jagged. When stroking pixel-based images, it is better to use the Outer Glow effect with the Spread value set between 70 and 80 percent.

5. *Lower the fill opacity.* Reduce the **Fill** value in the **Layers** palette to 70 percent. This reduces the *fill opacity*, which is the opacity of the contents of a layer. In this case, it makes the white talk balloon translucent without affecting the black stroke one iota, as in Figure 11-19. (The standard Opacity value would reduce the opacity of both the balloon and the stroke.) The Fill value gives you the option of controlling the opacity of a layer and its effects independently.

To change the Fill value from the keyboard, first make sure one of the selection tools is active, and then press Shift with a number key. In this example, you'd press Shift+7.

Figure 11-19.

Note that the Fill value in the Layers palette is identical to the Fill Opacity value in the Blending Options section of the Layer Style dialog box. Although they have slightly different names, they serve the same purpose; moreover, changing one value likewise changes the other.

6. ***Turn on the Tagline and Dialog layer group.*** Click the empty box next to this folder in the Layers palette to display the 👁 icon and make the layers inside the group visible. The set includes several text layers, including the contents of the talk balloon, as pictured in Figure 11-20.

7. ***Turn on the effects for the Logo layer.*** Click the **Logo** layer to make it active. (If you see path outlines around the blue letters, click the vector mask thumbnail for the Logo layer to turn the outlines off.) Then click the ▼ to the right of the layer name to twirl open the layer. Click in front of the word **Effects** to make all the 👁 icons black and turn on two layer effects, Drop Shadow and Bevel and Emboss.

Unfortunately, the introduction of the layer effects makes the text less legible than before. But as luck would have it, the official Happy Juice logo includes a couple of strokes around it, one light and one dark, which will help it stand out. The Stroke effect can't accommodate concentric rings of color, but an Outer Glow can.

8. ***Add an Outer Glow effect.*** Double-click either **Drop Shadow** or **Bevel and Emboss** to display the **Layer Style** dialog box. Then click **Outer Glow** in the left-hand list to turn on the effect and display its settings.

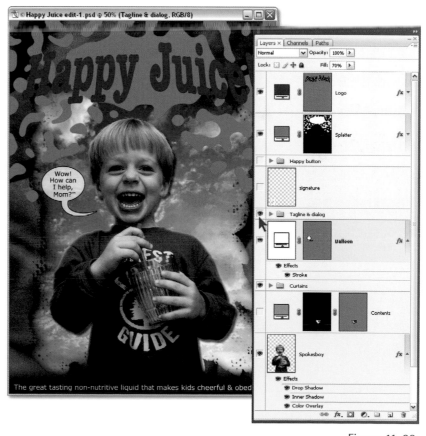

Figure 11-20.

Click to display
Gradient Editor

Figure 11-21.

Figure 11-22.

9. **Adjust the Outer Glow settings.** I often see artists use the Outer Glow effect to add bright, happy highlights behind a layer. But it's most useful for creating controlled stroke effects, as I've established in Figure 11-21. Here's how it works:

- As when applying the Stroke effect a moment ago, you want a fully opaque outline. So set the **Blend Mode** to **Normal** and the **Opacity** to 100 percent.

- The **Noise** option randomizes the display of pixels inside the Outer Glow effect. Leave it set to 0 percent.

- For the moment, skip the color swatch and move on to the **Technique** setting. The Softer option rounds off corners in a layer; the Precise option exactly traces them. Choose **Softer** for the smoothest, most consistent strokes.

- As when setting a Drop Shadow, the **Spread** value sharpens the effect, precisely what you need when creating strokes. Raise the value to 40 percent.

- To increase the thickness of the stroke, raise the **Size** value to 10 pixels.

The Quality settings allow you to create variations in the opacity of a stroke by selecting a Contour setting. You can also move the variations toward and away from the perimeter of the layer with the Range value. We have no need to do either, so leave these options set to their defaults.

10. **Assign a gradient.** Here's where things get interesting. The Outer Glow effect lets you outline a layer with a flat color or a gradient. The latter results in concentric rings of color, necessary for creating multicolored strokes. Click the gradient bar at the bottom of the **Structure** settings to open the **Gradient Editor** dialog box.

11. **Load and assign a custom gradient.** Click the **Load** button on the right side of the dialog box and then find the *Lesson 11* folder inside the *Lesson Files-PsCS3 1on1* folder. Open the file called *Logo gradient.grd*. A new white-to-blue swatch appears inside the Gradient Editor dialog box. Click the new gradient swatch. The Name option now reads Happy Juice Logo, as in Figure 11-22. Click **OK** to apply the gradient to the Outer Glow effect.

12. **Click the OK button.** Doing so closes the Layer Style dialog box and accepts your changes. Photoshop displays a double-stroke effect around the type, increasing its legibility as in Figure 11-23.

If the white portion of your stroke looks bluish, it's because you're zoomed out. Press Ctrl+Alt+⓪ (or ⌘-Option-⓪) to zoom in to the 100 percent view for a more accurate depiction of the style.)

13. **Save your composition.** Again choose **File→Save As**. Name your art "Happy Juice edit-2.psd" and save it in the *Lesson 11* folder inside *Lesson Files-PsCS3 1on1*. This step is not optional; the file you save serves as the starting point for the next exercise.

Figure 11-23.

Simulating Reflections with Bevel and Emboss

So far you've used layer effects to augment layers in a composition and trace shape outlines. But you can also use effects to transform flat, dull layers into photorealistic, three-dimensional ones. The best effect for this purpose is Bevel and Emboss. Another of Photoshop's directional effects, Bevel and Emboss traces highlights along one side of a layer and shadows along the opposite side.

The goal of this exercise is to employ the Bevel and Emboss effect to turn the layer of orange spots into deliciously plausible liquid. Whether it'll really fool viewers of your artwork is highly unlikely. But it'll make them *want* to believe—and in the realm of special effects, that's the greatest trick of all.

1. **Open the image you saved in the last exercise.** If it's already open, fantastic. If not, open the *Happy Juice edit-2.psd* file that you saved in Step 13 of the preceding exercise, which should be in the *Lesson 11* folder inside *Lesson Files-PsCS3 1on1*. The image should appear as in Figure 11-23. (If you can't locate the file, you'll need to follow the steps in the previous two sections.)

2. **Turn on the effects for the Splatter layer.** Click the **Splatter** layer to make it active. Then twirl open the layer and click in front of the word **Effects** to show the 👁 icon and turn on two layer effects, our dear friends Drop Shadow and Inner Shadow. Both are set to make authentic shadows, as shown in Figure 11-24. The effect is slightly slimy, but hardly liquid.

3. **Add a Bevel and Emboss effect.** Double-click either **Drop Shadow** or **Inner Shadow** to display the **Layer Style** dialog box. Then click **Bevel and Emboss** in the left list to turn on the effect and display its settings. The default settings give the Splatter layer a sense of depth, as in Figure 11-25. But we can do better.

4. **Adjust the settings.** The settings you're about to enter all appear in Figure 11-26. But because this effect is quite complicated, we're going to take it more slowly, starting with the **Structure** options:

 • The **Style** setting determines whether the beveled edges appear inside or outside the boundaries of the layer. Inner Bevel is in, Outer Bevel is out, Emboss

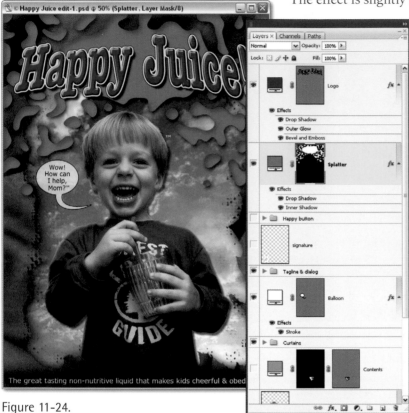

Figure 11-24.

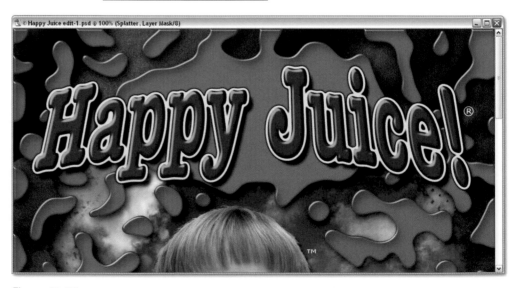

Figure 11-25.

and Pillow Emboss are both, and Stroke Emboss applies a beveled edge to an outline defined using the Stroke layer effect. Choose **Inner Bevel**.

- The **Technique** option controls just how "edgy" the beveled edges are. The two Chisel options result in different variations of serrated effects. If you don't want your layer to look as if it were cut with a bread knife—as you clearly do not when illuminating liquid—select **Smooth**.

- Use the **Depth** value to modify the degree of contrast and speed of transition between highlights and shadows. For this image, I recommend a Depth of 120 percent.

- Change the **Direction** option to invert the beveled edges, so the layer appears to recede away from you rather than swell toward you. In this case, we want the latter effect, so leave the Direction option set to **Up**.

- To increase the thickness of highlights and shadows, raise the **Size** value to 20 pixels.

- The **Soften** value smooths rough spots produced when Technique is set to one of the Chisel settings. Leave it set to 0 pixels.

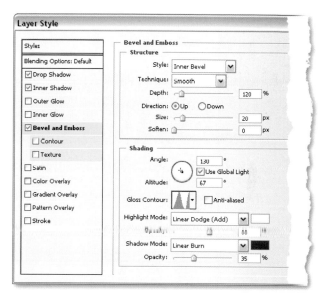

Figure 11-26.

At this point, the Splatter layer appears as depicted in Figure 11-27. Dimensional? Yes. Plastic? Most certainly. Molten? Maybe. But yummy, juicy liquid? No. There is more work to be done.

Figure 11-27.

5. **Set the Angle and Altitude values to 130 and 67, respectively.** As with other directional effects, the **Angle** value determines the angle of the light source, or sun, with respect to the layer. Turn on **Use Global Light** to set this value to 130 degrees, thus matching the other directional effects. Meanwhile, **Altitude** describes the angle of the sun along the horizon—90 degrees for noon, 0 degrees for sunset. Figure 11-28 shows a few variations. Notice that modifying this value affects the Splatter and Logo layers in unison, both of which are tied to Use Global Light. Feel free to experiment, but return the Altitude value to 67 degrees for the best results.

6. **Assign a contour.** The Gloss Contour option adjusts the way shadows and highlights play off the surface of the layer. Click the **Gloss Contour** icon (◪, not ▾) to display the **Contour Editor** dialog box pictured in Figure 11-29. The problem with all of Photoshop's default contours is that they're either too soft or too pointy to represent sharp water reflections. That's why we must design our own.

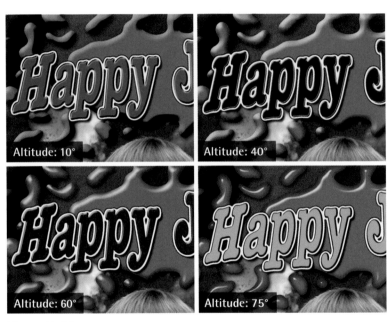

Figure 11-28.

7. **Load and assign a custom contour.** Click the **Load** button. Then find the *Lesson 11* folder inside the *Lesson Files-PsCS3 1on1* folder, and open the file called *Liquid shine.shc*. A radical zigzag of lines appears inside the central brightness graph, as pictured in Figure 11-29. You can click a point and move it if you like. But if you do, take heed to retain the sharp plateaus along the bottom and the top of the brightness graph. These ensure the sudden contrasts between lights and darks that appear regularly in water and other liquids. Click **OK** to accept the new contour and return to the **Layer Style** dialog box.

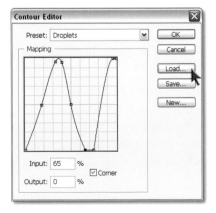

Figure 11-29.

8. **Turn off Anti-aliased.** This check box is designed to smooth precisely the sort of sharp-edged contour that you just loaded. But unless the transitions turned jagged, you really don't need it. To achieve the effect shown in Figure 11-30, leave the check box turned off.

Figure 11-30.

So far, so good. But I'm not quite satisfied with the level of contrast between the highlights and shadows. What we need are bright flashes of light—known as *specular highlights*—to provide glimmering sheen, complemented by translucent patches of color to suggest shadows refracted through water. This you can accomplish with blend modes.

9. **Set the Highlight Mode to Linear Dodge.** The Highlight Mode is currently set to Screen, which lightens universally. To amplify the highlights, change this setting to **Linear Dodge** and reduce the **Opacity** to 60 percent. The result is vivid yellowish highlights.

10. **Change the color and Shadow Mode.** Click the black swatch to open the **Color Picker** and then set the **H**, **S**, and **B** values to 30, 100, and 35, respectively, to create a deep, highly saturated orange. Click **OK** to return to the **Layer Style** dialog box. Then amplify the shadows by switching the **Shadow Mode** setting to **Linear Burn** and reducing the **Opacity** to 35 percent.

11. **Click the OK button.** And with that, Photoshop closes the Layer Style dialog box and applies your changes. You might regard the new effect, pictured in Figure 11-31, as less liquid than garish. But that's because we have one last change to make.

Figure 11-31.

12. **Change the blend mode and fill opacity.** Choose the **Screen** blend mode from the top of the **Layers** palette. Then change the **Fill** value to 85 percent. Or press Shift+Alt+S (Shift-Option-S on the Mac), and then hold Shift and press 8-5. The happy, juicy result appears in Figure 11-32.

Figure 11-32.

13. **Save the new layer style.** After spending this much time on such a nifty effect, you might as well save the result as a layer style. Display the **Styles** palette by clicking its tab or choosing **Window→Styles**.

- Move the cursor over an empty area of the palette so it looks like a paint bucket and click, as in Figure 11-33. (Note that the figure shows large thumbnails; yours will be smaller.)

- Name your style "Orange Liquid."

- Check **Include Layer Effects**, which saves all layer effects applied to the Splatter layer—namely Drop Shadow, Inner Shadow, and Bevel and Emboss.

- Also check **Include Layer Blending Options** to save the 85 percent fill opacity and Screen blend mode.

- Click the **OK** button to create the style.

Your new layer style appears as a small orange jewel in the Styles palette. To apply it to a layer in this or any other open document in the future, just click it.

Figure 11-33.

PEARL OF WISDOM

Unlike styles in other programs, no dynamic link exists between a layer style and a layer. And there's no way to update a style either. So if you decide to make changes, your only option is to save a new style. I agree, it's an oversight—but as your humble messenger, I feel compelled to let you know.

14. **Save your composition.** By now, you probably know the drill. But if not, here's how it goes: Choose **File→Save As**, name the file "Happy Juice edit-3.psd," and save it to the same *Lesson 11* folder inside *Lesson Files-PsCS3 1on1* that we used in the previous lessons. As before, this step is not optional; the file you save serves as the starting point for the next exercise. The composition thus far, with all layers and effects, appears in Figure 11-34.

Figure 11-34.

Simulating Reflections with Bevel and Emboss **425**

Fixing Problem Effects

As you gain more familiarity with layer effects, you'll discover how powerful and flexible they really are. But you'll also discover the occasional odd interaction between the effect, its layer, and the layers around it. The good news is that Photoshop permits you to address these interactions using a collection of check boxes. The bad news is, the check boxes are so strangely named and oddly placed that you'd never find them on your own. Hence the following exercise.

In all, Photoshop provides five check boxes for fixing problem effects. They appear smack dab in the middle of the Blending Options panel of the Layer Style dialog box:

- The first check box, Blend Interior Effects as Group, constrains effects that fall entirely inside a layer (specifically Inner Glow and the three Overlay effects). With the option off, Photoshop permits interior effects to blend through the active layer to the layers below. With the option on, interior effects are relegated to the active layer only. You'll see this option in action in Steps 7 and 12 (pages 429 and 430).

- The next check box, Blend Clipped Layers as Group, applies the blend mode assigned to a clipping mask to all masked layers above it. Leave it on; there's rarely any need to change it.

- On by default, Transparency Shapes Layer makes sure a layer effect traces the edge of a layer. About the only reason to turn off this option is to fill an entire image with one of the Overlay effects. But even then, there are better solutions. Leave this option turned on.

- Turn on Layer Mask Hides Effects to use a layer mask to clip the edges of a drop shadow, stroke, or other effect that falls outside the perimeter of a layer. To discover just how useful this option can be, see Step 19 (page 432).

- Vector Mask Hides Effects is similar to the preceding option, but it clips exterior effects with the vector mask instead of the pixel-based layer mask. In theory, the option seems like a good idea, but I have yet to apply it in practice.

To recap: Of the five options, the second and third are on by default and should be left that way, the fifth is of questionable merit, and the first and fourth are absolutely essential. In fact, you'll use the first and fourth options to solve a few problems that arise in this very exercise.

1. ***Open the image you saved in the last exercise.*** If the file is already open, fine. If not, open the file you saved in Step 14 of the preceding exercise, which is titled *Happy Juice edit-3.psd* in the *Lesson 11* folder inside *Lesson Files-PsCS3 1on1*. The composition should look like the one pictured in Figure 11-34 back on page 425.

 From a marketing perspective, our advertisement's biggest shortcoming is that Max holds an empty glass. The beverage may be near completion, but it should never actually be empty. Luckily, I have a layer of juice ready and waiting.

2. ***Select and show the Contents layer.*** Click the empty box to the left of the **Contents** layer to make it visible, and then click the layer to make it active. Orange with blurry edges, the layer should align precisely with Max's juice glass, as in Figure 11-35.

Figure 11-35.

3. *Change the blend mode to Overlay.* Choose **Overlay** from the blend mode pop-up menu at the top of the **Layers** palette or press Shift+Alt+O (Shift-Option-O on the Mac). This merges the juice and background so the former appears to be inside the glass. But I also want to add a bit of radioactive froth at the top. So it's time to add another layer effect.

4. *Choose the Gradient Overlay effect.* Click the *fx* icon at the bottom of the Layers palette and choose **Gradient Overlay** to see Photoshop's small array of gradient selection functions.

5. *Adjust the Gradient Overlay settings.* The default Gradient Overlay settings are mostly fine. The Gradient strip should show black to white, Reverse is off, Style is Linear, and the Angle is 90 degrees. Here's what you need to change:

Figure 11-36.

- Change the **Blend Mode** setting to **Screen**. This drops out the blacks and leaves only the whites.

- Reduce the **Scale** value to 50 percent to decrease the size of the gradient by half.

- Move your cursor into the image window to get the move tool. Then drag the gradient upward about the width of one of Max's fingers, as demonstrated in Figure 11-36. This wonderful technique lets you position a gradient inside the image window while the Layer Style dialog box is open.

At this point, the white froth at the top of the drink is the proper size and it fades nicely. But it doesn't look right at all. There's no real integration between froth and drink, and no matter how much I experiment with the opacity or blend mode, the solution eludes me. Good thing I have my check boxes.

6. *Switch to the Blending Options.* Click **Blending Options** in the upper-left corner of the **Layer Style** dialog box. This displays the various knockout and luminance blending features you learned about in Lesson 9, as well as the strange but cool check boxes that are the subject of this exercise.

7. **Turn on Blend Interior Effects as Group.**
The moment you do, Photoshop blends
the gradient froth into the glass and bever-
age, as in Figure 11-37. It's as if the white
and orange of the Contents layer were
merged before mixing the Contents and
Spokesboy layers using the Overlay blend
mode. More to the point, it looks great.

8. **Click the OK button.** Goodbye Layer Style
dialog box, hello incandescent Happy
Juice. Yum yum.

The Blend Interior Effects as Group check
box is an essential tool for integrating a layer
effect into the surrounding image. But you can
also use it to hide portions of a layer effect, as
you'll see in the following steps.

Figure 11-37.

9. **Select and show my signature.** Click the
Signature layer and turn on its 👁 to acti-
vate and display a scanned version of my
signature (unsuited for checks and credit
card receipts!) in the lower-left corner of
the image. As seen in Figure 11-38, the
signature is black against a white back-
ground, typical of scanned art and logos.
Alas, you can't scan a signature or logo
set against transparency, but you can do
the next best thing: With the help of a
blend mode, you can drop out the white
background and leave only the black.

10. **Change the blend mode to Multiply.**
Choose **Multiply** from the blend mode
pop-up menu at the top of the **Layers** pal-
ette or press Shift+Alt+M (or Shift-Option-
M). The Multiply mode treats white as
neutral, meaning that all traces of white
drop away entirely, as in Figure 11-39 on
the next page.

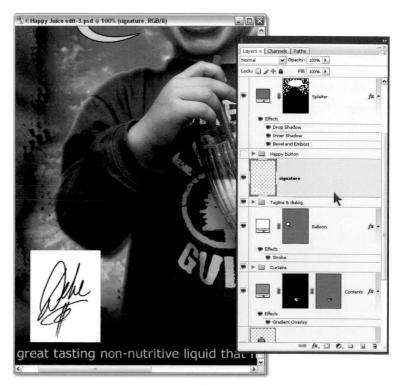

Figure 11-38.

Figure 11-39.

Figure 11-40.

Figure 11-41.

Now let's say you want to color the signature so that it appears red, more or less matching the fabric border. The problem is, how do you colorize the black script without upsetting the white? With the help of a Color Overlay effect, that's how.

11. **Apply a Color Overlay effect.** Click the *fx* icon at the bottom of the Layers palette to display the list of layer effects, and then choose **Color Overlay**.

- Leave the color swatch set to red. Also leave the **Opacity** at 100 percent.

- Change the **Blend Mode** to **Lighten**.

By all accounts, the Lighten mode should color the black script and leave the white unchanged. After all, when using Lighten, the lightest color wins, end of story. And yet, as Figure 11-40 shows, the white area is every bit as red as the black signature. The reason is that, by default, Photoshop permits an interior effect to mix with all layers in back of it. In other words, Photoshop blends the Signature layer with those behind it and *then* heaps on the Color Overlay effect. So the Lighten mode never sees white; it sees and lightens the composite colors.

12. **Turn on Blend Interior Effects as Group.** Click **Blending Options** in the upper-left corner of the **Layer Style** dialog box. Then turn on **Blend Interior Effects as Group**. Now the order changes. First, Photoshop mixes the Color Overlay effect with the blacks and whites of the Signature layer. Then it mixes the results with the underlying layers. Click the **OK** button to achieve the effect shown in Figure 11-41.

PEARL OF WISDOM

Now you might say, if Blend Interior Effects as Group is so great, why isn't it on by default? For the simple reason that most of the time, you don't want it on. For example, when the option is off, the Fill value in the Layers palette (as well as Fill Opacity in the Layer Style dialog box) changes the opacity of a layer but leaves the effects alone. Turn the check box on, and the Fill value changes the active layer and its effects as one, just like the Opacity value. So except in special cases, it's best to leave Blend Interior Effects as Group turned off.

13. ***Turn on and twirl open the Happy Button group.*** Turn on the 👁 for the **Happy Button** folder to make the layers inside the set visible, as in Figure 11-42. Then click the ▶ to the left of the folder to reveal its contents, the 0% Juice text layer and the green Circle shape layer. Select and twirl open the **Circle** layer and you'll see that it includes a sharp Outer Glow.

14. ***Add a layer mask to the Circle layer.*** Click the gray vector mask thumbnail for the **Circle** layer to hide the path outline (if it's visible). Then click the ▢ icon at the bottom of the **Layers** palette. Photoshop adds a white thumbnail to the layer.

15. ***Load the selection outline for the Spokesboy layer.*** Press Ctrl (⌘ on the Mac) and click the thumbnail of the **Spokesboy** layer in the Layers palette. The result is a series of marching ants that exactly trace the boundaries of Max.

16. ***Fill the selection with black.*** Press the D key to establish the default masking colors, white for the foreground and black for the background. Take a moment to make sure the layer mask for the Circle layer is active. (The white thumbnail should have double lines at all four corners.) Then press Ctrl+Backspace (⌘-Delete on the Mac) to fill the selection with black.

Figure 11-42.

Figure 11-43.

Figure 11-44.

17. **Dismiss the selection.** Press Ctrl+D (or ⌘-D) to make the selection outline go away. This not only clips the green circle but also forces Photoshop to trace the perimeter of the clipped circle, as in Figure 11-44. You may also notice a couple of white dots on Max's shoulder, the result of Outer Glow tracing stray pixels in the mask. That's unacceptable; let's fix it.

18. **Open the Blending Options.** Right-click the green thumbnail on the left side of the **Circle** layer and choose **Blending Options** from the shortcut menu. (If you have a one-button mouse or trackpad on the Mac, press the Control key and click to see the shortcut menu.) Up comes the **Layer Style** dialog box.

19. **Turn on Layer Mask Hides Effects.** Checking this option tells Photoshop to clip Outer Glow and shape alike using the layer mask. The result is a clean edge, free of extra strokes, as in the sublime Figure 11-45. Click the **OK** button to accept your change.

20. **Save your composition.** And for once, you can call it anything you want and toss it inside any old folder, because we're finished with this file. Figure 11-46 on the facing page shows the final result (with all groups and effects in the Layers palette twirled closed, just to be tidy).

Figure 11-45.

Figure 11-46.

Creating and Modifying Adjustment Layers

We now move from layer effects to the realm of adjustment layers. These insanely practical functions permit you to apply most of the commands in the Image→Adjustments submenu. For example, of the commands we discussed in Lessons 2 and 3, the only ones *not* implemented as adjustment layers are Shadow/Highlight and Variations (both of which are now available as smart filters). What's more, an adjustment layer works just like its command counterpart. The Levels adjustment layer shows you the same dialog box—complete with Input Levels values and histogram—as does Image→Adjustments→Levels. However, unlike commands, an adjustment layer affects all layers below it and remains editable far into the future.

Adjustment layers are so flexible, in fact, that many designers use them to correct flat photographs. If you later decide to tweak the colors in an image equipped with an adjustment layer to meet the

demands of a different screen or printing environment—not to mention the whims of an art director or a photographer—you always have your original photograph on hand, with the last-applied color correction ready and waiting in the wings.

Because adjustment layers are fully functioning layers, you can mix and match them, as well as combine them with blend modes, layer masks, shapes, layer effects, and even clipping masks. Simply put, they permit you to venture into creative territories that static commands simply can't accommodate.

In this exercise, your assignment is to build a book cover for a dime-store novel using a couple of digital photos and a petroglyph silhouette that I stored in an alpha channel. The publisher has asked for something "dark, brooding, and suspenseful." But because this is all the instruction you've received, it seems imprudent to make any permanent changes to the images. So you wisely decide to do everything with adjustment layers.

Figure 11-47.

1. **Open a layered composition.** This time we will work from a single file, *End of Road.psd*, which you'll find in the *Lesson 11* folder inside *Lesson Files-PsCS3 1on1*. (As always, if Photoshop asks to update the text layers, click the **Update** button.) Pictured in Figure 11-47, this composition contains a text layer sandwiched between two low-quality image layers, both shot more than a decade ago using a 1.5-megapixel Kodak DC265. The image of my shadow is set to the Multiply blend mode, thus burning into the orange type and drive-in movie screen.

2. **Add an Invert adjustment layer.** What's the easiest, most brain-dead way to make an image look scary? Invert it, of course. And that's exactly what we're going to do with the drive-in screen. Check that the Background

layer is active in the **Layers** palette. Click the half-black, half-white ◐ icon at the bottom of the palette to display a menu of fifteen specialty layers (three fills followed by twelve adjustments). Then choose **Invert**, as shown in Figure 11-48. Photoshop adds a layer called Invert 1 that creates a negative version of the drive-in movie screen behind it.

3. *Change the blend mode to Luminosity.* Currently, the Invert 1 layer reverses both the luminosity values and the colors in the drive-in image. This means that the blue of the sky turns to orange, and the orange of the ground turns to blue. Fine, but suppose you don't want that; suppose you want to invert only the luminosity values. Then choose **Luminosity** from the blend mode pop-up menu at the top of the Layers palette, or press Shift+Alt+Y (Shift-Option-Y on the Mac). Photoshop restores the blue sky and orange ground, as in Figure 11-49.

Figure 11-48.

Inverted background image Inversion set to Luminosity mode

Figure 11-49.

4. *Add a Levels adjustment layer.* Inverting the background made the image overly dark, and the best way to lighten it is with the Levels command. But you can't apply Levels to the Invert 1 layer, and if you lighten the Background layer directly, you'll darken the inverted image because the luminosity values are

Figure 11-50.

Figure 11-51.

reversed. Solution: Click the ⊘ icon at the bottom of the Layers palette and choose **Levels**. Once inside the **Levels** dialog box, advance to the second **Input Levels** value and change the gamma to 2.00, as demonstrated in Figure 11-50. Then click the **OK** button to apply the adjustment.

5. ***Turn on the Text Elements layer group.*** In the **Layers** palette, click the empty box to the left of the **Text Elements** folder to show the ⊙ icon and display text layers at the top and bottom of the cover. The publisher provided these layers with the directive, "Keep the quote and author's name in blue, and make them leap off the page." But because blue is one of the most pervasive colors in the image, the text gets a little lost, as witnessed in Figure 11-51. Obviously, another adjustment layer is warranted.

PEARL OF ⬤ WISDOM

Incidentally, all the blue text is housed on editable text layers. So you might wonder how I applied those round corners to the quote and author letters. Answer: I added an Inner Glow effect to each layer and lowered the Fill Opacity value to 0 percent. Want to know more? Just twirl open the **Text Elements** group and its layers and then double-click the **Inner Glow** items. Just like that, you'll see the exact settings I used. Yet another marvel of parametric effects—you can always conjure up what you've done as well as check out other people's work.

6. ***Add a Hue/Saturation adjustment layer.*** Click the **Levels 1** layer in the Layers palette to specify where you want to insert the next layer. Then press the Alt key (or Option key) as you choose **Hue/Saturation** from the ⊘ icon at the bottom of the palette. This allows you to name the new layer as you create it. Call it "Color Spin" and click the **OK** button to display the **Hue/Saturation** dialog box.

7. **Rotate the hues 180 degrees.** Change the **Hue** value to 180 degrees to invert all the colors in the image. Then boost the **Saturation** value to +50 percent and reduce the **Lightness** value to –50 percent. Click **OK** to accept the changes, pictured in Figure 11-52 below.

At this point, you might quite naturally wonder why in the world we just inverted the colors when we were so careful *not* to invert the colors in Step 3. The reason is that for the moment, all we're concerned about is making the blue text "leap off the page." After that's accomplished, we'll restore the appearance of the central portion of the image using a layer mask (see Step 9). But first . . .

8. **Change the blend mode to Multiply.** The background art remains too light to set off the blue text. To make it darker, choose **Multiply** from the blend mode pop-up menu at the top of the **Layers** palette, or press the shortcut Shift+Alt+M (Shift-Option-M on the Mac).

9. **Click the gradient tool in the toolbox.** If you look at the Layers palette, you'll see that each one of the three adjustment layers that you've created so far includes a white thumbnail to the right of it. This white thumbnail is a potential layer mask. Painting with black in the mask will hide that portion of the color adjustment. We'll paint inside the Color Spin layer mask using the gradient tool. Click the gradient tool's icon or press the G key to select it.

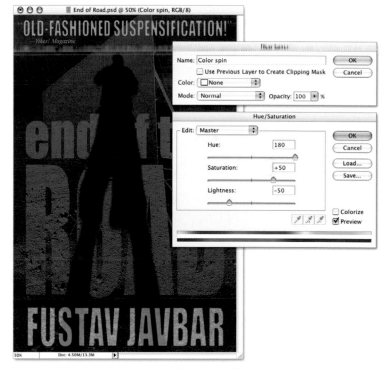

Figure 11-52.

10. ***Paint gradients at the top and bottom of the image.*** The aim is to relegate the effects of the Color Spin layer to the areas immediately behind the blue text at the top and the bottom of the image. That means painting the central portion of the layer mask black. It's a tricky proposition, so I'll break it into pieces:

- Press the D key to make the foreground color white and the background color black.

- Right-click the gradient tool icon on the far left side of the options bar and choose the **Reset Tool** command to restore the tool's default settings.

- Press Shift+⌐ (Shift+comma) to set the gradient tool to draw gradients from the foreground color to the background color, or white to black. (It might be set this way already, but it's a good precaution to make sure.)

- Press the Shift key and drag from directly below the top line of text to the chest in the shadow, as indicated by the yellow arrow at the top of Figure 11-53. This should lighten all but the topmost portion of the image.

- Now to reinstate some darkness at the bottom of the image. Press ⌐ (the period key) to change the style of gradient to Foreground-to-Transparent, so it starts white and fades to nothingness.

- In the image window, Shift-drag from directly above the author name (the esteemed Fustav Javbar) to about an inch or so up, as indicated by the orange arrow at the bottom of Figure 11-53. Both the top and bottom of the image should now appear dark.

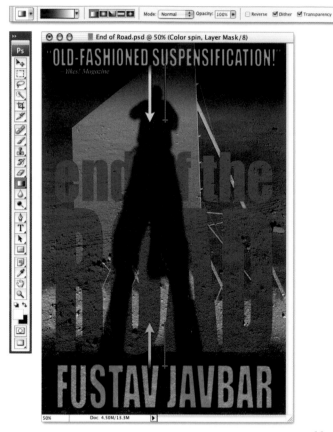

Figure 11-53.

11. ***Duplicate the End of the Road layer.*** Now we're ready to address the book's title. The publisher has informed us that as long as we make Fustav Javbar's name prominent, we can do anything we want with the title. So let's have some fun. For starters, create a backup copy of the title in case you need to revisit it later. Here's how:

- Click the **End of the Road** text layer in the Layers palette to make it active.

- Press Ctrl+J (⌘-J) to clone the text to a new layer.

- Click the **End of the Road** layer again.

- Press Ctrl+Shift+⬚ (or ⌘-Shift-⬚) to pop the layer to the top of the stack.

- Click the 👁 icon in front of the **End of the Road** layer to hide the layer.

- Click **End of the Road Copy** (the duplicate layer) to make it active. You'll be working on this layer.

- Double-click the layer name and rename it "Title Invert." The resulting Layers palette appears in Figure 11-54.

If this all seems like a lot of busy work, take heart: It prepares you for the upcoming steps and gets a few important housekeeping chores out of the way.

Figure 11-54.

12. **Convert the character outlines to shapes.** Right-click the **Title Invert** layer in the Layers palette and choose the **Convert to Shape** command. Photoshop traces the letters with path outlines, indicating that you now have a shape layer. An orange color swatch and a gray vector mask thumbnail also appear inside the Layers palette. The orange swatch shows that this is a solid color layer, which is a kind of specialty fill layer. And as it just so happens, you can convert a fill layer to an adjustment layer as easily as choosing a command.

13. **Replace the orange fill with an Invert layer.** Choose **Layer→ Change Layer Content→Invert**. The orange color of the letters is replaced with an Invert adjustment layer, which affects all layers below it. Shown in Figure 11-55 on the next page, the effect is high in drama but low in legibility, particularly if we were to turn off the path outlines (which, after all, will not appear in print). One solution is to increase the contrast of the inversion effect, as in the next step.

Figure 11-55.

14. ***Add a Threshold adjustment layer.*** Press the Alt (or Option) key and choose **Threshold** from the ◐ icon at the bottom of the Layers palette. (On the PC, you have to drag from the ◐ icon to choose the command; the Alt key prevents you from clicking.) This displays the **New Layer** dialog box. Enter the name "Black or White" because the Threshold command changes all colors to either black or white. Then turn on the **Use Previous Layer to Create Clipping Mask** check box (see Figure 11-56) to clip the new adjustment layer inside the letters of the Title Invert shape layer.

Figure 11-56.

15. ***Accept the default Threshold value.*** Click the **OK** button to display the **Threshold** dialog box. Shown in Figure 11-57, this dialog box changes all luminosity values darker than the Threshold Level to black and all values lighter to white. A **Threshold Level** of 128 splits the colors right down the middle. Click **OK** to apply this setting.

Figure 11-57.

Notice that rather than making the text layer black and white, the Threshold adjustment seems to have made it black and gravelly. The text is actually black and white; the Shadow layer above it is responsible for burning the gravel into the white areas.

16. ***Add a Color Overlay layer effect.*** Let's say you want the black portions of the text to appear in color. The easiest way to do this is to apply a Color Overlay effect. Make sure the **Black or White** layer is active. Then click the *fx* icon at the bottom of the **Layers** palette and choose **Color Overlay** to display the **Layer Style** dialog box.

17. ***Change the Color Overlay settings.*** By default, Photoshop fills the text with red. It's an interesting effect, but it's not what I want. Set the color and the blend mode as follows:

- Click in the red color swatch to display the **Color Picker** dialog box. Change the **S** value to 30 percent for a pale pink and then click the **OK** button.

- Back inside the **Layer Style** dialog box, set the **Blend Mode** option to **Lighten** (so the pink fills just the black areas). Leave the **Opacity** set to 100 percent. Click the **OK** button to accept your changes, shown in Figure 11-58.

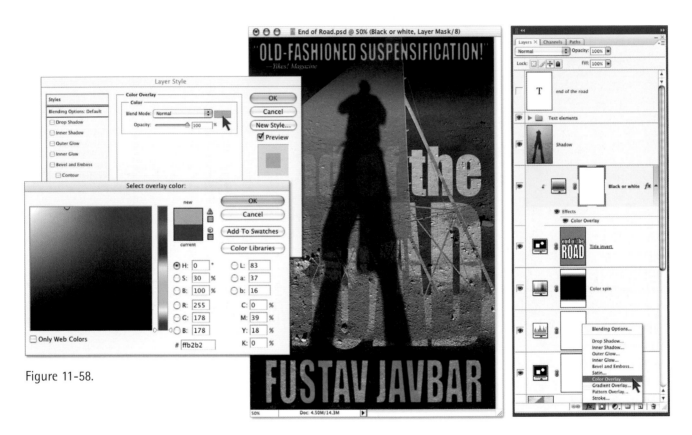

Figure 11-58.

18. ***Switch back to the Title Invert layer.*** The text could use a little extra definition in the form of a drop shadow. However, you can't apply the drop shadow to the Threshold layer (Black or White) because it has no edge; the layer is as big as the entire canvas. Instead, click the gray vector mask for the **Title Invert** layer to activate that layer and hide its path outlines.

19. ***Add a Drop Shadow layer effect.*** Click the *fx* icon at the bottom of the **Layers** palette and choose **Drop Shadow** to display the **Layer Style** dialog box. Then enter these settings:

- The **Blend Mode** and color are fine as is (**Multiply** and black, respectively).

- Change the **Opacity** value to 100 percent.

- Change the **Angle** value to –90 degrees so that the sun is shining from below and the shadow is straight up.

- Change both the **Distance** and **Size** values to 10 pixels.

- Click the **OK** button to accept your spine-tingling drop shadow, shown in Figure 11-59.

PEARL OF WISDOM

If you ask me, the title looks really cool, especially if you're right on top of it. It's the kind of cover that looks great when you hold it in your hands. But most people will never get that close to it. They'll see it on a crowded Web page or in a bookstore window across the aisle at an airport. And from any distance, this title is illegible. Although the original orange type was less interesting, even ugly, you have to admit in its defense it was legible. A compromise seems to be in order.

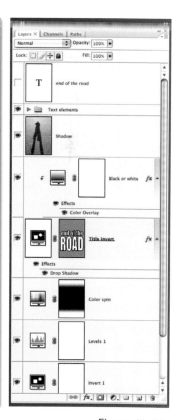

Figure 11-59.

20. ***Turn on the top layer and set the blend mode to Screen.*** Click the **End of the Road** layer at the top of the **Layers** palette to make it active, and then turn on its 👁. Then choose **Screen** from the blend mode pop-up menu, or press Shift+Alt+S (or Shift-Option-S on the Mac). In this one simple operation, we manage to maintain the interesting texture and detail from the Title Invert layer while increasing its legibility several times over, as witnessed in Figure 11-60.

 The next and final task is to add a ghost to the book cover. The publisher has provided us with a ghost in the form of an alpha channel. (For what it's worth, it actually hails from a several hundred-year-old Native American petroglyph.) We'll use this alpha channel to create one last adjustment layer.

21. ***Load the Petroglyph channel as a selection outline.*** Go to the **Channels** palette. There you'll see an alpha channel called Petroglyph. Press the Ctrl key (⌘ on the Mac) and click the **Petroglyph** item (see Figure 11-61 on the facing page) to convert the channel to a ghostly selection outline.

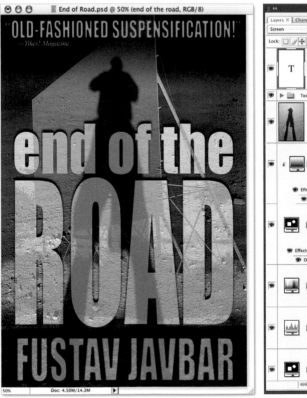
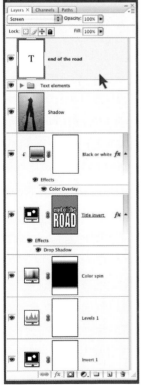

Figure 11-60.

22. ***Select the Color Spin layer in the Layers palette.*** The ghost needs to sit below the various title layers and above all but the Title Invert adjustment layer, given that those adjustment layers would otherwise modify the ghost. In other words, it belongs in front of the Color Spin layer. So return to the **Layers** palette and click the **Color Spin** layer to make it active.

23. ***Add a Hue/Saturation adjustment layer.*** To name the layer as you make it, press the Alt (or Option) key as you choose **Hue/Saturation** from the ⬤ icon at the bottom of the Layers palette. In the **New Layer** dialog box, name the layer "Blue Man" and click **OK**. Then adjust the settings in the **Hue/Saturation** dialog box as outlined below and shown in Figure 11-62:

 - Turn on the **Colorize** check box. This permits you to apply one uniform color to the layers below.

 - Change the **Hue** value to 220 degrees, a cobalt blue that matches the color of the text layers.

 - Increase the **Saturation** to 100 percent.

 - Raise the **Lightness** value to 80 percent. Normally, I recommend against using this option because it's such an indelicate tool. But in this case, we're using Lightness not to correct colors but to create an effect. And in that regard, it works just dandy.

 - Click the **OK** button to apply your settings.

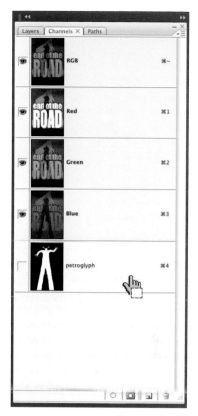

Figure 11-61.

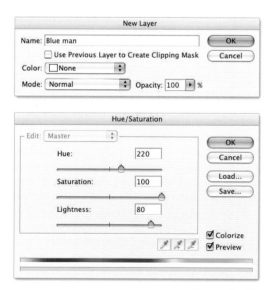

Figure 11-62.

24. **Save your composition.** Choose **File→Save As** and name the file "Bestseller in Blue.psd." Figure 11-63 shows the finished composition. Notice that the Hue/Saturation adjustment layer exactly filled the confines of the Petroglyph selection outline. Photoshop managed this by converting the selection into a layer mask, as you can see in the Layers palette. And in fact, this is the way Photoshop always works. If a selection outline is present when you create a new adjustment layer, Photoshop converts the selection to a layer mask.

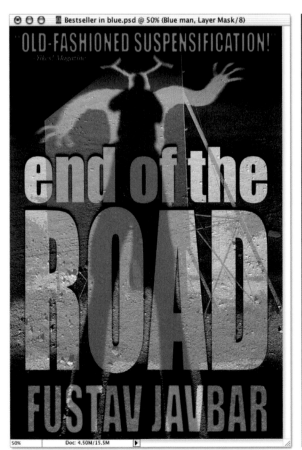
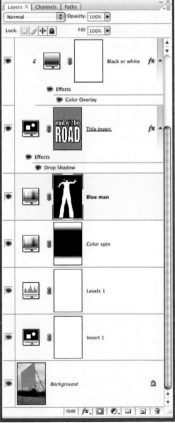

Figure 11-63.

Working with Smart Objects

One of the main frustrations when working in a pixel-based image editor is, well, the pixels. In a vector-based program such as Illustrator or the program in which this document was laid out, InDesign, edits are nondestructive, meaning that no matter how much you reshape or transform a work of vector art, it remains laser sharp. But try the same thing in Photoshop—for instance, shrink a layer, rotate it, and then scale it way up—and you're faced with a soft, blocky mess. And, excepting Undo and history, a pixel that goes bad stays bad.

With smart objects, Photoshop offers a kind of pixel-protection plan. Think of a smart object as a safe. You can put an image or a vector illustration inside this safe, and no matter how much you scale, rotate, warp, or filter it, Photoshop always references the original art and re-renders it to achieve the best possible transformation. Meanwhile, you can duplicate a smart object to create one or more *instances*. Change the original and all instances update in kind. And finally, you can place an Illustrator or a Camera Raw document and retain a dynamic link between the resulting layer and the original document data. (Photoshop embeds the original data inside the layered composition, so there's no chance of losing a linked file on disk.) Admittedly, smart objects suffer the occasional limitations. If you want to paint or edit a smart object, you have to open it in a separate window, making it difficult to determine the context. Even so, they're an astonishingly powerful and welcome addition to the program.

If all this sounds a bit abstract, no fear. Over the course of the next eight pages, abstraction will transform into brass-tacks practicality. In the next steps, you'll use smart objects to build a flexible project that responds easily and quickly to your edits. It's an exercise in workflow enhancement, and a fun one at that.

1. *Open an image.* Open the layered composition *Glistenex ad.psd*, included in the *Lesson 11* folder inside *Lesson Files-PsCS3 1on1*. Pictured in Figure 11-64, this document contains the beginnings of an advertisement for a new antibacterial soap, which features an image from iStockphoto's Joshua Blake. In this exercise, we'll simulate the all-too-common ritual of designing an image for a client only to have it returned with a list of

Figure 11-64.

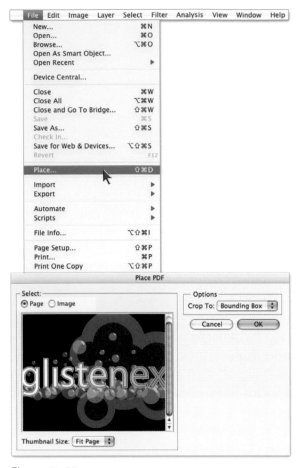

Figure 11-65.

Figure 11-66.

demands and corrections. Thankfully, we will have assembled the composition using smart objects, so our response will be a calm and cordial "No problem, boss."

2. **Place an Illustrator document.** To import a file as a smart object, choose **File→Place**. Then locate and select the vector-based Illustrator graphic *Glistenex logo.ai*, which you'll find in the *Lesson 11* folder inside *Lesson Files-PsCS3 1on1*.

Click the **Place** button, and you'll see a dialog box titled **Place PDF** (for *Portable Document Format*) as shown in Figure 11-65. (Note that I set the Thumbnail Size option to Fit Page and added a black background behind the preview to make the artwork show up well in print.) By default, Illustrator saves its native AI files with PDF encoding, which Photoshop needs to process the drawing as a smart object. Besides alluding to that fact, this dialog box is not much use to us. It confirms cropping and lets you select a specific page inside a multi-page PDF document. But the cropping is fine and this is a single-page document, so there's nothing for you to do besides click **OK**.

Another way to create a smart object from Adobe Illustrator is to use the clipboard. Select the paths you want to bring over, and press Ctrl+C (⌘-C on the Mac) to copy the artwork. Then switch to Photoshop and, with a document open, press Ctrl+V (⌘-V) to paste the artwork. In the ensuing dialog box, select Smart Object from the Paste As options and click OK.

3. **Scale and position the logo art.** Photoshop automatically generates a smart object and centers it in your composition, as shown in Figure 11-66. Surrounding the illustration, you'll see a bounding box with a giant X over it, which permits you to position and transform the illustration.

Just so we're in sync, I'd like you to manually enter the following values into the options bar, as I have in Figure 11-67. I found that I had the best luck when I entered the values slowly, waiting a beat after every digit for Photoshop to catch up. (It's irritating, but what is one to do?)

- Click the 🔗 icon to constrain the proportions of the logo, and then enter 50 percent for either the **W** or **H** scale value.

- Change the **X** value to 1250 pixels.

- Change the **Y** value to 970 pixels.

Figure 11-67.

Press the Enter or Return key twice to accept your changes and apply the transformation. Photoshop creates a new layer, names it automatically, and assigns its thumbnail a 🔳 icon to distinguish it from other, less smart layers.

4. *Add a drop shadow.* Smart objects support the parametric amenities available to other layers, including transparency, blend modes, and layer styles. This is fairly amazing, given that our Illustrator logo amounts to a foreign object, the appearance of which Photoshop has to calculate on-the-fly. To see for yourself, click the *fx* icon at the bottom of the **Layers** palette and choose **Drop Shadow**. Accept the default settings, which are:

- A color of black and a **Blend Mode** of **Multiply**.

- An **Opacity** value of 75 percent.

- An **Angle** of 138 degrees (already established as the global light direction).

- **Distance** and **Size** values of 5 pixels.

Click the **OK** button to create a slight drop shadow. The foreign object fits right in.

5. *Place a Photoshop image.* Choose **File**→**Place** to import another file as a smart object. This time, instead of using vectors, we'll place a pixel-based cartoon by artist Jason Woliner (who now directs MTV's hilarious Thursday-night skit comedy *Human Giant*). Select the file named *Germ.psd* in the *Lesson 11* folder and click the **Place** button. The germ enters our world big and scary, as in Figure 11-68.

Figure 11-68.

Figure 11-69.

Figure 11-70.

6. **Scale and position the germ cartoon.** The germ looks frightening, but he's really too big to hurt anyone. Once again, we'll scale and position the layer from the options bar. Click the ⚭ icon to constrain the proportions and enter a **W** value of 25 percent. Change the **X** value to 250 pixels and **Y** to 350 pixels. Then press Enter or Return twice to complete the transformation. Again, Photoshop names the layer automatically and marks it as a smart object.

7. **Clone the Germ layer.** Now the germ is the right size, but there's just one of him. He needs some pals to form a proper infection. Good thing he's a smart object, the only function in Photoshop that can give birth to an army of clones that all reference a single source image. To clone the little fellow, press the Alt (or Option) key and drag the **Germ** layer onto the ⬓ icon at the bottom of the **Layers** palette, as in Figure 11-69. Or press Ctrl+Alt+J (⌘-Option-J on the Mac). Name the duplicate smart object "Germ 2" and click **OK**.

8. **Transform the Germ 2 layer.** With the **Germ 2** layer selected in the Layers palette, press Ctrl+T (or ⌘-T). Notice that the options bar remembers the last values we entered, specifically, the 25 percent scaling. This may seem like a small thing, but where Photoshop is concerned, it borders on miraculous. It means that Photoshop knows this image is set to 25 percent of its full size. Change the **W** value to −35 percent and the **H** value to 35 percent. This enlarges the image and flips it horizontally. And because Photoshop is referencing the original artwork, the transformation is entirely nondestructive. Change the **X** and **Y** values to 1300 and 510 pixels, respectively, to move the germ to the other side of the fellow's head. Then press Enter or Return twice to accept the results, which appear in Figure 11-70.

9. **Clone the Germ layer again.** Click the original **Germ** layer to select it. Then press Ctrl+Alt (⌘-Option on the Mac) and drag the germ down and to the left, to a comfortable position above the fellow's hand. This clones the germ to a new location. Now double-click the new layer name in the Layers palette and call it "Germ 3." (There's no rule that says you have to clone from the first smart object; we did it just for placement.)

10. **Warp the Germ 3 layer.** We don't want our three germs to look identical—they're all individual infectors, after all—so let's use the Warp command to give the third germ some personality. Choose **Edit→Transform→Warp** or press my dekeKeys shortcut, Ctrl+Shift+R (⌘-Shift-R), to surround the newest germ with a mesh. I walked you through how to use this command a couple of lessons ago, so now's your chance to cut loose. Personally, I found that pushing the middle of the germ's face up and to the right (see Figure 11-71) enhanced the 3D feel of the character. Don't go too nuts, though, or you run the risk of making him look jagged. When you achieve an effect you like, press Enter or Return to accept the results.

Figure 11-71.

Change your mind after you press the Enter key? No problem. The germ is a smart object, so you can always revisit the point where you last left off. Just choose the Warp command again to redisplay the warp mesh, with all lines and handles intact. To remove the warp entirely, choose None from the Warp pop-up menu in the options bar.

And there you have it—a compelling, expertly assembled advertisement. Or so one would think. Naturally, the suits representing the soap company are demanding some crucial changes: For one, they think the logo is way too small. And the germs aren't unappealing enough. (One guy called them "cuddly"!) And they can't be blue—that's the logo color. They have to be green. These eleventh-hour fixes might be cause for alarm for someone who used a traditional Photoshop composition. But not for us. Let's see how smart objects save the day.

11. **Resize the logo.** Go to the Layers palette and click the vector-based **Glistenex Logo** layer. Then press Ctrl+T (⌘-T) to enter the free transform mode and do the following:

 - In the options bar, change the transformation origin to the bottom-right corner (▦, as in Figure 11-72).

 - Turn on the 🔗 icon to lock the proportions and increase the **W** value to 65 percent.

 - Press the Enter or Return key twice to accept your changes.

Figure 11-72.

Figure 11-73.

Figure 11-74.

Figure 11-75.

Back in the days before smart objects, one transformation would have been heaped upon the other, and the quality of the logo would have suffered considerably. But thanks to smart objects, Photoshop references the original Illustrator graphic and produces another razor-sharp transformation, as witnessed in Figure 11-73. But impressive as this new efficiency is, we've only begun to reap the benefits of working with smart objects. Let's keep reapin'.

12. *Edit one of the Germ smart objects.* To make the germs look less cuddly, we'll need to access the original embedded contents of our linked Germ layers. Double-click the thumbnail for any one of the three **Germ** layers. Photoshop greets you with the alert message shown in Figure 11-74.

13. *Confirm the warning.* Photoshop lets you modify a pixel-based smart object by opening a temporary file that's extracted from the layered composition. Saving this file updates the composition. Why the warning? Because if you save the temporary file to a new location or under a different name, the whole process will fall apart. Now that you know, turn on the **Don't show again** check box and click **OK**. The germ appears in a new window, as in Figure 11-75.

14. *Liquify the germ.* In this window, all the limitations of smart objects drop away, permitting us to manipulate the germ just like any other layer. So we might as well push some pixels around. Choose **Filter→Liquify** or press Ctrl+Shift+X (⌘-Shift-X on the Mac) to bring up the massive **Liquify** dialog box.

Using the techniques I discussed in the "Applying Free-Form Distortions" exercise (Lesson 8, page 293), liquify (sic) the germ (sick) to your liking. Remember, no cuddly. For my part, I used the pucker tool to decrease the size of the eyes and the bloat tool to thicken the eyebrows. Then I used the warp tool to make the eyes angrier and add a snarl to the mouth, as in Figure 11-76.

Have fun with it. And remember, the angrier the bet-
ter. If you want to exactly match my outrageously vi-
cious germ, click the **Load Mesh** button and select the
Angry germ.msh file, which I've placed in the *Lesson 11* folder.
When you get an effect you like, click the **OK** button to apply it.

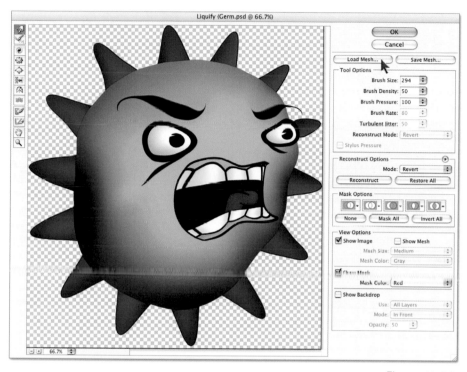

Figure 11-76.

15. *Display the Hue/Saturation dialog box.* Now to make the
 angry germ green. Choose the classic color command **Image→**
 Adjustments→Hue/Saturation or press Ctrl+U (⌘-U).

16. *Replace the cyans with green.* We don't want to change the
 red of the tongue and the pink of the gums. So relegate your
 edits to the germ's flesh by choosing **Cyans** from the **Edit** pop-
 up menu. Enter a value of –50 into the **Hue** option box, which
 pushes the light blues into a more germy-looking green territory.
 When your settings match those in Figure 11-77, click **OK**.

17. *Save your changes.* Choose **File→Save** or press Ctrl+S (⌘-S) to
 save your changes to the smart object inside the layered com-
 position. Then close the window that contains the mean green
 germ by clicking the ⊠ box in the title bar (⊙ on the Mac) or by
 pressing Ctrl+W (⌘-W). A moment later, Photoshop updates
 the three germs—scaled, flipped, and warped to our specifica-
 tions—and all without losing a smidgen of quality. Nice work!
 You finished the revision with time to spare.

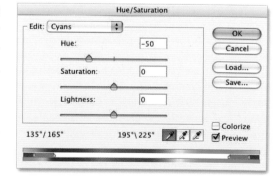

Figure 11-77.

18. **Turn on the Extras group.** Back inside the **Layers** palette, click the empty box to the left of the group labeled **Extras** to turn on its 👁 icon and reveal a few additional lines of text that round out our advertisement, all visible in Figure 11-78.

Figure 11-78.

19. **Export the contents of the Germ smart object.** As I mentioned earlier, Photoshop maintains no link to the original *Germ.psd* file on disk. So if you were to alter the original file after placing it as a smart object, none of your changes would affect the ad. But what if the clients are so happy with the modified germs that they want a version to use in other print material? The answer: export the smart object.

Right-click (or Control-click) any one of the **Germ** layers in the Layers palette and choose **Export Contents**. Go ahead and accept the default filename and click **OK**.

I love smart objects. But they come at a price. Adding smart objects to a composition can have the undesirable effect of ballooning the file size and slowing down the program. So while I encourage you to get in the habit of using them, I recommend that you use them judiciously. Remember, be smart.

Nondestructive Smart Filters

Smart filters are the long-awaited means of applying Photoshop's wide-ranging filter effects nondestructively and reversibly. Just as a live adjustment layer allows you to modify color adjustment settings any time you like, a smart object combined with a nondestructive smart filter lets you edit filter settings ad infinitum.

Smart filters are a new by-product of smart objects. As a result, they don't have the same tried-and-true feeling as Photoshop's more mature functions. Their implementation is sometimes strange, so it's a safe bet you may occasionally find yourself scratching your head trying to figure out how to pull off a specific effect. But while smart filters rely on a series of secret handshakes to get them up and running, the return on memorizing those handshakes—in the form of increased creative freedom—is well worth the commitment.

1. ***Open a flat photograph.*** In this exercise, we'll modify a basic (if beautiful) layer-free photograph. Go to the *Lesson 11* folder inside *Lesson Files-PsCS3 1on1* and open the file called *Soft portrait.jpg*. Provided to us by photographer Joey Nelson of iStockphoto, the image appears in Figure 11-79. In part due to the photographic process and in part thanks to my downsampling the photo with the Image Size command, the portrait is slightly soft. I want it to pop, so let's sharpen it with a smart filter.

PEARL OF WISDOM

Because smart filters demand so much planning and jumping through hoops, the exercise keeps it fairly simple, employing smart filters to modify the contours and colors in a flat digital photograph. If you're looking for a glimpse into something more ambitious—such as, say, smart filters integrated into an elaborate layered composition and even applied to live type—check out the appropriately named sidebar "Smart Filters on Steroids," which begins on page 464.

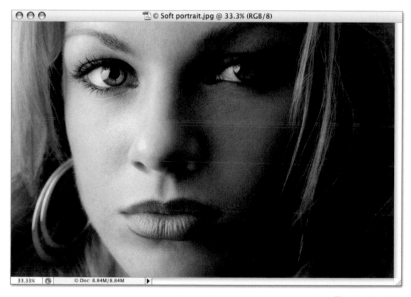

Figure 11-79.

Figure 11-80.

2. *Convert the layer to a smart object.* To add a smart filter, you need to convert the image to a smart object in one of the following ways:

- Choose **Layer→Smart Object→Convert to Smart Object**. If you loaded dekeKeys back in the Preface (see Step 7, page xviii), you can press the shortcut Ctrl+⬚ (or ⌘-⬚).

- Right-click the Background layer in the **Layers** palette and choose **Convert to Smart Object**.

- Try the new way in Photoshop CS3, **Filter→Convert for Smart Filters**. As shown in Figure 11-80, this method displays a message alerting you to the fact that the command makes a smart object. You already knew that, so turn on the **Don't Show Again** check box and click **OK**.

Photoshop names the new layer *Layer 0*. I suggest you rename it "Smart Object" or something equally meaningful.

3. *Apply the first filter, Smart Sharpen.* Let's start the filtering process by firming up the edges using Smart Sharpen (no relation). Choose **Filter→Sharpen→Smart Sharpen** to display the familiar **Smart Sharpen** dialog box and enter these settings:

- Increase the **Amount** to 400 percent.

- Change the **Radius** value to 2.0 pixels.

- Set the **Remove** pop-up menu to **Lens Blur**, generally the best setting for digital photographs like this one.

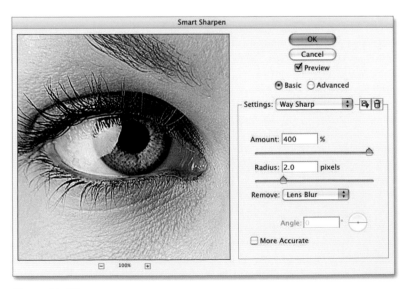

Figure 11-81.

To save your settings for later use, click the 🖫 icon on the right side of the dialog box, assign a name such as "Way Sharp," and click the **OK** button. Then choose **Way Sharp** from the **Settings** pop-up menu to prevent Photoshop from overwriting the default settings.

Click the **OK** button to apply the filter. Photoshop adds not one but two items to the Layers palette. Pictured in Figure 11-82, they include an empty mask with Smart Filters on the right and Smart Sharpen underneath. If you turn off the 👁 icon for either of the new items, you temporarily disable the filter. But be sure to turn all 👁s back on before you proceed to the next step.

4. *Modify the filter settings.* Suppose you decide the image is too sharp. Given that you can see the model's pores, bright edges around her hairs, and even a strong highlight line down the length of her nose, I think it's a wise conclusion. Had you applied a static filter, you'd have to choose Undo and reapply the filter. Instead, double-click the words **Smart Sharpen** in the **Layers** palette and adjust the settings like so:

- Reduce the **Amount** value to 300 percent. It's not a tremendous difference, but it helps.

- The edges are too thin for such a large image. So take the **Radius** value up to 4.0 pixels.

When your settings look like those in Figure 11-83, click the **OK** button. Photoshop automatically updates the Way Sharp settings (if you saved them) as well as the image itself.

Figure 11-82.

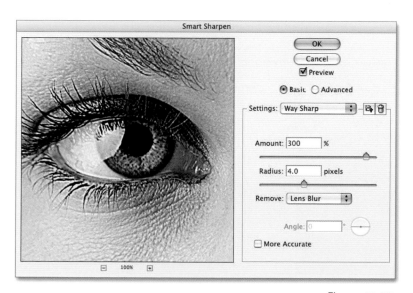

Figure 11-83.

5. **Open the Blending Options dialog box.** Smart filters allow you to change the opacity and blend mode assigned to a filtered image, free of the time constraints associated with Edit→ Fade. To display the blend settings, do one of the following:

- Right-click the **Smart Sharpen** entry and choose **Edit Smart Filter Blending Options**.

- Double-click the tiny sliders (⊼) to the far right of the **Smart Sharpen** item.

Either way, Photoshop displays the **Blending Options** dialog box for the Smart Sharpen effect.

6. **Change how the filtered effect blends with the original.** If you look closely, you may see hot strands of yellow outlining the model's hair, a function of the blue channel drifting slightly out of registration with the other two. To get rid of the hot yellow strands and reduce the effects of the filter overall:

- Change the **Mode** setting to **Luminosity**. As you may recall from Lesson 8 (see Step 11, page 275), this eliminates any color artifacts associated with the sharpening effect.

- The image remains oversharpened, so take the **Opacity** value down to 40 percent.

As Figure 11-84 shows, the result is a more natural blend of sharpness and softness. Click **OK** to accept your changes. If you later change your mind, just double-click the ⊼ icon again

Figure 11-84.

and Photoshop will once again display the Blending Options dialog box, with your last-applied settings intact.

7. ***Apply the second filter, Median.*** Now let's add another effect, this one designed to smooth over some of the choppier details in the image. Choose **Filter→Noise→Median**. Enter a high **Radius** value of 20 pixels and click the **OK** button. Thanks to the changeability of smart filters, you can start with a setting that you know to be too high and dial it back with the Opacity setting or a blend mode.

As you can see in Figure 11-85, the Median entry sits above Smart Sharpen in the Layers palette. Although I question how much sense it makes for smart filters to be listed below the layer that they affect—if anything, the filtered effects are *in front of* the original image—the order of the individual smart filters is logical, with the most recent entry positioned at the top of the list and the oldest at the bottom. Feel free to drag a filter entry up and down the list to change the order in which it is applied.

Figure 11-85.

8. ***Change the blend settings for the Median effect.*** Double-click the ⚏ icon to the right of **Median** in the **Layers** palette to bring up the **Blending Options** dialog box and do like so:

 • Change the **Mode** setting from Normal to **Lighten**, which keeps the Median effect only where its pixels are lighter than they were in the Smart Sharpen version below.

 • Reduce the **Opacity** value to 50 percent to coat the photograph with a light, even haze.

Click the **OK** button to accept your changes. To get a sense for the way in which the Median effect smooths over and lightens the pores and other harsh, dark edges, click the 👁 icon in front of **Median** to turn it off and on. Or check out Figure 11-86, which shows the two versions of the image side-by-side.

Figure 11-86.

Now I want you to add another pass of sharpening to achieve a heightened contrast effect. I could apply the Smart Sharpen command again, but if I did, I'd get another Smart Sharpen entry in the Layers palette, and telling one Smart Sharpen from another could prove confusing. So better to apply a different filter, one just as well suited to enhancing the contrast of an image: High Pass.

9. ***Apply the third filter, High Pass.*** Choose **Filter→Sharpen→ High Pass**. Enter a **Radius** value of 75 pixels and click **OK**. As shown in Figure 11-87 on the facing page, the image looks un-naturally gray; we'll solve that problem shortly.

10. **Move High Pass to the bottom of the stack.** High Pass appears at the top of the filter entries in the Layers palette because it was the last one applied. Under normal conditions, however, you're generally better off enhancing the contrast of an image before sharpening the edge detail and applying softening effects such as Median. To make it the first command in the smart filter pecking order, drag **High Pass** to the bottom of the **Smart Filters** list, as in Figure 11-87. After a moment's delay—as I mentioned earlier, smart filters are computationally intensive (which is to say, slow)—you should see a subtle shift on screen. As minor as this adjustment turns out to be, the simple act of reordering filters was not possible prior to smart filters.

Figure 11-87.

11. **Edit the settings of Median and High Pass.** Given that this is the very first implementation of smart filters in Photoshop, it's not surprising that it has its limitations. One example is the way Photoshop previews smart filter adjustments. Suppose you want to modify the blend settings associated with the Median (yes, again) and High Pass filters:

- Double-click the ⤮ icon for the **Median** entry to display the **Blending Options** dialog box and raise the **Opacity** value to 65 percent. The image window and dialog box preview update to reflect your edit, just as you'd expect them to. Click **OK** to accept the revised setting.

- Now double-click the ⤮ for the **High Pass** item. Photoshop displays a warning, telling you that any filters on top of this

Figure 11-88.

one will not be previewed (see Figure 11-88). You'll be able to preview the results of the filter you're editing and anything below it. There is nothing below High Pass, so High Pass is all you'll see. As unfortunate as this is, you don't need to be reminded of it later, so turn on the **Don't Show Again** check box and click **OK**.

- Set the **Mode** option to **Overlay** and the **Opacity** value to 50 percent to blend the High Pass effect into the original image, as in Figure 11-89. Without seeing the other effects you're working in the dark, but based on experience these settings should do the trick. Then click **OK**. A few seconds later, Photoshop applies your changes to High Pass and restores the Smart Sharpen and Median filters.

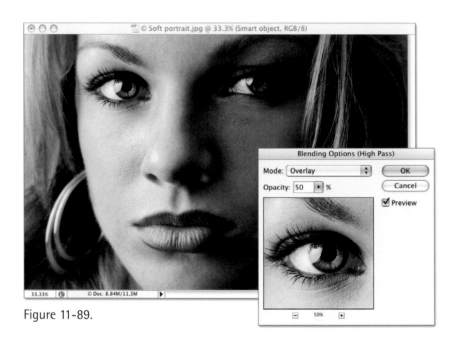

Figure 11-89.

12. *Load the Red channel as a selection.* To the left of the words Smart Filters in the **Layers** palette is an empty mask. You can use this *filter mask* to isolate the effects of your filters. I suggest that we focus the sharpening effects in particular to the darkest details by stealing a "natural" mask from the original image.

Here's how it works:

- Turn off all the smart filters by clicking the 👁 icon next to the Smart Filters mask. This restores the original image.

- Switch to the **Channels** palette. Since this is a portrait and thus rife with flesh tones, the Red channel is the brightest,

boasting the most contrast between highlights and shadows. Click the **Red** channel to view it in the image window, as in Figure 11-90. What you're seeing is called a *luminance mask*, because you can use it just as it is to select the light regions of the image.

- Ctrl-click (or ⌘-click) on the **Red** channel to load it as a selection outline. That's all it takes—your luminance mask is ready to roll.

13. ***Mask the effects of the smart filters.*** Return to the **Layers** palette. Turn on the filters by restoring the 👁 in front of **Smart Filters** and click on the filter mask to make it active. Press the D key to ensure that the background color is black. Then press Ctrl+Backspace (or ⌘-Delete) to fill the selection with black.

14. ***View the filter mask by itself.*** Press Ctrl+D (⌘-D on the Mac) to deselect the image. Next, Alt-click (or Option-click) the filter mask thumbnail to view only the mask. Pictured in Figure 11-91, this reverse version of the Red channel is known as a *density mask* because it reveals the darkest regions of the images, which in print are the areas of highest ink density. The upshot is that the effects of the smart filters are limited to the darkest areas of the photograph.

Alt-click (on the Mac, Option-click) the layer mask thumbnail to return to the image. To compare the masked version of the filters to the unmasked one, Shift-click the filter mask thumbnail, which turns it on and off. By masking away the filters in the bright areas, we are able to limit the sharpening and other effects to the dark details, which represent the real edges in the image, including the perimeter of the eyes, mouth, and nose. This is digital sharpening at its most subtle, not to mention its best.

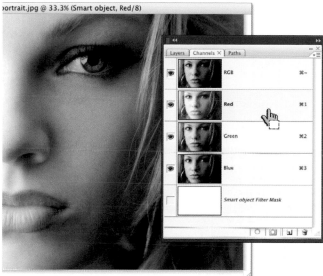

Figure 11-90.

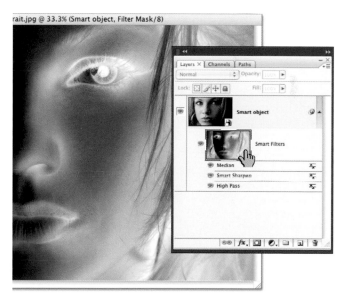

Figure 11-91.

Smart Filters on Steroids

During the step-by-step phase of our smart filter discussion, we stuck to the relatively prosaic task of applying corrective effects to a flat photograph. But in the right hands, smart filters can serve as radically creative tools as well. Only take care: As natural as it might seem to employ filters as creative tools, your artistic experimentation can turn into an unqualified efficiency pit as one filter after another fails to produce quite the effect you're looking for. And if you already have experience losing track of time playing with filters, it only gets worse with smart filters. Not only can you stir a near-infinite variety of filter cocktails, garnished with different blend modes and opacity settings, but you can do it all non-destructively. This may lead you to ignore the obvious side effect of the parametric wonderland: Your diminished capacity to get anything done. Few things are worse than wasting hours pilfering through filters only to wake up in the imaging equivalent of a foreign motel room with a lampshade on your head. So as with other cocktails, pace yourself. Keep an eye on the clock. Avoid aimless wandering. And recognize when it's time to stop.

That said, you can accomplish some interesting stuff. By way of example, I started with the letterboxed composition below, comprising little more than another Joey Nelson photograph (already converted to a smart object) and some live text set against a black background. I then applied a labyrinthine combination of smart filters, adjustment layers, masks, and layer effects to achieve the movie poster at the bottom of the facing page.

I started by applying a sequence of effects filters to the smart object photograph. To follow along, open *Kill Jill art.psd* in the *Lesson 11* folder and try the following (all available from the **Filter** menu):

- **Artistic→Cutout**. Number of Levels: 6, Edge Simplicity: 1, and Edge Fidelity: 2. I changed the blend mode to Linear Light and Opacity to 30 percent.
- **Sketch→Conté Crayon**. Default filter settings, with the blend mode set to Normal and 40 percent Opacity.
- **Noise→Add Noise**. Amount: 20 percent, Distribution: Gaussian, Monochrome: on. Opacity: 30 percent.

While I found the results intriguing (see the detail below), they didn't convey the effect I was looking for. So decided to switch out a couple of the filters for different ones. Happily, you can swap any filter that calls up the big Filter Gallery—which includes Cutout and Conté Crayon—for a different one. (To switch a non-Filter Gallery command such as Add Noise, you have to delete it and apply a new one.)

After a bit of investigation, I decided to replace Cutout and Conté Crayon with Poster Edges and Reticulation, respectively. Here's how:

- **Artistic→Poster Edges**. Edge Thickness: 2, Edge Intensity: 1, Posterization: 5.
- **Sketch→Reticulation**. Density: 20, Foreground Level: 50, Background Level: 30.

Reticulation created enough noise for my tastes, so I turned off **Add Noise** by clicking its 👁. The result appears below.

The file includes a few dormant adjustment layers and layer effects. Go ahead and turn on all the 👁s in the **Layers** palette. Shift-click on the **Eyes** layer mask to make it active. Set the Eyes layer to **Vivid Light** with a **Fill** value of 50 percent. Ctrl-click (⌘-click on the Mac) the Eyes mask to load it as a selection outline. Switch to the filter mask below the **Model** layer and press Ctrl+Backspace (⌘-Delete) to mask away the filters in the eyes. Then Alt-click (or Option-click) on the horizontal line between the Colorize and Model layers to combine the two into a clipping mask. The finished poster shows the result.

Smart filters are also applicable to editable type. Select the **Kill, Jill** layer, switch the blend mode to **Normal**, and choose **Filter→Convert for Smart Filters**. Then apply the following from the **Filter** menu:

- **Blur→Motion Blur**. Angle: 90 degrees, Distance: 200 pixels. I changed the Blend Mode to Linear Dodge (Add)

- **Other→Maximum**. Radius: 15 pixels. Changing the Blend Mode to Screen makes for letters inside letters.

For a bit more blur, I Alt-dragged (Option-dragged) the **Motion Blur** entry above Maximum to duplicate it. Then I double-clicked the ⚏ icon and reduced the **Opacity** to 20 percent.

You may be feeling more than sufficiently enlightened after this first level of initiation into smart filters. And if so, feel free to skip to the quiz, which begins on page 469. But if you're still craving mystery—and honestly, who isn't?—I've got a puzzle for you: The Layers palette includes one filter mask that affects all filters applied to a single smart object. But what do you do if you want to apply different masks to different filters? Well, you'll have to cue the *Twilight Zone* music because the only way to pull off this feat is to travel through another dimension, one where you can wrap one smart object inside another. That's the signpost up ahead—the next stop: Extra Credit.

In the case of our composition, the odd man out is Median. Because you set Median to the Lighten mode (Step 8, page 459), much of its power is limited to the lightest regions in the image. Meanwhile, the mask limits the filters to the darkest areas. As a result, Median produces a very slight effect. We need to unmask the Median filter while leaving the sharpening effects masked, as outlined in the following steps.

15. ***Duplicate the smart object.*** Press Ctrl+J (or ⌘-J) to duplicate the Smart Object layer and all of its filters. Rename the layer "Dummy." We'll come back to it in a moment.

16. ***Put the original smart object inside a new smart object.*** Click the **Smart Object** layer to select it. Then choose **Layer**→**Smart Object**→**Convert to Smart Object** or press my keyboard short-cut, Ctrl+⬚ (or ⌘-⬚). This puts the smart object, complete with its smart filters, into another smart object container.

17. ***Open the new smart object.*** In the Layers palette, double-click the layer thumbnail (still called Smart Object, but now without the smart filters or filter mask) to bring up an image window titled *Smart Object.psb*, which includes the nested smart object and all of your masked filters.

If you get the smart objects warning, it's because you didn't turn it off back in the "Working with Smart Objects" exercise (Step 13, page 452). Select the **Don't show again** check box and click **OK**.

18. ***Turn off the Median filter.*** This and the next couple of steps are devoted to the task of moving the Median filter from the smart object you duplicated in Step 15 to the newest "parent" object that you made in Step 16. It sounds much tougher than it is, but it means we won't be needing the Median filter here. Still inside the Layers palette, click the 👁 icon in front of **Median** to turn it off.

19. **Close the smart object and save your changes.** Close the *Smart Object.psb* file by clicking the ☒ box in the title bar (⊙ on the Mac). Then click the **Yes** (or **Save**) button to update the smart object and return to the *Soft portrait.jpg* composition.

20. **Move the Median filter from Dummy to Smart Object.** Again inside the Layers palette, drag the **Median** entry from the **Dummy** layer to the thumbnail for the **Smart Object** layer. Click the ▼ to the right of the ⊚ icon for the Smart Object layer to expand the layer and reveal the smart filter items, which include Median and an empty filter mask, as shown in Figure 11-92.

21. **Throw the Dummy layer away.** You don't need it anymore. Nuke it with impunity.

 Next, I want to expand the shadows and downplay the highlights a bit using the Shadow/Highlight command that we reviewed way back in Lesson 2, "Highlights, Midtones, and Shadows." Naturally, we want to apply the command as a nondestructive edit. Unfortunately, it isn't available as an adjustment layer. Why not? Because even though Shadow/Highlight is organized with the color commands, it's actually a filter. Fortunately, you can now apply the command nondestructively as a smart filter.

22. **Apply the fourth filter, Shadow/Highlight.** Choose **Image→ Adjustments** to reveal two filters disguised as color adjustment functions, Shadow/Highlight and Variations (see Figure 11-93). Choose the former to display the **Shadows/Highlights** dialog box. Make sure the **Show More Options** check box is turned on, then do the following:

 • Press the Alt key (Option on the Mac) and click what is now the **Reset** button (formerly Cancel) to restore the default settings.

 • In the **Shadows** section, set the **Amount** value to 5 percent. Then set the **Tonal Width** and **Radius** values to 50 percent and 100 pixels, respectively.

 • For **Highlights**, take the **Amount** value slightly higher, to 15 percent. Again set **Tonal Width** and **Radius** to 50 percent and 100 pixels.

 • Leave the other values set to their defaults, which include +20 for **Color Correction**, 0 for **Midtone Contrast**, and 0.01 for the **Clip** value.

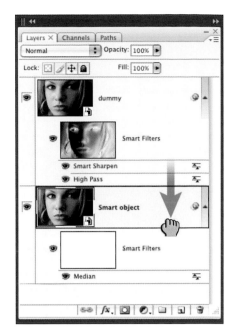

Figure 11-92.

Figure 11-93.

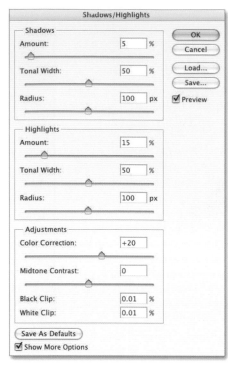

Figure 11-94.

All settings appear in Figure 11-94. Assuming that you've entered everything correctly, click the **OK** button.

23. ***Change the blend settings for the Shadow/Highlight effect.*** The Shadow/Highlight command has a habit of dimming the colors in an image, regardless of the Color Balance value. To compensate, double-click Shadow/Highlight's ⚏ icon in the **Layers** palette. Then change the **Mode** to **Luminosity** and the **Opacity** to 65 percent, which restores the original colors and backs off the effect, respectively. Click **OK** to accept.

The first two examples in Figure 11-95 compare the original image to the finished smart object. The changes are both subtle and precise. Even so, it may occur to you that you could have achieved the same goal with less chicanery using static filters. Very likely, but as with any parametric modification, the advantage of smart filters is changeability. If I decide I want a higher contrast effect with more brilliant colors, all I have to do is double-click the Shadow/Highlight filter's ⚏ icon, change **Mode** to **Overlay**, reduce the **Opacity** to 35 percent, and I'm rewarded with the final example in the figure below. While smart filters may be a bit overwrought, it's hard to object to anything that so willingly adapts to your every creative whim.

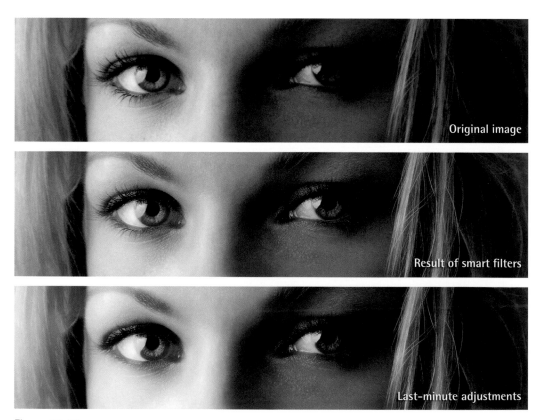

Figure 11-95.

WHAT DID YOU LEARN?

Match the key concept in the numbered list below with the letter of the phrase that best describes it. Answers appear upside-down at the bottom of the page.

Key Concepts

1. Layer effects
2. Drop shadow
3. Layer style
4. Directional effects
5. Use Global Light
6. Color Overlay
7. Strokes and glows
8. Specular highlights
9. Blend Interior Effects as Group
10. Adjustment Layer
11. Smart object
12. Smart filter

Descriptions

A. A group of layer effects that trace one or more colors uniformly around the perimeter of a layer.

B. A layer effect that casts colors both by a specified distance and at a specified angle.

C. When turned on, this check box blends a Glow or Overlay effect with the active layer before blending the layer with its neighbors.

D. This check box locks down the light source so that all directional effects cast highlights and shadows at a consistent angle.

E. One of a hundred of so commands from the Filter menu or Adjustments submenu that can be applied nondestructively to a smart object.

F. A collection of drop shadows, bevels, and other layer effects stored in the Styles palette.

G. This layer effect coats the active layer with a selected color, useful for colorizing the layer or replacing one color with another.

H. Useful for creating both shadows and highlights, this layer effect offsets and blurs a silhouette of the active layer.

I. A collection of color adjustment settings that corrects or modifies the colors of the layers below it.

J. A series of dynamic color and contour attributes that let you assign dimension, lighting, and texture to a layer.

K. Bright flashes of light that accompany a highly reflective surface, such as metal, glass, or liquid.

L. A special variety of layer that precludes direct pixel modifications in return for nondestructive transformations, multilayer editing, live Camera Raw access, and editable smart filters.

Answers

1J, 2H, 3F, 4B, 5D, 6G, 7A, 8K, 9C, 10I, 11L, 12E

PRINTING AND OUTPUT

PRINTING FROM Photoshop is at once a primitive and a sophisticated experience. On the primitive side, the program is designed to print one image per page. There's no way to print multi-page documents. Even if you open multiple files, you can't print them all in one fell swoop; you must print each image in turn. You can't even print independent layers; the program always prints all visible layers. And you can print just one copy of a file per page. So if you want to double up images, you have to repeat the image inside the file before choosing Print.

In fact, you could argue that Photoshop isn't a printing program at all. Rather, it's designed to prepare images that you plan to import into programs that are specifically designed to amass and print pages, such as Adobe InDesign and QuarkXPress. For example, I prepared the image in Figure 12-1 in Photoshop; but I laid out this and every other page of this book in InDesign.

So what's the sophisticated part? Well, what Photoshop lacks in page control, it makes up for in real-world acumen. First, it realizes that you have different output destinations. Sometimes you want to print a full-color page to a printer in your home or office. Other times, you want

Camera www.istockphoto.com/marianor

Figure 12-1.

ABOUT THIS LESSON

This final lesson covers topics related to inkjet printing, professional output, and CMYK color conversion. You'll learn how to:

- Print an image to an inkjet printer and ensure high quality and accurate color. page 475

- Use photo-grade paper to produce film-quality output from even an inexpensive inkjet printer . . . page 482

- Convert an image from RGB to CMYK for output to a commercial printing press page 486

- Make sense of the CMYK color model, including black generation and total ink limit page 494

- Combine multiple images onto a single printable page using the Picture Package command page 497

Video Lesson 12: From Screen to Print

When printing a photograph, Photoshop must convert the image from RGB to the radically different world of CMYK (or some similar standard). Every pixel in every color channel must undergo a change, and it's easier to make accurate changes if you understand how the conversion works.

Because color theory is at the heart of the printing process, I take you on a guided tour of both the theory and reality of color in the twelfth video lesson on the DVD. Insert the DVD and double-click the file *PsCS3 Videos.html*. Then click **Lesson 12: From Screen to Print** under the **Type, Styles, and Output** heading. The 14-minute, 7-second movie explains the following functions and shortcuts:

Operation	Windows shortcut	Macintosh shortcut
Display Preferences dialog box	Ctrl+K	⌘-K
Show Channels palette	F7, then click Channels tab	F7, then click Channels tab
Switch between RGB color channels	Ctrl+1, +2, or +3	⌘-1, -2, or -3
Fill image with white	Ctrl+Backspace	⌘-Delete
Hide or show toolbox and all palettes	Tab	Tab
Switch between CMYK color channels	Ctrl+1, +2, +3, or +4	⌘-1, -2, -3, or -4

to print several hundred copies of your artwork for mass distribution. Second, Photoshop understands that regardless of your destination, you want the colors that you see on your screen to translate accurately onto the printed page. Most programs don't give either of these very important aspects of printing much attention. Yet for Photoshop, these are the only printing issues that matter. And as you'll discover in this lesson, Photoshop happens to be right.

Local Printing Versus Commercial Reproduction

Technically speaking, print and output are different names for the same thing: the act of getting something you see on screen onto a piece of paper. But in the workaday world of computer imaging, the words tend to be used to imply different things:

- To *print* an image is to turn on your printer, choose the Print command from Photoshop's File menu, and wait for the page to come out.

- To *output* an image is a more deliberate operation. You might be rendering the image to a high-end film recorder or a Post Script-equipped imagesetter. Or more likely, you're preparing an image for inclusion in a newsletter or other widely distributed document. Output requires a greater investment of time and money, as well as more attention to detail.

The irony is that printing from a modern inkjet printer can produce better results than professional, commercial output. In fact, an inkjet print can look every bit as good as a photographic print from a conventional photo lab. But it's simply not affordable for large-scale reproduction. For example, printing a single copy of a 100-page glossy magazine would cost $50 to $100 in ink and paper. Commercially outputting that same magazine requires you to lay down more cash up front, but the per-issue costs are pennies per page.

So when you just want to make a few copies, printing offers the advantages of convenience and quality. But if you're planning a big print run, commercial output is the way to go.

Lights intersect to make lighter colors

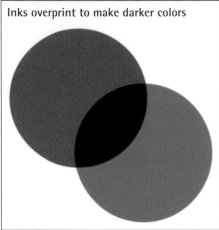

Inks overprint to make darker colors

Figure 12-2.

RGB Versus CMYK

Whether an image is bound for inkjet or imagesetter, it must make the transition from one color space to another. And that presents a problem because monitors and printers use opposite methods of conveying colors. Whereas images on a monitor are created by mixing colored lights, print images are created by mixing inks or other pigments. As illustrated in Figure 12-2, lights mix to form lighter colors, inks mix to form darker colors. Moreover, the absence of light is black, while the absence of ink is the paper color, usually white. Just how much more different could these methods be?

PEARL OF WISDOM

Given that monitors and printers are so different, it's not surprising they begin with different sets of primary colors. Monitors rely on the *additive primaries* red, green, and blue, which make up the familiar RGB color space. Printers use the *subtractive primaries* cyan, magenta, and yellow, known collectively as CMY. The two groups are theoretical complements, meaning that red, green, and blue mix to form cyan, magenta, and yellow—and vice versa—as illustrated in Figure 12-3. (For more information on this intriguing topic, watch Video Lesson 12, "From Screen to Print," introduced on page 472.) The intersection of all three additive primaries is white; the intersection of the subtractive primaries is a very dark, sometimes brownish gray that is nearly but not quite black. Therefore, a fourth primary ink, black, is added to create rich, lustrous shadows. Hence, the acronym CMYK for cyan, magenta, yellow, and the "key" color black.

Fortunately, Adobe and most printer vendors are aware of the vast disparities between RGB and CMYK. They are equally aware that you expect your printed output to match your screen image. So they've come up with a two-tiered solution:

- When printing an image directly to an inkjet printer or other personal device, leave the image in the RGB mode and allow the printer software to make the conversion to its native color space automatically.

- When preparing an image for commercial *color separation*—in which the cyan, magenta, yellow, and black inks are each printed to separate plates—you should convert the image to the CMYK color space inside Photoshop. Then save it to disk with a different filename to protect the original RGB image.

I provide detailed discussions of both approaches in the following exercises. And I'll provide insights for getting great looking prints with accurate colors along the way.

Printing to an Inkjet Printer

When it comes to printing full-color photographic images, your best, most affordable solution is an inkjet printer. Available from Epson, Hewlett-Packard, and a cadre of others, a typical inkjet printer costs just a few hundred dollars. In return, it's capable of delivering outstanding color and definition (see the sidebar "Quality Comes at a Price" on page 482), as good as or even better than you can achieve from your local commercial print house. But you can't reproduce artwork for mass distribution from a color inkjet printout. Inkjet printers are strictly for personal use.

In the following exercise, you'll learn how to get the best results from your inkjet device. If you don't have a color inkjet printer, don't fret. You won't be able to achieve every step of the exercise, but you can follow along and get an idea of how the process works.

Assuming you have an inkjet device at your disposal, please load it with the best paper you have on hand, ideally a few sheets of glossy or matte-finish photo paper, readily available at any office supply store (again, see "Quality Comes at a Price" for more information). If you don't have such paper, or if you simply don't feel like parting with the good stuff for this exercise, go ahead and load what you have. Just remember what kind of paper you loaded so you can address it properly in Steps 15 and 16 on page 480.

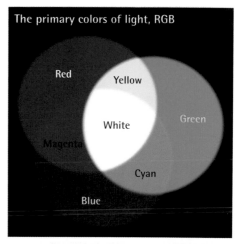

The primary colors of light, RGB

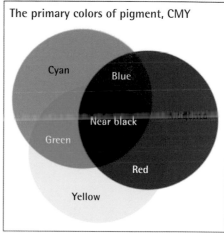

The primary colors of pigment, CMY

Figure 12-3.

1. *Open the test image.* Look in the *Lesson 12* folder inside *Lesson Files-PsCS3 1on1* and you'll find a file called *Y2K+10 Invite.psd*. Pictured in Figure 12-4 on the next page, this file hails from a wildly successful Y2K party some friends and I threw a few years back. In addition to making some adjustments for time—who knows what Y2010 has in store?—I expanded the range of hues and luminosity values to make it easier to judge the accuracy of our color prints. The image is sized at 4-by-5 inches with a resolution of 300 pixels per inch. But as you'll see, that can be changed to fit the medium.

2. ***Choose the Flatten Image command.*** This file contains a handful of pixel-based layers, a bit of rasterized text, and a shape layer. As you may recall from Lesson 10, text and shape layers can be output at the maximum resolution of a PostScript-compatible printer, but very few inkjet devices include PostScript processors (and those that do are expensive). So the layers won't help the image's print quality. Layers also require more computation and thus slow down the print process. Best solution: Get rid of them by choosing **Layer→Flatten Image**.

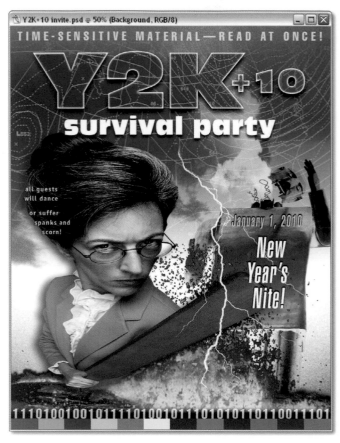

Figure 12-4.

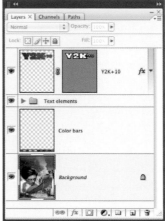

3. ***Save the image under a new name.*** Naturally, you don't want to run the risk of harming the original layered image, so choose **File→Save As**. As long as you save the image under a different name, you're safe. But here are the settings I recommend:

 - In the **Save As** dialog box, choose **TIFF** from the **Format** pop-up menu.

 - Make sure the **ICC Profile** check box is on (that's **Embed Color Profile** on the Mac).

 - Click the **Save** button.

 - In the **TIFF Options** dialog box, turn on the **LZW** option to minimize the file size without changing any pixels.

 - From **Byte Order**, select the platform that you're working on, PC or Mac.

 - Click the **OK** button to save the file.

 The original layered file is safe as houses (which is to say, very safe) and the flat file is ready to print.

4. **Choose the Print command.** Choose **File→Print** or press Ctrl+P
(⌘-P on the Mac) to display the **Print** dialog box, pictured in
all its enormity in Figure 12-5. Newly revamped in Photoshop
CS3, this one-stop print station is designed to provide every-
thing you need to output an image in one convenient location.
Granted, it's a little daunting to the uninitiated. But it's entirely
in keeping with Photoshop's underlying credo: When in doubt,
overwhelm the user with options.

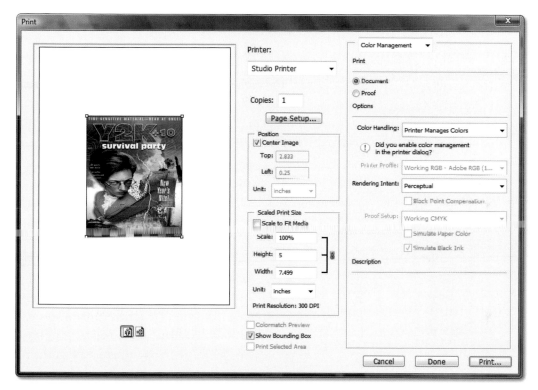

Figure 12-5.

5. **Select your printer model.** You may be working on a personal
computer cabled to a single USB printer. Or you may be working
on a network with a dozen or more shared printers. In either
case, select the model of printer that you want to use from the
Printer pop-up menu, positioned top and center in the dialog
box (see Figure 12-6).

6. **Click the Page Setup button.** I would call Photoshop CS3's
Print dialog box comprehensive were it not for the omission
of one essential option: You can't specify the size and type of
the paper that you want to print to. For that, you have to click
the **Page Setup** button to display your operating system's **Page
Setup** dialog box.

Figure 12-6.

7. *Choose the desired paper size.* If you're using special photo paper, consult the paper's packaging to find out the physical page dimensions. In the case of my Premium Glossy Photo Paper, each piece of paper measures 8-by-10 inches, slightly smaller than the letter-size format.

 - Under Windows, choose the page size from the **Size** pop-up menu in the **Paper** section of the Page Setup dialog box.

 - On the Mac, again choose your printer from the **Format For** pop-up menu. Then select the page size from the **Paper Size** option.

 Then click the **OK** button to return to the **Print** dialog box.

8. *Make sure the paper is upright.* Make sure that the page orientation option below the full-color preview in the bottom-left corner of the dialog box is set to ⬚ (see Figure 12-7) so that the image prints upright, in portrait mode.

9. *Turn on the Scale to Fit Media check box.* Located to the right of the image preview, this option expands the image to fill the maximum printable portion of the page. Note that Photoshop does not resample the image; it merely lowers the resolution value so that the pixels print larger. In Figure 12-7, for example, Photoshop has automatically reduced the resolution to 160 ppi. This way, you don't waste any of your expensive paper by, say, printing a tiny image smack dab in the middle of the page.

 But wait, isn't 160 ppi a very low resolution for printing? For commercial work, yes. But for personal work, a low resolution can be useful for examining the quality of an image. And as I mentioned back in Lesson 5, "Crop, Straighten, and Size," printing at a low resolution is preferable to upsampling.

10. *Choose the Color Management option.* The right side of the dialog box greets you with one of two groups of options: Output, which includes a bunch of PostScript printing functions applicable to commercial reproduction, or Color Management, which is what we want.

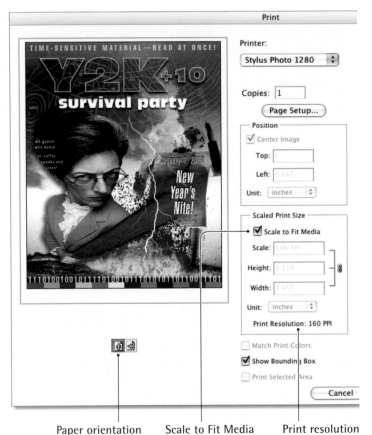

Paper orientation Scale to Fit Media Print resolution

Figure 12-7.

(If you see buttons marked Background, Border, Bleed, and the like, you're in the wrong area.) Make sure the top-right pop-up menu is set to **Color Management**.

11. *Confirm the source and method options.* To print the colors in an image as accurately as possible, you must identify the *source space*—the color space used by the image itself—and the method by which Photoshop translates the colors to the *destination space* used by the printer.

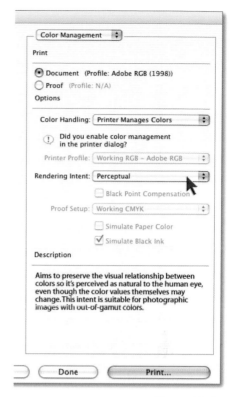

- In the **Print** area, select **Document: Adobe RGB (1998)**. This source space is the variety of RGB employed by the *Y2K+10 Invite* image file.

- Confirm that the **Color Handling** option is set to **Printer Manages Colors**. This setting conveys the source space and leaves the printer software in charge of the color conversion process. We just have to remember to let the printer software know it's in charge, which we will shortly.

- Set the **Rendering Intent** option to **Perceptual**, which maintains the smoothest transitions when converting colors—the best solution for photographic images.

Hover over a Color Management option to see an explanation of the active setting in the Description area in the bottom-right corner of the dialog box. Figure 12-8 shows the settings as they should appear at this point.

Figure 12-8.

12. *Click the Print button.* This closes Photoshop's Print dialog box and delivers you to the operating system's **Print** dialog box.

13. *Verify that the right printer is selected.* Selecting the right printer is mostly a problem on the Mac, but it's worth confirming on the PC, too. Under Windows, check the **Name** option. On the Mac, check the **Printer** option. Both appear in Figure 12-9.

14. *Display the specific properties for your printer.* From here on, things vary fairly significantly between the PC and the Mac, as well as from one printer model to another:

- Under Windows, click the **Properties** button to display the options defined by the printer's driver software.

- On the Mac, choose **Print Settings** from the third pop-up menu from the top of the dialog box (the pop-up menu that initially reads **Copies & Pages**).

Figure 12-9.

Figure 12-10.

15. *Indicate the type of paper loaded in your printer.* Look for an option called **Media Type** or the like. In my case, I changed Media Type to **Premium Glossy Photo Paper** (see the arrow cursors in the PC and Mac interfaces in Figure 12-10), which happens to be a literal match of the name listed on my paper's original packaging (see the second figure on page 482). If possible, try to find a literal match for your brand of paper as well.

16. *Select the highest print quality for your printer.* Select the highest quality when printing to photo-grade paper. If not, choose a lower setting. The quality setting can be hard to find, so you might have to do a bit of digging. For example, on the PC, I had to forage through the following options, illustrated by the numbered items in Figure 12-11:

- I first selected **Custom** from the **Mode** options (labeled ❶ in Figure 12-11) to get access to a more sophisticated set of options.

- Then I clicked the **Advanced** button (❷) to enter yet another dialog box.

- I found the option I was looking for, **Print Quality**. I set it to the printer's maximum, **SuperPhoto – 2880dpi** (❸ in the figure).

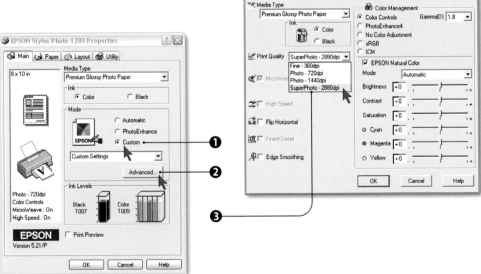

Figure 12-11.

On the Macintosh, I switched from **Automatic** to **Advanced Settings** (labeled ❶ in Figure 12-12). Then I changed the **Print Quality** option to **Photo – 2880dpi** (❷).

If you have problems finding the print quality option (or its equivalent), consult the documentation that came with your printer. Remember: Choose the highest setting *only* if you're using photo-grade paper. Standard photocopier-grade bond paper cannot handle that much ink; the high-quality setting will produce a damp, smeared page, thereby resulting in a ruined print and wasted ink.

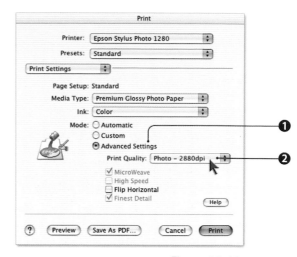

Figure 12-12.

After you've selected the right paper and the correct print resolution, all that's left to do is select the most accurate means of reproducing the colors.

17. *Select the best color management method.* Now it's time to activate your printer software's color management function and to specify how the software converts colors from the RGB space to CMYK.

Not all printer manufacturers allow you to modify the color management method. And those that do often offer paltry controls. As it turns out, Epson's printer drivers do about the best job of it, as illustrated in Figure 12-13.

- In the **Advanced** dialog box on the PC, there are a series of **Color Management** radio buttons. Most require you to mess with imprecise slider bars and image comparisons. The better solution is to select **ICM**, which uses the color-matching software built into the Windows operating system.

- On the Mac, I chose **Color Management** from the third pop-up menu (labeled ❶ in Figure 12-13), the one that previously said Print Settings. Then I selected the second radio button, **ColorSync** (❷). This enabled Apple's ColorSync color-matching software, which is built into OS X and just so happens to be one of the best color management solutions on the planet.

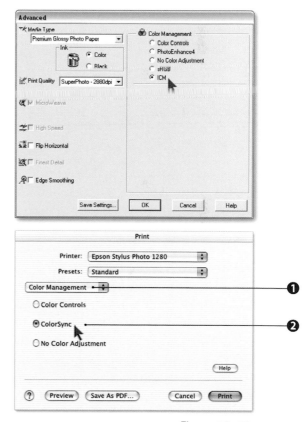

Figure 12-13.

Quality Comes at a Price

Inkjet printers are cheap, often sold at or below cost. But the *consumables*—the paper and the ink—are expensive, easily outpacing the cost of the hardware after a few hundred prints. Unfortunately, this is one area where it doesn't pay to pinch pennies. Simply put, the consumables dictate the quality of your inkjet output. Throwing money at consumables doesn't necessarily ensure great output, but scrimping guarantees bad output.

Consider the following scenario:

- Of the handful of inkjet devices I own, the one I use most often is my Epson Stylus Photo 1280. It's getting to be a little long in the tooth, but it works great, the software makes more sense than most, and it can print as many as 2880 dots per inch.

- The Stylus Photo 1280 requires two ink cartridges, pictured below. The first cartridge holds black ink; the second contains five colors: two shades of cyan, two shades of magenta, and yellow. (As the reasoning goes, the lighter cyan and magenta better accommodate deep blues, greens, and flesh tones.) Together, the cartridges cost about $60.00 and last for 45 to 120 letter-sized prints, depending on the quality setting you choose. The higher the setting, the more ink the printer consumes. So the ink alone costs 50¢ to $1.33 per page.

- You can print to regular photocopier-grade paper. But while such paper is inexpensive, it's also porous, sopping up ink like a paper towel. To avoid overinking, you have to print at low resolutions, so the output tends to look substandard—about as good as a color photo printed in a newspaper.

- To achieve true photo-quality prints that rival those from a commercial photo lab, you need to use *photo-grade paper* (or simply *photo paper*), which increases your costs even further. For example, 20 sheets of the stuff in the packet shown below costs $13.50, or about 67¢ per sheet.

The upshot: a low-quality plain-paper print costs about 50 cents; a high-quality photo-paper print costs about 2 bucks. Although the latter is roughly four times as expensive, the difference in quality is staggering. The figure below compares details from the two kinds of output magnified to six times their printed size. The plain-paper image is coarse, riddled with thick printer dots and occasional horizontal scrapes where the paper couldn't hold the ink. Meanwhile, the photo-paper image is so smooth, you can clearly make out the image pixels. Where inkjet printing is concerned, paper quality and ink expenditure are the great determining factors.

360 dpi, plain paper, 50¢ 2880 dpi, glossy photo paper, $2<u>00</u>

Because of the large number of printer vendors, your options may vary significantly in this area. You may even encounter additional options. For example, on the PC, Hewlett-Packard includes an **ICM Method** option (best set to **Host**) and an **ICM Intent** (best set to **Picture**). If none of the options I've mentioned so far are available for your printer, you'll need to experiment to find the settings that work best.

18. *Save your settings.* Whether you can save a collection of print settings on the PC depends on your printer software. In the case of my Epson device, I can click a **Save Settings** button in the **Advanced** dialog box and give the settings a name, such as "Premium hi-res."

 On the Mac, choose **Save As** from the **Presets** pop-up menu near the top of the **Print** dialog box. The named settings then appear as an option in the Presets pop-up menu.

19. *Send the print job on its way.* On the PC, you might have to exit a few dialog boxes to apply your changes. I had to click two **OK** buttons to dig my way back up to the Print dialog box, and then click **OK** again to start the job printing. On the Mac, click the **Print** button.

 If you see a warning about how some PostScript-specific printing settings "will be ignored since you are printing to a non-PostScript printer," click the **Don't show again** check box and then click the **OK** button. Obviously, PostScript options aren't going to work with a non-PostScript printer, which is why we so wisely avoided them.

20. *Wait and compare.* Printing a high-quality image from an inkjet printer takes a long time, usually several minutes. But thanks to the miracle of background printing, you can continue to use Photoshop and even get a head start on the next exercise. When the print job finishes, compare it to the image on the screen. Assuming that your printer is functioning properly (no missing lines, no paper flaws, all inks intact), the colors in the printout should bear a close resemblance to those in the screen image.

 But there are always variations. Figure 12-14 shows two versions of the same image printed to photo-grade paper from a

Stylus Photo 1280. The only differences are the computer and the method of color management used to print the image.

- Although a bit more yellow than the others, the ColorSync image is a very close match to what I saw on my Macintosh screen and well in keeping with what I hoped to achieve with the composition.

- The image printed from Windows using the ICM setting (pictured on the right side of Figure 12-14) appears a bit more cyan than the Macintosh image. But it bears a good resemblance to the image I saw on my PC screen, so the result is a success.

PEARL OF WISDOM

If the output doesn't match the screen image to your satisfaction, try experimenting with your printer-specific options (those covered in Steps 14 through 17) until you arrive at a better result. After you do, write the settings down—or save them if you can—and use them in the future.

Mac output, ColorSync (yellow)

Windows output, ICM (cyan, blue)

Figure 12-14.

Preparing a CMYK File for Commercial Reproduction

We now move from the realm of personal printers into the world of commercial prepress. The *prepress* process involves outputting film that is burned to metal plates (or output directly from computer to plates), which are then loaded onto a high-capacity printing press for mass reproduction. (Hence the *pre* in *pre*press.) Each page of a full-color document must be separated onto four plates, one for each of the four *process colors*: cyan, magenta, yellow, and black. By converting an image to CMYK in advance, you perform the separation in advance. All the page-layout or other print application has to do is send each color channel to a different plate, and the image is ready to output.

Converting an image from RGB to CMYK in Photoshop is as simple as choosing Image→Mode→CMYK Color. This one command separates a three-channel image into the four process colors. For insight into how this happens, read the sidebar "Why (and How) Three Channels Become Four" on page 494. Converting the image properly, however, is another matter. If you don't take time to *characterize* the output device—that is, explain to Photoshop how the prepress device renders cyan, magenta, yellow, and black inks—the colors you see on screen will not match those in the final output.

Photoshop gives you two ways to characterize a CMYK device:

- Ask your commercial print shop if they have a ColorSync or ICM *profile* for the press they'll be using to output your document. (They might also call it an ICC profile—same diff for our purposes.) Such profiles are entirely cross-platform, so the same file will work on either the PC or the Mac. Just make sure that the filename ends with the three-letter extension *.icc* or *.icm*. You can then load the profile into Photoshop.

- Wing it. Every print house should be able to profile its presses. But you'd be surprised how many won't have the vaguest idea what you're talking about when you request a profile or will proffer an excuse about why profiling isn't an option. In this case, you'll have to create a profile on your own through trial and error. It's not the optimal solution, but I've done it more often than not and I generally manage to arrive at moderately predictable output.

The following exercise explores both options. You'll learn how to load a CMYK profile, should you be so lucky as to procure one. I'll also show you how to edit the CMYK options to create your own profile. And finally, you'll see how to convert the image to CMYK and save it in a format that either QuarkXPress or Adobe InDesign can read.

1. *Open the test image.* For consistency's sake, we'll be using the same composition we used in the preceding exercise. So open *Y2K+10 Invite. psd* from the *Lesson 12* folder in *Lesson Files-PsCS3 1on1*. Make sure to open the original PSD file, not the TIFF file that you saved in Step 3 on page 476.

2. *Choose the Color Settings command.* Choose **Edit→Color Settings** or press Ctrl+Shift+K (⌘-Shift-K on the Mac) to display the **Color Settings** dialog box, pictured in all its gruesomeness in Figure 12-15.

3. *Click the Fewer Options button.* If you see a button in the dialog box labeled **Fewer Options** (instead of **More Options**), click it. Although not an essential step, this will help to simplify things a bit by reducing the number of options shown inside the dialog box.

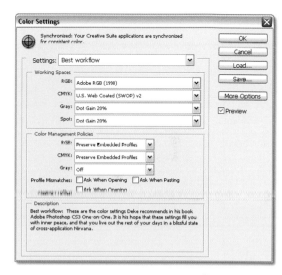

Figure 12-15.

4. *Load the CMYK profile provided by your commercial print house.* In this exercise, your print house happens to be the highly esteemed and completely fictional Prints-R-Us. Click the words **U.S. Web Coated (SWOP) v2** to the right of the first **CMYK** option to display a pop-up menu of CMYK profiles. As in Figure 12-16, choose **Load CMYK** to load an ICC profile from disk. Locate the file called *Prints-R-Us profile.icc* in the *Lesson 12* folder in *Lesson Files-PsCS3 1on1*. Then click the **Load** button to make the profile part of Photoshop's color settings.

5. *Click the OK button.* Photoshop closes the Color Settings dialog box and accepts your new CMYK settings.

6. *Turn off the Text Elements layer set.* Go to the **Layers** palette and click the 👁 icon in front of the **Text Elements** folder to hide the text layers. You'll have an easier time judging this image if the distracting text layers are out of the way.

Figure 12-16.

7. *Choose the CMYK Color command.* Choose **Image→Mode→ CMYK Color**. When Photoshop asks you whether you want to flatten the image, as in Figure 12-17, click the **Flatten** button to reduce the image to a single layer. Blend modes are calculated differently in CMYK than in RGB, so retaining layers can result in severe color shifts. Flattening isn't always the ideal solution, but there's no harm in this case, so we might as well.

Figure 12-17.

8. *Save the image under a new name.* You should never save over your original layered image, and you should never *ever* save a CMYK image over the original RGB. CMYK is a more limited color space than RGB, less suited to general image editing. So choose **File→Save As** and do the following:

- In the **Save As** dialog box, choose **TIFF** from the **Format** pop-up menu. TIFF is a wonderful format to use when handing off CMYK files because it enjoys wide support and prints without incident.

- Name the image "Y2K+10 CMYK.tif."

- Turn on **ICC Profile: Prints-R-Us profile** (or **Embed Color Profile: Prints-R-Us profile** on the Mac).

- Click the **Save** button.

- Inside the **TIFF Options** dialog box, turn on **LZW** under **Image Compression**. Every once in a while, a print house will balk at this setting. They can always open the file and resave it with this option off.

- Select the platform that your print house will be using from the **Byte Order** options.

- Click the **OK** button to save the file.

9. *Hand off the TIFF file to your commercial print house.* The only way to judge the success of the profile supplied to you by the print house is to actually put it to use. When you get the printed output back, you can decide whether changes are in order or not. For purposes of this exercise, we'll imagine that the overly light Figure 12-18 represents the final output provided to us by Prints-R-Us.

10. *Compare the output to the CMYK file on screen.* To see how the two images compare in my case, look at Figure 12-19. Fortunately, the colors in the printed image do not differ radically from those in the screen version. However, there is a big difference in brightness. The printed image is significantly lighter and the shadows are weak. We're also missing some of the richness in the reds of the flesh tones and the lava. In fact, the warm colors in the output suffer from a slightly yellow cast. These must all be resolved.

Figure 12-18.

The CMYK output

The CMYK image as it looks on screen

Figure 12-19.

To fix the CMYK image, you need to modify the Prints-R-Us CMYK profile. The best way to judge the results of our modifications is to apply them on-the-fly to the open image and compare the resulting screen image to the output. This means releasing the image from the grips of the existing CMYK profile. Admittedly, it's not a particularly intuitive step, but it's a necessary one. So here we go.

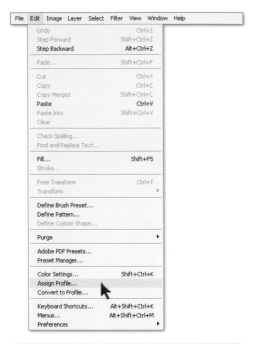

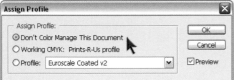

Figure 12-20.

11. *Disable color management for the current document.* Choose **Edit→Assign Profile**. Then select the **Don't Color Manage This Document** option, as in Figure 12-20, and click the **OK** button. From now on, the open image, *Y2K+10 CMYK.tif*, will respond dynamically to the changes you make to the CMYK color profile.

12. *Again, choose the Color Settings command.* Remember, the command is under the **Edit** menu on the PC and under the **Photoshop** menu on the Mac. Or simplify your life and press Ctrl+Shift+K (⌘-Shift-K). Photoshop redisplays the **Color Settings** dialog box.

Be sure that the dialog box doesn't entirely block your view of the image window. If that means dragging the dialog box most of the way off screen so only the Working Spaces options are visible, so be it. You can also zoom out from the image by pressing Ctrl+⊟ (⌘-⊟ on the Mac) to view more of your image at a time.

13. *Confirm that the Preview check box is turned on.* Your job will be to make the screen image look like the CMYK output. After all, the CMYK output is, by its very existence, the accurate representation of the printer's CMYK space; if the screen image doesn't match, Photoshop's CMYK display space must be wrong. Only with the **Preview** check box turned on can you judge the effects of the changes you're about to make.

Note that I'm *not* suggesting that you somehow adjust the brightness and contrast of your monitor to make it match the CMYK output. That would alter everything you see on the screen, inside Photoshop and out, and it wouldn't solve your problem. An incorrect adjustment to your monitor would alter your impression of future RGB images and thus further compound your problems. The aim here is to make sure Photoshop's understanding of the CMYK space matches that of the printer, and nothing more.

14. *Choose the Custom CMYK option.* Click the words **Prints-R-Us profile** to the right of the first **CMYK** option and choose **Custom CMYK**, as in Figure 12-21. Photoshop displays the little-known **Custom CMYK** dialog box, which allows you to change how the program converts colors to CMYK and displays them on the screen.

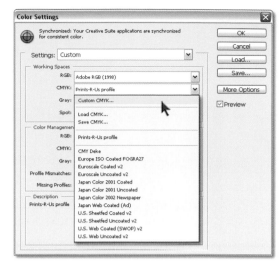

Figure 12-21.

Although I don't want to engender fear of the Custom CMYK dialog box, I caution you to regard most of its controls as off limits. This is especially true of the Separation Options at the bottom of the dialog box, which are based on attributes of the printing press that you could not possibly know unless you were to use it yourself or interview someone who does. For those who are curious, I discuss a couple of these options, GCR and Total Ink Limit, in the sidebar "Why (and How) Three Channels Become Four" on page 494. In fact, with the exception of Name, there's really only one subjective option in the dialog box: Dot Gain.

15. *Adjust the Dot Gain value.* With very few exceptions, commercial presses use small circles of colored ink, called *halftone dots,* to impart different shades of color. Dark areas get big dots, light areas get small dots. Illustrated in Figure 12-22, the term *dot gain* refers to how much the halftone dots grow when they're absorbed into the paper. The

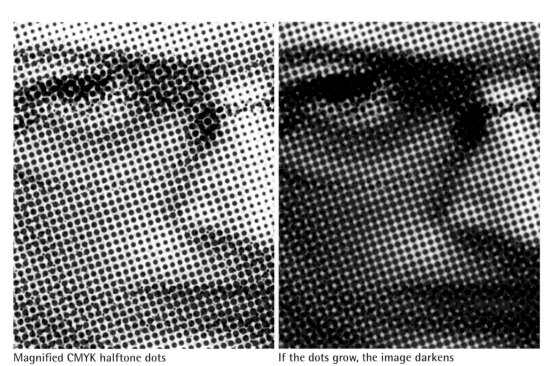

Magnified CMYK halftone dots If the dots grow, the image darkens

Figure 12-22.

Prints-R-Us profile includes a **Dot Gain** value of 35 percent, which means the print house anticipates that its halftone dots will grow 35 percent when printed on a specific grade of paper. Obviously, there's a mistake here; if the dot gain were really 35 percent, the image would tend to print dark, not overly light, as it did for us. So the current Dot Gain value is overcompensating.

The rules of thumb for adjusting the Dot Gain:

- If the printed image looks lighter than your screen display, as in this example, nudge the Dot Gain value down by pressing the ↓ key.

- If the printed image appears darker than your screen image, raise the value by pressing the ↑ key.

Small changes result in significant adjustments, so give the screen a moment to refresh between each press of the ↑ or ↓ key. I found that a value of 22 percent provides a pretty close match.

16. *Choose Curves from the Dot Gain pop-up menu.* The problem with adjusting the Dot Gain value is that it lightens or darkens all color channels at once. So while the brightness of the screen image roughly matches the output in Figure 12-18 on page 489, the reds don't appear washed out enough. To adjust each channel independently, choose the **Curves** option from the **Dot Gain** pop-up menu (see Figure 12-23). Photoshop responds with the **Dot Gain Curves** dialog box.

17. *Adjust the Dot Gain Curves values for each channel.* If the **All Same** option on the right side of the Dot Gain Curves dialog box is checked, turn it off. Use the **Cyan**, **Magenta**, **Yellow**, and **Black** options to switch between the four color channels and modify their luminosity values independently. This lets you correct the colors of the CMYK screen display one ink at a time.

To keep things as simple as possible—and by my reckoning, we could dearly use a bit of simplicity right about now—I modified only the **50** value for each channel. As shown in Figure 12-24 on the facing page, I lowered the values for the Cyan, Magenta, Yellow, and Black channels to 70, 66, 70, and 72, respectively.

Figure 12-23.

You might well ask how I arrived at these values. To which I would answer—as I so often do—trial and error. But to shed some light on my reasoning: Lower values lighten the screen image to bring it more in line with the CMYK output. Pressing ↓ lowers a value in increments of 0.1 percent; more useful, Shift+↓ lowers a value by a full 1 percent. Using Shift+↓, I lowered the Cyan and Magenta values by roughly equal amounts (18 and 19 percent, respectively). I lowered the Yellow and Black values by smaller amounts (15 and 13 percent, respectively) to keep more yellows and blacks in the image, which I found necessary to match the color balance of the output.

18. *Click the OK button three times in a row.* You are exiting the Dot Gain Curves, Custom CMYK, and Color Settings dialog boxes and updating the definition of the Prints-R-Us CMYK profile.

19. *Undo the last two operations.* Before you can apply the new color profile, you must first undo the effects of the previous one. So press Ctrl+Alt+Z (⌘-Option-Z on the Mac) twice in a row to undo the operations performed in Steps 11 and 7, respectively, first reinstating CMYK color management and then restoring the layered RGB image.

Be sure to press Ctrl+Alt+Z (⌘-Option-Z), and *not* Ctrl+Z (⌘-Z)! The latter will undo all the work that you've achieved in the Color Settings dialog box, everything from Step 12 through and including Step 18. If you do accidentally press Ctrl+Z, press Ctrl+Z again to restore the color settings, and *then* press Ctrl+Alt+Z twice. I know, it's weird, but that's how it works.

20. *Again, choose the CMYK Color command.* Choose **Image→Mode→CMYK Color** and click the **Flatten** button when asked to do so. The result doesn't look all that different than the CMYK image we created in Step 7. But now that you've improved the accuracy of the CMYK color space, you can trust what you see on the screen a bit more.

21. *Save the improved CMYK image.* Because you renamed the image *Y2K+10 CMYK.tif* back in Step 8, there's no harm in saving over it. Choose **File→Save** or press Ctrl+S (or ⌘-S) to update the file on disk.

Figure 12-24.

Why (and How) Three Channels Become Four

If this were a perfect world, cyan, magenta, and yellow would be all the colors you'd need to print an RGB image. But alas, the world is perfect only in its lack of perfection. Thus, it's the job of the key color, black, to set the world straight. In fact, you could argue that the fourth channel, Black, is the most important ink in CMYK output.

In the world of RGB, black exists naturally; in CMYK, it has to be generated. Let's start with RGB. Here, black is the default color, the one that appears if no other color is present. As pixels are turned on, the black goes away. As illustrated in the figure directly below, light pixels in the Red channel add red, those in the Green channel add green, and those in the Blue channel add blue. Any one channel is very dark on its own; only by combining channels can they overcome the darkness, as the middle and bottom rows of the figure show.

By contrast, color printing is about overcoming the lightness. In the collection of images below this column, we see the results of converting the RGB channels from the previous figure into cyan, magenta, yellow, and black using the CMYK profile that you created in "Preparing a CMYK File for Commercial Reproduction" (page 486). Assuming you output to white paper, the default color of printing is white, and therefore it's the job of the inks to make the white go away. The channels start out very light, as in the top row of the figure; but as one layer of ink mixes with another, the photograph becomes progressively darker, as in the middle and bottom rows. (To help you navigate through the figure, samples with three or more inks include a black outline.)

The CMY channels are derived in large part from their RGB complements. But because every printer subscribes to

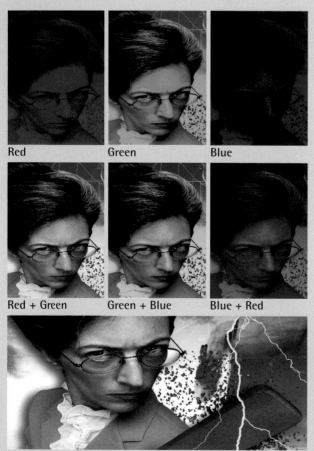

Red Green Blue

Red + Green Green + Blue Blue + Red

Red + Green + Blue

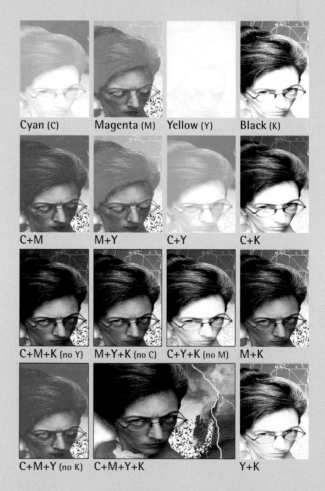

Cyan (C) Magenta (M) Yellow (Y) Black (K)

C+M M+Y C+Y C+K

C+M+K (no Y) M+Y+K (no C) C+Y+K (no M) M+K

C+M+Y (no K) C+M+Y+K Y+K

different standards, there is no one hard-and-fast formula. Rather, channels are mixed together in varying degrees according to the recipe outlined in the CMYK profile. So for example, the Cyan channel is mostly a duplicate of the Red channel, but it also mixes in bits of the Green and Blue channels to account for the idiosyncrasies of a given press.

Looking at the figure below, however, you might find this hard to believe. The top row shows grayscale versions of the RGB channels; the middle row shows their CMY complements. The CMY channels bear a passing resemblance to the ones above them, but it's as if the darkest levels have been replaced with light gray. And that's precisely what has happened. Photoshop generates the contents of the Black channel by leeching shadows from the Cyan, Magenta, and Yellow channels. When we add the Black channel, as in the bottom row of the figure, the

CMY channels more closely match the brightness of the RGB channels in the top row. (Yellow + Black appears lighter than Blue only because yellow is such a light ink.)

The most popular method for transferring dark pixels to the Black channel is called *gray component replacement*, or *GCR*. The idea is that paper can absorb only so much ink, after which point the ink begins to smear. Suppose that a press subscribes to a *total ink limit* of 300 percent. This means that the percentages of cyan, magenta, yellow, and black ink can add up to no more than 300. GCR makes sure the total ink limit never goes higher, even in the darkest shadows in the image. Photoshop steals the shadows from the CMY channels, puts them in the Black channel, and then darkens the old CMY shadows until the total ink limit is met. And so it is that black restores the darkness at the heart of the RGB image.

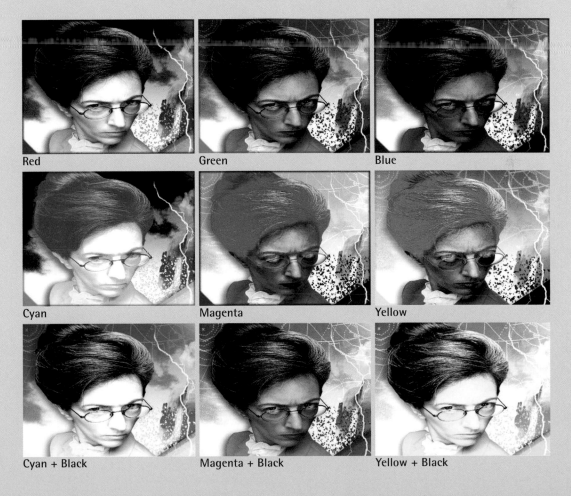

Red Green Blue

Cyan Magenta Yellow

Cyan + Black Magenta + Black Yellow + Black

22. ***Hand off the revised file to your commercial print house.*** This time, the image prints much more accurately. In fact, as demonstrated in Figure 12-25, it's difficult to tell the CMYK output from the CMYK image we see on the screen. The reds are still a tad weaker than I'd like, but the output is close enough to qualify as a successful conversion. (For proof beyond a shadow of a doubt, compare Figure 12-25 to Figure 12-19 on page 489.)

The new and improved CMYK output . . . better matches the image on screen

Figure 12-25.

Mind you, it's not always possible to create such accurate color conversions by winging it with Photoshop's Dot Gain controls. But given the uniformity of process inks and the fact that most domestic presses are calibrated to relatively common standards, it's worth a try. And there's nothing so empowering as successfully tweaking Photoshop's color settings so that your images output reliably to a commercial printing press.

Packing Multiple Pictures
onto a Single Page

Our final exercise is a cakewalk compared to the others in this lesson. I'll show you how to combine multiple copies of one or more images onto a single page using the Picture Package command. Originally designed to accommodate portrait photographers who routinely need to print common picture sizes onto cut sheets that they can sell to their clients, the command has increased in functionality to the point that I for one use it habitually. Whether you want to assemble quick-and-dirty proof sheets or make the most of expensive photo paper, Picture Package does a superb job of fitting differently sized images onto a page — which is precisely what we'll do in the following exercise.

1. *Open a photographic image.* For this, our swan song exercise, we'll create a proof sheet of my various children, starting with my eldest son, Max. Enter the folder *All my pirates* inside the *Lesson 12* folder inside *Lesson Files-PsCS3 1on1*. Then open the photograph *The Captain.jpg*, pictured in Figure 12-26. The image has been cropped and sized to 5-by-7 inches at 267 pixels per inch. But as you'll see, Picture Package doesn't give a darn about the size of the original photograph; it resamples the image to whatever size you specify in the following steps.

Figure 12-26.

2. *Choose the Picture Package command.* Go to the **File** menu and choose **Automate→Picture Package**. The job of the Picture Package command is to import multiple copies of an image into a new document. In fact, if you watch closely, you can see Photoshop create that new document before displaying the **Picture Package** dialog box. The command then offers to arrange two 5-by-7-inch copies of the photograph, as in Figure 12-27.

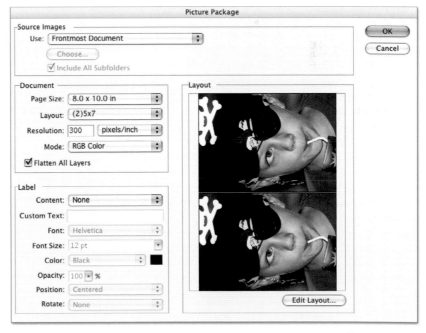

Figure 12-27.

3. *Specify the page size.* At first, Picture Package lets you select from three **Page Size** options, including letter and tabloid formats. (You can create others by clicking the Edit Layout button.) Assuming you'll be printing to a letter-sized page, the default setting, **8.0 × 10.0 in**, is fine.

4. *Select a Layout option.* Select the number of photos you want to print and the size of those photos from the **Layout** menu. I chose **(1)5×7 (2)3.5×5** to get a total of three photos, as in Figure 12-28. Notice that Photoshop automatically orients the images to fit as many on a page as possible. The assumption is that you'll slice apart the photos and turn them any which way you want after the page is printed.

5. *Adjust the Resolution value.* By default, the **Resolution** value is set to 300 pixels per inch, which is fine for our purposes. If disk space is scarce and you want the fewest pixels you can get by with, set the Resolution value between 240 and 267 ppi.

6. *Set the color mode to RGB.* Assuming that you'll be printing to an inkjet printer or some other personal color output device, leave the **Mode** option set to **RGB Color**.

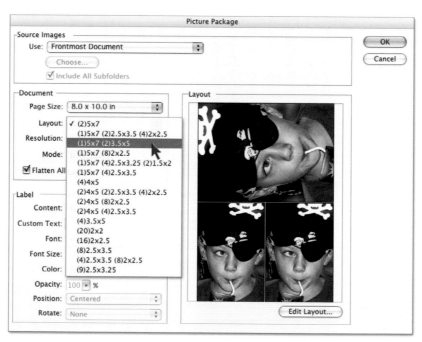

Figure 12-28.

7. *Set the Label options.* Featured in Figure 12-29, the **Label** options in the bottom-left quadrant of the dialog box permit you to add captions or copyright statements to your images.

- Start by selecting an option from the **Content** pop-up menu. The Custom Text setting adds whatever text you enter into the text field. In Figure 12-29, I selected **Filename**, which lists the name of the file on disk. The other Content options reference metadata entries created using **File→File Info** (see Lesson 1's "Using Metadata" exercise, page 23). If you plan on disseminating approval sheets, I recommend using the Bridge to copyright your images and then setting Content to Copyright.

- To streamline the command's performance, Picture Package permits you just three **Font** choices. For legibility's sake, I'd choose **Arial** on the PC or **Helvetica** on the Mac.

- Leave the **Font Size**, **Color**, and **Opacity** options set to their defaults (12 point, Black, and 100 percent, respectively).

- Set the **Position** to **Bottom Left** and leave **Rotate** set to None. As you'll see, these settings make it easier to reposition the text so that it doesn't overlap the images.

Note that Photoshop makes no attempt to preview your labels on the right side of the dialog box. But not to worry; the labels will appear when you click the OK button.

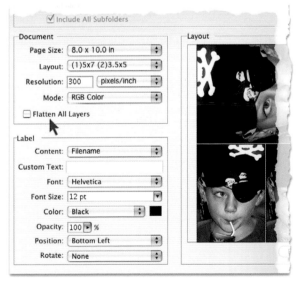

Figure 12-29.

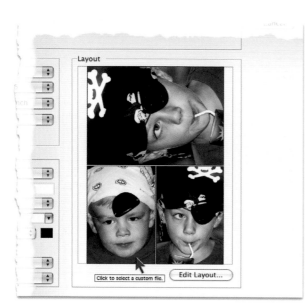

Figure 12-30.

8. **Turn off the Flatten All Layers check box.** If you ask me, labels are a wonderful idea with a very odd implementation. Regardless of which Position option you select, Photoshop places the labels directly in front of the images, thus obscuring some portion of the photograph. (The labels aren't intended as captions but as copy protection.) If you want to be able to move the text off the images, you must keep all the text layers intact by turning off **Flatten All Layers**.

9. **Load a second photograph.** By default, the Picture Package command repeats a single photograph multiple times. But you can switch out a photo if you prefer. Click the lower-left image in the preview area, as indicated by the position of the arrow cursor in Figure 12-30. An open dialog box appears. Navigate to the *All my pirates* folder inside *Lesson 12* inside *Lesson Files-PsCS3 1on1*. Then open the file named *The Henchman.jpg* to load a picture of my youngest, take-no-prisoners toughie, Sammy. Picture Package loads Sammy into the bottom-left corner of the page preview, as in the figure.

10. **Load a third photo.** Just to round things out, let's load a picture of the newest addition to the household. Click the lower-right picture of Sammy. Then open the image named *The Banana.jpg* from the same *All my pirates* folder. If you watched Video Lesson 8, "Filter Basics," you may find this piece of fruit familiar, albeit with some additions. Yes, my sanity is fragile—it's the end of the book, after all.

11. **Click the OK button.** Photoshop begins the automated process of opening files, scaling them, rotating them if necessary, and pasting them into the layered composition. Whatever you do, don't click anything as these operations are happening or you're liable to interrupt the process. Just wait until Photoshop adds the final image—the bandana'd banana itself—as in Figure 12-31 on the facing page.

12. ***Select the text layers and modify them.*** At first, you might think your text layers didn't make it. But if you look closely, you'll see that they overlap the lower-left corners of their photos. Fortunately, because the text is housed on independent layers, you can move and edit the layers.

- Select the top text layer, if it's not already selected.

- Choose **Select**→**Similar Layers**, which selects all the layers that are like the top layer. In our case, that means all the text layers.

- Photoshop automatically links the labels with their images so that you have to move them together. How inconvenient is that? Unlink the image layers by clicking the ⊷ icon along the bottom of the **Layers** palette, as in Figure 12-31.

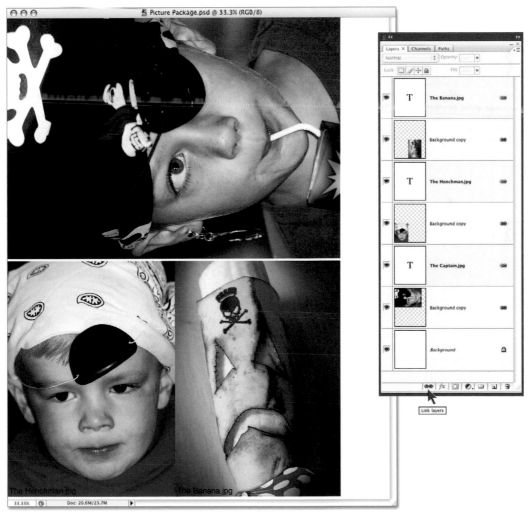

Figure 12-31.

- Press the Ctrl key (⌘ on the Mac) and drag inside the image window to move the selected layers.

- To change the font and size of the text layers as I've done in Figure 12-32, press T to switch to the type tool. Then choose the desired formatting attributes from the options bar at the top of the screen. Your settings will affect all selected layers.

You might have to adjust the position of one or two text layers individually as well. To do so, click the layer you want to move in the Layers palette. Back in the image window, Ctrl-drag (or ⌘-drag) the text to a different location. I also moved the images slightly apart to give them a little breathing room, sized the top image to make it fit better, and adjusted the canvas size.

13. **Save the composition.** Press Ctrl+S (⌘-S) or choose **File→Save.** Because the composition hasn't been saved before, Photoshop displays the **Save As** dialog box. Choose **Photoshop** from the **Format** pop-up menu. Name the image "All my pirates.psd" and click the **Save** button.

The composition is now ready for you to print to an inkjet printer or other device, as outlined in the exercise "Printing to an Inkjet Printer," which begins back on page 475.

Good job, you finished the book. (Unless you decided to start with this exercise, in which case, wow, you have a lot to go.) If you need some closure, check out the 1-minute, 10-second "Final Comments" movie, in which I invite you to buy more of my stuff and say, "See ya." (Oh man, I gave away the ending!)

Figure 12-32.

WHAT DID YOU LEARN?

Match the key concept in the numbered list below with the letter
of the phrase that best describes it. Answers appear upside-down
at the bottom of the page.

Key Concepts

1. Output
2. Subtractive primaries
3. Color separation
4. Print with Preview
5. Photo-grade paper
6. Commercial prepress
7. Color profile
8. Color Settings
9. Dot gain
10. Gray component replacement
11. Picture Package
12. The banana

Descriptions

A. A bit of code that describes a specific flavor of RGB or CMYK that is uniquely applicable to a display or print environment.

B. The most popular method for transferring dark pixels from the Cyan, Magenta, and Yellow channels to the Black channel, thus producing rich, volumetric shadows.

C. The best way to print images from Photoshop, this command lets you scale an image on the page and adjust the color management.

D. The output that occurs before a document is loaded onto a professional printing press for mass reproduction.

E. The act of preparing and rendering an image for mass reproduction, usually as a CMYK document.

F. This command combines multiple copies of one or more images into a single document so you can print them to a single sheet of paper.

G. The command that defines the RGB and CMYK color spaces employed by Photoshop.

H. A printing process that outputs each of the CMYK color channels to independent plates so that they can be loaded with different inks.

I. The degree to which professionally output halftone dots grow when they are absorbed by a sheet of printed paper.

J. A better pumpkin substitute than you might imagine—though, truly, not much of a pirate.

K. Cyan, magenta, and yellow, each of which absorb light when printed on paper and mix to form progressively darker colors.

L. A variety of glossy or matte-finished paper that holds lots of ink, allowing you to print extremely high-resolution images.

Answers

INDEX

hiding/showing toolbox and palettes, 4, 9
high-contrast images, 66
high bit depth, 98–99
high dynamic range (HDR), 99
highlights, 43
 changing highlight color, 245
 fading, 277
 protecting, 211
 toning down, 57
High Pass filter, 272, 273, 460
Histogram palette, 57–63
 expanded view, 58
 hiding color channels, 64
 showing all color channels, 58
histograms, 54–55
 black & white points, 54
 cached, 61
 clipping, 54
history brush, 182, 249
History palette, 203, 205, 207
Horizontal Filmstrip workspace, 16
HSL/Grayscale panel, 102–105, 110
hue, 71
Hue/Saturation adjustment layer, 436, 445
Hue/Saturation dialog box, 56, 62, 78–81
 Colorize check box, 83, 445
 Hue value, 445
 Lightness value, 445
 Saturation value, 445
 visible color spectrum wheel and, 75
Hue Jitter, 189

I

ICC Profile, 476, 486
 Prints-R-Us profile, 488
Illustrator
 creating smart objects from, 448
Image Compression option (TIFF), 37
images
 batch renaming, 30–34
 blending multiple, 329
 boundaries, 239
 copying, 114
 correction
 automatic, 44–50
 with Curves command, 57–63
 cycling between, 154
 duplicating, 44

extracting (see Video Lesson 7 on the DVD)
opening, 5–7
overdarkening, 256
packing multiple images on single page, 497–502
resizing, 171–176
rotating, 158
scaling, 156
selecting irregular, 133–141
sharpening, 65
straightening (see straightening images)
switching between layer mask and, 331
transferring from one background to another, 243–250
Image Size dialog box, 154, 171–176, 300, 360
 Document Size options, 173
 Pixel Dimensions options, 173
image stack, 20
image windows, 8
 resizing, 9
 status bar, 9
importing layers, 314–328
Include Layer Effects, 425
Indent Sides By value, 381
Inflate style, 325
Info palette, 154, 367
 show or hide, 154
inkjet printers
 photo-quality prints, 482
 printing to, 475–485
Inner Glow effect, 122, 123, 414
Inner Shadow effect, 319, 404, 408–414, 420, 425
 settings, 412
Input Levels, 51
interface and image window, 8–9
International Press Telecommunications Council (IPTC), 25
interpolation, 156
 settings, 173
Inverse command, 119, 126, 186
Invert adjustment layer, 435, 439
inverting brightness levels, 252–253
IPTC (metadata category), 25, 28
IPTC Core (metadata category), 25
isolating color, 80
isolating image element, 115
iStockphoto, 116, 447

J

Jitter values, 189
JPEG format, 48
justified type, 371
justifying text, 371

K

keyboard shortcuts
 adding to selection, 114
 adjusting selected value by 10x increment, 266
 adjusting select value incrementally, 266
 advance to next option, 70
 advancing to next/previous value, 266
 applying, canceling, and undoing adjustments, 42
 Auto Color, 42
 Auto Contrast, 42
 Auto Levels, 42
 backstepping through recent operations, 114
 Bring to Front command, 321
 Brushes palette, show/hide, 180
 brush tool
 changing attributes incrementally, 188
 eyedrop color, 180
 incrementally enlarging/shrinking brush, 180
 make brush harder/softer, 180
 Canvas Size command, 154
 changing opacity setting of layer, 304
 changing unit of measure, 154
 Character palette, 374
 cloning elements, 183
 closing all images, 50
 combining one layer style with another, 404
 copying an entire image, 114
 copying effect from one layer to another, 404
 Create Clipping Mask command, 198
 creating new layers, 199
 crop tool, 154
 deselecting images, 29
 displaying Layer Style dialog box, 404

ENJOY a Free Week
of training with Deke!

Get 24/7 access to every training video published by lynda.com. We offer training on Adobe® Photoshop® CS3 and 200+ other topics—including more great training from Deke!

The lynda.com Online Training Library™ includes 20,000+ training videos on hundreds of software applications, all for one affordable price.

Monthly subscriptions are only $25 and include training on products from Adobe, Apple, Corel, Google, Autodesk, Microsoft, Sony, and many, many others!

To sign up for a free 7-day trial subscription to the lynda.com Online Training Library™ visit **www.lynda.com/dekeps**.

lynda.com